The American Collections

COLUMBUS MUSEUM OF ART

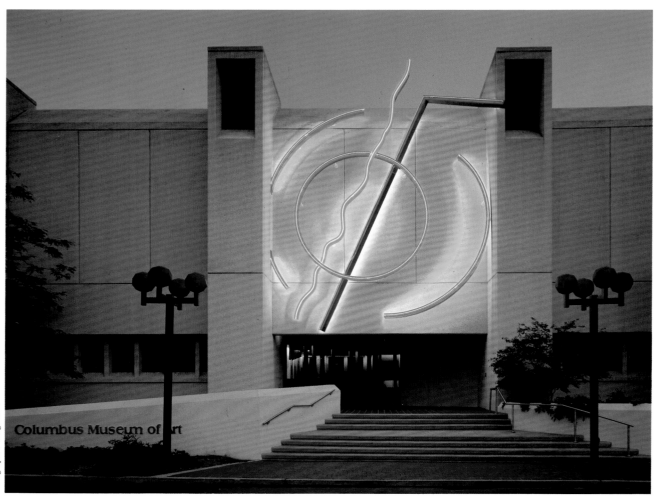

Columbus Museum of Art

The American Collections
COLUMBUS MUSEUM OF ART

CONSULTANTS

William C. Agee
John I. H. Baur (1909–1987)
Doreen Bolger

CONTRIBUTORS

Nannette V. Maciejunes *Laura L. Meixner*
E. Jane Connell *Debora A. Rindge*
William Kloss *Steven W. Rosen*
Richard L. Rubenfeld

EDITED BY

Norma J. Roberts

COLUMBUS MUSEUM OF ART
IN ASSOCIATION WITH
HARRY N. ABRAMS, INC.
NEW YORK

ISBN 0−918881−20−X (paper)
ISBN 0−8109−1811−0 (cloth)

LIBRARY OF CONGRESS CATALOGING IN PUBLICATION DATA

Columbus Museum of Art.
The American collections, Columbus Museum of Art / consultants,
William C. Agee, John I. H. Baur, Doreen Bolger; contributors,
Nannette V. Maciejunes . . . [et al.]; edited by Norma J. Roberts.
p. cm.
Bibiliography: p.
ISBN 0−8109−1811−0 ISBN 0−918881−20−X (pbk.)
1. Art, American—Catalogs. 2. Art—Ohio—Columbus—Catalogs.
3. Columbus Museum of Art—Catalogs.
I. Maciejunes, Nannette
V. (Nannette Vicars) II. Roberts, Norma J.
III. Title.
N6505.C64 1988
709'.73'07401715—dc 1988−23774

This catalogue is made possible by a generous grant from the Luce Fund for Scholarship
in American Art, a program of the Henry Luce Foundation, Inc. Additional support for the
catalogue was provided by a grant from the National Endowment for the Arts. Funds for
support of museum publications have been provided by
The Andrew W. Mellon Foundation.

FRONT COVER: Winslow Homer, *Haymaking*, detail [cat. no. 1]
BACK COVER: Edward Middleton Manigault, *The Rocket* [cat. no. 34]

PHOTOGRAPHY CREDITS
All black and white photographs in this book are from the museum's files unless otherwise
noted with the reproduction. Color photography, with the exception of catalogue numbers
40, 71, and 82 (which are from the museum's files),
has been provided by the following:

Lee Clockman
51

Greg Heins
86, frontispiece

Jon McDowell
24

Warren Motts
21, 23, 30, 32, 35, 69

Todd Weier
1–18, 20, 22, 25–29, 31, 33–34, 36–39,
41–50, 52–68, 70, 72–81, 83–85

Designed by Stephen Harvard and Paul Hoffmann
Typesetting and printing by Meriden-Stinehour Press,
Lunenburg, Vermont, and Meriden, Connecticut
The catalogue has been set in Palatino type with Diotima italic display
and printed on Warren's Lustro Offset Enamel.

Table of Contents

Part Two: Catalogue of the American Collections

Preface and Acknowledgments

The catalogue *The American Collections, Columbus Museum of Art* documents more than a century of assembling and studying what one prominent scholar describes as a "national treasure." Since its founding in 1878, the Columbus Museum of Art, the oldest art museum in the state of Ohio, has been acquiring and exhibiting the works of American artists. By the time its new Renaissance-revival building was opened in 1931, the museum housed what was considered to be one of the finest collections of American art in the country. Many of the works came from the distinguished collection of early modernist paintings formed by Ferdinand Howald, a long-time resident of Columbus, who was instrumental in realizing his own dream of a "real art museum in Columbus." Over the last fifty years the museum's American holdings have continued to expand until today over half of the collection is dedicated to American visual arts of the nineteenth and twentieth centuries.

In 1985 the Henry Luce Foundation, which had set aside funds for much needed research and publication in the field of American art through its Luce Fund for Scholarship in American Art, invited this museum to undertake research on its collections and to publish a catalogue. The project has been further assisted by the National Endowment for the Arts, which provided additional funds for the production of the catalogue, and by The Andrew W. Mellon Foundation, which provided support for the museum's publications program. We are at once proud and grateful for the support and recognition of these important agencies.

This catalogue represents the culmination of efforts by generations of serious collectors, scholars, benefactors, and museum leaders to nurture and develop an important artistic resource. It seems fitting to acknowledge at this writing our profound gratitude for their enlightenment and dedication, and equally to recognize the contributions of generous donors and civic-minded men and women who have defined this museum, bestowing upon it a special character. The names of those who have made possible the American collections catalogued herein appear with the works that have come to us through their generosity.

In carrying out this project the museum has been especially fortunate to enlist the fine minds and expertise of some of today's most prominent scholars in American art. Among those who served as consultants were the late John I. H. Baur, former director of the Whitney Museum of American Art, whose participation in the early stages of the project constitutes one of his last contributions to the study of American art. Doreen Bolger, associate curator of American paintings and sculpture and manager of The Henry R. Luce Center for the Study of American Art at the Metropolitan Museum of Art, continued superbly the work begun by Mr. Baur. William C. Agee, former director of the Museum of Fine Arts, Houston, and editor of the Stuart Davis catalogue raisonné, was with the project from beginning to end. The consultants helped in the planning process, reviewed the texts prepared for the highlights section, and provided insights, advice, and encouragement at every step.

Narratives on the eighty-six works selected as a representative sampling of the museum's American holdings were prepared by William Kloss, Laura L. Meixner, Debora A. Rindge, Richard L. Rubenfeld, and museum staff members. We are grateful to each of them for their informative texts and for their willingness to follow the work through various drafts.

Members of the curatorial, publications, and registration staff of the Columbus Museum of Art deserve special thanks for three years of steadfast dedication to the catalogue project. In particular, Assistant Curator Nannette V. Maciejunes, who served as project director for research, marshalled numerous forces to compile documentation of works and to prepare catalogue entries. The catalogue was edited by Norma J. Roberts, who indefatigably coordinated, incorporated, and edited the contributions of seven authors and three consultants. The work of these two principal project leaders was assisted and facilitated by the good work of many colleagues: in curatorial, Chief Curator Steven Rosen, Associate Curator E. Jane Connell, Curatorial Assistant Kathy Ferguson-Nell, and research volunteers Linda Fisher, Jan Leja, Elaine Tulanowski, Jeanette Cerney, Charles A. Brophy, Jr., Bernard Derr, and Caroline Russell; in registration, Registrar Christy Putnam and staff members Jane Isaacs, Maureen Alvim, and Rod Bouc; in publications, assistants Jean Kelly, Virginia Bettendorf, Kathleen Kopp, computer specialist Jenifer Roulette, and secretary Marveen Ahrendt. Former director Budd Harris Bishop administered the project in its initial stages, and former director of programs Craig McDaniel coordinated production and distribution of the catalogue.

In compiling the documentation of provenance, exhibition, and publications histories for eighty-six works, museum staff were especially grateful for the groundwork laid by former archivists, in particular Catherine C. Glasgow, and

for the generous cooperation of independent scholars, artists and their descendants, collectors, dealers, librarians, and staff members of other institutions. The following individuals deserve special thanks: Stephen Antonakos, Richard Anuszkiewicz, Walter Bareiss, Joseph H. Davenport, Jr., Earl Davis, Alvord L. Eiseman, Dan Flavin, Benjamin Garber, Thomas H. Garver, Mary Adam Landa, Peter Manigault, Clement Meadmore, Thomas N. Metcalf family, Ann Lee Morgan, Bernard B. Perlman, George Rickey, Kenneth Snelson, and Roberta Tarbell. Many others cheerfully searched through their institution's archives to provide answers to countless questions. The following were especially generous in their assistance: Kathy Hess of the Public Library of Columbus and Franklin County; Lisa Hubeny of the Carnegie Institute Museum of Art; Carol Clark, Gwendolyn Owens and Pamela Ivinski of the Maurice and Charles Prendergast Systematic Catalogue Project of the Williams College Museum of Art; Linda Ayres and Jane Myers of Amon Carter Museum of Art; Amy McEwen of the American Federation of Arts; Colleen Hennessey and Cynthia Ott of the Archives of American Art; Bruce Weber and Nancy Jo Barrow of the Norton Gallery and School of Art; Erica E. Hirshler of the Museum of Fine Arts, Boston; James L. Yarnall of the John La Farge Catalogue Raisonné Project; Bella Fishko of Forum Gallery; Elizabeth Broun of the National Museum of American Art; James and Timothy Keny of Keny and Johnson Gallery; Jennifer Saville of the M. H. de Young Memorial Museum; Katherine Kaplan of Kraushaar Galleries; Warren Adelson of Coe Kerr Gallery; Mary Ushay of Berry-Hill Galleries; Martha R. Severens of the Gibbes Art Gallery; Paul E. Cohen of the New York Historical Society; and Rowland P. Elzea of the Delaware Art Museum.

It is our hope that the research provided here will generate further study in American art and significantly expand our understanding of America's contributions in the visual arts. It is our further hope that this book will inspire readers to visit the Columbus Museum of Art to enjoy firsthand these unique, fascinating, and brilliant works of art.

Merribell Parsons
Director
Columbus Museum of Art

History of the Columbus Museum of Art

1878 On October 30 The Columbus Gallery of Fine Arts (CGFA) registered its charter with the State of Ohio. The document bears the signatures of trustees Joseph R. Swan, Francis C. Sessions, Alfred Kelley, James A. Wilcox, William B. Hayden, William G. Deshler, and Pelatiah W. Huntington. Joseph R. Swan (d. 1887) is elected the first president.

 Almost concurrently, the Columbus Art Association, which was to play a critical role in the development of the CGFA, is formed by a women's group to promote the arts "theoretically and practically," and to establish an art school. Mrs. Alfred Kelley is elected president.

1879 In January, the women of the Art Association establish the Columbus Art School.

1887 Because the CGFA is incorporated and the Art Association is not, the women of the Association decide against becoming a rival corporation and instead agree to become a legal agency of the CGFA. Three members of the Art Association are appointed trustees of the CGFA.

1888 In March the CGFA holds its first exhibition—at G.W. Early's Piano Parlors, Columbus.

1901 $30,000 is raised for art acquisitions and for the construction of a building at a future date.

1913 Monypeny property (mansion and barn) at East Broad Street and Washington is purchased for the art school and special exhibitions.

1919 The Francis C. Sessions home and property at 478 East Broad Street is deeded to the CGFA.

 Sessions, a founder of the CGFA and one of its first presidents (from February 1890 to 1892), was a descendant of the original colonists. Arriving from England in 1630, the Sessions family settled in Massachusetts. Francis's grandfather took part in the Boston Tea Party and fought in the Revolution. The young Sessions came to Columbus in 1840 and earned his living as a dry goods clerk. After serving in the Civil War he returned to Columbus and helped found the Commercial National Bank, becoming its first president. An art lover, humanitarian, collector, benefactor, author, traveler, as well as a successful businessman, Sessions was an early mover in establishing the arts in Columbus. He died in 1892, naming the museum as a beneficiary of his estate.

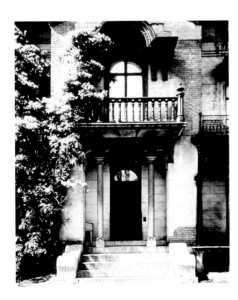

Entrance to Francis Sessions house.

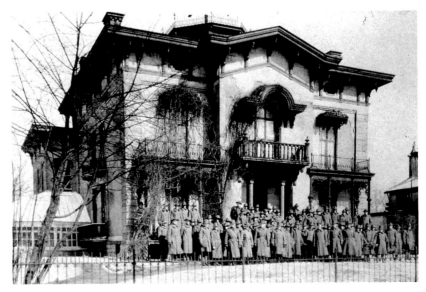

Francis Sessions house, ca. 1917.

1923　　The Columbus Art Association is dissolved, and its membership, along with the Columbus Art School, merge under the name of The Columbus Gallery of Fine Arts.

　　　　William M. Hekking is appointed the first director of the Gallery and the Art School.

　　　　The first Honorary Member is named: Warren G. Harding, President of the United States.

1926　　Karl S. Bolander is appointed director.

1928　　The Sessions house is torn down to make way for a new building.

1931　　The new building is opened to the public. It is designed in the Renaissance revival style by Columbus architects Richards, McCarty and Bulford, after drawings by Charles Platt of New York City, designer of the National Gallery of Art, Washington, D.C.

　　　　The opening exhibition celebrates the acquisition of the Ferdinand Howald Collection (a gift to the museum) and also features the Frederick W. Schumacher Collection (on extended loan), a group of George Bellows paintings (lent by his widow), and other loans from people in the community.

> Ferdinand Howald, a native of Switzerland who was raised in Columbus, Ohio, graduated from The Ohio State University in 1881, entered the coal mining industry in West Virginia, and through shrewd investments in Chesapeake and Ohio Railroad stock during the panic of 1893 made his fortune. He retired early—in 1906—and moved to New York, maintaining a residence in Columbus. Howald's interest in American art was sparked by a visit to the Armory Show in 1913. He began collecting in 1914. When his collection came to the museum in 1931 it included 280 works: 180 American paintings by artists such as Maurice Prendergast, Charles Demuth, Charles Sheeler, and Marsden Hartley; Flemish and Italian paintings of the fourteenth through sixteenth centuries; and works by European moderns such as Picasso, Degas, Derain, Braque, and Matisse. Howald also contributed a fifth of the money needed to pay for construction of the museum's new building and bequeathed additional funds earmarked primarily for the purchase of works by American artists.

1935　　Phillip Adams is appointed director.

1937　　The Amelia White collection of Southwestern American Indian artifacts is given to the museum.

1938　　Frederick W. Schumacher commissions sculptor Robert Aiken to produce a frieze depicting artists from Leonardo daVinci to George Bellows for the museum's facade on East Broad Street.

1942　　The Edward Bradford Titchener Collection of Polynesian and African art is given to the museum.

1946　　Lee H. B. Malone is appointed director.

1954　　Mrs. Earl C. Derby provides funds for the covering of an outdoor court at the center of the building, expanding exhibition space and, in later years, with the addition of tables and chairs, providing an all-weather, gardenlike setting for special events, lunches and conversation.

　　　　Mahonri Sharp Young is appointed director.

1957　　The Earl C. Derby and Lillie G. Derby Fund is established for the purchase of art objects by the masters.

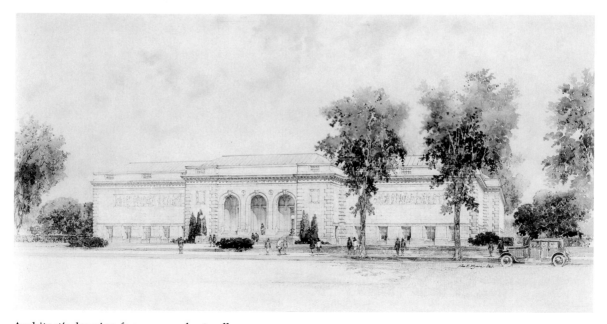

Architect's drawing for proposed art gallery, 1930.

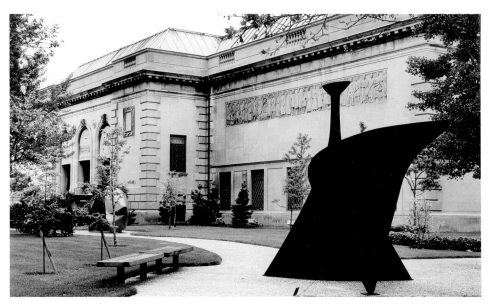

Columbus Museum of Art, Broad Street entrance, and portion of Sculpture Park.

1957 The Earl C. Derby and Lillie G. Derby Fund is established for the purchase of art objects by the masters.

The Frederick W. Schumacher Collection of 167 works becomes a permanent part of the museum's collections, adding paintings and sculpture by Dutch, Flemish, English, French, Italian, and American masters—artists such as Ingres, Moroni, Jordaens, Van Ruysdael, Lely, Gainsborough, Turner, Whistler, and others.

> Schumacher, who made his fortune as Vice President of the Peruna Drug Manufacturing Company in Columbus and in Canadian mining ventures, began collecting in 1899—mostly old masters. As he put it:
> In visiting European public and private galleries I came to the conviction that it would be best to concentrate on the Old Masters because there was little likelihood of their depreciation. I always believed that it should be possible with good judgment to find art works which would endure and remain objects of merit through the change of fashion. For this reason I acquired only a comparatively small number of modern paintings, intended for contrast with the classical periods as well as to indicate the future development of art, which never stands still.

1960 The Columbus Art School becomes the Columbus College of Art and Design.

1974 A 30,000 square-foot addition, now called the Ross Wing, is opened, providing space for temporary exhibitions, art storage, exhibition preparation, and offices. The Columbus Foundation authorizes grants to help with construction costs.

1976 Budd Harris Bishop is named director.

1977 Battelle Memorial Foundation provides funds for renovation of existing buildings to increase exhibition space.

The National Endowment for the Humanities provides a challenge grant to stimulate local giving to the renovation project and to the museum's operating fund.

1978 The museum's centennial year is celebrated, and the name is changed from The Columbus Gallery of Fine Arts to Columbus Museum of Art.

Ground is broken for a sculpture park and gardens on property surrounding the museum. Further renovations take place and a museum restaurant, the Palette, is established.

The John F. Oglevee bequest establishes a fund for the acquisition of Chinese and Japanese objects.

1979 The Sculpture Park and Gardens, designed by English landscape architect Russell Page, is dedicated.

1980 Funded through a grant from the National Endowment for the Arts, a reinstallation of the permanent collection is carried out.

1982 The Columbus College of Art and Design becomes an independent institution.

1983 Announcement is made that the Howard and Babette Sirak Collection of seventy-six works by French Impressionists, Post-Impressionists, German Expressionists, and others, will come to the museum in 1991 in a part-gift, part-purchase arrangement.

1985 A collection of Elijah Pierce woodcarvings is acquired by the museum.

1987 Merribell Parsons is appointed director.

Explanations

The catalogue is in two parts. Part One focuses in detail on eighty-six works by seventy artists selected to represent the museum's American collections. Catalogue entries in this section consist of biographical sketches on the artists, essays on the works, and full-page color reproductions. The works are arranged in approximate chronological sequence; variations have been dictated by stylistic considerations and the need to group together two or more works by a single artist over a long period of development. The title of each work is preceded by its catalogue number and followed by its date (if known) and the accession number assigned by the Columbus Museum of Art. Each work is fully documented (provenance, exhibition history, references, additional remarks) on pages 178 to 208.

Part Two of the catalogue is a checklist of nearly 800 works, citing dates (if known), medium and dimensions, signatures and inscriptions, and museum credit lines. Entries are in alphabetical order by artist's last name; works by anonymous artists are at the end, in chronological sequence, to the best of our knowledge. The checklist is followed by a summary of collections either too large to enumerate, such as prints, which include more than 2,500 works, or are only presently being developed by this museum (decorative arts, for example).

In measurements throughout the catalogue, height precedes width. In the case of most three-dimensional works, only the most prominent dimension is given (H. meaning height, L. meaning length, D. meaning diameter).

The signature or inscription line is included in cases where writing or other markings appear on any part of the work. The word "signed" is used only when the work is known to have been signed by the artist. The word "inscribed" is used for markings other than the signature and date applied by the artist.

Catalogue entries in Part One have been prepared by the following authors, whose initials appear at the end of their texts.

E. JANE CONNELL is associate curator at the Columbus Museum of Art. She is exhibitions organizer and author of the catalogues *More than Meets the Eye: The Art of Trompe l'Oeil* and *Made in Ohio: Furniture 1788–1888*.

WILLIAM KLOSS, an independent art historian in Washington, D.C., often writes and lectures on nineteenth- and early twentieth-century American art. He is the author of *Treasures from the National Museum of American Art* (Smithsonian Institution, 1985), and *Samuel F. B. Morse* (Harry N. Abrams, Inc., New York, 1988). He is preparing a catalogue of painting and sculpture in the White House, and another on the fine art belonging to the Department of State.

LAURA L. MEIXNER, assistant professor at Cornell University since 1983, has written and lectured on the interrelationship of American and French Barbizon and Impressionist painting. She was guest curator and catalogue author for the exhibition *An International Episode: Millet, Monet, and Their North American Counterparts*, organized for the Worcester Art Museum (Massachusetts), and is presently completing a book concerning nineteenth-century American cultural responses to French realism and Impressionism.

NANNETTE VICARS MACIEJUNES, assistant curator at the Columbus Museum of Art, is the exhibition organizer and author of the catalogue *A New Variety, Try One: De Scott Evans or S. S. David* and exhibition organizer and contributor to the catalogue *The Early Works of Charles E. Burchfield 1915–1921*.

DEBORA A. RINDGE, formerly director of duPont Gallery at Washington and Lee University, is pursuing doctoral studies in American art history at the University of Maryland. Her dissertation concerns the body of landscape subjects produced by artists and photographers on the major western surveys conducted after the Civil War.

STEVEN WHITE ROSEN has been chief curator at the Columbus Museum of Art since 1977. He is exhibition organizer and a contributor to the catalogue *Henry Moore: The Reclining Figure*.

RICHARD L. RUBENFELD received his Ph.D. from The Ohio State University in 1985. His dissertation is titled, "Preston Dickinson: An American Modernist," and includes a catalogue of selected works. He is presently associate professor of art history at Eastern Michigan University.

Part One

Highlights of The American Collections

*Endnotes, along with collections, exhibitions, and publications histories,
for works in Part One are to be found on pages 178 to 208.*

Winslow Homer, 1836–1910

In an era characterized by a taste for cosmopolitan cultural influences, Winslow Homer emerged as a strong proponent of the American scene, recording his impressions in both landscape and genre paintings. Homer was born in Boston, where he was apprenticed to the lithography shop of J.H. Bufford at the age of eighteen. In 1857 he became a freelance illustrator, selling his scenes of fashionable Boston and New England rural life to Ballou's Pictorial *and* Harper's Weekly. *He moved to New York City in 1859 and worked as a freelance illustrator while attending classes in Brooklyn and then, in 1861, at the National Academy of Design. His wood engravings of Civil War scenes, which rank among the finest records of wartime activity, were first published in* Harper's Weekly *in 1862, the year he completed* Yankee Sharpshooter *(private collection), his first painting based on the war. From 1863 through 1866 Homer exhibited war and home-front pictures annually at the National Academy of Design while continuing to illustrate for periodicals (*Our Young Folks *and* Frank Leslie's Chimney Corner). *In 1866 he departed for France, and in 1867 exhibited* Bright Side *(1865, private collection) and* Prisoners from the Front *(1866, Metropolitan Museum of Art) at the Universal Exposition in Paris.*

Homer returned to America in late 1867, again took up magazine illustration, and in his summer excursions to New England, the Adirondacks, the Jersey shore, and elsewhere painted some of his early masterpieces of summer resort life and rural genre scenes. In spring 1881, he made a second trip abroad, this time to Tynemouth, England, near Newcastle. The austere life of this North Sea fishing community inspired a series of oils and watercolors that were striking in their immediacy and heroic content—a complete departure from his earlier works. The English experience proved to be a turning point for Homer. After a brief return to New York City in 1882, he quit his residence there and in the summer of 1883 moved to the barren seacoast town of Prout's Neck, Maine, where he lived in increasing isolation for the rest of his life.

Man in contest with the sea became Homer's favorite theme and the one for which he is perhaps best known. The emotional content of Homer's paintings as well as his mastery of both watercolor and oil earned him recognition as one of America's leading painters and brought numerous honors and prizes worldwide. His brilliant tropical marines of Nassau, Cuba, and Bermuda, and enchanting studies of woods and lakes in the northern United States and Canada remain unequalled in American art.

1 *Haymaking*, 1864 42.83

Oil on canvas, 16 x 11 in. (40.6 x 27.9 cm.). Signed and dated lower left: Homer/64. Museum Purchase: Howald Fund, 1942

Among Homer's first oils are subjects drawn from the artist's love of country and his experience as a chronicler of the American Civil War. A war correspondent, and before that a lithographer's draftsman, Homer initially approached painting with a concern for the anecdotal qualities of time, place, and activity. In *Haymaking*, an early rural scene, the artist records his direct observations in a bold arrangement of crisp forms set against a simplified landscape background. The proximity of the subject to the viewer's space and the literal pose of the figure suggest the influence of the battlefield photography of Mathew Brady and his colleagues, whose work Homer may have seen while on assignment at the front. In choice of subject Homer's portrayal follows the example of William Sidney Mount and other pre-Civil War genre painters whose sunlit farm scenes captured the optimism of youth and bountiful nature.

Homer's remarkable feeling for color and light are both richly demonstrated in *Haymaking*. Through strong tonal contrasts and vibrant saturated colors he captures the brightness, warmth, and perhaps even the recollected aroma of a hayfield bathed in full summer sunlight. Choosing to record the view from a position marked by leafy shadows, the artist allows the viewer too to revel in the contrast of hot sun and cool shade. Homer's sensuous display of tones and colors is orchestrated to create a harmonious ambience that is in perfect accord with the optimism of harvest and plenty. The rustic lad goes about his labor with quiet authority. Young and hale, he personifies the American yeoman farmer and speaks to a nation's abiding faith in the myths of rural bounty and peace. But, as it reasserts a national pride in agrarian values, the painting also celebrates a rapidly vanishing rural innocence in the face of war and its implications for the human spirit.

Haymaking is the first work in a group of paintings and drawings that culminate with Homer's well-known *Veteran in a New Field* (1865, Metropolitan Museum of Art).[1] The subject of the later work is no longer the self-confident youthful farmer of *Haymaking* who confronts the viewer head-on. Instead, an older survivor of the war, with face averted, gratefully resumes the act of mowing a field. Like Homer's subjects, the nation, too, returned to the rhythmic comforts to be found in the natural cycles of life.

L.L.M.

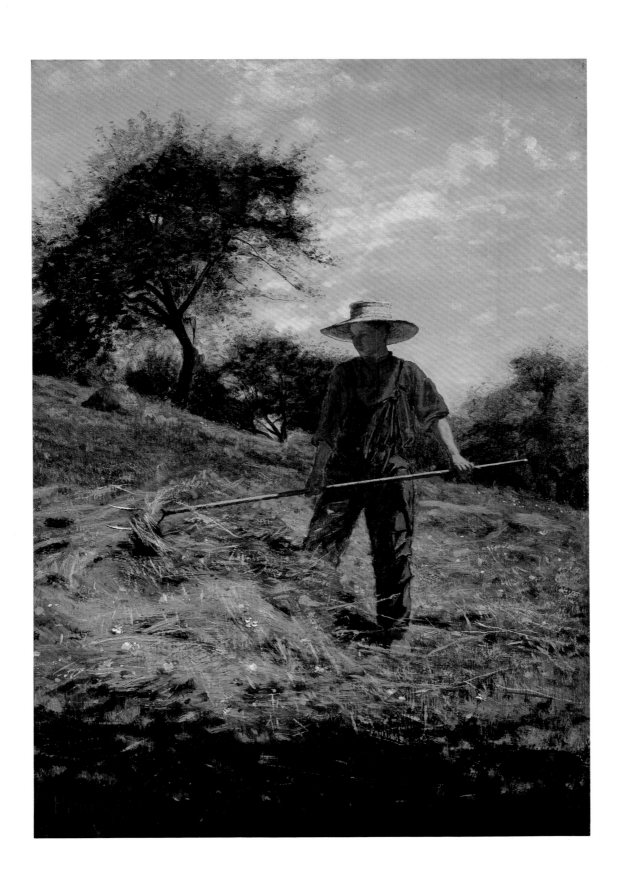

Winslow Homer, 1836–1910

2 *Girl in the Orchard*, 1874 48.10

Oil on canvas, 15⅝ x 22⅝ in. (39.7 x 57.5 cm.). Signed and dated lower right: Winslow Homer 1874. Inscribed upper left on stretcher frame: Winslow Homer/51 W 10th/N.Y. Museum Purchase: Howald Fund, 1948

Girl in the Orchard is as inviting as it is enigmatic. Homer has placed his attractive model in a cool, protective bower, against horizontal bands of lush green and golden fields, creamy sky, and dense orchard foliage. The young woman stands with eyes downcast, absently holding by her side a hat whose ribbons barely respond to a gentle summer breeze. The contemplative charm of the model and geometric clarity of the composition establish a mood of serenity and calm, which is enlivened by realist vignettes of scratching chickens and colorful daisies. Homer's careful draftsmanship is evident here, but his paint is thicker and more freely applied than in his paintings of the mid-1860s. Long strokes of pigment highlight the model's dress, as bold impasto highlights on her hat and the shoulder of her dress capture the sunlight that filters through the trees.

Homer devoted several oils and watercolors to the theme of a young woman isolated in a timeless landscape or interior setting. Because the model's features are not strictly portraitlike, her identity is a matter of speculation.[1] The girl in *Girl in the Orchard* must have occupied a very special place in Winslow Homer's life and career, judging from the number of times she appears in works throughout the 1870s. In an oil painting dating from 1872, entitled *Waiting an Answer* (Peabody Institute of Music, Baltimore), she appears in a pose and setting similar to those in *Girl in the Orchard*. Beside her on this occasion is a young farmer who momentarily turns away from his work as she approaches, perhaps implying that this scene describes a rural courtship. The girl appears alone in a series of watercolors beginning in 1874 in which she is typically engaged in various quiet activities such as reading, sewing, playing with a deck of cards, or simply lost in private thoughts. It has been suggested that her wistful or preoccupied gestures and poses may indicate psychological withdrawal from and eventual rejection of a present but unseen suitor—possibly Homer himself.[2] To heighten the mystery of the lovely model's identity and her apparent significance to Homer, it is known that he kept the painting *Girl in the Orchard* all his life, hanging it in a cottage near Kettle Cove, Maine, which he intended to occupy during his later years of self-imposed detachment and solitude.

L.L.M.

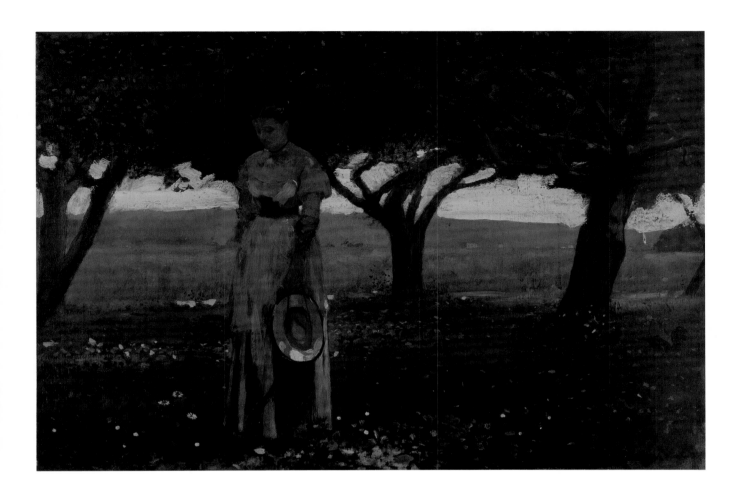

George Inness, 1825–1894

George Inness was a prolific artist who departed from the descriptive foundations of the prevailing Hudson River School to develop an independent style. His works introduced to American landscape painting a modern means of poetic expression. Inness's approach to painting is best reflected in his own words on the purpose of a work of art: "Its aim is not to instruct, not to edify, but to awaken emotion."[1]

Born in Newburgh, New York, and raised in Newark, New Jersey, Inness received only limited formal training—from John Jesse Barker, an itinerant artist, and from Regis Gignoux, a French artist living in this country. Nevertheless, Inness's professional career developed rapidly, beginning with his 1844 debut at the National Academy of Design and his establishment of a studio in New York City four years later. In 1850 Inness made the first of three sojourns in Europe, spending fifteen months in Italy and studying the landscapes of two seventeenth-century masters, Claude Lorrain and Nicholas Poussin. On a second trip abroad in 1853, Inness went to France and directed his attention to the works of early modern artists such as Theodore Rousseau and Camille Corot, two leaders of the Barbizon school of plein air landscape painting. From his assimilation of French art came such atmospheric, vibrant compositions as Clearing Up *(1860, George Walter Vincent Smith Art Museum, Springfield, Massachusetts) and* The Road to the Farm *(1862, Museum of Fine Arts, Boston). Beautiful works in their own right, paintings such as these led to more expressive allegorical paintings, which reveal Inness's intensely spiritual response to nature.*

In 1860 Inness moved from New York City to Medfield, Massachusetts, and four years later to Eagleswood, New Jersey (near Perth Amboy), where he came in contact with a community of artists that included William Page. Page encouraged Inness to follow the teachings of Swedish mystic Emanuel Swedenborg; as a result, during the mid-1860s, Inness painted symbolic landscapes with religious overtones, most notably the famous allegory Peace and Plenty *(1865, Metropolitan Museum of Art), inspired by the Civil War, and others more directly influenced by the Barbizon school.*

In the spring of 1870 Inness embarked upon his third trip to Europe, this time living in Rome and touring Tivoli, Albano, and Venice. In 1878 he took a studio in the New York University Building; purchased a home in Montclair, New Jersey; participated in the Universal Exposition, Paris; and published art criticism in the New York Evening Post *and* Harper's New Monthly Magazine. *A major retrospective organized by the American Art Association in 1884 brought Inness acclaim in the United States, and the Paris exposition of 1889 garnered him a gold medal abroad. His masterworks of the late 1880s and 1890s became increasingly expressive, nearly abstract.*

Inness died in 1894 at Bridge-of-Allan in Scotland. His achievements were commemorated in this country at a public funeral held at the National Academy of Design and by a memorial exhibition at the Fine Arts Building in New York City.

3 *The Pasture*, 1864 54.36

Oil on canvas, 11½ x 17½ in. (29.2 x 44.5 cm.). Signed and dated lower right: G. Inness 1864. Bequest of Virginia H. Jones, 1954

The Pasture exemplifies Inness's adaptation of the Barbizon style to the various moods of our native scene, in this case the rural tranquility of Medfield, Massachusetts. The painting shows the artist's appreciation of Corot, whom he numbered with Rousseau and Charles Daubigny among the landscapists he most admired. In *The Pasture*, Inness emulated Corot's mastery of poetic expression and aesthetic truths. Like Corot, he unified his composition with broad, loose handling of the brush.

Atmosphere is more important than detail, and color than line in Inness's lush field of green shades and tones. The light emanating from a bright blue sky suffuses the open pasture with a harmonious glow that is contrasted to the somber forest greens in the shadowed foreground. Inness maintains control of pictorial space through this conscious placement of vertical elements against the horizontal thrust of lake, stream, and pasture. The two trees that rise in the middle ground gently enframe the pastoral idyll in the center of the composition, and spatial balance overall lends a sense of psychological equilibrium, of hushed serenity. For Inness, this particular pasture represented isolated terrain momentarily untouched by the Civil War.

In scale and subject matter the picture is an eloquent demonstration of what Inness referred to as "civilized landscape." Drawn to scenes that quietly proclaim the imprint of man on natural surroundings, Inness here shows not an untamed wilderness but a clearing prepared for domesticated animals. A farmhouse in the background and a crude walking bridge in the foreground further attest to a human presence though no figures appear. Explaining his purpose in selecting such motifs, Inness wrote:

> Some persons suppose that landscape has no power of communicating human sentiment. But this is a great mistake. The civilized landscape peculiarly can; and therefore I love it more and think it more worthy of reproduction than that which is savage and untamed. It is more significant. Every act of man, every thing of labor, effort, suffering, want, anxiety, necessity, love, marks itself wherever it has been.[2]

L.L.M.

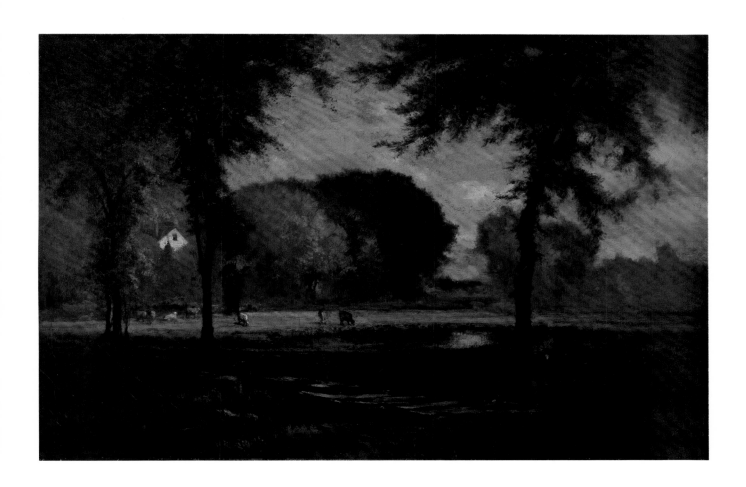

George Inness, 1825–1894

4 *Shower on the Delaware River*, 1891 54.2

Oil on canvas, 30¼ x 45⅛ in. (76.8 x 114.6 cm.). Signed and dated lower right: G. Inness 1891. Museum Purchase: Howald Fund, 1954

The expressive power of Inness's landscapes was never derived solely from the artist's imagination but was rooted in reality. As he maintained, "The poetic quality is not obtained by eschewing any truths of fact or of Nature. Poetry is the vision of reality."[1] In *Shower on the Delaware River* Inness gives form to his profound belief in a harmony of God, nature, and man.

In its simplicity, the scene possesses a moving universal symbolism. A cowherd watches as cattle graze in a meadow, a peaceful terrain undisturbed by the bordering village. In the distance are the symbols of regeneration and redemption: a rainbow, which suggests the renewal of the earth after rain; and a church steeple, which symbolizes man's union with God. The rainbow was a particularly meaningful motif for Inness, who had used it in a more literal way in earlier works such as *Delaware Water Gap* (1861, Metropolitan Museum of Art) and *A Passing Shower* (1860, Conajoharie Library and Art Gallery, New York). Its function in *Shower on the Delaware River* is more poetic, closer to the style of French Barbizon painter Camille Corot. As Inness said, "Let Corot paint a rainbow, and his work reminds you of the poet's description, 'The rainbow is the spirit of the flowers.'"[2]

Inness's perceptions of nature were intensified by his faith in Swedenborgianism. Swedenborg held that the spiritual world differed only slightly from the natural world in two regards: forms in the spiritual world were not subject to the law of gravity, and all colors were luminous and vibrant. Inness's late style suggests his artistic response to these beliefs. In *Shower on the Delaware River*, for example, the broad tonal areas that typified the style of his middle period are replaced by amorphous masses of color that float within pictorial space. Pronounced texture now creates an atmospheric veil that obliterates detail, and the scene is unified with blue-green sequences that evoke a sense of nature's burgeoning life forces. Aesthetic and emotional harmony transcend descriptive concerns in this metaphorical image.

Yet aside from its visionary effect and spiritual dimension, *Shower on the Delaware River* is modern in its bold, nearly autonomous, use of formal elements. Critics of his own era recognized Inness's works for this quality. In one famous instance, a critic referred to one of Inness's works as "more of a painting than a picture."[3]

L.L.M.

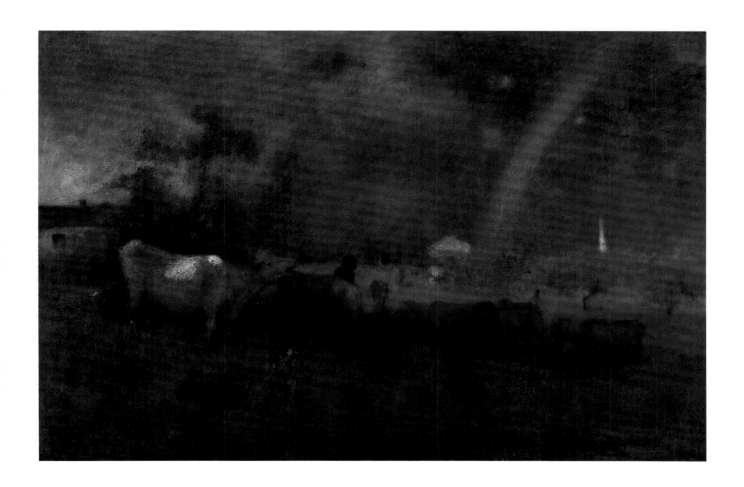

Albert Bierstadt, 1830–1902

Bierstadt, who was born in Solingen, Germany, came to the United States at the age of two and was raised in New Bedford, Massachusetts. In 1853 he began a period of study in Dusseldorf and Rome, returning to the United States in 1857. The next year he exhibited at the National Academy of Design, and in 1859 he established his studio in New York City. That same year he had his first encounter with the Western landscape as he traveled to Wyoming with the Pacific Coast Railway Survey team. His reputation was made with the 1864 exhibition of his Rocky Mountains at the Metropolitan Museum of Art.

Bierstadt's polished technique and majestic subject matter made him popular with patrons both at home and abroad. He was presented to Queen Victoria and decorated by Napoleon III. His epic canvases conveyed to easterners and foreigners alike the awesome power of the untamed American wilderness.

Toward the end of the century Bierstadt's popularity waned as tastes changed, and his works fell into obscurity.

5 *Landscape* 29.3

Oil on canvas, 27¾ x 38½ in. (70.5 x 100.3 cm.). Signed lower left: A Bierstadt. Bequest of Rutherford H. Platt, 1929

Though modest in size, this painting effectively captures the sweep of a lake ringed with mountains. An ominous storm cloud in the upper left portion sets the mood and dominates the painting as it shadows the rocky slope at the lower left. The dark edges frame a brilliantly lit central area, where the shining water and light-suffused clouds are spellbinding. Everything, even the placement of the lone bird, is calculated to attract the eye to this focus. The sharp contrast between the dark, cleanly etched foreground and the lighter, softer background modifies the sensation of distances. It is not the massive aspect of a real mountain landscape which Bierstadt chooses to express, but the other-worldly, pantheistic character of his own vision.

Man is utterly absent. Save for the soaring bird and the possible faint indication of a swimming deer, the animal world, too, is unrepresented. Nature is seen in Bierstadt's works as pure and inviolate, a poetic, spiritual transcendence. In this he may have been inspired by Goethe, who had written of the artist's need to "produce something spiritually organic, and to give his work of art a content and a form through which it appears both natural and beyond Nature."[1]

Bierstadt treated the American West with considerable topographical latitude in his paintings. In the museum's picture he depicted a scene that is similar to another in a much larger canvas called *Among the Sierra Nevada Mountains, California* (1868, National Museum of American Art).[2] Like the larger work, the untitled picture may have been painted during the artist's European travels of 1867–1869, raising the likelihood that both are composites of various scenes, whether in the Sierras or elsewhere.

W.K.

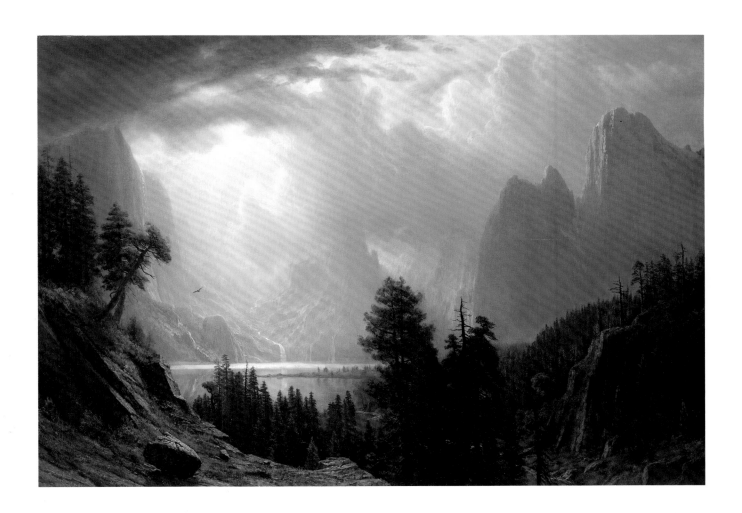

Martin Johnson Heade, 1819–1904

Martin Johnson Heade, who is now considered a major nineteenth-century American artist, achieved only a modest reputation during his lifetime and was forgotten almost entirely in the years following his death. Interest in his work revived in 1943 when his painting Thunderstorm Over Narragansett Bay *(1868, Amon Carter Museum, Fort Worth) appeared in the exhibition* Romantic Painting in America *at the Museum of Modern Art in New York and drew the attention of critics.*

Born in Lumberville, Pennsylvania, in 1819, Heade received his first artistic training in neighboring Newton, Pennsylvania, from noted primitive painter Edward Hicks and possibly from Thomas Hicks, Edward's cousin. Heade's earliest known work is a portrait from 1839. He began to exhibit his portraits and genre paintings in 1841 at the Pennsylvania Academy of the Fine Arts and subsequently—in 1843—at the National Academy of Design in New York. A compulsive traveler most of his life, Heade had visited Europe twice and lived in seven American cities by 1859, when he returned to New York. His mature style developed during the early to mid-1860s, when he experimented widely and introduced the subjects that would concern him for the

remainder of his career. Between 1863 and 1870 he made three trips to South America, which inspired his many tropical paintings of hummingbirds and orchids. In 1883, at the age of sixty-four, he married and settled in St. Augustine, Florida, continuing to paint until his death in 1904.

Heade's earliest dated landscape is from 1855. In 1859 he established a New York studio in the famed Tenth Street Studio Building along with noted landscape artists Albert Bierstadt, Sanford Gifford, and, most significantly for Heade, Frederic Church, who became a lifelong friend. Contact with these second generation Hudson River School artists stimulated Heade's interest in landscape painting and brought about a turning point in his career. Landscapes make up one-third of Heade's total oeuvre; more than 120 are marsh landscapes. Through the marsh scenes it is possible to trace the artist's entire development as a landscape painter.[1] Heade was the first to paint the marshes for their own sake,[2] as vast, lonely expanses where the dramas of nature are played out. The power of his understatement is as riveting as the grandeur of Hudson River School painting.

6 *Marsh Scene: Two Cattle in a Field*, 1869 80.2

Oil on canvas, 14⅜ x 30¼ in. (36.5 x 76.8 cm.). Signed and dated lower right: M/Heade · 69. Acquired through exchange: Bequest of J. Willard Loos, 1980

Whether defined by its broad philosophical implications or in terms of its narrower stylistic tendencies, the aesthetic of luminism, which flourished in America in the third quarter of the nineteenth century, is evident in Heade's marsh landscapes. The highly polished surfaces of his paintings; the meticulous detail that reveals no trace of brushwork; the clearly ordered, balanced compositions with their measured spatial recession; the intimate scale and horizontality of his canvases, which usually conform to a height:width ratio of 1:2; the palpable silence and brooding tranquility; and, most important, the smooth radiant glow of light created by minute tonal modulations make many of Heade's landscapes paradigms of luminism.[3] The format rarely varies. Working within the confines of a restricted vocabulary Heade experimented with selective pictorial elements over several decades, creating a series of works that are variations on a central compositional theme and a study in the unity of tone and atmosphere.

Marsh Scene: Two Cattle in a Field of 1869, one of Heade's first twilight marsh scenes,[4] represents a critical period of transition in the development of the marsh landscapes. Between 1860 and 1870, Heade narrowed his focus of interest—no longer experimenting with a wide variety of atmospheric effects but choosing to paint the twilight and the bright sunsets of clear days. The palette changes accordingly, with the cool tones of the 1860s giving way to brighter, warmer shades of red and orange in the 1870s and 1880s, and as a consequence the mood also changes. The museum's marsh scene is distinguished by the luminist pink-to-raspberry colored sky, which differs markedly from the orange sunsets of his later paintings.[5]

Unlike his Hudson River School colleagues, Heade seems to have done comparatively little sketching. The few drawings that have survived in his sketchbooks include favored motifs that were later incorporated into paintings. The scene depicted in the museum's painting, for example, is linked to two sketches from the decade of the 1860s: one of a covered haystack and another of two cattle.[6]

The museum's picture most likely depicts the marshes of Hoboken, New Jersey,[7] with their broad, flat topography and covered haystacks, which distinguish these from the Newburyport, Massachusetts, marshes that inspired some of the artist's earlier canvases. Following his return to New York in 1867 from his second trip to South America, he chose to paint the conveniently located marshes of a neighboring state.

Heade's vision was highly personal. His mysterious, poetic landscapes have a haunting, almost surrealistic quality that appeals to a particularly modern sensibility. A peripheral figure, overshadowed by the greater names of his day, Heade was little understood by his contemporaries. Clement and Hutton noted in the 1884 edition of their encyclopedia of American Artists that Heade had achieved a degree of popular success with his marsh landscapes, and "the demand has been so great that he has probably painted more of them than [of] any other class of subjects." The same paintings, however, were dismissed by other critics for their uninteresting subject matter and "hard and chilling" manner, which everyone agreed was "very peculiar."[8]

N.V.M.

Severin Roesen, 1815 or 1816 – after 1872

Severin Roesen was one of the most ambitious and prolific still-life painters of nineteenth-century America. While only the bare outlines of the artist's life are known, it is believed that he was born in or near Cologne and that he is the porcelain painter who exhibited a floral painting at the local art club of Cologne in 1847.[1]

Roesen immigrated to the United States in 1848, possibly as a result of political upheavals in Germany. Between 1848 and 1852 he exhibited and sold eleven paintings through the American Art-Union in New York. Other exhibitions of his work include those at the Maryland Historical Society in Baltimore in 1858, the Pennsylvania Academy of the Fine Arts in 1863, and the Brooklyn Art Association in 1873.[2] He remained in New York until 1857, when he abandoned his young family and moved to Pennsylvania. After a brief stay in Philadelphia, he moved on to the rural, strongly German communities of Harrisburg, Huntingdon, and finally Williamsport, where he arrived around 1863. His last known dated picture is from 1872, the year he is thought to have left Williamsport to return to New York.[3] The date and location of Roesen's death are unknown.

More than three hundred of Roesen's lavish floral and fruit still lifes have been recorded. Because no more than two dozen or so are dated, it is difficult to establish a chronology of his paintings. His works demonstrate little stylistic development, though there is some indication that his still lifes became increasingly elaborate until 1855, after which their complexity apparently depended upon his patrons' preferences.[4] The belief that the quality of his later work declined as a result of his excessive drinking has recently been called into question.[5] He seems rather to have been an artist of uneven abilities who has been aptly described as "a part-time perfectionist" capable of demonstrating both skill and carelessness, sometimes within the same picture.[6] His choice of subjects was limited and his paintings at times border on formulistic monotony. Favored objects and, in fact, whole compositional groups appear again and again in his paintings. A contemporary description of Roesen's studio suggests he worked on numerous still lifes simultaneously: "there were about a hundred pictures, mostly half finished and covered with dust, standing about the room, and about a half dozen easels holding canvases on which he worked alternately."[7]

His rich still lifes reflect the tradition of late seventeenth- and early eighteenth-century Dutch still lifes and the influence of contemporary painting in Dusseldorf—particularly the still lifes of Johann Wilhelm Preyer, with whose work Roesen's is closely associated. In addition, the elaborate character of Roesen's still lifes, with their proliferation of objects, embodies the taste and optimism of mid-nineteenth-century America. An underlying theme of the works is abundance—specifically, the endless bounty of nature in the New World and the secure good life in Victorian America.[8]

7 *Still Life* 80.32

Oil on canvas, 21¾ x 26¾ in. (55.3 x 67.9 cm.). Signed lower right: S. Roesen. Acquired through exchange: Bequest of J. Willard Loos, 1980

Roesen's consummate ability to visually represent abundance is demonstrated in the museum's still life. A small-scale work by the artist's standards, it nonetheless typifies his version of the well-stocked table. The luscious fruit on a marble ledge spills over the edge into the viewer's space. The large, metallic compote overflowing with peaches and grapes, the pilsner filled with effervescent champagne, and the bird's nest cradling three eggs are all familiar objects that populate countless Roesen still lifes. It has been suggested that the artist's repetition of objects and his use of fruits from different seasons in the same composition may indicate that he used templates or relied on botanical prints as models.[9]

Whatever its source, the fruit in the painting is tantalizingly fresh, with translucent drops of dew still clinging to it. Roesen's colors are bright, clear, and almost naive in their radiance. The fruit is carefully modeled and crisply delineated; twisting, serpentine vines and stems form an elegant calligraphy that unites and frames the intricate design. Another characteristic feature of his work is the solitary tendril extending over the ledge, whimsically forming the artist's script signature, with the initial *S* inside the *R* of Roesen.

<div align="right">N.V.M.</div>

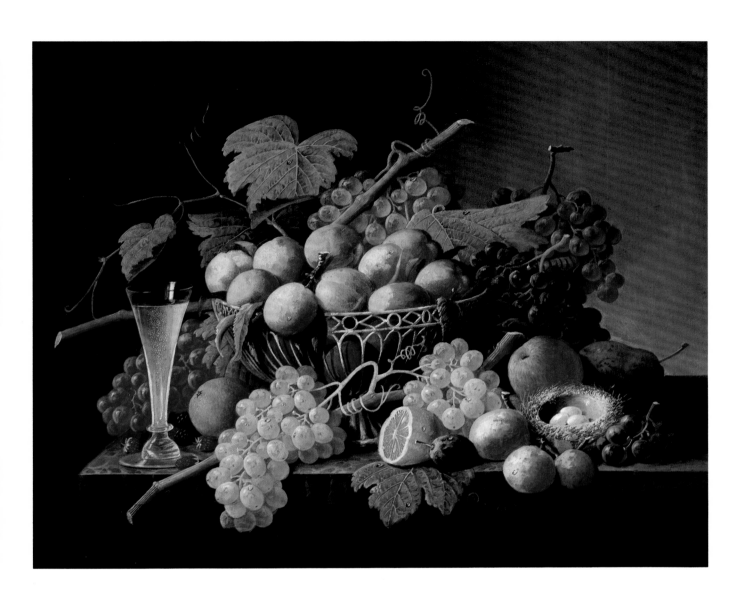

William Michael Harnett, ca. 1848–1892

Harnett, who was born in Ireland, was raised in Philadelphia. He trained as a silverware engraver, and then began his study of art at the Pennsylvania Academy of the Fine Arts in 1867. After moving to New York City in 1869, he studied at the Cooper Union and the National Academy of Design while supporting himself as a jewelry craftsman. He devoted his full attention to painting beginning in 1875, the year of his first exhibition at the National Academy. He moved back to Philadelphia the next year, opened a studio, and once again enrolled at the Pennsylvania Academy, where it is likely that he studied still-life painting with Thomas Eakins. He left for Europe in 1880, going first to London, then to Frankfurt, then (probably early in 1881) to Munich, where he remained until late 1884 or early 1885. He left Munich for sojourns in Paris and London before returning to New York in April 1886. Following a second European trip in 1889, he died in New York City at the age of forty-four.

From the outset of his career, Harnett was a specialist in the exacting art of still-life painting, producing numerous tabletop as well as trompe l'oeil compositions. Though he was considered old-fashioned by critics of his time, today he is recognized as the leading practitioner of late nineteenth-century American still-life painting.

8 *After the Hunt*, 1883 19.1

Oil on canvas, 52½ x 36 in. (133.4 x 91.4 cm.). Signed with monogram and dated lower left: W.M.Harnett/München/1883.
Bequest of Francis C. Sessions, 1919

Harnett painted four trompe l'oeil still lifes that bear the title *After the Hunt*. The version in the Columbus Museum of Art is one of the first two similar compositions painted in Munich in 1883 (the other is in the Amon Carter Museum, Fort Worth).[1] These paintings in all probability were inspired by the Alsatian Adolphe Braun's very large photographs of dead game and hunting gear hanging on a door or wall. The compositions established the artist's reputation and are still his most famous works. All were painted in Europe, where hunting subjects were especially popular. Coiled hunting horns and Tyrolean hats, needless to say, are a step closer to William Tell than to Daniel Boone.

Harnett is solidly within the tradition of trompe l'oeil painting in his hunt series. Such works, to have the maximum effect, must be strikingly realistic and must avoid the depiction of deep pictorial space. In *After the Hunt* the canvas appears to be a wooden door on which objects hang. The illusionistic birds and hunter's paraphernalia project relief-like from the "door" into our space. We are first attracted to Harnett's work by its bold forms, but it is through the tactility of the objects that the artist convinces us of their "reality." Imitative details of compelling naturalism abound: the dents in the horn, especially in the small coil; the rust stains below the lock plate and bolt on the left side; and the running stag carved into the rifle stock.

The painting is also remarkable for its unity of design. Curved shapes are played against strong diagonals within the triangle formed by the hunting objects. Balance is achieved by the subtle disposition of light and dark: for example, the large expanse of light on the mallard's breast is effectively balanced by the more intense light striking the feather in the hat. The echoing curves of birds' wings, powder horn, hunting horn, hat, feather, and corn tassel are visually sophisticated and compelling.

Curiously, the components in the Columbus hunt picture are placed so that they seem to suggest a figure. At the top, the hat becomes a head, and the horn next to it is ready to be sounded. The powderhorn slung below mimics an arm holding the gun to the shoulder. Just as there are many portraits in which objects associated with the sitter's profession or avocations are depicted to better express personality, here the things themselves seem to stand in place of the sitter. The painting is richly ambiguous.

It is also stylistically and emotionally in accord with the character of much American art of the last quarter of the nineteenth century. For there was another side to the Gilded Age's comfortable, sociable art, a dark counterpart of inward-turning late romanticism. In Harnett's picture, this mood is embodied in the somber lighting and the bold swellings and curves that push against the enveloping darkness. Dense and portentous, the picture has affinities with otherwise quite different paintings of the era: the nocturnal broodings of Ralph Blakelock; the paintings of hunted animals and hooked fighting fish by Winslow Homer; and, not least, Thomas Eakins's rigidly isolated portraits. While optimism and prosperity abounded in late nineteenth-century America, artists such as Harnett and others sounded their notes of melancholy counterpoint.

w.k.

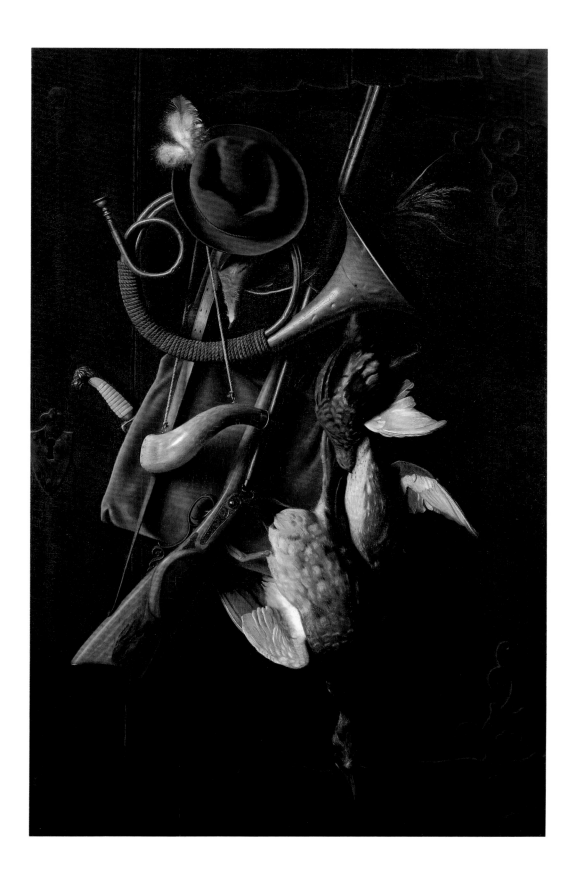

Attributed to De Scott Evans, 1847–1898

A Midwesterner by birth, De Scott Evans was a mainstream portrait and genre painter who worked first in rural Indiana, then in Cincinnati and Cleveland, Ohio. Between 1873 and 1875 he taught at Mount Union College in Alliance, Ohio, and between 1882 and 1887 at the Cleveland Academy of Art. He spent a year in Paris, from 1877 to 1878, studying with Adolphe William Bouguereau. In 1887, at the age of forty, he left the Midwest for the art world of New York. He died tragically in 1898, drowned in the shipwreck of the Paris-bound liner La Bourgogne.

Evans was best known for his genre paintings of modish young women in ornate settings. He was "a consummate master of stuffs," according to a critic of his times.[1] But interest in his work declined soon after his death and did not revive until a number of related trompe l'oeil still lifes bearing the signature S. S. David, or variations of that name, were attributed to

him.[2] The attributions are based in particular on two virtually identical trompe l'oeil compositions of pears, one signed De Scott Evans and the other Scott David. Because an artist named David could not be identified in connection with the time and place of any of these works, it is assumed that they are by a single artist and that he is Evans. The attribution is by no means a certainty, however.[3] It is equally tenable that the two paintings were produced by two artists and that one copied the work of the other, or that both painted the same subject.

While many questions remain concerning the authenticity of the attribution, there is no doubt about the quality of the paintings themselves. These small, exquisitely realistic works, are genuinely appealing for their inventiveness, whimsical presentation, and conceptual integrity.

9 *A New Variety, Try One* 76.42.2

Oil on canvas, 12⅛ x 10 in. (30.8 x 25.4 cm.). Signed lower right: S.S. David. Gift of Dorothy Hubbard Appleton, 1976

Ordinary nuts, especially peanuts, which entered the commercial food market in quantities after the Civil War, became the subject of a number of trompe l'oeil works by artists such as John Frederick Peto, Joseph Decker, and Victor Dubreuil. The theme of nuts behind broken glass, as in *A New Variety, Try One*, is particularly associated with a group of trompe l'oeil works attributed to De Scott Evans. These nuts do not appear to be accessible like those in Decker's *A Hard Lot* (present location unknown), or in Peto's *Peanuts—Fresh Roasted, Well Toasted* (private collection). Instead, these nuts are contained in a rough-hewn wooden niche, protected from surreptitious nibblers by a piece of broken glass. Moreover, there is often a menacing written invitation tempting the passerby to risk the jagged, dirty glass for the sake of a sample. The artist nearly always incorporates an unusual compositional device: one nut, balanced precariously on the edge of the niche and projecting into the viewer's space appears to be accessible, but if that nut could be removed the entire contents would cascade out of the niche.

As is typical of trompe l'oeil painting, the deception in *A New Variety, Try One* is achieved by meticulous illusionistic rendering of the actual-size image. Nearly all traces of brushwork are suppressed as the painter uses his technical virtuosity to hide any sense of his own presence. The illusion is enhanced by an unusual device: the edges of the canvas, where it wraps around the stretchers, are exposed, and these have been painted to look like the sawed and planed sides of a thick board. The top edge is darkened as if dust and dirt had accumulated on it.

A New Variety, Try One is one of more than twenty nut still lifes attributed to Evans.[4] The meaning, if one exists beyond the fascination of their visual deception, remains elusive. The ready market for these trompe l'oeil works (which were immensely popular despite the disdain of contemporary critics) no doubt accounts for the numerous replicas. Nevertheless, each is a masterful *tour de force* of illusion that continues to intrigue the viewer long after the visual deception has lost its initial power.

N.V.M.

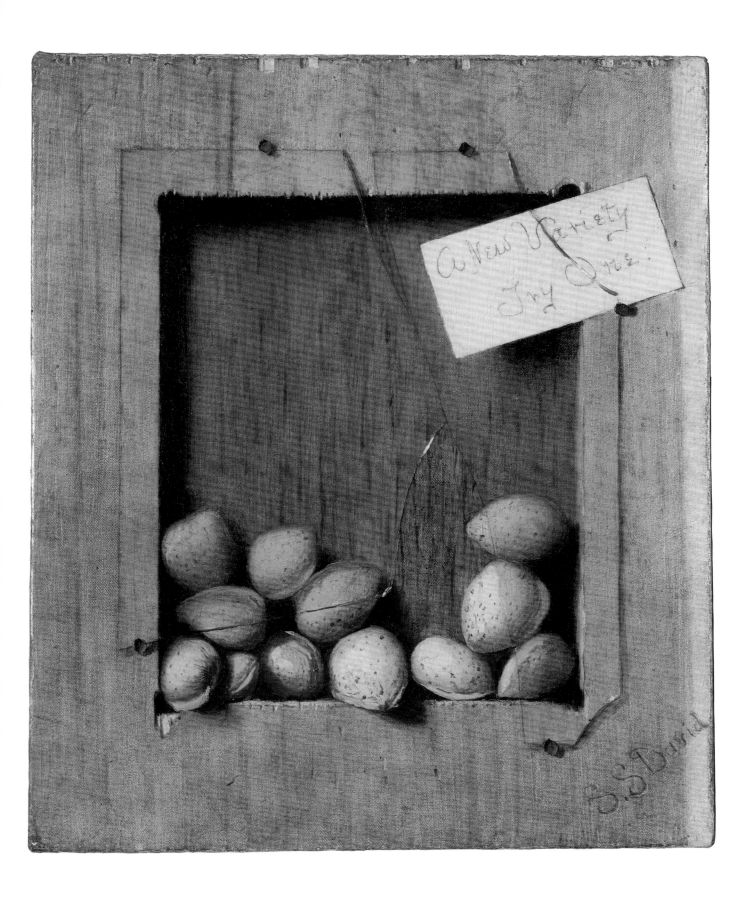

A New Variety
Try One.

Albert Pinkham Ryder, 1847–1917

Albert Pinkham Ryder began to paint landscapes in his hometown of New Bedford, Massachusetts, while still a youth. He received no formal training until in his early twenties he moved with his family to New York. There he studied first with William Edgar Marshall (1837–1906), a portraitist and engraver, and then at the National Academy of Design for four years. Ryder made the first of four trips to Europe in 1877.

Recent scholarship has challenged the traditional beliefs that Ryder was a recluse whose style developed in nearly total isolation, unaffected by contemporary currents in either American or European art, and that he was unappreciated outside a coterie of artist friends.[1] Only during the later years of his life did he retreat into the reclusive, nearly destitute, existence in which Marsden Hartley discovered him. His art was intensely personal, drawn from his own inner reality, but nevertheless rooted in his training and experience. Ryder was deeply influenced by the Barbizon school of painting as well as the Dutch Hague School with whose work he became familiar through his travels and through his association with Daniel Cottier, his dealer. A founding member of the Society of American Artists in 1877, Ryder also became closely associated with a circle of artists—among them painters Julian Alden Weir and Wyatt Eaton and the sculptor Olin Warner—who resided at the Benedick Building on New York's Washington Square East during the 1880s. Robert Loftin Newman (1827–1912), who shared Eaton's studio, was particularly important to Ryder's development and is believed to have influenced his shift from pastoral landscapes to imaginary and mystical-religious themes.[2] Ryder exhibited extensively through the 1880s and received favorable critical recognition at the time. His work enjoyed a particular popularity among the early twentieth-century American avant-garde, who heralded him as a harbinger of modernism in America. Ten of Ryder's paintings were exhibited in the Armory Show of 1913.

Ryder completed less than two hundred paintings and produced few, if any, new works after 1900. Although he always insisted on the preeminence of an artist's original inspiration, he often kept paintings in his studio for several years, reworking them again and again, building up successive layers of pigment and glazes. He never dated his pictures and only rarely signed them. Because he lacked certain technical knowledge and experimented with materials such as wax, candlegrease, and bitumen, his paintings suffered severe cracking and marked deterioration even during his own lifetime. He spent his later years attempting to restore and rework some of them.

The very personal nature of Ryder's artistic search is characterized in his own words:

> *Have you ever seen an inchworm crawl up a leaf or twig, and then clinging to the very end, revolve in the air, feeling . . . to reach something? That's like me, I am trying to find something out there beyond the place on which I have footing.[3]*

10 *Spirit of Autumn*, ca. 1875 [57]47.68

Oil on panel, 8½ x 5¼ in. (21.6 x 13.3 cm.). Signed lower left: A.P. Ryder. Bequest of Frederick W. Schumacher, 1957

Spirit of Autumn, painted by Ryder during his first years in New York when he was still a student, is the earliest documented work by the artist. Ryder apparently attempted to make a gift of the small picture, which is painted on a wooden cigar box panel, to his friend and fellow student Stephen G. Putnam. Putnam, it seems, did not accept the gift initially but later offered Ryder $5.00 for the painting; as a compromise Ryder agreed to sign the work and accept the payment.[4]

Ryder's works are haunting visual metaphors for the elemental forces of nature. In *Spirit of Autumn* the artist evokes the elegiac mood of the season. There is only a hint of landscape. The composition is dominated by the solitary figure of a woman standing at the edge of a wood, framed by russet foliage. She seems an apparition emerging only momentarily from the fall landscape. Her shoulders and bowed head are silhouetted against the blue sky that casts a halo-like aura around the upper half of her figure. Her contemplative pose and featureless anonymity enhance her visionary presence as an allegorical figure who is both eternal and elusive.

The thick encrusted pigment usually associated with the artist's works is not seen here. The warm reddish-brown of the thinly painted mahogany panel is visible throughout the background, much of which is covered only with varnish or an extremely thin wash. Only in the slight build-up of pigment on the tree trunk did Ryder create texture with a palette knife or the end of his brush.

The formative influences of American painters John LaFarge, George Inness, and William Morris Hunt, through whom Ryder first became acquainted with the Barbizon tradition, is evident in the painting. The work precedes by several years the turning point in Ryder's career, when around 1880 his interest in mystical and imaginative themes became more pronounced. In *The Spirit of Spring* (Toledo Museum of Art, Ohio), painted in 1880, Ryder further elaborated on the theme of the seasons. The composition in the later canvas, which places the figure in an expansive landscape, is more carefully conceived than that in the Columbus picture. In both, the cloaked female figure standing beneath a tree has been cast in the allegorical role of a season.

N.V.M.

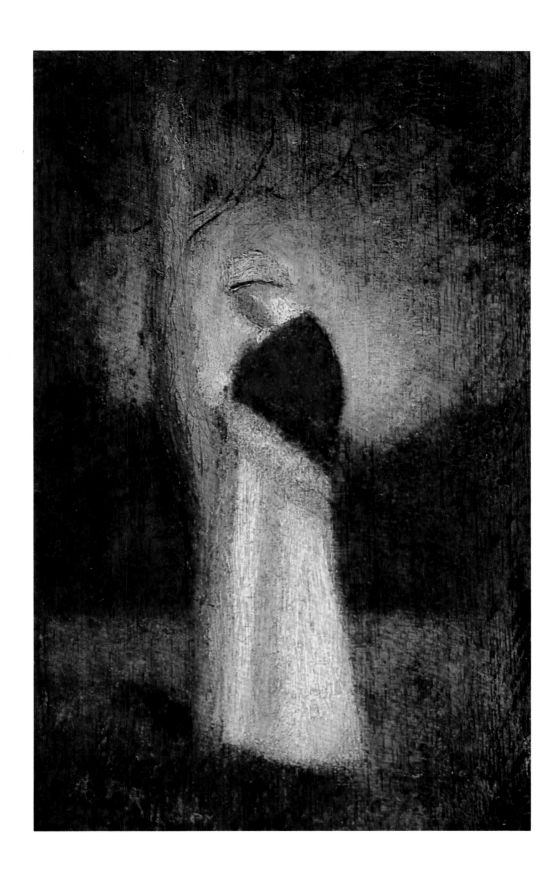

Ralph Albert Blakelock, 1847–1919

Ralph Blakelock was born in New York City. The son of a well-to-do physician, he was given to introspection, which in turn predisposed him to explore a visionary world in his paintings. His art was influenced by the French Barbizon school of landscape painting, both in his favorite subject matter—the interiors of dark forests—and in obsessively worked surfaces. These characteristics can also be found, for instance, in the paintings of Theodore Rousseau, as well as in works by the independent artist Adolphe Monticelli, both of whom were represented in the collections of Blakelock's patrons.[1]

Blakelock was essentially a self-taught artist, a technical explorer who learned through trial and error, guided by instinct. Working on pictures over a period of years, he would build up layers of paint, adding fresh pigment with his palette knife after an earlier application had just begun to set, then scoring the surface with a meat skewer. Occasionally he would rub through the upper layers of paint with a pumice stone until the lighter tones of the underpaint glowed through with magical luminosity. He was often inspired by the accidental patterns of color he found in everyday objects.[2] Improvisation was his method. An accomplished musician who also improvised at the piano to develop themes for his paintings, he would place a canvas on the piano or nearby easel, play until inspired, then work further on the painting.

The actual source material of Blakelock's mature art was drawn from three years of solitary travels in the West between 1869 and 1872. He wandered widely, painting and filling notebooks with sketches for future use and forming impressions of the American wilderness. His subsequent works were drawn as much from his remembered and internalized experience as from his sketches and may be characterized as poetic interweavings of the American wilderness and the Indians who were an inseparable part of it.

11 *Moonlight*, ca. 1885–1890 45.20

Oil on board, 12 x 16 in. (30.5 x 40.6 cm.). Signed lower right: R. A. Blakelock. Bequest of John R. and Louise Lersch Gobey, 1945

Moonlight, one of the artist's nocturnal meditations, is not about the passage of time, does not hint of the day to come. Instead, Blakelock engraves the very idea of night and the moon that reigns over it on his panel and in the mind's eye. Dark and light areas alike are marked by brush and palette knife. Though the green of the night sky is seen "through" the dark foliage of the trees at the right, in fact the green is laid on over the black mass. Time has darkened Blakelock's pigments, rendering two figures on horseback at the right nearly invisible, but they seem always to have been more acquainted with the night than with the light. In the scarred sky, the moon just holds its own, as though it had with difficulty burned through the blue-green and brown veils of paint. Blakelock has here reduced nature to few and basic components: the substantial sky, the fixed moon and its eerie shimmer on the foreground pond, the stratified trees clinging fast to their places, the unspecific barrier of the horizon.

In 1891, soon after *Moonlight* was painted, Blakelock, who was locked in unknowable psychic conflicts, suffered his first mental breakdown. Late in 1899, on the day his ninth child was born, he had his final collapse, which kept him in mental institutions for twenty years until nearly the end of his life. His paintings came to be increasingly admired, and in 1916—three years before he died—he was made an Academician of the National Academy of Design.

W. K.

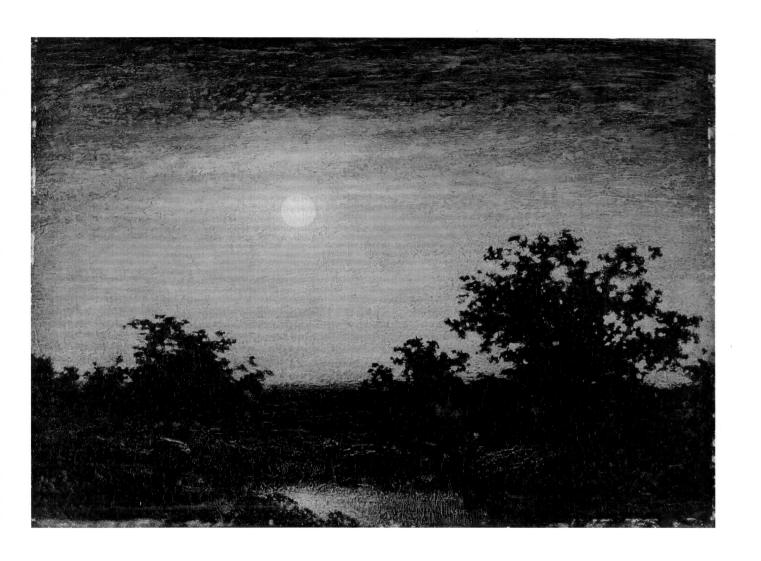

Elihu Vedder, 1836–1923

Elihu Vedder emerges as one of the most strikingly original American artists of the late nineteenth century. A friend of the English Pre-Raphaelites and Italian Macchiaioli painters, he was versed in Neoclassic form and imbued with the aura of Romanticism. He exhibited varied talents as a figure painter, landscapist, illustrator, muralist, and writer. By virtue of his innate, profoundly melancholic personality and his reliance on mystical inspiration, he managed to avoid either pedantry or imitation in his works. Through his decorative commissions—notably for the Library of Congress (1895)—Vedder contributed enormously to the development of the national consciousness of American art, though for most of his working life he was an expatriate in Italy. He is perhaps best known for his famous illustrations of 1883–1884 for the Fitzgerald translation of The Rubaiyat of Omar Khayyam.

12 *The Venetian Model*, 1878 69.7

Oil on canvas, 18 x 14⅞ in. (45.7 x 37.8 cm.). Signed and dated lower left: Vedder/1878. Museum Purchase: Schumacher Fund, 1969

The Venetian Model, a painting regarded by Vedder himself as one of his best works,[1] is much more than a studio painting of a nude model. In this picture the attributes of painting and sculpture, the ideal beauty of the nude, the artistic images of the Venetian past are carefully collated by the artist to suggest both irretrievable glories and present potentialities. Treated almost like a relief, the model is posed in a shallow space against the studio wall, seated on a Renaissance-style sideboard draped with a tapestry carpet, and resting her feet on a stool also partially covered with carpet (the right foot additionally propped up by a posing block). On a tapestry-covered wall behind the figure hang two paintings: a sketch of a gondola and a larger painting of an ancient Venetian state barge. The model leans upon the shoulder of a ship's wooden figurehead, beside which is a late sixteenth-century Venetian maiolica pharmacy jar containing the artist's brushes.

Painted in Venice, the picture seems intended to evoke a nostalgic daydream of that pearl of the Adriatic. The constrained profile pose creates tension in the upper body of the model, which vivifies the meditative, almost prayerful, pose. If we imagine a line extending upward from the model's upper left arm to the top right corner and downward to the midpoint of the left side of the painting, we will find that everything essential to the painting's mood and meaning is contained in the triangle above that line. The images of Venetian boats, especially the glorious barges of former days, are reiterated by the wooden figurehead, which seems to glance over its shoulder at those images. The melancholy mien of the sculpture echoes that of the model, and indeed they seem like spiritual and physical sisters.

The prominence of the artist's brushes in a maiolica container of bright blue, red, and yellow—the strongest passage of color in the painting—proclaims the artist's presence in this meditative compilation. Just as striking in this context is the parrot in the tapestry behind the sculpture's head, a time-honored symbol of eloquence—especially of imitative eloquence.

The Venetian Model did not immediately sell, as Vedder's daughter Carrie had predicted, "on account of its [model] being totally nude, although it is as modest as modest can be."[2] The artist, too, recorded that an "eminent heiress of Ithaca, New York . . . was so fearful of the public opinion of Ithaca that she dared not gratify her individual taste."[3] He briefly considered adding some drapery to placate Victorian opinion, but, he said, "I began to get ashamed of myself and *stopped*. It seemed like putting on the providential leaf in the creation of Adam and Eve and I did not feel as if I was that kind of Providence, *tutto al contrario*."[4]

—W. K.

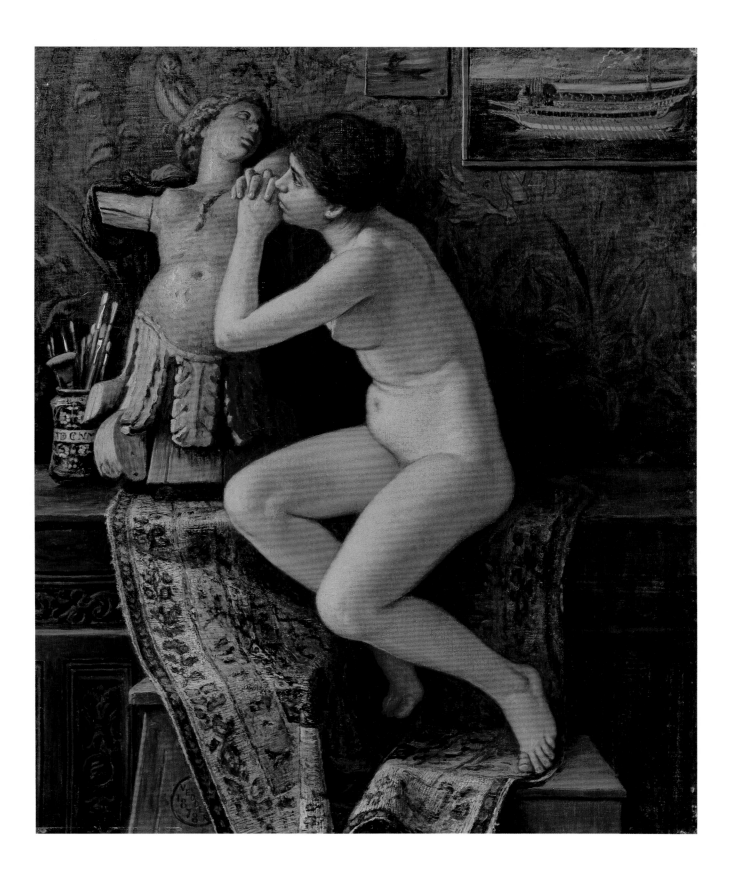

John La Farge, 1835–1910

John La Farge was nearly thirty years old when he decided to become a professional artist. Born in New York City to wealthy French parents, he was educated bilingually, with particular emphasis on literature and art. He also studied law. But in 1856 he left for Europe to develop his painting skills primarily by copying the old masters and sketching from nature. Back in the United States, he studied with William Morris Hunt in Newport, Rhode Island, and befriended fellow students William and Henry James. He became known particularly for his architectural decorations, such as painted panels and stained glass, and received important commissions like that in 1876 for the decoration of Trinity Church, Boston. He was one of the first American artists to show an interest in Japanese art, but his enthusiasm waned after a trip to Japan in 1886 with Henry Adams. During 1890 and 1891, also in the company of Adams, La Farge visited the South Seas, following in the footsteps of Robert Louis Stevenson and preceding the more famous journey of Paul Gauguin.

A celebrated, middle-aged artist by the time he visited the tropics, La Farge quickly immersed himself in the exotic, seeming paradise of Tahiti. The works he produced there reflect the particular climate and customs of the place. His Polynesian landscapes are often remarkably similar in color to Gauguin's of the same locale, and his figure paintings mingle ethnography and a foreigner's poetic fascination with the aura of place. Like other Western visitors, La Farge was continually comparing East and West, often to the disadvantage of the West. Of the Christianized Polynesians he came to know, he wrote: "the people [are] yet nearer to nature than Millet's peasants."[1] Such yearning for lost innocence, for a return to nature and purity, is a recurrent theme in the nineteenth century, especially poignant as the century closed.

13 *Girl in Grass Dress (Seated Samoan Girl)*, 1890 66.39

Oil on panel, 12 x 10 in. (30.5 x 25.4 cm.). Museum Purchase: Schumacher Fund, 1966

Otaota, the model in this small sketch, was the daughter of a Samoan Christian Protestant preacher. In an 1895 exhibition catalogue La Farge noted that while in her own mind Otaota was sitting for her portrait, he was more interested in getting "a memorandum of the peculiar dress made of leaves and brilliant colors, cut into shape and sewed on to a foundation of bark cloth, then rubbed with perfumed cocoanut oil."[2] He further recorded that "this costume had been worn the day before at a great feast, and is 'missionary' in complement to the European prejudice for clothing."[3]

One is struck by the power of this small painting. The room in which Otaota sits is suggested by the mahogany-stained or painted panel whose tone is the basis for the background. Strokes of green alternate with the dark wood to suggest the forest seen through strips of curtain. Within this ambience the figure is a small explosion of color applied in short, rather broad strokes. The treatment of the profile head is at once bold and restrained, the mass of black hair pulled back into a conspicuous shape while the face is blurred and indistinct, an area of transition from foreground to background rather than a focus of attention.

La Farge implied that Otaota's chatting friends were responsible for the unfinished face;[4] it may be, however, that the picture owes much of its dreamy charm to that elision of the features. Such avoidance of the literal or overly-descriptive is like the allusions of lyric poetry.

W.K.

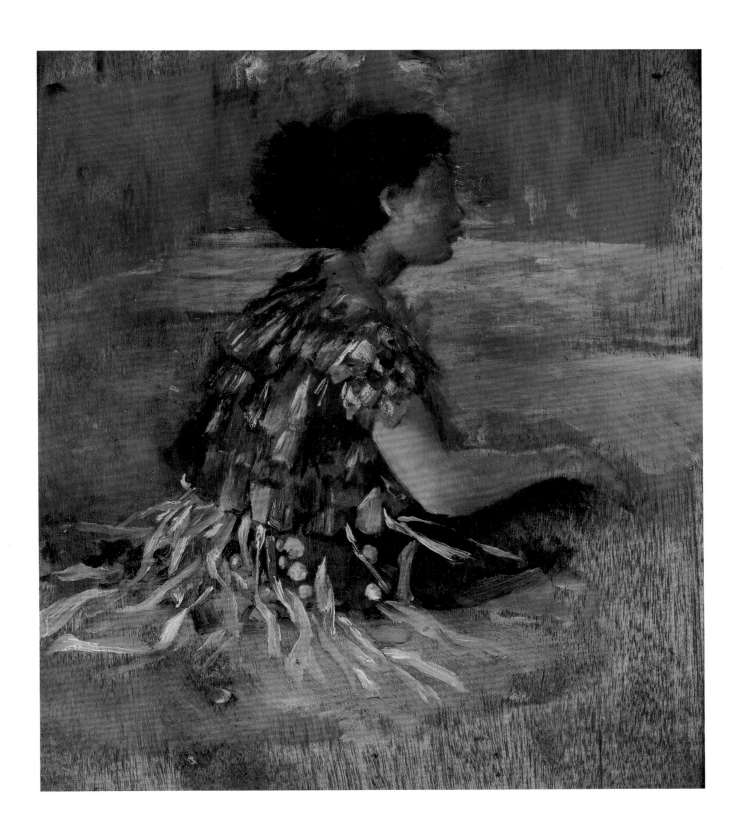

James A. McNeill Whistler, 1834–1903

During his entire career as a painter James McNeill Whistler lived and worked in Europe. Born in Lowell, Massachusetts, he received his first artistic training at the Imperial Academy of Fine Arts in St. Petersburg, Russia. Then as a cadet at the United States Military Academy at West Point he studied drawing under Robert W. Weir. After leaving West Point and working briefly as a surveyor and cartographer, he decided to become an artist. In 1855, at the age of twenty-two, he sailed for Europe, and began his training in Paris in the studio of Charles Gleyre, a teacher of the Impressionists. Soon the young artist was drawn to avant-garde circles, where he became acquainted with painters Gustave Courbet, Henri Fantin-Latour, Edouard Manet, and Edgar Degas, and critic Theophile Gautier. After 1859 he made London his home and developed close ties with Dante Gabriel Rosetti and other Pre-Raphaelites, who influenced his developing artistic sensibilities.

By the early 1860s Whistler had become firmly identified with the most radical trends in modern painting. His Symphony in White No. 1: The Girl in White scandalized viewers and critics alike at the Salon des Refusés in 1863. Ostensibly a portrait of his mistress, the painting embodies the artist's rebellion against nineteenth-century sentimental genre subjects and proclaims his commitment to the purely visual aesthetics of painting. Whistler shared Gautier's belief in "art for art's sake" and sought to strip his pictures of their narrative context so that they could be evaluated solely on their formal merits. He adopted musical titles for his paintings beginning in the late 1860s, explaining: "as music is the poetry of sound, so is painting the poetry of sight and the subject-matter has nothing to do with harmony of sound or of color."[1] During the following two decades, when he produced his most notable works, his aesthetics reached fruition. Keenly sensitive to a wide range of European painting styles, Whistler developed a distinctive personal mode of expression. He was fascinated with Oriental art, from which he borrowed motifs and colors, flat, decorative shapes, and asymmetrical compositions. The hallmark of his oeuvre—compositions subtly orchestrated in a limited range of tones—now identifies him as a leading exponent of tonalism, a dominant trend in American painting during the late nineteenth century.

Wide recognition and acceptance of his work—as well as financial success—did not come until after 1900, when Whistler was beginning to be acknowledged as a critical forerunner of Symbolism and Art Nouveau.

14 *Study of a Head*, ca. 1881–1885 [57] 43.8

Oil on canvas, 22⅝ x 14½ in. (57.5 x 36.8 cm.). Signed center right with butterfly symbol. Bequest of Frederick W. Schumacher, 1957

Study of a Head is a Whistlerian arrangement in brown and black in which the artist reveals his masterful handling of a nearly monochromatic range of muted tones. The figure emerges from the neutral background as a diffused pattern, with the white impasto of the shirt collar and a few touches of red in the cheek and mouth alone accenting the somber palette. Even the artist's butterfly signature,[2] just visible to the right of the figure's mouth, seems to have been painted over by Whistler in order to maintain the picture's uniform tonal harmony.[3]

The painting has the freshness of a rapidly executed oil sketch. With the exception of rare touches of impasto, the paint has been thinly applied; the texture of the coarse canvas is clearly visible. Handling the paint quickly and with economy, Whistler captured the essentials of the figure. Stylistically, the work is related to Whistler's watercolors executed in the mid-1880s.[4]

The identity of the sitter is not certainly known. The painting was exhibited by Parke-Bernet Galleries in 1942 as *Mr. Graves, Printseller*,[5] referring to Henry Graves (1806–1892), founder of a London firm of printsellers and of the publications *Art Journal* and *Illustrated London News*. The age and appearance of the subject soon led scholars to believe that the portrait was more likely of Henry's son Algernon (1845–1922), who worked in his father's firm (becoming president upon Henry's death). Both father and son were close to Whistler beginning in the mid-1870s, and Whistler continued to have dealings with the Graves family through the early 1890s. However, because no mention of such a portrait is found in the extensive surviving correspondence between Whistler and the family, doubts persist that the portrait is of either of the Graveses.[6]

A comparison of this work with the 1878 portrait of Algernon Graves by Rosa Corder, which Whistler supposedly knew and liked, raises additional questions. Though there is a similarity in the profiles of the two subjects, the thirty-three-year-old Graves of Corder's portrait appears older than the sitter in Whistler's later portrait, which scholars have variously dated from the early 1880s to the mid-1890s.

If *Study of a Head* is of Algernon Graves, it is surely a tribute to someone to whom Whistler was very grateful. He wrote to Graves in December 1890:

> You have shown that you understand how an artist whose work is without the pale of gross popularity, & whose purse is consequently not heavy with ill-gotten gold, may be met with, even great, patience, . . . and hereafter in history this shall not be forgotten.[7]

In any case, it is unlikely that Whistler would be sympathetic to arguments concerning the identity of the sitter. Whatever the personal significance of the portrait, one is reminded of Whistler's comment about *Arrangement in Grey and Black: Portrait of the Painter's Mother*:

> To me it is interesting as a picture of my mother; but can or ought the public care about the identity of the portrait? It must fall or stand on its merit as an arrangement.[8]

N.V.M.

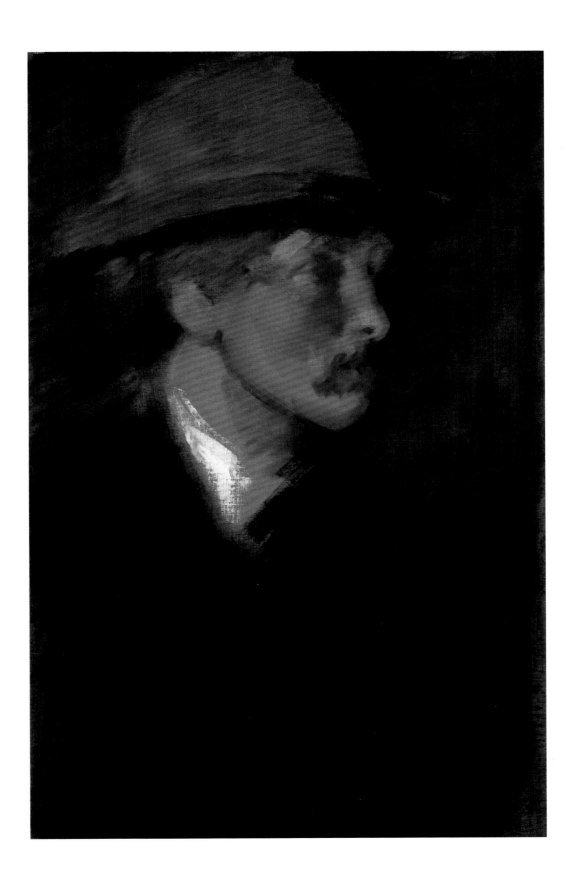

John Henry Twachtman, 1853–1902

A native of Cincinnati, where he studied with the influential artist and teacher Frank Duveneck, Twachtman showed an artistic temperament very different from the painterly robustness of his mentor. Instead, a refined aestheticism marks his mature style. Twachtman studied in Munich between 1875 and 1877, but it was not until his second trip to Europe in 1880–1885 and his contact with the French Impressionists and J.A.M. Whistler that he decisively formed his style. A painter of poetic moods, he was attuned to the special atmosphere of a place, and his residence on a farm at Cos Cob, Connecticut, from 1889 until his death provided him with a deeply felt subject to which he tuned his exquisitely subtle palette.

15 *Court of Honor, World's Columbian Exposition, Chicago,* 1893 [57]43.10

Oil on canvas, 25 x 30 in. (63.5 x 76.2 cm.). Signed lower right: J. H. Twachtman. Bequest of Frederick W. Schumacher, 1957

An unusual subject in Twachtman's oeuvre, *Court of Honor* was surely a *pièce d'occasion*, possibly commissioned by one John Bannon Esq., from whose 1905 sale it was purchased by Victor Harris. Twachtman was in Chicago in 1893 to accept a silver medal in painting at the Columbian Exposition, but the details of the supposed commission are not known. It was a significant year for the artist in another way too: he exhibited at a New York gallery with Claude Monet, whose daring minimization of the object in favor of the pictorial dominance of light Twachtman shared perhaps more than any other American painter.

Despite the ostensible architectural subject, some eighty percent of the surface of the museum's painting is devoted to sky and water. In this the work resembles innumerable paintings of Venice, whether by Monet, Renoir, or Turner. Twachtman's recollections of Venice, city of light and water, derive from his visits to the great city in 1877 and 1880. But instead of San Giorgio Maggiore floating on an island in a lagoon, there is Richard Morris Hunt's similarly domed Administration Building situated at the end of an artificial pond designed for the Exposition by Frederick Law Olmstead. To the left of the Administration Building is the Machinery Building; to the right, behind the exposition pennants, the Electricity Building. Also discernible is Frederick MacMonnies's enormous (sixty-foot long), many-figured Columbian Fountain, which stands directly in front of the Administration Building. Something of the concern with refined taste and European precedent that motivated the exposition's architects affected Twachtman too. This and other paintings by the artist are closely allied with the high aestheticism of European art and letters at the end of the century, a bias that was widespread among American artists of the day.

While photographs of the exposition invariably emphasize the buildings, in Twachtman's picture the architecture is no more material than the surrounding atmosphere. Except for the pale yellow dome of the Administration Building, the bright light green of a half dome on the building just to its left, and a scattering of pinks in banners and one roof, the architecture is absorbed into the overall blue-gray scheme imposed by the artist. Brushed over a mauve ground color, the brilliant white plaster facades seem to merge with the atmosphere. The asymmetry of the composition is reinforced by the direction of the dry, thin brushstrokes that represent the surface of the pond, their drifting parallels precisely capturing the appearance of windblown currents on a shallow basin. This sensation of moving water combines with a subtle modulation of light on the surface and the receding space to convey an effect of buoyancy beneath the darker form of the Administration Building.

Court of Honor was long thought to be unique in Twachtman's oeuvre, but recently a related, smaller painting (12½ x 16 inches) appeared on the art market: Twachtman's *The Chicago World's Fair, Illinois Building.*[1] More informal than the museum's picture, it stresses a parklike setting that is likewise little evident in photographs of the exposition.

w.k.

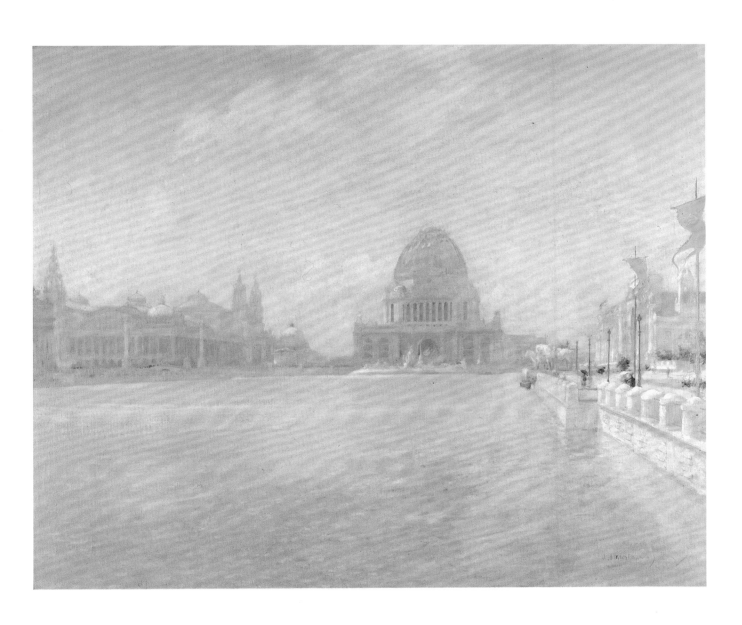

Childe Hassam, 1859–1935

One of the country's foremost exponents of Impressionist painting, Hassam enjoyed a long and productive career marked with many honors and awards. Born in Dorchester, Massachusetts, he began his training at the Boston Arts Club and the Lowell Institute. Early on, he worked as an engraver's draftsman, designing compositions for Harper's, Century, *and* Scribner's Magazine. *He first went abroad in 1883, traveling to The Netherlands and Italy. Returning to Boston that same year, he began to develop atmospheric city scenes such as* Rainy Day, Columbus Avenue, Boston *(1885, The Toledo Museum of Art), which today are among his most popular and endearing works.*

During his second trip abroad, from 1886 to 1889, Hassam studied in Paris at the Académie Julian under Gustave Boulanger and Jules Lefébvre. He was awarded a gold medal at the 1888 Paris Salon and a bronze medal at the 1889 Paris Exposition. While in France he initiated lifelong friendships with American Impressionists Theodore Robinson and Willard Metcalf. Upon his return to the United States, Hassam established himself in New York City and painted Impressionist urban genre scenes, particularly the activity around Washington Square and Fifth Avenue. Following another trip abroad in 1897, Hassam joined with John Twachtman, J. Alden Weir, and others in the founding of Ten American Painters, an organization of American Impressionists that mounted a series of independent exhibitions. At the end of the century Hassam taught at the Art Students League and painted some of his most successful landscapes in the New England coastal regions of Gloucester, Newport, and Provincetown. After a fourth stay in Paris in 1910, he turned his attention to the American scene once more, painting at Cos Cob and Old Lyme, Connecticut; Easthampton, New York; and, Appledore, Isles of Shoals, Maine.

Hassam, an exhibitor in the 1913 Armory Show, was not a revolutionary in style or temperament. His embrace of Impressionism came at a time when—in Boston, at least—the movement had found favor. His memberships include the American Water Color Society, the Society of American Artists, the National Academy of Design, and the Association of American Painters and Sculptors. A generous spirit, at the end of his life he bequeathed 450 of his works to the American Academy of Arts and Letters, stipulating that they were to be sold to create a fund for the purchase of works by young artists.

16 *The North Gorge, Appledore, Isles of Shoals*, 1912 [57]43.9

Oil on canvas, 20 x 14 in. (50.8 x 35.6 cm.). Signed and dated in lower right: Childe Hassam 1912. Bequest of Frederick W. Schumacher, 1957

The North Gorge, Appledore, Isles of Shoals is one of many works by Hassam devoted to the rocky prominences of an island off the coast of Maine. Hassam began to spend summers at Appledore during the mid-1880s, when writer Celia Thaxter invited him to join the group of artists who summered there at her island home. Thaxter, the daughter of a lighthouse keeper, recorded life along the Maine coast in memoirs such as *Among the Isles of Shoals* (1873) and a later work entitled *An Island Garden* (1894), which Hassam illustrated.

The Impressionist nature of this painting lies largely in Hassam's handling of space and in his brushwork. Here, as in other Appledore pictures, Hassam invokes his French predecessors Jean-François Millet and Claude Monet, who portrayed the rugged coastlines of Normandy and Brittany. His brushstrokes are lively, tightly woven, rhythmic in texture. His colors, from the myriad red-orange and russet tones of the rocks to the vivid turquoise of the sparkling sea, draw the viewer's attention upward. These devices supplant traditional spatial perspective with flat registers of paint and call attention to the canvas surface, much like the works of the earlier Impressionists.

But Hassam's response to Impressionism typifies the American preference for solidity and definition. No film of light between the painter and the subject dissolves the form of the great rocks that frame the sea view in this painting. In the ebb and flow of the waters too there is substance. Here, light illuminates structure, does not break it down. Typical of American Impressionism is the insistence on strong elements of design: the vertical format, the high horizon line, the severely cropped view, and the upward thrust of the composition.

The North Gorge, Appledore, Isles of Shoals is part of a continuing American tradition of dynamic seascapes. One is reminded in particular of Winslow Homer's many scenes of Prout's Neck, Maine, and of John Marin's explosive seascapes, also painted in Maine.

L.L.M.

John Singer Sargent, 1856–1925

John Singer Sargent was born in Florence to American parents, expatriates who constantly traveled the European continent. He did not make his first visit to the United States until 1877. Sargent received his first artistic training in Italy, where he was tutored in Rome by German-American artist Carl Welsch in 1868–1869. From 1871 to 1872 he studied at the Accademia di Belle Arti in Florence; two years later in Paris he joined the atelier of Emile Carolus-Duran and attended drawing classes at the Ecole des Beaux Arts. He made his Salon debut in 1877 and in the following year's Salon received honorable mention for the Oyster Gatherers of Cancale (1878, Corcoran Gallery of Art). While still living abroad he participated in the founding of the Society of American Artists, a group of young, progressive artists who were inspired by current European painting styles. He began to exhibit at the National Academy of Design in 1879. In Spain and The Netherlands during 1879–1880 he copied works by Velázquez and Hals, further assimilating their stylistic lessons. In Morocco on the same journey he absorbed the influence of Mediterranean portrait subjects.

Despite his formidable early success in France, Sargent abruptly departed for England in 1884 because of the controversy surrounding the Salon exhibition of his Madame X (1884, Metropolitan Museum of Art). England became his permanent home. He rented Whistler's former studio in London and divided his time between there and the village of Broadway, an artist colony on the River Avon, where in summers he painted outdoors. He maintained contact with French artists, exhibiting with Monet and other Impressionists at the Galerie Georges Petit in Paris in 1884 and working with Monet at Giverny in the late 1880s. Sargent explored the Impressionists' handling of light and color in his own work, but he never thoroughly embraced their style, refusing to abandon the modeling of forms through value contrasts.

In the United States in 1887 Sargent was offered numerous portrait commissions. In 1890 he accepted a major commission to produce a series of murals for the Boston Public Library. In 1897, two years after the installation of the first murals, he was elected a full member of the Royal Academy and of the National Academy of Design and was named an officier of the French Legion d'Honneur. Many other honors followed, including British knighthood, which Sargent declined rather than forfeit his American citizenship. By the turn of the century, he was the most celebrated portraitist in Europe and America, and his style was a dominating influence in the art world. He almost completely abandoned portraiture in his late career, choosing to concentrate on watercolor and oil landscapes and murals such as those in the rotunda of the Museum of Fine Arts, Boston, and the Widener Library at Harvard University.

After a major retrospective exhibition in 1924 at the Grand Central Galleries in New York City, Sargent returned to England. In April of the same year he died of heart disease and was buried at Woking, near London. The year following his death Sargent was honored with memorial exhibitions at the Metropolitan Museum of Art and at the Royal Academy in London.

17 Carmela Bertagna, ca. 1880 [57]43.11

Oil on canvas, 23½ x 19½ in. (59.7 x 49.5 cm.). Signed upper right: John S. Sargent. Inscribed upper left: à mon ami Poirson. Inscribed lower left: Carmela Bertagna/Rue du/16 Maine. Bequest of Frederick W. Schumacher, 1957

Carmela Bertagna bears the full imprint of Sargent's discerning study of the paintings of Velázquez and Hals and shows Mediterranean influences garnered from his 1880 journey to Tangiers. The artist's bravura brushwork is tempered here by his observation of the elegant painting in works by the Baroque masters, particularly Velázquez. Also evident in this portrait is the influence of Emile Carolus-Duran, from whom Sargent learned to use the brush to create shape and add color simultaneously, articulating form through summary passages of light and dark rather than by linear definition.

A vital aspect of the work is the dynamic coalescence of underpainting and surface brushwork, particularly effective where the blue underpainting delineates the shadowed areas of the model's face. Sargent's sketchlike brushwork and his vigorous paint application evoke a feeling of spontaneity, and the fluid character of the paint contributes to the vitality of the composition. His palette is arranged around warm blue-grays, siennas, and umbers heightened with pink. He enlivens the painting with the rose tints and white highlights of the young girl's shawl, sending cascades of light across the model's shoulders. In this portrait Sargent conveys the mystery and innocence of his model and the allure of an elegance yet to be.

Sargent noted the model's name on the lower left corner of the canvas followed by the address "rue du 16 Maine," most probably her residence. An inscription in the upper left corner of the portrait reads "à mon ami Poirson," a reference to Paul Poirson, Sargent's landlord and patron, who later commissioned from Sargent portraits of his daughter Suzanne (private collection, Paris) and of Madame Poirson (Detroit Institute of Arts).

L.L.M.

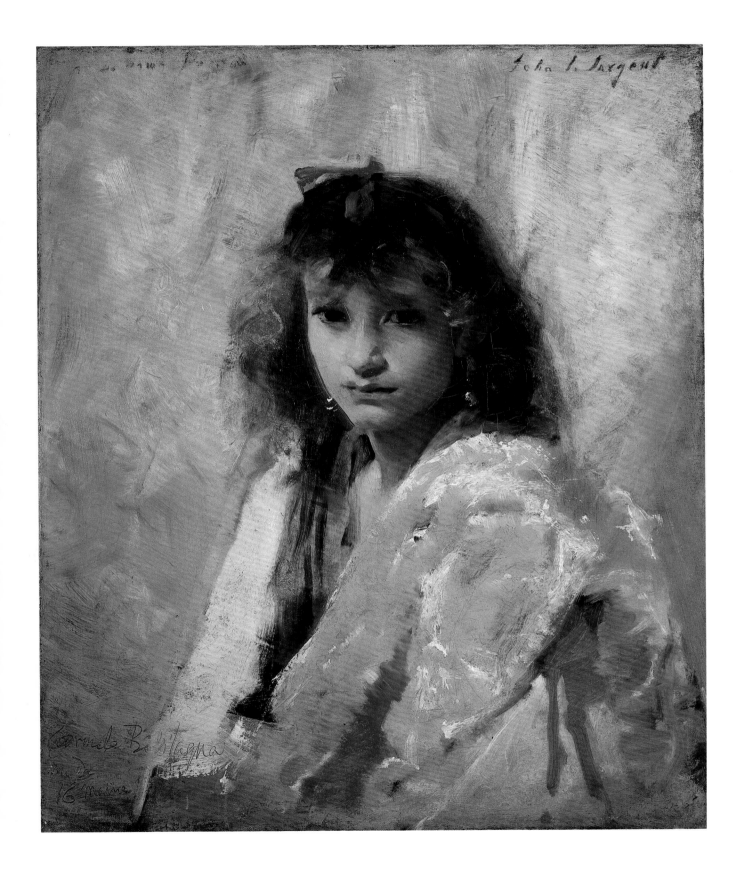

Mary Cassatt, 1845–1926

Mary Cassatt was one of the first American painters to seek the training of Paris ateliers in the period immediately following the Civil War. Her achievements are formidable, given the obstacles faced by women artists at the time. Both the struggle and the triumph of her life are encompassed in Edgar Degas's well-known remark about her aquatints: "I am not willing to admit that a woman can draw that well."

Cassatt, who is most closely associated with Paris and the French avant-garde circle that included Degas as well as Monet, was born in Allegheny City (near Pittsburgh). She began her career at the Pennsylvania Academy of the Fine Arts, where she studied from 1861 until 1865. She was in Paris from 1866 to 1870, studying at the atelier of Charles Chaplin and independently at the Louvre. Subsequently drawn to Italy, she studied the works of Correggio and Parmagianino, then continued on to Spain, Belgium, and Holland, where she studied the paintings of Velázquez, Rubens, and Hals. Cassatt exhibited in the French Salon on four occasions between 1872 and 1876. But she was growing increasingly restive with academic art, and in 1877, when Degas invited her to join the Impressionists (then called the Independents), she ended her participation in the official Salon. The only American ever to exhibit with the French Impressionists, Cassatt contributed to their fourth, fifth, sixth, and eighth exhibitions of 1879, 1880, 1881, and 1886, respectively.

18 *Susan Comforting the Baby No. 1*, ca. 1881 [57]54.4

Oil on canvas, 17 x 23 in. (43.2 x 58.4 cm.). Signed lower right: Mary Cassatt. Bequest of Frederick W. Schumacher, 1957

Susan Comforting the Baby No. 1 is an early product of Cassatt's lengthy and prodigious engagement with the familial theme. The company of her nieces and nephews, beginning with their arrival in France in 1880, is usually counted among the more prominent reasons why Cassatt turned her attention specifically to the world of women and children. The identity of the child pictured here is still a matter of speculation, but Susan has been identified as the cousin of Mathilde Vallet, Cassatt's housekeeper at Marly.[1] A larger version of the subject, *Susan Comforting the Baby* (Museum of Fine Arts, Houston)[2] includes a partial view of the Marly villa.

Susan Comforting the Baby No. 1 reveals Cassatt's debt to Japanese prints, her commitment to Impressionism, and her striking ability to use modern techniques to invigorate traditional subject matter. While the cropped figures and elevated viewpoint emanate from Japanese examples, the fluid brushwork and fresh treatment of light that activate the portrayal derive from French Impressionism, and the quiet restraint of a limited palette adds an element of classic control. Elegant passages of pearl-gray and blue-gray form cool shadows against the warm rose tints of Susan's face and that of the baby, amply demonstrating Cassatt's studied command of the sources of Impressionism, particularly the art of Rubens.

The scene is both spontaneous and penetrating. To sustain the effect of immediacy, and to enhance the illumination of the scene, Cassatt incorporates areas of exposed canvas into the composition, for instance in Susan's body, which is defined in part by the canvas surface itself. Cassatt controls these dynamic aspects of her style with an authoritative sense of design and draftsmanship. Thus she could depict the sitter's clothing, giving free reign to a rapid sequence of brushstrokes and colors, while preserving a rhythmic unity of form, stylistically and psychologically, in the linked ovals defining the heads of Susan and the baby.

Although Cassatt never married, never bore children, she developed and expressed through her art a profound understanding of the mother and child relationship. Moreover, she had the ability to see and clearly record children as individuals. The wary expression and the beginnings of a pout which Cassatt captures in the portrayal of this infant conveys something truthful about all children even as it depicts a particular baby with a mind and personality of her own. What is remarkable about Cassatt's achievement is that she was able to distance her art from the sentimentality typically associated with her subject matter.

L.L.M.

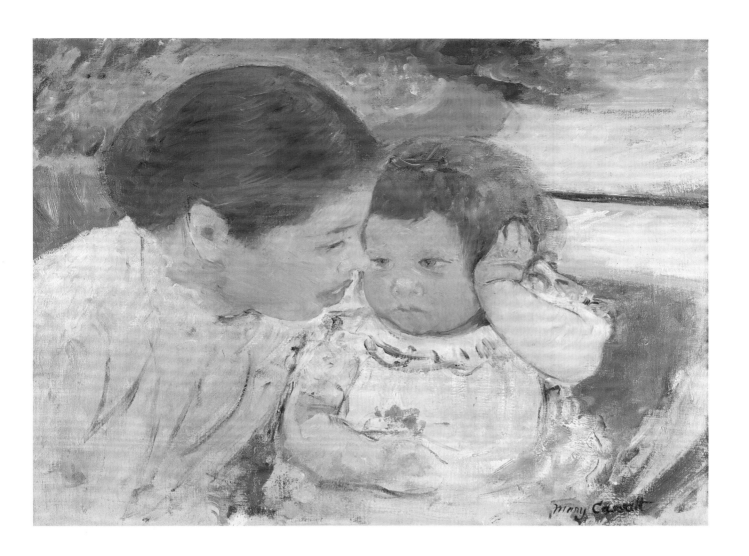

Theodore Robinson, 1852–1896

Theodore Robinson, an important American Impressionist, spent much of his life abroad and became one of several Americans to share a warm friendship with Claude Monet. A native of Vermont, Robinson lived in Wisconsin until 1874, when he moved to New York City to train at the National Academy of Design and to take classes at the newly formed Art Students League. In 1876, Robinson went to Paris where he and other American painters, including John Singer Sargent, joined the atelier of the popular independent artist Emile-Auguste Carolus-Duran. Subsequently, Robinson enrolled with the prominent academician Jean-Léon Gérôme, one of the influential French masters who taught American pupils at the Ecole des Beaux-Arts. Robinson first exhibited at the annual Salon of the French Academy in 1877.

Following a trip to Venice, where he met Whistler, Robinson returned to New York in late 1879. In 1884 he began a period of travel between France and the United States. Robinson visited Monet at Giverny briefly in 1887 and summered there annually until 1892. He was not a pupil of Monet in the traditional sense, and indeed took exception to such an identification.[1] Not content to rely on plein air studies entirely, as the French Impressionists did, Robinson used photographs as preliminary studies, which may account in part for the greater solidity and structure in his adaptations of the Impressionist style. His works from these years of travel in France, particularly his Seine Valley series of 1892, are thoughtful amalgams of Impressionism and its Barbizon sources.

By the time Robinson returned permanently to the United States in 1892, he had won signal honors in this country for his personal adaptation of Impressionism. He devoted the remainder of his brief career to painting the American scene. Toward the end of his life, he said rather wistfully to a friend: "You go 'round the earth; you come back to find the things nearest at hand the sweetest and best of all. All I have done seems cold and formal to me now. What I am trying to do this year is to express the love I have for the scenes of my native town."[2]

19 *Fifth Avenue at Madison Square*, 1894–1895 31.260

Oil on canvas, 24⅛ x 19¼ in. (61.3 x 48.9 cm.). Signed lower left: Th. Robinson. Gift of Ferdinand Howald, 1931

In 1894, two years before Robinson's death at the age of forty-five, August Jaccaci, the art editor of *Scribner's Magazine*, commissioned the artist to paint a view of Fifth Avenue. Robinson recorded the circumstances surrounding the project in three diary entries. The first, dated November 23, 1894, reads: "Lunch with Jaccaci—he wants me to do a Fifth Ave.—looking up from 22d St.—showing Fifth Ave. Hotel, etc." Four days later he wrote: "Met a photographer at Scribner's and went with him to take some views of 5th Av. from 22d St." The last reference, dated May 8, 1895, indicates that Jaccaci's response to the completed painting was less than enthusiastic: "Took my '5th Ave' to Jaccaci who said it wasn't as bad as he thought it was going to be—we had some squabble over the price."[3] Scribner's paid Robinson $75.00 for the painting,[4] which was reproduced in the November 1895 edition of the magazine with several illustrations accompanying an article entitled "Landmarks of Manhattan," by Royal Cortissoz.[5]

The picture recalls the delightful boulevard scenes of Impressionist contemporaries such as Monet, Renoir, Pissarro, and the American Impressionist Childe Hassam. But in this, as in other Robinson works, there is evidence of the artist's struggle to reconcile realism and Impressionism—a hallmark of his oeuvre. He balances the composition and structures its components by the repeated vertical accents that punctuate pictorial space and by his meticulous draftsmanship and abundant detail. These journalistic qualities are played against a luminous Impressionist sky, in which pastel pinks, blues, and white form a lively coalescence of color and light, unrestrained except for the linear pattern of telegraph wires cutting across the painterly field.

Though he was eminently successful in what he attempted to do in this picture, his temperament was ill-suited to such commissions, and he decided to accept no more. On May 9, 1895, the day following his delivery of the painting to Jaccaci, he recorded in his journal: "I got away determined to avoid illustration—and paint . . . and not try to get commissions for work that other men will do much better."[6] Thus, despite the engaging results, *Fifth Avenue at Madison Square* was to remain a rare achievement in the artist's oeuvre.[7]

L.L.M.

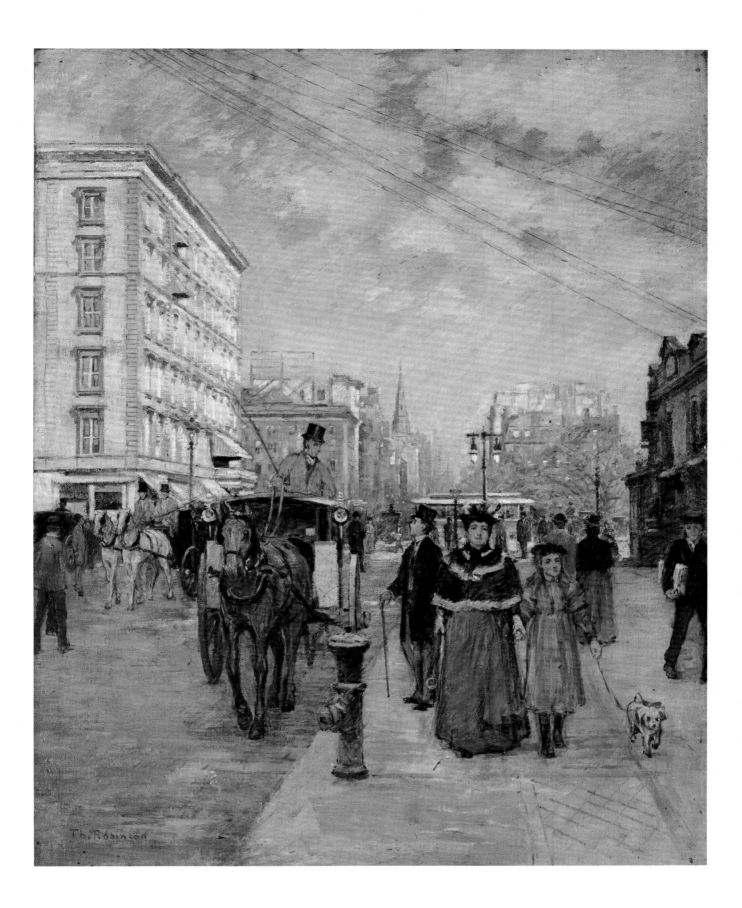

Thomas Eakins, 1844–1916

Thomas Eakins spent four years studying figure drawing at the Pennsylvania Academy of the Fine Arts, primarily working with antique casts rather than live models. During that same time he became thoroughly grounded in anatomy in the dissecting rooms at Jefferson Medical College in Philadelphia. Stemming in part from his interest in anatomy, he developed a fascination for sporting subjects. The sports world of Philadelphia provided ample opportunity to render scenes showing the human figure in action: amateur and professional rowing, boxing, baseball, and wrestling were all popular spectator sports, and there were also the recreational pastimes of swimming, sailing, skating, and hunting.

In the fall of 1866 Eakins left for Paris, where he studied at the Ecole des Beaux-Arts with Jean-Léon Gérôme and at the Louvre, furthering his skills in figure painting. After his return from Paris in 1870, he began to paint scenes of rowing on the Schuylkill River. By 1875 he turned his attention primarily to portraiture, his ambitious plans to paint subjects from contemporary life frustrated by lack of critical or popular favor.

20 *Weda Cook*, 1891[6?] 48.17

Oil on canvas, 24 x 20 in. (61 x 50.8 cm.). Signed and dated lower right: Eakins/1891[6?]. Initialed on reverse lower right: T.E.
Museum Purchase: Howald Fund, 1948

As a portrait artist Thomas Eakins had no equal in late nineteenth- and early twentieth-century America. His likenesses seem uncompromising in their descriptive honesty, yet whether they are as starkly realistic as they are sometimes said to be is questionable. The artist was not literal-minded; his probing of character takes precedence over faithful reproduction. Weda Cook's features, as revealed in a series of photographs probably taken by Eakins in 1892, were fuller and rounder than shown here, and her jawline less pronounced.[1] She had a straight nose but not as aquiline as the painting would indicate. The realism of this portrayal is emotional and psychological rather than imitative.

In 1892 Eakins painted Cook in the full-length picture he called *The Concert Singer* (Philadelphia Museum of Art).[2] In that work, Cook, a contralto who had achieved a notable reputation in the Philadelphia-Camden area, appears ingenuous and soulful, a youthful figure immersed in music-making. Eakins's relationship with the sitter had been ruptured before this picture was finished, apparently due to his importunings for her to pose in the nude (a request he made of other sitters as well), combined with rumors of the artist's sexual improprieties. Later, her doubts allayed, she consented to sit for this portrait, possibly about the same time her new husband, the pianist Stanley Addicks, whom she married in 1895, sat for his portrait.

In the museum's bust-length portrayal, Weda Cook appears melancholy and distant rather than absorbed and concentrated. The tilt of the head, back into the picture and down to the right; the fixed gaze; the *profil perdu*; and the slightly parted lips contribute to this effect. Abrupt cropping and the advancing warm tones of the flesh and blouse bring the figure close to the viewer, while the funnels and gatherings of the cloth create an impression of tactility. The right arm is broadly modeled with two brown and gray columns of shadow which initiate a sense of abrupt recession. The scumbled warm brown background on the right absorbs the loosely brushed contour of the left arm. Above, the brushwork at the right, playing against the contour of the face, is varied, with the long brushstrokes echoing the profile but at some distance from it.

Both this portrait and *The Concert Singer* share one detail of treatment: the beautifully drawn ear, accented by the lock of hair which lies across it. The attention paid to this ear seems to stress the faculty of listening, the phenomenon of sound. The vaguely floral markings in red, green, yellow, and black on the rose-pink dress add their own pensive melody to the singer's presence. It is at this point that doubts about Eakins's "realism" arise, for the melancholy that pervades this splendid work distinguishes it from both the full-length portrait and the photographs while linking it firmly to most of the artist's other portraits of women. The sadness, which is often felt in the company of Eakins's female subjects, may be the projection of the artist's own keen sense of isolation and mortality.

W.K.

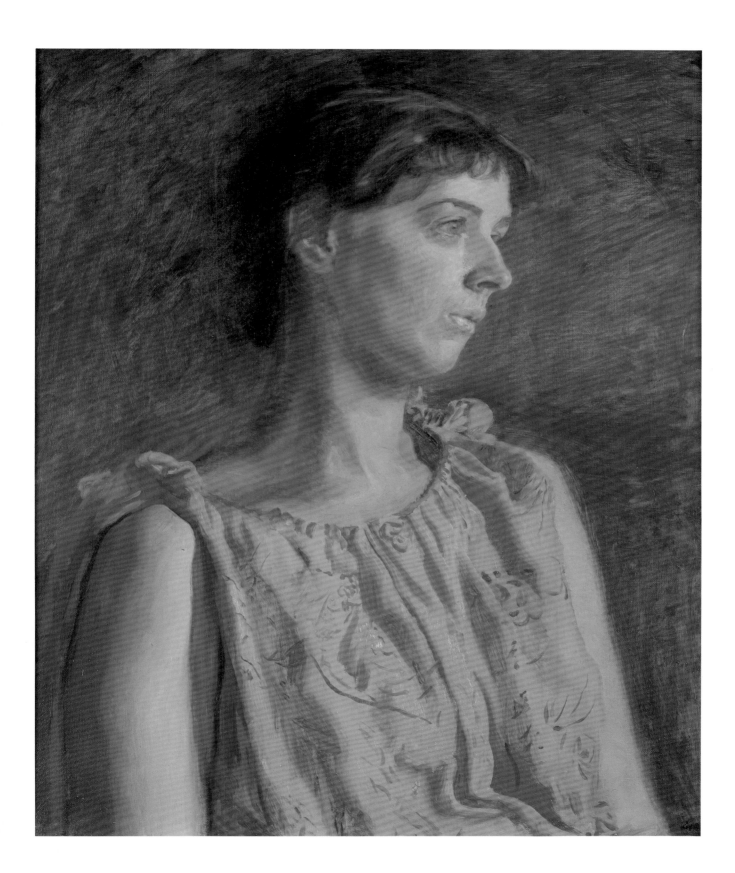

Thomas Eakins, 1844–1916

21 *The Wrestlers*, 1899 70.38

Oil on canvas, 48⅜ x 60 in. (122.9 x 152.4 cm.). Signed and dated upper right: Eakins/1899. Museum Purchase: Derby Fund, 1970

In 1898–1899 Eakins painted several boxing and wrestling pictures which are notable for their paradoxical qualities of stillness and repose. In Eakins's boxing pictures there is no contact between combatants; instead, the artist has chosen to depict moments between rounds, or after the knockdown, or after the fight. His wrestlers, intertwined in combat, are described with little feeling of action. Similarly, in Eakins's early rowing pictures there is also a suppression of motion. Laid out on perspective grids and locked into place by a variety of other devices, his rowers are poised to move but do not convey an impression of motion. Such inactivity—unusual in rowing scenes—is far more remarkable in combative scenes such as Eakins produced in the late nineties.

The models for *The Wrestlers* were members of the Quaker City Athletic Club. They were selected and posed by a Philadelphia sportswriter, Clarence Cranmer, who later described the occasion: "Joseph McCann is the man on top—being a [boxing] champion I had to pose him in the winning position, with a half nelson and crotch hold. . . . Tho not a champion wrestler, he was a very good one and a fine, most modest upstanding chap as well."[1]

Eakins first took a photograph of the two wrestlers nude, in the pose described. He made two oil studies: the first (Los Angeles County Museum) is small (16 x 20 inches), the second (Philadelphia Museum of Art) much larger (40 x 50 inches). Eakins may have painted the smaller study from life during the session when the photograph was taken, because the position of the top man differs slightly from the photograph. The figures in the larger study are virtually the same size as those in the Columbus museum's picture. In each of the larger works, the figures are nearly identical to the photograph. Traces of a squaring grid—which aided the enlargement from photograph to canvas—can be seen in both of the larger pictures.

Working from a photograph as well as other factors contribute to the stasis of this painting. Eakins has placed the prominent left scapula of the top wrestler almost at the center of the canvas, beneath the central vertical of a post that seems to "pin" him in place. The canvas is thus roughly divided into three areas: the upper left portion in which an athlete exercises on a rowing machine, the upper right with the cropped standing figures, and the entire lower half dominated by the foreground wrestlers. Dramatic foreshortenings are seen in the main group, reminiscent of Renaissance masters like Luca Signorelli. The strongly marked spine and extended right arm of the bottom man reiterates the horizontal of the rope and the boundary of the wrestling ring. The sharp triangles of his flexed left arm and his left leg are like symmetrical brackets that project into the upper parts of the painting and thus help unify the composition. The position of the left leg is the only significant deviation from the photographed pose; it is bent at a markedly more acute angle in order to strengthen the pictorial structure. Much of the wrestlers' immediacy derives from the low viewpoint, like that of a kneeling or crouching referee. Despite the fact that one of the wrestlers is in the dominant position a fall does not seem imminent, for contrary forces, pictorial as well as physical, hold everything in balance as though frozen in time.

One wonders why Eakins went to so much trouble to picture immobilized grapplers. To Eakins, the physical discipline of the athlete was perhaps an analogy for moral discipline. In *The Wrestlers* he offers not so much a sporting event as a symbol of persistent struggle with the real, material world. Locked ineluctably together, his wrestlers present a stoic image of unceasing resistance in the face of defeat and tireless effort in the determination to prevail.

Only as his brilliant career neared its end was Eakins belatedly (1902) elected to the National Academy of Design. Often embittered by official snubs, he was surely making a symbolic statement when he presented *The Wrestlers* as his requisite "diploma picture" to the Academy.

W.K.

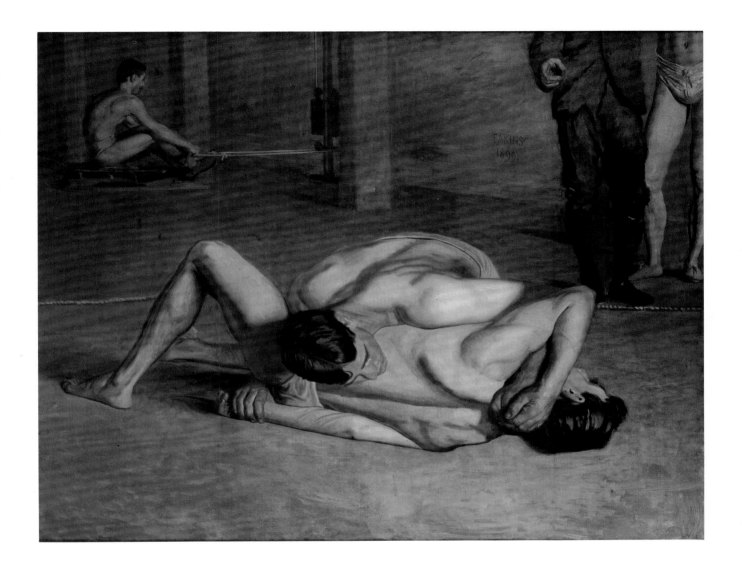

Thomas Eakins, *Wrestlers in Eakins' Studio*, ca. 1899, platinum print on paper, 3⅝ x 6 in. (9.0 x 15.2 cm.). Hirshhorn Museum and Sculpture Garden, Smithsonian Institution.

Cecilia Beaux, 1855–1942

During her lifetime Cecilia Beaux achieved an international reputation as a skilled portraitist. William Merritt Chase's now celebrated remark that "Miss Beaux is not only the greatest living painter but the best that ever lived" reflected critical and popular opinion at the turn of the century, when the artist was at the height of her powers and her talents were in demand.

Born in Philadelphia, the child of an American mother and a French father, Beaux was raised by her maternal relatives after her mother's early death. She received her formative art training in various private classes in Philadelphia. Her instructors included her cousin Katherine Drinker; Dutch artist Adolf van der Whelen; and, in 1881–1883, William Sartain from New York. Though in her autobiography (Background with Figures, published in 1930) she denied it, Beaux apparently studied at the Pennsylvania Academy of the Fine Arts from 1877 to 1879, during Thomas Eakins's tenure there.[1] Certainly the Academy was to play a significant role in her career, for it was there she exhibited for the first time, in 1879, and taught from 1895 to 1915 (long after her move to New York City in the 1890s).

Beaux enjoyed her first critical success with Les Derniers Jours d'Enfance *(private collection), which she completed in 1884 and exhibited at the Paris Salon in 1887. She first went abroad in 1888, at the age of thirty-two, and spent nineteen months traveling in France, Italy, and England. She studied at the Académie Julian and the Académie Colarossi in Paris and copied the old masters in the Louvre and in the National Gallery, London. Upon her return she opened a studio in Philadelphia and enjoyed success and critical acclaim from that time on.*

Beaux's European experience led her to abandon her early tonal realism, influences of Thomas Eakins and the Munich school. Her palette lightened, her brushwork became freer, and she demonstrated a heightened concern for composition and the textural possibilities of oil paint, all of which resulted in her acknowledged masterpieces of the 1890s.[2] After her second trip to Europe in 1896, Beaux began to adopt the ubiquitous international style of portraiture championed by John Singer Sargent. Her works increasingly were characterized by a painterly, fluid style and by the fashionable opulence of the sitters who became her subjects. Quite possibly, however, her reliance on this style to the growing exclusion of her own painterly instincts contributed to a decline in the quality of some of her later works. Due to failing health she painted very little after 1924.

Beaux was a sensitive portraitist who was able to capture both the likeness and the state of mind of her sitters. To her way of thinking, portraiture was "the idea of a soul to be given a body to be made of paint, turpentine, and canvas."[3] Beaux was always very careful in her choice of sitters, often refusing lucrative commissions because of her belief that portraiture should be a collaboration involving the artist, the sitter's personality, and the medium of paint. As a consequence, she thought a portraitist should not paint strangers.[4] The art of portraiture, she believed, was in the artist's imagination and the treatment of the subject, not in the subject alone. She sought in her works "to give veritable shape to a personality" through her treatment and design of the entire painted surface.[5]

22 *Mrs. Richard Low Divine, Born Susan Sophia Smith*, 1907 47.80

Oil on canvas, 74¾ x 48 in. (189.9 x 121.9 cm.). Signed lower left: Cecilia Beaux. Bequest of Gertrude Divine Webster, 1947

The portrait *Mrs. Richard Low Divine, Born Susan Sophia Smith* is a striking image of elegant simplicity, a harmonious blending of figure and setting.[6] The spare interior with its Oriental furnishings and the subject's unfocused, contemplative stare enhance the painting's mood of tranquil reverie. Beaux's placement of the settee along a sharp diagonal moves Mrs. Divine and her King Charles Spaniel, Peggy, into the viewer's space. The sitter's pose echoes the gentle undulating curves of the settee. Her folded hands, resting at the intersection of two strong compositional diagonals, are symbolic of her poise and bearing.

The figure of Mrs. Divine is painted with fluid, facile brushwork and is luminous with color. Her iridescent white dress, with its rich range of pastel hues, shimmers with light. Beaux's fascination with "the idea of light on an object as well as its effect" is evident in the work. A second light source from behind the figure illuminates her shoulder, rimming her upper body with an aura that suggests a clever visual pun on the sitter's last name.[7]

The portrait was painted in the summer of 1907, at Beaux's Gloucester, Massachusetts home, called Green Alley, when Beaux was fifty-two and her sitter sixty-three. There is a quiet strength in the representation of the sitter which may be attributed to Beaux's understanding of graceful aging and her preoccupation with thoughts on mortality. The previous year her beloved Aunt Elize Leavitt, whom she had painted in 1905 seated in the same settee, had died.

Meditating on the themes of the painting—aging and mortality—Beaux wrote in 1930:

There is only one remedy [for growing old] and only one palliative: to have a character that has absorbed the discipline of life as part of its nourishment and draws its happiness from the reflection its environment radiates, of what itself has bestowed.[8]

N.V.M.

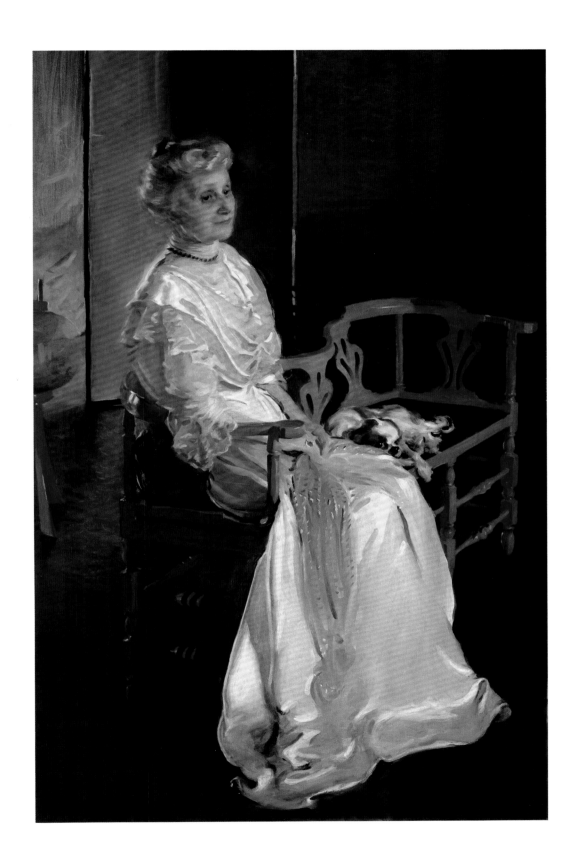

Robert Henri, 1865–1929

In the history of twentieth-century American art, few artists have left as indelible a mark as Robert Henri, champion of the common man, proponent of individuality, and crusader against academic restrictions in artmaking and exhibiting. His art education varied in emphasis and prepared him for his future independent stance. At the Pennsylvania Academy of the Fine Arts he studied under Thomas Eakins's protégé Thomas P. Anshutz, gaining a profound respect for subjects taken from everyday life. His education in Paris, under such conservative masters as Adolphe William Bouguereau, was less satisfying due to its emphasis on conventional techniques and literary subjects. But during his years abroad he traveled extensively, studying and absorbing in his memory the works of Rembrandt, Hals, Velázquez, and Manet, which were to have a strong influence on his art.[1]

Henri's accomplishments were manifold. Teaching at the Art Students League, the radical Ferrer school,[2] and elsewhere, he broke with the conventions of his day, and reacting against academic concentration on craftsmanship he refused to emphasize the mastering of skills and techniques. Rather, he encouraged his students to become directly involved in interpreting subjects from life and to regard aesthetic issues as secondary to that purpose. Henri claimed that "Art cannot be sepa-rated from life. . . . We value art not because of the skilled product, but because of its revelation of a life's experience."[3] A list of Henri's students reads like a "Who's Who" of twentieth-century American artists, including, among others, George Bellows, Rockwell Kent, Stuart Davis, and Edward Hopper.

As leader of the so-called Ashcan School, Henri was instrumental in gaining acceptance for urban genre imagery in American art. His compositions were realistic, often socially conscious in their emphasis on the working class. To him, vigor and truthfulness were more important than sentimentality and storytelling.

Henri also challenged the academic monopoly on exhibiting. In 1908 he organized the Macbeth Galleries Exhibition of The Eight, which included—in addition to his own paintings—works by John Sloan, William Glackens, Arthur B. Davies, Ernest Lawson, Maurice Prendergast, Everett Shinn, and George Luks. The show proved that Americans could exhibit successfully outside the confines of the powerful National Academy of Design. Two years later—in 1910—Henri was a major force behind the Exhibition of Independent Artists, the first major nonjuried show in America and an important prototype for the 1913 Armory Show.

23 *Dancer in a Yellow Shawl*, ca. 1908 10.2

Oil on canvas, 42 x 33½ in. (106.7 x 85.1 cm.). Signed lower left center: Robert Henri. Museum Purchase, 1910

Henri was at his best in portraiture because of his profound respect for the individual. He responded positively to each sitter's appearance, energy, and personality. Although he avoided compositional formulas, he generally posed and illuminated his subjects in a dramatic way. In addition, he paid close attention to costume as a means of bringing out the character of his subject.

Dancer in a Yellow Shawl is characteristic of Henri's portraits between 1900 and 1910.[4] With its dark brown background, spotlighted form, and broad, painterly brushwork, it is reminiscent of the psychological portraits of Hals and Manet. The identity of the dancer is not known, but Henri successfully conveys her personality through her pose, costume, and facial expression. She stands with her right hand on her hip and left arm at her side, resplendent in a rich yellow shawl draped over one shoulder. The shawl, similar to the tasseled "mantillas" Henri would have seen in Spain, gives the subject a theatrical, exotic quality, and is suggestive of the kinds of dances she most probably performed. Fluid brushstrokes energize her figure, implying her capacity for graceful movement. The brushstrokes in the face are most tightly handled to bring attention to the expression. The woman's elevated gaze and full smile seem public, not private. They evoke the pride and concentration of a performer on stage at curtain call.

Ordinary people such as this dancer most clearly revealed for Henri the sense of the universal spirit. Portraying them with love, Henri did not wish them to be reproductions of himself. He said:

> I do not wish to explain these people. I do not wish to preach through them. I only want to find whatever of the great spirit there is. . . . Each man must seek for himself the people who hold the essential beauty, and each man must eventually say as I do, "these are my people, and all that I have I owe to them."[5]

R.L.R.

John Sloan, 1871–1951

John Sloan grew up in Philadelphia. After he left school in 1888, he was employed in the shop of Porter and Coates, Philadelphia booksellers and dealers in fine prints. Inspired by the Rembrandt and Dürer prints he saw there, he taught himself printmaking. By 1890 he was working as a freelance artist, designing calendars and novelties. He began formal studies in art the same year in a night class in drawing at the Spring Garden Institute. In 1892 he became an illustrator for the Philadelphia Inquirer, *recording the subject matter of the city's streets in the direct, spontaneous manner that characterizes much of his subsequent work. From 1892 to 1894 he studied at the Pennsylvania Academy of the Fine Arts, where through his teacher Thomas Anshutz he absorbed the realist tradition that had begun there with Thomas Eakins.*

Through friends at the Academy, Sloan met Robert Henri, who was to have considerable influence on his art. In 1893, Sloan and Henri helped found the Charcoal Club, a group of artists, including newspaper illustrators William Glackens, George Luks, and Everett Shinn, who met to draw under Henri's guidance. Sloan moved to New York in 1904. Four years later, he and his Philadelphia friends, Henri, Glackens, Luks, and Shinn, joined with three others, Maurice Prendergast, Ernest Lawson, and Arthur B. Davies to exhibit together at the Macbeth Galleries in New York City. After the Macbeth exhibition, they were known collectively as The Eight, a stylistically diverse group of artists united by their insistence on artistic freedom and their opposition to the conservative policies of the National Academy of Design.

Though he exhibited frequently after 1900, Sloan did not sell a painting until 1913, when he was forty-two years old.

24 *East Entrance, City Hall, Philadelphia*, 1901 60.6

Oil on canvas, 27¼ x 36 in. (69.2 x 91.4 cm.). Signed and dated upper right: John/Sloan/1901. Museum Purchase: Howald Fund, 1960

In 1901, this announcement appeared in the *New York Times*:

> John Sloan, an artist whose pictures at the last Carnegie, Chicago, and New York American Fellowship exhibits brought him into prominence, is at work upon a series of studies of city scenes which will appear in the Fall exhibitions. Mr. Sloan is a believer in the capabilities of the modern city for artistic work, a theory which he shares with his friend Everett Shinn.[1]

One of Sloan's city scenes from this period, *East Entrance, City Hall, Philadelphia*, includes a portion of a prominent Philadelphia landmark and describes a commonplace street scene before the turn of the century. Reflecting on the picture, Sloan recalled:

> In the late 90's a load of hay, a hansom cab, and a Quaker lady were no rare sight in the streets of Philadelphia. A sample of each appears in this painting made when I was still drawing for the "Philadelphia Press."[2]

The painterly surface, earthy colors, and dominant architecture of the composition are typical of Sloan's early work, in which he emphasized structures rather than people. In this ambitious picture, figures bustle about in the street, dwarfed by the monumental scale of the building with its deftly rendered architectural detail and the dark looming arch at its center.

Sloan mused about the work and its relation to the mainstream of his time:

> This picture [was] made from memory and a few pencil notes. . . . My work in those days was not in line with the fashionable trend. The Impressionists were winning first place among the avant-garde of the time but my influences were Hals, Velásquez, Goya, Manet, and Whistler, mostly by way of Henri and photographs in black and white.[3]

Indeed, the subdued tonality and rich brushwork of the painting bear this out.

When Sloan moved to New York in 1904, he was immediately confronted with the vitality of his new home. Responding to Henri's teaching and encouragement, he began to emphasize the life of the city in his paintings. He adopted a brighter and more vibrant palette and turned his attention to human subjects in works such as *Spring Planting, Greenwich Village* (cat. no. 25) of 1913.

D.A.R.

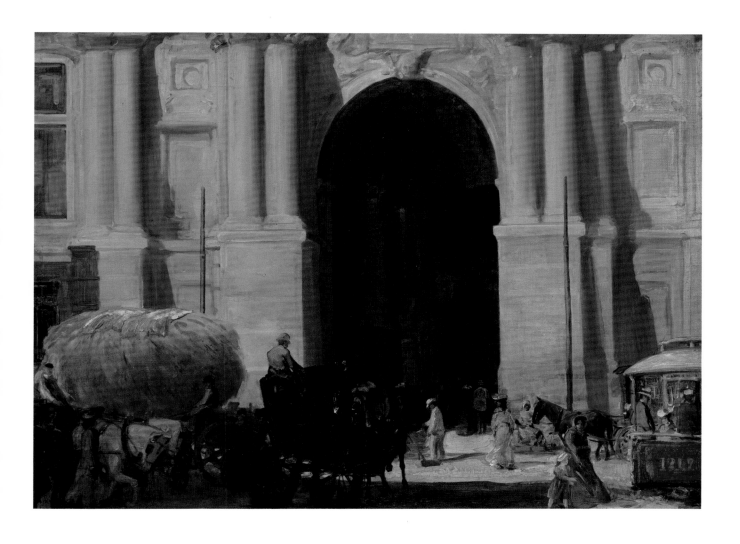

John Sloan, 1871–1951

25 *Spring Planting, Greenwich Village*, 1913 80.25

Oil on canvas, 26 x 32 in. (66 x 81.3 cm.). Signed lower right: John Sloan. Signed and inscribed on reverse of canvas: Spring Planting/ John Sloan. Inscribed along top of stretcher: SPRING PLANTING GREENWICH VILLAGE N.Y./John Sloan. Inscribed along bottom of stretcher: Spring Planting Greenwich Vill/John Sloan. Museum Purchase: Howald Fund II, 1980

Reflecting on this view of a neighboring garden from his New York apartment, the artist recalled: "The picture fixes a lovely spring day and a group of merry boarders in the next door yard filled with momentary energy to till the soil."[1]

A happy genre scene, the picture represents Sloan's developing interest in figural representation and the subjects surrounding the lives and activities of ordinary people. Here, the artist has captured the camaraderie of his Greenwich Village neighbors, whose behavior and dress suggest very different personalities and attitudes. The two at the left work closely with the soil, wearing suitable, simple dresses, while the third, too dressed-up for gardening, leans back comfortably against a laundry post with an upended rake in her hand. The fences that border the yards provide only a pretense of privacy; as the three young women work, they are observed by another woman in a nearby window and even by a crouching cat peering down from the top of a fencepost. This intimate backyard scene is played out in conscious contrast to life in the world beyond the fence. In the upper third of the composition are images of the crowded city: the back walls and fire escapes of surrounding buildings, drying laundry, trees, fence planks, a utility pole.

Sloan enlivens this springtime scene by his use of color contrasts: the pale greens and cool blues that suggest the brisk air of spring, the warm rosy glow of cheeks and arms, and the bright red hair of the gardener on the left. His heightened colors show the influence of color theorist Hardesty Maratta, whose palette and color system Robert Henri introduced to Sloan in 1909. In effect, Sloan's use of this system was to brighten and expand his palette considerably. The lively hues and throbbing energy of the painting suggest another probable influence—that of Vincent van Gogh, whose works Sloan saw at the Armory Show in February 1913 (Sloan helped to hang the exhibit, which included several of his own paintings).

Sloan painted many views of the neighborhood outside his apartment window. In another, similar, composition— *Backyards, Greenwich Village* (Whitney Museum of American Art), of 1914—the season is winter, and children are building a snowman beneath the ever-present lines of laundry, while a cat crouches on the fence and a little red-haired girl watches the scene from a window.

D.A.R.

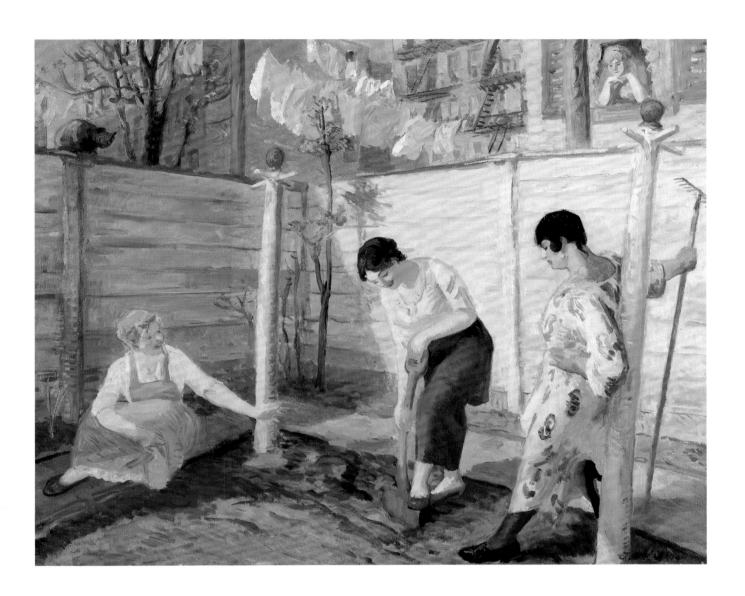

Ernest Lawson, 1873–1939

In his novel Of Human Bondage, Somerset Maugham is believed to have modeled his character Frederick Lawson on the Canadian-born artist Ernest Lawson, with whom he shared a Paris studio in 1894. In his portrayal of the fictitious twenty-one-year-old painter, Maugham identified the two intertwined passions that define his friend's life as an artist—Impressionism and a devotion to nature.

Lawson was a member of the generation of American artists who reached maturity in the last years of the nineteenth century and were responsible for continuing the development of Impressionism in the next century. He was introduced to the style as a student of John Henry Twachtman, first at the Art Students League in New York in 1891 and then at a sketching class conducted by Twachtman and Julian Alden Weir in Cos Cob, Connecticut, early in the summer of 1892. Lawson was in France from 1893 to 1896, studying briefly at the Académie Julian in Paris, then devoting himself to plein air painting in southern France and at Moret-sur-Loing near Fontainebleau. At Moret-sur-Loing, he met the English Impressionist Alfred Sisley, who—along with Twachtman—had a profound influence on the development of his style. In 1894 Lawson exhibited two of his canvases in the Paris Salon.

Lawson considered himself a traditionalist and his work a continua-tion of the Hudson River School. Though his style and choice of subject matter were unlike those of the urban realists, his friendship with William Glackens, whom he met in 1904, led to his inclusion in The Eight and participation in their 1908 exhibition at Macbeth Galleries. In 1913 he exhibited three works in the Armory Show.

A trip to Spain in 1916 brought about some significant changes in his style. His subsequent compositions reflect a more pronounced Cézannesque structure, and the range and brightness of his colors increased dramatically. Lawson's biographer, the critic Frederick Newlin Price, attributed the luminous results to the artist's "palette of crushed jewels."[1]

Lawson received several awards and prizes at the height of his career, and William Merritt Chase hailed him as America's greatest landscape painter, but he was not widely acclaimed in the United States during his lifetime. He was plagued with financial problems, poor health, and discouragement during his last years. Though he never abandoned Impressionism, his late works became increasingly expressionistic. Lawson died in Florida, where he had lived since 1936, of an apparent heart attack.

26 *The Hudson at Inwood* 31.201

Oil on canvas, 30 x 40 in. (76.2 x 101.6 cm.). Signed lower right: E. Lawson. Gift of Ferdinand Howald, 1931

In 1898, Lawson moved to New York City, settling in Washington Heights, where he lived for eight years. He concentrated on subjects in the neighborhoods of Upper Manhattan, along the Hudson and Harlem Rivers, for much of the next two decades. *The Hudson at Inwood* depicts an area at the northernmost tip of Manhattan which, during the artist's lifetime, was sparsely populated, wooded, and dotted with small farms. In choosing his subject matter, Lawson deliberately avoided picturesque sites. Certain contemporary critics faulted his choice, seeing in it, no doubt, a suggestion of the urban realist subjects of the Ashcan painters with whom Lawson was closely allied. He was criticized for his refusal "to disguise the more rugged elements in his canvases,"[2] and at the same time he was praised for his ability to "bring beauty out of a region infested with squalid cabins, dissoluted trees, dumping grounds and all the other important familiarities of any suburban wilderness."[3]

Nevertheless, there is a quiet lyricism in the lonely, uninhabited landscape of *The Hudson at Inwood*. While it is grounded in truth to location and season, the work is also an expression of the artist's personal response to a scene and his belief in the abiding beauty of nature. In this, it reflects the influence of Twachtman; in strength of form and composition it echoes the influence of Cézanne. Cézannesque structure, which began to influence Lawson after the Armory Show of 1913, is most notable in the form-defining brushstrokes in the roofs of the houses and in the trees that follow the contour of the hill in the background. The strength and vigor of Lawson's technique are evident in his thick strokes of pure and variegated colors, frequently applied with a palette knife to create a richly textured surface.

Ferdinand Howald purchased a small version of the painting in April 1918 and exchanged it a year later for the larger canvas of the same title now in the museum's collection. The smaller version (private collection) depicts the same scene from a nearly identical viewpoint but with a cover of snow.

N.V.M.

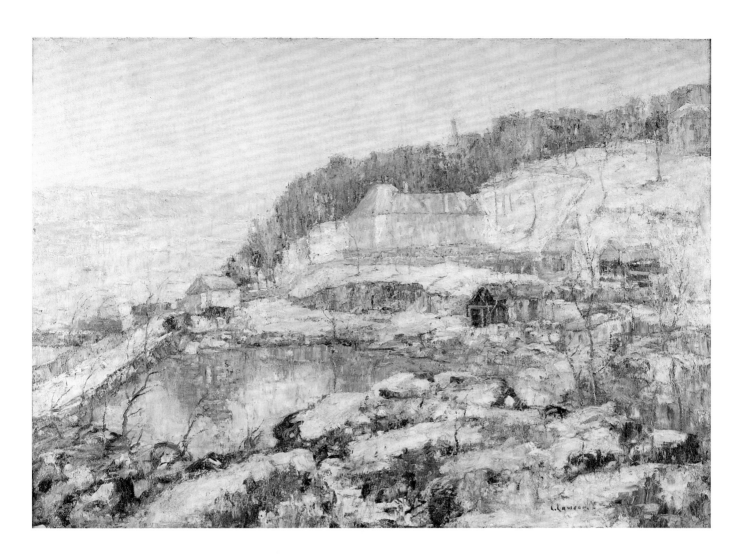

Maurice Prendergast, 1858–1924

Maurice Prendergast is considered to be America's first Post-Impressionist painter—probably the most modernist painter working in the United States between 1895 and 1909. He and his twin sister Lucy were born at the family's trading post in St. John's, Newfoundland. Raised in Boston's South End, he was apprenticed as a youth to a local art firm specializing in card painting. From his beginnings in graphic art and popular illustration, Prendergast, who was a self-taught painter, progressed to the study of fine art between 1891 and 1895 when in Paris he studied at the Académie Julian and the Académie Colarossi with Gustave Courtois and Benjamin Constant. French influences remained central to Prendergast's style throughout his career. During his years abroad, his friend, Canadian painter James Willson Morrice, introduced him to an abundance of fermenting modern styles, including Impressionism and Post-Impressionism, particularly the work of the Nabis. He also gained helpful insights from the Van Gogh and Seurat retrospectives in Paris in 1891 and 1892, respectively. Prendergast's personal style evolved rapidly in works produced during these critical years in Paris, moving from tonal paintings inspired by Whistler to brilliant colorist works in the vein of Vuillard and Bonnard.

In 1895 Prendergast returned to Boston. His early works were mostly watercolors or monotypes of idyllic beach and park scenes, subjects with which he would become most closely identified. He continued to paint in watercolor throughout his career but produced his more than two hundred monotypes between 1895 and 1902. He experimented with oils in the 1890s but did not concentrate on the medium until after the turn of the century. His mature style in oil, which developed as rapidly as his watercolor technique, is characterized by rich, bold color and layers of heavy impasto woven together with short rhythmic brushstrokes. His later oils have a drier and denser surface and an overall structural unity that was inspired by his growing awareness of Cézanne after 1907. His watercolors, though marked by greater color intensity in later years, always retain their clear, fresh color.

Prendergast earned critical acclaim as the result of two major exhibitions of his watercolors and monotypes in 1900, at the Art Institute of Chicago and at Macbeth Galleries in New York. In 1904 he participated in the National Arts Club exhibition, which brought him into contact with William Glackens, Robert Henri, and John Sloan. Glackens remained Prendergast's lifelong friend; in 1908 the two artists exhibited together again, this time as members of The Eight, at Macbeth Galleries. Critics found Prendergast's use of vibrant color and abstracted form more disconcerting than the dark urban realism of Sloan and Henri, in one case derisively likening this painting to "whirling arabesques that tax the eye."

Poor health during the final years of his life restricted his output. His formidable reputation, however, was sustained through major exhibitions such as those at the Carroll Gallery and the Daniel Gallery, which gained him the patronage of Albert Barnes and Ferdinand Howald. In 1916 the Montross Gallery exhibited Prendergast's works alongside those of Cézanne, Seurat, Van Gogh, and Matisse in the exhibition Fifty at Montross, and in 1921 the Joseph Brummer Gallery held a major retrospective, the climax of an important career.

27 *St. Malo No. 2*, ca. 1907–1910 31.247

Watercolor and graphite on paper, 12¾ x 19¼ in. (32.4 x 48.9 cm.). Signed lower left center: Prendergast. Gift of Ferdinand Howald, 1931

Prendergast's depictions of St. Malo date from the summers he spent in Brittany in 1907 and 1909. A medieval fortress, St. Malo became during Prendergast's era a popular resort and an artist colony. Its lively variety of architectural and landscape subjects, including its lighthouse, beaches, and ramparts, captured Prendergast's imagination. He frequently painted the famous high tides of St. Malo, but on this occasion he portrayed the beach at ebb tide, fully capitalizing upon the festive qualities of the scene.[1]

In Prendergast's depiction, the populated beach becomes a luminous array of delightful patterns. Striped cabanas, circular parasols carried by women on their promenades, and the square mosaics of the brick walkway are diverse motifs that receive varied applications of paint. Yet the composition is united by the flood of light emanating from the white watercolor paper. Prendergast's light and color gives shape to the cabanas, and the background is filled with fluid washes of blue-green representing gentle sea waves. Opaque accents and translucent masses weave a blend of textural variation as one technique is used for genre elements, man and man-made structures, and the other for the natural elements of sea and sky.

Unlike its more Impressionist counterpart *St. Malo No. 1* (also in the Columbus Museum of Art), *St. Malo No. 2* shows Prendergast's assimilation of Post-Impressionist and Fauve influences. Of particular significance are the examples of Cézanne's watercolors, which Prendergast praised as compositions that "leave everything to the imagination," and the works of Raoul Dufy and Albert Marquet, members of the LeHavre Fauve contingent who also recorded the gaiety of surrounding resort life.

Prendergast's contribution to the 1908 exhibition of The Eight at Macbeth Galleries included a number of St. Malo oil paintings and watercolors that drew an emphatic critical response. One writer imagined St. Malo to be, "a place where the sun shines in a curious manner, where color is wonderfully made manifest . . . and where everything else is a jumble of riotous pigment such as one does not see elsewhere. Hung in a group these canvases of Mr. Prendergast look for all the world like an explosion in a color factory."[2] Another critic dismissed the paintings as "so-called pictures that can only be the product of the cider much drunk at St. Malo," but he had the foresight to allow, "Prendergast may take heart . . . these pictures may be the Monets of a quarter century hence."[3]

L.L.M.

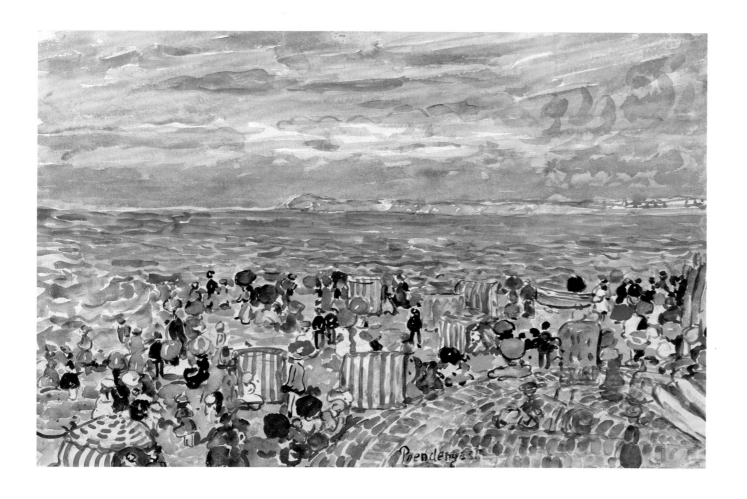

Maurice Prendergast, 1858–1924

28 *The Promenade*, ca. 1912–1913 31.244

Oil on canvas, 28 x 40¼ in. (71.1 x 102.2 cm.). Signed lower left: Prendergast. Gift of Ferdinand Howald, 1931

Maurice Prendergast's *The Promenade* exemplifies the artist's distinctive American modernism both in style and choice of subject. Repeatedly throughout his career Prendergast returned to the promenade theme, creating in each a personal arcadia that transcends the specifics of time and place. His vision is unique, setting his work apart from contemporary urban realist scenes of its kind, such as Glackens's *Beach Scene, New London* (cat. no. 29), which treats the subject as vernacular genre. Instead, Prendergast conjures an idyllic seaside scene inspired by his annual summer trips to the New England coast. Here he summons several sources with which his own creative instincts had a natural and enthusiastic affinity. Among these are the Italian Renaissance tradition of the pastoral or poetic, seen for example in works by Giorgionne and Botticelli; the wistful eighteenth-century *fêtes galantes* of Watteau, depicting elegantly dressed people at play in parklike settings; and the modern French decorative school of Pierre Puvis de Chavannes and Henri Matisse. Like Matisse's *Joy of Life* (1905, Barnes Foundation), Prendergast's *The Promenade* is plausible as an observed scene though it owes as much to the realm of poetic imagination.

An evocation of a pleasurable seaside experience, *The Promenade* is richly painted, its patterns of emphatic color applied with a daring that few artists of Prendergast's generation had yet achieved. In his oil paintings, Prendergast increasingly defined his subjects in terms of two-dimensional, simplified shapes, organizing these through color and brushstroke into a seamless structural entity. Both the figures and the surroundings become part of a rhythmic continuum of rolling, looping strokes that undulate throughout the canvas. To Prendergast, pattern and texture were of utmost importance. His brushwork combines smooth strokes with daubs and scumbling—a technique that is often described as stitchlike—to achieve an overall effect of tapestry or mosaic. In this he shares the sensibility of Vuillard and Bonnard, Nabis who brought to bear upon modern art the influences of the fourteenth-century pastoral frescoes at the Papal Palace of Avignon and the Dame à la Unicorne tapestry at the Musée de Cluny.

The Promenade is one of several Prendergast works purchased by Ferdinand Howald through the Daniel Gallery in New York City. When Howald bought the painting in 1916, he also acquired the original frame made by Prendergast's brother Charles, a decorative artist and craftsman. Among the many works in which Prendergast focuses on the promenade theme are those in the Meyer Potamkin Collection and the Whitney Museum of American Art.

L.L.M.

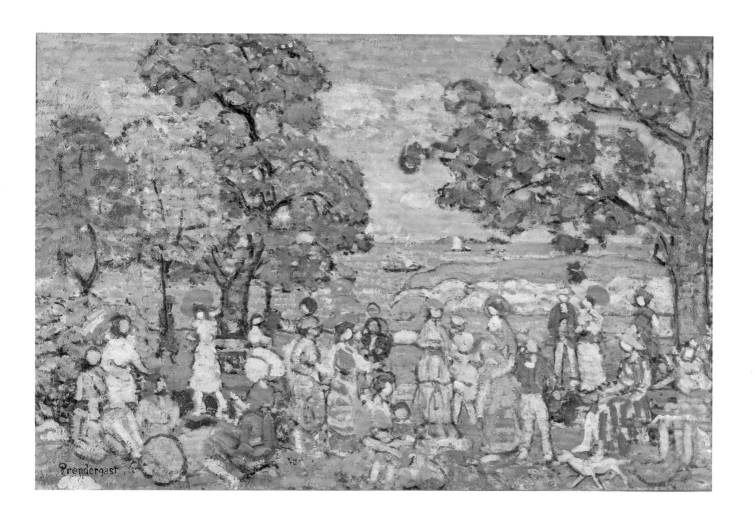

William Glackens, 1870–1938

William Glackens was born in Philadelphia, where in 1891 he began his career as an artist-reporter for the Philadelphia Record *and the* Philadelphia Press. *While employed as a newspaperman, he attended evening classes at the Pennsylvania Academy of the Fine Arts, studying under Thomas Anshutz, and he became acquainted with Robert Henri, with whom he shared a studio. Responding to Henri's advice to travel abroad, Glackens left in 1896 for a tour of Belgium, Holland, and France. A year later he returned to New York and worked as an illustrator for* Scribner's *and* McClure's. McClure's *sent him to Cuba in 1898 to cover the Spanish-American War, after which he returned home to paint.*

The pivotal event in Glackens's career came in 1908 when he exhibited as one of The Eight at Macbeth Galleries; thereafter his commitment to the advancement of modernism in this country led him to assume a variety of important roles. In 1912, he traveled to Paris to purchase art on behalf of his friend Alfred Barnes and returned with works by Cézanne, Renoir, Manet, and Matisse, which formed the nucleus of the Barnes Foundation Collection. The following year, Glackens assisted in the organization of the Armory Show and chaired the jury for the American section of the exhibition. He also served as the president of the Society of Independent Artists in 1916. Not neglectful of his art, between 1925 and 1932 Glackens frequently traveled to France, where he refined his study of the Impressionists, the Post-Impressionists, and the Nabis. His adaptation of the French styles in his figure painting and lyrical landscape-genre scenes was well received in this country. He received two gold medals from the Pennsylvania Academy of the Fine Arts, one in 1933 and another in 1936.

29 *Beach Scene, New London*, 1918 31.170

Oil on canvas, 26 x 31⅞ in. (66 x 81 cm.). Signed lower left: W. Glackens. Gift of Ferdinand Howald, 1931

According to the artist's son Ira, his father was particularly fond of painting public beach scenes during summers at the shore with the family.[1] In 1918, while passing the season at Pequot, near New London, Connecticut, Glackens painted *Beach Scene, New London*. While the work was clearly inspired by the immediate surroundings, it may also be viewed as an American variant of a French Impressionist theme: the urban middle class gathered for leisure bathing. Scenes such as *La Grenouillere*, painted in 1869 by both Monet (Metropolitan Museum of Art) and Renoir (National Museum, Stockholm, Sweden), and George Seurat's *Sunday Afternoon on the Island of La Grand Jatte* (1866, Art Institute of Chicago), are direct precedents. Such images must have struck a responsive chord in Glackens, who, like other members of The Eight, was interested in portraying ordinary people at labor or leisure.

With respect to temperament and style, Glackens is closer in spirit to Renoir than to The Eight—or any one of his fellow American artists. Indeed he came to be called the "American Renoir." Like his French counterpart, Glackens portrayed the middle class with an elegance and grace that emanated more from his artistic vision and sensibility than from the observation of reality. In paintings such as *Beach Scene, New London* he retains the primacy of the figure yet avoids likenesses or descriptive anecdotes. His figures, because of their amorphous nature, coalesce with the landscape surroundings. The salmon-toned sand provides a neutral yet lively background against which the artist plays the myriad color accents of the figures. Violet, turquoise, and pink tints dominate his palette. With his dry, delicate application of pigment, he catches the warm vibrancy of an atmospheric summer afternoon and conveys a sense of well-being.

Glackens's twentieth-century pastoral, *Beach Scene, New London*, is—in addition to being a descendant of French tradition—a precursor of American scenes from the Social Realist period, most notably Reginald Marsh's trenchant records of Rockaway Beach and Coney Island.

L.L.M.

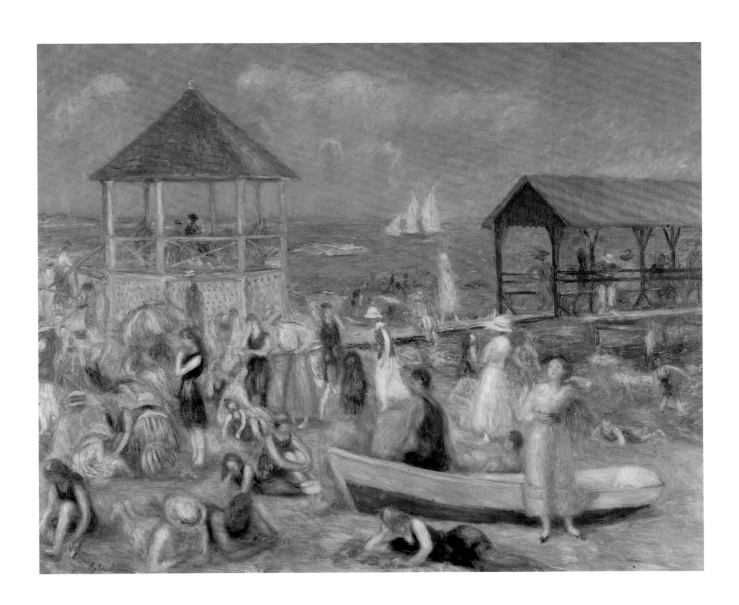

George Wesley Bellows, 1882–1925

A painter best known for his vigorous realism, George Bellows, a Columbus, Ohio, native, moved to New York City in 1904. He studied under Robert Henri at the New York School of Art from 1904 to 1906, along with Edward Hopper, Rockwell Kent, and others. Though he became a close associate of The Eight, or the Ashcan School as they were later called, he did not exhibit with those artists in their famous—and only—exhibition as a group at the Macbeth Galleries in 1908. Nevertheless, Henri, the leader of The Eight, had a profound influence on Bellows's art. Like Henri and others in his circle, Bellows painted dynamic city scenes. An avid sportsman who played semi-professional baseball, Bellows also painted athletic events that throb with energy and excitement. His portraits are no less vital. And because he had always been interested in drawing it was perhaps natural that he would experiment with lithography and produce a considerable body of works in that medium.

Bellows's career progressed very rapidly. He had been in New York only two years when he rented a studio of his own on Broadway in 1906. Within a year, he exhibited at the National Academy of Design for the first time and painted the first of his boxing scenes, Club Night *(private collection) and* Stag at Sharkey's *(Cleveland Museum of Art). The following year the Academy awarded him the Hallgarten Prize for* North River, *which was the first of his paintings to enter a major public collection (Pennsylvania Academy of the Fine Arts). In 1909 Bellows was named an Associate in the Academy, becoming the youngest Associate in the history of that institution. As testimony to his almost universal acceptance, in 1913 he became a full member of the conservative Academy and at the same time exhibited in the revolutionary Armory Show of modernist art.*

Peritonitis brought about Bellows's death in 1925, a year marked by numerous retrospectives held at major galleries and museums, such as Durand-Ruel Gallery, the Worcester Art Museum, the Metropolitan Museum of Art, and the Corcoran Gallery of Art.

30 *Blue Snow, The Battery,* 1910 58.35

Oil on canvas, 34 x 44 in. (86.4 x 111.8 cm.). Signed lower right: Geo. Bellows. Museum Purchase: Howald Fund, 1958

Blue Snow, The Battery is solidly within the urban realist tradition of city snow scenes. Works such as Robert Henri's *New York Street Scene in Winter* (1902, National Gallery of Art), a precedent from Bellows's immediate circle, surely helped direct the artist's attention to the subject. The appeal of snow scenes was twofold: snow obscured the less picturesque aspects of the city in winter, and provided a white, neutral background upon which the artist could develop varied effects of light and color reflection.

In *Blue Snow, The Battery* Bellows makes ample use of these advantages. Using a limited palette, largely confined to a range of blue shades and tones, the artist enlivens the composition by means of value contrasts and tonal accents set against a white field. Bellows, whose earlier works utilize a tonal palette usually of brown tones and white, had begun about this time to experiment with a color system devised by painter Hardesty Maratta, who manufactured premixed pigments in the full value range of each primary color. Bellows's use of Maratta's lively color schemes is seen in paintings after 1909.

The museum's city snow scene is articulated by Bellows's characteristic paint application in which the brushstrokes are broad and controlled and the brush is heavy with pigment. There is an ordered structural quality to the composition. Bellows carefully balances the horizontal expanses of snow with vertical elements such as trees to give the scene visual stability and, consequently, a sense of peace and stillness.

Despite its measured colors and spaces *Blue Snow, The Battery* is a vigorous work. So exuberant, in fact, is the artist's brushwork that a critic of the time thought the picture should be called "Assault and Battery."[1] Today Bellows is admired for the same energetic quality of his works, which, ironically, is as evident in this peaceful scene of a cold wintry day as it is in his forceful depictions of sporting events.

L.L.M.

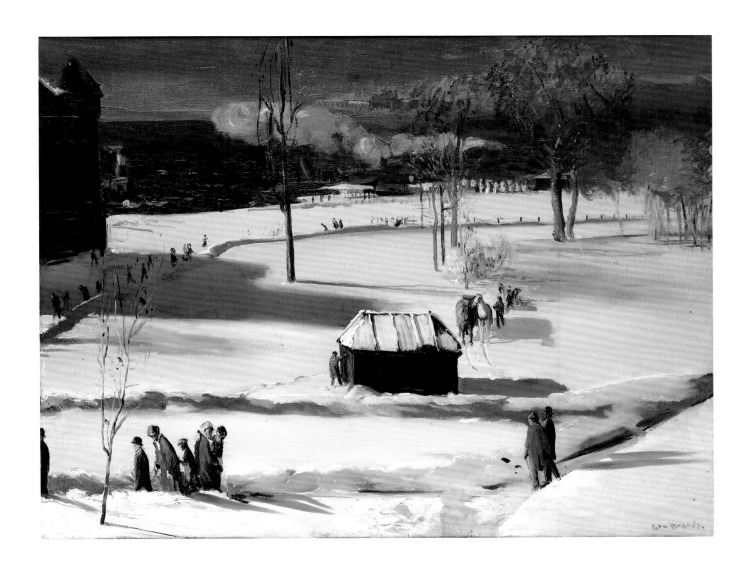

George Wesley Bellows, 1882–1925

31 *Riverfront No. 1*, 1915 51.11

Oil on canvas, 45⅜ x 63⅛ in. (115.3 x 160.3 cm.). Signed lower left: Geo. Bellows. Museum Purchase: Howald Fund, 1951

Concerning his choice of subject matter, Bellows remarked:

> I am always amused with people who talk about the lack of subject matter for painting. The great difficulty is that you cannot stop and sort [subjects] out enough. Wherever you go they are waiting for you. The men of the docks, the children at the river edge . . . prize fights . . . the beautiful, the ugly.[1]

Children swimming at a dockside, the urban equivalent of the "old swimming hole," provided Bellows and the urban realists an opportunity to depict the camaraderie of the lower classes. Bellows had made use of the theme earlier in his *River Rats* (1907, Everett D. Reese, Columbus, Ohio), a similar scene that he exhibited as his debut painting at the National Academy of Design.

Riverfront No. 1 is animated with tangled groups of young men and boys arranged to lead the viewer's eye back into space and forward once more. The figures are forcefully modeled, with heightened attention to anatomical structure—unlike the artist's typical, cursory figure style. Because the stages in which he applied his paint are discernible, the painting reveals much of his technique. First he drew the figures with his brush; then he worked the green underpainting into shadowed areas of the skin; and finally, he accentuated the figures with vivid red highlights that draw forward the complementary green tones. The dynamic quality of the scene is both enhanced and controlled by the diagonal lines of the pier to the right and the rocky ledge to the left which funnel toward the center of the scene. To offset these diagonal rhythms, Bellows added a horizontal dock and sailboats in the distance.

Bellows believed that successful pictures depended on a geometric basis. *Riverfront No. 1* suggests the beginnings of his growing interest in the systematic geometric ordering of compositions.[2] In subsequent years this interest led him to experiment with Jay Hambidge's theory of dynamic symmetry, which held that geometric ratios found in Greek and Egyptian art could be expressed in formulas for use by modern artists. As a consequence of these investigations he placed greater emphasis on mathematical divisions of the picture plane.

Riverfront No. 1 was awarded the gold medal at the Panama-Pacific Exposition in San Francisco in 1915. Frequently exhibited thereafter, the painting is one of Bellows's most significant and ambitious achievements.

L.L.M.

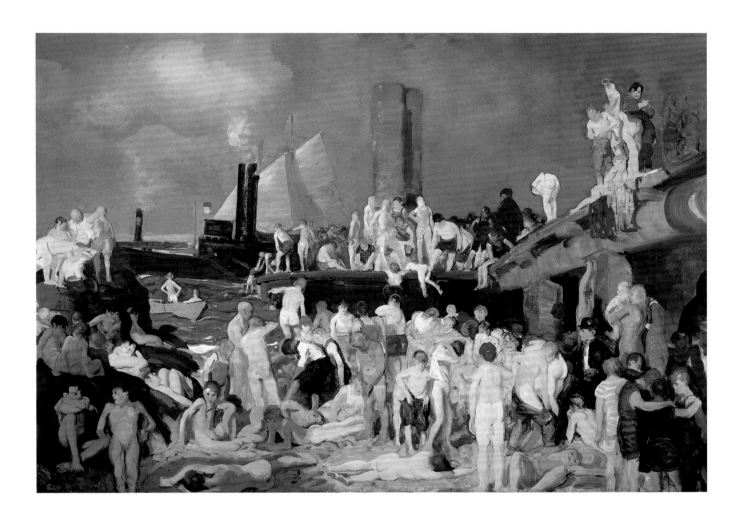

George Wesley Bellows, 1882–1925

32 *Portrait of My Mother No. 1*, 1920 30.6

Oil on canvas, 78¼ x 48¼ in. (198.7 x 122.5 cm.). Inscribed lower left: Geo. Bellows/E.S.B. [Emma S. Bellows]. Gift of Emma S. Bellows, 1930

At his summer home in Woodstock, New York, Bellows painted this portrait of his mother in September 1920. The following spring he completed a second version, now in the Art Institute of Chicago. Both portraits evince the warm relationship between Bellows and his mother, the former Anna Wilhelmina Smith. The daughter of a whaling captain, she married Bellows's father in 1878 when she was forty and he was fifty. Bellows, an only child, was born four years later.

With his characteristically rapid brushwork Bellows defines the rich, dark warmth of his mother's parlor in his childhood home at 265 East Rich Street, Columbus. The diffuse russet light that filters through shuttered windows permits only a selective view of her surroundings. Details such as her desk and writing materials emerge from the darkness as suggestions of her intellectual and social life. In contrast to the comparatively amorphous treatment of the interior, a more authoritative technique characterizes the portrayal of the artist's mother. Her figure dominates the space; she is positioned squarely in the center, enframed by the curving back of her parlor chair. A striking triangular form is created by her hands and head, suggesting perhaps the artist's feeling for her solidity and strength. In the Baroque portrait tradition of Velázquez, Rembrandt, and Hals, Bellows reserved the areas of highest finish, definition, and texture for the head and hands of his sitter while only evoking the figure beneath the dress. With a heavily loaded brush, he laid down the impasto passages of red and green that form luminous shadows on her skin and contribute to the modeling of form.

While the portrait recalls those of the seventeenth century, it is also true to American tradition. As a pupil of Robert Henri, the artist surely fell heir to the legacy of realist portraiture that Thomas Eakins passed on to Thomas Anshutz, who passed it on to Henri. In many ways this portrait is a reflection of Henri's teachings, particularly his advocacy of rapid execution and the creation of form by modeling with color. Henri's teachings had an emotional dimension that would likely appeal to Bellows's ebullient temperament. "Realize that your sitter has a state of being, that this state of being manifests itself to you through form, color, gesture . . . that your work will be the statement of what have been your emotions,"[1] Henri urged, and Bellows most certainly took it to heart.

<div align="right">L.L.M.</div>

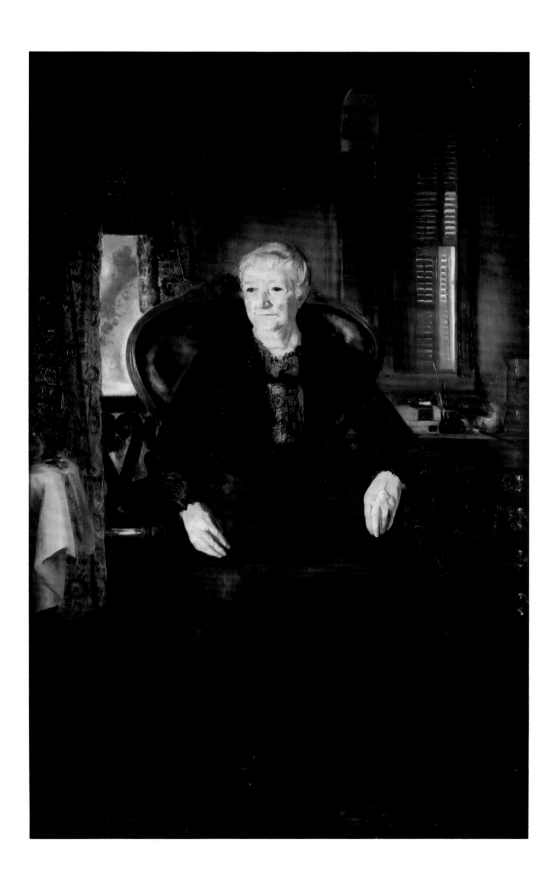

Rockwell Kent, 1882–1971

Rockwell Kent's life story is a saga that is fraught with conflicts both personal and political. In particular, Kent, an ardent and outspoken socialist, was falsely condemned as a Communist in 1936—at considerable cost to his career. He studied painting with William Merritt Chase during the summers from 1897 to 1900, and in 1902 he entered the celebrated class of Robert Henri at Chase's New York School of Art. He was apprenticed in 1903 to Abbott Thayer, whose vigorous application of paint he emulated and with whom he shared a spiritual affinity for an unpampered existence in wilderness outposts. Kent, one of the organizers of the Exhibition of Independent Artists *in 1910—spent much of his life in solitary, often forbidding natural surroundings: Monhegan Island, Maine; Newfoundland; Alaska; rural Vermont; Minnesota; Greenland; or the southern seas.*

Kent's painting Men and Mountains *was purchased by Ferdinand Howald from the Daniel Gallery in New York in 1917, before the collector and the artist had met. It was perhaps Howald's German-speaking Swiss heritage that cemented their friendship, for Kent spoke German from childhood and found many of his closest companions among persons of German culture. Owing in part to Howald's enlightened and committed patronage, Kent was able to travel to Alaska in 1918 to record the magisterial wilderness of that northernmost state.*

33 *Men and Mountains*, 1909 31.190

Oil on canvas, 33 x 43¼ in. (83.8 x 109.9 cm.). Signed and dated lower left: ROCKWELL KENT 1909. Gift of Ferdinand Howald, 1931

"Great things are done when Men & Mountains meet/This is not Done by Jostling in the Street."[1] The couplet, by William Blake, whose writing and art were among Kent's lifelong enthusiasms, is found amid Blake's verses about painting and painters and is quite probably the inspiration for the title of this painting. In 1913, when Kent exhibited *Men and Mountains* and other paintings in the town library of Winona, Minnesota, it was seen by composer, conductor, and amateur painter Charles Ruggles, who later composed an orchestral suite called *Men and Mountains*.[2] To his work Ruggles appended the epigraph from Blake, suggesting that perhaps he knew of a similar borrowing by Kent.[3]

Painted in the Berkshires in 1909, *Men and Mountains* evokes an idyllic Arcadian antiquity. Against a magnificent sweep of plain and mountain range and a sky bursting with massive cloudbanks the artist places pairs of naked men, the most prominent pair wrestling in the foreground. The landscape, wrote Kent, "was, to me, suggestive of Old Greece, of Mt. Olympus; so to enforce that thought, and with the struggle between Hercules and Antaeus in mind, I showed two naked wrestlers in combat."[4] Behind them a second pair of men may be seen sunbathing or, in the case of one of them, sunworshiping, for he stands with arms outstretched, head and torso thrown back, and his face turned to the heavens. Not as immediately apparent as the foreground figures are another twenty or so naked men—also in pairs—ranged all along the distant base of the hills. Kent introduces an ominous note of decay in this pagan paradise in the form of a dead dog lying on its back between two pairs of men in the foreground. Another duality, a powerful earth-sky dichotomy, strongly divides the canvas at its horizontal midpoint with a dark blue-gray band of shadow beneath the cloud bank.

Like Cézanne, who was also preoccupied with the theme of nudes in a landscape,[5] Kent obscured or eliminated the primary sexual characteristics of his male nudes (and did so throughout all his later work). Despite such tact, when *Men and Mountains* was first exhibited in Columbus in 1911, in a show organized by Robert Henri, it was "found so offensive to mid-western sensibilities and potentially so corruptive of the morals of the young, and of the fair both young and elderly, as to have been banned; and then, on Henri's threat to withdraw the entire show, hung in a separate room: for 'MEN ONLY.'"[6]

W.K.

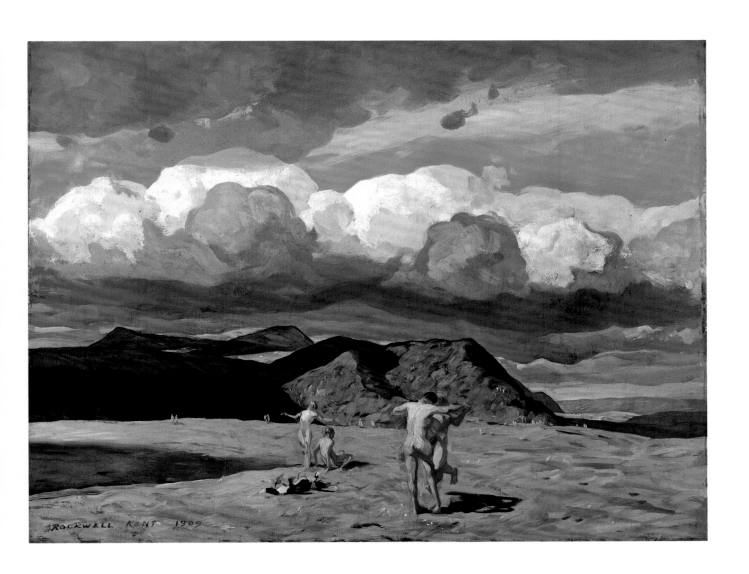

Edward Middleton Manigault, 1887–1922

Manigault's brief painting career coincided with the critical years of emerging American modernism. Interest in his work was eclipsed after his death at the age of thirty-five and did not revive until 1946, when his paintings were included in the exhibition Pioneers of Modern Art in America 1903–1918 *at the Whitney Museum of American Art.*

Born in London, Ontario, in 1887 to American parents from Charleston, South Carolina, Manigault left home in 1905 to study at the Art Students League in New York, where he became a student and close friend of Kenneth Hayes Miller. He made his New York exhibition debut in 1909 and in April of the following year participated in the Exhibition of Independent Artists, *organized by Robert Henri. Manigault traveled and worked abroad briefly in England and France in the spring of 1912. His first one-artist show at Charles Daniel Gallery in the spring of 1914 met with significant critical and popular acclaim for the startling originality of the works on exhibit. During World War I he joined the British expeditionary forces, serving in Flanders as an ambulance driver from April to November of 1915, when he was discharged for medical reasons.*

Although he worked steadily until the final year of his life, only a few of his works survive, for he himself destroyed numerous canvases (possibly as many as two hundred). The notebook record he kept of his works begins in 1906 and ends abruptly in 1919, when he and his wife—whom he married in 1915, two days before he was shipped abroad—moved to Los Angeles. Little of his late work satisfied him, least of all the Cubist and abstract experiments he attempted after 1919, and later, for the most part, destroyed.[1] After 1915 he increasingly earned money from artistic endeavors other than painting, such as ceramics, which he began to produce in 1916.

Manigault's deteriorating health was possibly complicated by fasting, which he believed would enable him "to approach the spiritual plane and see colors not perceptible to the physical eye."[2] Apparently he became too weak to transfer his visions to canvas. He collapsed and died while working in San Francisco in September 1922.

Manigault's career is characterized by insistent experimentation; his works are striking for their imaginative, decorative sense. His early works are grounded in the real world, but later works show that he became increasingly entranced by the world of the imagination. Before his war service he completed a series of fantastic visionary landscapes (for example, Mountainous, Landscape, [Wide Valley], *1913, Arnot Art Museum, Elmira, New York) and allegories (such as* Nymph and Pierrot [Eyes of Morning], *1913, Norton Gallery of Art, West Palm Beach, Florida) that align him with American symbolists and visionaries such as Arthur B. Davies. These works foreshadow the mystical themes of his late paintings, which reflect the influence of the Orient. Much of the potential of Manigault's prewar painting, heralded by the critics in 1914, was unrealized in the abstract experiments and visionary excesses of his late work.*

34 *The Rocket*, 1909 81.9

Oil on canvas, 20 x 24 in. (50.8 x 61 cm.). Signed and dated lower left: Manigault 09. Museum Purchase: Howald Fund II, 1981

Manigault painted *The Rocket* in October of the year he made his exhibition debut in New York. It is the work he selected for the *Exhibition of Independent Artists* the following year.

A painting of dazzling vibrancy and distinctive originality, *The Rocket* attests to the power of Manigault's artistic imagination and his instincts as a colorist in the early years of his career. The legacy of Impressionism, which Kenneth Hayes Miller identified as the source of Manigault's earliest canvases, is clearly apparent in the painting. A palette of pure color—dominated by red, blue, yellow, and orange—is used to create a brilliant array of short strokes and dots on a dark blue ground. Manigault has made the divisionist's brushstroke his own in order to explore the decorative potential of the scene and capture the intensity of his visual experience. Everything in the painting is orchestrated to achieve an impact of immediacy. An exploding shower of rhythmic color dominates the picture, illuminating a small boat floating on water that vibrates with reflections. Manigault's use of thick impasto and his juxtapositions of harmonious colors give palpable weight to the clouds and enliven patterns of color throughout the canvas. The infectious spontaneity of the painting belies its richly complex composition—the result of a calculated interplay of horizontal and vertical elements. Dark blue clouds rimmed with vermilion hover above the fireworks and frame the upper limits of the composition while vertical streaks of vermilion frame the clouds on either side. The lower fifth of the painting is executed entirely in short horizontal strokes, in sharp contrast to the upward thrust of vertical strokes in the rest of the picture. The horizontal strokes in effect provide a powerful compositional anchor to the work.

The inspiration for this subject may have been Whistler's *Nocturne in Black and Gold: The Falling Rocket* of 1875, which was on loan to the Metropolitan Museum of Art from 1907 to 1910. *The Rocket* and another painting by Manigault entitled *Battleship Firing Salute* (whereabouts unknown), both executed in October 1909, most likely commemorate an event from the Hudson-Fulton Celebration held along the Hudson River in New York State in the fall of 1909 in honor of Henry Hudson's discovery of the river (1609) and Robert Fulton's inauguration of steam navigation (1807). The festive occasion included numerous firework displays. Such scenes of New York and the surrounding area, together with an Impressionist's enthusiasm for rain, snow, and times of day, characterize Manigault's painting until about 1912, after which his subjects became increasingly visionary in concept.

N.V.M.

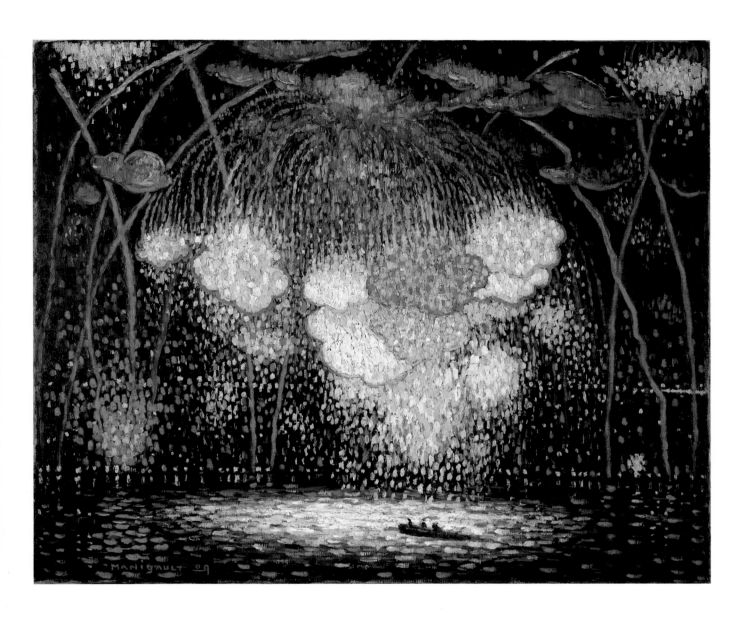

Edward Middleton Manigault, 1887–1922

35 *Procession*, 1911 31.208

Oil on canvas, 20 x 24 in. (50.8 x 61 cm.). Signed and dated lower right: Manigault 1911. Gift of Ferdinand Howald, 1931

The activities along the terraced paths of New York's Central Park are the subject of *Procession*, executed in May 1911. The original title of the painting, recorded in the artist's notebook as *In the Park—Late Afternoon*, reflects Manigault's lingering fascination with the specifics of time and place. By the time the painting appeared—with its current, amended title—in the exhibition at the Charles Daniel Gallery in March 1914, Manigault's visionary imagination had begun to dictate the direction of his work. Exhibited among the artist's 1913 works, *Procession* impressed contemporary critics with its decorative sumptuousness reminiscent of Persian miniatures, prompting one critic to write that the painting "betrays the spiritual significance of an art far removed from that of modern times."[1] Another critic wrote that the hint of Persian influence only quickened the artist's imagination, for "the feeling is of today and New York."[2] Numerous other reviews of the Daniel exhibition also singled out the work for particular praise.

The painting, with its pervasive mood of reverie, recalls the park processionals of Maurice Prendergast, another artist whose works were exhibited by Charles Daniel. The two painters had been part of the same artistic circle since 1908 or 1909, when Manigault first met Daniel. The tone of Manigault's daydream, however, is distinctly personal and much darker than that of Prendergast's compositions, for the dramatic sky and the web of trees that seems to imprison the figures hint of ominous overtones.

Procession represents a refinement of Manigault's decorative skills. The boldness of *The Rocket* (cat. no. 34) has here given way to intricate patterns and rhythms, investing an ordinary day in the park with the power of an elaborate contemporary ritual. Carefully segregated paths flow in alternating directions. The layered composition interweaves a tracery of tree branches, a flat, patterned landscape, and prominently outlined forms to provide an overall decorative quality to the work.

Manigault's *Procession* was the first work Ferdinand Howald acquired from the Charles Daniel Gallery. The transaction marks the forging of a link between dealer and collector that would insure the success of the four-month-old gallery and influence Howald's collecting pattern in American art for more than a decade. According to Daniel's recollection years later, Howald did not introduce himself at the time he visited the exhibition; he just looked. A month later he wrote from Columbus and asked that *Procession* be sent if it was still available.[3]

N.V.M.

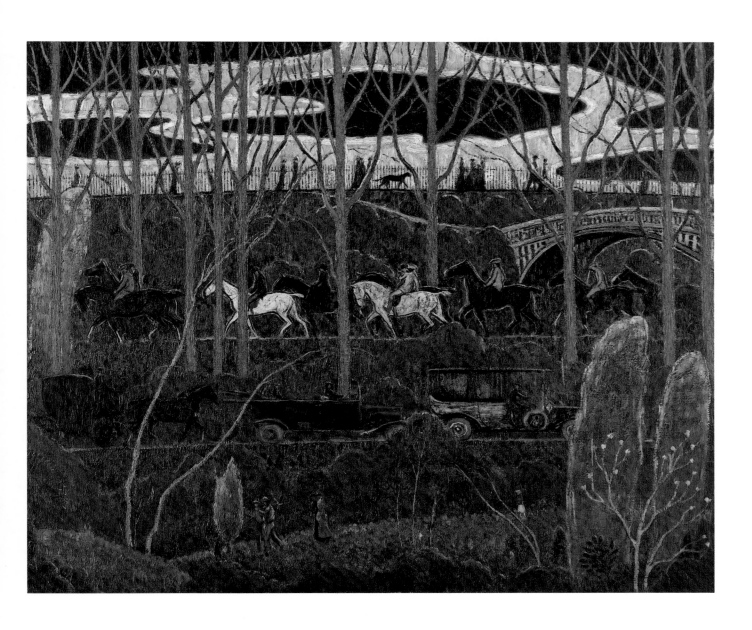

Arthur G. Dove, 1880–1946

Arthur G. Dove is generally recognized as the first American artist to develop an abstract style. His imagery, while derived from nature, does not replicate the appearance of the visual world but instead represents subjective responses to natural forms. He is thus a link between earlier artists who painted in the realist tradition and later artists who expressed feelings or moods or dealt mainly with problems of structure and design.

Born in Upstate New York, Dove attended Hobart College and Cornell University, graduating from Cornell in 1903. In New York City, he enjoyed success as an illustrator for Harper's *and the* Saturday Evening Post. *Deciding to become a painter, Dove went to France in 1907 and remained there until 1909, during which time he became acquainted with modern art. His* Lobster *(private collection), with its bright Fauve colors and Cézannesque structure, was exhibited at the Salon d'Automne of 1909.*

After returning to New York City in 1910, Dove met Alfred Stieglitz and came in touch with the group of avant-garde artists who gathered at the 291 gallery. That same year he exhibited in Younger American Painters, *a major early American modernist show that included works by John Marin, Edward Steichen, and Marsden Hartley. Stieglitz, a lifelong friend and advocate, gave Dove his first one-artist show in 1912. Dove experimented increasingly between 1924 and 1930, producing, among other things, assemblages and witty collages containing visual and verbal puns, inspired by Cubist and Dada examples.*

During the late 1930s, Dove was afflicted with a heart condition and Bright's disease, an inflammation of the kidney. Though slowed by deteriorating health, he nevertheless continued to paint, aided toward the end by his wife, the artist Helen Torr Weed. During the final two decades of his life, he exhibited annually at Stieglitz's An American Place and at major museums.

36 *Movement No. 1*, ca. 1911 31.166

Pastel on canvas, 21⅜ x 18 in. (54.3 x 45.7 cm.). Gift of Ferdinand Howald, 1931

Movement No. 1 dates from the outset of Dove's involvement with Stieglitz. It may be one of a series of pastels called The Ten Commandments, which Dove exhibited at Stieglitz's gallery in 1912.[1] In medium, dimensions, and style, the picture corresponds to other pastels in the series, but its inclusion cannot be confirmed with certainty because titles for individual works were not documented.

In *Movement No. 1* Dove does not attempt to describe an external reference point found in nature. Instead, he gives form to motion with hard-edged and organic shapes that establish a swirling visual rhythm. In an unpublished notebook he explains his artistic purpose: "I would like to make something that is real in itself, that does not remind anyone of any other thing, and that does not have to be explained—like the letter A for instance."[2]

In his passion for representing forms in motion, Dove acknowledges his debt to the Italian Futurists, the modernist group whose aggressive variations on Cubism emphasized violent pictorial rhythms and dynamic sequential movement. When describing his technique, he frequently used terms such as "force lines," which to his way of thinking conveyed a sense of energy and of the inner structure of objects, and "character lines," which, he said, mark the intersection of planes of color and give a sense of dimension to the forms.[3]

Movement No. 1 also attests to Dove's close study of Cubism. George Braque's designation of Cubist form as "inseparable from the space it engenders" surely influenced Dove's treatment of the picture plane as a volatile spatial field actuated by the emergence and dissolution of forms in motion. Like most avant-garde painters of his era, Dove was also keenly aware of contemporaneous scientific research into the kinetic nature of matter conducted by theorists such as Albert Einstein and Henri Bergson.

L.L.M.

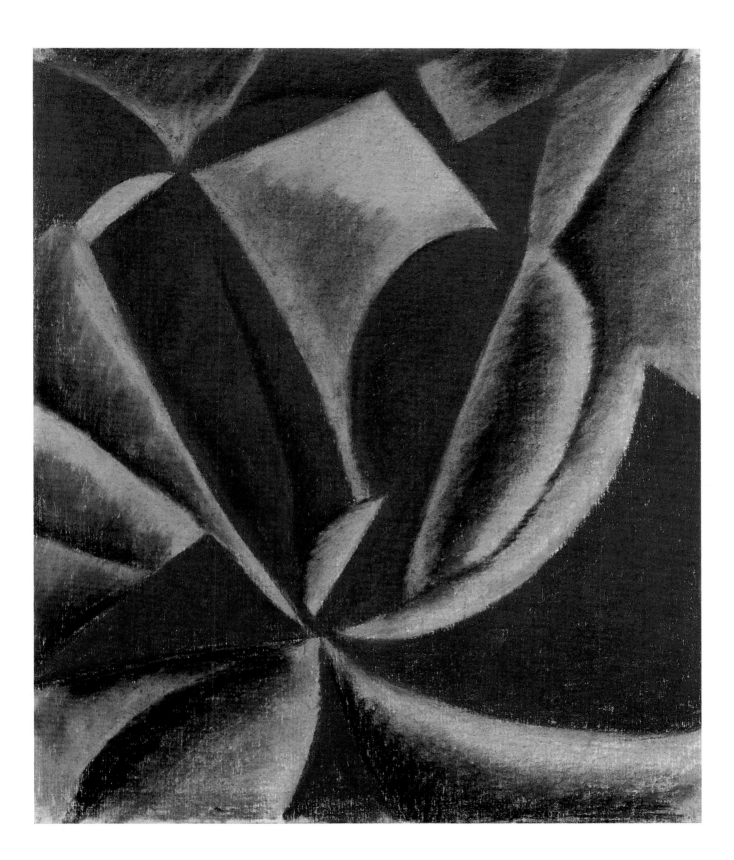

Arthur G. Dove, 1880–1946

37 *Thunderstorm*, 1921 31.167

Oil and metallic paint on canvas, 21½ x 18⅛ in. (54.6 x 46 cm.). Signed and dated on reverse, center: Dove/1921. Gift of Ferdinand Howald, 1931

Dove portrayed his impressions of thunderstorms in diverse media including charcoal (University of Iowa Art Museum) and oil and wax emulsion (Amon Carter Museum, Texas). The Columbus composition, an oil version with metallic paint, vividly summons the electric atmosphere and the fearful drama of a natural phenomenon. A saw-toothed silver form cuts through the scene vertically with the searing effect of a lightning bolt. Surrounding clouds, heavy with rain, are suspended ominously above the landscape. Black outlines and dense pigment reinforce a sense of foreboding as the brooding sky pelts the earth with rain.

Like other works by Dove, *Thunderstorm*, though it has its origins in external reality, demonstrates the artist's philosophy of "extraction"—that is, the distillation of the essential spirit of an object or a scene as opposed to overt description. The painting also illustrates the principle of synaesthesia: the evocation of one type of sensory experience through another—in this case, the visual evocation of a thunderclap.

Despite Dove's avoidance of descriptive details, his treatments of the American landscape convey a certain elemental rapport with the land. As Georgia O'Keeffe observed, "Dove is the only American painter who is of the earth."[1]

L.L.M.

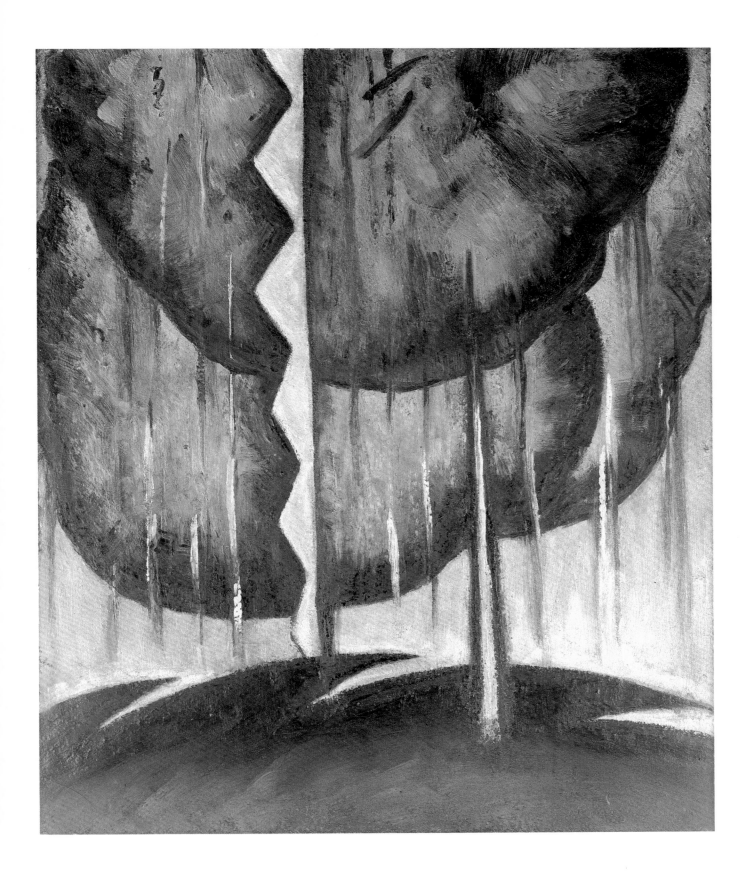

Georgia O'Keeffe, 1887–1986

Born near Sun Prairie, Wisconsin, Georgia O'Keeffe spent her child-hood in the rural Middle West. By the time she was ten years old she was determined to be an artist. She studied at the Art Institute of Chicago in 1905–1906 and then in 1907–1908 at the Art Students League in New York. Dissatisfied because she felt she had only learned to paint as everyone else was painting, she stopped painting for four years, until in 1912 she attended a summer drawing class at the University of Virginia. The course, taught by a student of Arthur Wesley Dow, exposed her to an entirely new approach to art. O'Keeffe went to New York to study directly under Dow at the Teachers College of Columbia University beginning in the fall of 1914 and again in the spring of 1916. In between, working in the isolation of North Texas and strongly influenced by Dow, who told her to "fill space in a beautiful way," O'Keeffe declared her stylistic independence in the fall of 1915 in a series of remarkably abstract charcoal drawings in which she demonstrated her intent "to strip away what I had been taught" and to "satisfy no one but myself." She sent the drawings to a friend, who showed them to Alfred Stieglitz. In May 1916, her works were included in an exhibition at Stieglitz's 291, and in the spring of 1917 Stieglitz sponsored her first one-artist exhibition there—the last show held at the galleries before they closed in July.

Through her association with Stieglitz, whom she married in 1924, O'Keeffe became part of New York's pioneering modernist circle and helped shape the course of American art. She did not go abroad to seek inspiration, as many others had done, but maintained her independence and initial commitment to her own intensely personal vision. Her works were accorded nearly universal approval from the start. She, however, often disagreed with the critical interpretation of her subjects, particularly the large flower paintings she began to produce in 1924, to which many critics attributed strong sexual overtones.

O'Keeffe's art encompasses the opposite poles of abstraction and representation. Seeing no conflict between the two, she invested all her works with the same vital spirit that speaks directly to the viewer. Her intuitive sense of abstraction lends to her most realistic works a purity of formal design. Hers is an art of essentials defined by strong, simplified forms and prismatic brilliance.

38 *Autumn Leaves—Lake George, N.Y.*, 1924 81.6

Oil on canvas, 20¼ x 16¼ in. (51.4 x 41.3 cm.). Museum Purchase: Howald Fund II, 1981

Between 1918 and 1928 O'Keeffe worked primarily in New York City and at the Stieglitz family's summer home at Lake George. O'Keeffe particularly enjoyed the autumns at Lake George. After a summer of entertaining guests and family, O'Keeffe, left alone with Stieglitz, was able to return to painting. Her spiritual kinship with the season is fully felt in *Autumn Leaves*, in which she captures the very essence of autumn.

In all her paintings O'Keeffe explores the line of demarcation between abstraction and representation. This tension between the two accounts in some measure for the vitality of her paintings. In *Autumn Leaves*, as in other works, she uses the natural object—in this case the leaf—as her point of departure, creating brilliant, semi-abstract compositions from the interlocking design of contours and silhouettes. Subtle nuances of color as well as distinct contrasts accentuate the rhythmic movement of the leaf forms in *Autumn Leaves*. To O'Keeffe the leaves are simultaneously living things and abstract miracles of shape, texture, and color. Hers is a selective realism. She isolates the leaves from their natural setting and magnifies them until they fill the space of the canvas. Her explanation of the magnified flowers, painted during the same decade, is equally applicable to the leaf paintings:

> Nobody sees a flower—really—it is so small—we haven't time—and to see takes time. . . . So I said to myself—I'll paint what I see—what the flower is to me but I'll paint it big and they will be surprised into taking time to look at it.[1]

As scholars have noted, Arthur Dove's painting of fall leaves, *Based on Leaf Forms and Spaces* (reproduced in Arthur Jerome Eddy's 1914 book *Cubists and Post-Impressionism*), anticipates O'Keeffe's leaf paintings.[2] Dove enlarged his leaves, slightly cropping them at the edges of the canvas, as O'Keeffe would do later. In addition, O'Keeffe's concern for isolating forms and cropping magnified details, her use of a strict frontal viewpoint, and her interest in abstract patterning were anticipated in photographs by Stieglitz, Edward Steichen, and Paul Strand.

O'Keeffe was intrigued with the idea of exploring a single theme through a series of pictures, as she did, for example, in six series of paintings on the jack-in-the-pulpit dating from 1930. While the Lake George leaf paintings, which she did throughout the 1920s, do not constitute a series, it is possible to trace through them O'Keeffe's evolving sense of the season. Commenting on the repetition of certain subjects in her work, O'Keeffe said: "I work on an idea for a long time. It's like getting acquainted with a person and I don't get acquainted easily."[3]

N.V.M.

Marsden Hartley, 1877–1943

Marsden Hartley was one of America's pioneer modernists and one of the country's first abstract painters. Though he was deeply influenced by European modernist movements and restlessly experimented with a number of styles over the length of his career, he maintained a particularly American artistic vision. Born in Lewiston, Maine, he received his first training in Cleveland, Ohio, in 1892, and won a scholarship to the Cleveland School (now Institute) of Art. He went to New York in 1898 to study at William Merritt Chase's New York School of Art, then at the National Academy of Design. Inspired by the writings of Ralph Waldo Emerson, Henry Thoreau, and Walt Whitman, Hartley came to think of art as a spiritual quest, a view that was strengthened by his acquaintance with Albert Pinkham Ryder and later, in Germany, with Wassily Kandinsky.

In the spring of 1909 Alfred Stieglitz gave Hartley his first one-artist show, at the 291 gallery. Through Stieglitz, Hartley became aware of European modernists, most significantly Cézanne, Picasso, and Matisse. In April 1912 he made his first trip to Europe. He was welcomed by the avant-garde society of Paris, especially the circle of Gertrude Stein, but was soon drawn to Germany, particularly to Kandinsky and Franz Marc.

Hartley's initial experiments resulted in an eclectic style he called "cosmic" or "subliminal" Cubism, which utilized a Cubist vocabulary but attempted to incorporate expressions of the "art of spiritual necessity," the latter an influence of Kandinsky. Always insistent on the power of his own intuitive mysticism, however, Hartley did not fully embrace Kandinsky's intellectual theorizing. In his late 1912 or early 1913 works (which he called Intuitive Abstractions), he experimented with "automatic" painting methods, eliminating all references to the outside world and drawing only upon his own emotional resources.

Hartley moved to Berlin in 1913, where he remained for the most part until 1915. In Berlin he was able to develop a distinctive abstract style. Inspired by the city's military pageantry—which enthralled him, at least until the outbreak of World War I—he produced a series of brightly colored and richly decorative works. Although Hartley often claimed that he used these identifiable military motifs in order to express "vivid sensations of finite and tangible things," most scholars agree that these images are invested with Hartley's own mystical symbolism which he steadfastly refused to explain.

After his return to the United States in early 1916, Hartley abandoned mysticism temporarily as well as the style of expressionism and abstraction he had developed in Europe. He returned to Europe in 1921 and remained until 1930, experimenting with various styles throughout this period, but with little success or satisfaction. Once back in the United States to stay, Hartley developed a highly personal response to American regionalism. In the final decade of his life he produced a series of expressive landscapes of Maine that equaled in power and intensity the abstract works he produced in Germany from 1913 to 1915.

39 Cosmos (formerly The Mountains), 1908–1909 31.179

Oil on canvas, 30 x 30⅛ in. (76.2 x 76.5 cm.). Signed lower right: MARSDEN HARTLEY. Gift of Ferdinand Howald, 1931

In the fall of 1908 Marsden Hartley moved to an abandoned farm outside North Lovell, Maine, where he painted what he considered to be his first mature works. Impressed by the strength of these works, in May 1909 Alfred Stieglitz gave Hartley his first one-artist show at the 291 gallery. Cosmos was among the works exhibited.

Hartley's art had evolved quickly during the three years before the Stieglitz show. In 1905 he was still painting in a derivative realist style, but by the autumn of 1908 he had assimilated not only Impressionism but aspects of Neo-Impressionism as well, and he had discovered in a color illustration from the January 1903 issue of the magazine Jugend the distinctive "stitch stroke" of Italian divisionist painter Giovanni Segantini. According to Hartley, Segantini's idiosyncratic technique showed him "how to begin painting my own Maine mountains."[1]

In Cosmos Hartley has used short interwoven strokes of intense color to create a vibrant autumnal mountainscape of coloristic vigor and compositional boldness. The paint is applied in a heavy impasto, creating a rich tapestry-like effect that captures the intricacies of a dense Maine woodland. A brilliant decorative pattern covers the entire surface of the canvas. Hartley began his compositions outdoors, completing them later in the studio and often reworking them over an entire season. He first painted mountainous landscapes in 1908–1909 and frequently returned to the motif throughout his career. To him, mountains represented the strength and constancy of nature in the face of human transience.[2] In Cosmos, undulating mountains push against the sky, dominating the composition. A single pine tree pierces the clouds, uniting earth and sky. This exuberant view of nature was to give way in the next year under the brooding influence of Albert Pinkham Ryder as Hartley turned to more ominous interpretations of nature in the "dark landscapes."

Cosmos is distinctive for its stylistic inventiveness, which placed its young creator—who had little direct experience with European avant-garde art at this point—in a very select company of American artists working in a Neo-Impressionist manner. The painting is also an early example of Hartley's intuitive mysticism in which the artist drew upon interior visions.[3] The title, which may have been inspired by lines from Walt Whitman's poem "Song of Myself," reinforces the visionary mood of the work and verifies Hartley's intention.[4] Hartley described such landscapes as "little visions of the great intangible," adding that "some will say he's gone mad—others will look and say he's looked in at the lattices of Heaven and come back with the madness of splendor on him."[5]

N.V.M.

Marsden Hartley, 1877–1943

40 *Berlin Ante War*, 1914 31.173

Oil on canvas with painted wood frame, 41¾ x 34½ in. (106 x 87.6 cm.). Gift of Ferdinand Howald, 1931

Marsden Hartley's Berlin paintings can be divided into two stylistic periods: the earlier works are characterized by the euphoria of military pageantry, and the later, emblematic works by a greater overall decorative effect. *Berlin Ante War* dates from the second part of Hartley's stay in Berlin, from March 1914 to December 1915. By the summer of 1914 Germany had declared war on Russia and France. War, Hartley observed, was no longer "a romantic but a real reality."[1] The simple pageantry of the earlier pictures was supplanted by an intense expressiveness in his later War Motif paintings, as he called them, which reflected his simultaneous fascination with and revulsion for war.

Though its title indicates that the subject is prewar, the painting was probably executed after the outbreak of hostilities and most likely after the death of Hartley's close friend Karl Von Freyburg, who was killed in action in early October. The painting depicts an Imperial Prussian Horse Guardsman—probably Von Freyburg—enveloped in clouds beneath the heraldic image of a kneeling white horse branded on the flank with the number 8. In this veiled tribute to his friend Hartley's symbolism is private and probably never will be fully understood. The motif of the cloud may have been drawn from Bavarian votive paintings published in the *Blaue Reiter* almanac, where clouds are symbols of the heavenly spirit.[2] In standard numerology, which Hartley never acknowledged as his source of inspiration, the number 8 represents spiritual and cosmic transcendence.[3] Greek crosses inscribed in roundels also appear, floating among the clouds. In spite of this abundant use of symbolism, Hartley insisted:

> The forms are only those which I have observed casually from day to day. There is no hidden symbolism whatsoever in them; there is no slight intention of that anywhere. Things under observation, just pictures of any day, any hour. I have expressed only what I have seen. They are merely consultations of the eye . . . my notion of the purely pictorial.[4]

Scholars however, have continually doubted Hartley's assertion since the paintings were exhibited at Stieglitz's 291 gallery in the spring of 1916. As Charles Caffin wrote in the *New York American*, "The motive of these is scarcely what has been seen, unless it be in the mind's eye."[5]

Though the symbolic meaning of the museum's painting remains elusive, we do know that Von Freyburg's death was a deep emotional blow to Hartley, who subsequently idealized the relationship, claiming that his friend was the sole icon of his artistic life.[6] Von Freyburg is certainly the emblematic subject of several other War Motif paintings, most notably *Portrait of a German Officer* (1914, Metropolitan Museum of Art).

Stylistically, the flat, clearly delineated color areas and the hieratic composition are extensions of what Hartley employed in his Amerika series just prior to the war.[7] Paintings in this group relied on a ritualistic imagery inspired by Native American themes epitomizing human nobility. Like these paintings, *Berlin Ante War* also exudes a mood of idyllic peacefulness. The compartmentalized tableau composition, on the other hand, may have its origins elsewhere—perhaps in the Bavarian folk art that Hartley appreciated and collected.[8]

Despite the originality of Hartley's late Berlin works, the continuing influence of Kandinsky, and of Franz Marc (an artist whom Hartley also came to know in Berlin) is still in evidence. Hartley's fascination with Marc's "rendering of the souls of animals" is reflected in his depictions of kneeling animals, such as the white horse in the museum's painting. *Berlin Ante War* has been linked to Marc's *White Bull* (Guggenheim Museum) of 1911.[9]

In late Berlin paintings such as *Berlin Ante War* Hartley finally achieved the personal artistic statement he had been pursuing since his arrival in Europe. He wrote to Stieglitz in the fall of 1914 saying that he was finally expressing himself truly:

> I have perfected what I believe to be pure vision and that is sufficient. Then too I am on the verge of real insight into the imaginative life. . . . I am no longer that terror stricken thing with a surfeit of imaginative experience undigested. . . . I am well on the verge of understanding which is beyond knowledge.[10]

<div align="right">N.V.M.</div>

Marsden Hartley, 1877–1943

41 *The Spent Wave, Indian Point, Georgetown, Maine, 1937–1938* 81.13

Oil on academy board, 22½ x 28½ in. (57.1 x 72.4 cm.). Signed, dated, and inscribed paper label on reverse in artist's hand: THE SPENT WAVE/INDIAN POINT/GEORGETOWN/MAINE 1937–38/Marsden Hartley. Museum Purchase: Howald Fund II, 1981

In the spring of 1936 Marsden Hartley announced the final philosophical stance of his art in the introduction to a catalogue of his exhibition at Alfred Stieglitz's An American Place: "This quality of nativeness [in my paintings] is colored by heritage, birth and environment, and it is therefore for this reason that I wish to declare myself the painter from Maine."[1] After years of wandering, he returned to Maine in the summer of 1937.

Hartley's artistic homecoming had actually begun in 1930, when he returned from Europe to a country that was by then considerably changed. In its newfound nationalism, which was often expressed in isolationist and xenophobic terms, Hartley found himself an outsider and saw his art regarded with suspicion. Certainly Hartley's new regionalism was influenced by this atmosphere, as well as by the opinions of writers like Paul Rosenfield, who claimed that Hartley's special gift as a painter was his ability "to record the genius of a place" and that only in Maine, where he had already painted with such conviction, could he restore cohesion to his art.[2]

In their rugged power and stark monumentality, Hartley's Maine landscapes from 1937 echo Winslow Homer's heroic marines painted at Prout's Neck, Maine, in the late nineteenth century. The works also recall Hartley's own paintings executed in New Hampshire during the summer of 1930 and in Dogtown Common, outside Gloucester, Massachusetts, in the summer of 1931. It was during his summer in Dogtown—following a devastating illness that made him keenly aware of his mortality—that the artist began what has been described as a process of personal integration and philosophical reassessment. His belief in himself and his inner vision revived, and again he began to produce intensely expressive landscapes.[3]

The Spent Wave, Indian Point, Georgetown, Maine fulfills the promise of early Maine landscapes such as *Cosmos* (cat. no. 39). Through works such as these Hartley attempted to reestablish the mystical bonding with nature he had experienced as a youth. Once again the influence of Albert Pinkham Ryder appears in his paintings as he attempts to recapture his imaginative expressiveness. The success of Hartley's late works lies in the artist's ability to reconcile the objective realism of a specific place with his own need to find personal meaning in art and to further develop as an abstract painter. His achievement was acknowledged by one Melville Upton, writing in *The Sun* in 1938: "What impresses one particularly in Mr. Hartley's exhibit is the fact that he seems to have struck a happy balance between the intellectual rigors of pure abstraction and the camera-like damnation of rigorous representation."[4]

Like other Georgetown seascapes executed in 1937–1938, the museum's painting depicts waves pounding against rugged brown and black rocks. In a letter to Hudson Walker, Hartley described such paintings as "crashing in their quality, as they are all granite up against the sea."[5] The foreground is compressed with powerful forms; the horizon line is high, with only a touch of slate-blue sea and sky visible. All the elements have been reduced to essential forms; details have been omitted in favor of bold patterns. The vital energy of the scene is transmitted through broad, agitated brushwork and dramatic contrasts between dark and light. The thick impasto and heavy black outlining gives the forms a palpable weight. Even the surf spray has a tangible density. The almost primitive quality of Hartley's approach and the stark monumentality of his composition confirms that he was, as he said, no longer interested in trivial existence.

The underlying theme of all the Georgetown seascapes is the relationship between man and the forces of nature.[6] Though the human figure does not appear in these works, there is a sense of pervading melancholy and tragedy that permeates many of the subjects, ascribing to nature human conditions and emotions. The paintings follow the drowning deaths of the sons of the Mason family, with whom Hartley had lived in Nova Scotia and to whom he was deeply attached.[7] In letters written at the time, Hartley compared his grief to that which he experienced at the death of Karl von Freyburg more than twenty years before. Death, like the relentless waves, exerts a power that is indifferent to man.

Hartley also found in nature a regenerative power, a strength and constancy that "makes us cling to it as a relief from the vacuities of human experience."[8] Maine was an anchor for Hartley throughout much of his life. He saw in the land a mythic quality; in his view, the rigor of a life lived there endowed those who endured it with a kind of moral superiority. It is fitting that his final works—the landscapes of Maine—have become recognized by many as his greatest masterpieces. By coming home, he finally satisfied his search for a pictorial statement uniquely his own.

N.V.M.

John Marin, 1870–1953

Educated at the Pennsylvania Academy of the Fine Arts in Philadelphia and the Art Students League in New York, Marin, like many of his contemporaries, also benefited from a prolonged sojourn abroad. He exhibited his early watercolors, oil paintings, and etchings—reminiscent of the works of James A. M. Whistler—in the official Paris Salons, where he got a firsthand exposure to modern art. A regular contributor to the modern art exhibitions at Alfred Stieglitz's 291 gallery in New York and a participant in the Armory Show in 1913, Marin began working in his mature expressionist style in the mid-1910s. Although the influences on his art were manifold—among them, Chinese painting, Impressionism, Fauvism, and Cubism—his approach was instinctive, not theoretical.

One of the first American artists to gain general public recognition for a highly personal, abstract style, Marin was able to capture in his art the very core of an experience. Representing the precise external appearance of a subject was less important to him than his heartfelt sensitivity to its underlying forces. His brushwork is reminiscent of calligraphy. The disposition of forms is active, not static; details are abbreviated; and the picture surface is an arena where the artist struggles to achieve a dynamic equilibrium among the various components of the composition. Remarkably consistent in intent and style over a long career, Marin explained the focus of his art as follows:

> *I see great forces at work—great movements . . . the warring of the great and small—influences of one mass on another greater or smaller mass. Feelings are aroused which give me the desire to express the reaction of these pull forces—those influences which play with one another. . . . In life all things come under the magnetic influence of other things. . . . While these powers are at work pushing, pulling, sideways, downwards, upwards, I can hear the sound of their strife and there is great music being played.[1]*

42 *Sunset, Maine Coast*, ca. 1919 31.233

Watercolor on paper, 15½ x 18½ in. (39.4 x 47 cm.). Gift of Ferdinand Howald, 1931

Marin was at his best when working in the watercolor medium. Among his most effective works are the seascapes he produced in Maine. An elemental composition of sky, surf, and shore, *Sunset, Maine Coast* deals with the eternal interaction among the forces of nature. Though the composition is symmetrical, this is no static icon, for everything is in motion. The painting is composed of three horizontal bands that differ in color, density, and brushwork. The passage from day to night is conveyed by the interaction of reds and blues in the sky. A long streak of red-orange at the horizon indicates that the sun has just set, releasing diagonal bursts of color before darkness takes over. The tones of dusk are evident in the water, a deep turquoise streaked with dark blues, where areas of exposed white paper indicate sea spray. In the turbulent middle ground are the most varied colors and the most active brushwork. The pounding of the waves on the shore is expressed by wriggling and diagonal strokes as shifts in value from dark blues, purples, and red-orange tones to pale turquoise and grays reinforce the violent confrontation between water and earth. The intermittent exposure of textured white paper in the immediate foreground is reminiscent of pebbles strewn along the rocky shore.

Sunset, Maine Coast is devoid of superfluous details. The picture is at once universal in its exposition of nature's energy and personal in the artist's identification with the subject. As Marin wrote:

> Seems to me the true artist must perforce go from time to time to the elemental big forms—Sky Sea Mountain Plain—and those things pertaining thereto—to sort of retrue himself up to recharge the battery. For these big forms have everything. But to express these you have to love these to be a part of these in sympathy.[2]

R.L.R.

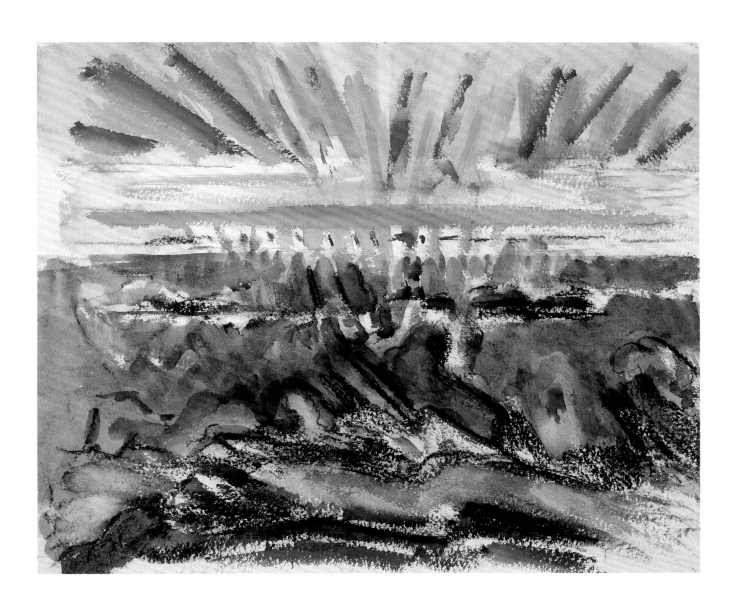

Man Ray, 1890–1976

Man Ray has a secure position in the history of modern art because of the originality of his ideas, images, and working methods. A major figure in the New York Dada group prior to 1920, he was an accomplished draftsman, painter, sculptor, photographer, and film director who continually experimented with media and technique in order to stimulate his imagination. With his close friends Marcel Duchamp and Katherine S. Dreier, he became a founder of the Société Anonyme, an American organization whose purpose was to exhibit, collect, and interpret modern art. After 1921, with the exception of a ten-year residence in California (1940–1951), the artist pursued his career in Paris, where he was active in Dada and Surrealist groups. The recognition he received was unusual for an American in the European avant-garde world.

While still a young man in his twenties, Man Ray was stimulated by the radical art he saw exhibited at the Armory Show in 1913 and at Alfred Stieglitz's 291 gallery in New York City. These early years were,

he said, a time of "greediness for everything: literature, music, art, painting, poetry."[1] While he was working as a commercial artist in New York and exploring the possibilities of Cubism and Fauvism in his personal art, he met Marcel Duchamp. The artists were kindred spirits in their desire to extend the limits of painting and to deal with content that was not restricted to literal interpretation. Dada artworks created after 1915 were cerebral in effect and often made with new methods and materials. In their acceptance of mechanical processes and readymade objects and in their affirmation of chance and irrationality, the Dada artists were a liberating force in art; they were instrumental in breaking down the traditional limitations of subjects, styles, and media. The new art celebrated life's variety and even its absurdities and was therefore thought by some to be closer to real life than traditional idealistic art. Man Ray believed that "perhaps the final goal desired by the artist is a confusion or merging of all the arts, as things merge in real life."[2]

43 *Jazz*, 1919 31.253

Tempera and ink (aerograph) on paper, 28 x 22 in. (71.1 x 55.9 cm.). Gift of Ferdinand Howald, 1931

Jazz is a superb example from a series of abstract "aerograph" paintings that Man Ray executed before 1920.[3] In these works the artist attempted to eliminate "the easel, brushes, and other paraphernalia of the traditional painter."[4] Using an airbrush and stencils and varying the flow and density of the paint, in *Jazz* he has created an elegant visual metaphor for music. The modulated blues, greens, yellows, oranges, tans, and grays evoke the sounds, from warm to cool, from soft to blaring, of different instruments, while the size, variety, and repetition of shapes suggest duration of tones, pitch, and rhythm. The vitality of the work is dependent upon shifts in focus from vague and atmospheric to crisply geometric. In this, as in other works in the series, Man Ray exploited the interplay of the abstract and the specific, allowing the images to develop as he worked. He said "the results were astonishing—they had a photographic quality, although the subjects were anything but figurative. . . . The result was always an abstract pattern. It was thrilling to paint a picture, hardly touching the surface—a purely cerebral act, as it were."[5]

Stylistically, *Jazz* is akin to Cubist paintings in its overlapping flat shapes, shifts from transparency to opacity, and inconsistent lighting. Its strong abstract design anticipates the formal emphasis of Man Ray's "rayographs"—photographic prints of the early 1920s, made without a camera by placing objects on photosensitive paper and exposing the materials to light.

Man Ray's visual interpretation of jazz is not unique in modern art. Artists such as Pablo Picasso, Henri Matisse, and Stuart Davis also created paintings inspired by jazz music.[6] Man Ray as film director used jazz as the inspiration for his 1926 film *Emak Bakia*, in which the music determined the varied rhythms and tempo of the shots.[7]

R.L.R

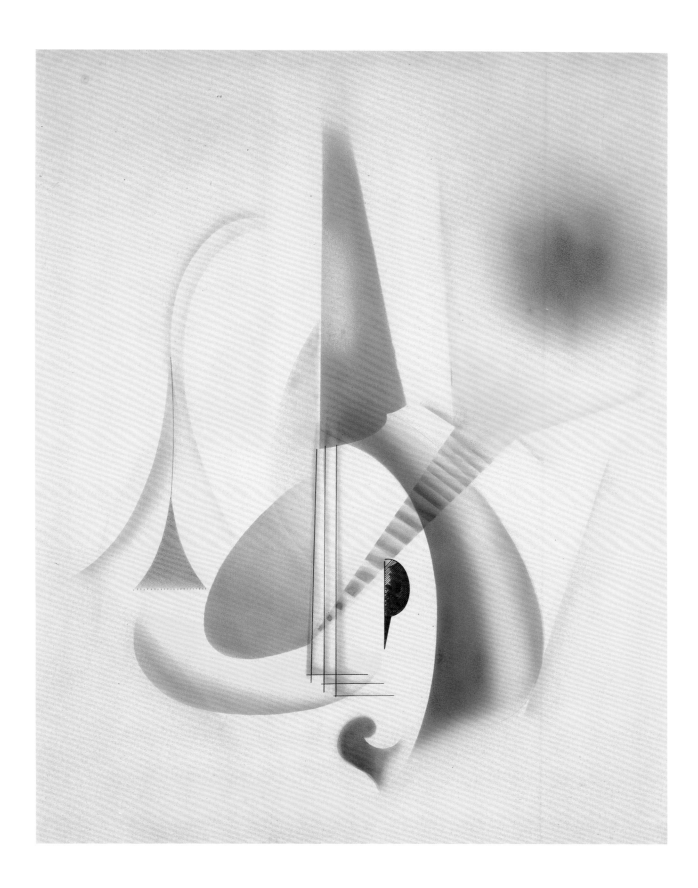

Man Ray, 1890–1976

44 *Regatta*, 1924 31.256

Oil on canvas, 20 x 24¼ in. (50.8 x 62.2 cm.). Signed and dated lower right: Man Ray 1924. Gift of Ferdinand Howald, 1931

In his desire to expand the possibilities of artistic expression, Man Ray dispensed with safe choices in favor of innovative media, techniques, and subjects. His reputation was built primarily on the quality of his Dada and Surrealist works as well as his photography. In addition, he produced works that are less known but equally intriguing—works such as *Jazz* (cat. no. 43) and *Regatta*, which reveal his inventive approach to artmaking. Man Ray refused to be an imitator, even of himself. He said that he wished "to paint as much as possible unlike other painters. Above all to paint unlike myself, so that each succeeding work, or series of works, shall be entirely different from preceding works."[1]

Unlike other paintings the artist executed during the 1920s, *Regatta* combines forceful execution and dramatic lighting contrasts. Man Ray painted the scene when he was living in Paris, supporting himself by photographing his friends and their artworks. He maintained his liaison with Marcel Duchamp while active in the Parisian Dada group and, in 1925, participated in the first Surrealist exhibition. He was inclined to create fantasies, or intellectually conceived artworks, while he also continued to make works that would be acceptable to his patrons. Ferdinand Howald, who had purchased a number of Man Ray's paintings, helped to finance the artist's trip to France in 1921.[2] Not particularly drawn to Dada, Surrealism, or photography, Howald chose works by Man Ray that were stylistically related to Cubism, Fauvism, and Expressionism. The emotional forcefulness of *Regatta* suited the collector's tastes for energetic, moody seascapes similar in intent to the work of one of Howald's favorite artists, John Marin.

The essence of *Regatta* is its dynamism as it successfully conveys the excitement of a sailboat race. The large dark shapes of the sails and sun, dispersed erratically across the picture surface, are urgent and restless. Perhaps Man Ray was experimenting here with the Surrealist process of automatism, in which configurations are produced "automatically," seemingly without conscious control, as in a dream state. In such works the artist deploys shapes on a canvas without a preconceived idea of subject matter, and then, seeing what the arrangement resembles—a race at sea, in this case—proceeds to develop the suggested theme.

In *Regatta*, Man Ray's brushwork is active and varied. Many long, nearly horizontal strokes in the boats and sea create the effect of fast, lateral movement, which is tempered only by the slashing vertical strokes in the riggings and masts. The wavy and feathery brushwork used for the water produces a choppy, murky appearance. The artist's thin, light strokes in the sky do not entirely cover the dark underpainting, thus suggesting the dissipating mists of morning. As a final touch he has scratched lines on the sails and wharf to refine these bold forms and to reinforce the sense of movement across the surface.

The composition is bold and unexpected, with boats silhouetted against a dramatic background in which glorious bands of pure white, red, and yellow appear below a blackened sun. Such contrasts and energy produce an aura of mystery and feeling as potent as that in any seascape by John Marin or Albert Pinkham Ryder.

R.L.R.

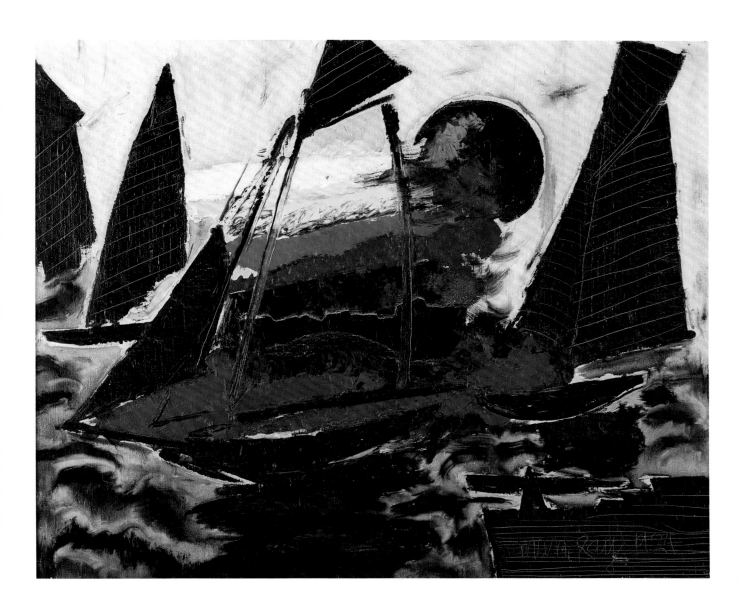

Morton Livingston Schamberg, 1881–1918

His life tragically cut short by the Spanish influenza epidemic that followed the First World War, Morton Livingston Schamberg, one of the first American painters to find beauty and meaning in industrial forms, made a major contribution to modern painting in the United States. A student of William Merritt Chase at the Pennsylvania Academy of the Fine Arts, he began his career producing works reminiscent of those by Chase and the artists who had influenced Chase's development, James A. M. Whistler and Edouard Manet. Commencing in 1905 Schamberg made several prolonged trips abroad, where he was awakened to the aesthetic possibilities of abstraction and intense, nonassociative color. Eventually a participant in the circle of avant-garde artists, writers, and intellectuals associated with Leo and Gertrude Stein in Paris, Schamberg probably came to know the Steins' collection of modern art. From 1909 to 1912 he created works that are stylistically related to those of Cézanne, Matisse, and Picasso; five works from this period were included in the Armory Show in 1913.

A crucial shift in imagery occurred in Schamberg's art by 1915. Possibly influenced by French Dada artists Marcel Duchamp and Francis Picabia, whom he had met in New York through collector Walter Arensberg, Schamberg started painting pictures that concentrate on mechanical forms.[1] His mechanistic images occasionally share the Dada predisposition for irony and mechanomorphic qualities (as for example, in God, ca. 1917, an assemblage of plumbing pipes on a miter box, in the Philadelphia Museum of Art). More typically, however, his emphasis is analytical. Clearly articulated geometric shapes, occasionally faceted and shifting, as in the Cubist style, are presented in a manner which varies in completeness, lighting, and nondescriptive color. Stylistically, Schamberg's late paintings run the gamut from objectively rendered studies of cogs, belts, and wheels—reminiscent of engineers' drawings—to more dynamic hybrids of Cubism, Fauvism, and Futurism.

45 *Telephone*, 1916 31.263

Oil on canvas, 24 x 20 in. (61 x 50.8 cm.). Signed and dated upper right: Schamberg/1916. Gift of Ferdinand Howald, 1931

Schamberg has here selected an ordinary household object as a suitable subject for a painting, a choice that was later echoed both in the Precisionists' fascination for mechanical artifacts and Pop Art's focus on everyday items. In Cubist style Schamberg represents a telephone resting on a tabletop to the right of a window, but even though he has reduced the base, speaker, receiver, and wire to severe geometric shapes, these elements remain recognizable. The composition is enlivened in various ways: through asymmetry; diversity of surfaces, textures, and treatment; and richness of color. The components of the telephone appear to be alternately transparent or opaque, flat or tubular. Precisely indicated contour lines occasionally extend beyond the forms they delineate, asserting the dominance of the picture plane, as crisp edges are juxtaposed with patchy application of paint to intermittently shift the focus in the work from sharp to blurred. The modulated background is dark at the top and bottom and shifts inexplicably from blue to green. Most of the telephone is shown in dull metallic grays, with occasional black components hovering on a plane even with that of the black table below. The bright yellow parts of the speaker and receiver and a small, brilliant red patch on the telephone's base seem to advance toward the viewer but exist on the same plane as the white portions of the telephone.

In composition and details, *Telephone* is similar to a painting (now lost) exhibited at the Montross Gallery in 1915.[2] The work may have been the inspiration for a later work by Schamberg's friend Charles Sheeler—*Self-Portrait* (1923, Museum of Modern Art), in which Sheeler appropriates the telephone as a personal symbol,[3] perhaps referring to the imagery of resourcefulness and proclaiming artistic independence.

R.L.R.

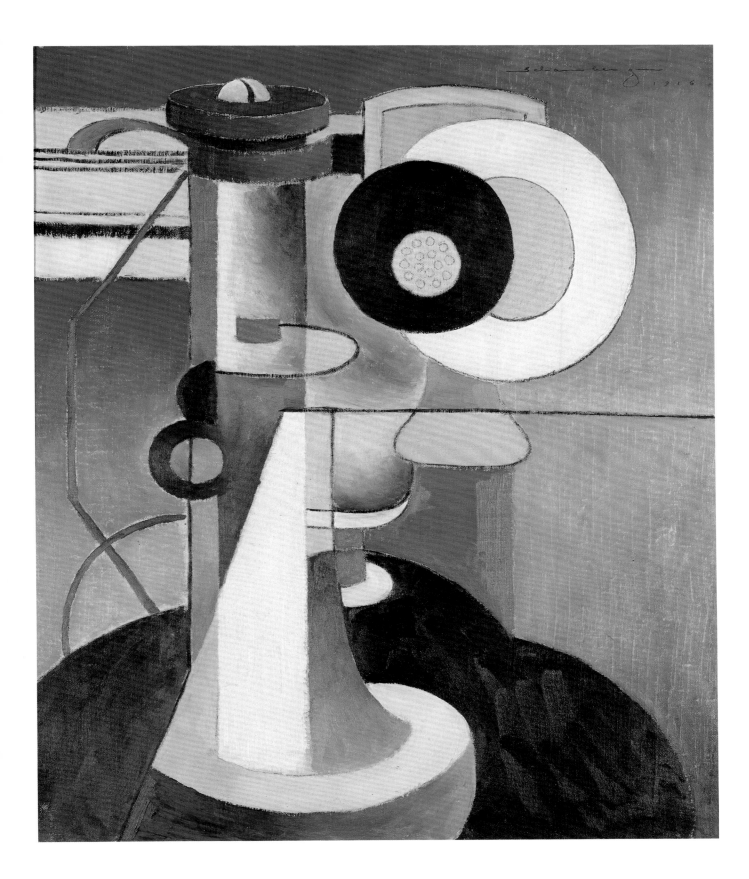

Thomas Hart Benton, 1889–1975

As a young painter in Paris (1908–1911) and New York (intermittently until 1918–1919), Thomas Hart Benton was a committed modernist. He subsequently turned to representational painting of the American regional scene, which—while popular during the thirties—has been severely judged by post–World War II critics as a betrayal of the avant-garde in American art. In truth, Benton, a prolific writer as well as artist, disassociated himself from the movers and innovators, but he did so with the conviction that a significant American art should be founded on the artist's sympathetic relationship to the environment, not upon theories of abstraction.

Nevertheless, as a young artist in Paris, Benton was thoroughly immersed in modernism. He had become friendly with Synchromist painters Stanton Macdonald-Wright and Morgan Russell, two Americans whose fascination with theories of color harmony led them to develop a system of painting in which form is derived from the organization of color planes. Of particular interest to Thomas Hart Benton were the dynamic "Baroque" rhythms he observed in Synchromist paintings, particularly the early studies using Michelangelo's sculptures as subjects. Much later he wrote:

> *Through its use of these rhythms Synchromism seemed to offer a more logical connection between the orderly form of the past and the coloristic tendencies of the present than any other of the Parisian schools. . . . I could not accept the repudiation of all representational art, which was the core of Synchromist dogma, but its procedures were interesting enough to induce experimentation.[1]*

Thus Benton, basing his experiments on Synchromist practices and to some extent on the art of the past, began to explore alternative systems of order and rhythm. Since the 1970s, he and other realist painters who worked outside the mainstream of modern art have been accorded a much deserved second look by revisionist scholars.

46 *Constructivist Still Life*, ca. 1917–1918 63.6

Oil on paper, 17½ x 13⅝ in. (44.4 x 34.6 cm.). Signed lower right: Benton. Gift of Carl A. Magnuson, 1963

Since many of Benton's modernist works have been lost or were destroyed in a fire in 1913, the museum's *Constructivist Still Life* assumes major historical importance. Here Benton depicts the sculptured planes of a three-dimensional construction which he created as the subject for painting. A jumbled arrangement of strikingly colored irregular geometric forms—cubes of red and green, a yellow metronome-like pyramid, and a silver-gray slab shaped like a stele or gravestone—strongly lit from the left, the composition suggests a landscape. The handsome palette and its disposition is related to Ogden Rood's theories of color triads, but Benton's adaptation of Rood's system is not as methodical or analytical as those of Morgan Russell and Stanton Macdonald-Wright. Some of Benton's color planes overlap and interpenetrate in the Synchromist manner, but these passages seem more interesting for their spatial ambiguity than for their color harmonies and thus seem close to Cubist practice, particularly in the paintings of Georges Braque from around 1908–1909.

Ultimately the comparisons with American or European painting of the same period fail to explain Benton's modernism. One of the main thrusts of contemporary art was the consciousness of the painted surface and the tension between that surface and any illusion of space. Such space was not only ambiguous but shallow. Benton, however, in his *Constructivist Still Life* intentionally retains the notion of foreground and background. He wrote:

> As you can see, the sketch is not "truly abstract" but is a sort of free representation of real objects in a real space. I judge [the museum's] painting was made in late 1917 or early 1918, at which time I began to try to compose in depth, using sculptural means.[2]

Benton also explained his subject:

> The "real" objects in this case were folded or cut out pieces of colored paper or cardboard set up like a "constructivist" sculpture. Several interpretations of such constructions could be made, and were, by slightly changing the angle of vision.[3]

Rather than a mainstream modern abstraction—which style, according to critics, he later abandoned for a "retrogressive" representationalism—the painting is instead a highly accomplished exploration of traditional spatial construction drawing upon some aspects of the modern vocabulary. Writing in 1962—with hindsight and a career to defend—Benton in his words about *Constructivist Still Life* lays claim to wholeness and consistency in his life's work.

> Whatever the nature of its color combinations [the museum's] painting belongs "formally" to the kind of "objective," "realistic," "sculptural" work I began after the War . . . and which I still pursue.[4]

W.K.

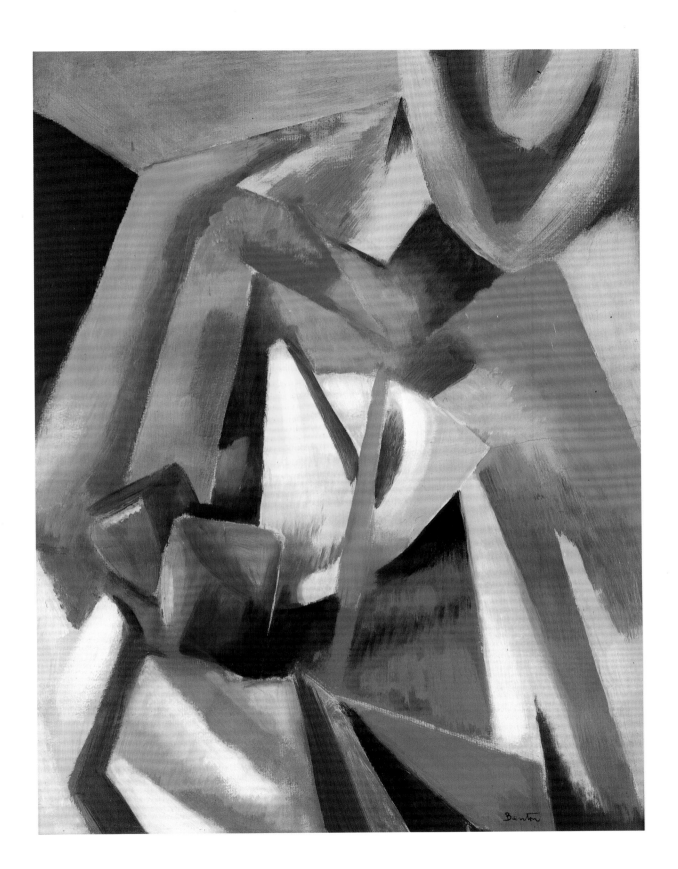

Stanton Macdonald-Wright, 1890–1973

Stanton Macdonald-Wright is best remembered as the cofounder, with Morgan Russell, of Synchromism, a style of painting which orchestrated prismatic colors in abstract shapes to suggest form and space.[1] The first American avant-garde art movement to gain international recognition, Synchromism was developed in Paris in the early 1910s. The Synchromists were profoundly influenced by the coloristic emphasis in the art of Cézanne, Matisse, and the Impressionists, and like Gauguin, Whistler, and Kandinsky before them, they also believed in an analogy between music and painting. In their attempts to liberate painting from its descriptive role, they were guided by purely intellectual choices of color to produce compositions which like music were perceived to be in harmonious balance.

An important impetus for the development of Synchromism was the color theory of Canadian painter Percyval Tudor-Hart, with whom Macdonald-Wright and Russell studied between 1911 and 1913. Tudor-Hart's system was based on the notion that the twelve intervals of the musical octave could be seen to correspond to twelve colors; tones of sound could thus be equated with hues, pitch with luminosity, and intensity of sound with color saturation.[2]

The term "synchromism" was coined by Russell in 1912 as an attempt to connect the disciplines of painting and music. According to Russell:

The word was born . . . by my searching [for] a title for my canvas . . . that would apply to painting and not to the subject. My first idea was of course, Synphonie, but on looking it up to see if it could reasonably be applied to a picture I found that Syn was "with" and "phone" sound—the word "chrome" (why I don't know) immediately flashed in my mind—(I knew it meant color).[3]

The sources of Synchromism are varied. The early works are Fauve-like, but the earliest Synchromist abstractions have a certain stylistic similarity to those of the contemporary French Orphist painters Robert and Sonia Delaunay, whose works Macdonald-Wright and Russell undoubtedly knew. The Synchromists, however, eschewed the Orphists's predilection for flatness and simultaneity, preferring the nonillusory evocation of light, form, and depth through choice of color.[4]

The Synchromists first exhibited their color abstractions in Munich in June 1913. Additional exhibitions in Paris in October 1913 and New York in March 1914 made them an influential force in modern art well into the 1920s.[5] Although the collaboration with Russell ceased after Macdonald-Wright moved back to the United States in 1914, both artists continued to paint abstract synchromies that were either nonrepresentational or based on specific subjects.

47 *California Landscape*, ca. 1919 31.275

Oil on canvas, 30 x 22⅛ in. (76.2 x 56.2 cm.). Gift of Ferdinand Howald, 1931

California Landscape was painted by Macdonald-Wright shortly after he moved from New York to California. The work is a synchromy that celebrates in a nonspecific way the sights and feelings experienced during a day at the shore. The artist seems to revel in his new home. The radiant colors and open geometry of the painting suggest fresh air, warm sunlight, cool water, and gentle breezes. This view of the Pacific Ocean, seen through a grouping of buildings and trees from an elevated vantage point, is dazzling in its color and light.

While the composition is similar in conception to Cézanne's many images of L'Estaque (for example, *The Bay from L'Estaque*, ca. 1886, Art Institute of Chicago), it is in contrast to the solid, architectonic quality of the Cézanne works. Macdonald-Wright's forms seem to dissolve in an atmosphere of rich colored light, like objects viewed through a prism. The intermittent contour lines stretch beyond the natural and architectural forms they establish, giving the effect of shifting planes in space. In counterpoint to these open faceted shapes are the modulated passages of color that gradually or sharply shift into other hues or white, making the images appear to move in and out of focus. The artist accentuates colors by taking advantage of the effects of complementary and analogous hues. For example, the dominant blues of the sky and water are intensified by small areas of complementary orange interspersed throughout the composition, and in turn the blue enlivens the orange. Elsewhere, smaller juxtapositions of complements interact in sometimes subtle, sometimes percussive ways. Sequences of analogous colors, such as the blue-greens and blue-violets in the upper left of the canvas, are gentle in their visual energy as they blend and shift from one predominant color to another like the sounds of musical lines and arpeggios.

R.L.R.

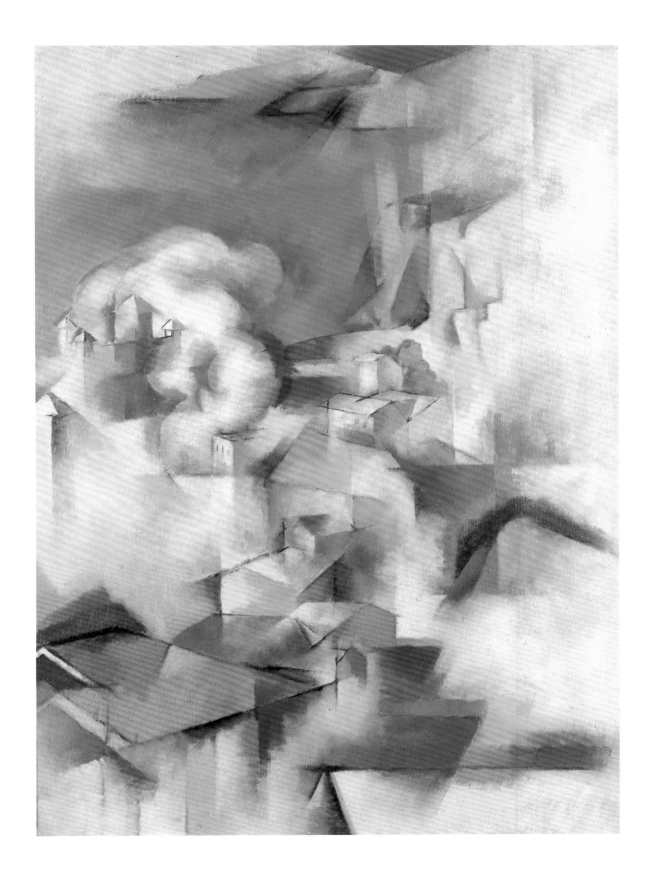

Preston Dickinson, 1889–1930

Although he explored a variety of traditional and avant-garde stylistic modes during his short career, Preston Dickinson is best remembered as a proponent of Precisionism, a major trend in early twentieth-century American art which takes its imagery predominantly (but not exclusively) from the world of technology, artifacts, and urban architecture. Dickinson was one of the first American modernists to choose industrial subjects for his drawings and paintings. His earliest Precisionist images of factory complexes and granaries, dating from 1914 to 1915, preceded such subjects in the works of Charles Sheeler and Charles Demuth by several years. According to his close friend Moritz Jagendorf, Dickinson was intensely interested in the forms of the technological world, and he believed that industry was beneficial to humanity.[1]

The emphasis in Dickinson's compositions varies; his response may be to the visual purity of industrial forms, or to their architectonic structure, or to their inherent dynamism, or even to their visionary qualities. His range of subject matter is also broad: from the dynamic and imaginary factory scenes of the early 1920s, such as Factory, to the severe inorganic still lifes of 1925, such as Hospitality (also in the Columbus Museum of Art). Adamant in his insistence on artistic freedom, Dickinson preferred an eclectic, nontheoretical approach to his work. The lessons he learned at the Art Students League in New York and the Académie Julian and the Ecole des Beaux-Arts in Paris were augmented by private experiments based upon the modern art with which he was familiar. His abstract works are generally tempered by a respect for time-honored techniques and compositional devices, but the strength of his most expressive works is in their innovative and sometimes inventive imagery and unusual blend of styles.

48 *Factory,* ca. 1920　　31.153

Oil on canvas, 29⅞ x 25¼ in. (75.9 x 64.1 cm.). Signed and dated lower right: P. Dickinson '2[?]. Gift of Ferdinand Howald, 1931

Factory, a majestic oil painting of an activated dynamo, is one of four closely related paintings from the early 1920s that clearly demonstrate Dickinson's reverence for technology.[2] Openly extolling the beauty of industrial architecture and power, these paintings predate Le Corbusier's influential treatise *Vers Une Architecture,* in which the celebrated architect lauds the pure functional beauty of American factories and grain elevators as the harbingers of a new architectural age.

The major sources for the style of *Factory* are Cubism, Futurism, Fauvism, and Synchromism, but the expressiveness of the work is primarily dependent on the intensity of the artist's fantasy. The composition is a dense arrangement of tanks, conduits, ramps, smokestacks, and a shed. Elements occasionally merge with one another to occupy the same space. Densest near the center, the configuration avoids the rationality of linear perspective but replaces that with the rationality of the Cubist grid. The distinctly geometric mechanical forms shift from transparency to opacity. Nonillusionistic lighting is randomly reflected or absorbed by the facets of the dynamo's parts. High-key colors heighten the visionary effects of the scene: strong yellows, oranges, and reds glow in a picture field of deep blue, suggesting the heat and light of an inferno. The artist is not concerned with describing an industrial process or transcribing a specific industrial complex; rather, he gives visual form to the apotheosis of machine power.

R.L.R.

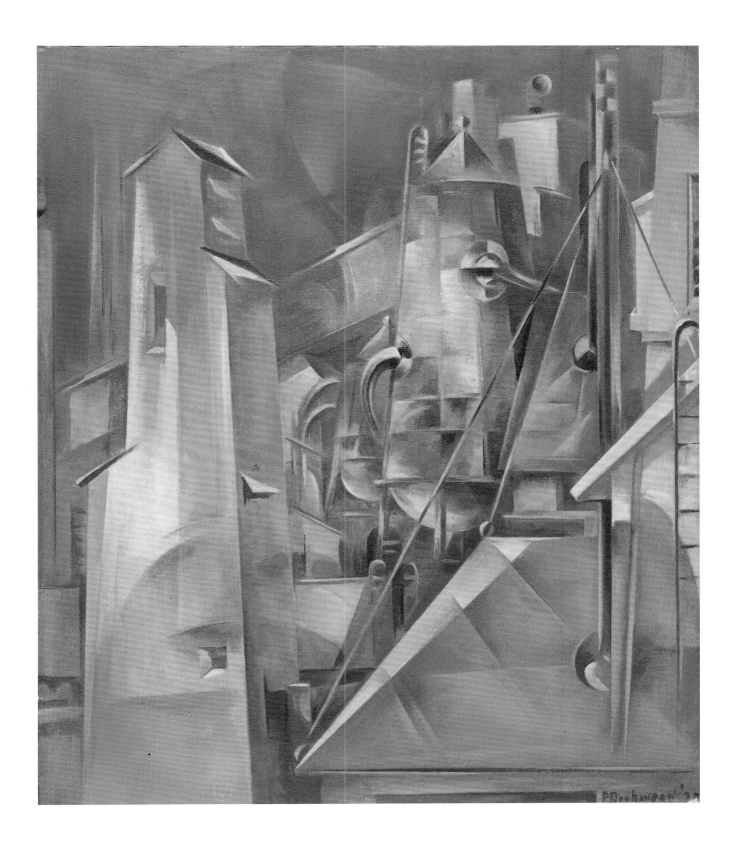

Preston Dickinson, 1889–1930

49 *Still Life with Yellow-Green Chair*, 1928 31.164

Oil on canvas, 15 x 21 in. (38.1 x 53.3 cm.). Signed lower left center: Dickinson. Gift of Ferdinand Howald, 1931

Near the end of his career Preston Dickinson became increasingly concerned with going beyond the limits of the Precisionist aesthetic he was instrumental in formulating. Most of his drawings and paintings after 1926 retain the kind of imagery he favored in earlier works—bridges, urban and industrial architecture, and still lifes made up primarily of artifacts. By virtue of their antiseptic appearance, hard-edged geometric planes, flatness, simplified lighting, and economy of detail, these works are ostensibly Precisionist in style. Yet there is clearly a shift in emphasis. By the late 1920s Dickinson moved away from the clarity, simplicity, and equilibrium of works such as *Factory* (cat. no. 48) and *Hospitality* (1925, also in the Columbus Museum of Art). Though he continued to design complex pictorial arrangements, his later compositions are often idiosyncratic and unsettling in effect. These energetic, crowded compositions are made up of steep angles, diagonals, and forms that tend to move toward the perimeters of the picture field. The combination of forms included in these works is often eccentric, and frequently the surfaces are embellished with unusual colors or reflecting light. In these effects Dickinson's late drawings and paintings share an affinity with sixteenth-century Italian Mannerist works, which, in turn, were personal responses to the purity, balance, and order of High Renaissance classicism.

Still Life with Yellow-Green Chair, purchased by Ferdinand Howald in 1928, is characteristic of Dickinson's late work and is perhaps his best known oil painting. The asymmetrical composition, focusing on an arrangement of objects on a table cut off by the lower edge of the picture, is derived from the artist's love of Japanese woodblock prints and is reminiscent of his earlier still lifes. In Precisionist fashion, Dickinson presents ordinary household utensils as sharply focused geometric shapes, rendered in a technique that suppresses the sense of the artist's touch. Although they are carefully arranged, the objects on the table do not seem firmly implanted because they are crowded near a corner of the table and the tabletop seems far too steep for anything to rest upon it.

Yet Dickinson has achieved a precarious equilibrium in this work by echoing the shapes of the utensils and table with those of the upholstered chair and the framed picture on the wall behind it. He relies on diagonals to direct the viewer's eye throughout the painting. Colors emphasize the shallowness of the picture field because they are close to one another in value. The grayed blues and greens of the knife, parfait glass, plate, and bottle are not far removed from the yellow-green of the chair, the tan of the roll, or even the colors of the butter squares and the red book. These medium-value areas are played against the slightly lighter gray wall behind the table and the bright whites of the tablecloth and matted picture.

Still Life with Yellow-Green Chair is memorable for the interaction of Precisionist order and compositional tension. The unusual array of objects is visually arresting but somewhat threatening for a domestic vignette. The plant is cleanly sliced off by the top picture edge; the jagged knife seems to defy gravity in its placement and to cancel out the book; and, finally, the empty chair asserts the absence of the artist, an effect in accord with the flawless, impersonal finish of the painting.

R.L.R.

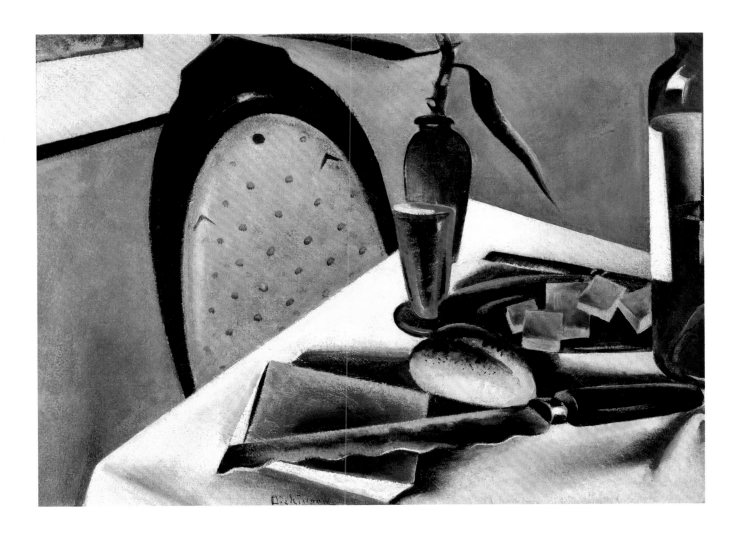

Charles Sheeler, 1883–1965

The quintessential Precisionist who sought to understand the underlying structure of his subjects, Charles Sheeler once commented on his concern for objectivity in his art: "The pictures I reproduce are attempts to put down the inherent beauty of the subject with as little personal interference as possible."[1] More than any other American artist of the twentieth century, Sheeler promoted a realist style of uncompromising purity, and in so doing helped pave the way for Pop Art and Super Realism.

A photographer as well as a painter, Sheeler saw no conflict between photography and painting. "Photography," he said, "is nature seen from the eyes outward, painting from the eyes inward."[2] Nor did he see any conflict between mass-produced, mechanical forms and hand-crafted items. To his way of thinking, a dynamo or a piece of Shaker furniture could equally serve as the basis for orderly designs of majestic simplicity. During the 1920s and 1930s Sheeler worked in his most classical Precisionist style. In contrast to the abstraction and experimentation of works such as Lhasa, his Precisionist drawings and paintings—mostly depictions of factories, engines, and still lifes—are more concrete and representational. Taking advantage of what he learned from Cézanne's art and Cubism, Sheeler focused on the basic configurations of his images, eliminating distracting details, varying vantage points, and manipulating lights and shadows to enliven his compositions in a variety of ways. Rendered in flawless technique, they reveal a world that is remarkably clean and free from the effects of time.

50 *Lhasa*, 1916 31.100

Oil on canvas, 25½ x 31¾ in. (64.8 x 80.6 cm.). Signed and dated lower right: Sheeler/1916. Gift of Ferdinand Howald, 1931

Lhasa, a view of the Buddhist holy city in Tibet, was most likely painted in January or February of 1916. It was shown in the *Forum Exhibition of Modern American Painters* held March 13–25 that same year, having been chosen by a jury that included Alfred Stieglitz and Robert Henri.[3] The painting is based on a photograph by John Claude White,[4] from which Sheeler made a conté crayon drawing (private collection, Philadelphia), presumably a preparatory sketch for the painting.[5]

Painted before Sheeler began to produce his Precisionist works, *Lhasa* nevertheless reveals the artist's propensity for architectural subjects and highly controlled compositions. The mountaintop shrine is conceived by the artist as a grouping of lucid, geometric forms, seemingly devoid of human occupants. Emphasizing parallels, Sheeler establishes the dominant axis from the lower left to the upper right by a series of long diagonals punctuated by intermittent stairs and ledges that provide measured increments in the ascension.

Countering the straight-edged architecture are the graceful curves and diagonals of the mountain. These intersect with the major axis, again with a preponderance of parallels. Sheeler simplifies his lighting and color to reinforce the solidity of his subject and to achieve a kind of graceful chiaroscuro. As in the art of Juan Gris, whose paintings Sheeler might have seen in Paris, the lighting (in this case coming from the upper left) is consistent but avoids the complexity of reflections and shadows.

Relying on the relative energy and brilliance of his colors, Sheeler also achieves a nonillusionistic sense of depth. To make up the prominent wall of the shrine, he uses a rich, flat orange that forcefully projects toward the viewer; at the same time he juxtaposes a rich blue for the receding shadows and lower portion of the mountain. Paler areas of modulated grayed blues and tans recede into space, merging with the large expanses of white that frame the scene and emphatically assert the prominence of the picture plane.

Inherent in *Lhasa* is Sheeler's belief that man's structures and nature are in perfect accord. The climb to the top of the shrine appears arduous, but the methodical organization and execution of the painting seem to suggest that a difficult ascension sometimes is appropriate for a meaningful experience.

R.L.R.

Charles Sheeler, 1883–1965

51 *Still Life and Shadows*, 1924 31.106

Conté crayon, watercolor, and tempera on paper, 31 x 21 in. (78.7 x 53.3 cm.). Signed and dated lower right: Sheeler 1924. Gift of Ferdinand Howald, 1931

Still Life and Shadows is part of a series of interior scenes in which Charles Sheeler concentrated on objects from his own home. A noted collector of American folk art and crafts—particularly Shaker objects—Sheeler looked for simplicity and grace even in common household objects. Choosing still life because he could leave his arrangements undisturbed for long periods when his painting was interrupted by photography commissions, he responded no less profoundly to humble domestic subjects than he did to factories and machinery.[1]

A seemingly straightforward presentation of a glass, a plate, and a teapot on a small table, the composition of *Still Life and Shadows* is animated in a number of ways. Sheeler uses several artificial light sources simultaneously, varying the prevalent axes and the tones of the playful shadows as they crisscross one another and the wall and tabletop, in marked contrast to the solemnity of the artifacts and table. The shapes of the cast shadows—most notably, those of the table, glass, and teapot—seem to have more substance and energy than the objects themselves. The shadows stabilize the design by echoing the verticals of the table legs (there is even a shadow for a leg that is not seen), and at the same time energize the composition by leading the eye upward to the objects on the table. Sensitive to subtle details, Sheeler wraps the shadows around the wall molding and introduces a diagonal shaft of light running counter to other diagonals to draw the eye back to the left. According to Sheeler, "the table is the result of all the things that are happening around it. It stands out in space, not through the subterfuge or suppression of environment . . . but through the use of projected shadows."[2]

Sheeler's ingenuity is also noticeable in other ways. The interaction between straight-edged and curving forms provides diversity within the design. Subtly changing viewpoints from the center to the side or upward or downward, he prevents an illusionistic reading of the work. The perspective of the table is askew; objects on it do not quite rest on its surface and are shown from a slightly lower vantage point, thus asserting the flatness of the picture and suggesting some pictorial tension.

Sheeler's use of chiaroscuro is exquisite in its refinement. His colors—primarily sober browns, grays, and greens—give the work an effect of quietude, while the richer touches of color in the Persian carpet below keep the composition from becoming static. The carpet, an afterthought, according to Sheeler, also adds textural variety.[3]

Still Life and Shadows is unusual in Precisionist art, which often tends to emphasize the purity of industrial forms. Sheeler's love of household objects and crafts is crucial to his style and imagery, and as he said, "as influential in directing the course of my work as anything in the field of painting."[4]

R.L.R.

Charles Demuth, 1883–1935

A painter of extraordinary technical virtuosity, Charles Demuth left a body of work that is noteworthy for its clarity, sensitivity and refinement, and broad range of imagery. He was undoubtedly in the vanguard of Precisionism, yet many of his best works—the lively figurative watercolors, symbolic poster portraits, and gracefully sensual still lifes—are only tangentially related to Precisionism through their disciplined technique and subtlety. According to his friends, Demuth was a complex individual;[1] he was alternately austere or flamboyant, reclusive or socially active, disciplined or hedonistic, and all of these diverse qualities of his personality are seen in his art.

A native of Lancaster, Pennsylvania, where he executed many of his most important works, Demuth studied painting at the Pennsylvania Academy of the Fine Arts, working under two of that institution's most

important teachers: Thomas P. Anshutz and William Merritt Chase. Like most of the other major American modernists of his generation, Demuth gained much from traveling abroad. He was in Europe for a brief period in 1904, and lived in Paris in 1907–1908 and 1912–1914. He attended classes at the Académie Julian and Académie Colarossi. His exposure to modern painting, particularly Post-Impressionism and Cubism, and his participation in the artistic and literary circle associated with Leo and Gertrude Stein contributed considerably to his cosmopolitan spirit and sophistication. He traveled to Bermuda in 1916, visited New York City often, and spent many summers in Gloucester and Provincetown, Massachusetts. After 1922 he remained, for the most part, at his family home in Lancaster.

52 *The Circus*, 1917 31.127

Watercolor and graphite on paper, 8 x 10⅝ in. (20.3 x 27 cm.). Signed and dated lower left: C. Demuth/1917. Gift of Ferdinand Howald, 1931

Between 1915 and 1919 Demuth executed a series of watercolors inspired by vaudeville, the circus, and the night life of New York City. He was certainly aware of similar scenes produced in France by artists such as Watteau, Degas, and Toulouse-Lautrec. Like them, Demuth reveled in the vigorous energy and sometimes showy banality of public spectacles, and he was master of a watercolor technique well-suited for capturing their fast pace.

The Circus, one of these energetic watercolors, is among Demuth's most entrancing works. The effectiveness of the painting is dependent on the artist's swift, delicate touch. Virtually everything in the scene is rendered in curving lines that keep the viewer's eye moving throughout the composition. The concentric movement of the arena is reinforced in the curve of the horse's back; played against the momentum of these elements are the sweeping arcs of the woman's arms and the red, yellow, and green banners that festoon a pole at the center of the arena. The tighter, wiry curves of the male acrobat suggest a wobbly movement appropriate for the uncertainty of his equilibrium. Demuth underplays the mass of his forms to accentuate their buoyancy; rather than appearing firmly implanted, the figures seem to float as if unaffected by gravity, their insubstantiality dependent on a technique called "softening off," in which the watercolor pigments are applied on wet paper and carefully blotted to create a mottled, atmospheric effect. With the exceptions of the inky blacks of the entertainers' garments, the brightly colored festoons, and the green band across the male performer's chest, the colors—mostly pinks and tans—are muted by the blotting and by the exposed areas of white paper.

In *The Circus* Demuth pays homage to the pleasures of popular, live entertainment. The appearance of this and so many images like it in the later 1910s indicates a growing nostalgia for forms of entertainment that were declining in popularity due to the success of film. As scholar Betsy Fahlman pointed out, Demuth would have agreed with the lament of his close friend Marsden Hartley:

> Where is our once charming acrobat—our minstrel of muscular music? What has become of these groups of fascinating people gotten up in silk and spangle? Who may the evil genius be who has taken them and their fascinating art from our stage, who the ogre of taste that has dispensed with them and their charm? . . . What are they doing since popular and fickle notions have removed them from our midst?[2]

R.L.R.

Charles Demuth, 1883–1935

53 *Modern Conveniences*, 1921 31.137

Oil on canvas, 25¾ x 21⅜ in. (65.4 x 54.3 cm.) Signed and dated lower left center: C. Demuth 1921. Gift of Ferdinand Howald, 1931

Charles Demuth's first experiments with a Precisionist style began during a prolonged visit to Bermuda with Marsden Hartley in the autumn of 1916, when he executed a series of watercolors based on architectural themes. In contrast to the figurative works he was doing around that time—such as *The Circus* (cat. no. 52)—his Bermuda paintings are structural in emphasis and related stylistically to the art of Cézanne and the Cubists. In his concern for the definition of hard-edged, angular, geometric planes in space, Demuth composed in a more calculating, impersonal way than he had ever before attempted. His friendship with Marcel Duchamp was also a factor in the development of this new aesthetic.

Modern Conveniences, which Demuth painted in Lancaster, is an excellent example of the artist's architectural compositions. It is Precisionist in its sharp delineation, geometric clarity, and crystalline lighting, yet it is far from being a celebration of the beauty of a structure. To the contrary, the painting is a tongue-in-cheek commentary on the limitations of a particular building. Based upon a view of the rear facade of a house seen from the garden of Demuth's home in Lancaster, the painting is an effective blend of realistic components and abstract forms.[1] A later photograph of the building indicates that Demuth generally respected the specific details of the structure but modified them to assert the picture's flatness or to make the work more dynamic.[2] The windows and doors, for example, are slightly askew, suggesting that the house is not in the best condition. Moreover, all of the horizontals are slightly off so that the building seems to lean toward the left. Demuth further accentuates the rickety appearance of the structure by making the diagonals too extreme or awry. Only a chimney, along with other vertical elements, provides some feeling of stability.

In contrast to the building, the space it occupies seems open and majestic. Several paired diagonals, which traverse the scene like searchlights or the force lines in Futurist paintings, energize the space and open it up beyond the perimeter of the picture. Occasional arcs, mostly near the bottom of the painting, are evocative of foliage but also provide diversity in a composition dominated by straight lines. The predominant colors—pinks, reddish browns, grays, and white—are characteristic of the domestic architecture seen around Demuth's Lancaster home.

Like Duchamp, Demuth made the titles of his works an integral part of the works themselves. Humorous, ironic, or ambiguous, the titles were clever counterpoints to the refined visual forms, and they were meant to cause the viewer to think about the meaning of the works. What are the modern conveniences of this building? Its shaky appearance is more indicative of the problems than the advantages of living there. The emphasis on the fire escape suggests that the building is a fire trap. Perhaps the ambivalence of the painting is related to Demuth's attitude toward his native city, which was hardly known in his time for its modernity. Despite the claims of a friend that Demuth loathed Lancaster,[3] life there was convenient and comfortable, and as his biographer noted, "to him the city's landscape was endlessly beautiful, so that he was always going home from Paris or elsewhere to paint."[4]

R.L.R.

Charles Demuth, 1883–1935

54 *Bowl of Oranges*, 1925 31.125

Watercolor on paper, 14 x 20 in. (35.6 x 50.8 cm.). Signed, dated, and inscribed lower center: Lancaster Pa. C. Demuth 1925. Gift of Ferdinand Howald, 1931

The primary source of Charles Demuth's income during the 1920s,[1] and certainly among his most successful works, were the still lifes he undertook largely as a result of his failing health. The debilitating effects of diabetes severely affected his activities as a painter but not the quality of his artworks. At times unable to work at all, when his strength began to return he turned to watercolor and to still-life subjects. He had always admired the beauty of the flowers in his garden and was also inspired by the fruits and vegetables his mother brought regularly from farmers' markets near the family home.[2] Arrangements of these objects could be set up for prolonged times and were easily accessible during periods of confinement. Devoid of irony and ambiguity of meaning, Demuth's still lifes are positive responses to the beauty of nature and consummate examples of the artist's compositional skills and refined technique.

Despite his wistful observation that "I get more out of my watercolors than anybody else,"[3] *Bowl of Oranges* is full of rewards for the viewer. Once again, the effectiveness of the picture is largely dependent on the artist's subtle touch. He depicts recognizable components—a bowl of oranges, a goblet holding an orange flower, and two bananas on a table in front of rich blue curtains—using devices introduced by Cézanne and the Cubists: the tabletop is seen from more than one vantage point; the forms seem to shift from transparency to opacity; and the shadows are given comparable weight to the forms themselves. Like his earlier figurative watercolors, such as *The Circus* (cat. no. 52), *Bowl of Oranges* is a graceful composition with curving graphite lines and fluid design. The symmetrical organization is energized by the curves that create a prominent "U" in the center of the picture. The interplay of the circular and oval fruit, the scalloped bowl, the drapery, and the shadows keeps the viewer's eye moving through the composition. The straight contours of the table divide the picture into two major horizontal bands, but these do not disrupt the flow between the forms in the foreground and those further back. As a result of Demuth's mottled application of paint, portions of the work seem to move in and out of focus. These suggestive passages of color that vary in hue, value, and intensity, together with the large areas of white paper, assert the flatness of the picture and at the same time, give the impression that the scene is forming before our eyes.

Demuth's colors are intense and sumptuous. He relies on the interaction of complementary colors—oranges and blues—to heighten the visual experience. The rich, warm colors, most intense near the center of the painting, project strongly from the receding blues in the drapery. The colors of the fruit are so highly saturated that the food seems overripe.

Thus in many ways Demuth takes a modest theme and makes it significant and memorable. An encounter with such a work is a rewarding visual experience, and that was precisely the artist's objective. He wrote:

> Paintings must be looked at and looked at. . . . They must be understood, and that's not the word either, through the eyes. No writing, no talking, no singing, no dancing will explain them. They are the final, the 'nth whoopee of sight.[4]

<div align="right">R.L.R.</div>

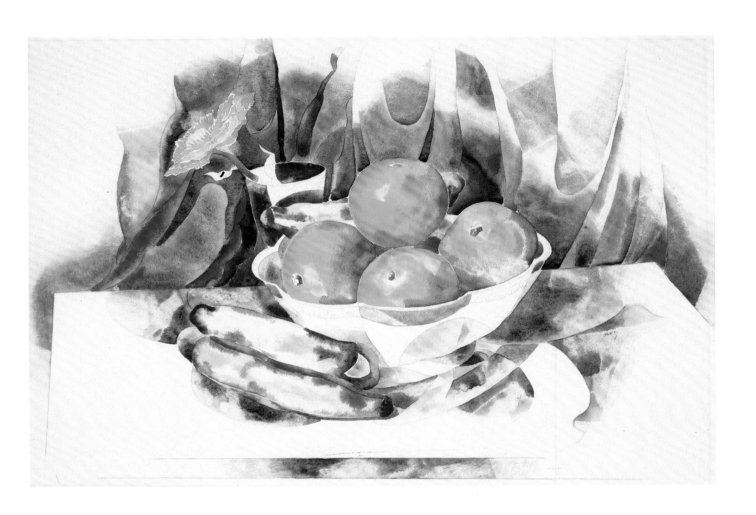

Niles Spencer, 1893–1952

Niles Spencer created a body of drawings and paintings in the Precisionist style that are noteworthy for their consistency of imagery, unrelenting discipline, and laconic impersonality. Educated at the Rhode Island School of Design between 1913 and 1915, Spencer gained an appreciation for careful craftsmanship and rigorous organization. His brief study with Robert Henri and George Bellows at the Ferrer Center in New York City in 1915 did little to advance his technical skills but alerted him to the beauty inherent in the modern urban and industrial world. Subsequent trips to Italy and France provided opportunities to examine firsthand the formal purity of Italian Renaissance art and Cubism; in particular, he was impressed by the lucid, monumental classicism of Giotto, Piero della Francesca, and Andrea Mantegna, as well as by the structural abstractions of Paul Cézanne, Georges Braque, and Juan Gris.[1]

Spencer's compositions of flattened geometric planes are the result of thoughtful observation and analysis of his subjects. Each work is an amalgam of reductive realistic components—almost always architectural—and pristine geometry. Temporal effects, weather conditions, and human figures are rejected in favor of timeless, architectonic designs. Although Spencer often used linear perspective, he was not concerned with creating an illusion of three-dimensionality. His paintings are emphatically two-dimensional, with simplified lighting and chiaroscuro and little internal detail. These works are hermetic entities in themselves, subject only to their own formal logic. A prolonged study of such a work is a meditative experience in which subtle relationships of forms and colors as well as a sense of the intelligent, reticent personality of the artist slowly become apparent. As his close friend, the painter Ralston Crawford, remarked:

> *Niles was relaxed, perhaps without much sense of time, [without] anxiety. In his best work he takes us to a world of charming nuance, of solid construction, always charged with his fine, subtle sense of colour. His search was, at times, slow, as meaningful searches often are. Occasionally he seemed to falter. But now that his work has been completed, we may say that he went toward a fuller and clearer statement.[2]*

55 *Buildings* 31.268

Oil on canvas, 24 x 30 in. (61 x 76.2 cm.). Signed lower left: Niles Spencer. Gift of Ferdinand Howald, 1931

Buildings, a forthright presentation of rooftops, building facades, chimneys, and smokestacks, is characteristic of Niles Spencer's many cityscapes. Human figures or details that would suggest the presence of people are absent. In this stable, grid-like composition, horizontal and vertical contours are only occasionally opposed by steep parallel diagonals, and the application of paint is strictly controlled and impersonal. The artist's palette, however, with its many warm browns, prevents the work from appearing cold and inhospitable. Color is also important in conveying depth and in regulating the movement within the painting. In a manner owing much to Cézanne, Spencer suggests planar connections between forms in different areas by using tones of the same value. Because the shifts in color are never abrupt, the viewer's eye moves smoothly, though guardedly, throughout the work. Vertical forms—the chimneys and smokestacks—are visual resting points as the eye follows the rhythm of the fenestration across the surface.

Spencer's continual choice of urban and industrial architecture for subjects suggests that he, like Charles Sheeler and Preston Dickinson, was attracted to the visual clarity and beauty of the forms. His oeuvre also includes landscapes, still lifes, and interior scenes, which—like the architectural subjects—are observations of the beauty to be found in structure.

R.L.R.

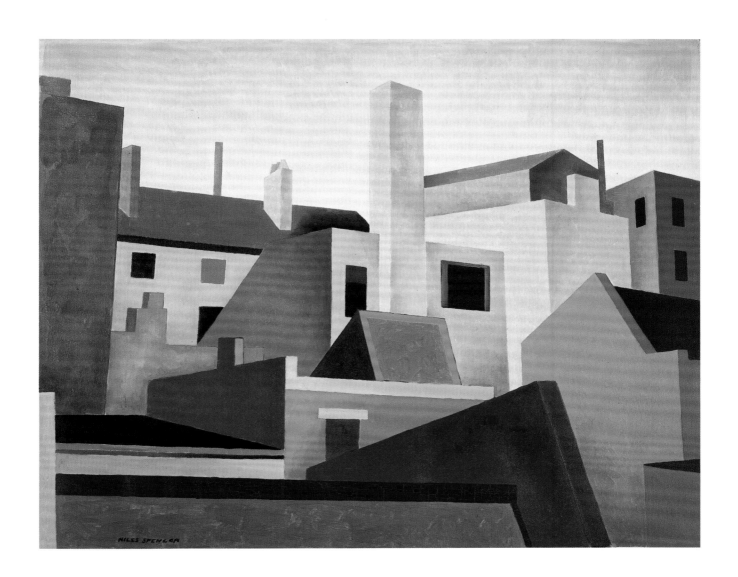

Yasuo Kuniyoshi, 1889–1953

Charles Daniel, in a letter of June 22, 1923, to the collector Ferdinand Howald, noted that Kuniyoshi had returned to Maine as he had done for many summers since 1918. "If his development continues," he wrote, "which I believe it will, he will have interesting stuff for next season." There is no formal reply from Howald, but his ledger book carefully records the purchases of three works by Kuniyoshi: Boy Stealing Fruit *and* Cock Calling the Dawn *in 1924, and* The Swimmer *in 1925. These works were among Howald's legacy to the Columbus Museum of Art in 1931.*

Kuniyoshi, who was born in Okayama, Japan, came to the United States in 1906. He studied first at the Los Angeles School of Art and Design, from 1907 to 1910. After moving to Brooklyn, he studied briefly at the National Academy of Design, then at Robert Henri's school, which was conducted in the master's studio, and at the Independent School of Art. In 1913, for unknown reasons, he left New York City for Syracuse and as a consequence missed much of the daily excitement surrounding the seminal Armory show. Returning to New York in the years 1914–1920 he continued his studies at the Independent School, the Art Students League, and briefly at the Woodstock Summer School. He had his first one-artist exhibition at the Daniel Gallery in January 1922, and continued to exhibit there until the gallery closed in 1931. He also exhibited his works in other major cities, including Philadelphia, Chicago, and Tokyo. From 1933 until he died, Kuniyoshi taught at the Art Students League and continued to exhibit his works— paintings, drawings, prints, and photographs. In 1948 he was the subject of the first ever one-artist exhibition to be organized by the Whitney Museum of American Art. Posthumous exhibitions of his work have been held at New York's Museum of Modern Art and Metropolitan Museum of Art, and at the National Museum of Modern Art in Tokyo.

56 *The Swimmer*, ca. 1924 31.196

Oil on canvas, 20½ x 30½ in. (52.1 x 77.5 cm.). Gift of Ferdinand Howald, 1931

The viewer who sees only a buoyant swimmer, a rocky island, and a rising sun illuminating a cloud bank overhead might well miss the subtleties in Kuniyoshi's *The Swimmer.* While it is thoroughly modernist in its stylized rendition and spatial manipulation, the picture also hints of precedents from ancient Egyptian and Assyrian bas reliefs in which swimmers or sea nymphs gambol among water weeds. Here as in the ancient examples the figure and architecture seem to float within a vacuous space having neither beginning nor end. And while the work is grounded in Western aesthetic traditions it also reflects a kinship with those of East Asia. Kuniyoshi's objects are suspended in a nonrecessional space infused with subtle low-key colors in a manner reminiscent of eighteenth- and nineteenth-century Japanese landscape paintings.

Certainly there is mystery and perhaps fantasy in the artist's depiction of a swimming figure and her enigmatic relation to the island and the lighthouse. All are impossibly suspended on a celadon-colored ocean. Half-submerged, the generously proportioned swimmer peers at the spectator with large, exaggerated, almond-shaped eyes, apparently surprised to have been discovered at her balletic performance. The work is purposefully primitive in its execution, as are most works by the artist around 1925. The perspective view of the figure includes not only the top and bottom but one side as well. There is an aura of quietude and passiveness—unusual for a subject that seems to promise action—achieved in part by the swimmer's arrested motion, in part by the low-key palette. Unlike his contemporaries, such as Georgia O'Keeffe and Arthur Dove, who used color expressively, Kuniyoshi carefully selected and modulated his colors to focus attention on discrete compositional details while yet creating overall unity. The viewer takes a journey through the composition, first making eye contact with the unathletic, motionless swimmer, then taking in other elements of the composition one at a time, as one takes in a Japanese landscape.

Kuniyoshi's iconography is broad yet personal. The viewer can only speculate on the logic of this visual compilation of seemingly disparate parts. For the Western eye accustomed to accurate depictions of three-dimensional space, Kuniyoshi's space seems distorted and untrue. But it is as a blend of Eastern and Western, ancient and modern that the work succeeds. Kuniyoshi's remarkable achievement is unmatched in modern American art.

S.W.R.

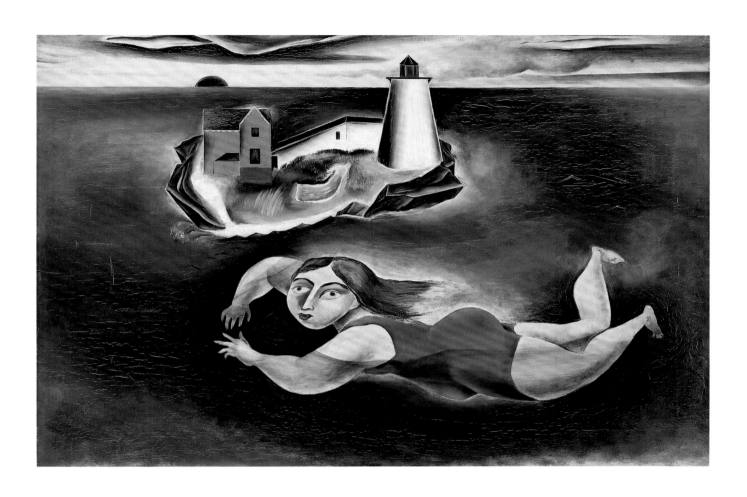

Paul Manship, 1885–1966

At the age of seven, Paul Manship began his studies at the Institute of Art in St. Paul, Minnesota, his hometown. He entered the Art Students League in New York in 1905, and later that year transferred to the Pennsylvania Academy of the Fine Arts. In 1909 he won the Prix de Rome, which enabled him to study at the American Academy in Rome. During his three years in Italy, he became absorbed in Classical art, especially stylized forms of Archaic Greek sculpture. He also studied the ancient sculptures of other Mediterranean countries, particularly Egypt. Manship returned to New York in 1912 and shortly thereafter held his first exhibition, a critical and financial success during which he sold nearly one hundred bronzes.

Throughout his career Manship worked predominantly in bronze, his fluid forms evoking the liquid origin of his chosen material. In the stylized rendition of mythological subjects he saw a way to infuse new vitality into modern art, somewhat as the Cubists had done in their adaptation of the simplified, geometric forms of African sculpture. In 1913, critic Kenyon Cox wrote of Manship's work: "To see this archaistic manner applied to figures with a quite unarchaic freedom of movement, doing things that no archaic sculptor would have thought of making them do, is oddly exhilarating."[1] Such subtleties, however, were probably not grasped by the general public, who knew nothing of the stylistic nuances separating Manship's archaism from more traditional neoclassicism. Instead, his works were appreciated both for their streamlined, modern appearance and their ties to ancient cultures. His work was so enormously popular that he maintained studios in both Europe and the United States to keep up with the demand. Manship's best known work probably is the Prometheus (1933), which he created for the fountain in New York's Rockefeller Plaza.

57 Diana, 1921 80.24

Bronze (cast 7), H. 37½ in. (95.3 cm.). Inscribed and dated on underside of leaves: Paul Manship 1921 © / No. 7. Foundry stamp on base: Roman Bronze Works N.Y. Museum Purchase: Howald Fund II, 1980

Manship's Diana is based on a mythological story recounted in Ovid's Metamorphoses in which Diana, the goddess of the hunt, transforms the young hunter prince Actaeon into a stag after he accidentally sees the virgin goddess at her bath. Diana then shoots and wounds Actaeon, who is immediately devoured by his own hunting dogs.

In this idealized depiction, Diana is armed as a huntress. Manship has chosen to portray her at the moment she has fired an arrow at her target, Actaeon. In one, smooth movement, Diana springs forward in graceful flight as she casts a backward look to determine the fate of Actaeon; her every move is echoed in the turned head and suspended leap of the dog. The dynamism of the figures is enhanced by their smooth tapering limbs. Only the vertical lines of the bow and the sinuous plant visually restrain the forward motion of the composition.

The museum's Diana is the first of several versions of the subject made by the artist between 1921 and 1925. In 1923, Manship made an Actaeon,[2] which was intended as a companion piece for the Diana. In the Actaeon, the hunter prince, sprouting stag's horns, reacts to the perfect marksmanship of the goddess with a strong, diagonal thrust of his body as two dogs leap to attack him. In both the Diana and the Actaeon, the influence of the artist's studies of Archaic Greek vase painting and sculpture can be seen in style as well as in choice of subject matter. There is, for example, an emphasis on silhouette, which tends to flatten the compositions, as do the incised linear details, which recall drawing more than modeling. In addition, the smooth, glistening surfaces and streamlined, mannerist poses make Manship's garden sculptures, such as Diana, and large-scale works and portraits elegant contributions to the Art Deco style, which perfectly reflects the prevailing popular taste of the 1920s and 1930s.

D.A.R.

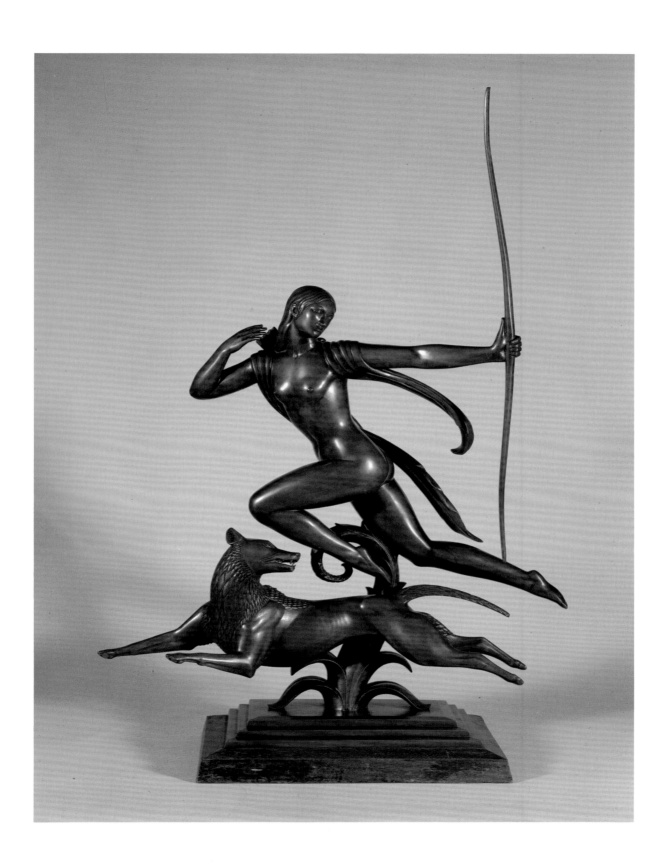

Charles E. Burchfield, 1893–1967

A romantic in spirit, Charles Burchfield was an American expressionist painter who responded deeply—even passionately and personally—to the landscape and to nature's moods and seasons. In general, during the early and late phases of his career he painted landscapes, and in between he portrayed the drab houses and industrial buildings of northeastern Ohio and Upstate New York. He often reworked earlier paintings. His chosen medium was watercolor but he also painted a few oils; only rarely did he combine gouache and oil, as he did in the museum's painting.

Born in Ashtabula Harbor, Ohio, Burchfield received his art education between 1912 and 1916 at the Cleveland School (now Institute) of Art. Henry G. Keller, one of Burchfield's teachers in Cleveland, nurtured the artist's love of nature and fostered his interests in contemporary painting, traditional Chinese and Japanese art, literature, and especially music. Early in his life Burchfield discovered the writings of the naturalist John Burroughs, whose fascination with the sights and sounds of the forest inspired the artist to attempt synesthetic effects in his art.[1]

Like his contemporaries, John Marin, Georgia O'Keeffe, and Edward Hopper, Burchfield concentrated on American places and the emotions they inspire. But in his interpretations, Burchfield often relied on remembrances of visual, emotional, and even aural aspects of a scene, adding imaginative touches to intensify the effect. He wrote:

> *The best work is done in retrospection. Even when working directly from nature, I am painting from memory, for not only am I trying to recapture the first vision or impression that attracted me (and which is all that is worth going after) but also the distillation of all previous experiences.[2]*

Burchfield's reverence for nature was profound, but in his art he was more concerned with the expressive possibilities of a scene than he was with representing appearances. He said:

> *While I feel strongly the personality of a given scene, its "genius loci" as it were, my chief aim in painting it is the expression of a completely personal mood.[3]*

58 *October*, ca. 1922–1924 31.116

Oil and gouache on paper glued to board, 31 x 42¾ in. (78.7 x 108.6 cm.). Signed lower right: C BURCHFIELD. Signed and dated on reverse: 2-October/Chas. Burchfield. Gift of Ferdinand Howald, 1931

Painted after Burchfield moved from Ohio to Buffalo, New York, in 1921, *October* is indicative of the artist's interest in the passage of time. Seasonal change is a recurring theme in his art[4] and was to him a subject of endless fascination:

> I love the approach of winter, the retreat of winter, the change from snow to rain and vice versa; the decay of vegetation and the resurgence of plant life in the spring. These to me are exciting and beautiful, an endless panorama of beauty and drama.[5]

A work from the middle phase of Burchfield's career, when his paintings were characterized by an interest in realistic imagery and representational details, *October* is unusual for its reliance on fantasy. Four galloping wild horses move mysteriously through a bleak forest setting in which barren trees and heavy clouds evoke the season. Vulture-like birds perch on high branches, adding a sense of foreboding. In this work Burchfield relies on the interplay between curving and angular forms and is particularly sensitive to the visual pacing of these elements. The trees are unevenly positioned; their varied diagonals play against the energetic curves of horses and clouds, suggesting the opposition of nature's unbridled forces. Burchfield's palette contributes to the dynamic effect: he juxtaposes warm oranges and cool blues to intensify the clash of curves and angles and perhaps to symbolize the yielding of the warmth of summer to the approaching cold of winter. Heavy lines, active brushwork, and strong value contrasts add to the raw vitality of the scene.

In *October* Burchfield delves beyond particular experience to embrace the visionary and mystical. In his intuitive expressions of nature's mysteries, he reveals his spiritual kinship with the transcendentalist philosophy of Ralph Waldo Emerson, but his fantasies are always subject to the natural scheme of things. As Burchfield said,

> The artist must come to nature, not with a ready-made formula, but in humble reverence to learn. The work of an artist is superior to the surface appearance of nature, but not to its basic laws.[6]

<div align="right">R.L.R.</div>

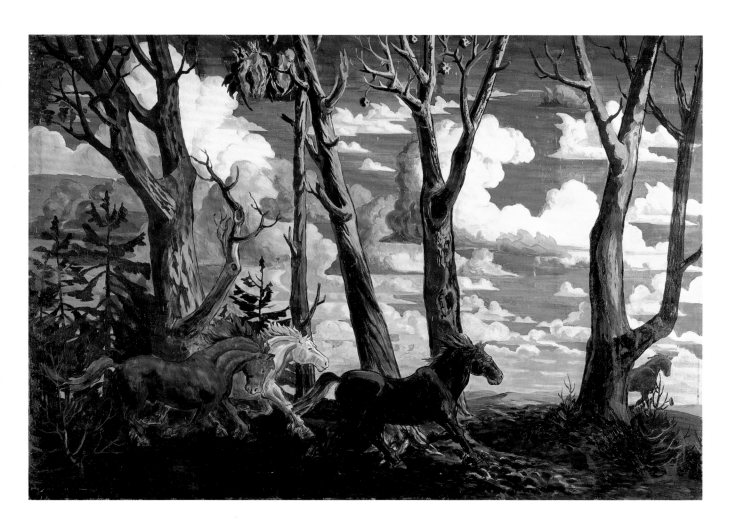

Guy Pène du Bois, 1884–1958

Guy Pène du Bois was born in Brooklyn, New York, to a Creole family still closely tied to its French heritage. Named after a family friend, the French writer Guy de Maupassant, Pène du Bois was raised in a sophisticated French literary environment; he did not speak English until the age of nine. In 1899 his father, writer and critic Henri Pène du Bois, enrolled him in William Merritt Chase's New York School of Art, where he began his studies under Chase. But it was the powerful influence of Robert Henri, who began to teach at the school in 1902, that made a lasting impression on the young artist. Henri's realist philosophy of "art for life's sake" became the foundation of Pène du Bois's own work.

Between the spring of 1905 and the summer of 1906, Pène du Bois studied briefly at the Académie Colarossi in Paris and privately with Theophile Steinlen. While in Paris he began to discover his own subject matter by sketching and painting scenes of fashionable cafe society. His keen interpretations of the spectacle of modern life very early earned him a reputation as a satirist in the tradition of Forain and Daumier, with whose work his was often compared. Throughout his career Pène du Bois focused on the international social set; capturing his subjects with cool detachment in revealing moments from their daily lives.

Pène du Bois supported his painting career through his activities as a writer and teacher. As an art critic for various New York newspapers and journals, he aligned himself with American modernism. In 1912 he joined the Association of American Painters and Sculptors and served on the publicity committee for the Armory Show. Pène du Bois, the critic, edited the special edition of Arts and Decoration *commemorating the Armory Show; Pène du Bois the painter exhibited six works in the exhibition.*

After the Armory Show he increasingly committed himself to the support of contemporary realism to the exclusion of other modernist trends. He resigned from the Association of American Painters and Sculptors but continued to be active in progressive circles. In 1917 he became a founding member of the Society of Independent Artists. Through his friendship with Gertrude Vanderbilt Whitney, he became a charter member of the Whitney Studio Club, which gave him his first one-artist show during its inaugural year in 1918.

His work as a critic left Pène du Bois little time to devote to painting during the early years of his career. It was not until the early 1920s that he developed the style that characterizes his mature works, a style that is dominated by solid, simplified figures that are minimally modeled. A critical five-year sojourn in France beginning in December 1924 presented Pène du Bois with his first opportunity in nearly two decades to concentrate on painting and to perfect his individual style.

59 *Woman Playing Accordion*, 1924 80.3

Oil on canvas, 48 x 38⅛ in. (122 x 96.8 cm.). Signed and dated lower right: Guy Pène du Bois '24. Acquired through exchange: Bequest of J. Willard Loos, 1980

Woman Playing Accordion was completed in the spring of 1924, before Pène du Bois returned to France for an extended stay. The essentials of his mature style can be seen in the attitude and distinctive stylization of the figure in this painting. The subject, a solitary musician, appears to be engrossed in a private performance. Lost in self-absorption, she gazes blankly into space. Shadows at the outer edge of the setting form a dark barrier between her and the outside world. The glare of the spotlight heightens the model's sense of physical isolation and emotional aloofness.

Despite the seemingly calm immobility of the subject, the painting abounds with visual tensions. The solidly modeled figure is placed slightly off center in the picture plane but in line with the edge of a blue shadow on the right-hand wall. This device, which draws attention to the musician's face, also acts to flatten the space, thrusting the figure forward. The woman's curving left arm functions visually to complete the back and arm of the chair. The heavily worked impasto of the flesh tones contrasts with the quickly applied brushstrokes that define the neckline of the sitter's dress and the shadow from the accordion strap, which add touches of spontaneity to the otherwise palpable stillness of the painting.

The work epitomizes Pène du Bois's ability to capture the essence of characters who conceal their emotions and personalities behind artificial masks of sophistication. In such works, the artist appeals to the reflective viewer to look beneath the facade, where the truths of their lives may be found.

N.V.M.

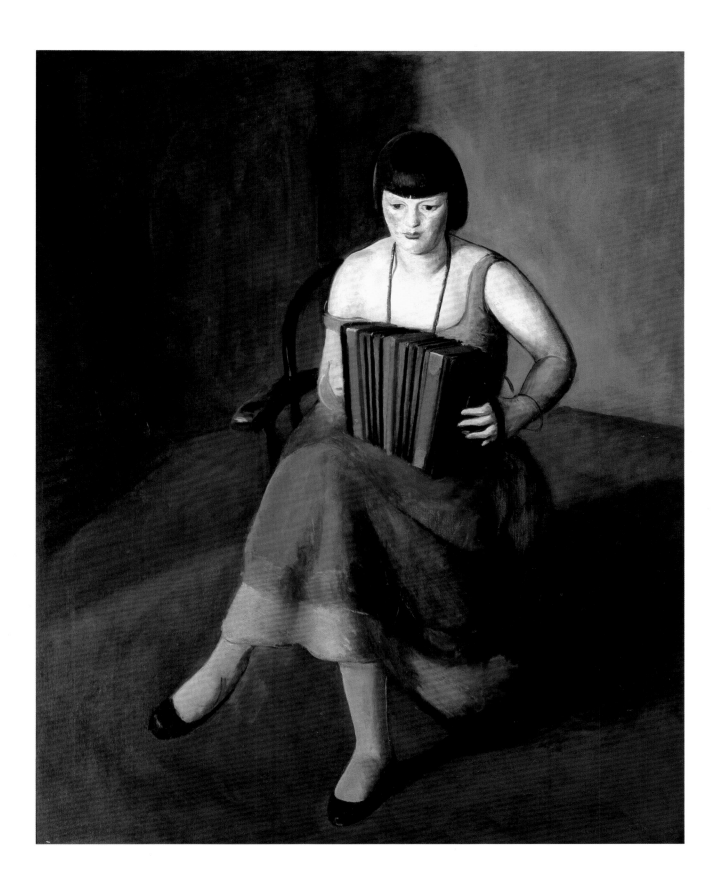

Peter Blume, born 1906

A Russian by birth, Peter Blume grew up in Brooklyn, where his family settled after emigrating in 1911. He studied art briefly between 1921 and 1925 in various schools in New York—the Educational Alliance, the Beaux Arts Institute of Design, and the Art Students League—before deciding to paint independently.

Blume first caught the attention of critics in 1934, when his picture South of Scranton (Metropolitan Museum of Art) was awarded first prize at the Carnegie International Exhibition of Painting, in Pittsburgh. The work drew both praise and derision, not unlike the critical response to much of the artist's subsequent work. In 1937 he completed his most famous work, The Eternal City (Museum of Modern Art), which is the product of his experiences in—and reaction to—Mussolini's Fascist Italy. The painting established Blume as a painter of expressive power whose thematic range includes statements of political and social protest, as well as mysterious and enigmatic subjects that border on the surreal. In his mature works he created conscious amalgamations of past and present, of memory and observation, meticulously painted to achieve the effects of fantastic realism.

60 *Home for Christmas*, 1926 31.109

Oil on canvas, 23½ x 35½ in. (59.7 x 90.2 cm.). Signed lower right: Peter Blume. Gift of Ferdinand Howald, 1931

Home for Christmas, one of Blume's earliest works, was painted in March 1926,[1] when the artist was nineteen. That same year, the picture was exhibited at the Charles Daniel Gallery and was purchased by Columbus collector Ferdinand Howald. Showing foresight and an eye for originality, Howald was the first prominent collector to purchase a work by Blume.[2]

Years after he painted *Home for Christmas*, Blume recalled that he had spent the winter of 1925–1926 in Northampton, Massachusetts, the home of Smith College. Intrigued by the college town atmosphere,[3] he chose to depict a young woman, perhaps from the college, attired in proper riding habit and silhouetted against a flat geometric landscape. The crisp, simplified forms reflect the influence of Precisionism. Blume and others in the Daniel Gallery milieu who painted in the Precisionist style (Charles Sheeler, Preston Dickinson, Charles Demuth, and Niles Spencer) saw physical realities as geometric forms which they could manipulate at will in their paintings. Blume has here created a painting of surprising visual and spatial complexity. Some elements of the design in effect flatten the composition: the sloping roof line of the building in the right foreground is continuous with the ridge line of the snow-covered mound in the background; and the crest line of the blue mountain in the distance is a continuation of the roof line of the tallest building. Other elements, however, combine to reestablish an implication of depth: the juxtaposition of receding and advancing colors, the subtle modeling of certain facades, and some unexpected passages of impasto.

The figures in the painting (unusual in a Precisionist work) and the flatness of the overall pattern suggest the additional influence of European and American primitive and naive art. Both horse and rider appear to be paper-thin cutouts. They float on the white surface, neither leaving footprints in the snow nor casting shadows, anchored to the landscape only by the tree silhouette and the slope that almost coincides with the top of the young woman's head. The horse, with its slightly pinched smile and arched eyebrow, gazes directly at the viewer like a fanciful hobby horse.

As a mature artist Blume developed a reputation as an exceptional technician and craftsman. His compositions evolved slowly, over a period of several months, through a series of sketches and studies. This process of methodical experimentation is apparent even in the early work *Home for Christmas* in which several pentimenti are visible. The most striking pentimento is the ghostly left rear leg of the horse, which Blume originally included and then painted over. His painstaking underdrawing is also clearly visible, especially in the contour of the young woman's chin and the four-finger hand holding the reins. According to Blume:

> The "idea" for a painting, even if you see it in your mind completely, goes through innumerable transformations. It goes through, in a sense, the process of being and becoming. Its state of being is determined by its own needs, while its state of becoming is related to some future work dimly visualized.[4]

There is a subtle disquiet in the silent, suspended world of *Home for Christmas* which is prelude to the mysterious power in Blume's later work. The disjunction between the lively figures and the stylized architectural backdrop becomes, in later works, a more conscious compilation of representation and abstraction. This early scene, however, is informed by simplicity and an inner cohesion seldom found in the artist's later compositions.

N.V.M.

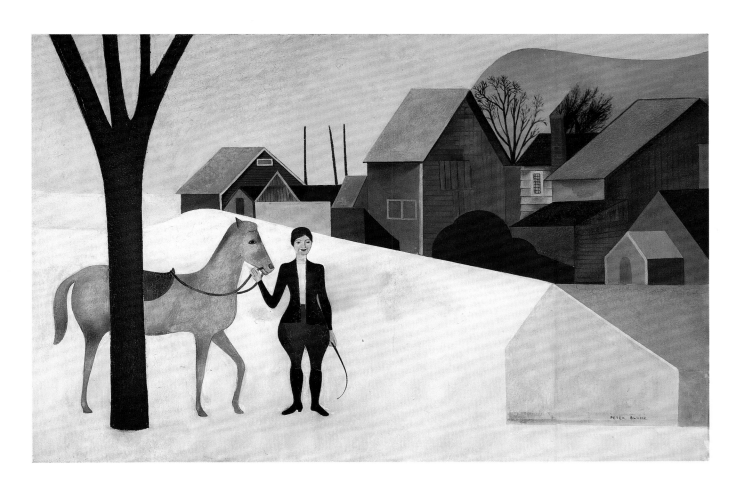

Elijah Pierce, 1892–1984

Elijah Pierce never had a lesson in woodcarving and never thought of himself as an artist, yet he created more than one thousand boldly carved and brightly painted wood sculptures which today are acknowledged as a significant contribution to American folk art.

Pierce was born in 1892 near Baldwin, Mississippi "in a log cabin, right out almost in the cotton field."[1] The son of a former slave and one of nine children, Pierce grew up on his father's farm. He did not like farming and left home as a young man "to see the bright city lights,"[2] traveling extensively in the South and Midwest before settling in Columbus, Ohio, in 1924. A licensed minister, Pierce resisted the ministry as a full-time profession and chose instead to be a barber. He established his own shop in 1954 at 534 East Long Street, only two blocks from the art museum.

Even as a child Pierce loved to whittle, first carving figures and animals into the bark of trees and later fashioning walking sticks from wood. He began carving in earnest in the 1920s when he made an elephant as a gift for his wife. She was so pleased that he created a zoo for her. And he kept on carving—works inspired by pictures, comic strips, stories, songs, sermons, and events of everyday life. By the 1930s, most of his carvings were based on biblical and religious subjects.

Pierce's powerful carvings were discovered quite unexpectedly in 1971 at a Y.M.C.A. exhibition in Columbus. Since his first exhibition at the Ohio State University that same year, his works have been included in solo and group exhibitions in New York, Washington, Philadelphia, and Columbus. In 1973, he won first prize at the International Meeting of Naive Art in Zagreb, Yugoslavia. In 1980, at the age of 88, he received an honorary Doctorate of Fine Arts from Franklin University in Columbus. The National Endowment for the Arts in 1982 awarded him a National Heritage Fellowship as one of fifteen master traditional artists.

61 *Crucifixion*, mid-1930s 85.3.1

Carved and painted wood mounted on panel, 47½ x 30½ in. (120.65 x 77.47 cm.). Signed lower right: E. P. Pierce. Museum Purchase, 1985

Crucifixion, created in the mid 1930s, is today counted among Pierce's masterpieces. The work consists of more than forty carved and painted figures, trees, flowers, and other objects. In its original form it was a tableau much like a stage set, with freestanding figures arranged on six levels of narrow step-like ledges.[3] Later, Pierce decided to mount the figures on a panel, two thirds of which is painted blue, a color that symbolizes both sky and heaven. The lower third of the panel is painted a brilliant red, the color of blood, martyrdom, and hellfire, which are traditionally associated with the Passion of Christ.

The apparently random distribution of figures across this colorful field has been carefully calculated by Pierce. The main characters of the story are aligned in the form of a cross—the primary symbol of the Passion. Centrally placed against the heavenly blue are the figures of Christ and the two thieves who were crucified with him. The vertical axis is formed by three elements: the cross, which is superimposed on a tree sparkling with glitter; a grief-stricken woman who kneels with hands raised in prayer; and Satan, his feet planted firmly in the red ground, sporting horns and a pointed tail and brandishing a sword and pitchfork. Many other characters from the Passion story are carefully woven into the composition. Blacksmiths forge nails for the cross, a centurion pierces Christ's side with a spear, and Mary, the mother of Christ, is comforted by the Apostle John. The drama is proclaimed an event of cosmic proportions by the presence of a crescent moon raining blood and the black, eclipsed sun, which withheld its light from the earth at the moment of Christ's death.

Though the composition is complex and the figures are many, Pierce's personal vision is direct and powerful. In addition to the Gospel accounts of Christ's sacrificial death, the artist includes symbolic allusions to the biblical themes of good and evil, sin and salvation. Christ's cross is grafted to the Tree of Knowledge of Good and Evil, from which Adam and Eve partook of the forbidden fruit. Satan, in a modern suit, stands with his arms outstretched, ironically imitating Christ's pose, yet seeming to gesture in triumph. Two seated figures gamble with dice, like the soldiers nearby who cast lots for Christ's robe. These visual parables emphasize the human aspects of the religious events, and are the instruments of Pierce's preaching.

Crucifixion is one of the greatest of the "sermons in wood." Though Pierce was only a preacher occasionally, he atoned for his reluctance to preach through his vocation as a woodcarver. He explained: "I ran from the ministry. I had a calling to preach, so God put me on the woodpile. I have to carve every sermon I didn't preach. Even after I'm dead I'll still be preaching these."[4]

E.J.C.

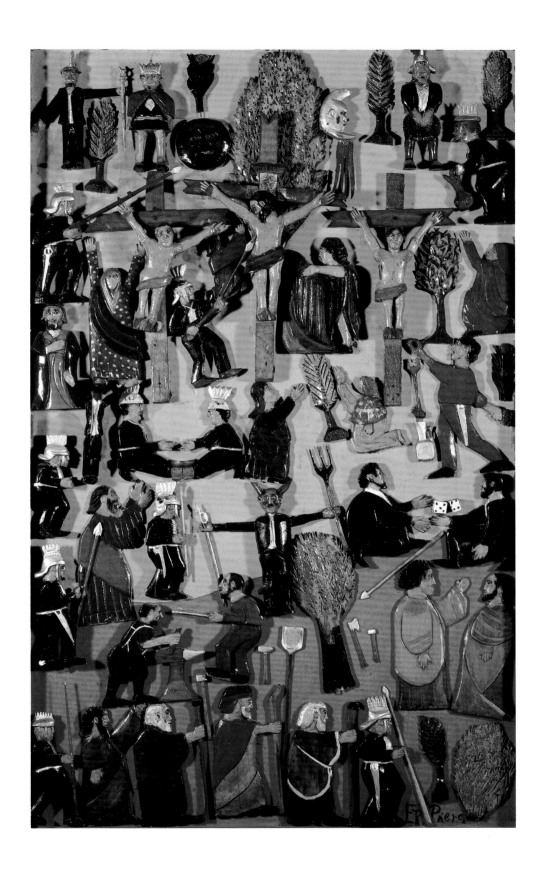

Reginald Marsh, 1898–1954

Reginald Marsh was born in Paris to American parents, both of whom were artists. The family returned to the United States in 1900, and lived first in Nutley, New Jersey, then in New Rochelle, New York. Marsh entered Yale University in 1916, and began art studies in his senior year. Throughout his college years he was a popular illustrator for the Yale Record. *He graduated in 1920 and moved to New York City, where he did freelance illustration for* Vanity Fair *and* Harper's Bazaar. *He took courses at the Art Students League, working under John Sloan and George Luks, among others. In 1922 Marsh was hired as an artist for the* New York Daily News; *in 1924 he joined the staff of the newly formed* New Yorker *and continued to be a contributor for the next seven years. His first one-artist show was held at the Whitney Studio Club in 1924.*

A major factor in the development of Marsh's art was his sojourn in Europe from 1924 to 1926, when he copied works by Rubens, Delacroix, Titian, and Rembrandt and was inspired by their masterful execution of form and anatomy. When he returned to New York, he studied with Kenneth Hayes Miller, who shared his interest in the old masters. At the time, Miller was painting subjects observed in the neighborhood of his Fourteenth Street studio—in one of the less fashionable areas of the city. Marsh adopted the same subjects, rendering them according to his own vision. His paintings express the vibrant, animated quality of New York city life and continue the tradition of realism advocated by The Eight. In their spontaneity and caricatural style they also reflect Marsh's experience as a newspaper artist.

62 *Hudson Bay Fur Company*, 1932 56.1

Egg tempera on muslin mounted to particle board, 30 x 40 in. (76.2 x 101.6 cm.). Signed and dated lower right: Reginald Marsh 1932.
Museum Purchase: Howald Fund, 1956

The subject of *Hudson Bay Fur Company* is a provocative scenario performed by live models in an overhead window of a shop on Union Square. A sign below the window indicates the establishment had a Broadway entrance. Fashion shows such as that pictured here were often presented by the Hudson Bay Company furriers. Women passing by may have looked up at the window with the dream of owning an inexpensive fur in the midst of the Depression, but the power of the scene lies in its appeal to male voyeurism. As these buxom young models display the furs, they become objects of consumption themselves. Heavy black brushwork emphasizes their curvaceous figures in clinging dresses. Marsh recalled that "the girls were beautiful, and attracted considerable attention before [a] lower sign was put on to obscure their ankles and thighs."[1]

All of this is very like burlesque, a favorite subject of Marsh's because he considered it one of the few forms of entertainment accessible to the poor man. In Marsh's work, modern gods and goddesses reveal their heroic proportions to the strollers of Fourteenth Street. The elevated placement and monumental form of the figures in *Hudson Bay Fur Company* and the close vantage point, which would be impossible from the street below, are elements of distorted reality. Bodies and faces are idealized and sexual attributes greatly exaggerated; the subjects seem larger than life. A 1930s fantasy, the work evokes memories of the film posters plastered everywhere in New York and the films themselves that provided momentary escape from the hard times of the Depression.

The visual power of this painting owes as much to Marsh's passion for drawing strong outlines as it does to textural brushwork and a rich buildup of thin washes of color. Also apparent is the artist's command of anatomy, which he studied at the College of Physicians and Surgeons in New York in 1931 and at Cornell Medical College in 1934. To enliven the setting, Marsh uses strong diagonals and offsets the blue dress worn by the model in the center with the yellow skirt of another model and accents of green and gold. This work is in tempera, a medium Marsh used extensively throughout his career. He found that tempera lent itself to layering, had sufficient body for a rich, textured surface, and was capable of the subtle translucency of watercolor.

Marsh also photographed a display-window fashion show and, in 1940 painted a watercolor, *Modeling Furs on Union Square* (private collection, New York), which includes a window washer cleaning the outside of the showroom glass. Among the numerous other signs and nearby buildings portrayed in this version, the window with posed models is just one of many visual stimuli.

To be nearer to his favored subject matter, Marsh established his studio on Fourteenth Street in 1929, and eight years later, in 1937, he moved the studio to 1 Union Square, even closer to the vicinity of the Hudson Bay Fur Company.

D.A.R.

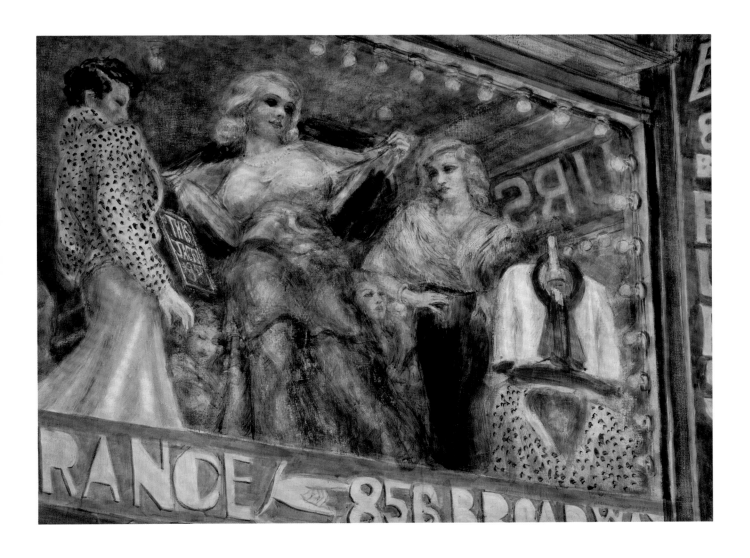

Walt Kuhn, 1877–1949

Two significant circumstances that influenced Walt Kuhn's life as an artist were his involvement in the organization of the 1913 Armory Show and his work in circuses, vaudeville, and stage reviews. The first was the culmination of his immersion in modern European art, and the second provided him with his favorite subject matter.

Kuhn began his artistic career as a cartoonist and subsequently studied in such conservative institutions as the Academy of Fine Arts, Munich, and the Académie Colarossi, Paris. With his contemporaries he shared an enthusiasm for Velázquez and Hals among the old masters. Kuhn typified the art-historically conscious artist, a phenomenon

increasingly apparent from Manet on, and it was his openness to many stylistic currents that initiated his responses to modernist art.

As one of the prime movers in the realization of the epochal International Exhibition of Modern Art *(the Armory Show of 1913), Kuhn was most responsible for the remarkable representation of works by Matisse. In addition, he responded to the works of Cézanne, about whom he wrote an intelligent essay published in conjunction with the exhibition, and to the works of Van Gogh, whose landscape style was echoed in one of Kuhn's own paintings in the exhibition.*

63 *Veteran Acrobat*, 1938 42.84

Oil on canvas, 24 x 20 in. (61 x 50.8 cm.). Signed and dated upper right: Walt Kuhn/1938. Purchased by special subscription, 1942

Veteran Acrobat, a late work, reflects the impact of European modernism on American art. The contrast of the broad, immobile mass of the sitter's head with the linear verve of the embroidered costume and the compression of the whole into a shallow space recalls Matisse, though Kuhn never permitted himself to flatten forms to the degree that Matisse did. The solemnity of the head with its dark brown pools of eyes is reminiscent of some of Cézanne's figures, but there is no hint of Cézanne's obsessive exploration of surface tensions. Instead, the acrobat's passive pose suggests reticence or stoicism. His volumetric, trapezoidal head and somewhat two-dimensional torso (only its vivid green and silver pulls it forward), both almost frontal, are blocked in and restricted by the frame as the subject confronts the viewer.

Kuhn's fascination with circus people follows an honored artistic tradition with roots in the Italian *commedia dell'arte*. The characters are archetypes of the human condition, borrowed by many artists outside the Italian comedy. Very often the subjects are performers—understood to represent all creative artists—whose true selves are concealed by costumes and masks, entertainers who must be entertaining regardless of their inner condition or the mood of the times.

Kuhn's model, the Italian acrobat Mario Venendi, embodied just such conflicts. A veteran of the First World War, Venendi was still morbidly affected by his wartime experiences.[1] Kuhn's representation of the hieratic, hypnotic rigor of Venendi's face conveys these undercurrents, while the archaic symmetry of the whole combines with striking economy of means to achieve a somber dignity. Unpretentious, not too insistent, the work is a Kuhn triumph, a vibrantly painted complex of meaning and emotion.

W.K.

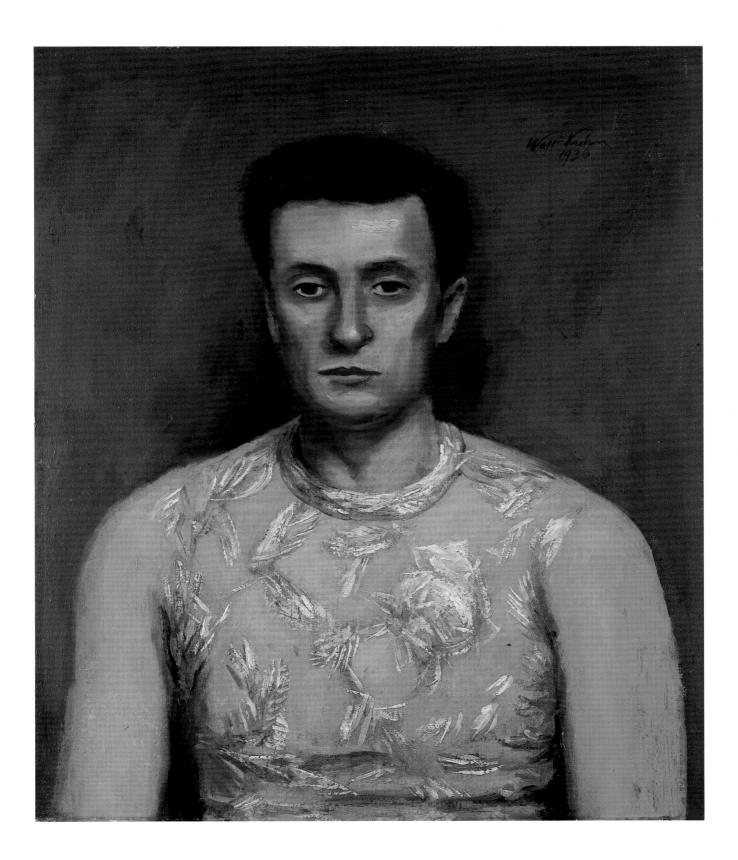

Alfred Maurer, 1868–1932

"I admit," confided Alfred Maurer in a rare statement about his art, "that for the moment I am all in doubt. I believe that I saw right before, but I am equally sure that I see right now. I can't explain the difference."[1] As an expatriate in Paris in 1908, Maurer expressed a cautious but confident excitement about his conversion to European modernism. Like many American artists of the early twentieth century, especially those studying in European cultural centers like Paris and Munich, Maurer stood at the crossroads of a wide range of artistic styles and concepts. In his mid-thirties, he chose to leave the security of a promising career in traditional painting to follow the revolutionary innovations of Cézanne, Matisse, and later Picasso. Maurer, it was said, produced *"the first real painting seen from an American brush."*[2]

Alfred Maurer was born in New York City in 1868—one year before Matisse, thirteen years before Picasso, and more than a decade before Arthur Dove, Stanton Macdonald-Wright, and other pioneering American modernists with whom he later associated. Maurer worked first in the family's lithographic business and studied art in his spare time at the National Academy of Design under Edgar Ward. In 1897, he left for Paris, where he lived until 1914, studying briefly at the Académie Julian and thereafter working alone, inspired by the works of Hals and Velázquez, and those of fellow Americans Sargent, Chase, and Whistler. He exhibited at the Paris Salon in 1899 and 1900 and won important prizes in the United States in the early twentieth century. Despite his successes, Maurer decisively changed his course between 1905 and 1907, probably as the result of his friendship with Leo and Gertrude Stein and his introduction to the paintings of Cézanne. His works began to reflect the emphatic brushwork and bold color and design he had observed in the works of the Fauves, while retaining a strong sense of Cézannesque structure. Maurer first exhibited his modernist works in 1909 in a joint exhibition with John Marin at Alfred Stieglitz's 291 gallery.

The outbreak of World War I forced Maurer to return home. He remained in New York for the rest of his life, maintaining and expanding his modernist vision in the face of conservative criticism and an often unsympathetic public. On August 4, 1932, Alfred Maurer committed suicide by hanging. Only after his death was he hailed as a leader of American modernism. As a New York art critic said in 1937: *"Alfred Maurer is dead but his pictures are still asking questions."*[3]

64 *Still Life with Red Cheese*, ca. 1929–1930 83.30

Oil on board, 18 x 21¾ in. (45.7 x 55.2 cm.). Signed lower right: A. H. Maurer. Acquired through exchange: Gift of Ione and Hudson D. Walker and the Howald Fund, 1983

Maurer began to paint still lifes perhaps as early as 1908. Some he painted with a rich, vibrant impasto; others he executed with thin glazes and muted tones; in still others he explored the transparent nature of gouache.[4] The representative still lifes he produced through the mid-1920s reflect an affinity with works by Matisse, Vlaminck, and other Fauve painters, and show the artist's receptiveness to the early Cubism of Picasso and Braque. Ultimately, however, it was the sculptural concerns of Cézanne that continued to challenge Maurer's imagination.

From 1928 to 1932 Maurer painted a distinguished group of abstract still lifes which were probably his most significant contributions to American modernism. *Still Life with Red Cheese*, one of these works, probably dates from the first half of this period.[5] It shows Maurer's full understanding of Synthetic Cubism and his delight in its pictorial syntax. A tabletop subject, it is founded on the geometric structure of a series of rectangles, triangles, and circular shapes. Consistent with Cubist vocabulary, the space is radically compressed, with the tabletop tilted forward to emphasize the flatness of the picture plane. Specific architectural elements such as sill, molding, and column have been reduced to bold outlines. The fluting of the column and the checkered patterning of the napkin add implications of texture, while the shadows—echoing both the angular forms of the table and napkins and the abundant curves of the braided bread—take on a lively, decorative existence of their own.

In brilliantly colored works like *Still Life with Red Cheese*, Maurer's love of painting is particularly evident. He drew with paint and modeled form with color. Pigments applied in a rich impasto are made more luminous and the objects given more substance through the use of transparent and semi-transparent glazes: for example, in the center of the picture, green-tinted glazing over the braided bread gives the effect of illumination through a stained-glass window. Perhaps symbolically, Maurer praises the act of painting by lending physical reality to the positioning, layering, and overlapping of one form and substance with another. He also celebrates the act of seeing, for the shift of opaque to glazed areas of color modifies the viewer's perceptions of surface and depth—at once "dissolving" the picture plane while also asserting its tangible presence.

In their completeness and resolution, Maurer's late still lifes surpass all his other works. The best liked and least controversial, they received critical praise during his lifetime and are still highly favored today.

E.J.C.

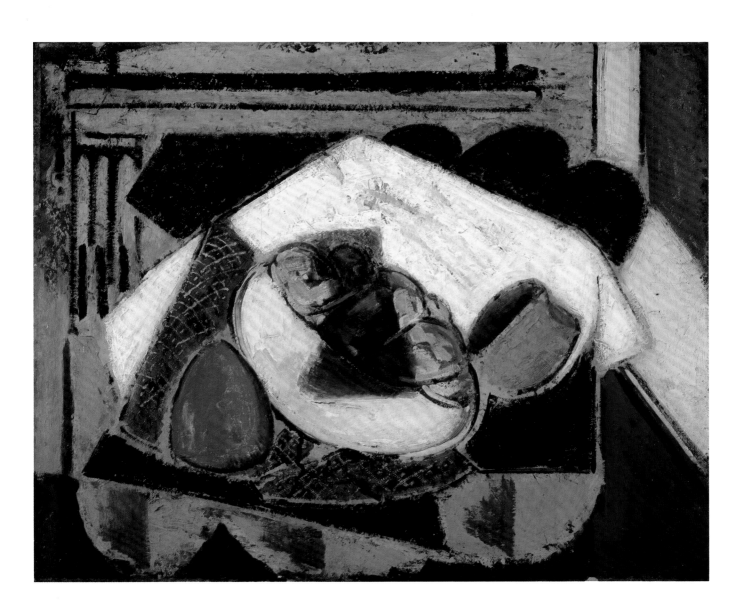

Stuart Davis, 1892–1964

Stuart Davis was born in Philadelphia, where his father was art director for the Philadelphia Press. *He grew up in a milieu that included American realist painter Robert Henri and newspaper illustrators John Sloan, George Luks, William Glackens, and Everett Shinn. After high school, he went to New York City to study with Henri. Although Davis's Cubist-influenced style is very different from Henri's, there is in his work an emphasis on the signs, colors, and rhythms of the urban environment that owes much to Henri's teaching.*

By 1913, Davis was contributing cartoons to Harper's Weekly *and* The Masses *and was one of the youngest exhibitors in the Armory Show, an exhibit that influenced him profoundly. The nonreferential color and simplified forms he saw in the works of Matisse, Van Gogh,*

and Gauguin were particularly inspiring, as he had already begun similar explorations. Confirmed in his purposes by these examples, he resolved "quite definitely . . . to become a 'modern' artist."[1]

His first solo exhibit was held in New York in 1917. In 1921 he experimented with collage and simulated collage, incorporating such elements as cigarette papers and advertising labels, and by 1922 he was investigating the multiple views and overlapping color planes of Cubism. In Paris for a year beginning in 1928, he studied the origins of the Cubist style, and absorbed the images of the city that appear in many of his works. Of the Parisian Cubists, he admired Fernand Léger for his emphasis on bold color and stylized forms.

65 *Landscape with Drying Sails,* 1931–1932 81.12

Oil on canvas, 32 x 40 in. (81.3 x 101.6 cm.). Signed top right: Stuart Davis. Museum Purchase: Howald Fund II, 1981

Landscape with Drying Sails was painted after Davis returned from Paris, during one of the many summers he spent in Gloucester, Massachusetts, between 1915 and 1934. The composition records a series of mental images—a dockside jumble of ships, sails, and buildings—gleaned from a long acquaintance with the picturesque seaside community. When asked to comment on the painting, Davis wrote:

> All that comes to mind is that I spent a great many years in Gloucester, Mass., always found it visually exciting, and eventually learned to organize some of this response in terms of Color-Space configurations. This picture, "Drying Sails," along with others of the same years after my return from one year in Paris, objectifies my intuitive preferences for certain aspects of that then exciting panorama. What is communicated of course has little or no factual content but is nevertheless directly referential to the Gloucester locale. The method of expression, the colors and shapes, were product[s] of experiences in life and art that were not confined to my Gloucester residence. In that sense the painting is not a "Gloucester" painting. But although the "Idea" in this painting is non-local in character, its application is realized in relation to a specific Gloucester subject matter. It has New York, Philadelphia, and Paris in it too, but remains Gloucester.[2]

Although Stuart Davis's images are recognizable, they do not mirror reality. In landscape scenes such as the museum's painting, Davis's forms are unmodulated and two-dimensional, obedient to a pictorial logic that relies on form and color relationships and on paint and canvas rather than on the external appearance of the subject matter. In spite of the presence of linear perspective in portions of the picture, there is little feeling of depth. The images advance and recede according to the artist's design and based in part on his choice of colors, but for the most part they seem to be flattened against the picture plane. Davis insisted that a painting should have a life of its own, equal to that observable in nature. Painting to him was "the extension of experience on the plane of formal invention."[3]

Sign imagery is a familiar aspect of his work and an important precursor to the commercial focus of Pop Art. He often made witty use of partial messages abstracted from the clutter of an urban environment. Here a sign on a building offers a tantalizing, because incomplete, explanation of the building's purpose. A preparatory sketch (private collection) for the painting shows the complete lettering to read, "Net and Seine Loft."

Landscape with Drying Sails exemplifies Davis's strong preference for representative American subject matter while at the same time it resounds with the influence of European modernism. In this Davis had few, if any, peers.

D.A.R.

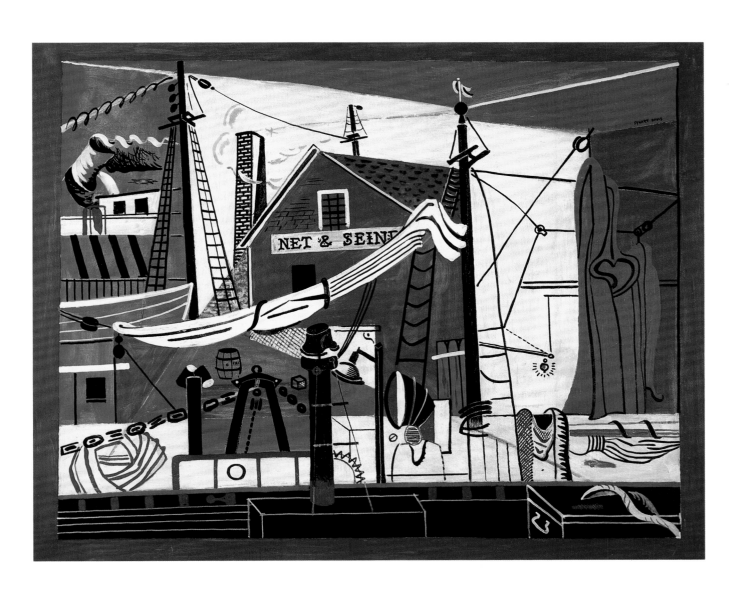

Lyonel Feininger, 1871–1956

In 1887, Feininger, who was born in New York City, returned to his parents' homeland, Germany, to study violin. Despite intentions to return to New York, he remained in Germany for fifty years, but he did not become a violinist. Disregarding the example of his parents, both professional musicians, Feininger turned to the study of art. He became proficient as a caricaturist and began a career as a political cartoonist. Having taught himself to draw, he said, "I am prouder of that fact, and take more pleasure in pen drawing than anything else."[1]

His delight in drawing remained constant throughout his life, and he achieved extraordinary subtlety and judgment in the use of line. Combining his drawing skills with an early fascination for watercolor effects, he had the technical elements of his mature art ready and waiting when at last he turned his attention solely to painting. There remained only an encounter with Cubism to complete the equation. That occurred in 1911 on his third visit to Paris.

In that Spring I had gone to Paris for two weeks and found the art world there agog with cubism—a thing I had never heard even mentioned before, but which I had already striven after for years. . . . [In] 1912 I worked entirely independently, striving to wrest the secrets of atmospheric perspective and light and shade gradation, likewise rhythm and balance between various objects, from Nature.[2]

His version of Cubism was unlike that of the French painters, whose works he said, "verge into chaotic dispersal of form."[3] Though his objects are always recognizable, there can be no doubt that it was French Cubism—specifically, the art of Robert Delaunay—that crystallized his own artistic vision. With Delaunay he shared interests in the emotional aspects of color and in architectural subject matter. His works are characterized by the use of lines threading surely through washes of color (watercolor or oil). From Analytic Cubism he assimilated the devices of transparencies and overlapping and interpenetration of atmospheric planes or facets. When Feininger was forty years old, his style was whole; as he aged, his style became increasingly poetic and contemplative.

66 *Blue Coast*, 1944 51.13

Oil on canvas, 18 x 34 in. (45.7 x 86.4 cm.). Signed upper left: Feininger. Museum Purchase: Howald Fund, 1951

In 1937, after his work was banned by the Nazis and included in the infamous Degenerate Art Exhibition in Munich, Feininger returned to the United States. Seven years later he painted *Blue Coast*, an almost archetypical example of his late work which also demonstrates the expressive possibilities of Cubism. It is less concerned with the formal analysis of objective reality than "with the problems of awareness, recollection and nostalgia," for, as the artist has said, "longing is the impulse and mainspring of creative achievement."[4]

Feininger had drawn and painted ships, especially sailing ships, all his life, made and sailed models of them, voyaged in them, and obviously regarded them in a fundamentally symbolic way in his art. In *Blue Coast* his ghostly fleet is sparse. A full-rigged ship dominates the left background, two smaller sailing craft are in the foreground, and a distant boat at the right is marked only by a black sail. The riggings are drawn with a taut linearity, like the strings of a violin. Their vibrations are visible in the sky, where the lines of the masts mark tonal shifts from dark blues to lighter blues. Together with the horizontals of the hills and water, these lines give rhythmic order to the surface of the composition.

At times a sponge or other tool seems to have been used to blot the paint, its imprint becoming part of the surface pattern. Elsewhere, thinly brushed orange and blue pigment over a pale cream primer give the effect of a watery atmosphere. Such improvisatory handling of paint lends an element of spontaneity and immediacy to the work. But Feininger's lyrical seascape is not so much an impression of a fleeting scene as it is a recollection drawn from the depths of the artist's life and experience and grounded in innumerable visual memories.

W.K.

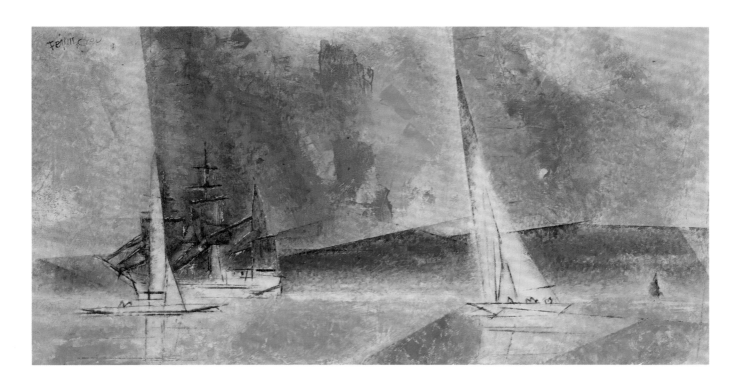

Edward Hopper, 1882–1967

Born in Nyack, New York, Edward Hopper began the study of art as a teenager through the Correspondence School of Illustrating. He also spent six years at the New York School of Art, where he was taught by Kenneth Hayes Miller, Robert Henri, and William Merritt Chase. Supporting himself as a commercial artist, he spent as much time as possible painting. He was included in the first Exhibition of Independent Artists, organized by Henri in 1910. He visited Europe twice, once in 1906 and again in 1910, spending time in London, Holland, Spain, Berlin, and Paris. In Paris he absorbed influences of French Impressionism, which appear in his paintings of 1907 to 1909. Back in the United States to stay, he established a home and studio at 3 Wash-ington Square North in Manhattan, where—except for summers in New England—he remained for more than half a century.

The fixed and steady nature of Hopper's residence was a reflection of his tenacious character, which in turn is reflected in his unswerving, coherent style and fascination with clearly delimited, though infinitely resonant, subjects. His mature style was formed by 1924, the year of his marriage to painter Josephine Nivison and of the first financially successful exhibition of his paintings. From the late 1920s Hopper exhibited in major museums nationwide, including the Whitney Museum of American Art, which organized two retrospective exhibitions, one in 1950 and another in 1964.

67 *Morning Sun*, 1952 54.31

Oil on canvas, 28⅛ x 40⅛ in. (71.4 x 101.9 cm.). Signed lower right: Edward Hopper. Museum Purchase: Howald Fund, 1954

> The morning comes to consciousness
>
> One thinks of all the hands
> That are raising dingy shades
> In a thousand furnished rooms.
> T.S. ELIOT, *Preludes*

Edward Hopper's people pass their time, more often than not, in waiting. For the night to end, for the day to begin, for arrival, for departure, for something to happen. His women, especially, frequently face intently into the sun, which often has more of brightness than of warmth, and they face it impassively, without pleasure.

In *Morning Sun*, painted in February 1952, according to the artist's notebook,[1] a no longer young woman (probably the artist's wife Josephine) sits stiffly, almost primly, on a bed facing—without seeing, one feels—an open window. All that is seen of the city outside is the top of a neighboring building reminiscent of that in other Hopper paintings, such as *Early Sunday Morning* (Whitney Museum of American Art) and *Room in Brooklyn* (Museum of Fine Arts, Boston). High above the street, the room is a barren enclosure.

Much of the pressing sense of confinement we feel in the presence of this woman is the result of her placement and pose. Her flattened, tense face lies almost on the vertical midline of the painting; her chin marks the horizontal crossing, effectively locking her in place. The most striking manipulation of her pose is in her left arm, which is illogically concealed; only the left hand is visible. So, too, the heel and toe of the left foot appear, though the left leg below the knee does not. This suppression of the left side is contrary to visual logic since our viewpoint is slightly to the left of the woman. We see part of her back and the underside of the right leg; we should also see the lower contour of the left leg. These rigorous adjustments or suppressions of reality project a disturbing tension.

So also the palette, which is based on altered primary colors, presents a litany of opposing and balancing color. The reds are shifted toward pink or purple. Yellows and blues are mixed for an extraordinary range, from the sunlit and shadowed green of the wall to the dark emerald window shade, to a gamut of saturated greens and pale or deep blues in the vertical strips of window molding. Even the woman's cream-colored flesh is modeled with yellow, blue, violet, and green; her warm pink hand is set off by dark red shadows (the color also of the shadowed left heel).

Similarly, the geometric design of the canvas presents its own contradictions. The triangular form of the woman in a light-defined rectangular space, for example, projects an obstinate passivity. This varied world of the painter's imagination, encompassing both harmonies and dissonances, is used to project the tensions Hopper sees in his subject: a woman alone and unoccupied in a busy city. Of inner currents there is no lack, for as Hopper knew so well "the inner life of a human being is a vast and varied realm."[2]

W.K.

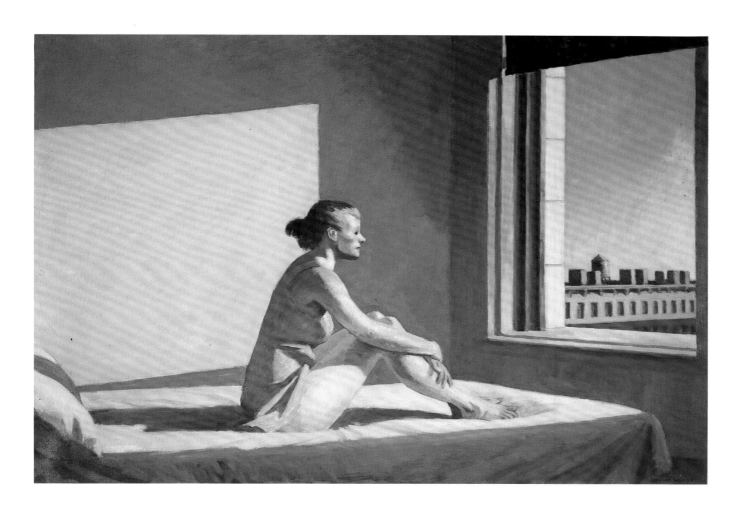

Isabel Bishop, 1902–1988

To capture the appearance of a subject in a particular instant in such a way that the result seems to be truthful as an experience, transitory in effect, and fresh in conception is a major concern in modern art which connects artists as diverse as, for example, Edgar Degas, Henri Toulouse-Lautrec, Henri Cartier-Bresson, and Isabel Bishop. Despite the differences in their attitudes, imagery, and working methods, each demonstrates an interest in the fleeting nature of life and how the passing moments are sensed. Choosing subjects which at first glance look mundane and unplanned, they produced works of art that celebrate brief events as essential parts of life.

Isabel Bishop, a keen observer of both life and art, was constantly in search of the exact moment to portray. She said, "I try to limit everything in order to get down to something in my work. . . . I struggle for months to make it look as momentary as it really is."[1] In contrast to the rapid and spontaneous execution that characterizes the art of the Impressionists, Isabel Bishop's execution was deliberate and methodical. Beginning with on-the-spot drawings of ordinary people, she would transform these into effective compositions in black and white etchings. Then, using the etchings and photographic enlargements of them, she developed her paintings, working usually in egg tempera with oil glazes over a brown or gray gesso ground. Her observations are not polished in their final form; rather, they remain vital because of their sketchy appearance.[2] As Bishop said, "Incompleteness is the essence of the matter."[3]

Her technique is based on careful study of the great traditions of Western art since the Renaissance. An important foundation for her development was her education between 1922 and 1924 at the Art Students League in New York, where she worked under Guy Pène du Bois and Kenneth Hayes Miller. She made four trips to Europe to study the works of the old masters and became acquainted with Baroque art, in particular the oil sketches of Peter Paul Rubens, which were to have a lasting influence on her work. Following Rubens's example, Bishop produced a body of works that are notable for their fusion of figure and ground, open form, emphasis on the momentary, and respect for humanity. "Everything I have tried to do is Baroque, within my concept of the Baroque," she said, adding that "The essence of the Baroque style to me is its 'continuity,' a seamless web."[4]

Along with artists such as Kenneth Hayes Miller, Reginald Marsh, and the Soyer brothers, Isabel Bishop is considered part of the "Fourteenth Street School," a name given to a group of urban realists who worked in the vicinity of Union Square in New York City.

68 *Snack Bar*, ca. 1954 54.47

Oil on masonite, 13½ x 11⅛ in. (34.3 x 28.2 cm.). Museum Purchase: Howald Fund, 1954

A characteristic work by Bishop, *Snack Bar* is essentially a glimpse at two working-class women in an informal everyday situation. The women do not communicate with one another; their proximity is physical only, the result of a chance encounter. Like Edward Hopper's people, Bishop's subjects seem to be alone in a crowd.

Bishop's incomplete lines, as well as her application and occasional removal of paint, give the figures only a shadowy existence. They are distinct yet part of the setting; they fade into the grayed gesso ground only to emerge again in areas of light and color, giving the painted surface a dynamism of its own. "Color," Bishop said, "is not the original motif for me. My fundamentals are form, space, and light."[5] The colors in *Snack Bar*—orange, green, and yellow—while unusually bright for Bishop's works, constantly advance and recede as they effectively characterize a garish fast food culture. A vivid distillation of an ordinary event, the painting has an element of *déjà vu*, depicting something at once familiar yet ultimately elusive in memory.

R.L.R.

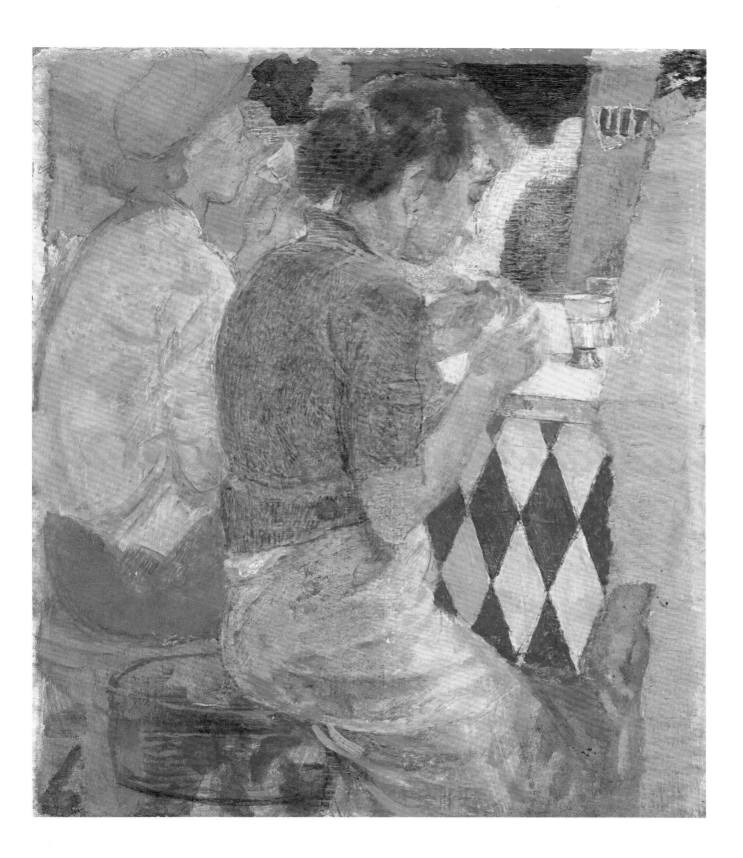

Hugo Robus, 1885–1964

Hugo Robus, who was born in Cleveland, attended the Cleveland School (now Institute) of Art as a young man. Both there and at the National Academy of Design in New York from 1910 to 1911 he worked primarily as a painter and was also active as a jewelry designer. He studied in Paris with Emile-Antoine Bourdelle until the outbreak of World War I. Experienced then in both modern painting and sculpture, he did not commit himself to a single medium until 1920, when he decided to concentrate on sculpture.

Robus's works are indebted to the polished elegance of Constantin Brancusi's sleek abstractions, as well as to the more assertive but complexly curvilinear works of Umberto Boccioni and the lithe, smooth figures of Bourdelle's late manner. But in his concern with creating responses to the sorrows and joys of the human condition Robus stayed closer than they to the literal appearance of the figure. Only during the 1940s did he depart for a while from his smooth, refined style to practice a rougher, more agitated manner.

Robus returned from Europe in 1915 and settled in New York, supporting himself there with a variety of teaching positions (appointments at Columbia University and Hunter College, among others) while developing and refining his art. Recognition came slowly. The first important show to include his works was the Whitney Museum annual in 1933, when the artist was forty-eight years old. Robus produced a large body of distinguished works during the last fifteen years of his life. In 1958 he was honored with a major retrospective at the Corcoran Gallery of Art, Washington, D.C.

69 *Figure in Grief*, original plaster 1952, cast ca. 1963 68.6

Bronze (from edition of 6), H. 12 in. (30.5 cm.). Signed on back of figure: Hugo Robus. Foundry mark: Fonderia Battaglia & C. Milano. Gift of Hugo Robus, Jr., in memory of his father, 1968

Figure in Grief is one of Robus's late creations. The sculpture was modeled in plaster in 1952, but the first of the six bronze casts was not produced until about 1962, by a foundry in Milan, Italy.

From the back, the sculpture looks more like a large helmet than a figure. The head is invisible from that point of view, the arms largely so. The piece seems inorganic; its smooth surface looks machined and tooled, and the dark, coppery patina enhances its abstract appearance.

The figure's right side only partially reveals the sculpture's true form and meaning. The right arm and the crossing left forearm for the most part obscure the head. The left hand lies weakly against the right arm, and only the thumb seems to speak of tension. Despair is the prevailing emotion expressed in this view.

The nearly symmetrical front view, showing the figure with angular crossed arms, is the most complete anatomically and structurally. While continuing the emphasis on abstract design, the pose suggests exhaustion as much as grief.

It is the view of the figure's left side that most fully reveals the impact of Robus's conception. As the grieving figure shrinks inward, head upon breasts, the "skin" becomes tauter, like some evolutionary adaptation for defense, and the helmet-like case of the back and arms appears to provide protection for the vulnerable head. It is this sense of active grieving rather than passive despair that makes this view the most resolved, the most expressive, and the most satisfying.

W.K.

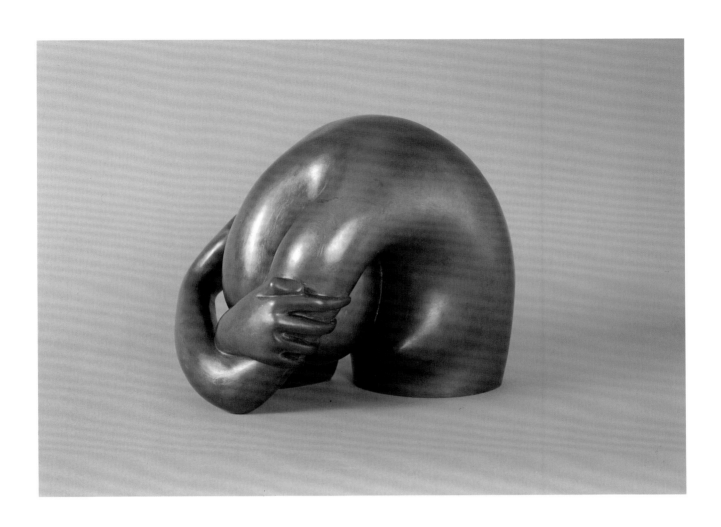

Chaim Gross, born 1904

Chaim Gross, an Austrian by birth, immigrated to New York City in 1921 when he was seventeen. He worked as a delivery boy, saving money to attend the Educational Alliance Art School and the Beaux-Arts Institute of Design, where he studied sculptural modeling briefly with Elie Nadelman. He first studied carving with Robert Laurent at the Art Students League in 1926–1927.

When Gross began direct carving, he favored hard wood but sometimes carved in stone as well. His interest in wood began in childhood, when he lived in a village surrounded by forest and where most of the community, including his father, worked in a lumber mill. He loved the smell of wood, and he remembered peasants carving toys, figures, and household objects for relaxation at the end of the working day. His involvement in the W.P.A. (Works Progress Administration) Federal Art Project and other Depression-era programs gave him opportunities to develop his distinctive style and to gain critical recognition. In 1957, as he was turning increasingly to the use of bronze in his work, he published The Technique of Woodcarving.

Bronze permitted greater freedom for the sculptor's imagination. Not limited by the boundaries of a block of wood, he was able to open up his compositions. Given his lifelong interest in wood, however, it is not surprising that many of his bronze works are translations from the woodcarver's art.

70 *Happy Mother*, 1958 82.2

Bronze (from edition of 6), L. 82 in. (208.2 cm.). Signed and dated top left of base: Chaim Gross 1958. Foundry mark on left side of base: Bedi-Makky Art Foundry N.Y. Gift of Ashland Oil, Inc., 1982

Typically, Gross's earlier sculptures are figures in active poses, with simplified masses that are often rounded and bulging. In *Happy Mother*, a mature work, he gave the principal figure elongated angular limbs that recall the hard-edged forms of Cubism. Like Picasso, Gross was inspired by the directness and vitality of African wood carvings and even in his bronze pieces sought to achieve the primitive character of a carved object. *Happy Mother*, for example, though it was modeled in plaster and cast in bronze, has the appearance of woodcarving in its "chiseled" edges and rough surface texture. Gross had begun to cast some of his woodcarvings in bronze in the late 1950s, when he discovered that modeling in plaster permitted him to work more rapidly and with greater ease and still retain some of the visual characteristics of woodcarving. Works cast from plaster in this period are more open, lyrical, and horizontal than the earlier carved sculptures.

During his childhood Gross was enchanted by circus people, especially the acrobats, whose grace and agility he later captured in his work. The nimble group in *Happy Mother* is from a long tradition of acrobatic family groups which he began to depict in the 1930s. The children, tiny versions of their mother, strike a circus-like pose, supported by the mother. The long, low arc of the mother's body suggests a gentle rocking motion and serves both to unify the composition and to give rhythm and strength to the idea of family. The theme of happy families recurs often in the artist's work, reflecting the circumstances of his own experience. His works are thus celebrations of the stability and joy of family life.

D.A.R.

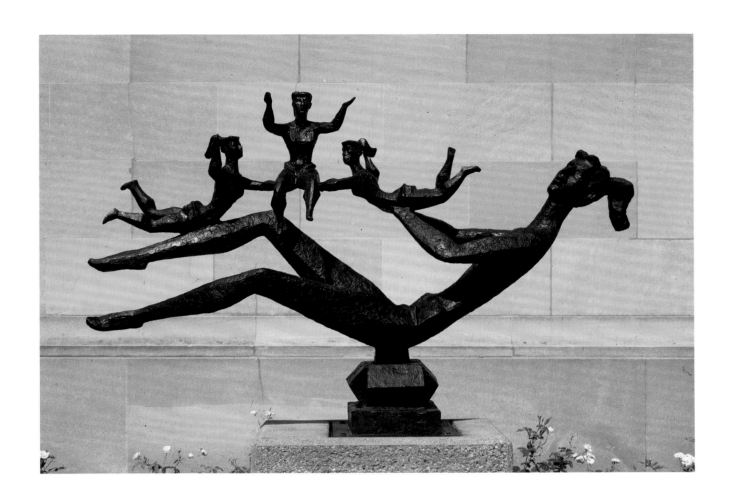

George Tooker, born 1920

Tooker was born in Brooklyn and educated at Phillips Academy and Harvard, where he was a literature major with a passion for poetry. He began his study of art in 1943 at the Art Students League in New York. His teachers, Reginald Marsh and Kenneth Hayes Miller, encouraged him to adopt the tempera technique, which he further developed under the guidance of Paul Cadmus.

Tooker's themes and moods are his alone. He forgoes topical social satire and moral commentary in favor of nonspecific but portentous tableaux in which his figures do not act out plots but embody feelings of alienation, isolation, and self-preservation. At once hero and victim, each insistently anonymous character is a modern Everyman.

Tooker was elected to the American Academy of Arts and Letters in 1983. His small oeuvre (he has often produced no more than two pictures a year), however, has precluded wider public recognition.

71 *Cornice*, ca. 1949 80.26

Tempera on panel, 24 x 15½ in. (61 x 39.4 cm.). Signed lower right: Tooker. Museum Purchase: Howald Fund II, 1980

The impact of Tooker's *Cornice* far exceeds its modest size. A young man on a ledge is being inexorably squeezed out of the picture, pressed forward by the wall behind him. With means at once subtle and insistent, the artist evokes sensations of claustrophobia, aversion, and fear. Of these claustrophobia is the most unexpected, given that the figure is not indoors, as are those in most of Tooker's paintings. He is, however, assuredly enclosed, caught between the wall and the picture plane. Nor is there any sense of openness or release in the flat, airless sky.

The low viewpoint (eye level is centered beneath the man's right foot) persuades us of a great height even though we don't see the ground, and it makes the man seem to loom. A literal reading of the subject might suggest an imminent leap, an approaching suicide, but instead the figure seems irrevocably anchored to the building. His muscular right arm and hand grip and adhere to the corner quoins; his body retreats from the corner; his left arm attaches itself to the quoins at the right edge of the picture (the little finger overlapping a quoin vividly projects a desire for security). Although the man is neither tall nor fully erect, he fills the space between the ledge and the top cornice with his shoulder pressing against the egg-and-dart molding. Attic half-stories such as this can be found, but this one is a Tooker invention to compress and stifle the figure.

The most significant objection to a literal reading of the picture as the moment before suicide is the hermetic stasis of the painting. The cross axes of the composition, like the cross hairs of a gunsight, track and fix the image. The horizontal midline crossing through the knuckles of the man's hands, and the vertical midline passing through his hypnotic left eye stop any imagined action. The artist is concerned here with a paralysis of will, a suspended moment of fearful indecision. This figure on the verge is an archetype of man faced with the unknown, whose future will be determined by choice not fate.

Tooker has said that the painting was inspired by W. H. Auden's *The Sea and the Mirror: A Commentary on Shakespeare's The Tempest*.[1] The relevant passage is found in Caliban's epilogue:

> Yet, at this very moment when we do at last see ourselves as we are, neither cozy nor playful, but swaying out on the ultimate wind-whipped cornice that overhangs the unabiding void—we have never stood anywhere else.[2]

To stop with this passage, on this too-literal cornice, would misrepresent both Auden's and Tooker's intent, for both have spiritual urgings at heart. Caliban's monologue goes on:

> Our shame, our fear, our incorrigible staginess, all wish and no resolve, are still, and more intensely than ever, all we have: only now . . . we are blessed by that Wholly Other Life from which we are separated by an essential emphatic gulf.[3]

Caliban has another line that Tooker, still at the beginning of his life and art, may well have identified with: "So, strange young man. . . . you have decided on the conjurer's profession."[4] A conjurer George Tooker was and is, an artist whose imaginings, steeped in mystery and expressed with infinite care, are among the most original and profound works of art of our time.

W.K.

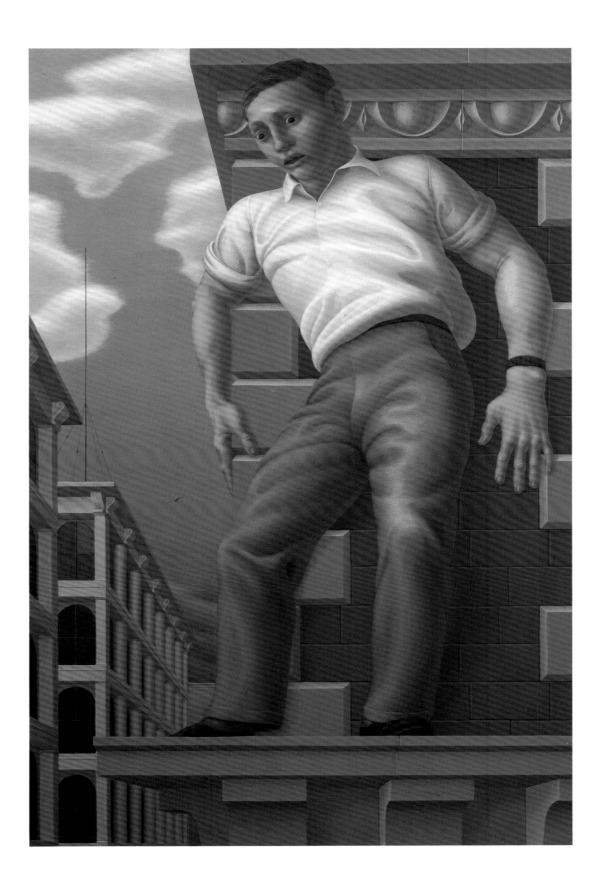

Andrew Wyeth, born 1917

Fifty years ago at the Macbeth Galleries in New York City, Andrew Wyeth, who was then twenty years old, first exhibited his paintings. Thus began a career that would propel the artist and his works into the very select ranks of America's most renowned painters. The son of illustrator N. C. Wyeth, Andrew is the leading member of a dynasty of painters that includes his sisters Carolyn and Henriette, their husbands John McCoy and Peter Hurd respectively, and his own two sons Nicholas and Jamie. Andrew, more than any of the others, was destined to capture the imagination and confound the sensibilities of legions of admirers and detractors from every corner of the world and from all walks of life.

Andrew Wyeth studied with his father and was strongly influenced by the elder Wyeth's predilection for a style of illustration that expresses sentimentality and strives for absolute reality. But very early the young artist gravitated away from his teacher to find inspiration in the quietly emotive works of Winslow Homer, and in the muscular strength and expressive conviction of works by Thomas Eakins. Wyeth's wide-ranging themes and special narrative content, like Edward Hopper's, are taken to represent a real sense of national character, both in figural subjects and topography. His personal interpretation of an American aesthetic has bred a lineage of images that are unmistakably his own.

72 *Inland Shell*, 1957 82.15

Watercolor and gouache on paper, 13½ x 21½ in. (34.3 x 54.6 cm.). Signed lower right: Andrew Wyeth. Gift of Mr. and Mrs. Harry Spiro, 1982

Wyeth's paintings are neither wholly photographic nor scenographic but a little of each. The result of this combination is a pictorial style that isolates a specific object or group of objects within an expansive, often panoramic, vista, whether an interior or exterior space. And Wyeth accomplishes this as well in portraiture, landscapes, domestic scenery, or seascapes. The technique results in haunting compositions, imbued with mystery and the hint of portentous events. One of the artist's most famous works, *Christina's World* (Museum of Modern Art, New York), is such a picture. So also is the museum's *Inland Shell.*

Inland Shell and related works such as *Sea Shell* (1953), *Beached Crab* (1955), and *Quaker Ladies* (1956) all belong to a program of works utilizing the shell motif. The picture is quintessential Wyeth, for it illustrates the artist's considerable technical expertise in wet and dry watercolor painting. Wyeth, whose preferred media are tempera and watercolor, has said: "the only virtue of a watercolor is to put down an idea quickly without too much thought about what you feel at the moment."[1] He added that his watercolors, unlike his oils, " . . . express the free side of my nature."[2]

In *Inland Shell* the artist has created a landscape, though it might seem more like an abstract watercolor from a generation later than Wyeth's. The work also recalls an earlier generation of photographers such as Edward Weston and Walker Evans, who made succinct, unemotional studies of natural phenomena. But Wyeth's work adds an emotional dimension simply by placing a shell in apparent suspension above the leafy forest floor and heightening its presence with whites and grays that have caught the sunlight. The contrast between the shell and the natural elements surrounding it is stark. How the shell arrived in this forest or why it is there Wyeth typically does not explain or interpret visually. One of the keys to his works is that he creates mysteries that defy resolution, and this is as apparent in *Inland Shell* as it is in *Christina's World* or the newly discovered "Helga pictures" of the 1980s.

S.W.R.

Tom Wesselmann, born 1931

An important figure in the American Pop Art movement, Tom Wesselmann was born and raised in the suburbs of Cincinnati. He attended the University of Cincinnati and Hiram College in Ohio and was drafted into the army in 1952. While in the service he began to draw cartoons about military life. He received a B.A. in psychology at the University of Cincinnati in 1954 and began taking courses at the Art Academy of Cincinnati. After he sold several cartoons, he decided to go to New York to be in closer contact with the growing commercial art market. In 1956 Wesselmann enrolled at Cooper Union, where he studied with Alex Katz and Nicolas Marsicano. His stylistic development was profoundly affected by the confrontational power of Willem de Kooning's paintings of women and Robert Motherwell's Elegy to the Spanish Republic, *which he saw at the Museum of Modern Art. By the time Wesselmann graduated from Cooper Union in 1959, he had lost all interest in cartooning and commercial art and had decided to devote his energies to painting.*

At first, he began to experiment with abstract collages. Gradually he developed more literal portrait collages, which usually consisted of a single female figure set against a vividly colored, boldly patterned background. Wesselmann emphasized the erotic aspects of figures to make the paintings as visually aggressive as the Abstract Expressionist imagery he had admired as a student. In his Great American Nude series, for which he is best known, he began to isolate parts of the figure and to exaggerate their scale. Wesselmann has said,

> *I view art as an aggressive activity—that is, you're asserting something in the face of resistance. The nude, I feel, is a good way to be aggressive, figuratively. I want to stir up intense, explosive reactions in the viewers. . . . As for the erotic elements, I use them formally, without any embellishment. I like to think my work is about all kinds of pleasure.*[1]

Wesselmann's work from the 1960s was linked with Pop Art because of its hard-edged forms, the impersonality of his models, and his use of commercial food containers. The women in his Great American Nude compositions are depersonalized sex objects set in commonplace environments, often along with elements from a contemporary consumer culture. The enlarged and simplified forms in both the Great American Nude and Seascape series are reminiscent of billboards and slick posters, with their hard edges and clean, shiny, flat surfaces.

73 *Study for Seascape #10,* 1966 76.33

Acrylic on corrugated cardboard mounted on particle board, 48 x 62 in. (121.9 x 157.5 cm.). Purchased with the aid of funds from the National Endowment for the Arts and an anonymous donor, 1976

From the Great American Nude series Wesselmann went on to develop his Seascape series, which focuses entirely on isolated areas of the human anatomy. *Study for Seascape #10* is a portrayal of a single limb. A painted assemblage, the work consists of a cut-out cardboard leg form and two schematized cloud shapes, one of which is also cut from cardboard and applied to the corrugated cardboard oval. The use of applied forms indicates Wesselmann's continuing interest in collage. He says that he likes to "use the third dimension to intensify the two-dimensional experience."[2] His concern with three-dimensionality is more apparent in the final version of *Seascape #10* (1966, collection of the artist), which is a molded and painted plastic relief. Just slightly smaller than the study, the final version consists of a single sheet of plexiglass out of which a leg form rises.

Wesselmann began his Seascape series in 1965, the year he made his first foot composition from a leftover fragment of a Great American Nude collage-painting. The idea for the beach setting came about after a vacation in Cape Cod, when the artist made a number of watercolor sketches. To give the feet a bolder presence, he simplified and stylized the coastal background, as in *Study for Seascape #10.*

Wesselmann has continued the Seascape series into the 1980s in paintings, collages, silkscreen, and molded plastic editions. His subject matter now includes other isolated areas of the female body such as breasts, torsos, and facial profiles. He has also begun to portray isolated areas of the male body, showing, for example, a penis against the coastline.

D.A.R.

Kenneth Snelson, born 1927

Kenneth Snelson's lifelong interest in structure began in childhood when he created model airplanes and other miniatures in the basement of his family home in Pendleton, Oregon. He took his first art courses in 1945 at the Corcoran School of Art when he was stationed in Washington, D.C, with the navy. From 1946 to 1948 he attended the University of Oregon in Eugene, studying accounting, English, architecture, and design before deciding to major in painting. But a summer program at Black Mountain College in North Carolina in 1948 was to set him on a very different course. Among the resident faculty that summer were Josef Albers, Willem de Kooning, Richard Lippold, and—most important to Snelson—the visionary designer Buckminster Fuller.

During that summer at Black Mountain, Fuller was exploring the principles of compression and tension. Stimulated by Fuller's ideas, Snelson invented and constructed his Wooden Floating Compression Column *consisting of two X-shaped forms, one suspended over the other. The forms did not touch but were connected by tightly strung nylon; all components were entirely interdependent. Such a system would eventually be called "tensegrity," a word Fuller coined in 1955 from "tension" and "integrity." In Snelson's structures, the members (rods or tubes) push while tightened cables or cords pull; everything depends on the equilibrium of these opposing forces. The sculptures, which in subsequent years have become more and more daring, literally defy gravity.*

Snelson's works were first shown in 1959, at the Museum of Modern Art. He has received numerous commissions for public sculptures in cities such as Baltimore, Buffalo, San Diego, and Hamburg and Hanover, Germany.

74 *V-X*, 1974 85.1

Stainless steel and wire (edition of 2), H. 96 in. (243.8 cm.). Given to the Columbus Museum of Art by friends in memory of Frances N. Lazarus, 1985

In works such as *V-X*, Snelson uses industrial materials such as aluminum or, as here, stainless steel. The idea for this sculpture grew in stages, beginning in 1960 with a small study for a helical tension structure. In 1967 Snelson picked up the idea once more and made a second study—this time using longer tubes (about 30 inches). A third model, made in 1968, added two tubes for a total of ten. That same year Snelson made his first *V-X* sculpture, which is six feet high and ten feet in diameter; this piece, which is in the artist's collection, became the basis for two monumental sculptures he made in 1974, one in the collection of the Columbus Museum of Art and the other belonging to the Hunter Museum, Chattanooga, Tennessee.

Snelson customarily begins with a maquette, which to his way of thinking is not an ancillary work but a small sculpture itself, with the same structural unity as the large piece. After establishing the desired dimensions for the full-scale piece and planning the engineering aspects, he is ready to assemble the materials. At the installation site he lays out a webbing of cable, and fits drilled and notched metal tubes in place before tightening the whole system to maximum tension. Of his process he says:

> When I direct my attention toward structure I concern myself with the actual physical forces which give rise to the form. The necessary ingredients of my kind of space are the minimum number of lines of force which must be present in order for the system to exist.[1]

The feat of orchestrating the intricate interdependency of cable and steel rods is complex. Each component is essential and must be in its exact place in relation to all other components. There is no mathematical formula for creating these intricate systems, for they depend as much on artistic instincts as they do on engineering prowess. In *V-X*, with its ten diagonal rods leaning counter-clockwise in a fourteen-foot diameter circle, there is a rhythmic dynamism that recalls the movement of dancers in a ring. The rods appear to fall forward, but are securely held in place by the cable, as the polished stainless steel catches and reflects light in changing patterns.

The idea for *V-X* is based on helix forms found in nature, in plants, shells, bones, and other objects. The helix, Snelson says, "appears in one form or another in all of my sculptures . . . quite especially in *V-X*."[2]

Situated in Columbus's Bicentennial Park, *V-X* is on permanent loan from the museum to the City of Columbus. The maquette, a gift from the artist, is also owned by the museum.

D.A.R.

Helen Frankenthaler, born 1928

A native of New York City, Helen Frankenthaler became familiar with the city's museums and galleries as she grew up. She studied art at Bennington College in Vermont with Paul Feeley, through whom she developed a strong consciousness of Cubist composition and space. After graduating in 1949, she returned to New York. She studied briefly with Hans Hofmann in Provincetown in 1950, and associated with many New York art and literary figures including Willem de Kooning, Franz Kline, and Clement Greenberg. Her work was first exhibited in New York in 1950.[1]

Frankenthaler is known for her innovative soak-stain technique in which she gently pours thinned paint onto unsized and unprimed canvas. She developed this style after seeing Jackson Pollock's dynamic Action Paintings exhibited at the Betty Parsons Gallery in 1951 when she was already using large canvases and studying the spontaneous approach of earlier artists such as Wassily Kandinsky and Joan Miró. Prompted by Pollock's example, she began to use large expanses of canvas rolled out on the floor, but instead of adopting Pollock's drip painting method, she devised her own method of pouring luminous washes of color onto raw canvas and manipulating the paint with a sponge. In Frankenthaler's paintings an illusion of depth is achieved in the organic flow of color and the overlapping of forms. At the same time, the literal flatness and physical character of the canvas is also emphasized, for the thinned oil paint soaks into unprimed canvas, merging image with ground.

Frankenthaler's paintings were daring innovations in the early 1950s, when stark, heavily painted canvases predominated in Abstract Expressionism. In her style and technique one sees the combined effects of the translucent structure of Cézanne's watercolors, the open format and sensations of light and atmosphere in the work of Claude Monet and Henri Matisse, the calligraphic markings of Wassily Kandinsky, and the biomorphic forms and fluid space of Joan Miró and Arshile Gorky. Frankenthaler is considered a leader of the second generation of Abstract Expressionists, who influenced much of the Color-Field painting that followed, especially the work of Morris Louis and Kenneth Noland.

75 *Captain's Paradise*, 1971 72.27

Acrylic on canvas, 60 x 156 in. (152.4 x 396.2 cm.). Signed and dated lower left: Frankenthaler '71. Purchased with the aid of funds from the National Endowment for the Arts and two anonymous donors, 1972

Beginning in the 1960s Frankenthaler chose to work in acrylic instead of oil, seeking brighter and more intense colors. In the transition she lost the fragile edges and some of the translucency of oil washes, but she maintained the soft natural flow that had become characteristic of her style. In *Captain's Paradise*, an acrylic painting, the edges of the brilliantly colored forms show more control than was possible in the earlier oils. The composition is bold and direct, its large central form sharpened against raw white canvas and accented with smaller edge-defining accents of color. Acrylic pigments, which are thicker and more opaque than oil, endow the colorful forms with an added dimension of mass, density, and gravity and make possible a new approach to considerations of flatness and illusionism.

Frankenthaler's works are spontaneous, evolving from her creative and innovative use of the media and materials. She names her paintings after they are completed according to the imagery suggested in the final composition. Though her forms are abstract—not engendered by references to external reality—analogies to landscapes or seascapes are often seen in her work, as she herself indicates by her choice of titles. The title *Captain's Paradise* conjures images of a lake or sea, and indeed the large expanse of blue also evokes such an impression. Even Frankenthaler's method of applying color implies the energies of nature, for in the sweep of blue paint across the length of the canvas there are varying degrees of color intensity and saturation, somewhat like the appearance of the ebb and flow of a body of water.

Against the larger fields of color, red and black lines are penned onto the surface with a marker. Some of these link land and sea forms or bridge apparent gulfs, resulting in the simultaneous perception of both aerial and land views of the seascape. Other lines scattered throughout the blue field serve as small animated accents. The influence of Frankenthaler's training is revealed in the subtle structural strength and spatial tension generated by these carefully placed markings.

D.A.R.

Kenneth Noland, born 1924

A native of Asheville, North Carolina, Kenneth Noland attended Black Mountain College in his home state and studied with Josef Albers and Ilya Bolotowsky. He was one of the first major painters to be educated solely in nonobjective art. In Paris from 1948 to 1949, Noland studied under sculptor Ossip Zadkine. When he returned to the United States, he moved to Washington, D.C., where he formed a friendship with Morris Louis. The two artists were to become important members of the Washington Color School, a name given to a group of painters who lived in the District of Columbia and whose work was primarily concerned with the exploration of color. In 1953, Noland and Louis visited the New York studio of Helen Frankenthaler, the progenitor of the soak-stain technique in painting. Noland recalled the significance of this occasion: "We were interested in Pollock, but could gain no lead from him. He was too personal. But Frankenthaler showed [us] a way to think about, and use color."[1] Emulating Frankenthaler's technique, they too poured thinned paint on unprimed canvas, producing a translucent, stained ground.

Noland and Louis went in different directions before Louis died in 1962. By the late 1950s Noland's work had become more hard-edged, a reaction against Abstract Expressionism, as were his emphasis on formal values and his elimination of emotion in his paintings. The only element he retained from Expressionism was the large canvas. What Noland gained from Frankenthaler, as well as from the works of Henri Matisse and Paul Klee, was luminous intensity and a fascination for color as structure.

While living in New York City after 1961, Noland became known as one of the Color-Field painters, whose works are characterized by their large scale and use of bold, geometric shapes. His early paintings consisted of single shapes, such as chevrons or diamonds, set boldly against a white ground. Sometimes the canvas itself was shaped and painted a single color to function almost as a sculptural object. Toward the end of the 1960s, Noland returned to color staining rectangular canvases much as he had done early in the previous decade. For a short time in the early 1970s he experimented with stained fields framed by overlapping strips of color before resuming his work with shaped canvases and juxtaposed bands of flat color.

76 *Shadow on the Earth*, 1971 72.28

Acrylic on canvas, 93 x 64¼ in. (236.2 x 163.2 cm.). Purchased with the aid of funds from the National Endowment for the Arts and two anonymous donors, 1972

Shadow on the Earth is representative of a format that Noland used only briefly. The works, which are referred to as "plaids," are vertically oriented canvases with overlapping ribbons of color along the borders. At the center is a vaporous wash that contrasts with the clarity and intensity of the edge treatment. The technique introduces subtle spatial complexities not previously explored by the artist. Crisp, interlacing bands of color establish a sense of depth in contrast to the flatness of the soft, saturated ground. Because border colors are either analogous (yellow, pink, ivory) or complementary (lavender, green, gray-blue) to the dominant field of orange, visual unity is maintained.

In the plaids Noland moved away from the bold, confrontational presence of his earlier works to showcase his ability to create intense luminosity. In succeeding years, he developed a format that grew out of the plaids. By 1973, using smaller canvases shaped as diamonds or tondos, he was painting crisscrossing bands clustered in the central area of the composition.

D.A.R.

Louise Nevelson, 1899–1988

Louise Nevelson, born Louise Berliowsky in Kiev, Russia, came with her family to Maine in 1905. In 1920 she married Charles Nevelson and moved to New York City, where she undertook private study in painting, drawing, voice, and drama. She attended the Art Students League between 1928 and 1933, studying briefly during that time with Hans Hofmann in Munich in 1931.

Nevelson worked predominantly as a painter until 1933, when she made her first sculptures. Her early works, executed in a variety of media, derive stylistically from both Cubism and Expressionism and always display a strong geometric orientation. She had her first solo sculpture exhibit in New York in 1941 at the Karl Nierendorf Gallery. Her stacked box sculptures were shown for the first time in the 1950s.

Constructed of found wooden objects and scrap lumber and painted in a single color, the artist's relief walls consist of compartmented assemblages of urban detritus. In these constructions Nevelson utilizes a vocabulary of commonplace objects—chair seats, finials, turned posts, wood scraps. Far removed from their original context and arranged within a created environment, these forms take on new and unexpected meaning.

77 *Sky Cathedral: Night Wall*, 1963–1976 77.20

Painted wood, 114 x 171 in. (289.6 x 434.3 cm.). Gift of Eva Glimcher and Derby Fund Purchase, 1977

In *Sky Cathedral: Night Wall*, rows of boxes frame arrangements of wooden fragments—from familiar objects to abstract geometric forms. Louise Nevelson dated the work 1963–1976, a period during which it stood in her studio in various stages of development until it evolved to its present configuration. The work thus may be viewed as a chronology of Nevelson's work during that thirteen-year period. Reading from left to right, there are first the tightly controlled compositions of smaller, detailed pieces, similar to other constructions she was producing in the mid-sixties. In the boxes forming the central area are the larger forms of chair segments and other found objects such as are seen in works of the late sixties and early seventies. To the far right are yet larger forms that may have been cut especially for the composition, for during the mid-seventies Nevelson was experimenting with compositions of machine-fabricated components. The progression is thus from found to fabricated, from small to medium to large, mirroring the artist's production in roughly three periods.[1]

Black monochrome, used for all works in the Sky Cathedral series, unifies the composition, intensifies its powerful presence, and emphasizes its imposing architectonic quality. The whole is made more dramatic by lighting effects and cast shadows. As the artist said, "The shadow, you know, is as important as the object. . . . I arrest it and I give it architecture as solid as anything can be."[2]

Nevelson used black often in the 1950s and 1960s: "I fell in love with black [because] it contained all color. It wasn't a negation of color. It was an acceptance. Because black encompasses all colors. Black is the most aristocratic color of all."[3] Entirely different effects, unlike the mysterious and surreal effects of black, are projected by the rich gold or pure white monochromes of Nevelson's later works.

Whatever their color, whether they are rendered in wood, mirrors, plexiglass, or welded steel, Nevelson's relief walls are intricate arrangements of forms made abstract by alteration and by context. In this her work is a descendant of Cubist tradition. She has said, "In all my work is the Image and the Symbol. I compose my work pretty much as a poet does, only instead of the word I use the plastic form for my images."[4]

D.A.R.

Dan Flavin, born 1933

Self-taught as an artist, Dan Flavin studied for a time at the New School for Social Research and at Columbia University but in 1959 decided to devote full time to a career in art. His first solo exhibition, held at the Judson Gallery in New York in 1961, consisted of watercolors and sculptures. That same year he began to make what he calls "electric light icons," boxes illuminated with or framed by electric lights. Flavin used light in his sculptures almost from the beginning; eventually, light became his only medium. He began working with fluorescent tubes in 1963. In the mid-1960s, Marcel Duchamp, who used readymade objects, personally encouraged Flavin's work with pre-existing components.

Flavin's earliest fluorescent sculptures were minimalist forms in which tubes were arranged in patterns or as components of geometric shapes. In his mature work the artist is more concerned with the compositional effects of light within a given space. His designs literally transform a room, illusionistically altering its appearance through carefully orchestrated mixtures of colored light. The fluorescent tubes, placed on walls or in corners, are arranged according to the effects their illumination will have on the space in which they are exhibited; they are not shown as objects in themselves.

78 *Untitled (to Janie Lee) one*, 1971 79.53

Blue, pink, yellow, and green fluorescent light (from edition of 5), L. 96 in. (243.8 cm.). Gift of Mr. and Mrs. William King Westwater, 1979

Flavin's composition in the museum's collection is a superb example of the artist's mature work. It consists of a single long tube that emits blue light and three smaller unseen tubes that cast pink, yellow, and green lights. The tubes are mounted in a corner; illuminated they cast blended colors on the architectural components of the space, in both geometric configurations and amorphous washes.

What Flavin accomplishes in this work is not the apotheosis of an industrially produced object but the dematerialization of the object as art. While the work is sculptural—that is, its components are three-dimensional and affect an environmental space—its impact lies not in its materiality but in the intangible properties of cast light.

A companion piece known as *Untitled (to Janie Lee) two* consists of the same elements, but the unseen smaller tubes cast green, yellow, and pink light, in reverse order of the colors in *Untitled (to Janie Lee) one*. These two works, which are usually shown independently, exhibited together provide an interesting variation on the way they visually transform an exhibit space. Mounted in adjacent corners of a room, they are like mirror images of each other, and the blue glow emitted by the larger tubes is intensified.

Flavin often dedicates his works to historical figures or to people he knows. This work is dedicated to an art dealer in Dallas, Texas.

D.A.R.

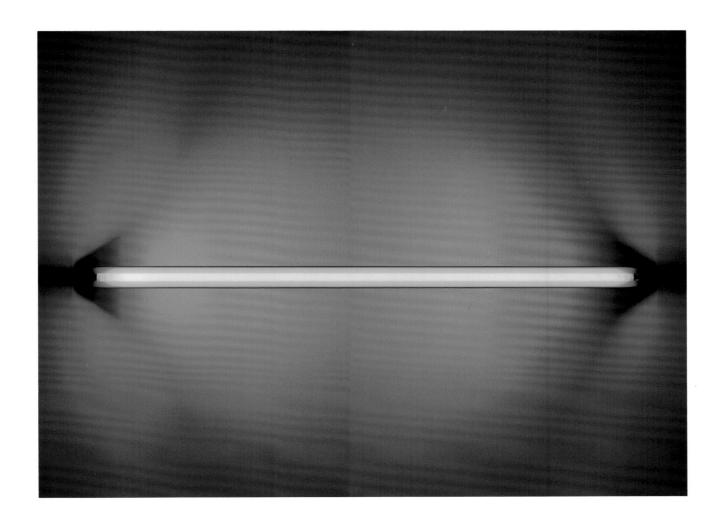

Clement Meadmore, born 1929

Australian-born sculptor Clement Meadmore initially studied engineering and industrial design. He executed his first sculptures in 1949 while still a student at the Royal Melbourne Institute of Technology. He had his first one-artist show in Melbourne in 1954 at the age of twenty-five. His first significant exposure to modern sculpture came during a trip to Europe in 1953, after which he decided to make welded steel sculptures. On a trip to Tokyo in 1959 he became acquainted with the work of the Abstract Expressionists, in particular Barnett Newman, whose work was especially important to the development of Meadmore's individual aesthetic.

Meadmore moved to the United States in 1963 and settled in New York. Within three years he abandoned the use of welded steel and began to create what he called "single form" sculptures made from a single section of squared metal tubing. In the ensuing decade, his investigations of the complexities of this simple twisting form ranged from the solitary angle of Bent Column (1966) to the undulating gordian knots of Out Of There. Meadmore resumed work on multi-piece sculptures in 1976.

79 *Out of There*, 1974 79.15

Painted aluminum (edition of 2), L. 201 in., H. 78 in. (L. 510.5 cm., H. 198.12 cm.). Gift of Ashland Oil, Inc., 1979

Meadmore has said he is "interested in using geometric forms to achieve the expressive energy which no longer seems possible with modeling or carving. This entails finding the rare combinations for forms which transcend their geometric origins."[1] Thus in his work he has sought to synthesize the geometric forms of Minimalism and the gestural movement of Expressionism in configurations that hold the forces of both in a vital equilibrium.

Works such as *Out of There* depend on this underlying tension. Its convoluted rectilinear form loops and twists and thrusts dramatically into space. At a distance, it has a calligraphic quality—as though the artist had drawn in space with "a very thick line." Up close, it becomes a precariously balanced mass of smooth black industrial aluminum; alert in its repose, it seems to defy gravity. Meadmore's title emphasizes the importance of directional movement in his conception of sculpture; movement in his works becomes a metaphor for that of the human body.

Meadmore's single-form sculptures originate as small hand-size maquettes. After the model is complete, and the artist has experimented with "letting it come to rest wherever it comes," he selects the position that gives the sculpture the greatest appearance of spontaneity.[2] The model is then enlarged and fabricated either of painted steel or aluminum or of Cor-ten steel, which has a rich brown patina.

Meadmore's mature works are monumental in scale. He believes a sculpture must be able to inhabit a space the way a person does. His pieces situated in outdoor urban settings create a bridge between the scale of passersby and that of contemporary multi-story buildings. He has even envisioned a series of sculptures, which—like the Eiffel Tower—would be visual bridges to an entire city.

N.V.M.

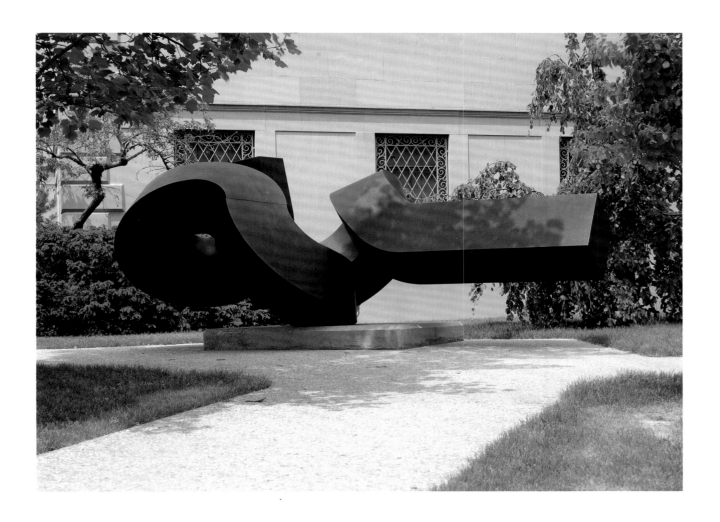

Alexander Calder, 1898–1976

Alexander Calder is one of this country's most renowned sculptors. The son of Alexander Stirling Calder (1870–1945), a sculptor who worked in the Beaux-Arts style, he earned a degree in mechanical engineering from the Stevens Institute of Technology in 1919, then worked for four years at various jobs related to his studies. His grasp of the theory and practice of engineering eventually became the most important influence in his approach to art, which he began to study at the Art Students League in New York in 1923. After three years of study, he went to Paris in 1926 and remained there for seven years. It was in Paris, where he conducted performances of his hand-animated Circus (Whitney Museum of American Art), that his work first attracted attention.

Calder's meeting with Piet Mondrian in Paris in 1930 was a major factor in his conversion to an abstract style. Adopting the biomorphic forms of the Surrealists (in particular his friends Jean Arp and Joan Miró), and the restrictive palette of primary colors and black and white used by Mondrian, Calder made his first moving sculptures in 1931.

These constructions, which were powered by hand or by motor, were called "mobiles" by Marcel Duchamp, as were the sculptures activated by air currents which Calder constructed later that same year. By the mid-1930s Calder was making nonmoving, large-scale outdoor sculptures in sheet metal and steel plates, which Jean Arp called "stabiles." Today Calder's large pieces stand in public plazas across the United States and in many other countries throughout the world. The stabiles are a kind of anthropomorphic architecture themselves, approaching contemporary buildings in both scale and physical presence.

Calder's career was long and his oeuvre is enormous, embracing a variety of subjects and styles and ranging in scale from the miniature Circus to the monumental stabiles. His works are ingenious amalgams of modern technology and the organic forms of nature—at times playful and exuberant, or formal and dignified, but always imaginative and almost universally appreciated.

80 *Intermediate Model for the Arch*, 1975 80.36

Painted steel, H. 144 in. (365.6 cm.). Museum Purchase: Derby Fund, 1980

In designing stabiles such as *The Arch*, Calder's goal was to create massive large-scale sculptures which appear to rest lightly on the ground. To achieve such contradictions of mass and scale required partial welding of the bolted metal plates and careful technical planning and supervision. First, Calder created a maquette of sheet aluminum, a material he could cut with shears, bend, manipulate, and bolt together. Technicians then would enlarge the piece to one-fifth the size of the monumental work so the artist could study the aesthetics and stability of the structure and make needed adjustments. The final piece utilizes the machinery and techniques of industrial metalwork, but even the largest works are designed so that they can be easily disassembled and shipped for reassembly at another site.

The museum's *Intermediate Model for the Arch* is one-fifth the size of the fifty-two-foot-high final version at Storm King Art Center, Mountainville, New York. Its bold, hulking presence is contradicted by the graceful pointed "foot" that provides equilibrium as it opens up the interior space and invites the viewer's explorations. The subject was one of the last that Calder executed before he died.

D.A.R.

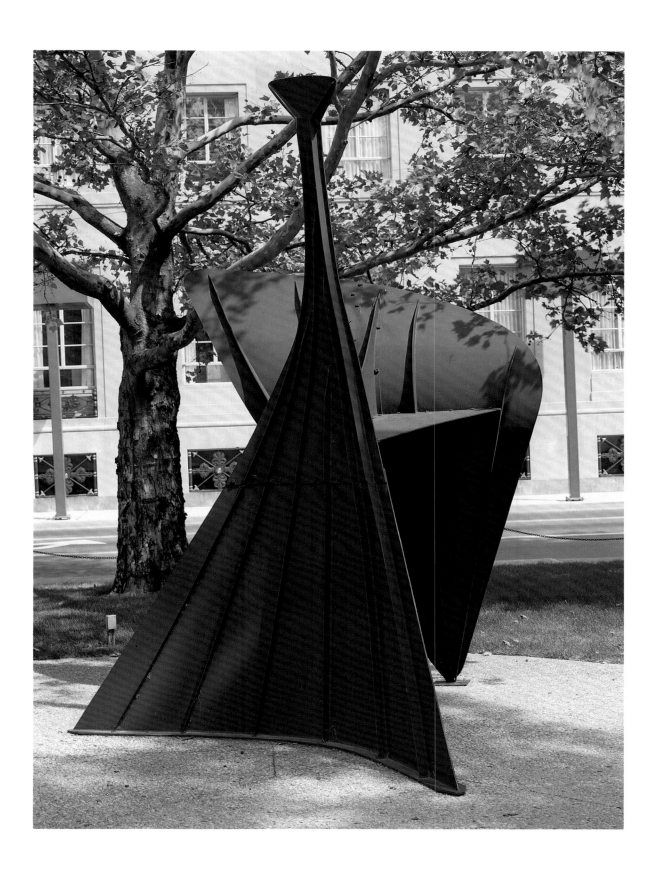

George Rickey, born 1907

Born in South Bend, Indiana, George Rickey moved with his family to Scotland in 1913, when he was six. He studied history at colleges in Scotland and England before attending the Ruskin School of Drawing at Oxford University in 1928–1929. In 1930 he took up residence in the United States, leaving briefly in 1933 to study painting in Paris with André Lhote, Fernand Léger, and Amédée Ozenfant. Rickey's interest in sculpture began during World War II, when he learned welding while serving with the United States Air Force.

Rickey was forty-two years old when he made his first steel sculptures with moving parts in 1949. Of his transition to kinetic sculpture, he said, "I had to learn to be a mechanic and to recall the physics I had learned at 16. . . . I wanted movement which would declare itself quietly, slowly, deliberately . . . I rejected jerks, bumps, bounces, vibration, and for the most part, all sound."[1] Using Alexander Calder's mobiles as a point of departure, Rickey simplified form in order to emphasize movement. His format is expressive of modern technology; the precise nature of the tapered shapes recalls both the machine aesthetic and the purist notions of Constructivism. An articulate writer as well as a sculptor, in 1967 he published a book entitled Constructivism: Origins and Evolution.

81 *Two Lines Up Excentric Variation VI*, 1977 78.31

Stainless steel (1 of 3), H. 264 in. (670.6 cm.). Signed, dated, and inscribed on base: 1/3 Rickey 1977. Given by the family of the late Albert Fullerton Miller in his honor and memory, 1978

George Rickey's sculptures consist of free-moving stainless steel blades with precisely engineered counterweights and bearings. The long, slender arms move slowly and gracefully, powered by currents of air and the pull of gravity.

Two Lines Up Excentric Variation VI is one of nine versions of two-blade sculptures made by Rickey between 1975 and 1983. The museum's version has two three-sided blades mounted side by side, turning and rotating independently on separate swivels. The blades move in silence following predetermined paths, with the wind choreographing their sweeps and spins, the sun glancing off the sleek steel. The dynamics are mesmerizing. Though it often seems the blades will collide, they never do. The sculpture, which is designed to withstand winds up to eighty miles per hour,[2] is a synthesis of contrasts in which technical precision is juxtaposed with unpredictable movement as fickle winds play with rigid industrial materials and gravity imposes its dependable restraints.

Rickey has said, "I do not imitate nature. . . . If my sculptures sometimes look like plants or clouds or waves of the sea, it is because they respond to the same laws of motion and follow the same mechanical principles."[3]

D.A.R.

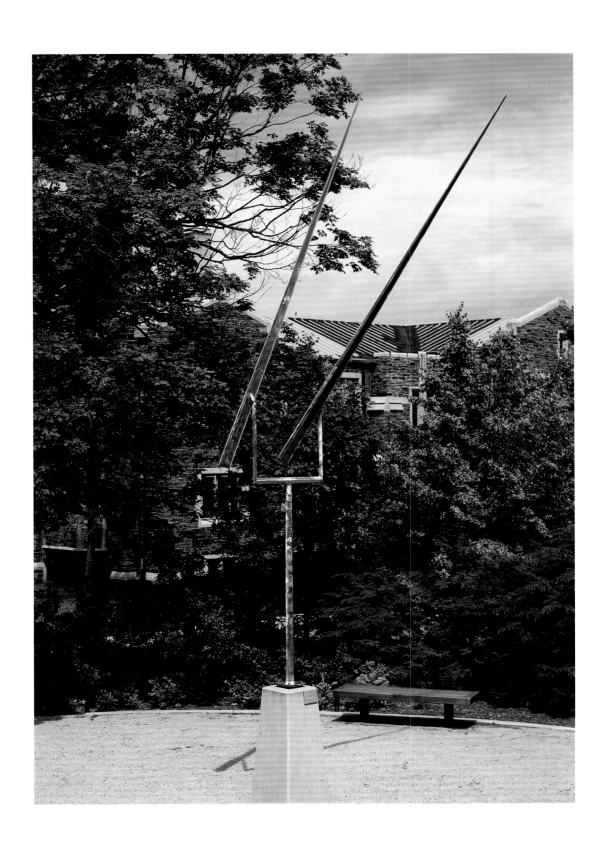

George Segal, born 1924

George Segal's art is in many respects traditional. His unvarying subject is the human being, and the condition of being human. Early in his career, when he was a painter, Segal's subjects were allegorical and Old Testament themes, which were then utterly out of favor. In his later sculptures he has sometimes dealt with significant narrative or symbolic motifs: for example, The Holocaust (1986), commissioned by the City of San Francisco. Through most of his career as a sculptor, however, he has been able to internalize and generalize the emotions generated by themes of this sort, to focus them upon the body, as it were, without specific narrative. In the process he has become a master of the language of the body.

The artist's chosen material is plaster. Its whiteness reminds us of marble sculptures of the Classical and Renaissance past as well as casts so prominent in studios, art schools, and museums from the seventeenth century to the present. Segal's "casts," however, are very different. His method is to apply plaster-impregnated cheesecloth over the living model and, when it has dried, to remove it in sections, then reassemble it. At first he did not produce casts from the smooth inside of this mold but presented us with the outside. Now he also casts from the inside of the mold. In either case, the surface is rough and full of accidents and marked by the artist's hand. The body is, in a sense, seen through the intervening plaster, veiled and protected by it.

82 *Girl on Blanket, Full Figure*, 1978 80.7

Painted plaster, H. 76 in. (193 cm.). Purchased with funds from the Livingston Taylor Family and the National Endowment for the Arts, 1980

Girl on Blanket, Full Figure is an absorbing and sophisticated work. The figure lies on the blanket as on a bed, the blanket seeming to gather itself to the girl, echoing her contour and enfolding her lean body. Her right elbow nests in it as though held by an unseen hand—a striking example of the way the artist intervenes with his cast to heighten expression.

Unexpectedly, the sculpture has a strong vertical presentation; a relief, it is intended to hang on the wall. Though the figure seems to hug or cling to the wall, there is nothing tentative or tenuous about it. Segal purposefully distances the figure from the viewer, presenting it pictorially rather than sculpturally. He disrupts the visual logic of a girl lying on a blanket. No perspective recession draws us into the space; rather it is "as though [the sculptor] were putting pictures into three dimensions, playing volumes against planes as a painter does."[1]

Beds figure prominently in Segal's sculptures. In a manner reminiscent of Edward Hopper's paintings, he makes us aware of our dependence on them. His men and women sit or lie, alone or together, on beds which are their only observable possessions, beds which seem more like islands or prisons. Occasionally, blessedly, they sleep. This girl is pressed into her bed; the seeming naturalness of her pose is belied by willful adjustments. The top, or right leg, retreats while the bottom, or left leg, seems to advance. The strong right angle of the girl's left arm and back, while by no means impossible, must be less than sleep-inducing. These pondered manipulations both create and allay tensions, as advancing the elements expose and retreating they safeguard. The result is an indelible image of the contrapposto of sleep.

W.K.

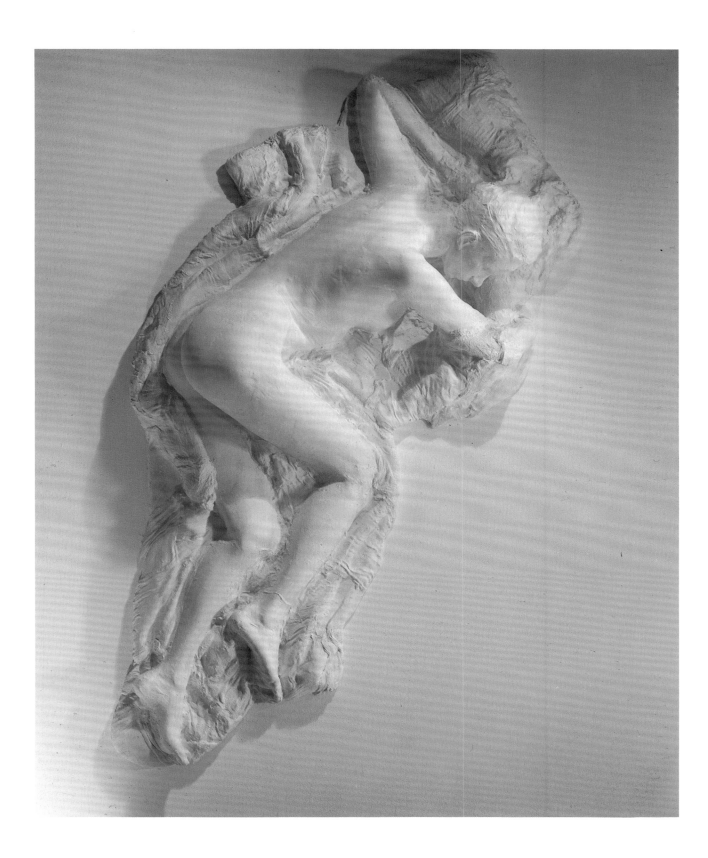

Richard Stankiewicz, 1922–1983

Richard Stankiewicz taught himself painting and sculpture while serving in the navy from 1941 to 1947. He began formal studies in art in 1948 when he enrolled at the Hans Hofmann School of Fine Arts in New York City. In 1950 he went to Paris and studied briefly under Fernand Léger and Ossip Zadkine. Returning to New York in 1951, he set aside his sculptural work in clay and began to create abstract forms in wire coated with plaster. This led to the production of witty assemblages of junk metal, for which the artist first became known in the 1950s.

A native of Philadelphia, Stankiewicz grew up in Detroit. An inventive youth, he made toys from scraps of metal scavenged in a foundry dump next to the apartment building where he lived. Later, in New York, while preparing a garden behind his studio, which was located on the site of a former scrap dump, he excavated large pieces of rusted and eroded metal. Inspired perhaps by the welding techniques of sculptor David Smith and recognizing the aesthetic possibilities of castoffs, Stankiewicz taught himself to weld in order to use the material for sculpture. The resulting junk metal sculptures were first exhibited in 1953.

Stankiewicz's compositions, with their raw and energetic forms, are often considered sculptural counterparts to Abstract Expressionist painting. His use of found materials associates him as well with the Dadaist tradition of the 1950s, which led to the development of Pop Art and its celebration of readymade and found objects. Stankiewicz, however, developed his own style of innovative, satirical personages using discarded mechanical equipment and scrap metal. His work is unusual in that he does not alter the scrap pieces in any way.

After a 1969 trip to Australia there was a decided change in Stankiewicz's work. The only metal objects easily accessible to him there were new building materials such as steel I-beams, metal tubes, and pipes. These materials dictated a completely different aesthetic from that of the rough scraps he had used previously. Though the resulting sculptures are not as playful as his earlier pieces, these cool, classical compositions have the same formal strength that is intrinsic to all of Stankiewicz's work.

83 *Untitled, 1979–21*, 1979 80.21

Steel, H. 63⅞ in. (162.2 cm.). Purchased with funds from an anonymous donor and the National Endowment for the Arts, 1980

Untitled, 1979–21, a late work in Stankiewicz's oeuvre, combines elements of the artist's earlier methods and styles. In this composition he uses both junk metal and new industrial steel, juxtaposing dynamic, twisted, rough-edged scraps with crisp geometric form. The rectangular frame set on a plinth harks back to Stankiewicz's experience as a painter in the early 1950s, for the emphasis here is on line rather than mass. Scrap metal forms, torn and curving into space, exert vitality and introduce spatial tension as they project away from the tight austerity of the two-dimensional frame. Using metal that rusts, the artist makes nature a part of his creative process. In time, as the work ages, it takes on richness of color and texture.

Unlike the artist's earlier works, those from 1979 utilize discarded elements that are not easily identified with their former existence but are chosen more for their form and texture. These found metal fragments in combination with new materials become a newly created formal abstraction, a lyrical statement about the aesthetics of open-form relationships, about old and new, about time and aging.

D.A.R.

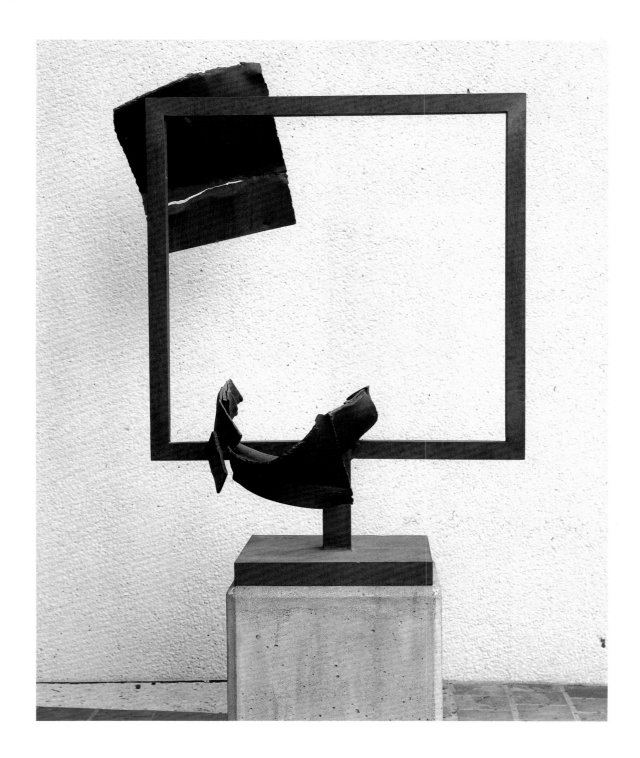

Richard Anuszkiewicz, born 1930

After graduating in 1953 from the Cleveland Institute of Art, Richard Anuszkiewicz went to Yale University, where he studied color theory and abstract art under Josef Albers and received the M.F.A. degree in 1955. While with Albers he studied the color-space interrelationships that effectively produce optical illusions. Albers's work in this area in the 1960s became the foundation for Op Art, which Anuszkiewicz helped develop.

In his M.F.A. thesis, Anuszkiewicz used design exercises completed under Albers's tutelage to explore theories of visual perception based on Rudolph Arnheim's studies of perceptual psychology. His early paintings—an outgrowth of his thesis studies—explored the figure-ground relationships of freely shaped forms in two or three complementary colors. These works are completely abstract—their subject, the investigation of the dynamics of color.

Reacting against the spontaneity and gestural nature of action painting, Anuszkiewicz makes tight compositions with hard-edged geometric forms. Paradoxically, however, he retains from Abstract Expressionism a sense of continuous action, derived in his case from optical vibrations rather than gesture. He achieves this effect by juxtaposing intense complementary colors, which when optically mixed produce a sensation of visual movement as well as an enhanced after-image. For maximum effectiveness he uses fast-drying acrylic paint and masking tape to sharpen the edges of his colors.

84 *Dual Red*, 1979 80.20

Acrylic on canvas, 90 x 180 in. (228.6 x 457.2 cm.). Museum Purchase: Howald Fund II, 1980

The electrifying *Dual Red* by Anuszkiewicz is one of the largest works the artist has ever painted on a single canvas. Its basic compositional format is derived from Albers's Homage to the Square series and is typical of the "centered square" imagery Anuszkiewicz developed in the 1960s. In *Dual Red* the format is doubled. Within each centered square are other sharply rendered squares layered one over the other in progressively larger dimensions from the center to the outside edge. Arranged side by side, the layered squares simultaneously advance and recede. Within each square format there is intense competition between complementary colors. The tension is heightened by razor-sharp lines at precisely calculated intervals, and the result is a visual fluctuation between figure and ground that cannot be resolved. There is nowhere for the eye to rest.

Op Art's momentum waned in the late 1960s, and most of the artists who were involved in the movement became interested in developing other ideas and styles. Anuszkiewicz, however, continues to explore optical illusion through the interrelationship of color and shape, placing more and more emphasis on sophisticated color mixes in his late paintings, such as *Dual Red*. "I really love color," he has said. "I try to manipulate it in schemes that give the viewer a particular feeling of excitement."[1]

D.A.R.

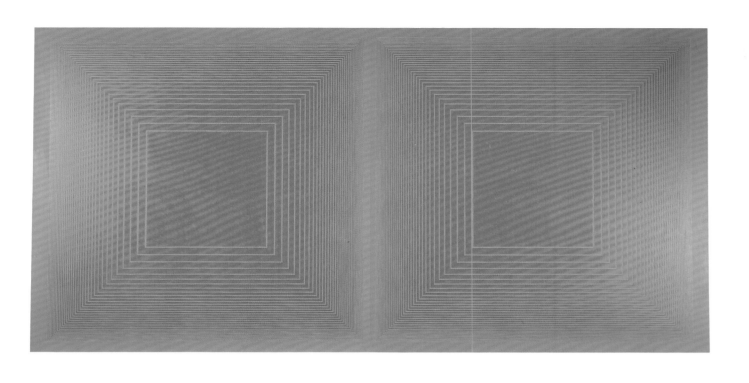

Robert Natkin, born 1930

A native of Chicago, Robert Natkin frequently visited the city's museums and movie houses as a child, and lingering impressions from these visits have influenced his work in many important ways ever since. From 1948 to 1952 he studied painting at the Art Institute of Chicago, where he came to admire and emulate the subtle colors in works by Claude Monet and Pierre Bonnard, and the decorative patterns in works by Henri Matisse and Paul Klee. The artist's continuing interest in color and decorative patterns is also rooted in other aspects of his Chicago experience: the Peruvian textiles he saw in the collection of the Field Museum of Natural History, and the rich architectural ornamentation of Chicago's famous turn-of-the-century buildings.

In 1949 Natkin discovered Abstract Expressionism and painted in that style throughout the 1950s. In the early 1960s, beginning with his Apollo series, he began to simplify his compositions by organizing colored textural forms into quasi-geometric patterns. Then in 1971, he began painting with a loosely woven cloth wrapped around a sponge, which made it possible to achieve meshlike textures. In the resulting compositions, Natkin uses overlapping shapes and complex decorative patterns for their expressive potential, adding dreamy, glowing color and rich textures to convey a mood or to create an environment for personal reflection.

85 *Hitchcock Series: Anticipation of the Night*, 1984 85.11

Acrylic on canvas, 84 x 94 in. (213.2 x 238.6 cm.). Signed lower edge: Natkin. Museum Purchase: Howald Fund, 1985

Anticipation of the Night is from a series named for film director Alfred Hitchcock. The composition embodies the fabric-like texture of stage curtains illuminated by a warm glow of colored lights—similar in effect to what Natkin had seen in childhood visits to vaudeville theaters and picture palaces. Natkin began his Hitchcock series in the 1980s. Influenced by his own recent printmaking experiments, he approached this new series with more forethought and less dependence on spontaneous reaction than are evident in his earlier paintings. He had discovered that the technical requirements of printmaking forced the artist to adopt a more disciplined working style and to conceptualize the finished work from the beginning. When he used this approach in painting, he saw analogies between the role of a painter and that of a movie director. He named the series after Hitchcock because he admired the filmmaker's ability to thread the darker aspects of human behavior through a playful and romantic storyline. In adapting Hitchcock's methods to painting, Natkin was able to deal with personal inner conflict in a pleasing visual context.

Like good film and theater, Natkin's paintings are filled with allusions. The titles are clues to their meanings. In *Anticipation of the Night* there is something of the suspense and fear that accompany the expectation of darkness, the shadows, the potential dreams and even nightmares that are not strangers to the night. Natkin translates these harbingers, which are as dramatic and entertaining as those of Hitchcock's thrillers, into the expressive language of light, color, texture, and pattern.

The large, nearly square canvas of luminous midnight blues and purples is filled with multicolored patterns of stripes, checks, dots, and grids. Opaque geometric shapes, bright yet somehow formidable, seem to float above the shimmering, textured ground. Repeated patterns pulsate throughout the picture, advancing and receding, appearing large then small, light then dark. Just below the center of the picture, there is a checkered shape that looks like a building—cozily lit, or seemingly aflame. Nearby, there is a sinuous path that disappears in misty darkness on its way to an unseen destination. Even Natkin's signature, which extends nearly the length of the picture's lower edge, becomes part of the composition. The emotional and psychological power of *Anticipation of the Night* lies in its contradictions, which create tension and strain for resolution. Ultimately, conclusions are delightfully left to the viewer's imagination.

D.A.R.

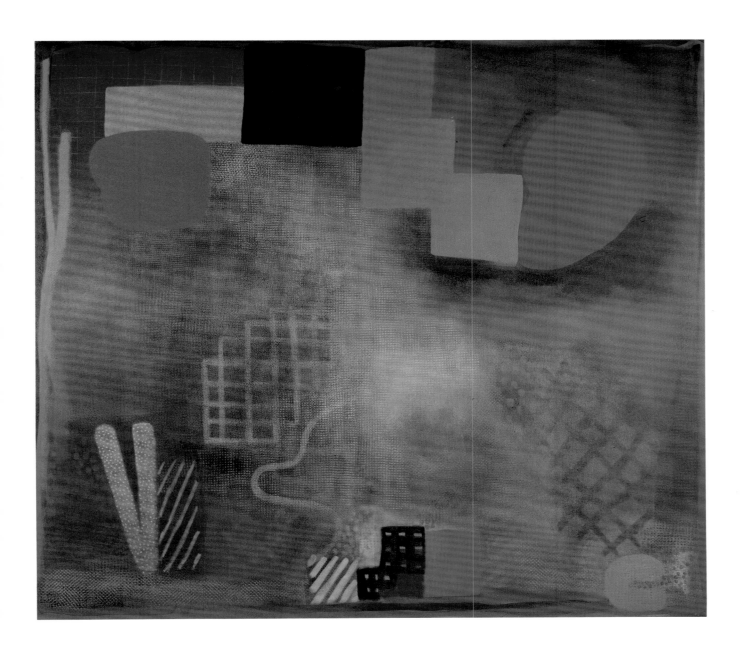

Stephen Antonakos, born 1926

When Steven Antonakos was four years old, his family emigrated from Greece to the United States, settling in New York City. He graduated from the New York Institute of Applied Arts and Sciences in 1947 and worked as a freelance illustrator. As time permitted, he began painting and making assemblages with found objects. By the late 1950s he was working with a variety of linear forms in wood. In the next few years, he incorporated electric lights in the wooden constructions and in a series of pillow constructions, which consist simply of pillows covered or split open to reveal various additional elements such as buttons, dowels, balls, nails, lights, rings, letters forming words such as "yes," "no," and "dream," and found objects.

Because of their intense color, linear form, and flexibility, neon tubes became the artist's chosen medium in 1962. At first he created simple geometric forms, which he mounted on pedestals and presented as sculptural objects. By 1965 he was designing works that interact with the environment. In later works there is always an involvement with the walls and other architectural forms on which the neons are positioned. Both the indoor and outdoor neons engage the very space

which contains them, through the effects of the ambient color glow around the tubes and through the crucial placements which the artist determines. Since the 1970s, Antonakos has been completing commissions for large-scale works in public sites.

One of the artists Antonakos admires most is Matisse, because in his cutouts "he took a simple idea and went so far with it, making his forms and colors so alive."[1] To Antonakos, neon too allows forms and colors to come alive; it is "a controlled paradise"[2] that lends itself to an infinite variety of scale and spatial designs. His work always reflects an abstract, geometric aesthetic. He is not interested in making reference to narrative subjects or to the traditional use of neon in commercial signs. He says:

> *I thought neon was many things, had many voices. . . . I wanted to use neon for itself, for its own qualities and I wanted to find new forms for neon which would give it new and rich uses and meanings. . . . I do not think of neon as being aggressive, but I do know that it can be very affecting.[3]*

86 *Neon for the Columbus Museum of Art*, 1986 86.1

Neon, glass, and stainless steel, 336 x 294 in. (853.4 x 746.8 cm.) Gift of Artglo Sign Company, Inc., and Museum Purchase: Howald Fund, 1986

In 1985 the Columbus Museum of Art commissioned Stephen Antonakos to create a neon sculpture for the exterior wall above the museum's north entrance. The artist prepared sketches of his design which were enlarged by computer to the size of the finished work. Artisans of the Artglo Sign Company of Columbus then formed the tubes to size. A joint cultural endeavor between the museum and a local company that donated its time and skills, the creation of the piece also exemplifies an extraordinary understanding between artist and skilled fabricators, a longstanding tradition in the history of sculpture.

Neon for the Columbus Museum of Art is an orchestration of shapes and radiating colors, in which the artist's characteristic incomplete circles and squares and straight and wavy lines are drawn by neon tubes mounted on both the fronts and backs of brightly painted steel raceways. The work, which is partially framed by the architecture, has been described by the artist as probably his most painterly work. Some of the components extend outward beyond the support so that they are not parallel to the surface of the wall on which they are mounted, giving a feeling of depth to an essentially linear work. In bright daylight the playful forms cast delicate washes on a small area of the building, but as the sky darkens, the composition becomes a bold, powerful presence, with an intense ambient light that colors and transforms a landscaped parking area and surrounding buildings.

Speaking of the changing dynamics of the sculpture, Antonakos said "it will change from hour to hour, from winter to summer, from a rainy day to a snowy day. . . . The people who see the museum every day will notice specific changes."[4]

<div align="right">D.A.R.</div>

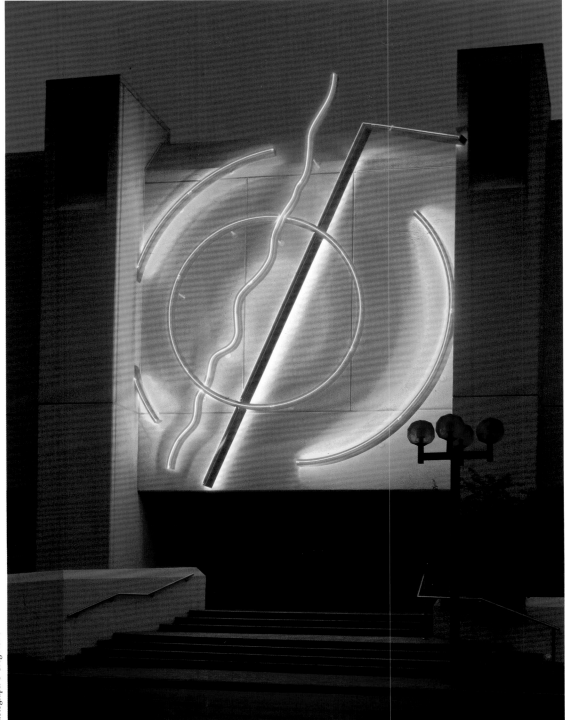

Endnotes and Documentation

NOTES ON DOCUMENTATION

Entries under Provenance, Exhibition History, and References are arranged in chronological sequence, from earliest to latest.

Under Provenance, specific dates of ownership are given, if known, but in many cases the dates are only the verified times of ownership, not necessarily the entire duration of ownership. Sales or other details of transfer are noted parenthetically.

The institution whose name begins an entry in the Exhibitions History is the organizer and, if dates follow the name, an exhibitor during the time specified. Exhibition titles are italicized if known; descriptive titles are in roman type. If the exhibition is documented by a catalogue or checklist, the catalogue or checklist number and other publication information is given following the name of the exhibition. Inclusive dates of a tour, if any, follow, with names of the venues (in a few cases only the city or country is known).

Exhibition catalogues cited under the Exhibitions History are not repeated under References.

Bracketed entries in any category signify that the information given is likely accurate with respect to the museum's work but is not confirmed beyond doubt.

Names of institutions cited in the entries are to the best of our knowledge the names used by the institutions at the time of the exhibition or publication. The Columbus Gallery of Fine Arts, for example, became the Columbus Museum of Art in 1978, and citations up to that date are under the earlier name.

ABBREVIATIONS USED IN DOCUMENTATION

INSTITUTIONS

AFA	American Federation of Arts (New York)
Carnegie Institute	Museum of Art, Carnegie Institute (Pittsburgh)
CGFA	Columbus Gallery of Fine Arts (Ohio)
CMA	Columbus Museum of Art (Ohio)
MMA	Metropolitan Museum of Art (New York)
MoMA	Museum of Modern Art (New York)
PAFA	Pennsylvania Academy of the Fine Arts (Philadelphia)
SITES	Smithsonian Institution Traveling Exhibition Service (Washington, D.C.)
WMAA	Whitney Museum of American Art (New York)

EXHIBITIONS

| AFA (1948–1949) | American Federation of Arts, *Early Twentieth Century American Watercolors*, no cat.; toured, September 5, 1948 – May 31, 1949, to Dayton Art Institute (Ohio), Rochester (New York), Western College (Oxford, Ohio), Williamstown (Massachusetts), Manchester (New Hampshire), Cambridge (Massachusetts), Minneapolis Institute of Arts. |

CGFA (1931)	Columbus Gallery of Fine Arts, *Inaugural Exhibition*, January–February 1931; exh. cat., *Bulletin of the Columbus Gallery of Fine Arts* 1 (January 1931).
CGFA (1935)	Columbus Gallery of Fine Arts, *Paintings from the Howald Collection*, January 6 – February 3, 1935, to Cincinnati Art Museum (Ohio).
CGFA (1941)	Columbus Gallery of Fine Arts, *Early Works from Ten Well-Known Contemporary American Painters* (or *Selections from the Permanent Collection of The Columbus Gallery of Fine Arts*); toured, December 2–31, 1941, to Dayton Art Institute (Ohio).
CGFA (February 1952)	Columbus Gallery of Fine Arts, *The Howald Collection from the Columbus Gallery of Fine Arts*, February 28 – April 13, 1952, to Museum of Art, Carnegie Institute (Pittsburgh).
CGFA (October 1952)	Columbus Gallery of Fine Arts, *One Man Collects: Selections from the Howald Collection*, October 7 – November 2, 1952, to Art Institute of Zanesville (Ohio).
CGFA (1956)	Columbus Gallery of Fine Arts, *Watercolors from the Ferdinand Howald Collection*, February 7 – May 27, 1956, to Philbrook Art Center (Tulsa, Oklahoma), Pasadena Art Museum (California), San Diego Fine Arts Gallery.
CGFA (1958)	Columbus Gallery of Fine Arts, *Howald Collection of Paintings*, January 6–29, 1958, to Albany Institute of History and Art (New York).
CGFA (1958–1960)	Columbus Gallery of Fine Arts, and American Federation of Arts (New York), *Adventure in Collecting*; toured, September 22, 1958 – November 5, 1960, to Wells College (Aurora, New York), Andrew Dickson White Art Museum (Ithaca, New York), Antioch College (Yellow Springs, Ohio), Charles and Emma Frye Museum (Seattle), J. B. Speed Art Museum (Louisville, Kentucky), Time, Inc. (New York), Brooks Memorial Art Gallery (Memphis, Tennessee), Miami Beach Art Center (Florida), John Jacob Astor House (Newport, Rhode Island), Slater Memorial Museum (Norwich, Connecticut), Watkins Institute (Nashville, Tennessee), Art Museum of the New Britain Institute (New Britain, Connecticut), Quincy Art Club (Illinois), Georgia Institute of Technology (Atlanta), Pensacola Art Center (Florida), Southwestern University (Georgetown, Texas), Art Gallery of Greater Victoria (British Columbia), University of Oregon Museum of Art (Eugene), Tacoma Art League (Washington), Eastern Illinois University (Charleston).
CGFA (1961)	Columbus Gallery of Fine Arts, *Watercolors from the Ferdinand Howald Collection*, April 1–18, 1961, to Allentown Art Museum (Pennsylvania).
CGFA (1968)	Columbus Gallery of Fine Arts, *Works from the Howald Collection*, April 19 – May 18, 1968, to Museum of Fine Arts, St. Petersburg (Florida).
CGFA (1969)	Columbus Gallery of Fine Arts, *Selections from the Ferdinand Howald Collection of the Columbus Gallery of Fine Arts*, March 2–30, 1969, to Butler Institute of American Art (Youngstown, Ohio).
CGFA (January 1970)	Columbus Gallery of Fine Arts, *The Ferdinand Howald Collection of the Columbus Gallery of Fine Arts*, January 11 – February 16, 1970, to Dayton Art Institute (Ohio).
CGFA (May 1970)	Columbus Gallery of Fine Arts, *The Ferdinand Howald Collection*, May 19 – July 3, 1970, to Wildenstein & Co. (New York).
CGFA (1970–1971)	Columbus Gallery of Fine Arts, and American Federation of Arts (New York), *Selections from the Ferdinand Howald Collection*; toured, September 20, 1970 – June 27, 1971, to Witte Memorial Museum (San Antonio, Texas), Cummer Gallery of Art (Jacksonville, Florida), Georgia Museum of Art (University of Georgia, Athens), Phoenix Art Museum (Arizona), Milwaukee Art Center (Wisconsin).

CGFA (1973)	Columbus Gallery of Fine Arts, *Ferdinand Howald: Avant-Garde Collector*; toured, June 20 – October 28, 1973, to Wildenstein & Co., Ltd. (London, England), National Gallery of Ireland (Dublin), National Gallery of Wales (Cardiff).
CGFA (1975)	Columbus Gallery of Fine Arts, *Selections from the Ferdinand Howald Collection*, February 7 – March 2, 1975, to Society of the Four Arts (Palm Beach, Florida).
CGFA (1977)	Columbus Gallery of Fine Arts, *Ferdinand Howald: Avant-Garde Collector*, April 21 – June 5, 1977, to Elvehjem Art Center (University of Wisconsin, Madison).
CMA (1983)	Columbus Museum of Art, and Art Gallery of Ontario (Toronto), *Chefs-d'Oeuvre from the Columbus Museum of Art Frederick W. Schumacher Collection*; toured, May 27 – December 4, 1983, to Timmins Museum, National Exhibition Centre (Ontario); Thunder Bay National Exhibition Centre (Ontario), Art Gallery of Windsor (Ontario); Art Gallery of Ontario.
CMA (1986)	Columbus Museum of Art, *Selections from the Frederick W. Schumacher Collection at the Columbus Museum of Art*, September 7 – October 7, 1986, to Paramount Arts Center Gallery (Ashland, Kentucky).
CMA (1986–1987)	Columbus Museum of Art, November 9, 1986 – January 4, 1987, *Choice by Choice: Celebrating Notable Acquisitions 1976–1986*.
Denison University (1962)	Visual Art Department, Denison University (Granville, Ohio), September 15 – November 15, 1962, *Modern American Painting*.
Indiana University (1964)	Fine Arts Gallery, Indiana University (Bloomington), April 19 – May 10, 1964, *American Painting 1910 to 1960: A Special Exhibition Celebrating the 50th Anniversary of the Association of College Unions*.
Ohio State University (1973)	Hopkins Hall Art Gallery, Ohio State University (Columbus), January 9 – February 2, 1973, *Six Centuries of Painting from the Columbus Gallery of Fine Arts*.
Ohio University (1977)	Trisolini Gallery of Ohio University (Athens), November 8–22, 1977, *Masters of the Nineteenth Century*, cat. by M. Barry Katz.

REFERENCES

Bishop (1981)	Budd Harris Bishop, "Nineteenth-century American Paintings at the Columbus Museum of Art," *The Magazine Antiques* 120 (November 1981).
CGFA (1976)	Columbus Gallery of Fine Arts, *The Frederick W. Schumacher Collection* (1976).
CMA (1986)	Columbus Museum of Art, *Modern Sculpture* (1986).
CMA, *Catalog* (1978)	Columbus Museum of Art, *Catalog of the Collection* (1978).
CMA, *Selections* (1978)	Columbus Museum of Art, *200 Selections from the Permanent Collection* (1978).
Tucker (1969)	Marcia Tucker, *American Paintings in the Ferdinand Howald Collection* (1969).
Valentiner (1955)	William R. Valentiner, *The Frederick W. Schumacher Collection* (privately printed, 1955).
Young (1973)	Mahonri Sharp Young, *The Eight: The Realist Revolt in American Painting* (1973).
Young (1974)	Mahonri Sharp Young, *Painters of the Stieglitz Group: Early American Moderns* (1974).
Young (1977)	Mahonri Sharp Young, *American Realists: Homer to Hopper* (1977).

1 *Haymaking* 42.83

ENDNOTES:

1. For a discussion of these and other related works, see John Wilmerding, "Winslow Homer's Creative Process," *The Magazine Antiques* 108 (November 1975): 965–971.

PROVENANCE:

(Sale: auction, March 23, 1866 [Somerville Galleries?]); F. H. Whitmore, New York and Farmington, Connecticut, 1866; Frederic Whitmore, Springfield, Massachusetts; Snedecor & Co., New York, 1916; Frederic Fairchild Sherman, Westport, Connecticut, ca. 1918; (consigned to Babcock Galleries, New York, October 19, 1927–January 22, 1929, returned to owner); Frederic Fairchild Sherman; (sale: Parke-Bernet Galleries, New York, June 4, 1942, sale no. 382, lot no. 14); CMA, 1942.

EXHIBITION HISTORY:

[Artist's Fund Society of New York, December 30, 1864, *5th Annual Exhibition*, cat. no. 97 (as *In the Hayfield*).]

Pennsylvania Museum of Art (Philadelphia), May 2–June 8, 1936, *Winslow Homer Centennial*, cat. no. 2.

George Walter Vincent Smith Art Gallery (Springfield, Massachusetts), March 31–May 4, 1941, *The Private Collection of Frederic Fairchild and Julia Munson Sherman—A Memorial Exhibit*, cat. no. 30, illus.

WMAA, October 3–November 2, 1944, *Oils and Watercolors by Winslow Homer*, no cat.

CGFA, October 9–November 28, 1948, *Romantic America*, cat. no. 22, p. 4.

CGFA (February 1952), no cat.

Hiestand Hall Gallery, Miami University (Oxford, Ohio), October 1–31, 1959, *The American Scene in 150 Years of American Art*, cat.

AFA, *Major Work in Minor Scale*, checklist no. 13; toured, December 4, 1959–December 22, 1960, to Jacksonville Art Museum (Florida), Des Moines Art Center (Iowa), Philbrook Art Center (Tulsa, Oklahoma), Charles and Emma Frye Museum (Seattle), Art Gallery of Greater Victoria (British Columbia, Canada), Andrew Dickson White Museum of Art (Ithaca, New York), Miami Beach Art Center (Florida), Spiva Art Center (Joplin, Missouri), Evansville Museum of Arts and Sciences (Indiana), Chatham College (Pittsburgh), Art Museum of the New Britain Institute (Connecticut).

University of Delaware and Wilmington Society of Fine Arts, Delaware Art Center, January 10–February 18, 1962, *American Painting 1857–1869*, cat. by Wayne Craven, no. 37, pp. 69, 78, illus. no. 37.

University of Arizona Art Gallery (Tucson), October 11–December 1, 1963, *Yankee Painter*, cat. no. 36, p. 82.

Springfield Art Association (Ohio), March 14–April 17, 1967, *Opening Exhibition of the Springfield Art Center*, no cat.

Indiana University Art Museum (Bloomington), January 18–February 28, 1970, *The American Scene 1820–1900*, cat. by Louis Hawes, no. 85, illus.

WMAA, April 3–June 3, 1973, *Winslow Homer*, cat. by Lloyd Goodrich, no. 2, p. 134; toured, July 3–October 21, 1973, to Los Angeles County Museum of Art, Art Institute of Chicago.

Terra Museum of American Art (Evanston, Illinois), September 11–November 15, 1981, *Life in 19th Century America*, cat. by David M. Sokol, no. 48, pp. 24, 31, illus.

REFERENCES:

Frederic Fairchild Sherman, "The Early Oil Paintings of Winslow Homer," *Art in America* 6 (June 1918): 205, 207, illus.

Frederic Fairchild Sherman, *American Painters of Yesterday and Today* (1919), pp. 28, 32, illus.

Ralph Henry Gabriel, "Toilers of Land and Sea," *The Pageant of America*, Vol. 3 (1926), p. 76, illus. no. 152.

Paintings by American Artists—An Illustrated Catalogue of the Paintings Owned by Frederic Fairchild Sherman (1930).

"Winslow Homer—Painter," *Index of Twentieth Century Artists* 1 (November 1933), reprinted in *The Index of Twentieth Century Artists 1933–1937* (1970): 33.

Nelson C. White, "Sherman Memorial Exhibition," *Art in America* 29 (July 1941): 162, 168, illus.

Forbes Watson, *Winslow Homer* (1942), p. 87, illus.

Warren Beach, "'Girl in an Orchard' by Winslow Homer," *The Columbus Gallery of Fine Arts Monthly Bulletin* 19 (fall 1948): 11, 12, illus.

Richard Hofstadter, "The Myth of the Happy Yeoman," *American Heritage* 7 (April 1956): 44, illus.

Lloyd Goodrich, *Winslow Homer* (1959), pl. 4.

John Wilmerding, *Winslow Homer* (1972), pp. 47, 75, pl. 2–25.

Julian Grossman, *Echo of a Distant Drum: Winslow Homer and the Civil War* (1974), p. 165, illus. no. 173.

Melinda Dempster Davis, *Winslow Homer: An Annotated Bibliography of Periodical Literature* (1975), p. 83.

John Wilmerding, "Winslow Homer's Creative Process," *The Magazine Antiques* 108 (November 1975): 966, fig. 2.

Young (1977), p. 17, illus.

CMA, *Catalog* (1978), pp. 58–59, 142, illus.

CMA, *Selections* (1978), pp. 58–59, illus.

Gordon Hendricks, *The Life and Work of Winslow Homer* (1979), no. CL–566, p. 319, illus.

Bishop (1981), p. 1174, pl. 2.

2 *Girl in the Orchard* 48.10

ENDNOTES:

1. See Henry Adams, "Winslow Homer's Mystery Woman," *Art and Antiques* (November 1984): 39–45.
2. Ibid., p. 43.

PROVENANCE:

The artist, until ca. 1910; Charles L. Homer, Quincy, Massachusetts; Thomas N. and Elizabeth P. Metcalf, Boston, Massachusetts, ca. 1940; John Nicholson Gallery, New York, ca. 1945; John Levy Galleries, New York; CMA, 1948.

EXHIBITION HISTORY:

John Nicholson Gallery (New York), ca. 1945, *Exhibition of American Paintings*, cat. no. 1, illus.

John Nicholson Gallery (New York), ca. 1945, *Important Examples from Three Centuries of Fine Landscape Paintings*, cat. no. 3, illus.

CGFA (February 1952), no cat.

Ohio University (1977), cat. no. 18, illus.

Mansfield Art Center (Ohio), March 11–April 8, 1984, *The American Figure: Vanderlyn to Bellows*, cat. no. 9, cover illus.

REFERENCES:

William Howe Downes, *The Life and Works of Winslow Homer* (1911), p. 116.

Art Quarterly 9 (Spring 1946): 185, illus.

Warren Beach, "'Girl in an Orchard' By Winslow Homer," *The Columbus Gallery of Fine Arts Fall Bulletin* 19, no. 1 (1948): 10–12, 15, cover illus.

Melinda Dempster Davis, *Winslow Homer: An Annotated Bibliography of Periodical Literature* (1975), p. 80.

Eloise Spaeth, *American Art Museums: An Introduction to Looking*, 3rd ed. (1975), p. 344.

Young (1977), p. 39, illus.

CMA, *Catalog* (1978), p. 142, illus.

Gordon Hendricks, *The Life and Work of Winslow Homer* (1979), pp. 299, 319, illus.

Bishop (1981), pp. 1172, 1174, fig. 4.

RELATED WORKS:

Waiting an Answer, 1872, oil on canvas, Peabody Institute of Music (Baltimore, Maryland).

Hunting for Eggs, 1874, watercolor, Sterling and Francine Clark Art Institute (Williamstown, Massachusetts).

Summer, 1874, watercolor, Sterling and Francine Clark Art Institute (Williamstown, Massachusetts).

Fresh Eggs, 1874, watercolor, WMAA.

REMARKS:

Attached to the stretcher frame is a paper label that reads: Addison Gallery/Phillips Academy/ Andover, Massachusetts/GIRL IN ORCHARD/ by Winslow Homer/Property of/ Mrs. Thomas N. Metcalf/(Elizabeth P.). The painting may have been included in an exhibition at the Addison Gallery, but this has not been confirmed.

3 *The Pasture* 54.36

ENDNOTES:

1. George Inness, "A Painter on Painting," *Harper's New Monthly Magazine* 56 (February 1878): 458. Reprinted in N. Cikovsky, Jr., and M. Quick, *George Inness* (exh. cat., Los Angeles County Museum of Art, 1985), p. 205.
2. Ibid., p. 209.

PROVENANCE:

Howard Young Galleries, New York; Mrs. Joshua Cosden, New York; Newhouse Galleries, New York; Mr. and Mrs. R. W. Lyons, Washington, D.C.; (sale: Parke-Bernet Gallery, New York, January 1945, cat. no. 48, p. 56); Virginia H. Jones, 1945; CMA, 1954 (bequest of Virginia H. Jones).

REFERENCES:

Leroy Ireland, *The Works of George Inness: An Illustrated Catalogue Raisonné* (1965), cat. no. 283, pp. 71–72, illus.

Nicolai Cikovsky, Jr., *George Inness* (1971) p. 38, illus. no. 27 (as *Landscape*).

CMA, *Catalog* (1978), p. 142.

Bishop (1981), pp. 1174, 1175, fig. 3.

4 *Shower on the Delaware River* 54.2

ENDNOTES:

1. George W. Sheldon, *American Painters* (1979), p. 34.
2. N. Cikovsky, Jr., and M. Quick, *George Inness* (exh. cat., Los Angeles County Museum of Art, 1985), p. 205.
3. "Some Living American Painters: Critical Conversations by Howe and Torrey," *Art Interchange* 32 (April 1894): 102.

PROVENANCE:

James William Ellsworth, Chicago and New York, by 1895 (acquired from the artist); Clare Ellsworth Prentice, New York, ca. 1925; Bernon S. Prentice, New York, ca. 1929; (sale: Parke-Bernet Galleries, New York, April 19, 1952, cat. no. 657, p. 124, illus.); Kleeman Galleries, New York, 1952; [John Nicholson Galleries, New York]; (sale: Parke-Bernet Galleries, New York, January 27, 1954, cat. no. 77, p. 41, illus.); CMA, 1954.

EXHIBITION HISTORY:

Art Association of Columbus, May 1895, *Columbus Art Loan Exhibition*, cat. no. 21, p. 7 (as *Shower, Delaware River*).

M. Knoedler & Co. (New York), November 16–28, 1953, *A Half Century of Landscape Paintings by George Inness (1825–1894)*, cat.

Paine Art Center and Arboretum (Oshkosh, Wisconsin), October 2–28, 1962, *Paintings by George Inness*, cat. no. 26, illus.

Oakland Museum Art Department (California), November 28, 1978–January 28, 1979, *George Inness Landscapes: His Signature Years 1884–1894*, cat. by Marjorie Dakin Arkelian and George W. Neubert, p. 58.

Nassau County Museum of Fine Art (New York), October 4, 1981–January 17, 1982, *Animals in American Art: 1880's–1980's*, cat. no. 92 and introduction (unpag.).

University Art Gallery, State University of New York at Binghamton, January 21–February 13, 1983, *19th-Century Painters of the Delaware Valley*, cat. essay by Matthew Baigell, no. 27, pp. 18, 41, illus.; toured, March 12–April 24, 1983, to New Jersey State Museum (Trenton).

REFERENCES:

George Inness, Jr., *Life, Art and Letters of George Inness* (1917), pp. 245, 248, illus.

"George Inness—Painter," *Index of Twentieth Century Artists* 4 (December 1936), reprinted in *The Index of Twentieth Century Artists 1933–1937* (1970): 660.

Leroy Ireland, *The Works of George Inness* (1965), pp. 355–356, illus.

CMA, *Catalog* (1978), pp. 61–62, 142, illus.

CMA, *Selections* (1978), pp. 61–62, illus.

Bishop (1981), pp. 1174, 1178, pl. 8.

REMARKS:

Shower on the Delaware River may have been included in an exhibition (dates unknown) at the John Nicholson Galleries (New York), according to Leroy Ireland, *The Works of George Inness* (1965), p. 356. It is likely that the painting was at Nicholson Galleries until January 1954 when it was consigned by Nicholson to Parke-Bernet.

In a copy of the catalogue for the Knoedler exhibition of November 1953 (WMAA Papers, Archives of American Art, Smithsonian Institution, Washington, D.C., Roll N667, Frames 257–259) there is a handwritten notation as follows: Shower on the Delaware River 1891: (Pot of Gold): [Rainbow].

5 *Landscape* 29.3

ENDNOTES:

1. From "Introduction to the Propylaen" (1798), anonymous translation published in *The Harvard Classics*, Vol. 39: *Prefaces and Prologues*, Charles W. Eliot, ed. (1938), p. 255.
2. Another painting which parallels the views recorded in these two works is *In the Mountains* (1867, Wadsworth Atheneum, Hartford, Connecticut), reproduced in Matthew Baigell, *Albert Bierstadt* (1981), pl. 14 (in reverse; correct on the jacket).

PROVENANCE:

Rutherford H. Platt, Columbus; CMA, 1929 (bequest of Rutherford H. Platt).

EXHIBITION HISTORY:

[Columbus, May 1895, *Columbus Art Loan Exhibition*, cat. no. 73, p. 16 (as *King Lake, California*)].

[CGFA and Art Association of Columbus, May 1–15, 1907, *Loan Exhibition of Paintings*, cat. no. 4, p. 5 (as *King Lake, California*)].

University Gallery, University of Minnesota, February 1–March 1, 1939, *Survey of Colonial and Provincial Painting*, cat. no. 3, pp. 26, 36, illus. (as *Yosemite Valley*).

CGFA, Exhibition of American Paintings from the CGFA, no cat.; February 27–March 20, 1941, to Johnson-Humrickhouse Memorial Museum (Coshocton, Ohio).

National Collection of Fine Arts (Washington, D.C.), April 30–November 7, 1976, *America as Art*, cat. by Joshua C. Taylor, no. 148 (as *Yosemite Valley*, after 1860).

Ohio University (1977), cat. no. 14, illus. (as *Yosemite Valley*, ca. 1870–1875).

SITES, *New Horizons: American Painting 1840–1910*, cat. no. 4, pp. 26, 28, 140, illus.; toured, November 16, 1987–July 10, 1988, to State Tretyakov Museum (Moscow, USSR), State Russian Museum (Leningrad, USSR), Minsk State Museum of Belorussiya Russia (Minsk, USSR), State Museum of Russian Art (Kiev, USSR).

REFERENCES:

Gordon Hendricks, "The First Three Western Journeys of Albert Bierstadt," *Art Bulletin* 46 (September 1964): 363, no. 223 (as *Yosemite Valley*).

John Maass, *The Glorious Enterprise, The Centennial Exhibition of 1876 and H. J. Schwarzmann, Architect-in-Chief* (1973), p. 78 (as *Yosemite Valley*; erroneously said to have been exhibited at the Centennial Exhibition, 1876).

Gordon Hendricks, *Albert Bierstadt: Painter of the American West* (1973), no. CL-189, illus. (as *Yosemite Valley* "[incorrect title]").

Joshua C. Taylor, *America as Art* (1976), p. 125, illus. (as *Yosemite Valley*, after 1860).

CMA, *Catalog* (1978), pp. 18, 19, 136, illus. (as *Yosemite Valley*).

CMA, *Selections* (1978), pp. 18, 19, illus. (as *Yosemite Valley*).

Bishop (1981), pp. 1173, 1174, pl. 1 (as *Yosemite Valley*).

Robert C. Frazier, Arnold H. Horwitch, and Lewis R. Marquardt, *The Humanities: A Quest for Meaning in Twentieth Century America* (1982), p. 123, fig. 8.7 (as *Yosemite Valley*).

Otto G. Ocvirk, et al., *Art Fundamentals: Theory and Practice* (5th ed., 1985), pp. 101, 102, illus. 7.14.

6 *Marsh Scene: Two Cattle in a Field* 80.2

ENDNOTES:

1. Theodore Stebbins, *The Life and Work of Martin Johnson Heade* (1975), p. 42.
2. Ibid.
3. Barbara Novak, "On Defining Luminism," in *American Light: The Luminist Movement, 1850–1875* (exh. cat., National Gallery of Art, 1980), pp. 23–29.
4. Letter from T. Stebbins to Jerald Fessenden, February 24, 1978 (CMA files).
5. Ibid.
6. Stebbins, pp. 49–50.
7. Stebbins letter to Fessenden.
8. "G.T.C.," *National Academy of Design Exhibition of 1868* (1868), p. 87; *Brooklyn Daily Eagle*, March 21, 1868.

PROVENANCE:

Private collector, Massachusetts; Robert C. Vose, Jr., Boston; Vose Galleries, Boston, 1976; Coe Kerr Gallery, New York, 1977; CMA, 1980.

EXHIBITION HISTORY:

Coe Kerr Gallery, New York, October 25–November 25, 1978, *American Luminism*, cat. no. 21, illus. (as *Sunset on the Marshes*).

CMA (1986–1987), cat. no. 34, pp. 18, 19, 32, illus.

REFERENCES:

Bishop (1981), p. 1174, pl. 3.

Ann Bremner, "From the Editor: The Lay of the Land," *Dialogue: An Art Journal* 10 (March/April 1987): 6, illus.

Theodore E. Stebbins, Jr., *The Life and Work of Martin Johnson Heade* (rev. ed., forthcoming, 1988).

RELATED WORKS:

Two Sketches of Cattle, pencil on paper, illus. in Theodore E. Stebbins, Jr., *The Life and Work of Martin Johnson Heade* (1975), cat. no. 395-39, fig. 20, p. 48.

Covered Haystack, pencil on paper, Museum of Fine Arts, Boston; illus. in Stebbins, cat. no. 395-4, fig. 21, p. 50.

7 *Still Life* 80.32

ENDNOTES:

1. Richard B. Stone, "Not Quite Forgotten: A Study of the Williamsport Painter, S. Roesen," *Lycoming Historical Society: Proceedings and Papers* 9 (November 1951): 7–8, 12–13.
2. William Gerdts, *Painters of the Humble Truth* (1981), p. 84.
3. Lois Goldreich Marcus, *Severin Roesen: A Chronology* (Lycoming County Historical Society and Museum, 1976), p. 7.
4. Ibid., p. 32.
5. Maurice A. Mook, "Severin Roesen, The Williamsport Painter," *Lycoming College Magazine* 25 (June 1972): 36; and Marcus, pp. 43, 47.
6. Stone, p. 26.

7. "August [Severin] Roesen, Artist: An Interesting Williamsport Genius Recalled by His Works," *Williamsport Sun and Banner*, June 27, 1895; reprinted in Stone, p. 32.

8. Gerdts, p. 87.

9. Ibid., pp. 87, 88.

PROVENANCE:
Johanna Schroeder, New York; private collection; (sale: Sotheby Parke Bernet, New York, October 27, 1978, cat., lot no. 4, illus. as *Still Life with Fruit*); Peter Findlay, New York, 1978; Coe Kerr Gallery, New York (as *Still Life with Bird's Nest*); CMA, 1980.

EXHIBITION HISTORY:
Mansfield Art Center (Ohio), March 10 – April 7, 1985, *The American Still Life: From the Peales to C. A. Meurer*, cat. no. 5, illus.

CMA (1986–1987), cat. no. 42, pp. 18, 32.

REFERENCES:
Bishop (1981), pp. 1173, 1179, fig. 2.

8 *After the Hunt* 19.1

ENDNOTES:
1. The third version (1884, Butler Institute of American Art, Youngstown, Ohio) and the fourth and largest version (1885, California Palace of the Legion of Honor) are more elaborate variants. For a further discussion of American trompe l'oeil painting and Harnett's hunt series, see *More than Meets the Eye: The Art of Trompe l'Oeil* (CMA, 1983), pp. 25–31.

PROVENANCE:
[Earles' Galleries and Looking Glass Warerooms, Philadelphia]; Francis C. Sessions, Columbus; Mary J. Sessions, Columbus, 1892 (bequeathed by Francis C. Sessions to Mary J. Sessions with the provision that upon her death the work should be given to the CGFA; CMA, 1919 (bequest of Francis C. Sessions).

EXHIBITION HISTORY:
CGFA, April 8–30, 1937, *Victorian Painting and Sculpture*, no cat.

Johnson-Humrickhouse Memorial Museum (Coshocton, Ohio), February 27 – March 20, 1941, *Exhibition of American Painting*, no cat.

California Palace of the Legion of Honor (San Francisco), September 1 – November 21, 1948, *William Harnett and His Followers*, no cat.

PAFA, January 15 – March 13, 1955, *The One Hundred and Fiftieth Anniversary Exhibition*, cat. no. 66, pp. 53, 56, illus. (as second version) [toured, April 21 – November 26, 1955, to Sala de la Direccion (Madrid, Spain), Palazzo Strozzi (Florence, Italy), Tiroler Landesmuseum Ferdinandeum (Innsbruck, Austria), Museum voor Schone Kunsten (Ghent, Belgium), Royal Swedish Academy (Stockholm, Sweden)].

Sports Illustrated and AFA, *Sport in Art*, cat. no. 45; toured, January 5 – October 28, 1956, to Corcoran Gallery of Art (Washington, D.C.), J. B. Speed Art Museum (Louisville, Kentucky), Dallas Museum of Fine Arts, Denver Art Museum, Los Angeles County Museum of Art, California Palace of the Legion of Honor (San Francisco), Dayton Art Institute (Ohio).

La Jolla Museum of Art (California), July 11 – September 19, 1965, *The Reminiscent Object: Paintings by William Michael Harnett, John Frederick Peto and John Haberle*, cat. essay by Alfred Frankenstein, no. 14, illus.; toured, September 28 – October 31, 1965, to Santa Barbara Museum of Art (California).

AFA, *A Century of American Still Life Painting: 1813–1913*, cat. by William H. Gerdts, no. 22; toured, October 1, 1966 – November 12, 1967, to University of Alabama (Tuscaloosa), Sterling and Francine Clark Art Institute (Williamstown, Massachusetts), Des Moines Art Center (Iowa), Hollywood Art Center (Florida), Portland Museum of Art (Maine), Pomona College (Claremont, California), Triton Museum of Art (San Jose, California), Charles and Emma Frye Art Museum (Seattle), Minneapolis Institute of Arts, University of Maryland College of Arts and Sciences (College Park).

MMA, April 16 – September 7, 1970, *19th-Century America: Paintings and Sculpture*, cat. no. 171, illus. (as first version).

Northern Illinois University Art Gallery (Dekalb), October 27 – November 22, 1974, *Near Looking: A Close-Focus Look at a Basic Thread of American Art*, cat. by Dorathea Beard, et al., no. 25, pp. 52, 53, illus. (as second version); toured, December 1, 1974 – January 26, 1975, to University of Notre Dame Art Gallery (South Bend, Indiana).

Wildenstein & Co. (New York), April 4 – May 3, 1975, *The Object as Subject: Still Life Paintings from the Seventeenth to the Twentieth Century*, cat. no. 33.

Taft Museum (Cincinnati), January 22 – March 28, 1976, *Look Again*, cat. essay by Marsha Semmel, unpag.

Milwaukee Art Center, October 15 – November 28, 1976, *From Foreign Shores: Three Centuries of Art by Foreign Born American Masters*, cat. no. 25, pp. 60, 61, illus.

CMA, December 7, 1985 – January 22, 1986, *More than Meets the Eye: The Art of Trompe l'Oeil*, cat. by William Kloss and E. Jane Connell, no. 51, pp. 6, 28, 36, 77, 105, illus.; toured, March 21 – April 27, 1986, to Norton Gallery and School of Art (West Palm Beach, Florida).

REFERENCES:
Harold Stacy, "Study in Similarity of Opposites," *Columbus Sunday Dispatch Magazine* (August 24, 1941), illus.

Hermann W. Williams, Jr., "Notes on William M. Harnett," *The Magazine Antiques* 43 (June 1943): 260, 261, fig. 2.

Wolfgang Born, "William M. Harnett: Bachelor Artist," *Magazine of Art* 39 (October 1946): 250.

Wolfgang Born, *Still Life Painting in America* (1947), p. 31.

Alfred V. Frankenstein, *"After the Hunt*—and After," *California Palace of the Legion of Honor Bulletin* 6 (August – September 1948), illus.

Alfred V. Frankenstein, *After the Hunt: William Harnett and Other American Still Life Painters, 1870–1900* (1953), cat. no. 81, pp. 66, 67, 169, pl. 58 (as first version); rev. ed. (1969), cat. no. 81, pp. x, 66, 67, 174–175, 191, pl. 58 (as first version).

Albert Teneyck Gardner, "Harnett's *Music and Good Luck*," *Metropolitan Museum of Art Bulletin* 22 (January 1964): 162, 164, fig. 5.

Alfred V. Frankenstein, "Harnett, Peto, and Haberle," *Artforum* 4 (October 1965): 28, illus.

Alfred V. Frankenstein, "The American 19th Century, Part 2: Saloon Salons," *ARTnews* 67 (September 1968): 46 (as second version).

Alfred V. Frankenstein, *The Reality of Appearance: The Trompe l'Oeil Tradition in American Painting* (1970), no. 44, pp. 80, 81, illus. (as second version).

Donald W. Graham, *Composing Pictures* (1970): 18, illus.

William H. Gerdts and Russell Burke, *American Still-Life Painting* (1971), pp. 140, 142, pl. 10–8 (as second version).

Maurice Grosser, *Painter's Progress* (1971), pp. 223, 224, fig. 57.

Eloise Spaeth, *American Art Museums: An Introduction to Looking*, 3rd ed., expanded (1975), p. 344.

M. L. d'Otrange Mastai, *Illusion in Art: Trompe l'Oeil, A History of Pictorial Illusionism* (1975), pp. 290, 291, 296, pl. 330.

Carol J. Oja, "The Still-Life Paintings of William Michael Harnett (Their Reflections Upon Nineteenth-Century American Musical Culture)," *The Musical Quarterly* 63 (October 1977): 514, 521.

Robert F. Chirico, "John Haberle and Trompe l'Oeil," *Marsyas* 19 (1977–1978): 38, pl. 17, fig. 2.

William H. Gerdts, *Painters of the Humble Truth: Masterpieces of American Still Life 1801–1939* (1981), pp. 159, 160, 177–178, fig. 8.5.

CMA, *Catalog* (1978), pp. 51, 141, illus.

CMA, *Selections* (1978), pp. 51–52, illus.

Bishop (1981), p. 1177, pl. 6 (as first version).

American Paintings, Drawings, and Sculpture of the 19th and 20th Centuries (sale cat. EDITH-5238, Christie, Manson & Woods International, New York, December 3, 1982), p. 54 (as second version).

Hirschl and Adler Galleries (New York), *The Art of Collecting* (exh. cat., 1984), p. 29 (as second version).

Olive Bragazzi, "The Story Behind the Rediscovery of William Harnett and John Peto by Edith Halpert and Alfred Frankenstein," *The American Art Journal* 16 (spring 1984): 59, 60, 61, fig. 7 (as first version).

Janet Wilson, "What You See is What You Get . . . Or is It?" *MD Magazine* (February 1987): 86, illus.

Henri La Borie, *Otis Kaye: The Trompe l'Oeil Vision of Reality* (Soutines, Inc., Oaklawn, Illinois, 1987), pp. 11, 35, fig. 4.

RELATED WORKS:
After the Hunt, 1883, oil on canvas, Amon Carter Museum (Fort Worth, Texas).

After the Hunt, 1884, oil on canvas, Butler Institute of American Art (Youngstown, Ohio).

After the Hunt, 1885, oil on canvas, M. H. de Young Memorial Museum (Fine Arts Museums of San Francisco).

REMARKS ON PROVENANCE:
A paper label on the frame (believed to be the original) reads "Earles' Galleries and Looking Glass Warerooms, 816 Chestnut Street, Philadelphia." Earles' may have sold the picture to Francis Sessions. If so, the transaction must have taken place between April 1886 (when Harnett returned, with his paintings, to New York after a six-year stay in Europe) and March 1892 (when Sessions died).

REMARKS ON EXHIBITIONS:
Earles' Galleries (Philadelphia), organized an exhibition in the fall of 1892 entitled *Paintings of the Late WM Harnett*, which included as cat. no. 32 a version, as yet unidentified, of *After the Hunt* (see Alfred Frankenstein Papers, Archives

of American Art, Smithsonian Institution, Washington, D.C., Roll 1374, Frames 273–277). It is possible that the CMA 1883 version was the one exhibited, even though Mr. Sessions is not cited in the catalogue as a lender. Most probably, however, it was the version presently owned by the Butler Institute; Monroe Smith, a former owner of this painting, is listed as a lender (Frankenstein Papers, Frame 276). None of the works were reproduced in the catalogue.

Born (1946 and 1947) erroneously lists the CMA painting among works exhibited at the Paris Salon, 1885.

Frankenstein (1948) states that the CMA painting was included in the annual exhibition of the Munich Academy in 1884, but this has not been confirmed.

REMARKS ON REFERENCES:

See also Thomas Birch's Sons, auctioneers, *Catalogue of Exquisite Examples in Still Life Being Oil Paintings By the Late William Michael Harnett including the Furnishings of His Studio*, sale, Philadelphia, Pennsylvania, February 23 and 24, 1893, p. 8, cat. nos. 38 and 40, illus.; p. 18, cat. no. 181 (Frankenstein Papers, Archives of American Art, Smithsonian Institution, Washington, D.C., Roll 1374, Frames 293, 307, 308), in which three objects depicted in *After the Hunt*—an old sword, a combination shotgun and rifle, and a felt hat—are described. In the archival copy of the Birch auction catalogue, there are anonymous hand-written annotations such as "After the Hunt #1 '83." Because these objects are depicted in both the CMA and Amon Carter versions of 1883, it is not clear to which of the two paintings the annotator was referring.

9 *A New Variety, Try One* 76.42.2

ENDNOTES:

1. Cromwell Childe, "A Painter of Pretty Women," *The Quarterly Illustrator* 1 (1893), 279–282. Reprinted in *Essays on American Art and Artists* (1895), pp. 105–108.
2. By William H. Gerdts and Russell Burke, in *American Still-Life Painting* (1971), pp. 167–168. Gerdts further explained the attribution in *Painters of the Humble Truth: Masterpieces of American Still Life Painting 1801–1939* (1981), pp. 200–203.
3. See Nannette V. Maciejunes, *A New Variety, Try One: De Scott Evans or S. S. David* (exh. cat., CMA, 1985).
4. Ibid., p. 8.

PROVENANCE:

Dorothy Hubbard Appleton, ca. 1955; CMA, 1976 (gift of Dorothy Hubbard Appleton).

EXHIBITION HISTORY:

CMA, December 7, 1985–January 22, 1986, *More than Meets the Eye: The Art of Trompe l'Oeil*, cat. by E. Jane Connell and William Kloss, no. 20, pp. 64, 65, 71, illus.; toured March 21–April 27, 1986, to Norton Gallery and School of Art (West Palm Beach, Florida).

CMA, December 7, 1985–January 22, 1986, *A New Variety, Try One: The Art of De Scott Evans*, cat.: *A New Variety, Try One: De Scott Evans or S. S. David*, by Nannette V. Maciejunes, pp. 2, 4, 5, 7, 8, 10, cover illus.

CMA (1986–1987), cat. no. 31, pp. 10, 31.

REFERENCES:

Bishop (1981), fig. 8.

Nannette V. Maciejunes, "A New Variety, Try

One: The Art of De Scott Evans," *Western Reserve Studies: A Journal of Regional History and Culture* 3 (1988), pp. 93, 100, fig. 1.

Nannette V. Maciejunes, "A Tangled Web, A Trompe l'Oeil Mystery," *Timeline* 5 (October–November 1988), pp. 34–43.

RELATED WORKS:

See CMA exh. cat., *A New Variety, Try One: De Scott Evans or S. S. David* (1986), p. 8.

10 *Spirit of Autumn* [57] 47.68

ENDNOTES:

1. Elizabeth Broun, *Albert Pinkham Ryder* (forthcoming, 1989).
2. Albert Boime, *Thomas Couture and the Eclectic Vision* (1980), p. 608.
3. Lloyd Goodrich, *Albert P. Ryder* (1959), p. 22.
4. Various versions of this story were published by Frederic Fairchild Sherman. See, for example, "Notes on Albert P. Ryder," *Art in America* 25 (October 1937): 168 (where the author also intimates that he gave the Columbus picture its title); and George Walter Vincent Smith Art Gallery (Springfield, Massachusetts), *The Private Collection of Frederic Fairchild and Julia Munson Sherman—A Memorial Exhibit* (exh. cat., 1941), cat. no. 69.

PROVENANCE:

Stephen G. Putnam, New York, ca. 1875 (acquired from the artist); Frederic Fairchild and Julia Munson Sherman, New York, 1920; Julia Munson Sherman, New York, 1940; Jacob Schwartz, Brookline, Massachusetts, 1944; (sale: Parke-Bernet Galleries, New York, February 26, 1947, cat. no. 32, pp. 9–10, illus.; Frederick W. Schumacher, Columbus, 1947; CMA, 1957 (bequest of Frederick W. Schumacher).

EXHIBITION HISTORY:

Fairchild Sherman Studio (New York), January 16–28, 1922, *Oil Paintings by Albert Pinkham Ryder*, cat. no. 7.

Fairchild Sherman Studio (New York), January 1925, *Paintings by Albert Pinkham Ryder*, cat. no. 6.

George Walter Vincent Smith Art Gallery (Springfield, Massachusetts), March 31–May 4, 1941, *The Private Collection of Frederic Fairchild and Julia Munson Sherman—A Memorial Exhibit*, cat. no. 69, illus.

California Palace of the Legion of Honor (San Francisco), January 22–April 2, 1972, *The Color of Mood: American Tonalism, 1880–1910*, cat. by Wanda M. Corn, no. 38, p. 30.

Ohio State University (1973), cat. no. 18, illus.

Ohio University (1977), cat. no. 16, illus.

REFERENCES:

Frederic Fairchild Sherman, *Albert Pinkham Ryder* (privately printed, 1920), illus. opp. p. 54.

Frederic Newlin Price, *Ryder: A Study of Appreciation* (1932), no. 168.

"Albert Pinkham Ryder—Painter," *Index of Twentieth Century Artists* 1 (February 1934), reprinted in *The Index of Twentieth Century Artists 1933–1937* (1970): 100.

Frederic Fairchild Sherman, "Notes on the Art of Albert P. Ryder," *Art in America* 25 (October 1937): 168.

Valentiner (1955), cat. no. 5, pp. 12, 13, illus.

"From Business Wealth: Great Gifts of Art, 1958," *Fortune* 58 (December 1958): 113, illus.

CGFA (1976), pp. 26–28, illus.

CMA, *Catalog* (1978), p. 149.

Bishop (1981), pp. 1175, 1176, fig. 5.

11 *Moonlight* 45.20

ENDNOTES:

1. Lloyd Goodrich, *Ralph Albert Blakelock Centenary Exhibition* (exh. cat., WMAA, 1947), p. 22.
2. For more on Blakelock's technique, see Goodrich, pp. 17–20.

PROVENANCE:

John R. and Louise Lersch Gobey; CMA, 1945 (bequest of John R. and Louise Lersch Gobey).

EXHIBITION HISTORY:

CGFA (1931), cat. no. 324, p. 1, 18.

REFERENCES:

CMA, *Catalog* (1978), p. 156.

Bishop (1981), pp. 1175, 1179, fig. 10.

REMARKS:

In 1974 *Moonlight* was examined by Norman A. Geske, Nebraska Blakelock Project, Sheldon Memorial Art Gallery, University of Nebraska, Lincoln, and catalogued as Inventory no. 34 in category II: "stylistically and technically correct attribution but painting does not have a complete provenance history."

12 *The Venetian Model* 69.7

ENDNOTES:

1. Regina Soria, *Elihu Vedder, American Visionary Artist in Rome (1836–1923)* (1970), p. 319.
2. Quoted in Regina Soria, "Elihu Vedder's Mythical Creatures," *Art Quarterly* 26 (summer 1963): 192.
3. Ibid.
4. Ibid.

PROVENANCE:

Mr. and Mrs. Davis Johnson, Staten Island, New York, March 1879 (purchased in Rome from the artist); George P. Guerry, New York; Ferdinand H. Davis, New York; Kennedy Galleries, New York, ca. 1964–1966; CMA, 1969.

EXHIBITION HISTORY:

Palace of Fine Arts (Chicago), August 5, 1892–October 30, 1893, *World's Columbian Exposition*, cat. no. 1038.

SITES, *Paintings and Drawings by Elihu Vedder*, cat. by Regina Soria, no. 47 (as *The Little Venetian Model*); toured October 3, 1966–February 4, 1968, to Cummer Gallery of Art (Jacksonville, Florida), Virginia Museum of Fine Arts (Richmond), Wichita Art Museum (Kansas), Oklahoma Art Center (Oklahoma City), M.H. de Young Memorial Museum (San Francisco), Long Beach Museum of Art (California), Seattle Art Museum, Allentown Art Museum (Pennsylvania), Albany Institute of History and Art (New York), Minneapolis Institute of Arts, Hopkins Center Art Galleries (Dartmouth College, Hanover, New Hampshire).

New York Cultural Center in association with Fairleigh Dickinson University (Rutherford, New Jersey), May 9–July 13, 1975, *Three Centuries of the American Nude*, cat. by William H. Gerdts and Leslie Cohen, no. 28, p. 7; toured August 6–November 16, 1975, to Minneapolis Institute of Arts, University of Houston Fine Art Center.

National Collection of Fine Arts, Smithsonian Institution (Washington, D.C.), October 13, 1978–February 4, 1979, *Perceptions and Evocations: The Art of Elihu Vedder*, checklist no. 125, also cat. (1979), no. 127, p. 107, illus. (as *The Little Venetian Model*); toured, April 28–July 9, 1979, to Brooklyn Museum (New York).

Mansfield Art Center (Ohio), March 11–April 8, 1984, *The American Figure: Vanderlyn to Bellows*, cat. no. 10.

REFERENCES:
W. H. Bishop, "Elihu Vedder," *American Art Review* 1 (1880): 328, 372, 373, engraving of painting by Gustav Kruell; also published in Walter Montgomery, ed., *American Art and American Art Collections*, Vol. 1 (1889), pp. 175, 176, illus.

Elihu Vedder's Pictures Reproduced in Photograph and Phototype (ca. 1887), cat. no. 22, illus.

Ernest Radford, "Elihu Vedder, and his Exhibition," *Magazine of Art* 23 (1899): 368.

Elihu Vedder, *The Digressions of V.*, Vol. 2 (1910), p. 476 (as *Venetian Model [small]*).

Regina Soria, "Elihu Vedder's Mythological Creatures," *Art Quarterly* 26 (summer 1963): 189, 192, fig. 11.

Kennedy Quarterly 4 (April 1964): no. 184, p. 175, illus. (as *The Venetian Model, small*).

Regina Soria, *Elihu Vedder, American Visionary Artist in Rome (1836–1923)* (1970), no. 322, pp. 121, 128–129, 319, pl. 26.

William H. Gerdts, *The Great American Nude* (1974), p. 137.

CGFA (1976), pp. 29–31, illus.

Bishop (1981), pp. 1175, 1176, fig. 6.

CMA, *Catalog* (1978), pp. 120–121, 152, fig. 6.

CMA, *Selections* (1978), pp. 120–121, illus.

REMARKS:
The Venetian Model is no. 95 in "A List of the Works of V. Sold Since the Year 1856," compiled by the artist (Elihu Vedder Papers, Archives of American Art, Smithsonian Institution, Washington, D.C., Roll 528, Frames 852–872).

13 *Girl in Grass Dress (Seated Samoan Girl)* 66.39

ENDNOTES:
1. John La Farge, *Reminiscences of the South Seas* (1912), p. 125.
2. Durand-Ruel, New York, February 25–March 5, 1895, *Paintings, Studies, Sketches and Drawings; Mostly Records of Travel by John La Farge, 1886 and 1890–1891*, cat. by John La Farge, no. 89 (as *Girl in Grass Dress*).
3. Ibid.
4. Ibid.

PROVENANCE:
Henry Lee Higginson, Boston, Massachusetts, 1893 (purchased from the artist); Dr. William Sturgis Bigelow, Boston, by 1919; Samuel K. Lothrop, Cambridge, Massachusetts, gift or bequest of Bigelow by 1926; Mrs. Samuel K. Lothrop (Joy Mahler), 1965; Graham Gallery, New York, 1966; CMA, 1966.

EXHIBITION HISTORY:
Durand-Ruel (New York), February 25–March 5, 1895, *Paintings, Studies, Sketches and Drawings; Mostly Records of Travel by John La Farge, 1886 and 1890–1891*, cat. by John La Farge, no. 89 (as *Girl in Grass Dress*).

Graham Gallery (New York), May 4–June 10, 1966, *John La Farge*, cat. no. 39 (as *Seated Samoan Girl*).

REFERENCES:
Salon, Champs de Mars (Paris), *Etudes, esquisses, dessins: Souvenirs et notes de voyage (1886 et 1890–91) par John La Farge* (exh. cat. for Paris version of Durand-Ruel exhibition, 1895), cat. no. 88 (catalogued as *Jeune fille revetue d'un costume de feuilles*, but not exhibited).

CGFA (1976), pp. 44–46, illus.

Letterpress Book of Bancel La Farge (1896), La Farge Family Papers, in Sterling Memorial Library, Yale University, New Haven, Connecticut, p. 77, no. 26 (as *Girl in grass dress Samoa*).

Henry A. La Farge, "Catalogue Raisonné of the Works of John La Farge" (1934–1974), La Farge Family Papers, in Sterling Memorial Library, Yale University, New Haven, Connecticut, p. 77 (as *Seated Samoan Girl, or 'Girl in Grass Dress'*).

CMA, *Catalog* (1978), p. 144.

Bishop (1981), pp. 1175, 1177, pl. 7.

Henry A. La Farge, James L. Yarnall, and Mary A. La Farge, *Catalogue Raisonné of the Works of John La Farge*, Vol. 1 (forthcoming), entry P1890.2.

14 *Study of a Head* [57]43.8

ENDNOTES:
1. James McNeill Whistler, *The Gentle Art of Making Enemies* (1890; reprinted 1967), p. 127; as quoted in Theodore E. Stebbins, Carol Troyen, and Trevor J. Fairbrother, *A New World: Masterpieces of American Painting 1760–1910* (exh. cat., Museum of Fine Arts, Boston, 1983), p. 144.
2. The butterfly symbol that appears in the CMA portrait was used as a signature by Whistler beginning in 1889. But Whistler did not always sign a painting when he finished it; he is known to have signed some works five to seven years later, or at the time he retouched them.
3. Pointed out by Andrew McLaren Young in a letter to CMA dated December 20, 1974.
4. Few of Whistler's paintings are dated. The portrait in the Columbus museum has been dated by most scholars to the early to mid-1880s (Young, letter of December 20, 1974), when Whistler was particularly interested in watercolor and demonstrated his interest even in oils such as the CMA portrait.
 The catalogue raisonné of Whistler's works, completed after the death of Andrew McLaren Young, dates the picture 1895. See Andrew McLaren Young, Margaret MacDonald, Robin Spencer, and Hamish Miles, *The Paintings of James McNeill Whistler* (1980), p. 190.
5. Parke-Bernet's title may be based on an inscription (date unknown) in ink found on the painting's wooden stretcher that reads "Portrait of Graves, Printseller/by J. McN. Whistler."
6. After examining the painting, Andrew McLaren Young expressed the likelihood that the portrait is of Algernon Graves (letter of December 20, 1974). The catalogue raisonné of Whistler's work, however, expresses reservations about the identity of the sitter; see Young, et al., p. 190.
7. Letter dated December 1890; quoted in Stan-

ley Weintraub, *Whistler: A Biography* (1974), p. 265.
8. Ibid., p. 148.

PROVENANCE:
Charles A. Walker, Boston, 1898 (according to 1942 Parke-Bernet cat.); Francis Bartlett, Boston, 1904; Herbert M. Sears, Boston, 1913; (sale: Parke-Bernet Galleries, New York, October 17, 1942, cat. no. 137, p. 46, illus. [as *Mr. Graves, Printseller*]); Frederick W. Schumacher, Columbus, 1942; CMA, 1957 (bequest of Frederick W. Schumacher).

EXHIBITION HISTORY:
Copley Society, Copley Hall (Boston), February 1904, *Memorial Exhibition of the Works of Mr. Whistler: Oil Paintings, Water Colors, Pastels, and Drawings*, cat. no. 52, p. 8 (as *Study of a Head*).

Art Institute of Chicago, January 14–February 25, 1954, *Sargent, Whistler and Mary Cassatt*, cat. by Frederick A. Sweet, no. 110, p. 96, illus. (as *Mr. Graves, the Printseller*, 1880); March 25–May 23, 1954, to MMA.

Grand Rapids Art Gallery (Michigan), September 15–October 15, 1955, *Cassatt, Whistler, Sargent Exhibition*, cat. no. 47, illus. (as *Mr. Graves, Printseller*).

Art Institute of Zanesville (Ohio), October 7–30, 1960, *Eleven Americans—1860–1960*, checklist (as *Portrait of a Man*).

Ohio University (1977), cat. no. 15, illus.

University of Michigan Museum of Art (Ann Arbor), August 27–October 8, 1978, *Whistler: The Later Years*, unpublished cat. no. 101 (as *Portrait of Algernon Graves [?]*).

CMA (1983), cat., pp. 40, 41, illus.

CMA (1986), no. cat.

REFERENCES:
Elisabeth Luther Cary, *The Works of James McNeill Whistler* (1907, reprinted 1913, 1971), p. 164, no. 52 (as *Study of a Head*).

Valentiner (1955), cat. no. 4, pp. 10, 11, illus. (as *Portrait of Mr. Graves, printseller*, 1880).

CGFA (1976), pp. 38–40, illus.

CMA, *Catalog* (1978), p. 152 (as *Algernon Graves*).

Andrew McLaren Young, Margaret MacDonald, and Robin Spencer, with Hamish Miles, *The Paintings of James McNeill Whistler* (1980), no. 427, p. 190, pl. 264 (as *Study of a Head*).

Bishop (1981), pp. 1177, 1180, fig. 7.

15 *Court of Honor, World's Columbian Exposition, Chicago* [57]43.10

ENDNOTES:
1. Sotheby's, New York, *American Impressionist and 20th Century Paintings, Drawings and Sculpture*, sale June 4, 1982, cat. no. 84.

PROVENANCE:
John Bannon, esq.; (sale: Fifth Avenue Art Galleries, New York, February 23–24, 1905, cat. no. 131, p. 99, as *A Bit of the World's Fair, 1893*); Victor Harris, New York, 1905; (sale: Parke-Bernet Galleries, New York, April 1, 1942, cat. no. 20, p. 6, illus.); Frederick W. Schumacher, Columbus, 1942; CMA, 1957 (bequest of Frederick W. Schumacher).

EXHIBITION HISTORY:
Ohio Wesleyan University Press (Delaware, Ohio), on loan February 2–May 25, 1960.

CMA (1983) cat., pp. 46, 47, illus.

CMA (1986), no cat.

REFERENCES:

Valentiner (1955), cat. no. 8, p. 18.

John Douglass Hale, "The Life and Creative Development of John H. Twachtman," Ph.D. diss., Ohio State University, 1957, Vol. 2, no. 157, p. 547 (as *World's Columbian Exposition, Court of Honor*).

CGFA (1976), pp. 41–43, illus.

CMA, *Catalog* (1978), p. 151.

Bishop (1981), pp. 1179, 1180, fig. 11.

16 *The North Gorge, Appledore, Isles of Shoals* [57]43.9

PROVENANCE:

(Sale: American Art Galleries, New York, donated by the artist[?], to *American Paintings and Sculpture: Contributed in Aid of the Relief Fund of the American Artists' Relief Committee of One Hundred*, May 3–4, 1917, cat. no. 116, illus. as *The North Gorge, Appledore*, 1916); Victor Harris, New York, 1917; (sale: Parke-Bernet Galleries, New York, April 1, 1942, cat. no. 23); Frederick W. Schumacher, Columbus, 1942; CMA, 1957 (bequest of Frederick W. Schumacher).

EXHIBITION HISTORY:

Fine Arts Gallery of San Diego, December 6, 1962–January 15, 1963, *Modern American Painting: 1915*, cat. no. 15, pp. 14, 15, illus. (as *The North Gorge*).

CMA (1983), cat., pp. 50, 51, illus.

CMA (1986), no cat.

REFERENCES:

Valentiner (1955), cat. no. 9 (as *The North Gorge*), p. 19.

CGFA (1976), pp. 50–52, illus.

CMA, *Catalog* (1978), p. 142.

Bishop (1981), pp. 1180, 1182, pl. 12.

RELATED WORKS:

South Gorge, Appledore, Isles of Shoals, 1912, Newark Museum (New Jersey).

17 *Carmela Bertagna* [57]43.11

PROVENANCE:

Mother of the sitter to her son in Paris, or to Maurice or Paul Poirson (in Paris); Albert Milch (E. and A. Milch Gallery), New York, spring 1927; Harold Somers, Brooklyn, New York, October 1927; Lillian Somers, New York; (sale: Parke-Bernet Galleries, New York, May 26, 1943, cat. no. 49, pp. 34, 35, illus.); Frederick W. Schumacher, Columbus, 1943; CMA, 1957 (bequest of Frederick W. Schumacher).

EXHIBITION HISTORY:

Akron Art Institute (Ohio), November 30–December 28, 1945, *40 American Painters*, cat. no. 21.

Art Institute of Chicago, January 14–February 25, 1954, *Sargent, Whistler, and Mary Cassatt*, cat. by Frederick A. Sweet, no. 51, p. 53, illus.; March 25–May 23, 1954, to MMA.

Grand Rapids Art Gallery (Michigan), September 15–October 15, 1955, *Cassatt, Whistler, Sargent Exhibition*, cat. no. 23, illus. (as dated 1884).

Carnegie Institute, October 17–December 1, 1957, *American Classics of the Nineteenth Century*, cat. no. 111 (as dated 1916).

Fort Worth Art Center (Texas), November 7–December 4, 1960, *Drawings, Watercolors, and Oils of John Singer Sargent*, no cat.

Joslyn Art Museum (Omaha, Nebraska), April 10–June 1, 1969, *Mary Cassatt Among the Impressionists*, cat. no. 45, pp. 51, 74, illus. (as dated 1884).

Coe Kerr Gallery (New York), May 28–June 27, 1980, *John Singer Sargent, His Own Work*, cat. no. 9, unpag., illus.

CMA (1983), cat., pp. 48, 49, illus.

CMA (1986), no cat.

REFERENCES:

International Studio 88 (November 1927): 71, illus. (as *A Spanish Girl*).

Milch Art Notes (1927–1928), p. 13.

"John Singer Sargent—Painter," *Index of Twentieth Century Artists* 2 (February 1935), reprinted in *The Index of Twentieth Century Artists 1933–1937* (1970): 363 (as *Carmela Bertagna* [sometimes called *Spanish Girl*]).

Allen S. Weller, "Expatriates' Return," *Art Digest* 28 (January 1954): 25.

Valentiner (1955), cat. no. 10, pp. 20, 21, illus. (as *Portrait Study of a Spanish Girl*).

David McKibbin, *Sargent's Boston* (1956), p. 84.

George Moore, *Esther Waters* (1960), cover illus.

Charles Merrill Mount, *John Singer Sargent: A Biography* (1969), p. 462, no. 8013.

CGFA (1976), pp. 32–34, illus.

Young (1977), p. 84, illus. (as *Carmela Bertagna*).

CMA, *Catalog* (1978), p. 149, illus.

Bishop (1981), pp. 1175, 1180, pl. 4.

Carter Ratcliff, *John Singer Sargent* (1982), fig. 85, p. 60.

Dean M. Larson, *Studying with the Masters* (1986), p. 96, illus.

RELATED WORKS:

Beggar Girl, a portrait of Carmela Bertagna, 1880, oil (also called *The Parisian Beggar Girl* or *Spanish Bride*), exhibited in the MMA, *Memorial Exhibition of the Work of John Singer Sargent* (exh. cat. [1926], no. 3).

18 *Susan Comforting the Baby No. 1* [57]54.4

ENDNOTES:

1. Letter from Adelyn D. Breeskin, April 1973 (CMA files).

2. Cited in Adelyn D. Breeskin, *Mary Cassatt: A Catalogue Raisonné of the Oils, Pastels, Watercolors and Drawings* (1970), as *Susan Comforting the Baby (No. 2)*, cat. no. 112, p. 69, illus.

PROVENANCE:

Durand-Ruel, New York; Harris Whittemore, Sr., 1898; J. H. Whittemore Co., Naugatuck, Connecticut, November 20, 1926 (deeded to, by Harris Whittemore, Sr.); (sale: Parke-Bernet Galleries, New York, May 19, 1948, sale no. 973, cat. no. 83, p. 23, illus. as *Mother and Child*, ca. 1882); Frederick W. Schumacher, Columbus, 1948; CMA, 1957 (bequest of Frederick W. Schumacher).

EXHIBITION HISTORY:

Baltimore Museum of Art, on loan 1941–1948 (as *Two Heads*).

Baltimore Museum of Art, November 28, 1941–January 11, 1942, *Mary Cassatt*, cat. no. 11 (as *Two Heads*, ca. 1882).

Grand Rapids Art Gallery (Michigan), September 15–October 15, 1955, *Cassatt, Whistler, Sargent Exhibition*, cat. no. 3, illus. (as *Mother and Child*).

Carnegie Institute, October 17–December 1, 1957, *American Classics of the Nineteenth Century*, cat. no. 72 (as *Mother and Child*, ca. 1882); toured, January 5–July 1, 1958, to Munson-Williams-Proctor Institute (Utica, New York), Virginia Museum of Fine Arts (Richmond), Baltimore Museum of Art, Currier Gallery of Art (Manchester, New Hampshire).

Art Institute of Zanesville (Ohio), October 7–30, 1960, *Eleven Americans: 1860–1960*, checklist (as *Mother and Child*).

Ohio University (1977), cat. no. 19, illus.

CMA (1983), cat., pp. 44–45, illus.

Coe Kerr Gallery (New York), October 3–27, 1984, *Mary Cassatt: An American Observer*, cat., fig. 13.

CMA (1986), no cat.

REFERENCES:

Valentiner (1955), cat. no. 7, pp. 16, 17, illus. (as *Mother and Child*).

Adelyn D. Breeskin, *Mary Cassatt: A Catalogue Raisonné of the Oils, Pastels, Watercolors, and Drawings* (1970), cat. no. 111, p. 67, illus.

CGFA (1976), pp. 35, 36, 37, illus.

Young (1977), p. 24, illus. (as *Susan Comforting the Baby*, ca. 1882).

CMA, *Catalog* (1978), p. 136, illus.

Frank Getlein, *Mary Cassatt: Paintings and Prints* (1980), pp. 40, 41, illus.

Bishop (1981), pp. 1176, 1180, pl. 5.

RELATED WORKS:

Susan Comforting the Baby, ca. 1881, oil on canvas, Museum of Fine Arts (Houston).

19 *Fifth Avenue at Madison Square* 31.260

ENDNOTES:

1. John I. H. Baur, *Theodore Robinson 1852–1896* (1947), p. 27.

2. Hamlin Garland, "Theodore Robinson," *Brush and Pencil* 4 (1899): 285–286.

3. Unpublished diaries, Frick Art Reference Library, New York City; quoted in Baur, p. 62.

4. Scribner's Magazine files, in the Brandywine River Museum.

5. *Scribner's Magazine* 18 (November 1895): 539.

6. Unpublished diaries; quoted in Baur, p. 62.

7. Robinson's *World's Fair View* (of which he made two versions) was also a commissioned illustration. See Baur, pp. 38, 94.

PROVENANCE:

Charles Scribner's Sons, New York, 1894 (commissioned from the artist); Robert Hosea; (sale: American Art Association, New York, February 7, 1918, cat. no. 18, as *Looking Up Fifth Avenue from Twenty-third Street*); Ferdinand Howald, New York and Columbus, 1918, inv. no. 101; CMA, 1931 (gift of Ferdinand Howald).

EXHIBITION HISTORY:

CGFA (1931), cat. no. 203, p. 1, 12 (as *Fifth Avenue at Twenty-third Street*).

Brooklyn Museum (New York), November 12–January 5, 1947, *Theodore Robinson 1852–1896*, cat. by John I. H. Baur, no. 66, p. 44 (as *Fifth Avenue at 23rd Street*, 1895).

Dayton Art Institute (Ohio), October 19–November 11, 1951, *America and Impressionism*,

no cat. (as *Fifth Avenue at 23rd Street* or *Looking Up 5th Avenue from 23rd Street*); toured, November 18 – December 16, 1951, to CGFA.

Memorial Union Gallery, University of Wisconsin (Madison), October 29 – November 10, 1964, *Theodore Robinson*, cat. no. 20, illus. (as *3rd Ave. at 23rd Street*).

CGFA (January 1970), no cat. (as *Fifth Avenue at Twenty-third Street*).

CGFA (May 1970), no cat. (as *Fifth Avenue at Twenty-third Street*).

ACA Galleries (New York), March 30 – April 17, 1971, *New York, N.Y.*, cat. no. 57, cover illus. (as *Fifth Avenue & 23rd Streets, 1895*).

Ohio State University (1973), cat. no. 21, illus. (as *Fifth Avenue at Twenty-Third Street*).

Baltimore Museum of Art, May 1 – June 10, 1973, *Theodore Robinson, 1852–1896*, cat. no. 57, p. 57, illus. (as *Fifth Avenue at Twenty-Third Street, 1895*); toured, July 12, 1973 – February 24, 1974, to CGFA, Worcester Art Museum (Massachusetts), Joslyn Art Museum (Omaha, Nebraska), Munson-Williams-Proctor Institute (Utica, New York).

Paine Art Center and Arboretum (Oshkosh, Wisconsin), April 12 – June 7, 1987, *The Figural Images of Theodore Robinson: American Impressionist*, cat. no. 42, pp. 37, 38, 86, illus.; toured June 28 – November 29, 1987, to Dixon Gallery and Gardens (Memphis, Tennessee), and Indianapolis Museum of Art.

REFERENCES:

Artist's diary, entries dated November 13, 1894, November 27, 1894, and May 8, 1895, Frick Art Reference Library, New York.

Royal Cortissoz, "Landmarks of Manhattan," *Scribner's Magazine* 18 (November 1895): 539, illus.

Forbes Watson, "American Collections No. 1: The Ferdinand Howald Collection," *The Arts* 8 (August 1925): 64, 84, illus. (as *Fifth Avenue at 23rd Street*).

Kennedy Galleries (New York), *Theodore Robinson, American Impressionist (1825–1896)* (exh. cat.), 1966), p. 15 (as *Fifth Avenue at 23rd Street*).

Tucker (1969), cat. no. 153, pp. 92, 94, illus. (as *Fifth Avenue at Twenty-third Street, 1895*).

CMA, *Catalog* (1978), p. 148 (as *Fifth Avenue at Twenty-third Street*).

Bishop (1981), pp. 1179, 1180, pl. 9 (as *Fifth Avenue at Twenty-third Street*).

20 *Weda Cook* 48.17

ENDNOTES:

1. See Lloyd Goodrich, *Thomas Eakins*, 2 vols. (1982), I, p. 236, figs. H182–184.
2. For a discussion of *The Concert Singer*, see Elizabeth Johns, *Thomas Eakins: The Heroism of Modern Life* (1983), pp. 115–143.

PROVENANCE:

Charles Bregler, Eakins's pupil; Stephen C. Clark, New York, ca. 1933; William Macbeth Galleries, New York; M. Knoedler & Co., New York, September 22, 1944 (as dated ca. 1895); CMA, 1948.

EXHIBITION HISTORY:

M. Knoedler & Co. (New York), June 5 – July 31, 1944, *A Loan Exhibition of the Works of Thomas Eakins, 1844–1944, Commemorating the Centennial of his Birth*, not in cat.; toured, Oct. 1 –

December 31, 1944, to Delaware Art Center (Wilmington), Doll and Richards (Boston, Massachusetts), Museum of Raleigh (North Carolina).

Person Hall Art Gallery, University of North Carolina (Chapel Hill), April 12–28, 1946, *American Painting*, cat. no. 20.

CGFA, October 9 – November 28, 1948, *Romantic America*, cat. no. 12, p. 4.

Birmingham Museum of Art (Alabama), April 8 – June 3, 1951, *Opening Exhibition*, cat., p. 38.

Syracuse Museum of Fine Arts (New York), September 16 – October 11, 1953, *125 Years of American Art*, cat. no. 19, p. 7.

Birmingham Museum of Art (Alabama), April 28 – May 31, 1961, *10th Anniversary Exhibition*.

National Gallery of Art (Washington, D.C.), October 8 – November 12, 1961, *Thomas Eakins: A Retrospective Exhibition*, cat. no. 63, p. 96, illus. (as dated ca. 1895); toured, December 1, 1961 – March 18, 1962, to Art Institute of Chicago, Philadelphia Museum of Art.

Portraits (New York), April 24 – May 21, 1968, *Portraits of Yesterday and Today*, cat. no. 36, illus. (as dated 1895).

San Jose Museum of Art (California), December 5, 1975 – January 10, 1976, *Americans Abroad: Painters of the Victorian Era*, brochure, illus.; also published in exhibition series catalogue *American Series: A Catalogue of Eight Exhibitions, April, 1974 – December, 1977* (1978), unpag.

Ohio University (1977), cat. no. 17, illus.

Brandywine River Museum (Chadds Ford, Pennsylvania), March 15 – May 18, 1980, *Eakins at Avondale and Thomas Eakins: A Personal Collection*, cat. no. 16, p. 37.

REFERENCES:

"Catalogue of the Works of Thomas Eakins," *Pennsylvania Museum Bulletin* 25 (March 1930), cat. no. 169, p. 26.

Lloyd Goodrich, *Thomas Eakins: His Life and Work* (1933), no. 277, p. 186 (as dated ca. 1895).

Jacob Getlar Smith, "The Enigma of Thomas Eakins," *American Artist* 20 (November 1956): 33.

Gordon Hendricks, *The Life and Work of Thomas Eakins* (1974), no. 201, pp. 192–194, 336, illus. (as dated ca. 1895).

Young (1977), p. 27, illus. (as dated 1895).

CMA, *Catalog* (1978), p. 139.

Bishop (1981), p. 1180, pl. 10.

Lloyd Goodrich, *Thomas Eakins: Critical Biography and Catalogue Raisonné*, Vol. 2 (1982), p. 92, illus. no. 187.

RELATED WORKS:

The Concert Singer, 1892, oil on canvas, Philadelphia Museum of Art (Pennsylvania).

21 *The Wrestlers* 70.38

ENDNOTES:

1. Letter to Fiske Kimball, April 23, 1935, Philadelphia Museum of Art archives; quoted in Theodor Siegl, *The Thomas Eakins Collection* (1978), p. 149.

PROVENANCE:

National Academy of Design, New York, 1902 (gift of the artist, diploma picture upon election as academician); (sale: Hirschl & Adler Galleries, New York, November 27, 1970); CMA, 1970.

EXHIBITION HISTORY:

Brooklyn Museum (New York), January 18 – February 28, 1932, *Paintings by American Impressionists and Other Artists of the Period 1880–1900*, cat. no. 46.

National Academy of Design (New York), December 3–23, 1951, *The American Tradition 1800–1900*, cat. by Eliot Clark, no. 49, p. 9.

Sports Illustrated, and AFA, *Sport in Art*, cat. no. 30, illus.; toured, October 31, 1955 – November 1956, to Time-Life Building Reception Hall (New York), Museum of Fine Arts (Boston), Corcoran Gallery of Art (Washington, D.C.), J.B. Speed Art Museum (Louisville, Kentucky), Dallas Museum of Fine Arts, Denver Art Museum, Los Angeles County Museum of Art, California Palace of the Legion of Honor (San Francisco), Dayton Art Institute (Ohio), unknown venue in Australia.

Cummer Gallery of Art (Jacksonville, Florida), November 10 – December 31, 1961, *The American Tradition in Painting: A Selection from the Permanent Collection of the National Academy of Design*, cat., pp. 12, 23, illus.

Hirschl and Adler Galleries (New York), October 29 – November 22, 1969, *The American Scene: A Survey of the Life and Landscape of the 19th Century*, cat. no. 25, p. 27, illus.

PAFA, January 7 – February 15, 1970, *Thomas Eakins: His Photographic Works*, cat. by Gordon Hendricks, no. 95, pp. 52, 56, 71, fig. 62.

National Museum of Western Art (Tokyo, Japan), September 11 – October 17, 1976, *Masterpieces of World Art from American Museums*, cat. no. 59, illus.; toured, November 2 – December 5, 1976, to Kyoto National Museum (Japan).

Mansfield Art Center (Ohio), March 11 – April 8, 1984, *The American Figure: Vanderlyn to Bellows*, cat. no. 12, illus.

REFERENCES:

Elizabeth Hamlin, "Painters of the Nineties," *Brooklyn Museum Quarterly* 19 (April 1932): 53, illus.

Lloyd Goodrich, *Thomas Eakins, His Life and Work* (1933), no. 317, p. 189.

"Thomas Cowperthwait Eakins—Painter," *Index of Twentieth Century Artists* 1 (January 1934), reprinted in *The Index of Twentieth Century Artists 1933–1937* (1970): 73, 81.

Eliot Clark, *History of the National Academy of Design* (1954), p. 176.

Fairfield Porter, *Thomas Eakins* (1959), illus. no. 58 (as dated 1889).

Sylvan Schendler, *Eakins* (1967), pp. 155, 158, fig. 74.

Henry A. LaFarge, "The Quiet Americans," *ARTnews* 68 (November 1969): 35, 72, illus.

Elisabeth Stevens, "The American Scene at Hirschl and Adler," *Arts Magazine* 44 (November 1969): 47, illus.

"Recent Accessions of American and Canadian Museums, January-March 1971," *Art Quarterly* 34 (autumn 1971): 372, 382, illus.

Lincoln Kirstein, "Walt Whitman and Thomas Eakins: A Poet's and a Painter's Camera-Eye," *Aperture* 16, no. 3 (1972): 382, illus.

William H. Gerdts, *The Great American Nude* (1974), p. 124 (as dated 1889).

Gordon Hendricks, *The Life and Work of Thomas*

Eakins (1974), no. 202, pp. 239–240, 336, fig. 260.

Eloise Spaeth, *American Art Museums: An Introduction to Looking*, 3rd ed. (1975), p. 344.

"Editorial: Problems and Pleasures of American Art," *Apollo* 104 (September 1976): 164, 165, pl. 2.

Benjamin Lowe, *The Beauty of Sport: A Cross-Disciplinary Inquiry* (1977), p. 132.

Young (1977), p. 29, illus.

CMA, *Catalog* (1978), pp. 43–44, 139, illus.

CMA, *Selections* (1978), pp. 43–44, illus.

Carl S. Smith, "The Boxing Paintings of Thomas Eakins," *Prospects* 4 (1979): 417, note 22, illus.

Bishop (1981), p. 1180, fig. 12.

Lloyd Goodrich, *Thomas Eakins: Critical Biography and Catalogue Raisonné*, 2 Vols. (1982), Vol. 1, p. 251, Vol. 2, pp. 156–159, illus. no. 219.

RELATED WORKS:

Wrestlers, ca. 1898, photograph, Hirshhorn Museum and Sculpture Garden, Smithsonian Institution (Washington, D.C.).

The Wrestlers, 1898, oil on canvas, Philadelphia Museum of Art.

The Wrestlers (sketch of CMA version), 1899, oil on canvas, Los Angeles County Museum of Art.

22 *Mrs. Richard Low Divine, Born Susan Sophia Smith* 47.80
ENDNOTES:
1. Frank H. Goodyear, Jr., *Cecilia Beaux: Portrait of an Artist* (1974–1975), p. 21.
2. Dorinda Evans, "Cecilia Beaux, Portraitist: Exhibition Review," *American Art Review* 2 (January-February 1975): 92–94.
3. Cecilia Beaux, lecture at Simmons College, May 14, 1907, typed transcript in Cecilia Beaux Papers, Archives of American Art, Smithsonian Institution, Washington, D.C.
4. Goodyear, p. 30.
5. Beaux, lecture at Simmons College.
6. The portrait was commissioned by the sitter's daughter Gertrude (later Gertrude Divine Webster) and son-in-law William McClelland Ritter. References to the portrait are found in Beaux's journals from early July through mid-August 1907. It is also listed in her journal summary list of works executed in 1907.
7. Evans, p. 98
8. Cecilia Beaux, *Background with Figures* (1930); quoted in Elizabeth Graham Bailey, "Cecilia Beaux: Background with a Figure," *Arts and Antiques* 3 (March/April 1980): 61.

PROVENANCE:
Commissioned from the artist by the sitter's daughter, Gertrude Divine Ritter (Mrs. William McClelland Ritter), Columbus, later Gertrude Divine Webster, Manchester, Vermont; estate of Gertrude Divine Webster, March 31, 1947; CMA, 1947 (bequest of Gertrude Divine Webster).

EXHIBITION HISTORY:
Carnegie Institute, April 13 – June 13, 1908, *Twelfth Annual Exhibition*, cat. no. 17, illus.

CGFA and Art Association of Columbus, *Exhibition of Paintings by American Artists*, cat. no. 3, p. 6 (as *Portrait—Mrs. D.*); February 1910, at Columbus Public Library.

M. Knoedler & Co. (New York), February 2–14, 1914, *Exhibition of the National Association of Portrait Painters*, no. 11, p. 28, illus. (as *Mrs. William McC. Ritter*).

American Academy of Arts and Letters (New York), 1935, *Exhibition of Paintings by Cecilia Beaux*, cat. no. 37, p. 16.

Deshler-Hilton Hotel (Columbus), on loan January 1954 – July 1963.

PAFA, *Cecilia Beaux: Portrait of an Artist*, cat. no. 63, pp. 104, 105, illus. (as *Mrs. Richard Low Divine [Susan Sophia Smith]*); toured, September 6, 1974 – March 2, 1975, to Museum of the Philadelphia Civic Center and Indianapolis Museum of Art.

Grey Art Gallery and Study Center, New York University, November 13 – December 22, 1984, *Giovanni Boldini and Society Portraiture: 1880–1920*, cat. by Gary A. Reynolds, no. 33, illus.

Hoyt L. Sherman Gallery, Ohio State University (Columbus), May 19 – June 29, 1986, *Memorable Dress: Ohio Women*, no cat.

REFERENCES:
Cecilia Beaux Diaries, entries of July 5 – August 16, 1907, Archives of American Art, Smithsonian Institution, Washington, D.C., Cecilia Beaux Papers, Roll 427; Painting List of 1907, Roll 428.

Henry S. Drinker, *The Paintings and Drawings of Cecilia Beaux* (1955), pp. 41–42 (as *Mrs. Richard Low Divine [Susan Sophia Smith]*).

Dorinda Evans, "Cecilia Beaux, Portraitist: Exhibition Review," *American Art Review* 2 (January – February 1975): 98, 99, illus.

CMA, *Catalog* (1978), p. 135.

Bishop (1981), pp. 1180, 1182, fig. 14.

23 *Dancer in a Yellow Shawl* 10.2
ENDNOTES:
1. William Innes Homer, *Robert Henri and His Circle* (1969), p. 237.
2. An experiment in fusing revolutionary anarchist and socialist ideologies with the arts, the Ferrer Center, a school on 107th Street in New York City, was open between 1912 and 1915. The school was named after the Spanish anarchist Francisco Ferrer, whose modernist schools in Spain defied government control of the arts. For further elaboration see Ann Uhry Abrams, "The Ferrer Center: New York's Unique Meeting of Anarchism and the Arts," *New York History* 59 (July 1978): 306–325.
3. Quoted in "The New York Exhibition of Independent Artists," *Craftsman* 18, no. 2 (1910); reprinted in Barbara Rose, *Readings in American Art Since 1900* (1968), p. 41.
4. Homer, p. 237.
5. Quoted in "My People," *Craftsman* 27 (1915): 459–460; reprinted in William Yarrow and Louis Bouché, *Robert Henri: His Life and Works* (1921), p. 32.

PROVENANCE:
CMA, March 3, 1910 (purchased from the artist?).

EXHIBITION HISTORY:
CGFA and Art Association of Columbus, February 1910, *Exhibition of Paintings by American Artists*, cat. no. 27, p. 17.

CGFA, July–August, 1923, *Paintings from the*

Collections of Columbus Residents, checklist no. 61 (as *Spanish Dancer*).

CGFA (1931), cat. no. 428, p. 1, 21 (as *Woman in the Yellow Shawl*).

CGFA, January 1937, *Paintings by Robert Henri*, no cat.

Johnson-Humrickhouse Memorial Museum (Coshocton, Ohio), February 27 – March 20, 1941, *Exhibition of American Paintings*, no cat.

Ohio State Fair, Columbus, August 28 – September 4, 1953(?).

Buckeye Federal Building and Loan Co. (Columbus), June 30 – August 1, 1967, *Selections from the Gordian Knot Exhibit*, no cat.

Gallery of Modern Art, New York Cultural Center, in association with Fairleigh Dickinson University, October 14 – December 14, 1969, *Robert Henri, Painter-Teacher-Prophet*, cat. by Alfredo Valente, p. 92, illus. (as dated 1924).

Ohio State University (1973), cat. no. 24, illus.

REFERENCES:
Dorothy Grafly, "Robert Henri," *American Magazine of Art* 22 (June 1931): 444, illus.

"Robert Henri—Painter," *Index of Twentieth Century Artists* 2 (January 1935), reprinted in *The Index of Twentieth Century Artists 1933–1937* (1970): 312 (as *Woman in the Yellow Shawl*), 317 (as *Dancer in a Yellow Shawl*).

Paul Sherlock, "Robert Henri," *Ohio State Grange Monthly* 58 (March 1955): 15, 16, cover illus.

Mahonri Sharp Young, *The Eight* (1973), pp. 6, 32, 33, illus. (as dated 1908).

George W. Knepper, *An Ohio Portrait* (1976), pp. 215, 278, illus.

CMA, *Catalog* (1978), pp. 56, 142, illus.

CMA, *Selections* (1978), p. 56, illus.

Bishop (1981), pp. 1172, 1180, 1183, fig. 15.

24 *East Entrance, City Hall, Philadelphia* 60.6
ENDNOTES:
1. "Notes and News-Items from Philadelphia," *New York Times Saturday Review of Books and Art*, September 7, 1901.
2. John Sloan, *Gist of Art* (1939), p. 201.
3. University of Minnesota (Minneapolis), *Forty American Painters, 1940–1950* (exh. cat., 1951), unpag.

PROVENANCE:
Helen Farr Sloan, the artist's wife (acquired from the artist), 1951; John Sloan Trust, 1956; CMA, 1960 (acquired through Mrs. Sloan and Kraushaar Galleries).

EXHIBITION HISTORY:
Philadelphia Art Club, exhibition (title not known), closing December 15, 1901.

PAFA, January 20 – March 1, 1902, *Seventy-first Annual Exhibition*, cat. no. 553, p. 46 (as *East Entrance, City Hall*).

Kraushaar Art Galleries (New York), April 11–30, 1921, *Exhibition of Paintings by John Sloan*, checklist no. 10.

City of Philadelphia, March 27 – April 3, 1922, *Philadelphia Art Week*.

Philadelphia Museum of Art, December 17, 1931 – January 18, 1932, *Some Living Pennsylvania Artists*, no cat.

Hunt Hall, Bucknell University (Lewisburg, Pennsylvania), January 19 – February 1, 1935, *Contemporary Pennsylvania Artists*, no cat.

Wanamaker Galleries (New York), November 4 – December 1939, *Retrospective Exhibition: John Sloan Paintings, Etchings and Drawings*, checklist no. 29.

Wanamaker Galleries (Philadelphia), January 8–29, 1940, *John Sloan: Paintings, Etchings, and Drawings*, checklist no. 29.

Philadelphia Museum of Art, October 14 – November 18, 1945, *Artists of the Philadelphia Press*, cat. no. 48, p. 14.

Carpenter Galleries, Dartmouth College (Hanover, New Hampshire), June 1 – September 1, 1946, *John Sloan Painting and Prints*, cat. no. 1.

Kraushaar Galleries (New York), February 2–28, 1948, *John Sloan: Retrospective Exhibition*, checklist no. 1.

WMAA, January 10 – March 2, 1952, *John Sloan 1871–1951*, cat. by Lloyd Goodrich, no. 2, pp. 15, 81, illus.; toured, March 15 – June 8, 1952, to Corcoran Gallery of Art (Washington, D.C.), Toledo Museum of Art (Ohio).

Mineral Industries Gallery, Pennsylvania State University (University Park), October 7 – November 6, 1955, *Pennsylvania Painters*, cat. no. 40, illus.

Denver Art Museum, June 4–29, 1958, *Collector's Choice*, cat. no. 20, illus. (as *East Entrance—City Hall*).

Cincinnati Art Museum, October 4 – November 4, 1958, *Two Centuries of American Painting*, cat. no. 39 (as *East Entrance City Hall*).

Denison University (1962), no cat.

National Gallery of Art (Washington, D.C.), September 18 – October 31, 1971, *John Sloan 1871–1951*, cat. by David W. Scott and E. John Bullard, no. 21, p. 67, illus.; toured, November 20, 1971 – October 22, 1972, to Georgia Museum of Art (University of Georgia, Athens), M. H. de Young Memorial Museum (San Francisco), City Art Museum of St. Louis, CGFA, PAFA.

Philadelphia Museum of Art, April 11 – October 10, 1976, *Philadelphia: Three Centuries of American Art*, cat. no. 395, pp. 463–464, illus.

Delaware Art Museum (Wilmington), July 15 – September 4, 1988, *John Sloan: Spectator of Life*, cat. by Rowland Elzea and Elizabeth Hawkes, no. 6, pp. 14, 42, illus.; toured April 26 – December 31, 1988, to IBM Gallery of Science and Art (New York), CMA, Amon Carter Museum (Fort Worth, Texas).

REFERENCES:
John Sloan, *Gist of Art* (1939), p. 201, illus.

Ben Wolf, "Philadelphia Story—Told by Four Artists," *Art Digest* 20 (October 1945): 14, illus. (as *Philadelphia City Hall* and *City Hall, East Entrance*).

University of Minnesota (Minneapolis), *Forty American Painters, 1940–1950* (exh. cat., 1951), unpag.

Milton W. Brown, "The Two John Sloans," *ARTnews* 50 (January 1952): 25, 27, illus. (as *City Hall, Philadelphia*).

Van Wyck Brooks, *John Sloan: A Painter's Life* (1955), p. 38 (as *East Entrance, City Hall*).

"Accessions of American and Canadian Museums, October–December, 1959," *Art Quarterly* 23 (spring 1960): 96.

"Accessions of American and Canadian Museums, April–June, 1960," *Art Quarterly* 23 (autumn 1960): 309.

Walker Art Museum, Bowdoin College (Brunswick, Maine), *The Art of John Sloan: 1871–1951* (exh. cat., 1962), p. 12.

Bruce St. John, "John Sloan in Philadelphia, 1888–1904," *American Art Journal* 3 (fall 1971): 86.

Mahonri Sharp Young, "Letter from U.S.A.: The American Hogarth," *Apollo* 94 (November 1971): 411, fig. 2.

Bruce St. John, *John Sloan* (1971), pl. 2.

Mahonri Sharp Young, *The Eight* (1973), p. 52, illus.

David Scott, *John Sloan* (1975), pp. 35, 42–43, illus.

Richard F. Snow, "The American City," *American Heritage* 27 (April 1976): 33, illus.

Stuart Preston, "The Confident Culture of Philadelphia," *Apollo* 104 (September 1976): 206, 207, fig. 16.

Anthony N. B. Garvan, *City Chronicles: Philadelphia's Urban Image in Painting and Architecture* (1976), p. 29, fig. 36.

CMA, *Catalog* (1978), pp. 111–112, 150, illus.

CMA, *Selections* (1978), pp. 111–112, illus.

Bernard B. Perlman, *The Immortal Eight: American Painting from Eakins to the Armory Show, 1870–1913* (1979), p. 70, illus.

Bishop (1981), pp. 1180–1181, fig. 13.

Rowland Elzea, *John Sloan's Oil Paintings: A Catalog Raisonné* (forthcoming), cat. no. 38.

25 *Spring Planting, Greenwich Village* 80.25

ENDNOTES:
1. John Sloan, *Gist of Art* (1939), p. 238.

PROVENANCE:
W. B. Maxwell; J. Alice Maxwell; (sale: Parke-Bernet Galleries, New York, October 8, 9, and 10, 1942, sale no. 392, estate of J. Alice Maxwell, cat., lot. no. 462, p. 74); Major Edward J. Bowes; Kraushaar Galleries, New York, 1946; Mrs. Cyrus McCormick, 1948; (sale: Sotheby Parke-Bernet, New York, April 25, 1980, sale no. 4365, estate of Mrs. Cyrus McCormick, cat., lot no. 112, illus.); CMA, 1980.

EXHIBITION HISTORY:
PAFA, February 6 – March 26, 1916, *111th Annual Exhibition of the Pennsylvania Academy of the Fine Arts*, checklist no. 172.

Chicago Art Institute, November 2 – December 7, 1916, *Twenty-ninth Annual Exhibition of American Oil Painting and Sculpture*, cat. no. 251 (as *Spring Planting, Greenwich Village, Manhattan*).

Corcoran Gallery of Art (Washington, D.C.), December 17, 1916 – January 21, 1917, *Sixth Exhibition: Oil Paintings by Contemporary American Artists*, cat. no. 140 (as *Spring Planting, Greenwich Village, Manhattan*).

C. W. Kraushaar Art Galleries (New York), March 19 – April 7, 1917, *Exhibition of Paintings, Drawings and Etchings by Joan Sloan*, cat. no. 15.

Albright Art Gallery (Buffalo, New York), May 12 – September 17, 1917, *Eleventh Annual Exhibition of Selected Paintings by American Artists*, cat. no. 122, p. 18 (as *Spring Planting, Greenwich Village, Manhattan*).

Art Institute (Milwaukee), March 1918, *Exhibition of Paintings by George Luks, Augustus Vincent Tack and John Sloan*, checklist no. 46.

Galeries Georges Petit (Paris), July 4–30, 1921, *Exposition d'une Groupe de Peintre Americains*, cat. no. 96, illus.

Whitney Studios (New York), November 2–17, 1921, *Overseas Exhibition*, cat. no. 96.

Carnegie Institute, April 26 – June 17, 1923, *Twenty-Second Annual International Exhibition of Paintings*, cat. no. 8.

Peabody Gallery (Baltimore), January 29 – March 2, 1924, *15th Annual Exhibition of the Charcoal Club*, cat., illus.

Kraushaar Galleries (New York), February 2–28, 1948, *John Sloan: Retrospective Exhibition*, cat. no. 7 (as *Spring Planting*).

WMAA, January 10 – March 2, 1952, *John Sloan 1871–1951*, cat. by Lloyd Goodrich, no. 36, p. 39, illus. (as *Spring Planting*); toured, March 15 – June 8, 1952, to Corcoran Gallery of Art (Washington, D.C.), Toledo Museum of Art (Ohio).

CMA (1986–1987), cat. no. 39, pp. 18, 19, 32, illus.

Delaware Art Museum (Wilmington), July 15 – September 4, 1988, *John Sloan: Spectator of Life*, cat. by Rowland Elzea and Elizabeth Hawkes, no. 70, p. 106, illus.; toured April 26 – December 31, 1988, to IBM Gallery of Science and Art (New York), CMA, Amon Carter Museum (Fort Worth, Texas).

REFERENCES:
A. E. Gallatin, *John Sloan* (1925), unpag., illus.

"John Sloan—Painter and Graver," *Index of Twentieth Century Artists* 1 (August 1934), reprinted in *The Index of Twentieth Century Artists 1933–1937* (1970): 231, 237.

John Sloan, *Gist of Art* (1939), p. 238, illus.

Walker Art Museum, Bowdoin College (Brunswick, Maine), *The Art of John Sloan: 1871–1951* (exh. cat., 1962), p. 13.

David Scott, *John Sloan* (1975), p. 122, illus.

Art at Auction: The Year at Sotheby Parke Bernet 1979–80 (1980), p. 156, illus.

Rowland Elzea, *John Sloan's Oil Paintings: A Catalog Raisonné* (forthcoming) cat. no. 226.

26 *The Hudson at Inwood* 31.201

ENDNOTES:
1. "Lawson of the Crushed Jewels," *International Studio* 78 (February 1924): 367–510.
2. Ira Glackens, *William Glackens and the Ashcan Group* (1957), p. 90.
3. Adeline Lee Karpiscak, *Ernest Lawson 1873–1939* (exh. cat., University of Arizona Museum of Art, 1979), p. 7.

PROVENANCE:
Daniel Gallery, New York; Ferdinand Howald, New York and Columbus, April 1919, inv. no. 141, in exchange for earlier, smaller version (Howald inv. no. 117); CMA, 1931 (gift of Ferdinand Howald).

EXHIBITION HISTORY:
Detroit Museum of Art, December 1917, *Group Exhibition of Paintings by Ernest Lawson, Hayley Lever, Karl Anderson and Leopold Seyffert*, cat. no. 128, p. 12 (as *The Hudson at Ironwood*); toured, November 8, 1917 – May 31, 1918, to Albright Art Gallery (Buffalo, New York), cat. no. 1 (separate cat. published); Milwaukee Art Institute; City Art Museum (St. Louis, Missouri), checklist no. 21 (separate publication, as *The Hudson at Ironwood*); Cincinnati Museum Association; John Herron Art Institute (Indianapolis); Carnegie Institute.

[Musée National du Luxembourg (Paris), Oc-

tober–November 1919, *Exposition d'Artistes de l'Ecole Americaine*, cat. no. 154 (version unknown), p. 28].

CGFA (1931), cat. no. 117, p. 1, 10.

Dayton Art Institute (Ohio), October 19 – November 11, 1951, *America and Impressionism*, no cat.; toured November 18 – December 16, 1951, to CGFA.

CGFA (May 1970), no cat.

CGFA (1970–1971), cat. no. 31, illus.

Henry Art Gallery, University of Washington (Seattle), January 3 – March 2, 1980, *American Impressionism*, cat. by William H. Gerdts, pp. 117, 133, illus.; toured, March 9 – August 31, 1980, to Frederick S. Wight Gallery (University of California at Los Angeles), Terra Museum of American Art (Evanston, Illinois), Institute of Contemporary Art (Boston).

Mansfield Art Center (Ohio), March 8 – April 5, 1981, *The American Landscape*, cat. no. 37, illus.

Parkersburg Art Center (West Virginia), March 21 – May 17, 1987, *Exhibition of American Impressionist Painting*, no. cat.

REFERENCES:
C.B., "Four American Painters," *American Magazine of Art* 9 (March 1918): 185, illus. (as *Hudson River at Ironwood*).

"The Paintings of Anderson, Lawson, Lever and Seyffert," *Academy Notes* 13 (January–October 1918): 2, 3, 6, illus.

Forbes Watson, "American Collections: No. 1—The Ferdinand Howald Collection," *The Arts* 8 (August 1925): 73, 86, illus. (as *Landscape*).

Henry and Sidney Berry-Hill, *Ernest Lawson: American Impressionist 1873–1939* (1968), pl. 75.

Tucker (1969), cat. no. 94, pp. 62, 63, illus.

John Wilmerding, ed., *The Genius of American Painting* (1973), pp. 188, 189, illus.

Richard J. Boyle, *American Impressionism* (1974), pp. 222–223, illus.

CMA, *Catalog* (1978), p. 144.

William H. Gerdts, *American Impressionism* (1984), p. 278, fig. 364.

RELATED WORKS:
The Hudson at Inwood, ca. 1913, oil on canvas (SITES, *Impressionistes Americains*, exh. cat., 1982–1983, no. 135, p. 101, illus. [as measuring 20 x 24 in.]; and *American Paintings IV* [Berry-Hill Galleries, 1986], pp. 78–79, illus.).

REMARKS:
There are at least two paintings by Lawson entitled *The Hudson at Inwood*, but there is no known painting by Lawson entitled *The Hudson at Ironwood*; references to the latter are in reality to one of the other paintings. Howald purchased a smaller version of *The Hudson at Inwood* from Daniel on April 19, 1918, for $700; in April 1919, he exchanged this painting for a larger work with the same title (now in the CMA), noting that he paid Daniel $1,500 for this version. The Detroit Museum of Art attempted to purchase the larger painting in December 1917, offering $750 for it; Daniel accepted the offer on Lawson's behalf, but for unknown reasons the painting never entered the Detroit collection and was thus available to Howald.

It is not known to whom Daniel resold the smaller version of the painting. A smaller version—presumably the one previously owned by Howald—was included in the 1982–1983 SITES exhibition and the 1986 Berry-Hill Gal-

leries catalogue (see Related Works above); this painting was executed from the same viewpoint as the larger version, but the small picture is a snow scene and the larger is not.

27 *St. Malo No. 2* 31.247

ENDNOTES:
1. For a further discussion of Prendergast's St. Malo tide scenes, see Helen Cooper, "American Watercolors from the Collection of George Hopper Fitch," *Yale University Art Gallery Bulletin* 37 (spring 1980): 11–12.

2. Quoted by Eleanor Green, *Maurice Prendergast* (exh. cat., University of Maryland Art Gallery, 1976), p. 54.

3. Ibid.

PROVENANCE:
Daniel Gallery, New York; Ferdinand Howald, New York and Columbus, January 1916, inv. no. 45 (as *St. Malo*); CMA, 1931 (gift of Ferdinand Howald).

EXHIBITION HISTORY:
[Macbeth Galleries (New York), February 3–15, 1908, *Exhibition of "The Eight"*, no cat.].

[Boston Water Color Club, January 6–29, 1909, *22nd Annual Exhibition*, cat. no. 111 (as *Plage des Bains St. Malo*)].

[CGFA, July–August 1923, *Paintings from the Collections of Columbus Residents*, cat. no. 22 (as *St. Malo Beach*)].

[Gallery of Living Art, New York University, December 13, 1927 – January 25, 1928, *Opening Exhibition*, cat. (as *St. Malo*)].

CGFA (1931), cat. no. 189, p. 1, 11.

Dayton Art Institute (Ohio), February 1–28, 1948, *Maurice Prendergast, Paintings*, no cat.

CGFA, *30 Pictures from the Ferdinand Howald Collection*, no cat.; ca. May 1951, to Cleveland Institute of Art.

CGFA, *Pictures from the Ferdinand Howald Collection*, no cat.; June 9 – August 31, 1951, Hilltop Public Library (Columbus).

CGFA (1958), no cat.

CGFA (1958–1960), no cat.

CGFA, *Watercolors from the Ferdinand Howald Collection*, no cat.; June 22 – July 10, 1964, to School of Art, Ohio State University (Columbus).

CGFA (May 1970), no cat.

CGFA (1970–1971), cat. no. 57 (as dated ca. 1910).

University of Maryland Art Gallery (College Park), September 1 – October 6, 1976, *Maurice Prendergast*, cat. by Eleanor Green et al., no. 54, pp. 25, 54, 122, illus.; toured, October 17, 1976 – May 28, 1977, to University Art Museum (University of Texas, Austin), Des Moines Art Center (Iowa), CGFA, Herbert F. Johnson Museum of Art (Cornell University, Ithaca, New York), Davis and Long, Co. (New York).

Parkersburg Art Center (West Virginia), March 21 – May 17, 1987, *Exhibition of American Impressionist Paintings*, no cat.

REFERENCES:
"Maurice Brazil Prendergast—Painter," *Index of Twentieth Century Artists* 2 (March 1935), reprinted in *The Index of Twentieth Century Artists 1933–1937* (1970): 358.

Tucker (1969), cat. no. 146, p. 91 (as dated ca. 1910).

Eleanor Green, "Maurice Prendergast: Myth

and Reality," *American Art Review* (July 1977): 97, illus.

[Eleanor Green, *Maurice Prendergast* (1977), p. 122].

CMA, *Catalog* (1978), p. 166.

Helen A. Cooper, "Maurice Prendergast, *Rising Tide, St. Malo*," *Yale University Art Gallery Bulletin* 37 (spring 1980): 11, fig. 2.

Gwendolyn Owens, *The Watercolors of David Milne* (exh. cat., Herbert F. Johnson Museum, Cornell University, 1984), p. 14.

Gail Levin, *Twentieth-Century American Painting: The Thyssen-Bornemisza Collection* (1987), pp. 50, 51, fig. 1.

RELATED WORKS:
St. Malo No. 1, ca. 1907, watercolor on paper, Columbus Museum of Art.

Rising Tide, St. Malo, ca. 1907, watercolor, Yale University Art Gallery (New Haven, Connecticut).

St. Malo, 1909, watercolor (see *The Arts* 9 [April 1926]: 190).

The Lighthouse, St. Malo, 1909, oil, William Benton Museum of Art, University of Connecticut (Storrs).

The Sands at St. Malo (see *International Studio* 73 [May 1921]: 76).

Resting, St. Malo, oil (see *The Magazine Antiques* 118 [October 1980]: 611).

28 *The Promenade* 31.244

PROVENANCE:
Daniel Gallery, New York; Ferdinand Howald, New York and Columbus, October 1916, inv. no. 25; CMA, 1931 (gift of Ferdinand Howald).

EXHIBITION HISTORY:
[Memorial Art Gallery (Rochester, New York), February 16 – March 7, 1915, *A Collection of Paintings Representative of the Modern Movement in American Art*, cat. no. 62 (version unknown)].

[CGFA, July–August 1923, *Paintings from the Collections of Columbus Residents*, cat. no. 15 (as *Picnic by the Sea*)].

CGFA (1931), cat. no. 186, p. 1, 11.

Horace H. Rackham School of Graduate Studies, University of Michigan (Ann Arbor), July 1–31, 1940, *Exhibition of American Painting*, cat. no. 34, p. 12.

Dayton Art Institute (Ohio), February 1–28, 1948, *Maurice Prendergast, Paintings*, no cat.

Dayton Art Institute (Ohio), October 19 – November 11, 1951, *America and Impressionism*, no cat.; toured, November 18 – December 16, 1951, to CGFA.

Brooks Memorial Union, Marquette University (Milwaukee), April 22 – May 3, 1956, *75 Years of American Painting*, cat. no. 59.

AFA, *Children of the City*, checklist no. 19; toured, January 11, 1957 – March 30, 1958, to Atlanta Public Library, New Britain Institute (Connecticut), Art Gallery of Canada (Hamilton, Ontario), J. B. Speed Art Museum (Louisville, Kentucky), Jacksonville Art Museum (Florida), Miami Beach Art Center, Springfield Art Museum (Missouri), Quincy Art Club (Illinois), Dickinson College (Carlisle, Pennsylvania), Greenwich Library (Connecticut), Des Moines Art Center (Iowa), Oklahoma Art Center (Oklahoma City), Philbrook Art Center (Tulsa, Oklahoma).

Art Institute of Zanesville (Ohio), October 7–30, 1960, *Eleven Americans—1860–1960*, checklist.

American Embassy, Belgrade, Yugoslavia, January 16, 1962 – October 14, 1963, *Art in Embassies Project of the International Council of the Museum of Modern Art.*

American Embassy, Buenos Aires, Argentina, on loan November 1965 – June 1966.

CGFA (January 1970), no cat.

CGFA (May 1970), no cat.

CGFA (1970–1971), cat. no. 58 (as dated ca. 1913).

CGFA (1973), cat. no. 45, illus. (as dated ca. 1913).

CGFA (1975), no cat.

San Jose Museum of Art (California), December 5, 1975 – January 10, 1976, *Americans Abroad: Painters of the Victorian Era*, cat., unpag.; also in series catalogue: *American Series: A Catalogue of Eight Exhibitions, April 1974 – December 1977* (1978), unpag.

University of Maryland Art Gallery (College Park), September 1 – October 6, 1976, *Maurice Prendergast*, cat. by Eleanor Green et al., no. 82, pp. 120, 142–144, illus.; toured, October 17, 1976 – April 15, 1977, to University Art Museum (University of Texas, Austin), Des Moines Art Center (Iowa), CGFA, Herbert F. Johnson Museum of Art (Cornell University, Ithaca, New York).

CGFA (1977), no cat.

Tacoma Art Museum (Washington), November 15 – December 30, 1979, *The American Eight*, cat. no. 48, unpag.

SITES, *New Horizons: American Painting 1840–1910*, cat. no. 41, pp. 96, 97, 98, 141, illus.; toured, November 16, 1987 – May 13, 1988, to State Tretyakov Museum (Moscow, USSR), State Russian Museum (Leningrad, USSR), Minsk State Museum of Belorussiya Russia (Minsk, USSR).

REFERENCES:
Forbes Watson, "American Collections No. 1—The Ferdinand Howald Collection," *The Arts* 8 (August 1925): 70, illus.

Margaret Breuning, *Maurice Prendergast*, American Artists Series (1931), pp. 9, 28, 29, illus. (as dated 1915 and erroneously as belonging to the Barnes Foundation).

"Maurice Prendergast—Painter," *Index of Twentieth Century Artists* 2 (March 1935), reprinted in *The Index of Twentieth Century Artists 1933–1937* (1970): 358, 361.

Mahonri Sharp Young, "Letter from Columbus, Ohio: Ferdinand Howald: The Art of the Collector," *Apollo* 90 (October 1969): 340, 341, illus.

Tucker (1969), pp. 90, 91, 148, illus. (as dated ca. 1913?).

Kasha Linville, "The Howald Collection at Wildenstein," *Arts Magazine* 44 (summer 1970): 16, 18, illus. (as dated ca. 1913).

Mahonri Sharp Young, *The Eight* (1973), p. 131, illus.

Richard J. Boyle, *American Impressionism* (1974), pp. 198, 226–227, illus.

Mahonri Sharp Young, "Letter from the U.S.A.: Explosion in a Colour Factory," *Apollo* 105 (March 1977): 207, fig. 2.

CMA, *Catalog* (1978), p. 147, illus.

William H. Gerdts, *American Impressionism* (1984), pp. 288, 289, pl. 383.

Gail Levin, *Twentieth-Century American Painting: The Thyssen-Bornemisza Collection* (1987), pp. 52, 53, illus.

RELATED WORKS:
Landscape with Figures, ca. 1912–1913, oil on canvas, Munson-Williams-Proctor Institute (Utica, New York).

Promenade, 1913, oil on canvas, WMAA.

Promenade, 1913–1915, oil on canvas, Meyer Potamkin Collection.

REMARKS:
Fragments of a label found on the back of the stretcher cite Prendergast's address as "56 Mt. Vernon St., Boston, Mass.," where Maurice and his brother Charles lived from 1903 to December 1914, when they moved to New York. The frame was made by Charles Prendergast.

29 *Beach Scene, New London* 31.170

ENDNOTES:
1. Ira Glackens, *William Glackens and the Ashcan Group* (1957), p. 189.

PROVENANCE:
Daniel Gallery, New York; Ferdinand Howald, New York and Columbus, May 2, 1919, inv. no. 160 (as *The Beach at New London*); CMA, 1931 (gift of Ferdinand Howald).

EXHIBITION HISTORY:
Memorial Art Gallery (Rochester, New York), February 16 – March 7, 1915, *The Modern Movement in American Art*, cat. no. 50, illus.

CGFA (1931), cat. no. 82-a, p. 1, 9 (as *Beach Scene near London*).

WMAA, December 14, 1938 – January 15, 1939, *William Glackens Memorial Exhibition*, cat. no. 42, p. 12 (as *Beach Scene near New London*).

Department of Fine Arts, Carnegie Institute, February 1 – March 15, 1939, *Memorial Exhibition of Works by William J. Glackens*, cat. no. 12, p. 12 (as *Beach Scene near New London*).

CGFA (February 1952), no cat.

Brooks Memorial Union, Marquette University (Milwaukee), April 22 – May 3, 1956, *Festival of American Arts: 75 Years of American Painting*, cat. no. 28.

Contemporary Arts Center and Cincinnati Art Museum, October 12 – November 17, 1957, *An American Viewpoint: Realism in Twentieth Century American Painting*, cat. essay by Alfred Frankenstein, unpag.; toured, November 27 – December 29, 1957, to Dayton Art Institute (Ohio).

Thiel College (Greenville, Pennsylvania), May 5 – June 5, 1961, *Painting of the Month*, no cat.

Denison University (1962), no cat.

AFA, *American Impressionists: Two Generations*, cat. no. 11; toured, October 1, 1963 – May 3, 1965, to Fort Lauderdale Art Center (Florida), Brooks Memorial Art Gallery (Memphis, Tennessee), Cummer Gallery of Art (Jacksonville, Florida), Delaware Art Center (Wilmington), Michigan State University (East Lansing), Evansville Public Museum (Indiana), Roanoke Fine Arts Center (Virginia), Vancouver Art Gallery (British Columbia, Canada), Beaverbrook Art Gallery (Fredericton, New Brunswick, Canada), Queen's University (Kingston, Ontario, Canada), Norman MacKensie Art Gallery (Regina, Saskatchewan, Canada), University of Newfoundland (St. John's, Canada), London

Public Library and Art Museum (London, Ontario, Canada), Art Gallery of Greater Victoria (British Columbia, Canada).

City Art Museum of St. Louis (Missouri), November 18 – December 13, 1966, *William Glackens in Retrospect*, cat. no. 54, illus.; toured, February 1 – June 11, 1967, to National Collection of Fine Arts (Smithsonian Institution, Washington, D.C.), WMAA.

CGFA (1968), no cat.

CGFA (January 1970), no cat.

CGFA (May 1970), no cat.

CGFA (1970–1971), cat. no. 20, illus.

CGFA (1973), cat. no. 15, illus.

CGFA (1975), no cat.

CGFA (1977), no cat.

REFERENCES:
Forbes Watson, "American Collections No. 1—The Ferdinand Howald Collection," *The Arts* 8 (August 1925): 74, illus.

"William J. Glackens—Painter," *Index of Twentieth Century Artists* 2 (January 1935), reprinted in *The Index of Twentieth Century Artists 1933–1937* (1970): 323, 325 (as *Beach Scene Near London*).

Ira Glackens, *William Glackens and the Ashcan Group* (1957), illus. (as *Beach Scene Near New London*).

Tucker (1969), cat. no. 63, pp. 44, 46, illus.

Gerald Carson, "Once More on to the Beach," *American Heritage* 22 (August 1971): 79, illus.

Matthew Baigell, *A History of American Painting* (1971), pp. 193, 277, illus. no. 9–19.

Journal of the American Medical Association 221 (July 1972): 123, cover illus.

Mahonri Sharp Young, *The Eight* (1973), p. 99, illus.

CMA, *Catalog* (1978), pp. 47–49, 140, illus.

CMA, *Selections* (1978), pp. 47–49, illus.

William H. Gerdts, *American Impressionism* (1984), p. 281, pl. 372.

30 *Blue Snow, The Battery* 58.35

ENDNOTES:
1. Charles H. Morgan, *George Bellows: Painter of America* (1965), p. 125.

PROVENANCE:
Emma Bellows, the artist's wife, ca. 1925; Frank Rehn Gallery, New York; Mr. and Mrs. Otto L. Spaeth, New York, 1930s; Spaeth Foundation, New York; CMA, 1958.

EXHIBITION HISTORY:
MMA, October 12 – November 22, 1925, *Memorial Exhibition of the Work of George Bellows*, cat., p. 50, illus. no. 12.

Albright Knox Gallery (Buffalo, New York), January 10 – February 10, 1926, *Memorial Exhibition of the Work of George Bellows*, cat. no. 4, p. 9.

Art Institute of Chicago, January 31 – March 10, 1946, *George Bellows: Paintings, Drawings, and Prints*, cat. no. 11, pp. 20, 39, illus.

CGFA, June 8 – September 1955, *The Spaeth Collection*, cat. no. 2 (as *Battery*).

National Gallery of Art (Washington, D.C.), January 19 – February 24, 1957, *George Bellows: A Retrospective Exhibition*, cat. no. 20, pp. 17, 54, illus.

CGFA, March 21 – April 21, 1957, *Paintings by George Bellows*, cat. no. 17, illus.

United States Information Agency (Moscow, USSR), July 25 – September 5, 1959, *American National Exhibition*, no cat.

Akron Art Institute (Ohio), February 2–28, 1965, *Masterpieces from Our Neighbor Museums*, no cat.

Gallery of Modern Art (New York), March 15 – May 1, 1966, *George Bellows: Paintings, Drawings, Lithographs*, cat. no. 22.

Ohio State Fair, Columbus, August 24 – September 4, 1967, *George Bellows*, cat. no. 6 (as *Along the Battery* or *Blue Snow*).

CMA, April 1 – May 8, 1979, *George Wesley Bellows: Paintings, Drawings, and Prints*, cat. no. 13, p. 24, illus.; toured, June 29 – December 28, 1979, to Virginia Museum (Richmond), Des Moines Art Center (Iowa), Worcester Art Museum (Massachusetts).

Cummer Gallery of Art (Jacksonville, Florida), January 22 – March 8, 1981, *George Bellows: 1882–1925*, cat. no. 17, p. 29, illus.

WMAA (Downtown Branch), February 23 – April 30, 1982, *Lower Manhattan from Street to Sky*, checklist, no. 5.

REFERENCES:

George Bellows, "Studio Books," Book A, p. 88 (H. V. Allison and Co., New York).

Emma S. Bellows, *The Paintings of George Bellows* (1929), no. 24, illus. (as *Blue Snow, The Battery, N.Y.*).

"George Wesley Bellows—Painter and Graver," *Index of Twentieth Century Artists* 1 (March 1934), reprinted in *The Index of Twentieth Century Artists 1933–1937* (1970): 122.

Charles H. Morgan, *George Bellows: Painter of America* (1965), 125.

Mahonri Sharp Young, "George Bellows: Master of the Prize Fight," *Apollo* 89 (February 1969): 135, 137, fig. 5 (as *Along the Battery, Blue Snow*).

Donald Braider, *George Bellows and the Ashcan School of Painting* (1971), pp. 66–67.

Mahonri Sharp Young, *The Paintings of George Bellows* (1973), pp. 54, 55, pl. 17.

Eloise Spaeth, *American Art Museums: An Introduction to Looking*, 3rd ed. (1975), p. 344.

Young (1977), p. 150, illus.

CMA, *Catalog* (1978), p. 135.

James Atlas, "New York for Real," *ARTnews* 82 (September 1983): 72, illus.

Seymour Chwast and Steven Heller, eds., *The Art of New York* (1983), p. 17, illus.

REMARKS:

According to the records of former owner Otto Spaeth, *Blue Snow, The Battery* was exhibited as follows: Madison Gallery, 1911; Columbus, 1912; Copley Gallery (Boston), 1913; Westchester (Pennsylvania), 1915; Addison Gallery, 1944. These exhibitions have not been confirmed. An exhibition of Bellows's work held at the Columbus Public Library in November 1912 did not include this painting.

31 *Riverfront No. 1* 51.11

ENDNOTES:

1. M.C.S. Christman and M. Sadik, *Portraits by George Bellows* (1981), p. 13.

2. Frederick S. Wight, *New Art in America: Fifty Painters of the Twentieth Century*, ed. John I. H. Baur (1957), p. 25.

PROVENANCE:

Emma S. Bellows, the artist's wife; CMA, 1951.

EXHIBITION HISTORY:

Palace of Fine Arts (San Francisco), summer 1915, *Panama-Pacific International Exposition*, Vol. 2, cat. no. 4441, illus. (as *Riverfront*).

Rhode Island School of Design (Providence), October 3–24, 1917, *Autumn Exhibition*, cat. no. 2.

CGFA and Art Association of Columbus, January 30 – February 13, 1918, *Exhibition of Paintings by George Bellows*, cat. no. 9 (as *Riverfront*).

Detroit Museum of Art, April 9 – May 30, 1918, *Fourth Annual Exhibition of Selected Paintings by American Artists*, cat. no. 13; toured, June–July 31, 1918, to Toledo Museum of Art (Ohio), cat. no. 155 (separate cat. published).

Art Gallery of Toronto (Ontario, Canada), 1918, *Canadian National Exhibition*, cat. no. 3.

Art Students League (New York), 1943, *50 Years on 57th Street*, no cat.

Art Institute of Chicago, January 31 – March 10, 1946, *George Bellows: Paintings, Drawings and Prints*, cat. no. 24, pp. 34, 41, illus.

Art Gallery of Toronto (Ontario, Canada), August 26 – September 10, 1949, *Canadian National Exhibition*, cat. no. 61.

National Gallery of Art (Washington, D.C.), January 19 – February 24, 1957, *George Bellows: A Retrospective Exhibition*, cat. no. 27, p. 61, illus.

CGFA, March 21 – April 21, 1957, *Paintings by George Bellows*, cat. no. 33.

M. H. de Young Memorial Museum, California Palace of the Legion of Honor, and San Francisco Museum of Art, November 10, 1964 – January 3, 1965, *Man: Glory, Jest and Riddle*, cat. no. 235 (as *Riverboat #1*).

Gallery of Modern Art (New York), October 19 – November 15, 1965, *About New York: Night and Day*, cat., p. 11.

New York State Exposition (Syracuse), August 30 – September 5, 1966, *125 Years of New York State Painting and Sculpture*.

Grand Rapids Art Museum (Michigan), April 1–30, 1967, *Twentieth Century American Painting*, cat. no. 9 (as *Riverfront*).

Ohio State Fair, Columbus, August 24 – September 4, 1967, *George Bellows*, cat. no. 18.

Akron Art Institute (Ohio), September 27 – November 7, 1971, *Celebrate Ohio*, cat.

Carnegie Institute, October 26, 1974 – January 5, 1975, *Celebration*, cat. no. 53, illus.

Katonah Gallery (New York), November 1, 1975 – January 4, 1976, *American Painting 1900–1976: The Beginning of Modernism 1900–1934*, cat. by John I. H. Baur, no. 1, illus.

CMA, April 1 – May 8, 1979, *George Wesley Bellows: Paintings, Drawings, and Prints*, cat. no. 29, p. 40, illus.; toured, June 29 – December 28, 1979, to Virginia Museum (Richmond), Des Moines Art Center (Iowa), Worcester Art Museum (Massachusetts).

National Gallery of Art (Washington, D.C.), September 5, 1982 – January 2, 1983, *Bellows: The Boxing Pictures*, cat. by E. A. Carmean, Jr., John Wilmerding, Linda Ayres, Deborah Chotner, p. 23, illus. no. 19.

REFERENCES:

George Bellows, "Studio Books," Book A, p. 286 (H. V. Allison and Co., New York).

"Exhibitions in the Galleries," *Arts and Decoration* 5 (April 10, 1915): 238.

"Bellows' Estate," *Art Digest* 1 (January 1927): 11.

"George Wesley Bellows—Painter and Graver," *Index of Twentieth Century Artists* 1 (March 1934), reprinted in *The Index of Twentieth Century Artists 1933–1937* (1970): 128.

"Art Students League Sends Out S.O.S.," *Art Digest* 17 (February 1943): 5, illus. (as *Water Front Number One*).

Richard Graham, "The A.S.L.'s First 50 Years on 57th Street," *ARTnews* 42 (February 1943): 11, illus.

"Recent Acquisitions," *Pictures on Exhibit* 13 (June 1951): 44.

Charles Z. Offin, "Gallery Previews in New York," *Pictures on Exhibit* 13 (July 1951): 11, illus. (as *Riverfront*).

"Columbus' 'Bellows Room,'" *Art Digest* 25 (July 1951): 11, illus.

Frederick S. Wight, "George Bellows," *New Art in America: Fifty Painters of the Twentieth Century*, ed. John I. H. Baur (1957), p. 23, illus.

Charles H. Morgan, *George Bellows: Painter of America* (1965), pp. 180, 185.

Mahonri Sharp Young, "Master of the Prize Fight," *Apollo* 89 (February 1969): 133, 134, fig. 3.

Donald Braider, *George Bellows and the Ashcan School of Painting* (1971), p. 95.

Mahonri Sharp Young, *The Paintings of George Bellows* (1973), p. 90, pl. 35.

George W. Knepper, *An Ohio Portrait* (1976), p. 214, illus. no. 16.

CMA, *Catalog* (1978), pp. 14, 135, illus.

CMA, *Selections* (1978), p. 14, illus.

Seymour Chwast and Steven Heller, eds., *The Art of New York* (1983), pp. 62–63, illus.

REMARKS:

According to the artist's "Studio Books," Book A, p. 286 (H. V. Allison and Co., New York), the painting was also exhibited as follows: MacDowell Club, 1915; Rochester, New York, 1916; Arts Club of Chicago, Illinois, 1917; Newport, Rhode Island, 1917; Lynchburg, Virginia, 1919. No additional information is known concerning these.

32 *Portrait of My Mother No. 1* 30.6

ENDNOTES:

1. Robert Henri, *The Art Spirit* (1960), pp. 26–28.

PROVENANCE:

Emma S. Bellows, the artist's wife; CMA, 1930 (gift of Emma S. Bellows).

EXHIBITION HISTORY:

Galerie de la Chambre Syndicale des Beaux-Arts (Paris), June 9 – July 5, 1924, *Exhibition of American Art*.

CGFA (1931), cat. no. 262, pp. 1, 15 and 1, 16, illus.

CGFA, March 21 – April 21, 1957, *Paintings by George Bellows*, cat. no. 53.

Butler Institute of American Art (Youngstown, Ohio), April 4–30, 1967, *Pageant of Ohio Painters*, cat. no. 7.

Ohio State Fair, Columbus, August 24 – September 4, 1967, *George Bellows*, cat. no. 25, cover illus.

Guild Hall of East Hampton (New York), August 14 – October 3, 1976, *Artists and East Hampton: A 100 Year Perspective*, cat., illus.

CMA, April 1 – May 8, 1979, *George Wesley Bellows: Paintings, Drawings, and Prints*, cat. no. 45, p. 56, illus.; toured, June 19 – December 28, 1979, to Virginia Museum (Richmond), Des Moines Art Center (Iowa), Worcester Art Museum (Massachusetts).

National Portrait Gallery (Washington, D.C.), November 4, 1981 – January 3, 1982, *Portraits by George Bellows*, cat., pp. 9, 48, 49, illus.

REFERENCES:
George Bellows, "Studio Books," Book B, p. 261 (H. V. Allison and Co., New York).

MMA, *George Bellows Memorial Exhibition Catalog* (1925), p. 29.

Emma S. Bellows, *The Paintings of George Bellows* (1929), no. 109, illus.

"A Group of Museum Exhibitions," *Parnassus* 3 (February 1931): 46.

"George Wesley Bellows—Painter and Graver," *Index of Twentieth Century Artists* 1 (March 1934), reprinted in *The Index of Twentieth Century Artists 1933–1937* (1970): 118, 127, 133.

V. M. Hillyer, and E. G. Huey, *A Child's History of Art* (1934), p. 155, illus.

Frank J. Roos, Jr., *An Illustrated Handbook of Art History* (1937), p. 250, fig. B.

Peyton Boswell, Jr., *George Bellows* (1942), p. 77, illus.

Frederick A. Sweet, and Carl O. Schniewind, *George Bellows: Paintings, Drawings and Prints* (exh. cat., Art Institute of Chicago, 1946), p. 23.

"Columbus Honors its Famous Son—Bellows," *Art Digest* 22 (October 1947): 12.

"Columbus' 'Bellows Room,'" *Art Digest* 25 (July 1951): 11.

Eloise Spaeth, *American Art Museums: An Introduction to Looking* (1960), p. 127; 2nd ed. (1969), p. 197; 3rd ed. (1975), p. 344.

[Charles H. Morgan, *George Bellows—Painter of America* (1965), pp. 244, 300].

Mahonri Sharp Young, "George Bellows: Master of the Prize Fight," *Apollo* 89 (February 1969): 141, illus.

Donald Braider, *George Bellows and the Ashcan School of Painting* (1971), fig. 29.

Mahonri Sharp Young, *The Paintings of George Bellows* (1973), p. 138, illus.

Harold Spencer, "Criehaven: A Bellows Pastoral," *Bulletin of The William Benton Museum of Art, The University of Connecticut* 1 (1976–1977): 36.

RELATED WORKS:
My Mother, 1921, oil on canvas, Art Institute of Chicago.

REMARKS:
According to the artist's "Studio Books," Book B, p. 261 (H. V. Allison and Co., New York), the painting was also exhibited as follows: New Society, New York, 1921; Boston Art Club, 1922; Worcester; Pittsburgh, Pennsylvania, 1925; Buffalo, New York, 1926. No additional information is known concerning these.

33 *Men and Mountains* 31.190
ENDNOTES:
1. David V. Erdman, ed., *The Complete Poetry & Prose of William Blake* (rev. ed., 1982), p. 511.

2. Rockwell Kent, *It's Me O Lord: The Autobiography of Rockwell Kent* (1955), p. 269.

3. Ruggles's composition with its lines from Blake was pointed out by pianist Charles Timbrell.

4. Kent, p. 233.

5. Conceptual affinities also appear in contemporaneous scenes by Kent's friend Arthur B. Davies, in particular *Girdle of Ares* (1908, Metropolitan Museum of Art); see Doreen Bolger Burke, *American Paintings in the Metropolitan Museum of Art*, Vol. 3 (1980), p. 426. See also *Dream Vision: The Work of Arthur B. Davies* (exh. cat., Institute of Contemporary Art, Boston, 1981), unpag.

6. Kent, p. 233.

PROVENANCE:
Daniel Gallery, New York; Ferdinand Howald, New York and Columbus, March 14, 1917, inv. no. 80; CMA, 1931 (gift of Ferdinand Howald).

EXHIBITION HISTORY:
CGFA and Art Association of Columbus, January 1911, *Exhibition of Paintings by American Artists*, checklist no. 38, illus.

Gallery of the Society of Beaux Arts Architects (New York), March 26 – April 21, 1911, *Independent Exhibition of the Paintings and Drawings of Twelve Men*, cat. no. 8.

CGFA (1931), cat. no. 106, p. 1, 10.

Bowdoin College Museum of Art (Brunswick, Maine), August 15 – October 15, 1969, *Rockwell Kent: The Early Years*, not in cat.

CGFA (May 1970), no cat.

Santa Barbara Museum of Art (California), June 29 – September 1, 1985, *"An Enkindled Eye": The Paintings of Rockwell Kent*, cat. by Richard V. West, et al., no. 17, pp. 17–18, 44, illus.; toured, October 12, 1985 – May 18, 1986, to CMA, Portland Museum of Art (Maine), Everson Museum of Art (Syracuse, New York).

REFERENCES:
Forbes Watson, "American Collections: No. 1—The Ferdinand Howald Collection," *The Arts* 8 (August 1925): 76, 89, illus. (as *Landscape with Figures*).

"Rockwell Kent—Painter and Graver," *Index of Twentieth Century Artists* 1 (April 1934), reprinted in *The Index of Twentieth Century Artists 1933–1937* (1970): 146, 151 (as *Landscape with Figures*).

Frank J. Roos, Jr., *An Illustrated Handbook of Art History* (1937), p. 275, fig. C (as *Man and Mountains*).

Rockwell Kent, *It's Me O Lord: The Autobiography of Rockwell Kent* (1955), pp. 233, 239, illus. opp. p. 43.

Tucker (1969), cat. no. 82, pp. 55, 57, illus.

Mahonri Sharp Young, "Ferdinand Howald and His Artists," *American Art Journal* 1 (fall 1969): 126, fig. 5.

Richard V. West, "Rockwell Kent Reconsidered," *American Art Review* 4 (December 1977): 132, 133, illus.

CMA, *Catalog* (1978), pp. 64, 143, illus.

CMA, *Selections* (1978), p. 64, illus.

David Traxel, *An American Saga: The Life and Times of Rockwell Kent* (1980), p. 62, illus.

James R. Mellow, "Not Norman Rockwell: An American Saga," *New York Times Book Review*, August 31, 1980, p. 10.

Fridolf Johnson, ed., *Rockwell Kent, An Anthology of His Works* (1982), pp. 27, 258, illus.

34 *The Rocket* 81.9
ENDNOTES:
1. Edward Middleton Manigault Papers, Archives of American Art, Smithsonian Institution, Washington, D.C., Roll D234.

2. "Starves to See New Color," *New York Times*, September 7, 1922.

PROVENANCE:
Alexander Morten, 1910 (purchased from the artist); Earl Luick, New York and Hollywood; Christian Aubosson, New York; Benjamin Garber, ca. 1957; Joan Washburn Gallery, 1980; CMA, 1981.

EXHIBITION HISTORY:
Galleries 29–31 West Thirty-Fifth Street (New York), April 1–27, 1910, *Exhibition of Independent Artists*, cat. no. 7.

Butler Institute of American Art (Youngstown, Ohio), September 14 – October 26, 1986, *Fireworks: American Artists Celebrate the Eighth Art*, cat., unpag., illus. (as *Untitled Landscape [Fireworks]*).

CMA (1986–1987), cat. no. 51, pp. 20, 32 (as *Untitled Landscape [Fireworks]*).

REFERENCES:
Louis A. Zona, "Fireworks: American Artists Celebrate the Eighth Art," *Dialogue* (September–October 1986), p. 65 (as *Untitled Landscape: Fireworks*).

REMARKS:
Listed in artist's notebook: no. 64, The Rocket, Alexander Morten, sold November 20–24, $40.00; also in accounts section of notebook as having been sold in 1910 for $40.00 (E. M. Manigault Papers, Archives of American Art, Smithsonian Institution, Washington, D.C., Roll D234, Frame 760).

35 *Procession* 31.208
ENDNOTES:
1. "Manigault at Daniel Gallery," *American Art News* (March 21, 1914).

2. Charles H. Caffin, "Invention and Artistry Displayed by Manigault," *The New York American* (March 23, 1914).

3. Tracey Atkinson, Elizabeth J. Morris, and James Slagle, "Notes from Interview with Charles Daniel" (CMA archives).

PROVENANCE:
Daniel Gallery, New York, 1913 (acquired from the artist); Ferdinand Howald, New York and Columbus, April 1914, inv. no. 65; CMA, 1931 (gift of Ferdinand Howald).

EXHIBITION HISTORY:
Daniel Gallery (New York), March 1 – April 7, 1914, *Exhibition of Paintings by Middleton Manigault*, cat. no. 3.

CGFA (1931), cat. no. 124, p. 1, 10.

CGFA (1969), checklist no. 19.

CGFA (1970–1971), cat. no. 35, illus.

CGFA (May 1970), no cat.

Grey Art Gallery and Study Center, New York University, October 24 – December 8, 1979, *American Imagination and Symbolist Painting*, cat. by Charles C. Eldredge, no. 36, pp. 113, 114, 156–157, fig. 75; toured, January 20 – March 2,

1980, to Helen Foresman Spencer Museum of Art (University of Kansas, Lawrence).

High Museum of Art (Atlanta), March 4–May 11, 1986, *The Advent of Modernism: Post-Impressionism and North American Art, 1900–1918*, cat. essays by Peter Morris, Judith Zilezer, William C. Agee, pp. 114–115, 186, illus.; toured, June 22, 1986–April 19, 1987, to Center for the Fine Arts (Miami), Brooklyn Museum (New York), Glenbow Museum (Calgary, Alberta, Canada).

REFERENCES:
Review of Manigault Exhibition, *New York Times*, March 21, 1914.

"Manigault at Daniel Gallery," *American Art News*, March 21, 1914.

"Exhibits Scenes in Fifth Avenue: Middleton Manigault Presents Familiar Views in Water Color Work," *New York Press*, March 22, 1914.

"What is Happening in the World of Art," *New York Sun*, March 22, 1914.

Charles H. Caffin, "Invention and Artistry Displayed by Manigault," *New York American*, March 23, 1914.

Forbes Watson, "American Collections No. 1—The Ferdinand Howald Collection," *The Arts* 8 (August 1925): 79, illus.

Elizabeth McCausland, "The Daniel Gallery and Modern American Art," *Magazine of Art* 44 (November 1951): 281.

William H. Pierson, Jr., and Martha Davidson, eds., *Arts of the United States: A Pictorial Survey* (1960), p. 351, illus. no. 3249.

Tucker (1969), cat. no. 107, pp. 70, 71, illus.

CMA, *Catalog* (1978), p. 145.

REMARKS:
Procession is recorded in the artist's notebook, p. 6, as *In the Park—Late Afternoon (Procession)*, painted May 1911; on pp. 33, 37, Manigault recorded the sale of the painting to Daniel Gallery for $20.00 in 1913, and on p. 37 he later recorded receipt of a bonus of $80 from Daniel, apparently related to Howald's purchase in March 1914 (E. M. Manigault Papers, Archives of American Art, Smithsonian Institution, Washington, D.C., Roll D234, Frame 765).

36 *Movement No. 1* 31.166
ENDNOTES:
1. Possibly it is the work described in the *New York Evening Mail* review of the exhibition. See William Innes Homer, "Identifying Arthur Dove's The Ten Commandments," *American Art Journal* 12 (summer 1980): 30.
2. Quoted in Barbara Haskell, *Arthur Dove* (exh. cat., San Francisco Museum of Art, 1975), p. 16.
3. Haskell, pp. 21, 24.

PROVENANCE:
Daniel Gallery, New York; Ferdinand Howald, New York and Columbus, April 28, 1920, inv. no. 175 (as *Movement*); CMA, 1931 (gift of Ferdinand Howald).

EXHIBITION HISTORY:
CGFA (1931), cat. no. 79, p. 1, 9.

Cincinnati Art Museum, February 2–March 4, 1951, *Paintings: 1900–1925*, cat. no. 49.

CGFA (February 1952), no cat.

Art Galleries of the University of California (Los Angeles), May 1–June 15, 1959, *Arthur G. Dove*, cat. by Frederick S. Wight, no. 5, pp. 35, 93; toured, September 30, 1958–September 30, 1959, to WMAA, Phillips Gallery (Washington, D.C.), Museum of Fine Arts (Boston), Marion Koogler McNay Art Institute (San Antonio, Texas), La Jolla Art Center (California), San Francisco Museum of Art.

Denison University (1962), no cat.

Corcoran Gallery of Art (Washington, D.C.), April 27–June 2, 1963, *The New Tradition: Modern Americans Before 1940*, cat. no. 34, pp. 24, 58, illus.

Public Education Association (New York), *Seven Decades 1895–1965: Crosscurrents in Modern Art*, cat. by Peter Selz, no. 100, p. 62, illus.; April 26–May 21, 1966, at M. Knoedler & Co. (New York).

Bernard Danenberg Galleries (New York), March 24–April 12, 1969, *The Second Decade*, cat.

CGFA (January 1970), no cat.

CGFA (May 1970), no cat.

CGFA (1970–1971), cat. no. 18.

Fine Arts Gallery of San Diego, November 20, 1971–January 2, 1972, *Color and Form 1909–1914*, cat. by Henry G. Gardiner, no. 17, pp. 55, 93, illus.; toured, January 25–May 7, 1972, to Oakland Museum (California), Seattle Art Museum.

Ohio State University (1973), cat. no. 25, illus.

CGFA (1973), cat. no. 14, illus.

Delaware Art Museum and University of Delaware (Wilmington), April 4–May 18, 1975 (Delaware Art Museum), *Avant-Garde Painting and Sculpture in America 1910–25*, cat., pp. 66, 67, illus.

AFA, *American Master Drawings and Watercolors: Works on Paper from Colonial Times to the Present*, checklist, p. 6 (book published simultaneously; see References: Stebbins, 1976); toured, September 1, 1976–April 17, 1977, to Minneapolis Institute of Arts, WMAA, Fine Arts Museums of San Francisco.

Grey Art Gallery and Study Center, New York University, October 24–December 8, 1979, *American Imagination and Symbolist Painting*, cat. by Charles Eldredge, no. 20, pp. 120, 148, fig. 82 (as one of *The Ten Commandments*); toured, January 20–March 2, 1980, to Helen Foresman Spencer Museum of Art (University of Kansas).

Phillips Collection (Washington, D.C.), June 13–August 16, 1981, *Arthur Dove and Duncan Phillips: Artist and Patron*, cat. by Sasha M. Newman, no. 7, pp. 65, 145, pl. 1; toured, September 11, 1981–November 14, 1982, to High Museum of Art (Atlanta), William Rockhill Nelson Gallery of Art—Atkins Museum of Fine Arts (Kansas City, Missouri), Museum of Fine Arts (Houston), CMA, Seattle Art Museum, New Milwaukee Art Center.

REFERENCES:
"Arthur G. Dove—Painter," *Index of Twentieth Century Artists* 3 (January 1936), reprinted in *The Index of Twentieth Century Artists 1933–1937* (1970): 512.

Tucker (1969), cat. no. 59, pp. 42, 43, illus.

Kasha Linville, "Critique: The Howald Collection at Wildenstein," *Arts Magazine* 44 (summer 1970): 16, 18, illus.

Kasha Linville, "Howald's American Line," *ARTnews* 69 (summer 1970): 55.

"Art Across North America: Outstanding Exhibitions," *Apollo* 95 (March 1972): 222, fig. 5.

Marina Vaizey, "Ferdinand Howald: Avant-Garde Collector," *Arts Review* 25 (June 1973): 440.

Christopher Neve, "A Crucial American Collection," *Country Life* 154 (July 1973): 25, fig. 4.

Ann Lee Morgan, "Toward the Definition of Early Modernism in America: A Study of Arthur Dove," Ph.D. diss., University of Iowa, 1973, Vol. 1, cat. no. 11.11, pp. 233, 234, 450, illus.

Young (1974), pp. 90, 91, pl. 34.

Theodore E. Stebbins, Jr., *American Master Drawings and Watercolors* (1976), pp. 6, 302, 303, fig. 262.

William Innes Homer, *Alfred Stieglitz and the American Avant-Garde* (1977), pp. 118, 120, 121, fig. 58 (as one of *The Ten Commandments*).

William Innes Homer, "Identifying Arthur Dove's The Ten Commandments," *American Art Journal* 12 (summer 1980): 30, fig. 9 (as one of *The Ten Commandments*, 1911–1912).

CMA, *Catalog* (1978), pp. 40–41, 159, illus.

CMA, *Selections* (1978), pp. 40–41, illus.

Ann Lee Morgan, *Arthur Dove: Life and Work, With a Catalogue Raisonné* (1984), cat. no. 11/12.3, pp. 43, 44, 104, 105, illus.

REMARKS:
Tucker (1969), p. 43 notes: "*Movement No. 1* was later entitled *Nature Symbolized*; it was shown by Stieglitz in 1912 with other undated works of the same name." The belief that the work was included in Dove's first one-artist show at Stieglitz's 291 Gallery (February 27–March 12, 1912, *Arthur G. Dove First Exhibition Anywhere*, and March 14–30, 1912, at the W. Scott Thurber Galleries, Chicago) as one of the pastels that have become known as "The Ten Commandments" (see Homer, 1980) is based on the painting's stylistic compatibility with other pastels in the proposed group. In addition, a white label banded in red on the work's reverse reads: "Arthur G. Dove/291 Fifth Avenue/New York/C." And another inscription in pencil reads: "4–20/Daniel/Forum Exhibition/Dove/Arthur G. Dove/Feb. to. . . . (?) June with slip fill in blank."

If the work was renamed *Nature Symbolized*, in all probability it was shown in the Anderson Galleries (New York), March 13–25, 1916, *Forum Exhibition of Modern American Painters*, cat. no. 19 (as *Nature Symbolized C*); and in the National Arts Club (New York), February 5–March 7, 1914, *Exhibition of Contemporary Art*, cat. no. 22 (as *Nature Symbolized No. 3*).

37 *Thunderstorm* 31.167
ENDNOTES:
1. Quoted in B. Haskell, *Arthur Dove* (exh. cat., San Francisco Museum of Art, 1975), p. 118.

PROVENANCE:
(Sale: Anderson Galleries, New York, February 23, 1922, cat. no. 171); Ferdinand Howald, New York and Columbus, 1922, inv. no. 216; CMA, 1931 (gift of Ferdinand Howald).

EXHIBITION HISTORY:
CGFA (1931), cat. no. 80, p. 1, 9.

CGFA (1935), no cat.

Taft Museum (Cincinnati), January 31–March 18, 1951, *History of an American: Alfred Stieglitz: "291" and After*, cat. no. 96, p. 15.

CGFA (February 1952), no cat.

CGFA (October 1952), no cat.

Norfolk Museum (Virginia), March 1953, *Significant American Moderns*, cat., unpag.

Art Galleries of the University of California (Los Angeles), May 1 – June 15, 1959, *Arthur G. Dove*, cat. by Frederick S. Wight, no. 13, p. 93; toured, September 30, 1958 – September 30, 1959, to W M A A, Phillips Collection (Washington, D.C.), Museum of Fine Arts (Boston), Marion Koogler McNay Art Institute (San Antonio, Texas), La Jolla Art Center (California), San Francisco Museum of Art.

C G F A (May 1970), no cat.

C G F A (1970–1971), cat. no. 19, illus.

University Art Museum, University of Texas at Austin, October 15 – December 17, 1972, *Not So Long Ago: Art of the 1920s in Europe and America*, cat., p. 37, illus.

Minneapolis Institute of Arts, *Painters and Photographers of Gallery 291* (also entitled *I Am An American: Artists of Gallery 291*); Artmobile Tour, August 1, 1973 – August 1, 1974, statewide.

C G F A (1977), no cat.

Phillips Collection (Washington, D.C.), June 13 – August 16, 1981, *Arthur Dove and Duncan Phillips: Artist and Patron*, cat. by Sasha M. Newman, no. 14, pp. 76, 146, pl. 12; toured, September 11, 1981 – November 14, 1982, to High Museum of Art (Atlanta), William Rockhill Nelson Gallery of Art–Atkins Museum of Fine Arts (Kansas City, Missouri), Museum of Fine Arts (Houston), C M A, Seattle Art Museum, New Milwaukee Art Center.

Birmingham Museum of Art (Alabama), September 12 – November 4, 1987, *The Expressionist Landscape: North American Landscape Painting 1920–1945*, cat. no. 38, p. 30, fig. 75; toured November 24, 1987 – August 21, 1988, to IBM Gallery of Science and Art (New York), Akron Art Museum (Ohio), Vancouver Art Gallery (British Columbia).

REFERENCES:
"Arthur G. Dove—Painter," *Index of Twentieth Century Artists* 3 (January 1936), reprinted in *The Index of Twentieth Century Artists 1933–1937* (1970): 512 (as watercolor).

Wallace Spencer Baldinger, "Formal Change in Recent American Painting," *Art Bulletin* 19 (December 1937): 586, 588, fig. 13.

Raymond Sites, *The Arts and Man* (1940), p. 812.

Tucker (1969), cat. no. 60, pp. 43, 45, illus.

Ann Lee Morgan, "Toward the Definition of Early Modernism in America: A Study of Arthur Dove," Ph.D. diss., University of Iowa, 1973, no. 21.5, p. 240.

Young (1974), pp. 96, 97, pl. 37.

C M A, *Catalog* (1978), p. 139.

Ann Lee Morgan, *Arthur Dove: Life and Work, With a Catalogue Raisonné* (1984), cat. no. 21.5, pp. 124–125, illus.

RELATED WORKS:
Thunderstorm, 1917–1920, charcoal on paper, University of Iowa Art Museum (Iowa City).

Thundershower, 1939–1940, oil and wax emulsion on canvas, Amon Carter Museum of Western Art (Fort Worth, Texas).

REMARKS:
An unpublished list of Dove's paintings, annotated by the artist (and still in his family's possession in 1978) includes the entry, "Thunder Storm, oil," followed by the note "1920, Howald, Westport."

38 *Autumn Leaves—Lake George, N.Y.* 81.6

ENDNOTES:
1. *Georgia O'Keeffe* (1977), illus. p. 27.
2. Susan Fillin Yeh, "Innovative Moderns: Arthur G. Dove and Georgia O'Keeffe," *Art Magazine* 52 (June 1982): 69.
3. Lloyd Goodrich and Doris Bry, *Georgia O'Keeffe* (exh. cat., W M A A, 1970), p. 19.

PROVENANCE:
An American Place, New York, until 1946 (acquired from the artist); Doris Bry, New York; Martin Diamond, New York; John Berggruen Gallery, San Francisco, November 1977; Coe Kerr Gallery, New York, October, 1978; private collection, after October 1979; Coe Kerr Gallery, New York, 1981; C M A, 1981.

EXHIBITION HISTORY:
[An American Place (New York), January 27 – March 11, 1935, *Georgia O'Keeffe: Exhibition of Paintings (1919–1934)*, checklist no. 7 (as *Autumn Leaves*, 1926)].

C M A (1986–1987), cat. no. 49, pp. 20, 32.

REFERENCES:
[Inventory of Georgia O'Keeffe works, WMAA papers, 1946, Archives of American Art, Smithsonian Institution, Washington, D.C., Roll N678, Frame 002–003 (as *Autumn Leaves*, 1924)].

Fine Art Reproductions of Old and Modern Masters (1978), p. 340, fig. 5030.

REMARKS:
According to John Berggruen, when the painting was in his possession there was an unfinished painting on the reverse of the canvas. The painting has since been relined.

39 *Cosmos* (formerly *The Mountains*) 31.179

ENDNOTES:
1. Samuel M. Kootz, *Modern American Painters* (1930), p. 40; quoted in Barbara Haskell, *Marsden Hartley* (exh. cat., W M A A, 1980), p. 13.
2. Haskell, p. 17.
3. Ibid., p. 14.
4. Gail Levin, "Marsden Hartley and Mysticism," *Arts Magazine* 60 (November 1985), p. 16.
5. Hartley to Seumus O'Sheel, October 19, 1908, quoted in Haskell, p. 17.

PROVENANCE:
Alfred Stieglitz, New York (acquired from the artist); Daniel Gallery, New York; Ferdinand Howald, New York and Columbus, January 1917 (as *Mountain [Cosmos]*), inv. no. 69; C M A, 1931 (gift of Ferdinand Howald).

EXHIBITION HISTORY:
Little Galleries of the Photo-Secession (New York), May 8–18, 1909, *Exhibition of Paintings in Oil by Mr. Marsden Hartley of Maine*, no. 2.

C G F A (1931), cat. no. 94, p. I, 9 (as *The Mountains*).

Cincinnati Modern Art Society, October 24 – November 24, 1941, *Marsden Hartley / Stuart Davis*, cat., p. 10 (as *The Mountains*, ca. 1908).

C G F A, Paintings from the Columbus Gallery of Fine Arts, no cat.; March 1965, to Otterbein College (Westerville, Ohio) (as *The Mountains*).

University Galleries, University of Southern California (Los Angeles), November 20 – December 20, 1968, *Marsden Hartley: Painter/Poet*

1877–1943, cat. no. 21, illus. (as *The Mountains*, 1908); toured, January 10 – April 27, 1969, to Tucson Art Center (Arizona), Art Museum (University of Texas, Austin).

C G F A (January 1970), no cat.

C G F A (May 1970), no cat.

Corcoran Gallery of Art (Washington, D.C.), October 9 – November 14, 1971, *Wilderness*, cat. no. 94 (as *The Mountains*, 1909).

C G F A (1973), cat. no. 20, illus.

C G F A (1975), no cat.

C G F A (1977), no cat.

W M A A, March 4 – May 25, 1980, *Marsden Hartley 1877–1943*, cat. by Barbara Haskell, no. 3, pp. 14, 17, 146, 212, pl. 71; toured, June 10, 1980 – January 4, 1981, to Art Institute of Chicago, Amon Carter Museum of Western Art (Fort Worth, Texas), University Art Museum (University of California, Berkeley).

Art Gallery of Ontario (Toronto, Canada), January 14 – March 11, 1984, *The Mystic North: Symbolist Landscape Painting in Northern America, 1890–1940*, cat. no. 136, pp. 205, 206, 207, illus.; toured, April 1 – May 15, 1984, to Cincinnati Art Museum.

Salander-O'Reilly Galleries (New York), March 6 – April 27, 1985, *Marsden Hartley: Paintings and Drawings*, cat. essay by Karen Wilkin, no. 1, illus.

REFERENCES:
"Marsden Hartley—Painter," *Index of Twentieth Century Artists* 3 (January 1936), reprinted in *The Index of Twentieth Century Artists 1933–1937* (1970): 514 (as *Mountains*).

Tucker (1969), no. 65, pp. 51, 53, illus.

Kasha Linville, "Howald's American Line," *ARTnews* 69 (summer 1970): 54, 55, illus. (as *The Mountains*, 1909).

Kasha Linville, "The Howald Collection at Wildenstein," *Arts Magazine* 44 (summer 1970): 16 (as *The Mountains*, 1909).

David W. Scott, et al., "Marsden Hartley," *Britannica Encyclopedia of American Art* (1973), p. 270 (as *The Mountains*, 1909).

Young (1974), pp. 68, 69, pl. 23 (as *The Mountains*, 1909).

C M A, *Catalog* (1978), pp. 53–54, 141, illus. (as *The Mountains*, 1909).

C M A, *Selections* (1978), pp. 53–55, illus. (as *The Mountains*, 1909).

Karin Anhold Rabbito, "Man Ray in Quest of Modernism," *Rutgers Art Review* (January 1981): 59, 60, fig. 2 (as dated 1908).

Susan Fillin Yeh, "Innovative Moderns: Arthur G. Dove and Georgia O'Keeffe," *Arts Magazine* 56 (June 1982): 68.

William H. Gerdts, *American Impressionism* (1984), pp. 291, 298, fig. 394 (as *The Mountains*, 1909).

Gail Levin, "Marsden Hartley and Mysticism," *Arts Magazine* 60 (November 1985): 16, fig. 1.

RELATED WORKS:
Carnival of Autumn, 1908–1909, oil on canvas, Museum of Fine Arts (Boston).

The Summer Camp, 1908–1909, oil on canvas, Fine Arts Museums of San Francisco.

40 *Berlin Ante War* 31.173

ENDNOTES:

1. Hartley, in a letter to Stieglitz dated July 31–August 1, 1914, as cited by Barbara Haskell, *Marsden Hartley, 1877–1943* (exh. cat., WMAA, 1980), p. 42.
2. Gail Levin, "Hidden Symbolism in Marsden Hartley's Military Pictures," *Arts Magazine* 54 (October 1979): 158; illus. in Haskell, p. 43.
3. In August 1913 Hartley wrote Stieglitz that he was exploring the mystical significance of the number 8, which he saw everywhere in Berlin (see William Innes Homer, *Alfred Stieglitz and the American Avant-garde* [1977], p. 222).
4. "Hartley's Exhibition," *Camera Work* 48 (October 1916): 12; Levin, p. 154.
5. Ibid., p. 59 (Levin, p. 155).
6. Haskell, p. 43.
7. Ibid., pp. 42–43.
8. Ibid., p. 43.
9. Gail Levin, "Marsden Hartley and The European Avant-Garde," *Arts Magazine* 54 (September 1979): 160–161.
10. Letter of November 8, 1914; quoted in Haskell, p. 44.

PROVENANCE:

Arthur B. Davies, New York (acquired from the artist); (sale: American Art Association, New York, April 17, 1929, estate of Arthur B. Davies, cat. no. 436, as *Berlin Anti-War*); Ferdinand Howald, New York and Columbus, April 17, 1929, inv. no. 354; CMA, 1931 (gift of Ferdinand Howald).

EXHIBITION HISTORY:

[Münchener Graphik—Verlag (Berlin, Germany), October 1915, *Marsden Hartley*].

[Little Galleries of the Photo-Secession (New York), April 4–22, 1916, *Paintings by Marsden Hartley*].

CGFA (1931), cat. no. 88, p. 1, 9 (as *Berlin Anti War*).

Cincinnati Modern Art Society, October 24 – November 24, 1941, *Marsden Hartley: Stuart Davis*, cat., p. 10 (as dated 1915).

CGFA (1968), no cat.

CGFA (May 1970), no cat.

CGFA (1970–1971), cat. no. 25, illus. (as dated ca. 1914–1915).

CGFA (1973), cat. no. 23, illus. (as dated ca. 1914–1915).

CGFA (1975), no cat.

CGFA (1977), no cat.

C.W. Post Art Gallery, Long Island University (Greenvale, New York), November 6 – December 14, 1977, *Marsden Hartley, 1877–1943*, cat. no. 8, p. 32, cover illus. (as dated ca. 1914–1915).

WMAA, March 4 – May 25, 1980, *Marsden Hartley, 1877–1943*, cat. by Barbara Haskell, no. 23, pp. 43, 47, 214, fig. 38, pl. 17 (as dated 1914); toured, June 10, 1980 – January 4, 1981, to Art Institute of Chicago, Amon Carter Museum of Western Art (Fort Worth, Texas), University Art Museum (University of California, Berkeley).

REFERENCES:

"Marsden Hartley—Painter," *Index of Twentieth Century Artists* 3 (January 1936), reprinted in *The Index of Twentieth Century Artists 1933–1937* (1970): 514 (as *Berlin Anti War*).

Tucker (1969), cat. no. 72, pp. 50, 52, illus. (as dated 1914–1915).

Mahonri Sharp Young, "The Man from Ohio: Ferdinand Howald and His Painters," *The Arts in Ireland* 2, no. 3 (1974): 7, illus. (as *Berlin, Anti-War*).

Young (1974), pp. 78, 79, pl. 28 (as dated 1915).

Arthur B. Davies: Artist and Collector (exh. cat., Rockland Center for the Arts and Edward Hopper Landmark Preservation Foundation, 1977), illus. under cat. no. 62.

CMA, *Catalog* (1978), pp. 53, 141, illus.

CMA, *Selections* (1978), p. 53, illus.

Gail Levin, "Marsden Hartley and The European Avant-Garde," *Arts Magazine* 54 (September 1979): 160, 161, fig. 6.

Rosana Barry, "The Age of Blood and Iron: Marsden Hartley in Berlin," *Arts Magazine* 54 (October 1979): 171.

Gail Levin, "Hidden Symbolism in Marsden Hartley's Military Pictures," *Arts Magazine* 54 (October 1979): 157, 158, fig. 11.

J. P. Forsthoffer, "Building on Existing Strengths," *Horizon* (November 1984): 31, illus.

41 *The Spent Wave, Indian Point, Georgetown, Maine* 81.13

ENDNOTES:

1. Marsden Hartley, "On the Subject of Nativeness—A Tribute to Maine" (1917), published in *Marsden Hartley: Exhibition of Recent Paintings* (exh. cat., An American Place, 1936); reprinted in *On Art*, ed. Gail R. Scott (1982), p. 115.
2. Gail R. Scott, "Marsden Hartley at Dogtown Common," *Arts Magazine* 54 (October 1979): 160.
3. Barbara Haskell, *Marsden Hartley, 1877–1943* (exh. cat., WMAA, 1980), p. 82.
4. "Not to 'Dilate Over the Wrong Emotion,'" *Art Digest* 12 (March 15, 1938): 21.
5. Letter dated October 1, 1937, Archives of American Art, Smithsonian Institution, Washington, D.C., Roll D268.
6. Ronald Nasgaard, *The Mystic North: Symbolist Landscape Painting in Northern Europe and North America, 1890–1940* (1984). p. 213.
7. Haskell, p. 111.
8. Hartley, "On the Subject of Mountains," unpublished essay, quoted in Haskell, p. 17.

PROVENANCE:

Hudson D. Walker Gallery, New York, 1938; Museum of Modern Art, New York, 1940; (sale: Parke-Bernet Galleries, New York, May 11, 1944, *Notable Paintings and Sculptures, Property of the Museum of Modern Art*, cat. no. 41, p. 15, illus. [as *The Spent Wave*]); Walter Bareiss, New York and Greenwich, Connecticut, 1944 – ca. 1962; E. V. Thaw and Company, New York; Mr. and Mrs. Harry W. Anderson, Atherton, California, mid-1960s; Hirschl and Adler Galleries, 1981; CMA, 1981.

EXHIBITION HISTORY:

Hudson D. Walker Gallery (New York), February 28 – April 2, 1938, *Marsden Hartley: Recent Paintings of Maine*, cat. no. 16 (as *The Spent Wave [Indian Point, Georgetown]*).

MMA, April 19–27, 1941, *Contemporary Painting in the United States*, cat. no. 68, p. 14 (as *The Spent Wave*); Spanish version of cat. *La Pintura Contemporanea Norteamericana*, p. 57 (as *The Spent Wave*); toured, July 3 – December 8, 1941, to Museo Nacional de Bellas Artes (Buenos Aires, Argentina), Galeria del Teatro Solis (Montevideo, Uruguay), Museu de Belas Artes (Rio de Janeiro, Brazil).

MoMA, *Thirty European and American Paintings* (as *The Spent Wave*); toured, September 7, 1943 – April 3, 1944, to State University of Iowa (Iowa City), Vanderbilt University (Nashville, Tennessee), Vassar College (Poughkeepsie, New York), Amherst College (Massachusetts), Society for the Four Arts (Palm Beach, Florida), Wellesley College (Massachusetts).

Stedelijk Museum (Amsterdam, Holland) and AFA, December 1, 1960 – March 25, 1962, *Marsden Hartley*, cat. essay by Elizabeth McCausland (*The Spent Wave* not cited in cat.); European tour, December 1960 – March 1962 (*The Spent Wave* not included); American tour (including *The Spent Wave*), August 12, 1961 – April 8, 1962, to Portland Museum of Art (Maine), Walker Art Center (Minneapolis), City Art Museum (St. Louis, Missouri), Cincinnati Art Museum, WMAA.

Taft Museum (Cincinnati), September 25 – December 5, 1982, *1930s Remembered: "The Fine Arts"*, cat., unpag.

CMA (1986–1987), cat. no. 53, pp. 20, 33.

REFERENCES:

"Marsden Hartley, Noted Artist, Dies," *New York Times*, Friday, September 3, 1943 (as *The Spent Wave*).

Vivian Endicott Barnett, "Marsden Hartley's Return to Maine," *Arts Magazine* 54 (October 1979): 175 (as *The Spent Wave*).

Barbara Haskell, *Marsden Hartley, 1877–1943*, (exh. cat., WMAA, 1980), p. 199.

RELATED WORKS:

Rising Wave, Indian Point, Georgetown, Maine, 1937–1938, oil on academy board, Baltimore Museum of Art (Maryland).

42 *Sunset, Maine Coast* 31.233

ENDNOTES:

1. John Marin, "Notes on '291': The Water Colors of John Marin," *Camera Work* (April–July 1913): 18.
2. Quoted from a manuscript dated August 26, 1928, in *John Marin by John Marin*, ed. Cleve Gray (no copyright date), p. 161.

PROVENANCE:

Daniel Gallery, New York; Ferdinand Howald, New York and Columbus, CMA, 1931 (gift of Ferdinand Howald).

EXHIBITION HISTORY:

CGFA (1931), cat. no. 149, p. 1, 11 (as *Sunset*).

CGFA (1935), no cat.

Dudley Peter Allen Memorial Art Museum, Oberlin College (Ohio), January 7 – January 29, 1941, *John Marin Watercolors*, no cat.

Colorado Springs Fine Arts Center, April 4 – June 11, 1947, *Exhibition of the Work of Homer, Sargent, and Marin.*

University of Michigan Museum of Art (Ann Arbor), May 4–25, 1948, *John Marin Watercolor Exhibition*; toured, January 7 – June 23, 1948, to Cranbrook Academy of Art (Detroit), Grand Rapids Art Gallery (Michigan), Hackley Art Gallery (Muskegon, Michigan), Michigan State

College (East Lansing), Flint Institute of Fine Arts (Michigan).

Norton Gallery of Art (West Palm Beach, Florida), February 3–26, 1950, *Masters of Water Color: Marin, Demuth, and Prendergast*, checklist no. 1 (as *Sunset*, 1919).

Venice (Italy), June 8 – October 15, 1950, *XXV Biennale Internazionale d'Arte di Venezia*, cat. no. 36 (as *Tramonto*, 1919).

CGFA, Ferdinand Howald Collection Pictures; May 1951, to Cleveland Institute of Art, no cat.

CGFA (October 1952), no cat.

Kalamazoo Institute of Arts (Michigan), April 5–30, 1953, *John Marin*, no cat.

AFA, *Pioneers of American Abstract Art*, cat. no. 22, p. 6 (as *Sunset*, 1919); toured, December 1, 1955 – January 9, 1957, to Atlanta Public Library, Louisiana State Exhibit Museum (Shreveport), J.B. Speed Art Museum (Louisville, Kentucky), Lawrence Museum (Williamstown, Massachusetts), George Thomas Hunter Gallery (Chattanooga, Tennessee), Rose Fried Gallery (New York).

CGFA (1958–1960), no cat.

St. Paul Episcopal Church, Chillicothe (Ohio), June 16–18, 1961, *Festival of the Arts*, cat. no. 2 (as *Sunset*).

MoMA, *The Stieglitz Circle*, checklist (as dated 1919); toured, February 1, 1962 – June 9, 1963, to J.B. Speed Art Museum (Louisville, Kentucky), Quincy Art Club (Illinois), Charles and Emma Frye Art Museum (Seattle), University of Oregon Museum of Art (Eugene), Boise Art Association (Idaho), Allentown Art Museum (Pennsylvania), Gibbes Art Gallery (Charleston, South Carolina), Brooks Memorial Art Gallery (Memphis, Tennessee), Public Library of Winston-Salem and Forsyth County (North Carolina), Duke University (Durham, North Carolina), Rochester Memorial Art Gallery (New York), Augustana College (Rock Island, Illinois), Fine Arts Patrons of Newport Harbor (California).

Montclair Art Museum (New Jersey), February 23 – March 29, 1964, *John Marin: America's Modern Pioneer (A Retrospective Exhibition of the Watercolors and Oil Paintings from 1903–1953)*, cat. no. 13 (as dated 1919).

Huntington, West Virginia, Arts Festival, July 20 – August 20, 1966, no cat.

Springfield Art Association (Ohio), March 14 – April 17, 1967, *Opening Exhibition of Springfield Art Center*, no cat.

Allen County Museum Gallery (Lima, Ohio), January 12 – February 11, 1968, *Freedom and Order Exhibit*, checklist no. 19 (as dated 1919).

Cincinnati Art Museum, February 14 – March 16, 1969, *Three American Masters of Watercolor: Marin, Demuth, Pascin*, cat. essay by Richard J. Boyle, no. 13, pp. 11, 15, illus. (as dated 1919).

CGFA (May 1970), no cat.

CGFA (1970–1971), cat. no. 44 (as *Sunset Coast*, 1919).

CGFA (1973), cat. no. 31, illus. (as dated 1919).

CGFA (1975), no cat.

PAFA, April 22 – December 31, 1976, *In This Academy: The Pennsylvania Academy of the Fine Arts, 1805–1976*, cat. no. 291, p. 310 (as dated 1919).

CGFA (1977), no cat. (as dated 1919).

Hudson River Museum (Yonkers, New York), October 30, 1983 – January 8, 1984, *The Book of Nature: American Painters and the Natural Sublime*, cat., pp. 60, 66, 108, illus. fig. 50 (as dated 1919).

REFERENCES:

CGFA (1931), cat. no. 149, p. I, 11.

"John Marin — Painter," *Index of Twentieth Century Artists* 1 (October 1933), reprinted in *The Index of Twentieth Century Artists 1933–1937* (1970): 12, 23 (as *Sunset*).

E. M. Benson, *John Marin: The Man and His Work* (1935), p. 41, pl. 17 (as dated 1919).

E. M. Benson, "John Marin: The Man and His Work (Part 1: Marin, the Man)," *American Magazine of Art* 28 (October 1935): 606, illus. (as dated 1919).

Tucker (1969), cat. no. 124, pp. 77, 79, illus. (as dated 1919).

Sheldon Reich, *John Marin: A Stylistic Analysis and Catalogue Raisonné*, Part II (1970), cat. no. 19.41, p. 474, illus.

Young (1974), p. 34, pl. 6 (as dated 1919).

CMA, *Catalog* (1978), p. 164 (as dated 1919).

Christopher Finch, *American Watercolors* (1986), p. 184, illus. no. 236 (as dated 1919).

43 *Jazz* 31.253

ENDNOTES:

1. Quoted in Arturo Schwarz, *New York Dada: Duchamp, Man Ray, Picabia* (1973), p. 87.

2. Quoted in Zabriskie Gallery (New York), *Man Ray: Publications and Transformations* (1982), unpag.

3. *Jazz* was dated 1919 by Arturo Schwarz (in letter of May 9, 1977, to the CGFA).

4. Man Ray, *Self Portrait* (1963), p. 72. Man Ray's desire to eliminate the traditional tools and methods of painters anticipates Jackson Pollock's concerns of the later 1940s.

5. Ibid.

6. See Mona Hadler, "Jazz and the Visual Arts," *The Arts* (June 1983): 91–101.

7. Ibid., p. 94.

PROVENANCE:

Daniel Gallery, New York; Ferdinand Howald, New York and Columbus, April 1926, inv. no. 314; CMA, 1931 (gift of Ferdinand Howald).

EXHIBITION HISTORY:

Daniel Gallery (New York), November 17 – December 1, 1919, *Man Ray: An Exhibition of Selected Drawings and Paintings Accomplished During the Period 1913–1919*, checklist no. 18.

CGFA (1931), cat. no. 194, p. I, 12.

CGFA (1935), no cat.

CGFA, *Pictures from the Ferdinand Howald Collection*, June 9 – August 31, 1951, Hilltop Public Library (Columbus, Ohio), no cat.

Junior Art Gallery (Louisville, Kentucky), September 16 – November 15, 1957, *The Big City*, cat. no. 31.

University of Minnesota Art Gallery, April 4 – May 18, 1958, *Music in Art*, no cat.; toured, June 15 – July 29, 1958, to Grand Rapids Art Gallery (Michigan).

CGFA (1961), no cat.

New Gallery, University of Iowa (Iowa City), May 24 – August 2, 1962, *Vintage Moderns: American Pioneer Artists 1903–1932*, cat. essay by Frank Seiberling, no. 58, pp. 23, 26, illus.; WMAA, February 27 – April 14, 1963, *The Dec-*

ade of The Armory Show: New Directions in American Art 1910–1920, cat. essay by Lloyd Goodrich, no. 80, pp. 60, 74, illus.; toured, June 1, 1963 – February 23, 1964, to City Art Museum of St. Louis, Cleveland Museum of Art, PAFA, Art Institute of Chicago, Albright-Knox Art Gallery (Buffalo, New York).

Los Angeles County Museum of Art, October 27, 1966 – January 1, 1967, *Man Ray*, cat. no. 30, p. 55.

Grand Rapids Art Museum (Michigan), April 1–30, 1967, *20th Century American Painting*, cat. essay by Anne E. Warnock, no. 15, pp. 11, 12, 40, illus.

CGFA (1969), checklist no. 32.

CGFA (January 1970), no cat.

CGFA (May 1970), no cat.

CGFA (1970–1971), cat. no. 33, illus. (as dated ca. 1919).

Birmingham Museum of Art (Alabama), January 16 – February 13, 1972, *American Watercolors 1850–1972*, cat., pp. 35, 70, illus. (as dated ca. 1919); toured, February 22 – March 13, 1972, to Mobile Art Gallery (Alabama).

Ohio State University (1973), cat. no. 30, illus.

New York Cultural Center, in association with Fairleigh Dickinson University (Rutherford, New Jersey), December 19, 1974 – March 2, 1975, *Man Ray: Inventor, Painter, Poet*, cat. no. 218, illus.; toured, April 11 – September 30, 1975, to Institute of Contemporary Arts (London, England), Il Palazzo delle Esposizioni di Roma (Italy), Italian cat. no. 38, pp. 60, 125, 126.

Solomon R. Guggenheim Museum (New York), January 23 – March 21, 1976, *Twentieth-Century American Drawing: Three Avant-Garde Generations*, cat. essay by Diane Waldman, no. 44, p. 48, illus. (as dated ca. 1919).

AFA, *American Master Drawings and Watercolors: Works on Paper from the Colonial Times to the Present*, checklist, p. 14; toured, September 1, 1976 – April 17, 1977, to Minneapolis Institute of Arts, WMAA, Fine Arts Museums of San Francisco.

Grand Rapids Art Museum (Michigan), October 1 – November 30, 1977, *Themes in American Painting*, cat. by J. Gray Sweeney, pp. 172, 173, pl. 86.

Tate Gallery (London, England), February 6 – April 13, 1980, *Abstraction: Towards a New Art: Painting 1910–1920*, cat. no. 446, p. 120.

REFERENCES:

Milton W. Brown, *American Painting from the Armory Show to the Depression* (1955, reprinted 1970), p. 105, illus.

Carl Belz, *The Role of Man Ray in the Dada and Surrealist Movements* (1963), pp. 94–95, fig. 47.

Lloyd Goodrich, *Pioneers of Modern Art in America: The Decade of the Armory Show, 1910–1920* (1963), p. 60, illus.

Tucker (1969), cat. no. 104, pp. 68, 69, illus. (as dated ca. 1919).

Mahonri Sharp Young, "Ferdinand Howald and His Artists," *American Art Journal* 1 (fall 1969), p. 122, fig. 3.

George Heard Hamilton, *19th and 20th Century Art* (1970), p. 295, fig. 273.

Kasha Linville, "Howald's American Line," *ARTnews* 69 (summer 1970): 55.

Roland Penrose, *Man Ray* (1975), pp. 46–48, 50, illus. no. 23.

Theodore E. Stebbins, Jr., *American Master*

Drawings and Watercolors (1976), pp. 308, 309, fig. 268.

Arturo Schwarz, *Man Ray: The Rigour of Imagination* (1977), pp. 47, 51, illus. no. 47.

CMA, *Catalog* (1978), pp. 73–74, 164, illus.

CMA, *Selections* (1978), pp. 73–74, illus.

Victoria Thorson, ed., *Great Drawings of All Time: The Twentieth Century*, Vol. 2 (1979), cat. no. 259, illus. (as dated ca. 1919).

Howard Risatti, "Man Ray: The Work," *Man Ray: Photographs and Objects* (exh. cat., Alabama: Birmingham Museum of Art, 1980), pp. 23, 24, fig. 13.

Elizabeth Turner, "The Great American Artistic Migration to Paris between the Great War and the Great Depression," Ph.D. diss., University of Virginia, 1985; see Turner, *American Artists in Paris 1919–1929* (1988, forthcoming).

Christopher Finch, *American Watercolors* (1986), pp. 206, 207, fig. 264.

44 *Regatta* 31.256

ENDNOTES:

1. Man Ray, quoted in *Phaidon Encyclopedia of Art and Artists* (1978), p. 542.

2. Man Ray, *Self Portrait* (1963), p. 103.

PROVENANCE:

Ferdinand Howald, New York and Columbus, March 1927, inv. no. 335 (purchased from the artist); CMA, 1931 (gift of Ferdinand Howald).

EXHIBITION HISTORY:

CGFA (1931), cat. no. 197, p. I, 12.

CGFA (1935), no cat.

CGFA (February 1952), no cat.

CGFA (October 1952), no cat.

Denison University (1962), no cat.

CGFA (1969), checklist no. 31.

CGFA (May 1970), no cat.

CGFA (1970–1971), cat. no. 34.

New York Cultural Center, in association with Fairleigh Dickinson University (Rutherford, New Jersey), December 19, 1974 – March 2, 1975, *Man Ray: Inventor, Painter, Poet*, cat. no. 24, illus.; toured, April 11 – September 30, 1975, to Institute of Contemporary Arts (London, England), Il Palazzo delle Esposizioni di Roma (Italy).

REFERENCES:

Tucker (1969), cat. no. 105, pp. 66, 69, illus.

Mahonri Sharp Young, "Ferdinand Howald and His Artists," *American Art Journal* 1 (fall 1969): p. 122, fig. 2.

CMA, *Catalog* (1978), p. 145.

45 *Telephone* 31.263

ENDNOTES:

1. Ben Wolf, *Morton Livingston Schamberg* (1963), pp. 30–33; William C. Agee, *Morton Livingston Schamberg* (exh. cat., New York: Salander-O'Reilly Galleries, Inc., 1982), pp. 5–10.

2. Agee, p. 10.

3. Agee, pp. 10–11.

PROVENANCE:

M. Knoedler & Co., New York; John Quinn, New York, June 3, 1919, Quinn ledgers, 1913–1924, vol. 1, p. 287; John Quinn estate, 1924; (sale: American Art Association, New York,

February 9–12, 1927, cat. no. 106, p. 46, as *The Telephone*); Ferdinand Howald, New York and Columbus, 1927, inv. no. 331; CMA, 1931 (gift of Ferdinand Howald).

EXHIBITION HISTORY:

M. Knoedler & Co. (New York), May [10]–24, 1919, *Paintings and Drawings by Morton L. Schamberg*, cat. no. 8.

CGFA (1931), cat. no. 207, p. I, 12.

Walker Art Center (Minneapolis), November 13 – December 31, 1960, *The Precisionist View in American Art*, cat. by Martin L. Friedman, p. 57; toured, January 24 – August 6, 1961, to WMAA, Detroit Institute of Art, Los Angeles County Museum of Art, San Francisco Museum of Art.

New Gallery, University of Iowa (Iowa City), May 24 – August 2, 1962, *Vintage Moderns: American Pioneer Artists: 1903–1932*, cat. no. 60, p. 24.

PAFA, November 21 – December 24, 1963, *Paintings by Morton L. Schamberg (1881–1918)*, checklist no. 32 (as *The Telephone*).

Zabriskie Gallery (New York), January 6–25, 1964, *Morton L. Schamberg (1881–1918)*, cat. no. 17, illus. (as *The Telephone*).

Milwaukee Art Center, April 9 – May 9, 1965, *Pop Art and the American Tradition*, cat. by Tracy Atkinson, no. 57, pp. 2, 12, 15, illus. (as *The Telephone*).

National Collection of Fine Arts (Washington, D.C.), December 2, 1965 – January 9, 1966, *Roots of Abstract Art in America 1910–1930*, cat. no. 146, illus.

University of New Mexico Art Museum (Albuquerque), February 10 – March 19, 1967, *Cubism: Its Impact in the USA 1910–1930*, cat. by Clinton Adams, no. 51, pp. 50, 51, illus.; toured, April 9 – August 27, 1967, to Marion Koogler McNay Art Institute (San Antonio, Texas), San Francisco Museum of Art, Los Angeles Municipal Art Gallery.

CGFA (1969), checklist no. 33.

CGFA (January 1970), no cat.

CGFA (May 1970), no cat.

CGFA (1970–1971), cat. no. 63, illus.

Museum of Fine Arts (St. Petersburg, Florida), October 6 – November 4, 1973, *The City and the Machine*, cat. (printed in *Pharos* 40, no. 2 [1973]), by Bradley Nickels and Margie Miller, no. 26, pp. 37, 41, illus.; toured, November 15, 1973 – February 10, 1974, to Loch Haven Art Center (Orlando, Florida), Cummer Gallery of Art (Jacksonville, Florida).

National Collection of Fine Arts (Washington, D.C.), May 9 – July 6, 1975, *Pennsylvania Academy Moderns 1910–1940*, cat. no. 39, p. 34, illus.; toured, July 30 – September 6, 1975, to School of the Pennsylvania Academy of the Fine Arts.

Museum of Fine Arts (Houston), July 1 – September 25, 1977, *Modern American Paintings 1910–1940: Toward a New Perspective*, cat. by William C. Agee, no. 66, pp. 12, 24, illus.

Hirshhorn Museum and Sculpture Garden, (Washington, D.C.), June 15 – September 4, 1978, *"The Noble Buyer:" John Quinn, Patron of the Avant-Garde*, cat. by Judith Zilczer, no. 68, pp. 139, 183, illus.

Salander-O'Reilly Galleries (New York), November 3 – December 31, 1982, *Morton Livingston Schamberg (1881–1918)*, cat. by William C. Agee and Pamela Ellison, no. 33, illus. (as *Painting 1 [Telephone]*); toured, January 22, 1983 – March 27, 1984, to CMA, School of the

Pennsylvania Academy of the Fine Arts, Milwaukee Art Museum.

Brooklyn Museum (New York), October 17, 1986 – February 16, 1987, *The Machine Age in America, 1918–1941*, checklist, unpag.; toured, April 4, 1987 – February 14, 1988, to Carnegie Institute, Los Angeles County Museum of Art, High Museum of Art (Atlanta).

REFERENCES:

Estate of John Quinn, Deceased, "Catalogue of the Art Collection Belonging to Mr. Quinn," July 28, 1924, John Quinn Memorial Collection, New York Public Library, inv., unpag.

John Quinn, 1870–1925, Collection of Paintings, Water Colors, Drawings and Sculpture (1926), p. 25 (as *The Telephone*).

"Sale of the Quinn Collection is Completed," *Art News* 25 (February 1927): 1 (as *The Telephone*).

Milton W. Brown, *American Painting from the Armory Show to the Depression* (1955, reprinted 1970), p. 117, illus.

William H. Pierson, Jr., and Martha Davidson, eds., *Arts of the United States: A Pictorial Survey* (1960), no. 3353, p. 358, illus.

Ben Wolf, *Morton Livingston Schamberg* (1963), no. 42, pp. 52, 97, illus. (as *The Telephone*).

Lillian Natalie Dochterman, "The Stylistic Development of the Work of Charles Sheeler," Ph.D. diss., State University of Iowa, 1963, pp. 26, 133, fig. 23.

Vivien Raynor, "In the Galleries," *Arts Magazine* 38 (March 1964): 61, illus. (as *The Telephone*).

Tucker (1969), cat. no. 155, pp. 95, 98, illus.

George Heard Hamilton, *19th and 20th Century Art* (1970), p. 300, fig. 278.

Matthew Baigell, *A History of American Painting* (1971), pp. 213, 281, fig. 10–16.

Marshall B. Davidson, *The Artists' America* (1973), p. 293, illus.

Perry London, *Beginning Psychology* (1975), p. 571, illus. (as *The Telephone*); rev. ed. (1978), p. 619, illus.

Henry F. Graff and Paul Bohannan, *The Promise of Democracy* (1978), p. 662, illus.

Susan Fillin Yeh, "Charles Sheeler's 1923 'Self-Portrait,'" *Arts Magazine* 52 (January 1978): 108, illus.

CMA, *Catalog* (1978), pp. 106–107, 149, illus.

CMA, *Selections* (1978), pp. 106–107, illus.

Julie Wosk, "Artists on Technology," *Technology Review* 82 (December–January 1980): 68, fig. b.

Susan Fillin Yeh, "Charles Sheeler and the Machine Age," Ph.D. diss., City University of New York, 1981, pp. 85–86, 268, pl. 16.

William C. Agee, "Morton Livingston Schamberg (1881–1918): Color and the Evolution of His Painting," *Arts Magazine* 57 (November 1982): 116–119, illus. (as *Painting I [Telephone]*).

Horace Freeland Judson, "Reweaving the Web of Discovery," *The Sciences* 23 (November–December 1983): 53, illus.

Board of Governors of the Federal Reserve System, *Morton Livingston Schamberg: Color and Evolution of His Painting*, unpag., fig. 1; reprinted from Agee (exh. cat., 1982).

46 Constructivist Still Life 63.6

ENDNOTES:

1. Thomas Hart Benton, *An American in Art: A Professional and Technical Autobiography* (1969), p. 33.

2. Benton in a letter to the CGFA, August 6, 1962.

3. Ibid.

4. Ibid.

PROVENANCE:

[Sale: Anderson Galleries, New York, February 23, 1922]; [Ferdinand Howald, New York and Columbus, 1922, inv. no. 217 (*Still life*)]; Carl A. Magnuson, Columbus, ca. 1943; CMA, 1963 (gift of Carl A. Magnuson).

EXHIBITION HISTORY:

Indiana University (1964), cat. no. 5, illus. (as *Early Abstraction, 1917*, oil on cardboard).

M. Knoedler & Co. (New York), October 12 – November 6, 1965, *Synchromism and Color Principles in American Painting 1910–1930*, cat. by William C. Agee, no. 1, pp. 10, 28 (as dated 1919), 49, illus. (as *Constructivist Still Life: Synchromist Color*, 1917).

ACA Heritage Gallery (New York), March 14 – April 9, 1966, *Commemorating the 50th Anniversary of The Forum Exhibition of Modern American Painters*, cat. no. 4 (as *Constructivist, Still Life*).

MoMA, *Synchromism and Related American Color Painting 1910–1930*, organized by William C. Agee (based on Knoedler's 1965 exhibition), checklist no. 2, illus. (as *Constructivist Still Life: Synchromist Color*, 1917); toured, February 4, 1967 – June 17, 1968, to State University College (Oswego, New York), Santa Barbara Museum of Art (California), California Institute of Arts (Los Angeles), Allen Memorial Art Museum (Oberlin College, Ohio), Rose Art Museum (Brandeis University, Waltham, Massachusetts), Museum of Art (Rhode Island School of Design, Providence), Goucher College (Towson, Maryland), Cummer Gallery of Art (Jacksonville, Florida), San Francisco Museum of Art.

Madison Art Center (Wisconsin), March 22 – April 12, 1970, *Thomas Hart Benton*, checklist.

Ohio Exposition Center, Fine Arts Exhibition at ExpOhio '71 (Columbus), August 26 – September 6, 1971, *Thomas Hart Benton: Profiles of America*, checklist no. 31 (as *Constructivist Still Life, Synchromist*, 1917).

Fine Arts Gallery of San Diego, November 20, 1971 – January 2, 1972, *Color and Form 1909–1914*, cat. by Henry G. Gardiner with contributions by Joshua C. Taylor, Peter Selz, Lilli Lonngren, Herschel B. Chipp, and William C. Agee, no. 3, pp. 46, 93, illus. (as *Constructivist Still Life, Synchromist Color*, 1917); toured, January 25 – May 7, 1972, to Oakland Museum (California), Seattle Art Museum (Pavilion, Washington).

University Art Gallery, Rutgers University (New Brunswick, New Jersey), November 19 – December 30, 1972, *Thomas Hart Benton: A Retrospective of His Early Years, 1907–1929*, cat. no. 19, fig. 8 (as *Constructivist Still Life, 1917–1918*).

Ohio State University (1973), cat. no. 29, illus. (as *Constructivist Still Life, Synchromist Color*).

Delaware Art Museum and the University of Delaware (Wilmington), April 4 – May 18, 1975, *Avant-Garde Painting and Sculpture in America 1910–1925*, cat., pp. 32, 33, illus. (as *Constructivist Still Life, Synchromist Color*).

San Jose Museum of Art (California), October 19 – November 28, 1976, *America VII: America Between the Wars*, checklist, unpag.; also in catalogue of exhibition series: *American Series: A Catalogue of Eight Exhibitions, April 1974 – December 1977* (1978), unpag., illus. (as *Constructivist Still Life, Synchromist Color*).

WMAA, January 24 – March 26, 1978, *Synchromism and American Color Abstraction 1910–1925*, book accompanying exh. by Gail Levin (1978), p. 137, pl. 120 (as *Constructivist Still Life: Synchromist Color*, 1917); toured, April 20, 1978 – March 24, 1979, to Museum of Fine Arts (Houston), Des Moines Art Center (Iowa), San Francisco Museum of Modern Art, Everson Museum of Art (Syracuse, New York), CMA.

REFERENCES:

William C. Agee, "Synchromism: The First American Movement," *ARTnews* 64 (October 1965): 30, illus. (as *Constructivist Still-Life*, 1917, subtitled *Synchromist Color*).

Thomas Hart Benton, "An American in Art: A Professional and Technical Autobiography," *Kansas Quarterly* 1 (spring 1969): 83, illus.

Matthew Baigell, "Thomas Hart Benton in the 1920's," *Art Journal* 29 (summer 1970): 424, fig. 4.

Sam Hunter, *American Art of the 20th Century* (1972), p. 87, fig. 152; rev. ed. (1973), p. 107, fig. 184 (as *Constructivist Still Life, Synchromist Color*, 1917).

Matthew Baigell, *Thomas Hart Benton* (1973), p. 45, pl. 21.

Sumio Kuwabara, "American Art from the Beginning of the Twentieth Century until the Eve of World War II," *Mizue* 1 (January 1976): 31, illus.

CMA, *Selections* (1978), p. 17, illus.

Milton W. Brown, et al., *American Art* (1979): 384, pl. 402 (said to have been in Forum Exhibition of Modern American Painting in 1916).

Gail Levin, "Thomas Hart Benton, Synchromism and Abstract Art," *Arts Magazine* 56 (December 1981): 145, 148, fig. 7 (as *Constructivist Still Life, Synchromist Color*, 1917).

"Thomas Hart Benton," *The Oxford Companion to Twentieth-Century Art*, ed. by Harold Osborne (1981), p. 53.

Abraham A. Davidson, *Early American Modernist Painting 1910–1935* (1981), p. 133.

James M. Dennis, *Grant Wood: Still Lifes as Decorative Abstractions* (exh. cat., Elvehjem Museum of Art, University of Wisconsin, 1985), pp. 4, 5, fig. 2.

47 California Landscape 31.275

ENDNOTES:

1. William C. Agee, *Synchromism and Color Principles in American Painting 1910–1930* (exh. cat., M. Knoedler & Co., 1965), pp. 7–12, 19.

2. Gail Levin, *Synchromism and American Color Abstraction 1910–1925* (exh. cat., WMAA, 1978), p. 14; Alastair Alpin MacGregor, *Percyval Tudor-Hart 1873–1954: Portrait of an Artist* (1969), p. 114.

3. Morgan Russell letter to Andrew Dasburg, March 12, 1914, quoted in Agee, p. 19.

4. See Levin, p. 27, for additional commentary on Orphism and Synchromism.

5. Agee, p. 2; Levin, p. 9.

PROVENANCE:

Daniel Gallery, New York; Ferdinand Howald, New York and Columbus, November 8, 1920,

inv. no. 188 (*California Landscape [Blue and Green Fantasy]*), or July 1923, inv. no. 262 (*California Landscape*); CMA, 1931 (gift of Ferdinand Howald).

EXHIBITION HISTORY:

CGFA (1931) cat. no. 234, p. 1, 12.

Rose Fried Gallery (New York), November 20 – December 31, 1950, *3 American Pioneers of Abstract Art*, checklist no. 2.

CGFA (February 1952), no cat.

Denison University (1962), no cat.

New Gallery, University of Iowa (Iowa City), May 24 – August 2, 1962, *Vintage Moderns: American Pioneer Artists: 1903–1932*, cat. essay by Frank Seiberling, no. 28, pp. 13, 15, illus.

Corcoran Gallery of Art (Washington, D.C.), April 27 – June 2, 1963, *The New Tradition: Modern Americans Before 1940*, cat. essay by Gudmund Vigtel, no. 68, p. 62 (as dated ca. 1916).

Indiana University (1964), cat. no. 44, illus. (as dated 1916).

National Collection of Fine Arts (Washington, D.C.), December 2, 1965 – January 9, 1966, *Roots of Abstract Art in America 1910–1930*, cat. no. 102 (as dated ca. 1916).

National Collection of Fine Arts (Washington, D.C.), May 4 – June 18, 1967, *The Art of Stanton Macdonald-Wright*, cat. no. 9, pp. 27, 28, illus. (as dated 1916).

PAFA, January 31 – March 3, 1968, *Early Moderns*, checklist no. 12 (as dated ca. 1916).

CGFA (1969), checklist no. 18 (as dated ca. 1916).

CGFA (January 1970), no cat.

CGFA (May 1970), no cat.

CGFA (1970–1971), cat. no. 32, illus.

CGFA (1973), cat. no. 26, illus.

CGFA (1975), no cat.

CGFA (1977), no cat.

WMAA, January 24 – March 26, 1978, *Synchromism and American Color Abstraction 1910–1925*, book accompanying exh. by Gail Levin (1978), p. 140, pl. 118 (as dated ca. 1916); toured, April 20, 1978 – March 24, 1979, to Museum of Fine Arts (Houston), Des Moines Art Center (Iowa), San Francisco Museum of Modern Art, Everson Museum of Art (Syracuse, New York), CMA.

Allentown Art Museum (Pennsylvania), March 3 – May 30, 1987, *Modernist Idylls: Nature and the Avant-Garde, 1905–1930*, cat. no. 20, illus.

REFERENCES:

Tucker (1969), cat. no. 177, pp. 110, 113, 115, illus.

Helen Mullaly, "Certainties in Twentieth-Century Art," *Apollo* 98 (July 1973): 51, fig 3.

UNESCO (Paris, France), *Catalogue of Reproductions of Paintings 1860 to 1973* (1974), p. 194, fig. 700 (as *Paysage de Californie*).

New York Graphic Society, *Fine Art Reproductions of Old and Modern Masters* (1978), p. 363, illus.

CMA, *Catalog* (1978), pp. 72–73, 144, illus.

CMA, *Selections* (1978), pp. 72–73, illus.

48 Factory 31.153

ENDNOTES:

1. Interview with Moritz Jagendorf, conducted

by Richard Rubenfeld, New York City, July 29, 1978.

2. The other three works, all from the early 1920s, are: *Modern Industry* (Dartmouth College Museum and Galleries, Hanover, New Hampshire), which is the study for the Columbus Museum's *Factory*; *Industry II* (WMAA); and *Industry* (Museum of Fine Arts, Houston).

PROVENANCE:
Daniel Gallery, New York; Ferdinand Howald, New York and Columbus, April 1922, inv. no. 224; CMA, 1931 (gift of Ferdinand Howald).

EXHIBITION HISTORY:
[Daniel Gallery (New York), closing March 20, 1923, *Paintings and Drawings by Preston Dickinson*, cat. no. 1 (as *Factories*)].

CGFA (1931), cat. no. 67, p. 1, 9.

[Knoedler Galleries (New York), February 8–27, 1943, *Preston Dickinson Exhibition of Paintings*, cat. no. 25 (as *Factories*, 1925)].

CGFA (October 1952), no cat.

Walker Art Center (Minneapolis), November 13 – December 25, 1960, *The Precisionist View in American Art*, cat. essay by Martin L. Friedman, pp. 41, 55, illus. (as dated 1924); toured, January 24 – August 6, 1961, to WMAA, Detroit Institute of Art, Los Angeles County Museum of Art, San Francisco Museum of Art.

MoMA (administered by), American Embassy, Belgrade, Yugoslavia, January 16, 1962 – October 14, 1963, *Art in Embassies Program of the International Council of the Museum of Modern Art*, no cat.

School of the Pennsylvania Academy of the Fine Arts, January 31 – March 3, 1968, *Early Moderns*, cat. no. 8.

CGFA (1969), checklist no. 9 (as dated 1924).

CGFA (May 1970), no cat.

CGFA (1970–1971), cat. no. 15 (as dated 1924).

University Art Museum, University of Texas at Austin, October 15 – December 17, 1972, *Not So Long Ago: Art of the 1920s in Europe and America*, cat., p. 35, illus. (as dated 1924).

CGFA (1973), cat. no. 12, illus. (as *Factories*, 1924).

CGFA (1975), no cat. (as *Factories*).

Delaware Art Museum, and University of Delaware (Wilmington), April 4 – May 18, 1975 (at Delaware Art Museum), *Avant-Garde Painting & Sculpture in America 1910–25*, cat., p. 172 (as dated 1920?).

National Collection of Fine Arts (Washington, D.C), April 30 – November 7, 1976, *America as Art*, cat. essay by Joshua C. Taylor, no. 223 (as dated 1924).

CGFA (1977), no cat. (as *Factories*).

Heckscher Museum (Huntington, New York), July 7 – August 20, 1978, *The Precisionist Painters 1916–1949: Interpretations of a Mechanical Age*, cat., p. 29.

Sheldon Memorial Art Gallery, University of Nebraska—Lincoln, September 4 – October 7, 1979, *Preston Dickinson 1889–1930*, cat. essay by Ruth Cloudman, no. 21, pp. 25, 52, 53, pl. 4; toured, December 18, 1979 – August 10, 1980, to WMAA, University Art Museum (University of New Mexico, Albuquerque), Colorado Springs Fine Arts Center, Georgia Museum of Art (University of Georgia, Athens).

Hirschl and Adler Galleries (New York), October 29 – November 29, 1980, *Buildings: Ar-chitecture in American Modernism*, cat. no. 27, pp. 5, 30–31, illus. (as dated ca. 1921).

Cedar Rapids Museum of Art (Iowa), June 25 – September 19, 1982, *Twentieth Century American Masters 1911–1957*, cat. by Joseph S. Czestochowski, no. 20, illus.; toured, January 16 – November 14, 1982, to Miami University Museum of Art (Oxford, Ohio), Tennessee Botanical Gardens and Fine Arts Center (Nashville), Springfield Art Museum (Missouri).

Brooklyn Museum (New York), October 7, 1986 – February 16, 1987, *The Machine Age in America 1918–1941*, checklist, unpag. (as dated 1924); toured, April 4, 1987 – February 14, 1988, to Carnegie Institute, Los Angeles County Museum of Art, High Museum of Art (Atlanta).

REFERENCES:
Forbes Watson, "Preston Dickinson," *The Arts* 5 (May 1924): 288, illus. (as *Factories*, Daniel Galleries).

Tucker (1969), cat. no. 50, pp. 37, 39, illus. (as *Factories*, 1924).

"Preston Dickinson—Painter," *Index of Twentieth Century Artists* 3 (January 1936), reprinted in *The Index of Twentieth Century Artists 1933–1937* (1970): 510, 511, 525 (as *Factories*).

John Wilmerding, ed., *The Genius of American Painting* (1973), p. 241, illus. (as dated 1924).

Marina Vaizey, "Ferdinand Howald: Avant-Garde Collector," *Arts Review* 25 (June 1973): 440 (as *Factories*, 1924).

Joshua C. Taylor, *America as Art* (1976), p. 200, illus.

CMA, *Catalog* (1978), pp. 37–38, 138, illus.

CMA, *Selections* (1978), pp. 37–38, illus.

Abraham A. Davidson, *Early American Modernist Paintings, 1910–1935* (1981), pp. 210, 211, fig. 109.

49 *Still Life with Yellow-Green Chair* 31.164

PROVENANCE:
Daniel Gallery, New York; Ferdinand Howald, New York and Columbus, November 1928, inv. no. 349; CMA, 1931 (gift of Ferdinand Howald).

EXHIBITION HISTORY:
MoMA, December 13, 1929 – January 12, 1930, *Paintings by Nineteen Living Americans*, cat. no. 17, pp. 21, 23, illus. (as *Still Life*).

CGFA (1931), cat. no. 77, p. 1, 9.

MoMA, September 14 – October 18, 1936, *American Art Portfolios*, checklist; published simultaneously: *American Art Portfolios: The First Series* (1936), no. 11, illus. (as *Still Life*).

MoMA, May 24 – October 15, 1944, *Art in Progress: Fifteenth Anniversary Exhibition*, cat., pp. 78, 220, illus.

CGFA (February 1952), no cat.

Contemporary Arts Center, Cincinnati Art Museum, October 12 – November 17, 1957, *An American Viewpoint: Realism in Twentieth Century American Painting*, cat. essay by Alfred Frankenstein, illus.; toured, November 27 – December 29, 1957, to Dayton Art Institute (Ohio).

Walker Art Center (Minneapolis), November 13 – December 25, 1960, *The Precisionist View in American Art*, cat. essay by Martin L. Friedman, pp. 44, 47, 55, illus.; toured, January 24 – August 6, 1961, to WMAA, Detroit Institute of Arts, Los Angeles County Museum of Art, San Francisco Museum of Art.

Indiana University (1964), cat. no. 20, p. 37, illus.

National Collection of Fine Arts (Washington, D.C.), December 2, 1965 – January 9, 1966, *Roots of Abstract Art in America 1910–1930*, cat. no. 41.

University of New Mexico Art Museum and Junior League of Albuquerque, February 10 – March 19, 1967, *Cubism: Its Impact in the USA, 1910–1930*, cat. no. 26, p. 28, illus.; toured, April 9 – August 27, 1967, to Marion Koogler McNay Art Institute (San Antonio, Texas), San Francisco Museum of Art, Los Angeles Municipal Art Gallery.

AFA, *American Still Life Painting 1913–1967*, cat. by William H. Gerdts, no. 8, illus.; toured, October 6, 1967 – November 14, 1968, to Cedar Rapids Art Center (Michigan), Roberson Memorial Center (Binghamton, New York), Huntington Galleries (West Virginia), Portland Museum of Art (Maine), Flint Institute of Arts (De Waters Art Center, Michigan), Mansfield Fine Arts Guild (Ohio), Allentown Art Museum (Pennsylvania), Kalamazoo Institute of Art (Michigan), Cornell University (Ithaca, New York), Dulin Gallery of Art (Knoxville, Tennessee), University of Maryland (College Park).

CGFA (January 1970), no cat.

CGFA (May 1970), no cat.

CGFA (1970–1971), cat. no. 16, illus.

CGFA (1973), cat. no. 13, illus.

CGFA (1975), no cat.

CGFA (1977), no cat.

Sheldon Memorial Art Gallery, University of Nebraska–Lincoln and Nebraska Art Association (Lincoln), September 4 – October 7, 1979, *Preston Dickinson 1889–1930*, cat. by Ruth Cloudman, no. 67, Foreword, and pp. 34, 35, 62, 63, illus.; toured, December 18, 1979 – August 10, 1980, to WMAA, University Art Museum (University of New Mexico, Albuquerque), Colorado Springs Fine Arts Center, Georgia Museum of Art (University of Georgia, Athens).

Taft Museum (Cincinnati), April 4 – June 7, 1981, *Small Paintings from Famous Collections*, cat. unpag.

REFERENCES:
The Art News 28 (December 14, 1929): 7, illus. (as *Still Life*, as lent by Cleveland Museum of Art).

Forbes Watson, "The All American Nineteen," *The Arts* 16 (January 1930): 306, illus. (as *Still Life*).

Samuel M. Kootz, *Modern American Painters* (1930), pl. 15 (as *Still Life with Chair*).

"A Group of Museum Exhibitions," *Parnassus* 3 (February 1931): 46 (as *Still Life with Bottle*).

Samuel M. Kootz, "Preston Dickinson," *Creative Art* 8 (May 1931): 340, illus. (as *Still Life*).

"Preston Dickinson—Painter," *Index of Twentieth Century Artists* 3 (January 1936), reprinted in *The Index of Twentieth Century Artists 1933–1937* (1970): 510, 511, 525 (as *Still Life with Chair*).

Catalogue of Selected Color Reproductions Prepared for the Carnegie Corporation of New York, Vol. 1 (1936), unpag.

Walter Pach, "A First Portfolio of American Art," *ARTnews* 35 (October 1936): 12, illus. (as *Still Life in Oils*).

Philip McMahon, "New Books on Art," *Parnassus* 8 (December 1936): 35, illus. (as *Still Life*).

Fine Art Reproductions, Old & Modern Masters

(New York Graphic Society, 1951), p. 274, no. 6676.

Lee H. B. Malone, "He Chose with Conviction," *Carnegie Magazine* 26 (March 1952): 79, illus.

Lillian Natalie Dochterman, "The Stylistic Development of the Work of Charles Sheeler," Ph.D. diss., State University of Iowa, 1963; pp. 19–20, 130, fig. 17.

Milton W. Brown, *American Painting from the Armory Show to the Depression* (1955, reprinted 1970), p. 129, illus.

William H. Pierson, Jr., and Martha Davidson, eds., *Arts of the United States: A Pictorial Survey* (1960), p. 338, illus. no. 3078.

Tucker (1969), cat. no. 58, pp. 36, 40, fig. 58.

Phaidon Dictionary of Twentieth-Century Art (1973), p. 96.

"NRTA Treasury of American Painting," *NRTA Journal* 28 (November–December 1977): 47, illus.

CMA, *Catalog* (1978), pp. 39–40, 138, illus.

CMA, *Selections* (1978), pp. 39–40, illus.

Abraham A. Davidson, *Early American Modernist Painting 1910–1935* (1981), pp. 207, 208, fig. 106.

Matthew Baigell, *Dictionary of American Art* (Harper and Row Icon Editions, 1979; reprinted 1982), p. 96.

50 *Lhasa* 31.100

ENDNOTES:

1. *Charles Sheeler Papers*, Archives of American Art, Smithsonian Institution, Washington, D.C., Roll NSH-1, Frame 3.

2. Charles Sheeler, quoted in Constance Rourke, *Charles Sheeler: Artist in the American Tradition* (1938), p. 119; see also Martin Friedman, *Charles Sheeler* (1975), p. 71.

3. Theodore E. Stebbins, Jr., and Norman Keyes, Jr., *Charles Sheeler: The Photographs* (exh. cat., Museum of Fine Arts, Boston, 1987), pp. 3, 53, n. 10.

4. John Claude White, *Tibet and Lhasa*. See Stebbins and Keyes, p. 4, fig. 6.

5. Friedman, pp. 30–31.

PROVENANCE:

Modern Gallery, New York; John Quinn, New York, November 9, 1917, Quinn ledgers, 1913–1924, vol. 1, p. 264 (as *Landscape*); Quinn Estate, New York, 1924; (sale: American Art Association, New York, February 9–12, 1927, cat. no. 496, p. 194, as *Landscape No. 3*); Ferdinand Howald, New York and Columbus, 1927, inv. no. 334; CMA, 1931 (gift of Ferdinand Howald).

EXHIBITION HISTORY:

CGFA (1931), cat. no. 214, p. I, 12 (as *Impressionism*).

MoMA, October 4 – November 1, 1939, *Charles Sheeler: Paintings, Drawings, Photographs*, intro. by William Carlos Williams, cat. no. 8, pp. 10, 46.

CGFA, Paintings from the Howald Collection, no cat.; November 23 – December 10, 1941, to Art Center (Parkersburg, West Virginia).

Cincinnati Art Museum, March 12 – April 14, 1941, *A New Realism: Crawford, Demuth, Sheeler, Spencer*, cat. no. 24, p. 14.

Dayton Art Institute (Ohio), November 2 – December 2, 1944, *Paintings by Charles Sheeler*, no cat.

WMAA, April 9 – May 19, 1946, *Pioneers of Modern Art in America*, cat. by Lloyd Goodrich, no. 139, p. 27, illus. (as *Impressionism [Lhasa]*); toured, July 1, 1946 – May 30, 1947, to University of Michigan (Ann Arbor), George Walter Vincent Smith Art Museum (Springfield, Massachusetts), Wilmington Society of Fine Arts (Delaware), Baltimore Museum of Art, Phillips Memorial Gallery (Washington, D.C.), Isaac Delgado Museum of Art (New Orleans, Louisiana), M. H. de Young Memorial Museum (San Francisco), St. Paul Gallery and School of Art (Minnesota), CGFA, Munson-Williams-Proctor Institute (Utica, New York), Smith College Museum of Art (Northampton, Massachusetts).

Cincinnati Art Museum, February 2 – March 4, 1951, *Paintings: 1900–1925*, cat. no. 58 (as *Impressionism*).

CGFA (February 1952), no cat.

Art Galleries, University of California (Los Angeles), October 11 – November 7, 1954, *Charles Sheeler: A Retrospective Exhibition*, cat. no. 2, pp. 9, 45 (as *Impressionism*); toured, November 18, 1954 – June 15, 1955, to M. H. de Young Memorial Museum (San Francisco), Fine Arts Gallery of San Diego, Fort Worth Art Center (Texas), PAFA, Munson-Williams-Proctor Institute (Utica, New York).

AFA, *Pioneers of American Abstract Art*, cat. no. 40, p. 11 (as *Lhasa [or Impressionism]*); toured, December 1, 1955 – January 9, 1957, to Atlanta Public Library (Georgia), Louisiana State Exhibition Museum (Shreveport), J. B. Speed Art Museum (Louisville, Kentucky), Lawrence Museum (Williamstown, Massachusetts), George Thomas Hunter Gallery (Chattanooga, Tennessee), Rose Fried Gallery (New York).

Allentown Art Museum (Pennsylvania), November 17 – December 31, 1961, *Charles Sheeler Retrospective Exhibition*, cat. no. 3, pp. 8, 17.

Downtown Gallery (New York), March 19 – April 21, 1962, *American Abstraction, 1903–1923*, no cat.

New Gallery, Department of Art, University of Iowa (Iowa City), May 24 – August 2, 1962, *Vintage Moderns: American Pioneer Artists: 1903–1932: Plus 4 Related Photographers*, cat. no. 61, pp. 25, 27, illus.

Denison University (1962), no cat.

Corcoran Gallery of Art (Washington, D.C.), April 27 – June 2, 1963, *The New Tradition: Modern Americans Before 1940*, cat. essay by Gudmund Vigtel, no. 89, p. 65.

Poses Institute of Fine Arts, Rose Art Museum, Brandeis University (Waltham, Massachusetts), October 4 – November 10, 1963, *American Modernism: The First Wave*, cat. no. 2, illus.

National Collection of Fine Arts (Washington, D.C.), December 2, 1965 – January 9, 1966, *Roots of Abstract Art in America 1910–1930*, cat. no. 151, illus.

ACA Heritage Gallery (New York), March 14 – April 9, 1966, *Commemorating the 50th Anniversary of "The Forum Exhibition of Modern American Painters" March 1916*, cat. no. 34, illus.

University of New Mexico Art Museum (Albuquerque), February 10 – March 19, 1967, *Cubism: Its Impact in the USA 1910–1930*, cat. no. 53, p. 52, illus.; toured, April 9 – August 27, 1967, to Marion Koogler McNay Art Institute (San Antonio, Texas), San Francisco Museum of Art, Los Angeles Municipal Art Gallery.

CGFA (1968), no cat.

National Collection of Fine Arts (Washington, D.C.), October 10 – November 24, 1968, *Charles Sheeler*, cat. essays by Martin Friedman, Bartlett Hayes, and Charles Millard, no. 13, pp. 12, 71, 73, illus.; toured, January 10 – April 27, 1969, to Philadelphia Museum of Art, WMAA.

CGFA (May 1970), no cat.

CGFA (1970–1971), cat. no. 64, illus.

National Collection of Fine Arts (Washington, D.C.), May 9 – July 6, 1975, *Pennsylvania Academy Moderns 1910–1940*, cat. no. 40, p. 35, illus.; toured, July 30 – September 6, 1975, to PAFA.

Grand Rapids Art Museum (Michigan), September 17 – November 1, 1981, *Pioneers: Early Twentieth Century Art from Midwestern Museums*, cat. no. 29, illus.

REFERENCES:

Estate of John Quinn, Deceased, "Catalogue of the Art Collection Belonging to Mr. Quinn," July 28, 1924, John Quinn Memorial Collection, New York Public Library, unpag. (as *Landscape*).

Forbes Watson, "Charles Sheeler," *The Arts* 3 (May 1923): 337, illus. (as *Landscape*).

John Quinn 1870–1925: Collection of Paintings, Water Colors, Drawings and Sculpture (1926), p. 25 (as *Landscape*).

"Sale of the Quinn Collection is Completed," *ARTnews* 25 (February 1927): 10 (as *Landscape No. 3*).

AFA, *American Art Annual* (1927), no. 496, p. 385 (as *Landscape No. 3*).

Constance Rourke, *Charles Sheeler: Artist in the American Tradition* (1938), pp. 66–67.

["Charles Sheeler—Painter and Photographer," *Index of Twentieth Century Artists* 3 (January 1936), reprinted in *The Index of Twentieth Century Artists 1933–1937* (1970): 521 (as *Impressionism*); see also p. 523 (*Landscape*)].

Lillian Natalie Dochterman, "The Stylistic Development of the Work of Charles Sheeler," Ph.D. diss., State University of Iowa, 1963, no. 16.049, pp. 16, 24, 38, 51, 197, illus. (as *Lhasa* [formerly called "Impressionism"]).

Tucker (1969), cat. no. 159, pp. 96, 99, 101, illus.

Sam Hunter and John Jacobus, *Art of the Twentieth Century* (1973), p. 138, fig. 232.

Martin Friedman, *Charles Sheeler* (1975), pp. 31, 52, illus. pl. 4.

CMA, *Catalog* (1978), p. 150, illus.

Judith Zilczer, *"The Noble Buyer:" John Quinn, Patron of the Avant-Garde* (1978), p. 187 (as *Lhasa [Landscape no. 3]*).

Susan Fillin-Yeh, "Charles Sheeler and the Machine Age," Ph.D. diss., City University of New York, 1981, pp. 99, 125, 216.

Theodore E. Stebbins, Jr., and Norman Keyes, Jr., *Charles Sheeler: The Photographs* (exh. cat., Museum of Fine Arts, Boston, 1987), pp. 3, 4, fig. 5, 53 n. 10.

RELATED WORKS:

Lhasa, 1916, pencil and crayon, collection of Mrs. Earle Horter (Doylestown and Philadelphia, Pennsylvania).

Landscape, 1916, black crayon on white paper, Fogg Art Museum, Harvard University (Cambridge, Massachusetts).

Untitled (Lhasa), photograph by John Claude White, published in White, *Tibet and Lhasa* (Calcutta, 1907–1908).

REMARKS:
Lhasa has been exhibited under the titles *Land-scape*, *Landscape No. 3*, and *Impressionism*. Sheeler may have changed the title to *Lhasa* at the time of the retrospective held at MoMA in 1939. See Sheeler's remarks in the 1939 MoMA exhibition catalogue, p. 10.

51 *Still Life and Shadows* 31.106
ENDNOTES:
1. Patterson Sims, *Charles Sheeler: A Concentration of Works From the Permanent Collection of the Whitney Museum of American Art* (1980), p. 18.
2. Charles Sheeler, quoted in Constance Rourke, *Charles Sheeler: Artist in the American Tradition* (1938), p. 106.
3. Rourke, p. 106.
4. Charles Sheeler, quoted in Sims, p. 18.

PROVENANCE:
Daniel Gallery, New York; Ferdinand Howald, New York and Columbus, October 1925, inv. no. 298; CMA, 1931 (gift of Ferdinand Howald).

EXHIBITION HISTORY:
Gallery of Living Art, New York University, December 13, 1927 – January 25, 1928, *Opening Exhibition*, cat.

CGFA (1931), cat. no. 215, p. I, 12 (as *Still Life, No. 1*).

CGFA (1935), no cat. (as *Still Life No. 1*).

MoMA, October 4 – November 1, 1939, *Charles Sheeler: Paintings, Drawings, Photographs*, cat. no. 65, pp. 21, 50, illus. (as *Still Life with White Teapot*).

Dayton Art Institute (Ohio), November 2 – December 2, 1944, *Paintings by Charles Sheeler*, no cat.

Ohio State Fair, Columbus, August 23–30, 1946.

AFA (1948–1949), no cat.

CGFA (February 1952), no cat.

Art Galleries, University of California (Los Angeles), October 11 – November 7, 1954, *Charles Sheeler: A Retrospective Exhibition*, cat. no. 8, p. 45 (as *Objects on Table*); toured, November 18, 1954 – June 15, 1955, to M. H. de Young Memorial Museum (San Francisco), Fine Arts Gallery of San Diego, Fort Worth Art Center (Texas), PAFA, Munson-Williams-Proctor Institute (Utica, New York).

CGFA (1956), no cat.

CGFA (1958), no cat.

CGFA (1958–1960), no cat.

CGFA (1961), no cat.

University of Iowa Museum of Art (Iowa City), March 17 – April 14, 1963, *The Quest of Charles Sheeler*, cat. essay by Lillian Dochterman, no. 26, pp. 16, 17, 48, fig. 9 (as *Objects on a Table*).

Flint Institute of Arts (Michigan), April 28 – May 29, 1966, *Realism Revisited*, cat. no. 45, pp. 4, 15, illus. (as *Objects on a Table*).

Cedar Rapids Art Center (Iowa), October 25 – November 26, 1967, *Charles Sheeler: A Retrospective Exhibition*, cat. essay by Donn L. Young, no. 8 (as *Objects on Table*).

CGFA (1968), no cat.

National Collection of Fine Arts (Washington, D.C.), October 10 – November 24, 1968, *Charles Sheeler*, cat. essays by Martin Friedman, Bartlett Hayes, and Charles Millard, no. 33, pp. 16, 115, illus. (as *Objects on a Table*); toured, January 10 – April 27, 1969, to Philadelphia Museum of Art, WMAA.

CGFA (May 1970), no cat.

Carnegie Institute, November 18, 1971 – January 9, 1972, *Forerunners of American Abstraction*, cat. essay by Herdis Bull Teilman, no. 89 (as *Objects on a Table*).

University Art Museum, University of Texas at Austin, October 15 – December 17, 1972, *Not So Long Ago: Art of the 1920s in Europe and America*, cat., p. 87, cover illus. (as *Objects on a Table*).

Museum of Art, Pennsylvania State University (University Park), February 10 – March 24, 1974, *Charles Sheeler: The Works on Paper*, cat. by John P. Driscoll, no. 24, pp. 50, 54, 55, 56, cover illus. (as *Objects on a Table*); toured, April 12 – 20, 1974, to Terry Dintenfass (New York).

Northern Illinois University Art Gallery (DeKalb), October 27 – November 22, 1974, *Near-Looking: A Close Focus Look at a Basic Thread of American Art*, cat. by Dorathea K. Beard, et al., no. 34, pp. 65, 66, illus. (as *Objects on a Table [Still Life with Teapot]*); toured, December 1, 1974 – January 26, 1975, to University of Notre Dame Art Gallery (South Bend, Indiana).

Philadelphia Museum of Art, April 11 – October 10, 1976, *Philadelphia: Three Centuries of American Art*, cat. no. 448, pp. 526, 527, illus. (as *Objects on a Table*).

Terry Dintenfass (New York), May 10–30, 1980, *Charles Sheeler (1883–1965)*, cat. no. 15, pp. 20, 27, illus.

Yale University Art Gallery (New Haven, Connecticut), April 1 – May 31, 1987, *Charles Sheeler: American Interiors*, cat. by Susan Fillin-Yeh, no. 4, pp. 9, 10, 25, 27, 28, illus. (as *Objects on a Table [Still Life with White Teapot]*).

Museum of Fine Arts (Boston), October 13, 1987 – January 3, 1988, *Charles Sheeler: Paintings, Drawings, and Photographs*, cat. Vol. 1: *Charles Sheeler: Paintings and Drawings*, by Carol Troyen and Erica E. Hirshler, no. 27, pp. 15, 100, 101, illus.; toured, January 28 – July 10, 1988, to WMAA, Dallas Museum of Art.

REFERENCES:
"'Living Art' Now on View," *Art News* 26 (December 17, 1927): 4.

"Charles Sheeler—Painter and Photographer," *Index of Twentieth Century Artists* 3 (January 1936), reprinted in *The Index of Twentieth Century Artists 1933–1937* (1970): 521 (as *Still Life No. 1*).

Frank J. Roos, Jr., *An Illustrated Handbook of Art History* (1937), 3rd ed. (1970), p. 304, fig. D (as *Still Life Number One*).

Constance Rourke, *Charles Sheeler: Artist in the American Tradition* (1938), pp. 73, 106, 107, 110, 111, 179, illus. (as *Still Life with White Teapot*).

Wolfgang Born, *Still Life Painting in America* (1947), fig. 131 (as *Still Life with Teapot*).

Lillian Natalie Dochterman, "The Stylistic Development of the Work of Charles Sheeler," Ph.D. diss., State University of Iowa, 1963, no. 24.108, pp. 32, 256, illus. (as *Objects on a Table*).

Hilton Kramer, "Charles Sheeler: American Pastoral," *Artforum* 7 (January 1969): 39, illus. (as *Objects on a Table*).

Tucker (1969), cat. no. 166, pp. 102, 104, 105, illus. (as *Objects on a Table [Still Life with White Teapot]*).

"Art Across the U.S.A.: Outstanding Exhibitions," *Apollo* 89 (March 1969): 239, fig. 1 (as *Objects on a Table*).

Kasha Linville, "The Howald Collection at Wildenstein," *Arts Magazine* 44 (summer 1970): 16, illus. (as *Objects on a Table*).

John Wilmerding, ed., *The Genius of American Painting* (1973), p. 240, illus.

Martin Friedman, *Charles Sheeler* (1975), p. 59, pl. 11 (as *Objects on a Table*).

CMA, *Catalog* (1978), pp. 109–111, 168, illus.

CMA, *Selections* (1978), pp. 109–111, illus.

Van Deren Coke, *Andrew Dasburg* (1979), pp. 66, 70, fig. 35.

Susan Fillin-Yeh, "Charles Sheeler and the Machine Age," Ph.D. diss., City University of New York, 1981, pp. 125, 281, pl. 29 (as *Objects on a Table*).

William Carlos Williams: Selected Poems, introduction by Randall Jarrell and a portfolio of paintings by Charles Sheeler (1984), unpag.

John Baker, *Henry Lee McFee and Formalist Realism in American Still Life, 1923–1936* (1987), p. 100, fig. 127.

52 *The Circus* 31.127
ENDNOTES:
1. Emily Farnham, *Charles Demuth: Behind a Laughing Mask* (1971), pp. 5–29.
2. Betsy Fahlman, in *Pennsylvania Modern: Charles Demuth of Lancaster* (exh. cat., Philadelphia Museum of Art, 1983), p. 31. The Hartley statement originally appeared in Marsden Hartley, *Adventures in the Arts: Informal Chapters on Painters, Vaudeville, and Poets* (1921), p. 155.

PROVENANCE:
Daniel Gallery, New York; Ferdinand Howald, New York and Columbus, October 15, 1917, inv. no. 90; CMA, 1931 (gift of Ferdinand Howald).

EXHIBITION HISTORY:
CGFA (1931), cat. no. 34, p. I, 8.

Cleveland Museum of Art, June 23 – October 4, 1937, *American Painting from 1860 until Today*, cat. no. 43, p. 18, pl. 28.

WMAA, December 15, 1937 – January 16, 1938, *Charles Demuth Memorial Exhibition*, cat. no. 69, illus. (as dated 1919).

MoMA, May 10 – September 30, 1939, *Art in Our Time: An Exhibition to Celebrate the Tenth Anniversary of the Museum of Modern Art*, cat. no. 215, illus.

Phillips Memorial Gallery (Washington, D.C.), May 3 – 25, 1942, *Charles Demuth Exhibition of Water Colors and Oil Paintings*, checklist no. 46.

Dayton Art Institute (Ohio), February 2 – March 4, 1945, *19 Paintings by Charles Demuth*, no cat.

Walker Art Center (Minneapolis), and Inter-American Office of the National Gallery of Art (Washington, D.C.), April 24 – May 8, 1946 (at Walker Art Center), *Watercolor—U.S.A.*, cat. no. 37, p. 54; toured, May 18 – December 1946(?), to Pan American Union (Washington, D.C.), Buenos Aires (Argentina), Rio de Janeiro (Brazil), Sao Paulo (Brazil), Montevideo (Uruguay), Santiago (Chile), Lima (Peru), Mexico City.

AFA (1948–1949), no cat.

Albertina Gallery (Vienna, Austria), October

1949, *Amerikanische Meister des Aquarells*, cat. no. 20, p. 14 (as dated 1919).

MoMA, March 7 – June 11, 1950, *Charles Demuth*, cat. by Andrew Carnduff Ritchie, no. 68, pp. 35, 91, illus.

Museum of Art, University of Michigan (Ann Arbor), November 9–29, 1950, *Sport and Circus*, cat. no. 12.

CGFA (1952), no cat.

Norfolk Museum (Virginia), March 1953, *Significant American Moderns*, cat., unpag.

AFA, *American Watercolor Exhibition*, cat. (for Tokyo showing); toured, October 11, 1954 – August 14, 1955, to New Delhi (India), Calcutta (India), Bombay (India), Madras (India), Lahore (Pakistan), Peshawar (Pakistan), Karachi (Pakistan), Colombo National Museum (Ceylon), Manila (The Philippines), Tokyo (Japan).

CGFA (1956), no cat.

CGFA (1958–1960), no cat.

CGFA (1958), no cat.

Milwaukee Art Center, September 21 – November 5, 1961, *10 Americans*, cat. no. 8.

WMAA, February 27 – April 14, 1963, *The Decade of the Armory Show: New Directions in American Art 1910–1920*, cat. no. 25, pp. 23, 72, illus.; toured, June 1, 1963 – February 23, 1964, to City Art Museum of Saint Louis, Cleveland Museum of Art, PAFA, Art Institute of Chicago, Albright-Knox Art Gallery (Buffalo, New York.)

CGFA, *Watercolors from the Ferdinand Howald Collection*, no cat.; June 22 – July 10, 1964, to Ohio State University (Columbus).

WMAA, September 27 – November 27, 1966, *Art of the United States: 1670–1966*, cat. no. 66.

Cincinnati Art Museum, February 14 – March 16, 1969, *Three American Masters of Watercolor: Marin, Demuth, Pascin*, cat. essay by Richard J. Boyle, no. 29, p. 12.

CGFA (January 1970), no cat.

CGFA (May 1970), no cat.

CGFA (1970–1971), cat. no. 5.

Birmingham Museum of Art (Alabama), January 16 – February 13, 1972, *American Watercolors 1850–1972*, cat., p. 33, illus.; toured, February 22 – March 31, 1972, to Mobile Art Gallery (Alabama).

CGFA (1973), cat. no. 5, illus.

Andrew Crispo Gallery (New York), May 16 – June 30, 1974, *Ten Americans*, cat. no. 30, illus. (as not dated).

CGFA (1975), no cat.

CGFA (1977), no cat.

Cleveland Museum of Art, on loan May 1978.

REFERENCES:
"Charles Demuth—Painter," *Index of Twentieth Century Artists* 2 (July 1935), reprinted in *The Index of Twentieth Century Artists 1933–1937* (1970): 430.

"Watercolors to Serve as Good-Will Guests," *Art Digest* 20 (June 1, 1946): 17.

Emily Farnham, "Charles Demuth: His Life, Psychology and Works," Ph.D. diss., Ohio State University, 1959; Vol. 1, pp. 269–271, 367, 388, fig. 5, Vol. 2, no. 248, pp. 505, 794, fig. 38.

Tucker (1969), cat. no. 20, pp. 20–22, illus.

Emily Farnham, *Charles Demuth: Behind a Laughing Mask* (1971), pl. 1.

Alvord L. Eiseman, "A Study of the Development of an Artist: Charles Demuth," Ph.D. diss., New York University, 1974, pp. 277-279, illus. no. 159.

Young (1974), pp. 50, 51, pl. 14.

Allen S. Weller, et al., *Watercolor U.S.A. National Invitational Exhibition* (exh. cat., Springfield [Missouri] Art Museum, 1976), p. 28, illus.

Donelson F. Hoopes, *American Watercolor Painting* (1977), pp. 133, 149, pl. 37.

Alvord Eiseman, *Charles Demuth* (1982), p. 45, pl. 11.

REMARKS:
The Circus is no. w-399 in the scrapbooks of Richard C. Weyand (died 1956), a close associate of Demuth's and the compiler of this early "catalogue raisonné" of the artist's works.

53 *Modern Conveniences* 31.137

ENDNOTES:
1. S. Lane Faison, "Fact and Art in Charles Demuth," *Magazine of Art* 43 (April 1950): 126.

2. Ibid.

3. George Biddle, in response to a questionnaire on Demuth, commented on his friend's antipathy toward Lancaster. See Emily Farnham, *Charles Demuth: Behind a Laughing Mask* (1971), p. 38.

4. Farnham, p. 38.

PROVENANCE:
Daniel Gallery, New York; Ferdinand Howald, New York and Columbus, January 1923, inv. no. 246; CMA, 1931 (gift of Ferdinand Howald).

EXHIBITION HISTORY:
Daniel Gallery (New York), December [1], 1922 – January 2, 1923, *Recent Paintings by Charles Demuth*, cat. no. 9, illus.

Société Anonyme, *International Exhibition of Modern Art*, cat. no. 236; November 19 – December 20, 1926, Brooklyn Museum (New York).

MoMA, December 13, 1929 – January 12, 1930, *Paintings by Nineteen Living Americans*, cat. no. 11, p. 17 (as dated 1922).

CGFA (1931), cat. no. 44, p. 1, 9.

Smith College Museum of Art (Northampton, Massachusetts), May 19 – June 19, 1934, *Five Americans*, not in checklist.

CGFA (1935), no cat.

WMAA, December 15, 1937 – January 16, 1938, *Charles Demuth Memorial Exhibition*, cat. no. 16.

Cincinnati Modern Art Society, and Cincinnati Art Museum, March 12 – April 14, 1941, *A New Realism: Crawford, Demuth, Sheeler, Spencer*, cat. no. 14, p. 13.

Phillips Memorial Gallery (Washington, D.C.), May 3–25, 1942, *Charles Demuth*, cat. no. 47.

WMAA, April 9 – May 19, 1946, *Pioneers of Modern Art in America*, cat. by Lloyd Goodrich, no. 31, p. 21; toured, July 1, 1946 – May 30, 1947, to University of Michigan (Ann Arbor), George Walter Vincent Smith Art Museum (Springfield, Massachusetts), Wilmington Society of Fine Arts (Delaware), Baltimore Museum of Art, Phillips Memorial Gallery (Washington, D.C.), Isaac Delgado Museum of Art (New Orleans, Louisana), M. H. DeYoung Memorial Museum (San Francisco), St. Paul Gallery and

School of Art (Minnesota), CGFA, Munson-Williams-Proctor Institute (Utica, New York), Smith College Museum of Art (Northampton, Massachusetts).

Corcoran Gallery of Art (Washington, D.C.), January 9 – February 20, 1949, *De Gustibus: An Exhibition of American Paintings Illustrating a Century of Taste and Criticism*, cat. by Eleanor B. Swenson, no. 45, illus.

MoMA, March 7 – June 11, 1950, *Charles Demuth*, cat. by Andrew Carnduff Ritchie, no. 113, p. 92 (exhibition toured, but *Modern Conveniences* exhibited only at MoMA).

Smith College Museum of Art (Northampton, Massachusetts), [May–October] 1951, no cat.

Norfolk Museum (Virginia), March 1953, *Significant American Moderns*, cat., illus.

Wildenstein & Co. (New York), May 4–28, 1955, *Special Exhibition of Paintings by American and French Modern Masters for the Benefit of the La Napoule Art Foundation Henry Clews Memorial*, cat. no. 7 (as dated 1920).

Brooks Memorial Union, Marquette University (Milwaukee, Wisconsin), April 22 – May 3, 1956, *75 Years of American Painting: Festival of American Arts*, cat. no. 18.

Davison Art Center, Wesleyan University (Middletown, Connecticut), September 15 – [October 10] 1957, *America Seen*, no cat.

Ohio Wesleyan University (Delaware, Ohio), November 13 – December 13, 1959 (exhibition title unknown).

Walker Art Center (Minneapolis), November 13 – December 25, 1960, *The Precisionist View in American Art*, cat. by Martin L. Friedman; toured, January 24 – August 6, 1961, to WMAA, Detroit Institute of Arts, Los Angeles County Museum of Art, San Francisco Museum of Art.

Denison University (1962), no cat.

WMAA, February 27 – April 14, 1963, *The Decade of the Armory Show: New Directions in American Art 1910–1920*, cat. no. 27, pp. 49, 72, illus.; toured, June 1, 1963 – February 23, 1964, to City Art Museum of St. Louis, Cleveland Museum of Art, PAFA, Art Institute of Chicago, Albright-Knox Art Gallery (Buffalo, New York).

Indiana University (1964), cat. no. 18, illus.

AFA, *Realism and Reality*, cat. no. 14; toured, January 2, 1965 – January 24, 1966, to Quincy Art Center (Illinois), Laguna Gloria Art Museum (Austin, Texas), Tougaloo College (Mississippi), Art Department of the University of Rhode Island (Kingston), Oak Ridge Community Art Center (Tennessee), Mobile Art Gallery (Alabama), Evansville Public Museum (Indiana), Charles and Emma Frye Art Museum (Seattle, Washington), Witte Memorial Museum (San Antonio, Texas), Wichita Art Museum (Kansas).

WMAA, September 27 – November 27, 1966, *Art of the United States: 1670–1966*, cat. no. 68.

Grand Rapids Art Museum (Michigan), April 1–30, 1967, *Twentieth Century American Painting*, cat. no. 32, p. 41.

CGFA (1969), no cat.

CGFA (January 1970), no cat.

CGFA (May 1970), no cat.

CGFA (1970–1971), cat. no. 10.

Art Galleries, University of California at Santa Barbara, October 5 – November 14, 1971, *Charles Demuth: The Mechanical Encrusted on the Living*,

cat. by David Gedhard and Phyllis Plous, no. 76, p. 83; toured, November 22, 1971 – April 16, 1972, to University Art Museum (University of California, Berkeley), Phillips Collection (Washington, D.C.), Munson-Williams-Proctor Institute (Utica, New York).

Hathorn Gallery, Skidmore College (Saratoga Springs, New York), October 12–29, 1972, *The Americans Circa 1922*, cat. no. 5, pp. 11, 15, 17, 20, illus.

Terry Dintenfass (New York), November 4–29, 1975, *Shapes of Industry: First Images in American Art*, cat. by Roxana Barry, no. 7.

Contemporary Arts Center (Cincinnati), October 13 – November 25, 1979, *The Modern Art Society: The Center's Early Years 1939–1954*, cat. by Ruth K. Meyer, no. 34, illus.

San Francisco Museum of Modern Art, September 9 – November 7, 1982, *Images of America: Precisionist Painting and Modern Photography*, cat. by Karen Tsujimoto, no. 38, pp. 57, 233, pl. 2; toured, December 6, 1982 – October 9, 1983, to Saint Louis Art Museum, Baltimore Museum of Art, Des Moines Art Center (Iowa), Cleveland Museum of Art.

REFERENCES:
Forbes Watson, "Charles Demuth," *The Arts* 3 (January 1923): 75, illus.

Samuel M. Kootz, *Modern American Painters* (1930), fig. 6 (as dated 1922).

William Murrel, *Charles Demuth: American Artist Series* (1931), no. 32, illus. (as dated 1920).

"Charles Demuth—Painter," *Index of Twentieth Century Artists* 2 (July 1935), reprinted in *The Index of Twentieth Century Artists 1933–1937* (1970): 430, 432.

Frank J. Roos, Jr., *An Illustrated Handbook of Art History* (1937), p. 273, fig. E (as dated 1922).

Martha Davidson, "Demuth, Architect of Painting," *ARTnews* 36 (December 1937): 7, illus.

S. Lane Faison, Jr., "Fact and Art in Charles Demuth," *Magazine of Art* 43 (April 1950): 125, 126, fig. 8.

Emily Farnham, "Charles Demuth: His Life, Psychology and Works," Ph.D. diss., Ohio State University, 1959: Vol. 1, pp. 17, 108, 152–153, 325–326; Vol. 2, p. 571; Vol. 3, pp. 852, 909, fig. 99.

Tucker (1969), cat. no. 29, pp. 23, 24, 27, illus.

George Heard Hamilton, *19th and 20th Century Art* (1970), pp. 277, 298, 299, illus.

Kasha Linville, "The Howald Collection at Wildenstein," *Arts Magazine* 44 (summer 1970): 16.

Kasha Linville, "Howald's American Line," *ARTnews* 69 (summer 1970): 55.

Matthew Baigell, *A History of American Painting* (1971), pp. 218, 275, fig. 11–2.

Emily Farnham, *Charles Demuth: Behind a Laughing Mask* (1971), pp. 120, 148, 205.

Alvord L. Eiseman, "A Charles Demuth Retrospective Exhibition," *Art Journal*, 31 (spring 1972): 284–285.

Mahonri Sharp Young, "The Man from Ohio: Ferdinand Howald and his Painters," *The Arts in Ireland* 2, no. 3 (1974): 11, illus.

Abraham A. Davidson, *The Story of American Painting* (1974), p. 132, pl. 120.

Alvord L. Eiseman, "A Study of the Development of an Artist: Charles Demuth," Ph.D. diss., New York University, 1974, pp. 357, 359, 360, illus. no. 214.

Young (1974), pp. 62, 63, pl. 20.

Daniel Catton Rich, ed., *The Flow of Art: Essays and Criticisms of Henry McBride* (1975), illus. no. 6 (as watercolor and as MoMA).

CMA, *Catalog* (1978), p. 138, illus.

Abraham A. Davidson, *Early American Modernist Painting 1910–1935* (1981), p. 175, 194.

Frank Getlein, "The Paintings and Photographs of 'Precisionism'" (or "In paint and film they saw a precise image of America"), *Smithsonian* 13 (November 1982): 130–141, illus.

Betsy Fahlman, *Pennsylvania Modern: Charles Demuth of Lancaster* (exh. cat., Philadelphia Museum of Art, 1983), pp. 11, 20.

Alvord L. Eiseman, *Charles Demuth* (1982), pp. 21, 25, 65, pl. 27.

Betsy Fahlman, "Charles Demuth of Lancaster, Pennsylvania," *Art and Antiques* 6 (July-August 1983): 82–89, illus.

Betsy Fahlman, "Charles Demuth's Paintings of Lancaster Architecture: New Discoveries and Observations," *Arts Magazine* 61 (March 1987): 25.

REMARKS:
Modern Conveniences is no. W-353 in the scrapbooks of Richard C. Weyand (died 1956), a close associate of Demuth's and the compiler of this early "catalogue raisonné" of the artist's works.

54 *Bowl of Oranges* 31.125

ENDNOTES:
1. Betsy Fahlman, *Pennsylvania Modern: Charles Demuth of Lancaster* (exh. cat., Philadelphia Museum of Art, 1983), p. 62.

2. Ibid., p. 53.

3. Quoted by Darrell Larson, in Emily Farnham, "Charles Demuth: His Life, Psychology and Works," Ph.D. diss., Ohio State University, 1959: Vol. 3, p. 994.

4. Charles Demuth, "Across a Greco Is Written," *Creative Art* 5 (September 1929): 634.

PROVENANCE:
Daniel Gallery, New York; Ferdinand Howald, New York and Columbus, April 1925, inv. no. 293 (as *Oranges and Bananas*); CMA, 1931 (gift of Ferdinand Howald).

EXHIBITION HISTORY:
CGFA (1931), cat. no. 32, p. 1, 8.

Smith College Museum of Art (Northampton, Massachusetts), May 19 – June 19, 1934, *5 Americans*, checklist no. 15 (as *Still Life*).

CGFA (1935), no cat.

CGFA, *Paintings from the Howald Collection*, no cat.; November 23 – December 10, 1941, to Art Center (Parkersburg, West Virginia).

University of Minnesota, November 29 – December 20, 1942, *Our Leading Watercolorists*, checklist.

Dayton Art Institute (Ohio), February 2 – March 4, 1945, *19 Paintings by Charles Demuth*, no cat.

AFA, *Early Twentieth Century American Watercolors*, no. cat.; toured, September 5, 1948 – May 31, 1949, to Dayton Art Institute (Ohio), Rochester (New York), Western College (Oxford, Ohio), Williamstown (Massachusetts), Manchester (New Hampshire), Cambridge (Massachusetts), Minneapolis Institute of Arts.

MoMA, March 7 – June 11, 1950, *Charles Demuth*, cat. by Andrew Carnduff Ritchie, no. 131, p. 92; toured, October 1, 1950 – May 5, 1951, to

Detroit Institute of Art, University of Miami (Coral Gables), Winnipeg Art Gallery (Manitoba, Canada), Williams College (Williamstown, Massachusetts), University of Delaware (Newark), Oberlin College (Ohio).

CGFA (October 1952), no cat.

CGFA (1956), no cat.

CGFA (1958), no cat.

CGFA (1958–1960), no cat.

CGFA (1961), no cat.

Corcoran Gallery of Art (Washington, D.C), April 27 – June 2, 1963, *The New Tradition: Modern Americans Before 1940*, cat. essay by Gudmund Vigtel, no. 28, p. 57.

Pennsylvania Historical and Museum Commission, William Penn Memorial Museum (Harrisburg), September 24 – November 6, 1966, *Charles Demuth of Lancaster*, cat. essay by Emily Genauer, no. 104.

Cincinnati Art Museum, February 14 – March 16, 1969, *Three American Masters of Watercolor: Marin, Demuth, Pascin*, cat. essay by Richard J. Boyle, no. 42, p. 13.

CGFA (May 1970), no cat.

CGFA (1970–1971), cat. no. 13.

Art Galleries, University of California at Santa Barbara, October 5 – November 14, 1971, *Charles Demuth: The Mechanical Encrusted on the Living*, cat. by David Gedhard and Phyllis Plous, no. 92, p. 84; toured, November 22, 1971 – April 16, 1972, to University Art Museum (University of California, Berkeley), Phillips Collection (Washington, D.C.), Munson-Williams-Proctor Institute (Utica, New York).

Minneapolis Institute of Arts, *Painters and Photographers of Gallery 291* (also entitled *I am an American: Artists of Gallery 291*); Artmobile Tour, August 1, 1973 – August 1, 1974, statewide.

Taft Museum (Cincinnati), March 24 – May 8, 1977, *Best of 50*, cat., illus.

WMAA, October 15, 1987 – January 17, 1988, *Charles Demuth*; toured, February 25–July 10, 1988, to Los Angeles County Museum of Art, CMA (*Bowl of Oranges* exhibited only at CMA).

REFERENCES:
"Charles Demuth—Painter," *Index of Twentieth Century Artists* 2 (July 1935), reprinted in *The Index of Twentieth Century Artists 1933–1937* (1970): 430.

Emily Farnham, "Charles Demuth: His Life, Psychology and Works," Ph.D. diss., Ohio State University, 1959: Vol. 2, no. 457, p. 592; Vol. 3, p. 866, fig. 113.

Tucker (1969), cat. no. 41, p. 34.

Thomas E. Norton, ed., *Homage to Charles Demuth: Still Life Painter of Lancaster* (1978), p. 109, illus.

CMA, *Catalog* (1978), p. 158.

Alvord L. Eiseman, "A Study of the Development of an Artist: Charles Demuth," Ph.D. diss., New York University, 1974, pp. 393–394, illus. no. 237.

Alvord L. Eiseman, *Charles Demuth* (1982), pp. 18, 71, pl. 31.

REMARKS:
Bowl of Oranges is no. W-471 in the scrapbooks of Richard C. Weyand (died 1956), a close associate of Demuth's and the compiler of this early "catalogue raisonné" of the artist's works.

55 Buildings 31.268

ENDNOTES:
1. Richard B. Freeman, *Niles Spencer* (exh. cat., University of Kentucky Art Gallery, 1965), p. 13.
2. Ralston Crawford, "Niles Spencer: A Tribute," in Freeman, p. 21.

PROVENANCE:
Daniel Gallery, New York; Ferdinand Howald, New York and Columbus, December 1924, inv. no. 290; CMA, 1931 (gift of Ferdinand Howald).

EXHIBITION HISTORY:
CGFA (1931), cat. no. 220, p. I, 12.

CGFA (1935), no cat.

Cincinnati Modern Art Society, and Cincinnati Art Museum, March 12 – April 14, 1941, *A New Realism: Crawford, Demuth, Sheeler, Spencer*, cat. no. 32, p. 15.

CGFA, Paintings from the Howald Collection, no cat.; November 23 – December 10, 1941, to Art Center (Parkersburg, West Virginia).

CGFA (February 1952), no cat.

MoMA, June 23 – August 15, 1954, *Niles Spencer: A Retrospective Exhibition*, checklist (as dated ca. 1926); toured, February 1 – October 1, 1954, to Akron Art Institute (Ohio), Cincinnati Art Museum, Currier Gallery of Art (Manchester, New Hampshire), Walker Art Center (Minneapolis).

CGFA, Paintings from the Columbus Gallery of Fine Arts, no cat.; March 1965, to Otterbein College (Westerville, Ohio).

University of Kentucky Art Gallery, October 10 – November 6, 1956, *Niles Spencer*, cat. by Richard B. Freeman, no. 42, pp. 32, 65, illus. no. 14 (as dated 1926); toured, November 16, 1965 – June 12, 1966, to Munson-Williams-Proctor Institute (Utica, New York), Portland Museum of Art (Maine), WMAA, Allentown Art Museum (Pennsylvania), Currier Gallery of Art (Manchester, New Hampshire), Museum of Art (Rhode Island School of Design, Providence).

University of New Mexico (Albuquerque), February 10 – March 19, 1967, *Cubism: Its Impact in the USA, 1910–1930*, cat. no. 57, pp. 53, 54, illus. no. 57 (as dated 1926); toured, April 9 – August 27, 1967, to Marion Koogler McNay Art Institute (San Antonio, Texas), San Francisco Museum of Art, Los Angeles Municipal Art Gallery.

CGFA (May 1970), no cat.

REFERENCES:
Tucker (1969), cat. no. 168, pp. 105–107, illus. (as dated 1926).

State of Ohio Department of Education, *Guidelines for Planning Art Instruction in the Elementary Schools of Ohio* (1970), illus.

CMA, *Catalog* (1978), p. 151.

Abraham A. Davidson, *Early American Modernist Painting, 1910–1935* (1981), pp. 215–217, 218, illus. no. 116 (as dated 1926).

Frank Anderson Trapp, *Peter Blume* (1987), p. 25, illus.

56 The Swimmer 31.196

PROVENANCE:
Daniel Gallery, New York; Ferdinand Howald, New York and Columbus, February 1925, inv. no. 292; CMA, 1931 (gift of Ferdinand Howald).

EXHIBITION HISTORY:
Daniel Gallery (New York), January 3–31, 1925, *Paintings by Yasuo Kuniyoshi*.

CGFA (1931), cat. no. 112, p. I, 10.

Art Institute of Chicago, June 1 – November 1, 1933, *A Century of Progress: Exhibition of Paintings and Sculpture*, cat. no. 587, p. 72.

CGFA (1935), no cat.

CGFA (1941), no cat.

Downtown Gallery (New York), May 5–29, 1942, *Kuniyoshi Retrospective Loan Exhibition, 1921–1941*, checklist no. 4.

WMAA, March 27 – May 9, 1948, *Yasuo Kuniyoshi Retrospective Exhibition*, cat. essay by Lloyd Goodrich, no. 21, p. 52 (as dated 1924).

Museum of Art, University of Michigan (Ann Arbor), November 9–29, 1950, *Sport and Circus*, cat. no. 23 (as dated 1922).

CGFA (February 1952), no cat.

Junior Art Gallery (Louisville, Kentucky), January 31 – April 21, 1956, *Exercise: Art About Action*, checklist no. 18, illus. (detail).

Ohio Wesleyan University (Delaware, Ohio), November 13 – December 13, 1959 (exhibition title unknown).

Corcoran Gallery of Art (Washington, D.C.), April 27 – June 2, 1963, *The New Tradition: Modern Americans Before 1940*, cat. essay by Gudmund Vigtel, no. 56, pp. 34, 61, illus. (as dated 1922).

Bixler Art and Music Center, Colby College Museum of Art (Waterville, Maine), June 25 – September 30, 1964, *Maine: 100 Artists of the Twentieth Century*, cat., p. 36.

CGFA (January 1970), no cat.

CGFA (May 1970), no cat.

CGFA (1970–1971), cat. no. 29, illus.

University Art Museum, University of Texas at Austin, February 9 – March 23, 1975, *Yasuo Kuniyoshi 1889–1953, A Retrospective Exhibition*, cat., pp. 16, 30, 31, 65, illus.; toured, April 13, 1975 – February 8, 1976, to Elvehjem Art Center (University of Wisconsin, Madison), Georgia Museum of Art (University of Georgia, Athens), Prefectural Museum of Aichi (Nagoya, Japan), Bridgestone Museum Tokyo (Japan), Hyogo Prefectural Museum (Kobe, Japan), Art Gallery of Windsor (Ontario, Canada).

Flint Institute of Arts (Michigan), November 16, 1978 – January 21, 1979, *Art of the Twenties: American Painting at the Crossroads*, cat. no. 27, pp. 38, 40, illus.

WMAA, April 11 – June 19, 1986, *Yasuo Kuniyoshi*, checklist (as dated 1924).

REFERENCES:
Dudley Poore, "Current Exhibitions," *The Arts* 7 (February 1925): 114.

"Yasuo Kuniyoshi—Painter," *Index of Twentieth Century Artists* 1 (April 1934), reprinted in *The Index of Twentieth Century Artists 1933–1937* (1970): 153.

"Art," *Time* 51 (April 12, 1948): 53, illus.

Eloise Spaeth, *American Art Museums and Galleries* (1960), p. 125, illus.

Donelson F. Hoopes, "Maine: A Faith in Nature," *Art in America* 51, no. 3 (1963): 74, illus. (as dated 1924).

John I. H. Baur, "The Beginnings of Modernism, 1914–1940," in Gertrude A. Mellon and Elizabeth F. Wilder, eds., *Maine and Its Role in American Art, 1740–1963* (1963), pp. 139, 144, illus.

Tucker (1969), cat. no. 89, pp. 58, 59, illus.

Irma B. Jaffe, "The Forming of the Avant-Garde 1900–30," in John Wilmerding, ed., *The Genius of American Painting* (1973), pp. 240, 241, illus.

Akira Muraki, *Masters of Modern Japanese Art 10: Yasuo Kuniyoshi*, Vol. 8 (1976), p. 112, pl. 8.

Benjamin Lowe, *The Beauty of Sport: A Cross-Disciplinary Inquiry* (1977), pp. 131, 147, pl. 10a.

Hideo Tomiyam, ed., *The Works of Yasuo Kuniyoshi* (1977).

CMA, *Catalog* (1978), p. 143.

Franklin Riehlman, Tom Wolf, and Bruce Weber, *Yasuo Kuniyoshi: Artist as Photographer* (exh. cat., Edith C. Blum Art Institute, Milton and Sally Avery Arts Center, Bard College Center with the Norton Gallery and School of Art, 1983), pp. 12, 13, fig. 5.

Frank Anderson Trapp, *Peter Blume* (1987), pp. 29, 49, illus.

RELATED WORKS:
The Swimmer, 1924, ink with pen and dry brush, WMAA.

57 Diana 80.24

ENDNOTES:
1. Kenyon Cox, "Art: A New Sculptor," *The Nation* 96 (February 13, 1913): 163; quoted in Susan Rather, "The Past Made Modern: Archaism in American Sculpture," *The Arts* (November 1984): 116.
2. See Edwin Murtha, *Paul Manship* (1957), no. 155.

PROVENANCE:
(Sale: Sotheby Parke Bernet, April 25, 1980, lot no. 192); CMA, 1980.

EXHIBITION HISTORY:
[Smithsonian Institution (Washington, D.C.), February 23 – March 16, 1958, *A Retrospective Exhibition of Sculpture by Paul Manship*, cat. no. 38].

CMA (1986–1987), cat. no. 38, pp. 18, 19, 32, illus.

CMA, October 11 – November 29, 1987, *Accent on Sculpture: Small-scale Works from the Permanent Collection*, checklist, illus.

REFERENCES:
[Edwin Murtha, *Paul Manship* (1957), cat. no. 138, p. 161].

CMA (1986), p. 31, illus.

RELATED WORKS:
Diana (same edition as CMA work), bronze, Minnesota Museum of Art (St. Paul).

Diana (same edition as CMA work), bronze, National Museum of American Art (Washington, D.C.).

Diana (same edition as CMA work), bronze, Snite Museum of Art, University of Notre Dame (South Bend, Indiana).

Diana (same edition as CMA work), bronze [Hudson River Museum (Yonkers, New York)].

Diana (same edition as CMA work), bronze, Carnegie Institute (Pittsburgh, Pennsylvania).

Actaeon, 1923, bronze (see Edwin Murtha, *Paul Manship* [1957], no. 155).

REMARKS:
The CMA cast is the original and smallest version of the subject, which was intended as a companion piece for the artist's *Actaeon*. A heroic-size group, cast in 1924, is presently in the Brookline Gardens, South Carolina. An intermediate version was cast in 1925.

58 *October* 31.116
ENDNOTES:
1. John I. H. Baur, *Charles Burchfield* (1956), p. 19; and Matthew Baigell, *Charles Burchfield* (1976), pp. 25–26, 31. Baur also cites the writings of Thoreau as influences on the art of Burchfield.
2. Charles Burchfield, foreword to *Charles Burchfield* (1945), unpag.
3. Ibid.
4. Burchfield's interest in presenting the light, colors, and weather of the seasons is also seen in earlier works such as *February Thaw* (1920, Brooklyn Museum). For other examples, see *The Early Works of Charles E. Burchfield 1915–1922* (exh. cat., Columbus Museum of Art, 1987).
5. Quoted in Baur, p. 70.
6. Burchfield, unpag.

PROVENANCE:
Montross Gallery, New York (acquired from the artist); Ferdinand Howald, New York and Columbus, April 1924, inv. no. 279; CMA, 1931 (gift of Ferdinand Howald).

EXHIBITION HISTORY:
Montross Gallery (New York), March 18 – April 5, 1924, *Exhibition: Water Colors by Charles Burchfield*, checklist no. 2.
Carnegie Institute, October 16 – December 7, 1930, *Twenty-ninth International Exhibition of Paintings*, cat. no. 107, pl. 19.
CGFA (1931), cat. no. 21-a, p. 1, 8.
CGFA (1941), no cat.
Frank K. M. Rehn Galleries (New York), January 3–28, 1961.
Art Gallery, University of Arizona (Tucson), November 14, 1965 – January 9, 1966, *His Golden Year: A Retrospective Exhibition of Watercolors, Oils and Graphics by Charles E. Burchfield*, cat. no. 37, pp. 92, 116, illus.
Museum of Art, Munson-Williams-Proctor Institute (Utica, New York), April 9 – June 14, 1970, *The Nature of Charles Burchfield: A Memorial Exhibition 1893–1967*, cat. no. 144.
Ohio Expositions Center, ExpOhio 70 (Columbus), August 27 – September 7, 1970, *Charles Burchfield*, checklist no. 3.
Corcoran Gallery of Art (Washington, D.C.), October 9 – November 14, 1971, *Wilderness*, checklist.
Schumacher Gallery, Capital University (Columbus, Ohio), September 1 – October 3, 1983, *Charles Burchfield*, no cat.
Butler Institute of American Art (Youngstown, Ohio), December 11, 1983 – January 8, 1984, *Charles Burchfield in Ohio*, no cat.

REFERENCES:
William B. M'Cormick, "A Small Town in Paint," *International Studio* 80 (March 1925): 470, illus.
"The International Exhibition at Pittsburgh," *American Magazine of Art* 21 (December 1930): 674, illus.

"Charles E. Burchfield—Painter," *Index of Twentieth Century Artists* 2 (December 1934), reprinted in *The Index of Twentieth Century Artists 1933–1937* (1970): 293, 295.
John W. Straus, "Inventory of Burchfield's Work," Ph.D. diss., Harvard College, 1942, no. 530.
Milton W. Brown, "The Early Realism of Hopper and Burchfield," *College Art Journal* 7 (autumn 1947): 11.
Milton W. Brown, *American Painting from the Armory Show to the Depression* (1955, reprinted 1970), p. 181, illus. (as dated 1924).
Tucker (1969), cat. no. 10, pp. 14, 15, illus.
Joseph S. Trovato, *Charles Burchfield: Catalogue of Paintings in Public and Private Collections* (1970), cat. no. 693, pp. 114, 116, illus. (as painted October 2, 1922–1924, in Buffalo).
CMA, *Catalog* (1978), p. 157.

59 *Woman Playing Accordion* 80.3
PROVENANCE:
Graham Gallery, New York (probably acquired from the artist's estate); Harry Spiro, New York, before 1970; Coe Kerr Gallery, New York, 1980; CMA, 1980.

EXHIBITION HISTORY:
C. W. Kraushaar Art Galleries (New York), March 17 – April 2, 1924, *Paintings and Drawings by Guy Pène du Bois*, cat. no. 6 (as *Girl with Accordion*).
Art Institute of Chicago, October 29 – December 13, 1925, *The Thirty-Eighth Annual Exhibition of American Paintings and Sculpture*, cat. no. 53 (as *The Accordeon Player*).
Graham Gallery (New York), January 6–31, 1970, *Guy Pene du Bois*, cat. no. 30 (as *Woman with Accordian*).
CMA (1986–1987), cat. no. 35, p. 32.

60 *Home for Christmas* 31.109
ENDNOTES:
1. Letter dated November 9, 1934, from the artist to Phillip Adams, director of CGFA.
2. Ibid.
3. Ibid.
4. Museum of Contemporary Art (Chicago), *Peter Blume* (exh. cat., 1976), unpag.

PROVENANCE:
Daniel Gallery, New York (purchased from the artist); Ferdinand Howald, New York and Columbus, April 17, 1926, inv. no. 315; CMA, 1931 (gift of Ferdinand Howald).

EXHIBITION HISTORY:
Daniel Gallery (New York), spring exhibition [April] 1926.
CGFA (1931), cat. no. 14, p. 1, 8.
CGFA (1935), no cat.
CGFA (1941), no cat.
Art Gallery of Toronto (Ontario, Canada), February 1945, *Museum's Choice: Paintings by Contemporary Americans*, cat. no. 37.
CGFA (February 1952), no cat.
Currier Gallery of Art (Manchester, New Hampshire), April 18 – May 31, 1964, *Paintings and Drawings: Peter Blume in Retrospect 1925–1964*, cat. essay by Charles E. Buckley, no. 3, pp. 21, 43; toured, July 9 – August 16, 1964, to Wadsworth Atheneum (Hartford, Connecticut).

CGFA (1969), checklist no. 1.
CGFA (May 1970), no cat.
CGFA (1970–1971), cat. no. 1, illus. (as dated ca. 1926).
Museum of Contemporary Art (Chicago), January 10 – February 29, 1976, *Peter Blume: A Retrospective Exhibition*, cat. essay by Dennis Adrian, unpag., illus.
Metropolitan Museum and Art Centers (Miami), February 18 – March 27, 1977, *American Magic Realists*, cat., p. 4 (as dated ca. 1926).

REFERENCES:
Lloyd Goodrich, "New York Exhibitions," *The Arts* 9 (May 1926): 283, 286, illus.
"Peter Blume—Painter," *Index of Twentieth Century Artists* 3 (May 1936), reprinted in *The Index of Twentieth Century Artists 1933–1937* (1970): 583, 584.
Milton W. Brown, "Cubist-Realism: An American Style," *Marsyas* 3 (1946): 154.
Lee H. B. Malone, "He Chose with Conviction," *Carnegie Magazine* 26 (March 1952): 79.
Milton W. Brown, *American Painting from the Armory Show to the Depression* (1955, reprinted 1970), p. 125, illus.
Tucker (1969), cat. no. 3, pp. 9–10, 12, illus. (as dated ca. 1926).
John Wilmerding, ed., *The Genius of American Painting* (1973), p. 241, illus. (as dated ca. 1926).
CMA, *Catalog* (1978), pp. 19–20, 136, illus.
CMA, *Selections* (1978), pp. 19–20, illus.
Abraham A. Davidson, *Early American Modernist Painting 1910–1935* (1981), pp. 185, 220–222, fig. 120.
Frank S. Trapp, *Peter Blume* (1987), pp. 18, 27, 29, illus.

61 *Crucifixion* 85.3.1
ENDNOTES
1. *Elijah Pierce: Wood Carver* (exh. cat., CGFA, 1973), unpaginated.
2. Ibid.
3. The original configuration is documented by two period photographs of Pierce standing beside the *Crucifixion* (in private collection, Columbus, Ohio).
4. Richard A. Aschenbrand, "Elijah Pierce: Preacher in Wood," *American Craft Magazine* (June/July 1982): 25.

PROVENANCE:
Collection of the artist; Mrs. Elijah Pierce; CMA, 1985.

EXHIBITION HISTORY:
Krannert Art Museum, University of Illinois at Urbana-Champaign, December 12, 1971 – January 2, 1972, *Elijah Pierce*, no cat.
MoMA, January 25 – March 13, 1972, Untitled III (Art Lending Service Exhibition and Sale), no cat.
Bernard Danenberg Galleries (New York), June 6–24, 1972, *Elijah Pierce: Painted Carvings*, cat. no. 4, p. 5, illus. (as dated 1933).
PAFA, December 21, 1972 – January 28, 1973, *An Exhibition of Painted Carvings by Elijah Pierce*, checklist no. 9.
CGFA, November 30 – December 30, 1973, *Elijah Pierce: Wood Carver*, cat., unpag.
Ohio State Fair, Columbus, August 12–24, 1980, *American Folk Art from Ohio Collections*, cat. no. 187, p. 114, illus. (as dated 1930).

Corcoran Gallery of Art (Washington, D.C.), January 15 – March 28, 1982, *Black Folk Art in America 1930–1980*, cat. by Jane Livingston, John Beardsley, and Regenia Perry, no. 203, pp. 118, 119, 120, 174, illus. (as dated 1940); toured, April 26, 1982 – May 15, 1983, to J. B. Speed Art Museum (Louisville, Kentucky), Brooklyn Museum (New York), Craft and Folk Art Museum (Los Angeles), Institute for the Arts (Rice University, Houston).

CMA (1986–1987), cat. no. 89, pp. 29, 34, illus.

Akron Art Museum (Ohio), June 13 – August 16, 1987, *On Earth as it is in Heaven: The Carvings of Elijah Pierce*, no cat.

Southern Ohio Museum and Cultural Center (Portsmouth), February 12 – March 13, 1988, *Elijah Pierce: Woodcarver*, no cat.

REFERENCES:
Herbert W. Hemphill, Jr., and Julia Weissman, *Twentieth-Century American Folk Art and Artists* (1974), pp. 100, 101, illus. (as dated ca. 1933).

Gaylen Moore, "The Vision of Elijah," *New York Times Magazine* (August 26, 1979): 28, 30, illus. (as dated 1933).

Sue Gorisek, "Folk Art," *Ohio Magazine* 3 (November 1980): 20.

Mary Schmidt Campbell, "Black Folk Art in America," *Art Journal* 42 (winter 1982): 346.

Robert Hughes, "Finale for the Fantastical," *Time* 119 (March 1, 1982): 70, 71, illus. (as dated 1940).

Richard A. Aschenbrand, "Elijah Pierce: Preacher in Wood," *American Craft Magazine* 42 (June–July 1982): 25, cover illus. (as dated 1940).

C. Kurt Dewhurst, Betty MacDowell, and Marsha MacDowell, *Religious Folk Art in America: Reflections of Faith* (1983), pp. 93, 128, 129, fig. 173 (as dated ca. 1933).

Gary Schwindler, "Elijah Pierce (1892–1984)," *Dialogue* 9 (January–February 1986): 18, 19, illus. (as unknown date).

REMARKS:
A paper label on the back of the relief is inscribed: By E. Pierce/N.F.S./1930 [the "3" in 1930 is overlaid by a "4"].

62 *Hudson Bay Fur Company* 56.1
ENDNOTES:
1. Lloyd Goodrich, *Reginald Marsh* (1972), p. 36.

PROVENANCE:
Estate of the artist, 1954; (sale: Frank K. M. Rehn Galleries, New York, 1956); CMA, 1956.

EXHIBITION HISTORY:
PAFA, January 28 – February 25, 1934, *129th Annual Exhibition*, cat. no. 272, p. 61, illus.

Currier Gallery of Art (Manchester, New Hampshire), July 6 – September 26, 1938, *Midsummer Exhibition*, no cat.

Berkshire Museum (Pittsfield, Masachusetts), August 3–31, 1944, *Works by Reginald Marsh: A Retrospective Exhibition*, cat. no. 23.

WMAA, September 21 – November 6, 1955, *Reginald Marsh*, cat. no. 6, p. 21, illus.; toured, November 27, 1955 – October 14, 1956, to CGFA, Detroit Institute of Arts, City Art Museum of Saint Louis, Dallas Museum of Fine Arts, Los Angeles County Museum, Santa Barbara Museum of Art (California), San Francisco Museum of Art.

CGFA, Paintings from the Columbus Gallery of Fine Arts, no cat.; March 1965, to Otterbein College (Westerville, Ohio).

University of Arizona Museum of Art (Tucson), March 14 – April 13, 1969, *East Side, West Side, All Around the Town: A Retrospective Exhibition of Paintings, Watercolors and Drawings by Reginald Marsh*, cat. no. 62, p. 76, illus.

Newport Harbor Art Museum (Newport Beach, California), November 2 – December 10, 1972, *Reginald Marsh: A Retrospective Exhibition*, cat. no. 11, illus.; toured, January 8 – May 31, 1973, to Des Moines Art Center (Iowa), Fort Worth Art Center Museum (Texas), University Art Museum (University of Texas, Austin).

REFERENCES:
"Reginald Marsh—Painter and Graver," *Index of Twentieth Century Artists* 3 (November 1935), reprinted in *The Index of Twentieth Century Artists 1933–1937* (1970): 487.

Maude Riley, "Reginald Marsh Featured by Berkshire," *Art Digest* 18 (August 1944): 8, illus.

"Accessions of American and Canadian Museums," *Art Quarterly* 19 (January–March 1956): 311.

Lloyd Goodrich, *Reginald Marsh* (1972), pp. 36, 53, illus.

CMA, *Catalog* (1978), pp. 79, 145, illus.

CMA, *Selections* (1978), p. 79, illus.

Marilyn Cohen, *Reginald Marsh's New York: Paintings, Drawings, Prints and Photographs* (exh. cat., WMAA, 1983), pp. 24, 25, 27, fig. 43.

Mark Bockrath, "A Tempera Technique of Reginald Marsh," *Intermuseum Conservation Association Newsletter* 15 (June 1984): 1, 2, fig. 1.

RELATED WORKS:
Modeling Furs on Union Square, 1940, watercolor, private collection.

63 *Veteran Acrobat* 42.84
ENDNOTES:
1. Paul Bird, *Fifty Paintings by Walt Kuhn* (1940), unpag.

PROVENANCE:
Collection of the artist, until 1942; CMA, 1942.

EXHIBITION HISTORY:
CGFA, April 3 – May 4, 1942, *Paintings by Walt Kuhn*, checklist no. 9.

Dayton Art Institute, October 1943, *Paintings by Walt Kuhn*, no cat.; toured, November 1943, to Art Institute of Zanesville (Ohio).

Art Gallery of Ontario (Toronto, Canada), February 2–25, 1945, *Museums' Choice: Paintings by Contemporary Americans*, cat. no. 35.

Akron Art Institute (Ohio), November 30 – December 28, 1945, *40 American Painters: A Survey of American Painting from Colonial to Modern Times, for the Opening of the Institute, December 1945*, cat. no. 29, illus.

Cincinnati Art Museum, October 1 – November 5, 1948, *An American Show*, cat. no. 30.

Birmingham Museum of Art (Alabama), April 8 – June 3, 1951, *Opening Exhibition*, cat., p. 45.

Cincinnati Art Museum, October 5 – November 9, 1960, *Walt Kuhn 1877–1949*, cat. no. 78, illus.

CGFA, Paintings from the Columbus Gallery of Fine Arts, no cat.; March 1965, to Otterbein College (Westerville, Ohio).

Amon Carter Museum (Fort Worth, Texas), August 6 – September 10, 1978, *Walt Kuhn: A Classic Revival*, checklist no. 39; toured, September 30, 1978 – April 15, 1979, to Joslyn Art Museum (Omaha, Nebraska), Wichita Art Museum (Kansas), Colorado Springs Fine Arts Center (Colorado).

Milwaukee Art Center (Wisconsin), May 7 – June 28, 1981, *Center Ring, The Artist: Two Centuries of Circus Art*, cat. by Dean Jensen, no. 54, pp. 62, 72, 91, illus.; toured, August 30, 1981 – June 6, 1982, to CMA, New York State Museum (Albany), Corcoran Gallery of Art (Washington, D.C.).

REFERENCES:
Paul Bird, *Fifty Paintings by Walt Kuhn* (1940), p. 39, illus.

"American Museums Acquire Americans," *ARTnews* 41 (June–July 1942): 28, illus.

"Sensitive Kuhn Acrobat Goes to Columbus," *Art Digest* 16 (August 1942): 7, illus.

"The Year in Art: A Review of 1942," *ARTnews* 41 (January 1943): 25, illus.

Eloise Spaeth, *American Art Museums: An Introduction to Looking*, 3rd ed. (1975), p. 344.

Philip R. Adams, *Walt Kuhn, Painter: His Life and Work* (1978), pp. 182, 187, 201, 225, 267, no. 384.

CMA, *Catalog* (1978), pp. 65, 143, illus.

CMA, *Selections* (1978), p. 65, illus.

REMARKS:
According to Adams (1978), p. 266, *Veteran Acrobat* may have been included in the following exhibitions: Grace Horne Gallery (Boston), 1941; Denver Art Museum, 1941.

64 *Still-Life with Red Cheese* 83.30
ENDNOTES:
1. Elizabeth McCausland, *A. H. Maurer* (1951), p. 95.

2. Ibid., p. 32.

3. Henry McBride, "The Art of Alfred Maurer," *New York Sun*, November 27, 1937.

4. See Reich, pp. 62–76, figs. 53–79; Salander-O'Reilly Galleries, *Alfred H. Maurer (1868–1932): Modernist Paintings* (1983), figs. 11, 33–36, 41–51; Stephanie Terenzio, *Alfred H. Maurer: Watercolors 1926–1928* (exh. cat., The William Benton Museum of Art, University of Connecticut, Storrs, 1983), figs. 5, 10, and cover.

5. Regarding the dating of Maurer's still lifes, see Elizabeth McCausland Papers, Archives of American Art, Smithsonian Institution, Washington, D.C., Roll D379, Frame 506. The degree of representation in the museum's picture, the regular positioning of architectural features, the patterning of shadows, and the textures of cloth closely relate to Maurer's *Still Life* in the Brooklyn Museum of Art, which appeared in a November 1928 photo of the artist's studio (see McCausland, p. 198). The museum's picture also relates to descriptions of still lifes in an article in the *New York Times* of July 15, 1928 (See McCausland, p. 211).

PROVENANCE:
Bertha Schaefer, New York; Mr. William Dean, New York; Salander-O'Reilly Galleries, New York; CMA, 1983.

EXHIBITION HISTORY:
[Uptown Gallery Continental Club (New

York), October 30 – December 3, 1934, *Memorial Exhibition: Works of the Late Alfred Maurer*, cat. intro. by Robert Ulrich Godsoe, no. 20 (as *Still Life with Cheese*)].

Wichita Museum of Art (Kansas), October 27 – December 1, 1985, *American Art of the Great Depression: Two Sides of the Coin*, cat. by Howard E. Wooden, pp. 43 (as dated 1930), 66, 126, fig. 116.

CMA (1986–1987), cat. no. 82, p. 33.

65 *Landscape with Drying Sails* 81.12
ENDNOTES:
1. James Johnson Sweeney, *Stuart Davis* (exh. cat., Museum of Modern Art, 1945), p. 10.
2. Letter dated October 18, 1946, from Stuart Davis to Mr. D. S. Defenbacher, Director, Walker Art Center, Minneapolis.
3. Quoted in Matthew Baigell, *Dictionary of American Art* (1980), p. 89.

PROVENANCE:
Downtown Gallery, New York; Walker Art Center, Minneapolis, 1946; Downtown Gallery, New York, 1955 (acquired from Walker Art Center in exchange for Davis's *Colonial Cubism*, 1954); Stuart Davis; Mrs. Stuart Davis, New York, 1964; (sale: Grace Borgenicht Gallery, New York, 1981); CMA, 1981.

EXHIBITION HISTORY:
Downtown Gallery (New York), March 8–21, 1932, *"The American Scene": Recent Paintings New York and Gloucester by Stuart Davis*, checklist no. 4 (as *Drying Sail*).

Corcoran Gallery of Art (Washington, D.C.), March 24 – May 5, 1935, *The Fourteenth Biennial Exhibition of Contemporary American Oil Paintings*, cat. no. 389, pp. 44, 120, illus.

Arts Council of Great Britain, *The Modern Spirit: American Painting, 1908–1935*, cat. by Milton W. Brown, no. 125, p. 72; toured, August 20 – November 20, 1977, to Royal Scottish Academy (Edinburgh), Hayward Gallery (London, England).

Grace Borgenicht Gallery (New York), February 6 – March 4, 1982, *The Gloucester Years*, cat., pp. 5, 11, 22, illus.

Rahr-West Museum (Manitowoc, Wisconsin), March 31 – May 8, 1983, *Stuart Davis: The Formative Years 1910–1930*, cat. no. 30, unpag., illus.

CMA (1986–1987), cat. no. 52, pp. 20, 21, 32, illus.

REFERENCES:
Edward Alden Jewell, "Stuart Davis Offers a Penetrating Survey of the American Scene—Native Talent in Drawing Shown," *New York Times*, March 10, 1932 (as *Drying Sail*).

Melvin Geer Shelley, "Around the Galleries: Downtown Galleries," *Creative Art* 10 (April, 1932): 302 (as *Drying Sail*).

Famous Artists Magazine 4 (autumn, 1955): unpag., illus.

Bruce Weber, *Stuart Davis' New York* (exh. cat., Norton Gallery and School of Art, 1985), pp. 13, 18, fig. 4.

William C. Agee, "Cézanne, Color, and Cubism: The Ebsworth Collection and American Art," in *The Ebsworth Collection, American Modernism, 1911–1947* (exh. cat., Saint Louis Art Museum, 1987), p. 26, fig. 6.

William C. Agee, *Stuart Davis: A Catalogue Raisonné* (forthcoming 1989–1990).

RELATED WORKS:
Drawing for *Landscape with Drying Sails*, ink on paper, private collection (see *Stuart Davis: Provincetown and Gloucester Paintings and Drawings* [1986], illus. [as dated ca. 1933]).

REMARKS:
Two labels on the back of the painting give the dates "1931–32" and "1931 or 1932." According to William Agee, who is preparing the catalogue raisonné of Davis's work, the painting is stylistically consistent with others of the dates given. The picture is known to have been completed by March 1932, when it was exhibited at Downtown Gallery (New York).

66 *Blue Coast* 51.13
ENDNOTES:
1. Quoted in Ernst Scheyer, *Lyonel Feininger, Caricature and Fantasy* (1964), p. 36.
2. Ibid., p. 128.
3. Ibid.
4. Ibid., p. 152.

PROVENANCE:
Van Diemen-Lilienfeld Galleries, New York; CMA, 1951.

EXHIBITION HISTORY:
[Fine Arts Gallery of San Diego (California), 1945, Exhibition of Contemporary American Painting].

PAFA, January 26 – March 2, 1947, *142nd Annual Exhibition of Painting and Sculpture*, checklist no. 37.

Toledo Museum of Art (Ohio), June 1 – August 31, 1947, *34th Annual Exhibition of Contemporary American Paintings*, checklist no. 29.

Baltimore Museum of Art, April 15 – May 23, 1948, *Themes and Variations in Painting and Sculpture*, cat. no. 105, p. 67.

College of Fine and Applied Arts, University of Illinois (Urbana), February 26 – April 2, 1950, *National Exhibition of Contemporary American Painting*, cat. essay by Allen S. Weller, no. 40, p. 23, pl. 89.

CGFA, March 9 – April 8, 1951, *"Few Are Chosen,"* cat. no. 2, p. 7 (as dated ca. 1941).

Cleveland Museum of Art, November 2 – December 16, 1951, *The Work of Lyonel Feininger*, cat. no. 35, p. 17.

Junior Art Gallery, Louisville Free Public Library (Kentucky), October 4 – December 27, 1954, *What is an Art Reproduction?*, no. 9.

CGFA, February 10 – March 9, 1961, *German Expressionism*, cat. no. 12, p. 9 (as dated ca. 1941).

Pasadena Art Museum (California), April 26 – May 29, 1966, *Lyonel Feininger, 1871–1956: A Memorial Exhibition*, cat. no. 55; toured, July 10 – October 23, 1966, to Milwaukee Art Center, Baltimore Museum of Art.

Lima Art Association, Allen County Museum (Ohio), January 12 – February 11, 1968, *Freedom and Order*, checklist no. 8 (as dated 1930).

Institut für Auslandsbeziehungen (Stuttgart, West Germany), Württembergischer Kunstverein (Stuttgart, West Germany), and Bauhaus-Archiv (Darmstadt, Germany), *50 Years Bauhaus*, cat. no. 12 (as dated 1940); toured, December 6, 1969 – March 28, 1971, to Art Gallery of Toronto (Ontario, Canada), Pasadena Art Museum (California), Museo Na-

tional de Bellas Artes (Buenos Aires, Argentina), Museum of Modern Art (Tokyo, Japan).

Oklahoma Art Center (Oklahoma City), May 7 – June 20, 1982, *American Masters of the Twentieth Century*, cat. intro. by John I. H. Baur, no. 18, pp. 25, 54, 55, 102, illus.; toured, July 11 – September 15, 1982, to Terra Museum of American Art (Evanston, Illinois).

REFERENCES:
Allen S. Weller, "Illinois Annual, Comprehensive in Aim, Accents the Advanced," *Art Digest* 24 (March 1950): 7–8.

"Columbus Acquires a Feininger," *Art Digest* 25 (September 1951): 14.

"Art News of the Year," *Art News Annual* (1953): 190, 191, illus.

Twentieth Century Highlights of American Painting (1958), cat. no. 22, pp. 52, 53, illus.

Hans Hess, *Lyonel Feininger* (1961), no. 443, p. 291, illus.

René Huyghe, ed., *Larousse Encyclopedia of Modern Art* (1961, reprinted 1967), p. 415, no. 1135, illus.

Donald Herberholz, *A Child's Pursuit of Art* (1966), illus.

G. Robert Carlsen, et al., *Perceptions: Themes in Literature* (1969, reprinted 1976), p. 479, illus.

Fine Art Reproductions of Old and Modern Masters (1978), p. 357 (as dated 1920).

CMA, *Catalog* (1978), pp. 44, 139, illus.

CMA, *Selections* (1978), pp. 44, illus.

Werner Haftmann, *Verfemte Kunst: Bildende Künstler der inneren und äuberen Emigration in der Zeit des Nationalsozialismus* (1986), p. 202, illus.

67 *Morning Sun* 54.31
ENDNOTES:
1. WMAA.
2. Quoted in Gail Levin, *Edward Hopper: The Art and the Artist* (1980), p. 9.

PROVENANCE:
F.K.M. Rehn Galleries, New York, 1954 (acquired from the artist); CMA, 1954.

EXHIBITION HISTORY:
Worcester Art Museum (Massachusetts), February 17 – April 3, 1955, *Five Painters of America*, cat., p. 2.

Museum of Art, Rhode Island School of Design (Providence), March 7–28, 1956, *Paintings by Hopper and Corbino*, no cat.

Brooks Memorial Union, Marquette University (Milwaukee), April 22 – May 3, 1956, *Festival of American Arts: 75 Years of American Painting*, cat. no. 39, illus.

Butler Institute of American Art (Youngstown, Ohio), June 29 – September 1, 1958, *23rd Annual Midyear Show*, cat. no. 70.

Boston Arts Festival, June 5–28, 1959, *New England Invitational*, cat. no. 8.

Heistand Hall Gallery, Miami University (Oxford, Ohio), October 1–31, 1959, *The American Scene in 150 Years of American Art*, checklist, unpag.

University of Arizona Art Gallery (Tucson), April 20 – May 19, 1963, *A Retrospective Exhibition of Oils and Watercolors by Edward Hopper*, cat. no. 46, pp. 16, 17, 36, illus.

Edward W. Root Art Center, Hamilton College (Clinton, New York), May 10 – June 7, 1964,

Edward Hopper: Oils, Watercolors, Prints, cat. no. 10.

WMAA, September 29 – November 29, 1964, *Edward Hopper*, cat. by Lloyd Goodrich, no. 58; toured, December 18, 1964 – May 9, 1965, to Art Institute of Chicago, Detroit Institute of Arts, City Art Museum of Saint Louis.

Fine Arts Gallery of San Diego, February 23 – March 24, 1968, *Twentieth Century American Art*, cat. no. 30, illus.

William A. Farnsworth Library and Art Museum (Rockland, Maine), July 9 – September 5, 1971, *Edward Hopper 1882–1967*, cat. no. 44 (as dated 1954); toured, September 24 – October 31, 1971, to PAFA.

Newport Harbor Art Museum (Newport Beach, California), January 12 – February 23, 1972, *Edward Hopper*, no cat.; toured, March 7 – April 30, 1972, to Pasadena Art Museum (California).

WMAA, September 16, 1980 – January 25, 1981, *Edward Hopper: The Art and the Artist*, cat. by Gail Levin, p. 42, pl. 400 [the exhibition toured, but *Morning Sun* was not included in the tour].

Haus der Kunst (Munich, West Germany), November 14, 1981 – January 31, 1982, *Amerikanische Malerei 1930–1980*, cat. no. 145, p. 140, fig. 145.

Neuberger Museum, State University of New York at Purchase, September 21, 1986 – January 18, 1987, *The Window in Twentieth-Century Art*, cat. by Suzanne Delehanty, pp. 74, 101, illus.; toured, April 24 – June 29, 1987, to Contemporary Arts Museum (Houston).

REFERENCES:
John S. Still, ed., *Midwest Museums Quarterly* 15 (January 1955): 35.

Lawrence Campbell, "Hopper: Painter of 'Thou Shalt Not,' " *ARTnews* 63 (October 1964): 43, illus.

Mahonri Sharp Young, "Letter from the U.S.A.: Of Kings and Things," *Apollo* 86 (August 1967): 150, fig. 5 (as dated 1954).

Lloyd Goodrich, *Edward Hopper* (1971), pp. 104–105, 151, 153, illus.

Young (1977), p. 201, illus. (as dated 1954).

John Baker, "Voyeurism in the Art of John Sloan: The Psychodynamics of a 'Naturalistic' Motif," *Art Quarterly* 1, no. 4 (1978): 391, 395, fig. 19.

CMA, *Catalog* (1978), pp. 59–60, 142, illus.

CMA, *Selections* (1978), pp. 59–60, illus.

Erwin Leiser, "Zur Wanderausstellung des Amerikanischen Realisten Edward Hopper," *Weltwoche Kultur* 21 (May 20, 1980): 29, illus.

Ann Barry, "The Full Range of Edward Hopper," *The New York Times*, September 21, 1980.

Peter Selz, *Art in Our Times: A Pictorial History 1890–1980* (1981), pp. 412, 413, fig. 1122 (as dated 1954).

Anna Bing Arnold, "Cross Country," *Horizon* (April 1981): 6 (as *Morning Sunlight*).

J. P. Forsthoffer, "Building on Existing Strengths," *Horizon* (November 1984): 32, illus.

Raymond Carney, *American Vision: The Films of Frank Capra* (1986), pp. 10, 219, 220, 443, illus.

John Wilmerding, *Andrew Wyeth, The Helga Pictures* (1987), p. 18, illus.

Robert Hobbs, Edward Hopper (1987), pp. 139, 142, 143, illus.

Heinz Liesbrock, *Edward Hopper: Vierzig Meisterwerke* (Berlin, 1988), p. 27, fig. 35.

RELATED WORKS:
Two drawings for *Morning Sun*, conté crayon on paper, WMAA.

Drawing for painting, *Morning Sun*, conté crayon and pencil on paper, WMAA.

68 *Snack Bar* 54.47
ENDNOTES:
1. Quoted in "They Drink and Fly Away," *Time* (May 23, 1949): 63.
2. For a discussion of Bishop's working methods and techniques, see Sheldon Reich, *Isabel Bishop* (exh. cat., University of Arizona Museum, 1974), p. 23.
3. Quoted in Karl Lunde, *Isabel Bishop* (1975), p. 43.
4. Quoted in Lunde, pp. 42–43. For a fuller explanation and discussion of Bishop's ideas concerning Baroque art, see her essay, "Concerning Edges," *Magazine of Art* (May 1945): 168–173.
5. Quoted in E. Harms, "Light is the Beginning—The Art of Isabel Bishop," *American Artist* 25 (February 1961): 28–33.

PROVENANCE:
Midtown Galleries, New York (acquired from the artist); CMA, 1954.

EXHIBITION HISTORY:
Midtown Galleries (New York), October 25 – November 19, 1955, *Bishop: Paintings and Drawings*, checklist no. 8.

Ohio Wesleyan University Press (Delaware, Ohio), on loan December 1964 – March 1966.

Akron Art Institute (Ohio), September 27 – November 7, 1971, *Celebrate Ohio*, cat., unpag.

University of Arizona Museum of Art (Tucson), November 3 – December 1, 1974, *Isabel Bishop Retrospective*, cat. by Sheldon Reich, no. 43, p. 199, illus. no. 31; toured, January 17 – July 31, 1975, to Ulrich Museum (Wichita State University, Kansas), WMAA, Brooks Memorial Art Gallery (Memphis, Tennessee).

Butler Institute of American Art (Youngstown, Ohio), May 2–23, 1976, *Salute the Women*, cat. no. 2.

REFERENCES:
John S. Still, ed., "News of the Museums— Ohio," *Midwest Museums Quarterly* 15 (January 1955): 35.

Charles McCurdy, ed., *Modern Art: A Pictorial Anthology* (1958), p. 166, illus. no. B60.

Ernest Harms, "Light is the Beginning: The Art of Isabel Bishop," *American Artist* 25 (January 1961): 62, illus.

Karl Lunde, *Isabel Bishop* (1975), pl. 131.

CMA, *Catalog* (1978), pp. 19, 136, illus.

CMA, *Selections* (1978), pp. 19, illus.

RELATED WORKS:
Snack Bar, n.d., etching (see Una E. Johnson, *Isabel Bishop, Prints and Drawings, 1925–1964* [1964], p. 17, pl. 38).

69 *Figure in Grief* 68.6
PROVENANCE:
Hugo Robus, Jr., New York; CMA, 1968 (gift of Hugo Robus, Jr., through Forum Gallery, New York).

EXHIBITION HISTORY:
[Forum Gallery (New York), 1963, cat. no. 14].

[Sculptor's Guild, Lever House (New York), October 18 – November 26, 1964, *Sculpture 1964*, cat., illus.].

[Forum Gallery (New York), 1966, cat. no. 3].

CMA, October 11 – November 29, 1987, *Accent on Sculpture: Small-Scale Works from the Permanent Collection*, checklist.

REFERENCES:
[*Today's Art* (March 1965), cover illus.].

George W. Knepper, *An Ohio Portrait* (Ohio Historical Society, 1976), pp. 215, 278, illus.

Roberta K. Tarbell, *Hugo Robus (1885–1964)* (1980), pp. 99, 101, 208, 209, fig. 82.

CMA, *Catalog* (1978), p. 198, illus.

CMA (1986), pp. 5, 6, 32, illus.

RELATED WORKS:
Figure in Grief (same edition as CMA work), bronze, University of Delaware (Newark).

Figure in Grief (same edition as CMA work), bronze, private collection (acquired from Forum Gallery, New York).

Figure in Grief (same edition as CMA work), bronze, private collection.

Figure in Grief (same edition as CMA work), bronze, private collection.

Figure in Grief (same edition as CMA work), bronze, unknown location, sold at auction to benefit WMAA, 1966.

70 *Happy Mother* 82.2
PROVENANCE:
Forum Gallery, New York (acquired from the artist); Ashland Oil, Kentucky, 1980; CMA, 1982 (gift of Ashland Oil, Inc.).

EXHIBITION HISTORY:
[WMAA, January 14 – March 1, 1959, *Four American Expressionists: Doris Caesar, Chaim Gross, Karl Knaths and Abraham Rattner*, cat. by Lloyd Goodrich and John I. H. Baur, pp. 66–67, illus.; toured, April 8, 1959 – January 3, 1960, to Currier Gallery of Art (Manchester, New Hampshire), Colorado Springs Fine Arts Center (Colorado), CGFA, Dallas Museum of Fine Arts].

[Forum Gallery (New York), October 1–25, 1974, *Chaim Gross Sculpture: Retrospective Exhibition*, no cat.].

CMA (1986–1987), cat. no. 64, pp. 22, 23, 33, illus.

REFERENCES:
CMA (1986), p. 30, illus.

RELATED WORKS:
Happy Mother (same edition as CMA work), bronze, private collection, Milwaukee (Wisconsin).

Happy Mother (same edition as CMA work), bronze, private collection, Southampton (New York).

Happy Mother (same edition as CMA work), bronze, Albert Einstein College of Medicine, Yeshiva University (New York).

Happy Mother (same edition as CMA work), bronze, Forum Gallery (New York).

Mother Playing (sketch for sculpture), 1957, pen, brush, and ink (see Alfred Werner, *Chaim Gross: Watercolors and Drawings* [1979], p. 129).

71 *Cornice* 80.26

ENDNOTES:
1. See Thomas H. Garver, *George Tooker* (1985), p. 29.
2. *The Collected Poetry of W. H. Auden* (1945), p. 402.
3. Ibid.
4. Ibid., p. 384.

PROVENANCE:
[Edwin Hewitt Gallery, New York]; Theodore Starkowski, New York, ca. 1951; (sale: Sotheby Parke Bernet, April 25, 1980, estate of Theodore Starkowski, lot no. 271); CMA, 1980.

EXHIBITION HISTORY:
WMAA, December 16, 1949 – February 5, 1950, *1949 Annual Exhibition of Contemporary American Painting*, cat. no. 152 (as *The Cornice*).
Edwin Hewitt Gallery (New York), February 20 – March 10, 1951, *Paintings by George Tooker*, checklist no. 12 (as *The Cornice*).
Jaffe-Friede Gallery, Hopkins Center, Dartmouth College (New Hampshire), August 5 – September 5, 1967, *George Tooker*, cat. essay by Robert L. Isaacson, no. 3.
Emerson Gallery, Hamilton College (Clinton, New York), January 4 – February 10, 1986, *The Surreal City: 1930–1950s*, no cat. [Note: This was an expanded version of an exhibition organized by WMAA at Philip Morris].
Gibbes Art Gallery (Charleston, South Carolina), in conjunction with Spoleto Festival USA, May 21 – June 28, 1987, *George Tooker* cat. (reprint of Garver [1985]; see refs. below).
CMA (1986–1987), cat. no. 40, p. 32.

REFERENCES:
"Egg Tempera Painting with Technical Commentary by Frederic Taubes and Illustrated with Selected Examples by George Tooker," *American Artist* 21(May 1957): 21, illus.
Thomas H. Garver, *George Tooker* (1985), pp. 29, 132, illus.

72 *Inland Shell* 82.15

ENDNOTES:
1. Canton Art Institute, *Andrew Wyeth: From Public and Private Collections* (exh. cat., 1985), p. 7.
2. Ibid.

PROVENANCE:
R. Frederick Woolworth, New York, ca. 1956 (purchased from the artist); (sale: Coe Kerr Gallery); Joseph H. Davenport, Lookout Mountain, Tennessee, 1970; Kennedy Galleries, New York, ca. 1972; Harry Spiro, New York; CMA, 1982 (gift of Mr. and Mrs. Harry Spiro through Coe Kerr Gallery).

EXHIBITION HISTORY:
Canton Art Institute (Ohio), September 15 – November 3, 1985, *Andrew Wyeth from Public and Private Collections*, cat., p. 73, illus.
CMA (1986–1987), cat. no. 73, pp. 23, 33, illus.
Southern Ohio Museum and Cultural Center (Portsmouth), May 27 – June 28, 1987, *Contemporary Landscape*, no cat.

73 *Study for Seascape #10* 76.33

ENDNOTES:
1. Paul Gardner, "Tom Wesselmann," *ARTnews* 81 (January 1982): 69.

2. Slim Stealingworth [Tom Wesselmann], *Tom Wesselmann* (1980), p. 47.

PROVENANCE:
Sidney Janis Gallery, New York (acquired from the artist), 1966; CMA, 1976.

EXHIBITION HISTORY:
Sidney Janis Gallery (New York), May 10 – June 4, 1966, *New Paintings by Wesselmann*, cat. no. 28, illus.
Swarthmore College Art Gallery (Pennsylvania), 1968, *The Big Detail*, no cat.
CGFA, January 1976 – April 1977, *Recent Acquisitions*, no cat.
CMA (1986–1987), cat. no. 3, pp. 10, 31.

REFERENCES:
CMA, *Catalog* (1978), pp. 127, 169, illus.
CMA, *Selections* (1978), p. 127, illus.

RELATED WORKS:
Seascape #10, 1966, painted molded plastic, collection of the artist.

74 *V–X* 85.1

ENDNOTES:
1. Deborah Perlberg, "Snelson and Structure," *Artforum* (May 1977): 48.
2. Letter dated September 29, 1986 (CMA files).

PROVENANCE:
CMA, 1985 (acquired from the artist).

EXHIBITION HISTORY:
Public Arts Council (New York), November 1974 – April 1975 (at Waterside Plaza, New York), *Kenneth Snelson*.
Nationalgalerie Berlin, and Neuen Berliner Kunstverein and Berliner Künstler programs des DAAD (West Germany), March 31 – May 8, 1977, *Kenneth Snelson Skulpturen*, cat., p. 10, illus.; toured, July 29 – September 4, 1977, to Wilhelm-Lehmbruck-Museum (Duisburg, West Germany).
Albright-Knox Art Gallery (Buffalo, New York), September 12 – November 8, 1981, *Kenneth Snelson*, cat. by Douglas G. Schultz and Howard N. Fox, pp. 25, 38, illus.; toured, June 4, 1981 – February 21, 1982, to Hirshhorn Museum and Sculpture Garden (Washington, D.C.), Sarah Campbell Blaffer Gallery (University of Houston).
Construct Gallery, Chicago, 1982.
CMA (1986–1987), cat no. 88, pp. 28, 34.

REFERENCES:
CMA (1986), pp. 22, 23, 32, illus.

RELATED WORKS:
V–X (same edition as CMA work), 1974, stainless steel and wire, Hunter Museum (Chattanooga, Tennessee).
Study for *V–X*, 1968, stainless steel and wire, collection of the artist.
Maquette of Study for V–X, 1968, aluminum and wire (edition of 4).
Drawing for V–X, 1968–1973, pencil on paper (see exh. cat. by Schultz and Fox [1981], p. 65).
Working Model for V–X, 1974–1984, aluminum and wire, artist's proof, CMA.

75 *Captain's Paradise* 72.27

ENDNOTES:
1. Jacques Seligmann and Co., *Bennington Col-*

lege Alumnae Paintings (May 1950); Samuel Kootz Gallery, *Fifteen Unknowns* (also called *Twelve Unknowns*) (December 1950).

PROVENANCE:
André Emmerich Gallery, New York, 1971 (acquired from the artist); CMA, 1972.

EXHIBITION HISTORY:
André Emmerich Gallery (New York), November 6 – December 1, 1971, *Helen Frankenthaler*, cat.

REFERENCES:
Lawrence Alloway, "Frankenthaler as Pastoral," *ARTnews* 70 (November 1971): 68, 89, illus.
CMA, *Catalog* (1978), pp. 45, 140, illus.
CMA, *Selections* (1978), p. 45, illus.

76 *Shadow on the Earth* 72.28

ENDNOTES:
1. James McC. Truitt, "Art—Arid D. C. Harbors Touted 'New' Painters," *The Washington Post*, December 21, 1961.

PROVENANCE:
André Emmerich Gallery, New York, 1971 (acquired from the artist); CMA, 1972.

EXHIBITION HISTORY:
André Emmerich Gallery (New York), October 9 – November 3, 1971, *Kenneth Noland: New Paintings*, cat. no. 6.

REFERENCES:
CMA, *Catalog* (1978), pp. 85, 147, illus.
CMA, *Selections* (1978), p. 85, illus.

77 *Sky Cathedral: Night Wall* 77.20

ENDNOTES:
1. The author is indebted to Chief Curator Steven Rosen for his observations on the reading of this work.
2. From a taped conversation with Diana Mackown, in Louise Nevelson, *Dawns and Dusks* (1976), p. 127.
3. Ibid., p. 126.
4. Claude Marks, *World Artists: 1950–1980* (1984), p. 607.

PROVENANCE:
Pace Gallery, New York and Columbus, March 1976 (acquired from the artist).

EXHIBITION HISTORY:
CMA (1986–1987), cat. no. 6, pp. 12, 13, 31, illus.

REFERENCES:
CMA, *Catalog* (1978), pp. 84, 197, illus.
CMA, *Selections* (1978), p. 84, illus.
CMA (1986), pp. 12, 13, 21–22, 32, illus.

78 *Untitled (to Janie Lee) one* 79.53

PROVENANCE:
Sperone, Westwater, Fischer, New York, ca. 1977 (acquired from the artist); Mr. and Mrs. William King Westwater, Columbus, September 11, 1979; CMA, 1979 (gift of Mr. and Mrs. William King Westwater).

EXHIBITION HISTORY:
[Janie C. Lee Gallery (Dallas), April 1971, *Dan Flavin*].
[Rice University Institute of Arts (Houston), October 5 – November 26, 1972, *cornered Fluorescent light from Dan Flavin*].

[Leo Castelli (New York), September 19 – October 16, 1973, *Group Exhibition*].

[Saint Louis Art Museum, January 26 – March 11, 1973, *Drawings and Diagrams from Dan Flavin, 1963–1972*, cat. Vol. 2: *corners, barriers and corridors in fluorescent light from Dan Flavin*, by Emily S. Rauh and Dan Flavin, no. 35, pp. 27, 34, 35, illus.].

REFERENCES:
CMA (1986), pp. 14, 28, 30, illus.

RELATED WORKS:
Untitled (to Janie Lee) one, 1971, four (same edition as CMA work), in private collections.

Untitled (to Janie Lee) two, 1971, blue, green, yellow, and pink fluorescent light (edition of 5).

79 *Out of There* 79.15
ENDNOTES:
1. Colin Naylor and Genesis P-Orridge, eds., *Contemporary Artists* (1977), p. 631.
2. Jeanne Siegel, "Clement Meadmore: Circling the Square," *ARTnews* 70 (February 1972): 56.

PROVENANCE:
Hamilton Gallery of Contemporary Art, New York (acquired from the artist); Knoedler & Co., New York, 1979; CMA, 1979.

EXHIBITION HISTORY:
Galerie Denise René-Hans Mayer (Düsseldorf, West Germany), June 1974, *Clement Meadmore*, no cat.

On loan to Galerie Alfred Schmela Sculpture Park (Düsseldorf, West Germany), 1976–1979.
CMA (1986–1987), cat. no. 24, pp. 16, 31.

REFERENCES:
Hugh M. Davies, "Clement Meadmore," *Arts Magazine* 51 (March 1977): 7.
CMA (1986), p. 31, illus.
[H. H. Arnason, *History of Modern Art: Painting, Sculpture and Architecture* (2nd ed., 1979), pp. 655, 657, fig. 1181].

RELATED WORKS:
Out of There, 1974, painted aluminum (edition of 2), Hale Boggs Building (New Orleans).

80 *Intermediate Model for the Arch* 80.36
PROVENANCE:
M. Knoedler & Co., New York, 1978; CMA, 1980.

EXHIBITION HISTORY:
CMA (1986–1987), cat. no. 44, pp. 18, 32.

REFERENCES:
CMA (1986), pp. 25, 28, illus.

RELATED WORKS:
The Arch, 1975, steel plate (painted black), H. 56 feet, Storm King Art Center (New York).

81 *Two Lines Up Excentric Variation VI* 78.31
ENDNOTES:
1. John Gruen, "The Sculpture of George Rickey: Silent Movement Performing in a World of Its Own," *Art News* (April 1980): 95.
2. Letter of November 25, 1987, from George Rickey Workshop to CMA.
3. George Rickey, "The Metier," *Contemporary Sculpture*, Arts Yearbook 8, ed. James R. Mellow (1965), pp. 164–166; quoted in Herschel

B. Chipp, *Theories of Modern Art* (1968), p. 588.

PROVENANCE:
CMA, 1978 (acquired from the artist).

EXHIBITION HISTORY:
CMA (1986–1987), cat. no. 17, pp. 14, 15, 31, illus.

REFERENCES:
CMA (1986), pp. 6, 9, 25, 27, 32, illus.

RELATED WORKS:
Two Lines Up Excentric Variation VI, 1977, stainless steel (same edition as CMA work), private collection, Plano, Illinois.

Two Lines Up Excentric Variation VI, 1977, stainless steel (same edition as CMA work), Scottish National Gallery of Modern Art, Edinburgh, Scotland.

Two Lines Up Excentric, 1975 (edition of 5).

Two Lines Up Excentric Variation II, 1975.

Two Lines Up Excentric Variation III, 1975–1977.

Two Lines Up Excentric Variation IV, 1975 (edition of 3).

Two Lines Up Excentric Variation V, 1976 (edition of 3).

Two Lines Up Excentric Variation VII, 1977 (edition of 1).

Two Lines Up Excentric Variation VIII, 1978 (edition of 3).

Two Lines Up Excentric Variation IX, 1983 (edition of 3).

82 *Girl on Blanket, Full Figure* 80.7
ENDNOTES:
1. Ellen Johnson, "Cast from Life," in *Modern Art and the Object* (1976), p. 168.

PROVENANCE:
Sidney Janis Gallery, New York, 1978 (acquired from the artist); CMA, 1980.

EXHIBITION HISTORY:
Sidney Janis Gallery (New York), November 30 – December 30, 1978, *New Sculpture by George Segal*, cat. no. 12, illus.

Hope Makler Gallery (Philadephia), February 9 – March 17, 1979, *George Segal*, no cat.

Neuberger Museum, State University of New York at Purchase, April 1 – May 21, 1979, *Christo, Mark di Suvero, Robert Irwin and George Segal on Sculpture*.

REFERENCES:
Jan Van der Marck, *George Segal* (1979), p. 2, fig. 173.
CMA (1986), pp. 17–18, 32, illus.

RELATED WORKS:
Girl on Blanket: Finger to Chin, 1973, plaster, Collection Xavier Fourcade (New York).

Girl on Blanket, Hand on Leg, 1973, plaster, Sidney Janis Gallery (New York), 1978.

Red Girl in Blanket, 1975, painted plaster, Collection Baron H. H. Von Thyssen-Bornemisza (Lugano, Italy).

83 *Untitled, 1979–21* 80.21
PROVENANCE:
Zabriskie Gallery, New York (acquired from the artist), 1979; CMA, 1980.

EXHIBITION HISTORY:
Ohio State Fair, Columbus, August 1–17, 1986, *Assemblage: Piece by Piece*, checklist no. 106.

REFERENCES:
CMA (1986), pp. 13, 28, 32, illus.

84 *Dual Red* 80.20
ENDNOTES:
1. Quoted by Grace Glueck in "Art Notes: Blues and Greens on Reds," *The New York Times*, February 21, 1965.

PROVENANCE:
CMA, 1980 (purchased from the artist).

EXHIBITION HISTORY:
CMA (1986–1987), cat. no. 37, p. 32.

85 *Hitchcock Series: Anticipation of the Night* 85.11
PROVENANCE:
Gimpel & Weitzenhoffer, New York, 1984 (acquired from the artist); CMA, 1985.

EXHIBITION HISTORY:
CMA (1986–1987), cat. no. 93, p. 34.

RELATED WORKS:
Hitchcock Series: Anticipation of the Night, 1984, acrylic on paper, Gimpel & Weitzenhoffer, New York (see *Robert Natkin: Recent Paintings from Hitchcock Series* [Gimpel & Weitzenhoffer, 1984], p. 12, illus.).

Hitchcock Series: Variation of Anticipation of Night, 1985, acrylic on canvas, Gimpel & Weitzenhoffer, New York (see *Robert Natkin: Recent Paintings from Hitchcock Series* [Gimpel & Weitzenhoffer, 1984], p. 21, illus.).

86 *Neon for the Columbus Museum of Art* 86.1
ENDNOTES:
1. David Shapiro, *Stephen Antonakos New Works/1982* (exh. cat., Roslyn Harbor, New York: Nassau County Museum of Fine Art, 1982), unpag.
2. Ibid.
3. From a talk given at the Conference on Glass in London, sponsored by the Crafts Council of Great Britain, April 1986.
4. Quoted by Nancy Gilson in "Neon for the Columbus Museum of Art," *The Columbus Dispatch*, April 13, 1986.

PROVENANCE:
CMA, 1986 (commissioned from the artist).

EXHIBITION HISTORY:
CMA (1986–1987), cat. no. 99, pp. 30, 34, 36, illus.

REFERENCES:
Robert Arnold, "Stephen Antonakos: Neon for the Columbus Museum of Art: Columbus Museum of Art Permanent Installation," *Columbus Art* 7 (summer 1986): 10, cover illus.

CMA (1986), pp. 2, 3, 27–28, 29, cover illus.

"Neon Art and Display," *Signs of the Times* 208 (September 1986): 94, cover illus. (detail).

RELATED WORKS:
Maquette of *Neon for the Columbus Museum of Art*, 1985, mat board, balsa wood, and wire, CMA.

Four study drawings for *Neon for the Columbus Museum of Art*, 1985, private collections.

Part Two

Catalogue of The American Collections

Checklist—Paintings, Sculpture, Works on Paper

Robert Ingersoll Aitken, 1878–1949
George Bellows, ca. 1910 31.305
Bronze, H. 20 in. (50.8 cm.)
Signed on right shoulder: Aitken Fecit
Gift of the artist, 1931

Robert Ingersoll Aitken, 1878–1949
Ralph Beaton 31.306
Bronze, H. 24½ in. (62.2 cm.)
Signed lower right: Aitken
Gift of the Board of Trustees, 1931

Dianne Almendinger, born 1931
My Kitchen Table, 1973 73.31
Graphite and tempera on paper, 17¼ x 25½ in. (43.8 x 64.8 cm.)
Signed and dated lower right: Almendinger '73
Purchased with funds from the Alfred L. Willson Charitable Fund of The Columbus Foundation, 1973

Carl Andre, born 1935
Steel-Steel Plain, 1969 73.13 A-Z, a-j
Steel, 72 in. (182.9 cm.) square
Museum Purchase: Howald Fund, 1973

Stephen Antonakos, born 1926
Maquette of *Neon for the Columbus Museum of Art* 85.29
Mat board, balsa wood, and wire, H. 16 in. (40.6 cm.)
Gift of Stephen Antonakos, 1985

Stephen Antonakos, born 1926
Neon for the Columbus Museum of Art, 1986 86.1

Neon, glass, stainless steel, 336 x 294 in. (853.4 x 746.8 cm.)
Gift of Artglo Sign Company, Inc., and Museum Purchase: Howald Fund, 1986
Cat. no. 86

Richard Anuszkiewicz, born 1930
Dual Red, 1979 80.20
Acrylic on canvas, 90 x 180 in. (228.6 x 457.2 cm.)
Museum Purchase: Howald Fund II, 1980
Cat. no. 84

Alexander Archipenko, 1887–1964
Flat Torso, 1914 81.26.2
Gilded bronze, H. 19½ in. (49.5 cm.)
Signed bottom front: Archipenko 1914
Gift of Philip V. Oppenheimer, 1981

Alexander Archipenko, 1887–1964
Walking, ca. 1958 65.6
Bronze, H. 52 in. (132.1 cm.)
Signed, dated, and inscribed lower left: 2/8 Archipenko Paris 1912/Après moi viendront des/jours quand cette oeuvre gui-/dera et les artistes sculpte/ront l'espace et le temps
Museum Purchase: Howald Fund, 1965

Jane B. Armstrong, born 1921
Flamingo Fledgling, 1971 72.43
Marble, H. 13¾ in. (34.9 cm.)
Gift of Dr. and Mrs. Lewis Basch, 1972

Aitkin, *George Bellows*

Andre, *Steel-Steel Plain*

Archipenko, *Walking*

Ault, *Rick's Barn, Woodstock*

Avery, *The Swans*

Barber, *Cows Grazing*

Jane B. Armstrong, born 1921
Sleeping Otter, 1973 73.3
Marble, H. 8 in. (20.3 cm.)
Signed on bottom left: J B A
Museum Purchase: Howald Fund, 1973

Carlton Atherton, 1900–1964
Untitled, ca. 1950 85.15.6
Ink on paper, 3½ x 4⅝ in. (8.9 x 11.7 cm.)
Gift of Browne Pavey, 1985

Tracy Atkinson, born 1928
Experimental Drawing, 1960 60.51
Ink on paper, 18 x 15⅞ in. (45.7 x 40.3 cm.)
Signed and dated on reverse: Tracy Atkinson/11–29–60
Gift of the artist, 1960

George C. Ault, 1891–1948
Rick's Barn, Woodstock, 1939 61.90
Gouache on paper, 18 x 25½ in. (45.7 x 64.8 cm.)
Signed and dated lower right: G. C. Ault '39
Gift of Louise Ault, 1961

Milton Avery, 1885–1965
The Swans, 1940 81.32.1
Oil on canvas, 36 x 28¼ in. (91.5 x 71.8 cm.)
Signed lower left: Milton Avery
Gift of Mr. and Mrs. Harry Spiro, 1981

Brian Baker, born 1945
Penelope, 1971 72.19
Graphite on paper, 22½ x 30 in. (57.1 x 76.2 cm.)
Signed, dated, and inscribed lower left to right:
 Brian Baker '71 Penelope
Purchased with funds from the Alfred L. Willson Chari-
 table Fund of The Columbus Foundation, 1972

John Jay Barber, 1840–after 1905
The Loitering Herd, 1883 19.47
Oil on canvas, 20 x 40 in. (50.8 x 101.6 cm.)
Signed and dated lower left: J. Jay Barber/1883
Bequest of Francis C. Sessions, 1919

John Jay Barber, 1840–after 1905
Cows Grazing 76.42.1
Oil on canvas, 12 x 18 in. (30.5 x 45.7 cm.)
Signed lower right: J. Jay Barber
Gift of Dorothy Hubbard Appleton, 1976

Will Barnet, 1911
Dark Balustrades, 1971 74.2
Oil on canvas, 73½ x 23½ in. (186.7 x 59.7 cm.)
Signed lower right: Will Barnet
Museum Purchase: Howald Fund, 1974

Victoria Barr, born 1937
A Green Thought in a Green Shade, 1970 71.12
Acrylic on canvas, 69 x 80½ in. (175.3 x 204.5 cm.)
Signed lower right: V. Barr
Museum Purchase: Howald Fund, 1971

John Joseph Barsotti, born 1914
Bateson's Farm, 1950–1951 54.45
Watercolor on paper, 11⅛ x 17⅛ in. (28.3 x 43.5 cm.)
Museum Purchase: Howald Fund, 1954

John Joseph Barsotti, born 1914
Of Wandering Forever and The Earth Again, 1940–1941
 41.9
Oil on canvas, 12¼ x 18¼ in. (31.1 x 46.3 cm.)
Signed and dated lower left: J. Barsotti 40–41
Gift of Orlando A. Miller, 1941

Paul Wayland Bartlett, 1865–1925
Head No. 62, 1930 59.22
Bronze, H. 15 in. (38.1 cm.)
Signed and dated lower left: 1930 P W B
Gift of Mrs. Armstead Peter III, 1959

Paul Wayland Bartlett, 1865–1925
Lion No. 41 59.23
Bronze, H. 5¾ in. (14.6 cm.)
Signed on base: Bartlett/P W
Gift of Mrs. Armstead Peter III, 1959

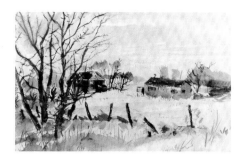

Barsotti, *Bateson's Farm*

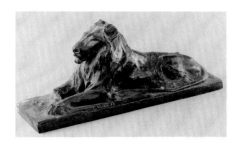

Bartlett, *Lion No. 58*

Barnet, *Dark Balustrades*

Paul Wayland Bartlett, 1865–1925
Lion No. 58 59.23
Bronze, H. 6¼ in. (15.9 cm.)
Signed on base: PWB
Gift of Mrs. Armstead Peter III, 1959

Leonard Baskin, 1922
Horseback-Comanche Civil Chief, 1971 71.32
Ink on paper, 40 x 27½ in. (101.6 x 69.8 cm.)
Signed, dated, and inscribed lower right: Baskin/
 HORSEBACK-COMANCHE CIVIL CHIEF/1971
Museum Purchase: Howald Fund, 1971

Mary Bauermeister, born 1934
SHE-RA, 1969 80.5
Wood, glass, plaster, and ink, H. 11⅞ in. (30.2 cm.)
Inscribed top center: 197A SHE-RA Mary Bauermeister
 1969
Gift of Mr. and Mrs. Arthur J. Kobacker, 1980

Lucie Bayard, born 1899
White Peonies 56.16

Oil on canvas, 28½ x 24 in. (72.4 x 60.9 cm.)
Signed lower left: Lucie Bayard
Gift of Emma S. Bellows, 1956

Gifford Beal, 1879–1956
Circus Day, Elephants 65.35
Oil on composition board, 13½ x 21½ in. (34.3 x 54.6 cm.)
Museum Purchase: Howald Fund, 1965

Cecilia Beaux, 1855–1942
Mrs. Richard Low Divine, Born Susan Sophia Smith, 1907
 47.80
Oil on canvas, 74¾ x 48 in. (189.9 x 121.9 cm.)
Signed lower left: Cecilia Beaux
Bequest of Gertrude Divine Webster, 1947
Cat. no. 22

C. Ronald Bechtle, born 1924
One Primal Instant, 1970 71.22
Gouache on paper, 17½ x 23½ in. (44.4 x 59.7 cm.)
Signed and dated lower right: Bechtle/LXX
Gift of the artist, 1971

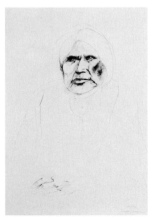

Baskin, *Horseback-Comanche Civil Chief*

Bauermeister, *SHE-RA*

Bayard, *White Peonies*

Bellows, *Polo at Lakewood*

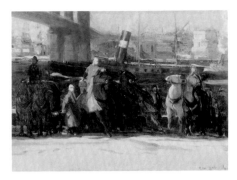

Bellows, *Snow Dumpers*

Bellows, *Portrait of My Father*

George Wesley Bellows, 1882–1925
Portrait of My Father, 1906 52.48
Oil on canvas, 28⅜ x 22 in. (72.1 x 55.9 cm.)
Gift of Howard B. Monett, 1952

George Wesley Bellows, 1882–1925
Summer Night, Riverside Drive, 1909 [57]37.24
Oil on canvas, 35½ x 47½ in. (90.2 x 120.6 cm.)
Signed lower center: Geo. Bellows
Bequest of Frederick W. Schumacher, 1957

George Wesley Bellows, 1882–1925
Blue Snow, The Battery, 1910 58.35
Oil on canvas, 34 x 44 in. (86.4 x 111.8 cm.)
Signed lower right: Geo. Bellows
Museum Purchase: Howald Fund, 1958
Cat. no. 30

George Wesley Bellows, 1882–1925
Polo at Lakewood, 1910 11.1
Oil on canvas, 45¼ x 63½ in. (114.9 x 161.3 cm.)
Signed lower left: Geo. Bellows
Columbus Art Association Purchase, 1911

George Wesley Bellows, 1882–1925
An Island in the Sea, 1911 52.25
Oil on canvas, 34¼ x 44⅜ in. (87 x 112.7 cm.)
Signed lower right: Geo. Bellows. Signed and inscribed
 on reverse: An Island in the Sea/Geo. Bellows/
 146 E. 19/N.Y.
Gift of Howard B. Monett, 1952

George Wesley Bellows, 1882–1925
Snow Dumpers, 1911 41.1
Oil on canvas, 36⅛ x 48⅛ in. (91.8 x 122.2 cm.)
Signed lower right: Geo. Bellows
Museum Purchase: Howald Fund, 1941

George Wesley Bellows, 1882–1925
Arcady, 1913 [57]42.2
Oil on panel, 15 x 19 in. (38.1 x 48.3 cm.)
Signed lower left: Geo. Bellows
Bequest of Frederick W. Schumacher, 1957

George Wesley Bellows, 1882–1925
Churn and Break, 1913 48.53
Oil on panel, 17¾ x 22 in. (45.1 x 55.9 cm.)
Signed lower right: Geo. Bellows
Gift of Mrs. Edward Powell, 1948

George Wesley Bellows, 1882–1925
The Grey Sea, 1913 [52]40.35
Oil on panel, 12⅞ x 19⅜ in. (32.7 x 49.2 cm.)
Signed lower right: Bellows
Gift of Jessie Marsh Powell in memory of Edward Thom-
 son Powell, 1952

George Wesley Bellows, 1882–1925
Mrs. Albert M. Miller (or *White Dress*), 1913 74.30
Oil on canvas, 77 x 40¼ in. (195.6 x 102.2 cm.)
Signed lower left: Geo. Bellows. Dated lower right: 1913
Gift of Barbara Miller Arnold (Mrs. H. Bartley Arnold),
 1974

George Wesley Bellows, 1882–1925
Mrs. H. B. Arnold, 1913 55.58
Oil on canvas, 77½ x 37 in. (196.8 x 94 cm.)
Signed lower right: Geo. Bellows
Gift of H. Bartley Arnold, 1955

George Wesley Bellows, 1882–1925
Riverfront No. 1, 1915 51.11
Oil on canvas, 45⅜ x 63⅛ in. (115.3 x 160.3 cm.)
Signed lower left: Geo. Bellows
Museum Purchase: Howald Fund, 1951
Cat. no. 31

George Wesley Bellows, 1882–1925
Romance of Autumn, Sherman's Point, 1916 60.2
Oil on panel, 17¾ x 21⅞ in. (45.1 x 55.6 cm.)
Inscribed lower right: Geo. Bellows/ E S B [Emma S.
 Bellows]
Signed, dated, and inscribed on reverse: Romance of
 Autumn/by/George Bellows/Painted in Camden Oct.
 1916/Pg. 96 Bellows catalogue
Museum Purchase: Howald Fund, 1960

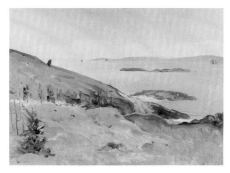

Bellows, *Arcady*

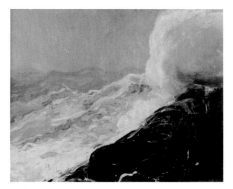

Bellows, *Churn and Break*

Bellows, *Boy with Calf*

George Wesley Bellows, 1882–1925
Boy and Calf, Coming Storm, 1919 76.45
Oil on canvas, 26¼ x 38¼ in. (66.7 x 97.1 cm.)
Inscribed lower left: Geo. Bellows, J.B.B. [Jean Bellows
 Booth]
Gift of Mr. and Mrs. Everett D. Reese, 1976

George Wesley Bellows, 1882–1925
Boy with Calf, ca. 1919 79.99
Graphite on paper, 17¼ x 20¼ in. (43.8 x 51.4 cm.)
Gift of Mr. and Mrs. Everett D. Reese, 1979

George Wesley Bellows, 1882–1925
Children on the Porch (or *On the Porch*), 1919 47.94
Oil on canvas, 30¼ x 44 in. (76.8 x 111.8 cm.)
Signed lower left: Geo. Bellows
Museum Purchase: Howald Fund, 1947

George Wesley Bellows, 1882–1925
Hudson at Saugerties, 1920 47.95
Oil on canvas, 16½ x 23¾ in. (41.9 x 60.3 cm.)
Signed lower left: Geo. Bellows
Museum Purchase: Howald Fund, 1947

George Wesley Bellows, 1882–1925
Portrait of My Mother No. 1, 1920 30.6
Oil on canvas, 78¼ x 48¼ in. (198.7 x 122.5 cm.)
Inscribed lower left: Geo. Bellows/E.S.B. [Emma S.
 Bellows]
Gift of Emma S. Bellows, 1930
Cat. no. 32

George Wesley Bellows, 1882–1925
Cornfield and Harvest, 1921 47.96
Oil on masonite, 18 x 22 in. (45.7 x 55.9 cm.)
Signed lower right: Geo. Bellows
Museum Purchase: Howald Fund, 1947

George Wesley Bellows, 1882–1925
John Carroll, 1921 72.25
Conté crayon on paper, 11¾ x 9¾ in. (29.8 x 24.8 cm.)
Inscribed lower left: Geo. Bellows/J.B.B. [Jean Bellows
 Booth]
Museum Purchase: Howald Fund, 1972

George Wesley Bellows, 1882–1925
Life Study, Standing Nude, ca. 1923 73.4
Conté crayon on paper, 13 x 10 in. (33 x 25.4 cm.)
Initialed lower left: GB. Inscribed on reverse: Life Study
 Standing Nude
Museum Purchase: Howald Fund, 1973

George Wesley Bellows, 1882–1925
Charles E. Albright 47.100
Ink on paper, 9⅜ x 7¼ in. (23.8 x 18.4 cm.)
Signed lower right: Bellows
Gift of Rose L. Fullerton, 1947

George Wesley Bellows, 1882–1925
I Remember Being Initiated Into the Frat 40.20
Graphite, conté crayon, and ink on paper, 19 x 23½ in.
 (48.3 x 59.7 cm.)
Signed lower left: Geo. Bellows
Gift of Mrs. Joseph R. Taylor, 1940

George Wesley Bellows, 1882–1925
Tugboat and Steamer 86.13
Graphite on paper, 4¼ x 5¼ in. (10.8 x 13.3 cm.)
Inscribed bottom right: Geo Bellows/J.B.B. [Jean Bellows
 Booth]
Gift of James and Timothy Keny, 1986

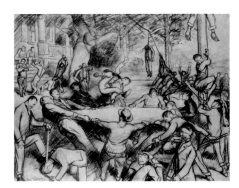

Bellows, *I Remember Being Initiated into the Frat*

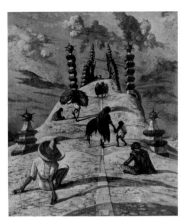

Berman, *The Steep Bridge II*

Bidner, *Embassy Bay Window*

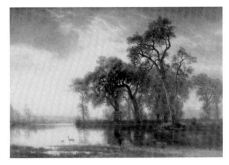

Bierstadt, *Landscape on the Platte River*

Thomas Hart Benton, 1889–1975
Constructivist Still Life, ca. 1917–1918 63.6
Oil on paper, 17½ x 13⅝ in. (44.4 x 34.6 cm.)
Signed lower right: Benton
Gift of Carl A. Magnuson, 1963
Cat. no. 46

Eugene Berman, 1899–1972
The Steep Bridge II, 1948 49.48
Oil on canvas, 32 x 25 in. (81.3 x 63.5 cm.)
Signed and dated lower center: E. B. 1948.
Signed, dated, and inscribed on reverse, upper left: E B/
 August 1948 September/Los Angeles/Salida Del Puente
 II (The Steep Bridge II)
Gift of Knoedler & Co., 1949

Patrick V. Berry, 1843–1913
Landscape with Cattle 64.23
Oil on canvas, 26 x 22⅛ in. (66 x 56.2 cm.)
Signed lower left: P. V. Berry
Gift of the Hildreth Foundation in memory of
 Mr. and Mrs. Louis R. Hildreth, 1964

Richard Berry, born 1927
Still Life, 1965 65.31
Oil on paper, 23¾ x 47½ in. (60.3 x 120.7 cm.)
Museum Purchase: Howald Fund, 1965

Robert D. H. Bidner, 1930–1983
Embassy Bay Window, 1978 79.7
Acrylic on illustration board, 36 x 23⅝ in. (91.4 x 60 cm.)
Signed lower center: Bidner
Museum Purchase: Robert H. Simmons Memorial Fund,
 1979

Albert Bierstadt, 1830–1902
Landscape on the Platte River 19.57
Oil on board, 17½ x 23½ in. (44.5 x 59.7 cm.)
Signed lower left: A Bierstadt
Bequest of Francis C. Sessions, 1919

Albert Bierstadt, 1830–1902
Landscape 29.3
Oil on canvas, 27¾ x 38½ in. (70.5 x 100.3 cm.)
Signed lower left: A Bierstadt
Bequest of Rutherford H. Platt, 1929
Cat. no. 5

Isabel Bishop, 1902–1988
Girl at Lunch Counter, ca. 1954 60.35
Ink and wash on paper, 5¾ x 2¹³⁄₁₆ in. (14.6 x 7.1 cm.)
Signed lower right: Isabel Bishop
Museum Purchase: Howald Fund, 1960

Isabel Bishop, 1902–1988
Snack Bar, ca. 1954 54.47
Oil on masonite, 13½ x 11⅛ in. (34.3 x 28.2 cm.)
Museum Purchase: Howald Fund, 1954
Cat. no. 68

Isabel Bishop, 1902–1988
Two Girls at Lunch Counter, ca. 1954 60.34
Ink and wash on paper, 5¾ x 2¹³⁄₁₆ in. (14.6 x 7.1 cm.)
Signed lower left: Isabel Bishop
Museum Purchase: Howald Fund, 1960

David Black, born 1928
Now Showing, 1961 65.5
Ceramic, H. 20 in. (50.8 cm.)
Signed and dated center front: BLACK 61
Museum Purchase: Howald Fund, 1965

Ralph Albert Blakelock, 1847–1919
Indian Encampment, ca. 1885 78.47
Oil on canvas, 11¼ x 15¼ in. (28.6 x 38.7 cm.)
Signed lower left: R. A. Blakelock
Gift of Dr. Bernard Cohen, 1978

Ralph Albert Blakelock, 1847–1919
Moonlight, ca. 1885–1890 45.20
Oil on board, 12 x 16 in. (30.5 x 40.6 cm.)
Signed lower right: R. A. Blakelock
Bequest of John R. and Louise Lersch Gobey, 1945
Cat. no. 11

Block, *Veranda*

Bluemner, *Somewhere in Harlem, Along the Harlem River*

Blume, *Cyclamen*

Albert Bloch, 1882–1961
Veranda, 1920 31.108
Oil on paper, 17¼ x 20⅝ in. (43.8 x 52.4 cm.)
Signed lower left: A B. Signed, dated, and inscribed on
 reverse: Albert-Bloch/Ascona—1920/"Veranda"
Gift of Ferdinand Howald, 1931

Oscar Bluemner, 1867–1938
Somewhere in Harlem, Along the Harlem River, 1910
 79.81
Watercolor on paper, 6⅝ x 9⅜ in. (16.8 x 23.8 cm.)
Signed lower left: O. Bluemner/10
Gift of Coe Kerr Gallery, Inc., 1979

Peter Blume, born 1906
Cyclamen, 1926 31.110
Oil on canvas, 17 x 10 in. (43.2 x 25.4 cm.)
Signed lower right: Peter Blume
Gift of Ferdinand Howald, 1931

Peter Blume, born 1906
Home for Christmas, 1926 31.109
Oil on canvas, 23½ x 35½ in. (59.7 x 90.2 cm.)
Signed lower right: Peter Blume
Gift of Ferdinand Howald, 1931
Cat. no. 60

Peter Blume, born 1906
Cafe, 1957 60.47
Ink on paper, 5⅜ x 8⅜ in. (13.6 x 21.3 cm.)
Signed and dated lower right: P. Blume 1957
Museum Purchase: Howald Fund, 1960

Peter Blume, born 1906
Farmyard, 1957 60.46
Ink on paper, 5½ x 8¼ in. (14 x 20.9 cm.)
Signed and dated lower right: P. Blume 1957
Museum Purchase: Howald Fund, 1960

Paul Bogatay, 1905–1972
Blue Horse 36.41

Ceramic, H. 8⅝ in. (21.9 cm.)
Source unknown, 1936

Louis Bouché, 1896–1969
Still Life with Flowers, 1919 31.111
Oil on canvas, 24 x 20 in. (61 x 50.8 cm.)
Signed and dated lower right: L. Bouché 1919
Gift of Ferdinand Howald, 1931

Louis Bouché, 1896–1969
Still Life with Brown Pitcher, 1924 31.112
Oil on canvas, 20⅛ x 24 in. (51.1 x 61 cm.)
Signed and dated upper center: Louis Bouché 1924
Gift of Ferdinand Howald, 1931

Isabelle Bowerman, died 1971
Winter Competition, St. John Arena, O.S.U., 1960 63.37
Gouache on paper, 29⅝ x 35⅝ in. (75.2 x 90.5 cm.)
Signed lower right: Isabelle Bowerman
Museum Purchase: Howald Fund, 1963

Fiske Boyd, 1895–1975
Composition, 1923 31.113
Oil on canvas, 32⅜ x 24¼ in. (82.2 x 61.6 cm.)

Bouché, *Still Life with Flowers*

Boyd, *Composition*

Bruss, *Laurentian Summer No. 6*

Burchfield, *Winter Solstice*

Burkhart, *Portrait of a Man*

Signed and dated lower right: Fiske Boyd 1923
Gift of Ferdinand Howald, 1931

Emile Pierre Branchard, 1881–1938
Moonlight 31.114
Oil on paper, 8⅞ x 11⅞ in. (22.5 x 30.2 cm.)
Signed lower right: EMILE/BRANCHARD
Gift of Ferdinand Howald, 1931

Katherine Bell Brown, born 1902
Color, 1955 76.23
Watercolor on paper, 20¾ x 16 in. (52.7 x 40.6 cm.)
Purchased with funds from the Alfred L. Willson
 Charitable Fund of The Columbus Foundation, 1976

James Bruss, born 1944
Final Curtain, 1974 74.16
Watercolor and photo-silkscreen on paper, 24 x 33 in.
 (61 x 83.8 cm.)
Signed and dated lower right: Bruss 74
Theodore R. Simson Purchase Award, 1974

James Bruss, born 1944
Laurentian Summer No. 6, 1974 76.16
Acrylic on canvas, 84 x 60¼ in. (213.4 x 153 cm.)
Signed, dated, and inscribed on reverse: Laurentian
 Summer No. 6 (Series of 6), Dec. 74, Jim Bruss
Howald Memorial Purchase Award, 1976

Charles E. Burchfield, 1893–1967
Winter Solstice, ca. 1920–1921 31.117
Watercolor on paper, 21½ x 35½ in. (54 6 x 90.2 cm.)
Signed lower right: C. BURCHFIELD
Gift of Ferdinand Howald, 1931

Charles E. Burchfield, 1893–1967
The Visit, ca. 1920–1924 31.115
Watercolor and graphite on paper, 22 x 29⅞ in.
 (55.9 x 75.9 cm.)
Signed lower right: C. BURCHFIELD
Gift of Ferdinand Howald, 1931

Charles E. Burchfield, 1893–1967
October, ca. 1922–1924 31.116
Oil and gouache on paper glued to board, 31 x 42¾ in.
 (78.7 x 108.6 cm.)
Signed lower right: C. BURCHFIELD. Signed and dated
 on reverse: 2-October/Chas. Burchfield
Gift of Ferdinand Howald, 1931
Cat. no. 58

Emerson C. Burkhart, 1905–1969
Arthur J. Packard, 1946 71.31
Oil on canvas, 36 x 30 in. (91.4 x 76.2 cm.)
Signed upper left: Emerson C. Burkhart.
 Signed and dated on reverse, upper left:
 Oct. 1946/E.C.B.
Gift of Arthur J. Packard, 1971

Emerson C. Burkhart, 1905–1969
Portrait of a Man, 1950 55.9
Oil on canvas, 49¼ x 38¼ in. (125.1 x 95.2 cm.)
Signed upper left: Emerson C. Burkhart
Museum Purchase: Howald Fund, 1955

Emerson C. Burkhart, 1905–1969
Eastside Columbus, ca. 1951 86.18
Oil on panel, 8½ x 10¾ in. (21.6 x 27.3 cm.)
Signed bottom right: EMERSON BURKHART
Gift of Daniel Arnold, M.D., 1986

Emerson C. Burkhart, 1905–1969
Canary Islands, 1963 84.8
Acrylic on canvas, 28 x 35 in. (71.1 x 88.9 cm.)
Signed and dated lower right: E. Burkhart 63
Bequest of Lucille Mercer, 1984

Emerson C. Burkhart, 1905–1969
Hong Kong, 1965 67.1
Oil on canvas, 31½ x 40 in. (80 x 101.6 cm.)
Signed and dated lower left: E. Burkhart 65
Museum Purchase: Howald Fund, 1967

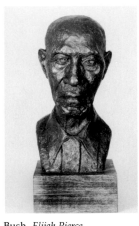

Bush, *Elijah Pierce*

Butler, *Fountain, Central Park*

Camp, *Benicia*

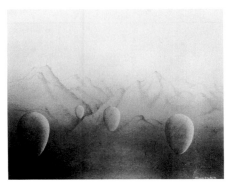

Carter, *Pilgrimage No. 2*

Elwyn Bush, born 1931
Elijah Pierce, 1974 75.3
Bronze, H. 15½ in. (39.4 cm.)
Signed, dated, and inscribed left shoulder:
ELIJAH PIERCE/BY ELWYN BUSH '74
Gift of the artist, 1975

Theodore Earl Butler, 1860–1936
A Tiller of Soil, 1894 41.39
Oil on canvas, 23½ x 28¾ in. (59.7 x 73 cm.)
Signed and dated lower left: T. E. Butler 94
Bequest of Alfred L. Willson, 1941

Theodore Earl Butler, 1860–1936
Fountain, Central Park, 1915 79.10
Oil on canvas, 23¾ x 28¾ in. (60.3 x 73 cm.)
Signed and dated lower right: T. E. Butler '15
Gift of Mr. and Mrs. Harry William Hind, 1979

Alexander Calder, 1898–1976
Snake and Butterfly, 1966 67.69
Gouache on paper, 22⅞ x 30⅝ in. (58.1 x 77.8 cm.)
Signed and dated lower right: Calder 66
Gift of Mr. and Mrs. Joseph H. Hirshhorn, 1967

Alexander Calder, 1898–1976
Intermediate Model for the Arch, 1975 80.36
Painted steel, H. 144 in. (365.6 cm.)
Museum Purchase: Derby Fund, 1980
Cat. no. 80

Kenneth Callahan, 1905–1986
Woods Interior No. 1, 1954 60.38
Ink and wash on paper, 24 x 18¾ in. (61 x 47.5 cm.)
Signed and dated lower right: Kenneth Callahan '54
Museum Purchase: Howald Fund, 1960

Larry R. Camp, born 1939
Benicia, 1974 74.13
Acrylic on canvas, 81 x 105 in. (205.7 x 266.7 cm.)
Howald Memorial Purchase Award, 1974

David M. Campbell, born 1931
Toledo, 1964 68.24
Oil on canvas, 34 x 48¼ in. (86.4 x 122.5 cm.)
Signed and dated lower right: 14–4–64 DMC
Gift of Mrs. Harold J. Andreae, 1968

Harriet Dunn Campbell, 1873–1959
Huron, Ohio 60.57
Watercolor on paper, 9¹⁵⁄₁₆ x 11¾ in. (25.1 x 29.9 cm.)
Signed lower right: HARRIET-DUNN-CAMPBELL
Gift of Ernest Zell, 1960

Joseph V. Canzani, born 1915
The Violinist, 1968 70.1
Oil on canvas, 36 x 49¹¹⁄₁₆ in. (91.4 x 126.2 cm.)
Signed and dated lower right: joseph v. canzani '68
Gift of the artist, 1970

Jon Carsman, born 1944
A Forgotten View, ca. 1980 83.35
Watercolor on paper, 23½ x 16½ in. (59.7 x 41.9 cm.)
Signed and dated lower left: Carsman 78
Gift of Mr. and Mrs. Stanley Gottlieb, 1983

Clarence H. Carter, born 1904
Pilgrimage No. 2, 1973 74.32
Mixed media, 21½ x 29¼ in. (54.6 x 74.3 cm.)
Signed and dated lower right: Clarence H. Carter 73
Museum Purchase: Howald Fund, 1974

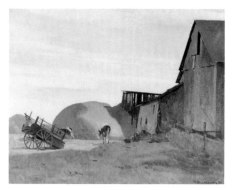
Chadeayne, *Barnyard*

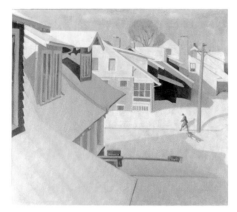
Chadeayne, *Cliffside Drive*

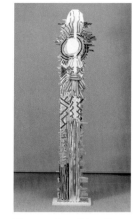
Chavous, *Jazz Totem #4*

Aldo J. Casanova, born 1929
Bird 55.16
Metal, H. 36½ in. (92.7 cm.)
Museum Purchase: Howald Fund, 1955

Mary Cassatt, 1845–1926
Susan Comforting the Baby No. 1, ca. 1881 [57]54.4
Oil on canvas, 17 x 23 in. (43.2 x 58.4 cm.)
Signed lower right: Mary Cassatt
Bequest of Frederick W. Schumacher, 1957
Cat. no. 18

John Cavanaugh, 1921–1985
Boy in Sling Chair, 1952 55.21
Ceramic, H. 7½ in. (19 cm.)
Museum Purchase: Howald Fund, 1955

Robert O. Chadeayne, 1897–1981
Winter Wash, 1921 73.5
Oil on canvas, 28 x 36 in. (71.1 x 91.4 cm.)
Signed and dated lower right: R O CHADEAYNE '21
Museum Purchase: Howald Fund, 1973

Robert O. Chadeayne, 1897–1981
Barnyard, 1931 31.283
Oil on canvas, 26 x 31 in. (66 x 78.7 cm.)
Signed and dated lower right: r.o. CHADEAYNE '31
Columbus Art League Purchase Award, 1931

Robert O. Chadeayne, 1897–1981
The Big Sky, 1970 72.16
Pastel on paper, 18¾ x 24¾ in. (47.6 x 62.9 cm.)
Signed and dated lower right: R. O. Chadeayne '70
Chet Long Memorial Purchase Award and Howald Fund
 Purchase, 1972

Robert O. Chadeayne, 1897–1981
Cliffside Drive 37.9
Oil on canvas, 24 x 26 in. (61 x 66 cm.)
Gift of Orlando A. Miller, 1937

Robert O. Chadeayne, 1897–1981
Trees with Red Buildings 38.5

Oil on canvas, 26 x 36 in. (66 x 91.4 cm.)
Gift of Frederick W. Schumacher, 1938

Adele Chafetz, born 1922
City Houses, 1953 56.30
Watercolor and ink on paper, 16½ x 13½ in.
 (41.9 x 34.3 cm.)
Museum Purchase: Howald Fund, 1956

Adelaide Cole Chase, 1869–1944
Mrs. Ralph Adams Cram, 1905 06.1
Oil on canvas, 75¾ x 35½ in. (192.4 x 90 cm.)
Signed and dated upper left: Adelaide Chase 1905
Museum Purchase, 1906

Barbara Chavous, born 1936
Jazz Totem #2, 1979 79.36
Painted wood, metal, H. 85 in. (215.9 cm.)
Inscribed lower right: J.T.2
Purchased with funds from the Alfred L. Willson
 Charitable Fund of The Columbus Foundation, 1979

Barbara Chavous, born 1936
Jazz Totem #4, 1979 79.37
Painted wood, metal, H. 110 in. (279.4 cm.)
Inscribed lower right: J.T.4
Purchased with funds from the Alfred L. Willson
 Charitable Fund of The Columbus Foundation, 1979

Barbara Chavous, born 1936
Jazz Totem #11, 1979 79.38
Painted wood, rope, H. 94 in. (238.8 cm.)
Inscribed lower right: J.T.11
Purchased with funds from the Alfred L. Willson
 Charitable Fund of The Columbus Foundation, 1979

Edward Christiana, born 1912
Amsterdam from Thruway No. 2, 1962 63.13
Oil on canvas, 38 x 44 in. (96.5 x 111.8 cm.)
Signed and dated lower right: EDWARD CHRISTIANA/'62
Museum Purchase: Howald Fund, 1963

Christy, *Corn and Wheat*

Cieslewski, *Imaginative Introverts*

Cocks, *The Stagecoach*

Howard Chandler Christy, 1873–1952
Corn and Wheat, 1893–1894 85.15.1
Oil on canvas, 29 x 20¼ in. (73.6 x 51.4 cm.)
Signed bottom center: Howard Chandler Christy
Gift of Browne Pavey, 1985

Howard Chandler Christy, 1873–1952
Captain Edward V. Rickenbacker, 1943 43.5
Oil on canvas, 49 x 37½ in. (124.4 x 95.2 cm.)
Signed and dated lower left: Howard Chandler Christy/
 March 1943
Gift of Ralph H. Beaton, Orlando A. Miller and Frederick
 W. Schumacher, 1943

Joseph M. Cieslewski, born 1953
Imaginative Introverts, 1977 77.5
Mixed media on paper, 29⅝ x 21¼ in. (75.2 x 53.9 cm.)
Theodore R. Simson Purchase Award for Painting from
 the 67th Annual Columbus Art League May Show,
 1977

Nicolai Stepanovich Cikovsky, 1894–1984
Before the Storm, 1959 59.14
Oil on paper, 11⅞ x 16 in. (30.2 x 40.6 cm.)
Signed lower right: Nicolai Cikovsky
Purchased with funds from the Alfred L. Willson
 Foundation, 1959

Benton Henderson Clark, 1895–1964
Sunday Visitors 74.38.35
Oil on canvas, 22 x 55 in. (55.9 x 139.7 cm.)
Signed lower left: Benton/Clark
Bequest of J. Willard Loos, 1974

Evelyn Clark, born 1914
The Mood is Love 71.9
Watercolor, 16 x 21 in. (40.6 x 53.3 cm.)
Signed lower right: E. Clark
Purchased with funds from the Alfred L. Willson
 Charitable Fund of The Columbus Foundation, 1971

Matt Clark, born 1903
Sheriff Shooting Outlaw 74.38.32
Gouache on paper, 5⅝ x 15¾ in. (14.3 x 40 cm.)
Signed upper right: Matt Clark
Bequest of J. Willard Loos, 1974

T. Cocks
The Stagecoach, 1879 86.14
Oil on canvas, 9⅞ x 13 in. (25 x 33 cm.)
Signed and dated bottom right: Th. Cocks—79
Gift of Charlotte Curtis in honor of Lucile Atcherson
 Curtis, her mother, 1986

May Elizabeth Cook, 1881–1951
Molly Brown, 1914 63.26
Plaster, H. 10 in. (25.4 cm.)
Signed and dated on back: M. E. Cook—1914
Gift of Mr. and Mrs. John M. Caren, 1963

May Elizabeth Cook, 1881–1951
Joseph Jeffrey, 1927 55.10
Marble, H. 23½ in. (59.7 cm.)
Signed and dated on base: M. E. Cook—1927
Gift of Mrs. Charles Harris, 1955

Kathleen McKeith Cooke, 1908–1978
Buffalo 85.24.4
Cast plaster, H. 5 in. (12.6 cm.)
Gift of the Betty Parsons Foundation, 1985

Kathleen McKeith Cooke, 1908–1978
Elephant 86.2.2
Graphite on paper, 5⅛ x 6⅞ in. (13 x 17.3 cm.)
Gift of the Betty Parsons Foundation, 1986

Kathleen McKeith Cooke, 1908–1978
Goat 85.24.11
Cast plaster, H. 4¼ in. (10.6 cm.)
Gift of the Betty Parsons Foundation, 1985

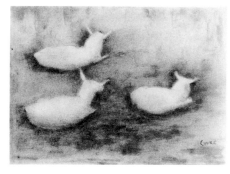

Cooke, *The Great Bison*

Costigan, *Landscape with Flowers*

Crawford, *First Avenue No. 4*

Cooke, *Three Goats*

Kathleen McKeith Cooke, 1908–1978
The Great Bison 86.2.1
Papier-mâché, H. 20 in. (50.8 cm.)
Gift of the Betty Parsons Foundation, 1986

Kathleen McKeith Cooke, 1908–1978
Three Goats 86.2.3
Charcoal on paper, 9 x 11¾ in. (22.9 x 29.8 cm.)
Signed lower right: Cooke
Gift of the Betty Parsons Foundation, 1986

Kathleen McKeith Cooke, 1908–1978
Untitled (sketchbook with eight drawings) 86.2.4 a–h
Graphite on paper, each 24 x 18 in. (61 x 45.7 cm.)
Inscribed on sketchbook cover: Kathleen Cooke/Sketches
Gift of the Betty Parsons Foundation, 1986

Kathleen McKeith Cooke, 1908–1978
Yak 85.24.1
Oil on canvas, 14 x 18 in. (35.6 x 45.7 cm.)
Signed lower right: Cooke
Gift of the Betty Parsons Foundation, 1985

John Edward Costigan, 1888–1972
Landscape with Flowers, 1924 45.12
Oil on canvas, 44¼ x 44¼ in. (112.4 x 112.4 cm.)
Signed and dated lower left: J. E. Costigan/1924
Bequest of Edward D. and Anna White Jones, 1945

Robert Cottingham, born 1935
Blues, 1987 87.13
Watercolor on paper, 18 x 18 in. (45.7 x 45.7 cm.)
Gift of the American Academy and Institute of Arts and
 Letters/Hassam and Speicher Purchase Fund, 1987

Laura Cowman, died 1981
Lost Pavilion 67.10
Oil and collage on canvas, 32 x 48 in. (81.3 x 122 cm.)
Signed lower left: Cowman
Museum Purchase: Howald Fund, 1967

Ralston Crawford, 1906–1978
First Avenue No. 4, 1968 73.8
Oil on canvas, 40 x 30 in. (101.6 x 76.2 cm.)
Signed lower right: R C
Museum Purchase: Howald Fund, 1973

José de Creeft, 1884–1982
Two Girls, 1958 70.23
Ink on paper, 13¾ x 20¾ in. (34.9 x 52.7 cm.)
Signed and dated lower right: José de Creeft/'58
Purchased with funds from the Alfred L. Willson
 Foundation, 1970

Jasper Francis Cropsey, 1823–1900
Fishing, 1868 85.22
Oil on canvas, 10 x 15 in. (25.4 x 38.1 cm.)
Dated lower left: 1868
Museum Purchase: J. Willard Loos Bequest, 1985

Stephen Csoka, born 1897
Fatherless, 1947 48.9
Oil on canvas, 40 x 34 in. (101.6 x 86.4 cm.)
Signed and dated lower right: S. Csoka/1947
Gift of Gallery Links, 1948

Charles Csuri, born 1922
Wanderers 57.31
Oil on canvas, 34⅛ x 40¼ in. (86.7 x 102.2 cm.)
Museum Purchase: Howald Fund, 1957

Davidson, *William Guthrie*

Davies, *Sicily, Flowering Isle*

Davis, *Street Scene*

Lee Csuri, born 1927
King Bacchus, 1960 61.29
Ink and graphite on paper, 26 x 19¾ in. (66 x 50.2 cm.)
Signed and dated lower right: Lee Csuri/21/11/60
Museum Purchase: Howald Fund, 1961

Lee Csuri, born 1927
St. George 57.30
Oil on masonite, 34⅛ x 28½ in. (86.7 x 72.4 cm.)
Museum Purchase: Howald Fund, 1957

Jay Norwood Darling, 1876–1962
There Must Be a Reason 34.39.2
Ink on paper, 27½ x 22 in. (69.9 x 55.9 cm.)
Signed lower right: Ding
Gift of the artist, 1934

Jay Norwood Darling, 1876–1962
Three Hitchhikers Look for a Lift 34.39.1
Ink on paper, 27½ x 22 in. (69.9 x 55.9 cm.)
Signed lower right: Ding
Gift of the artist, 1934

Jo Davidson, 1883–1952
William Guthrie, 1924 56.56
Bronze, H. 14½ in. (36.8 cm.)
Signed and dated on reverse: J. Davidson/New York—
 1924
Gift of Mrs. William D. Guthrie, 1956

Arthur B. Davies, 1862–1928
Untitled (reclining female nude), ca. 1910 60.37
Charcoal, crayon, and pastel on paper, 11¾ x 16³⁄₁₆ in.
 (29.8 x 41.1 cm.)
Purchased with funds from the Alfred L. Willson
 Foundation, 1960

Arthur B. Davies, 1862–1928
Coming of Summer 31.119
Oil on canvas, 18 x 30 in. (45.7 x 76.2 cm.)
Signed lower center: A. B. Davies
Gift of Ferdinand Howald, 1931

Arthur B. Davies, 1862–1928
Italian Landscape 60.8
Watercolor on paper, 9 x 12 in. (22.9 x 30.5 cm.)
Museum Purchase: Howald Fund, 1960

Arthur B. Davies, 1862–1928
Nude 60.9
Pastel on paper, 12 x 10 in. (30.5 x 25.4 cm.)
Museum Purchase: Howald Fund, 1960

Arthur B. Davies, 1862–1928
Reluctant Youth 31.118
Oil on canvas, 17¼ x 22½ in. (43.8 x 57.2 cm.)
Signed lower left: A. B. Davies
Gift of Ferdinand Howald, 1931

Arthur B. Davies, 1862–1928
Sicily, Flowering Isle 31.120
Oil on canvas, 18 x 30¼ in. (45.7 x 76.8 cm.)
Signed lower left: A. B. Davies. Inscribed on reverse, on
 stretcher: Sicily Flowering Isle
Gift of Ferdinand Howald, 1931

Arthur B. Davies, 1862–1928
Untitled (standing female nude) 60.36
Charcoal, crayon, and pastel on paper, 16⅜ x 11¾ in.
 (41.6 x 29.8 cm.)
Purchased with funds from the Alfred L. Willson
 Foundation, 1960

Stuart Davis, 1892–1964
Street Scene, 1926 81.32.2
Oil on panel, 24 x 16⅛ in. (61 x 41 cm.)
Inscribed on reverse: Stuart Davis 1926
Gift of Mr. and Mrs. Harry Spiro, 1981

Stuart Davis, 1892–1964
Landscape with Drying Sails, 1931–1932 81.12
Oil on canvas, 32 x 40 in. (81.3 x 101.6 cm.)
Signed top right: Stuart Davis
Museum Purchase: Howald Fund II, 1981
Cat. no. 65

Dawson, *Sun Through the Arch*

Dehner, *Viking II*

Demuth, *The Drinkers* (or *Chez Ritz*)

Manierre Dawson, 1887–1969
Sun Through the Arch, 1910 80.35
Oil on panel, 10³⁄₁₆ x 13⁷⁄₈ in. (25.9 x 35.2 cm.)
Signed and dated lower right: Dawson '10
Purchased with funds from the Alfred L. Willson
 Charitable Fund of The Columbus Foundation, 1980

Leo Dee, born 1931
Eroding Dunes, Truro, 1977 79.82
Silverpoint on paper, 12 x 18 in. (30.5 x 45.7 cm.)
Signed lower right: Leo Dee. Inscribed on lower left:
 Eroding Dunes, Truro
Gift of Coe Kerr Gallery, Inc., 1979

Franklin DeHaven, 1856–1934
October 64.21
Oil on canvas, 29½ x 23½ in. (74.9 x 59.7 cm.)
Signed lower right: F. DeHaven
Gift of the Hildreth Foundation in memory of
 Mr. and Mrs. Louis R. Hildreth, 1964

Virginia Dehn, born 1922
Peacock Cloud, 1970 71.5
Oil on canvas, 40 x 40 in. (101.6 x 101.6 cm.)
Signed lower right: Virginia Dehn
Museum Purchase: Howald Fund, 1971

Dorothy Dehner, born 1908
Drawing, 1961 63.11
Ink and wash on paper, 34¼ x 22¾ in. (87 x 57.8 cm.)
Signed and dated lower right: Dehner '61
Museum Purchase: Howald Fund, 1963

Dorothy Dehner, born 1908
Viking II, 1969 70.30
Steel and bronze, H. 76 in. (193 cm.)
Museum Purchase: Howald Fund, 1970

Charles Demuth, 1883–1935
Poppies, ca. 1915 31.141
Watercolor on paper, 17½ x 11³⁄₈ in. (44.5 x 28.9 cm.)

Signed upper left: C. Demuth
Gift of Ferdinand Howald, 1931

Charles Demuth, 1883–1935
The Drinkers (or *Chez Ritz*), 1915 31.122
Watercolor on paper, 10¾ x 8¼ in. (27.3 x 21 cm.)
Signed, dated, and inscribed on lower left: C. Demuth
 1915/Chez Ritz. Inscribed on reverse: C. Philadelphia
 Pa.
Gift of Ferdinand Howald, 1931

Charles Demuth, 1883–1935
Bermuda Landscape, 1916 31.124
Watercolor on paper, 9½ x 13½ in. (24.1 x 34.3 cm.)
Signed and dated lower left: C. Demuth/1916
Gift of Ferdinand Howald, 1931

Charles Demuth, 1883–1935
The Nut, Pre-Volstead Days, 1916 31.138
Watercolor on paper, 10⁹⁄₁₆ x 7¹³⁄₁₆ in. (26.9 x 19.9 cm.)
Signed and dated lower left: C. Demuth 1916
Gift of Ferdinand Howald, 1931

Charles Demuth, 1883–1935
The Circus, 1917 31.127
Watercolor and graphite on paper, 8 x 10⁵⁄₈ in.
 (20.3 x 27 cm.)
Signed and dated lower left: C. Demuth/1917
Gift of Ferdinand Howald, 1931
Cat. no. 52

Charles Demuth, 1883–1935
Landscape, 1917 31.136
Watercolor on paper, 9⁷⁄₈ x 13⁷⁄₈ in. (25.1 x 35.2 cm.)
Signed and dated lower left: C. Demuth/1917
Gift of Ferdinand Howald, 1931

Charles Demuth, 1883–1935
Houses, 1918 31.121
Watercolor on paper, 13¾ x 9¾ in. (34.9 x 24.8 cm.)
Signed and dated lower left: C. Demuth/1918
Gift of Ferdinand Howald, 1931

Demuth, *Housetops*

Demuth, *In Vaudeville: Columbia*

Demuth, *Cottage Window*

Charles Demuth, 1883–1935
Housetops, 1918 31.134
Watercolor on paper, 9¾ x 13½ in. (24.8 x 34.3 cm.)
Signed and dated lower left: C. Demuth/1918
Gift of Ferdinand Howald, 1931

Charles Demuth, 1883–1935
In Vaudeville: Columbia, 1919 31.128
Watercolor and graphite on paper, 11¹⁵⁄₁₆ x 8 in.
 (30.3 x 20.3 cm.)
Signed and dated lower left: C. Demuth 1919
Gift of Ferdinand Howald, 1931

Charles Demuth, 1883–1935
Cottage Window, ca. 1919 31.129
Tempera on pasteboard, 15⅜ x 11⁵⁄₁₆ in. (39 x 28.7 cm.)
Signed on reverse: Charles Demuth
Gift of Ferdinand Howald, 1931

Charles Demuth, 1883–1935
Zinnias and Snapdragons, ca. 1919 31.148
Watercolor and graphite on paper, 9⅝ x 12¹¹⁄₁₆ in.
 (24.5 x 32.2 cm.)
Gift of Ferdinand Howald, 1931

Charles Demuth, 1883–1935
Flowers, 1919 31.131
Watercolor on paper, 13¾ x 9¹¹⁄₁₆ in. (34.9 x 25 cm.)
Signed and dated lower right: C.D./1919
Gift of Ferdinand Howald, 1931

Charles Demuth, 1883–1935
The Tower (or *After Sir Christopher Wren*), ca. 1920
 31.146
Tempera on pasteboard, 23¼ x 19½ in. (59 x 49.5 cm.)
Initialed and inscribed in pencil on reverse: After Sir
 Christopher Wren[?] Provincetown, Mass./1 B O[?]—
 C.D.
Gift of Ferdinand Howald, 1931

Charles Demuth, 1883–1935
Aucassin and Nicolette, 1921 31.123
Oil on canvas, 24⅛ x 20 in. (61.3 x 50.8 cm.)
Signed and dated on back center: C. Demuth/1921
Gift of Ferdinand Howald, 1931

Charles Demuth, 1883–1935
Incense of a New Church, 1921 31.135
Oil on canvas, 26 x 20⅛ in. (66 x 51.1 cm.)

Demuth, *Zinnias and Snapdragons*

Demuth, *Aucassin and Nicolette*

Demuth, *Incense of a New Church*

Demuth, *Paquebot "Paris"*

Demuth, *California Tomatoes*

Dennison, *Steamer Stack*

Signed, dated, and inscribed on reverse: C. Demuth
 Lancaster Pa. 1921
Gift of Ferdinand Howald, 1931

Charles Demuth, 1883–1935
Modern Conveniences, 1921 31.137
Oil on canvas, 25¾ x 21⅜ in. (65.4 x 54.3 cm.)
Signed and dated lower left center: C. Demuth 1921
Gift of Ferdinand Howald, 1931
Cat. no. 53

Charles Demuth, 1883–1935
Paquebot "Paris", 1921–1922 31.139
Oil on canvas, 25 x 20 in. (63.5 x 50.8 cm.)
Gift of Ferdinand Howald, 1931

Charles Demuth, 1883–1935
Fruit No. 1, 1922 31.132
Watercolor and graphite on paper, 9¼ x 12¾ in.
 (23.5 x 32.4 cm.)
Signed and dated lower center: C. Demuth/1922
Gift of Ferdinand Howald, 1931

Charles Demuth, 1883–1935
Pears and Plums, 1924 31.140
Watercolor and graphite on paper, 11½ x 17¼ in.
 (29.2 x 43.8 cm.)
Signed, dated, and inscribed lower center:
 C. Demuth—1924—Lancaster
Gift of Ferdinand Howald, 1931

Charles Demuth, 1883–1935
Bowl of Oranges, 1925 31.125
Watercolor on paper, 14 x 20 in. (35.6 x 50.8 cm.)
Signed, dated, and inscribed lower center: Lancaster Pa.
 C. Demuth 1925
Gift of Ferdinand Howald, 1931
Cat. no. 54

Charles Demuth, 1883–1935
California Tomatoes, ca. 1925 31.126

Watercolor on paper, 11½ x 13¾ in. (29.2 x 34.9 cm.)
Gift of Ferdinand Howald, 1931

Charles Demuth, 1883–1935
Still Life No. 1 31.143
Watercolor and graphite on paper, 11¾ x 17¾ in.
 (29.8 x 45.1 cm.)
Gift of Ferdinand Howald, 1931

N. Penney Denning, born 1941
Cloth Construction No. 7708, 1977 77.8
Cloth/mixed media, 13¾ x 19½ in. (35 x 49.5 cm.)
Signed lower right: © Denning
Jean Lamb Hall Memorial Purchase Award from the 67th
 Annual Columbus Art League May Show, 1977

Dorothy Dell Dennison, born 1908
Steamer Stack, 1967 68.27
Oil on canvas, 20 x 14³⁄₁₆ in. (50.8 x 36 cm.)
Signed and dated lower right: Dorothy D. Dennison 67.
 Inscribed on reverse: MAR. 67
Museum Purchase: Howald Fund, 1968

Gertrude Derby, active twentieth century
Studio for Rent 65.30
Charcoal on paper, 17 x 22½ in. (43.2 x 57.1 cm.)
Signed lower right: Derby
Museum Purchase: Howald Fund, 1965

Ann Dewald, born 1930
Beyond the Limit, 1977 77.19
Neon and aluminum, H. 24 in. (60.9 cm.)
Jean Lamb Hall and The Alfred L. Willson Charitable
 Fund of The Columbus Foundation, 1977

Thomas Wilmer Dewing, 1851–1938
Portrait 45.23
Pastel on paper, 15½ x 11½ in. (39.4 x 29.2 cm.)
Signed lower right: T. W. Dewing
Bequest of John R. and Louise Lersch Gobey, 1945

Dewald, *Beyond the Limit*

Dickinson, *Hospitality*

Dodd, *Stone Structures*

Preston Dickinson, 1889–1930
A Bridge, 1918 31.151
Oil on canvas, 20 x 26 in. (50.8 x 66 cm.)
Signed and dated lower right: P. Dickinson '18
Gift of Ferdinand Howald, 1931

Preston Dickinson, 1889–1930
Hillside, 1919 31.155
Watercolor and graphite on paper, 16⅜ x 11 in.
 (41.6 x 27.9 cm.)
Signed and dated lower right: P. Dickinson 19
Gift of Ferdinand Howald, 1931

Preston Dickinson, 1889–1930
Factory, ca. 1920 31.153
Oil on canvas, 29⅞ x 25¼ in. (75.9 x 64.1 cm.)
Signed and dated lower right: P. Dickinson '2[?]
Gift of Ferdinand Howald, 1931
Cat. no. 48

Preston Dickinson, 1889–1930
Grain Elevators, 1924 31.154
Pastel and graphite on paper, 24⅝ x 17¾ in.
 (62.5 x 45.1 cm.)
Signed and dated lower left: Dickinson '24
Gift of Ferdinand Howald, 1931

Preston Dickinson, 1889–1930
Hospitality, 1925 31.157
Pastel on paper, 21¼ x 13½ in. (54 x 34.3 cm.)
Signed lower left: Preston Dickinson
Gift of Ferdinand Howald, 1931

Preston Dickinson, 1889–1930
Still Life with Yellow-Green Chair, 1928 31.164
Oil on canvas, 15 x 21 in. (38.1 x 53.3 cm.)
Signed lower left center: Dickinson
Gift of Ferdinand Howald, 1931
Cat. no. 49

Preston Dickinson, 1889–1930
The Black House 31.150
Watercolor and pastel on paper, 16½ x 10¾ in.
 41.9 x 27.3 cm.)
Signed center right: P. Dickinson
Gift of Ferdinand Howald, 1931

Preston Dickinson, 1889–1930
Outskirts of the City 31.160
Watercolor on paper, 9⅞ x 14⅞ in. (25.1 x 37.8 cm.)
Signed lower left: Preston Dickinson
Gift of Ferdinand Howald, 1931

Preston Dickinson, 1889–1930
Still Life with Vegetables 31.162
Oil on canvas, 20 x 18 in. (50.8 x 46.7 cm.)
Signed lower right: P. Dickinson
Gift of Ferdinand Howald, 1931

Lamar Dodd, born 1909
Stone Structures, 1951 52.19
Oil on canvas, 18 x 12 in. (45.7 x 30.5 cm.)
Signed and dated lower right: Lamar Dodd '51
Museum Purchase: Howald Fund, 1952

Thomas Doughty, 1793–1856
Stenton Hall, Orange County, New Jersey, ca. 1840
Oil on canvas, 26 x 36 in. (66 x 91.4 cm.)
Signed lower right: T DOUGHTY
Gift of Mr. and Mrs. Harry Spiro, 1893

Arthur G. Dove, 1880–1946
Movement No. 1, ca. 1911 31.166
Pastel on canvas, 21⅜ x 18 in. (54.3 x 45.7 cm.)
Gift of Ferdinand Howald, 1931
Cat. no. 36

Arthur G. Dove, 1880–1946
Thunderstorm, 1921 31.167
Oil and metallic paint on canvas, 21½ x 18⅛ in.
 54.6 x 46 cm.)

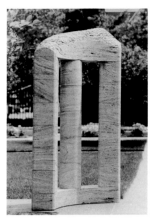

Dusenbery, *Lopeglia*

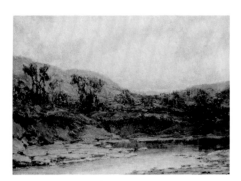

DuVall, *Sunset over Hills*

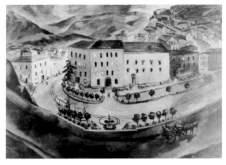

Eastman, *Perugia Looking Down on the Old Town*

Signed and dated on reverse, center: Dove/1921
Gift of Ferdinand Howald, 1931
Cat. no. 37

Elsie Driggs, born 1898
Cineraria, ca. 1926 31.168
Pastel on paper, 16⅝ x 13⁵⁄₁₆ in. (42.2 x 35.4 cm.)
Signed lower right: Elsie Driggs
Gift of Ferdinand Howald, 1931

Elsie Driggs, born 1898
Illustration for Dante's Inferno, ca. 1932 65.24
Watercolor and graphite on paper, 11¾ x 9⅞ in.
 (29.8 x 25.1 cm.)
Signed lower right: Elsie Driggs
Gift of Robert Schoelkopf Gallery, 1965

Donald Drum, born 1935
Untitled, 1973 75.26
Aluminum with mirror, H. 57 in. (144.8 cm.)
Purchased with funds from the Alfred L. Willson
 Charitable Fund of The Columbus Foundation, 1975

James Dupree, born 1950
Untitled, ca. 1972 72.17
Acrylic on canvas, 58 x 72 in. (147.3 x 182.9 cm.)
Museum Purchase: Howald Fund, 1972

Walter Dusenbery, born 1939
Lopeglia, 1980 81.4
Yellow travertine, H. 89 in. (226.1 cm.)
Given in loving memory of Mr. H. Richard Peterson
 Niehoff by Mrs. H. Richard Peterson Niehoff, H. R.
 Peterson Niehoff, Christopher Will Niehoff, Patricia
 LeVeque Niehoff, and Elsa Will Niehoff, with
 additional assistance from the National Endowment
 for the Arts, 1981

Charles William DuVall, 1865–1966
Landscape, 1911 79.12
Oil on canvas, 16 x 20 in. (40.6 x 50.8 cm.)

Signed and dated lower left: Chas. DuVall—1911
Gift of Dr. and Mrs. Robert H. Magnuson, 1979

Charles William DuVall, 1865–1966
Sunset over Hills, 1928 37.145
Oil on canvas, 27¾ x 36 in. (70.5 x 91.4 cm.)
Signed and dated lower left: Ch. Wm. DuVall—1928
Bequest of Dr. Hervey Williams Whitaker, 1937

Charles William DuVall, 1865–1966
The Glory of the Day, 1928 37.147
Oil on canvas, 28 x 36 in. (71.1 x 91.4 cm.)
Signed lower right: Ch. Wm. DuVall 1928
Bequest of Dr. Hervey Williams Whitaker, 1937

Frank Duveneck, 1848–1919
Sketch for *Reading of Tasso*, ca. 1884 57.26
Oil on canvas, 27⅝ x 39¾ in. (70.2 x 101 cm.)
Gift of Josephine W. Duveneck, 1957

Thomas Eakins, 1844–1916
Weda Cook, 1891[6?] 48.17
Oil on canvas, 24 x 20 in. (61 x 50.8 cm.)
Signed and dated lower right: Eakins/1891[6?].
 Initialed on reverse, lower right: T.E.
Museum Purchase: Howald Fund, 1948
Cat. no. 20

Thomas Eakins, 1844–1916
The Wrestlers, 1899 70.38
Oil on canvas, 48⅜ x 60 in. (122.9 x 152.4 cm.)
Signed and dated upper right: Eakins/1899
Museum Purchase: Derby Fund, 1970
Cat. no. 21

William Joseph Eastman, 1888–1950
Perugia Looking Down on the Old Town 52.49
Oil on canvas, 35¼ x 49⅝ in. (89.5 x 126.1 cm.)
Signed lower right: William Joseph Eastman
Gift of Mabel M. Eastman, 1952

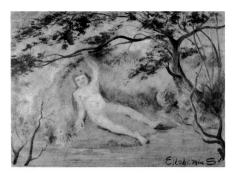

Eilshemius, *Nymph with Pink Scarf*

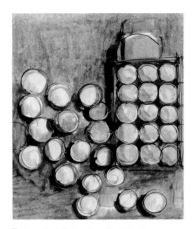

Estes, *Aerial: Loading Red Truck with Oil Drums*

Farny, *Apache Indians in the Mountains*

Levi B. Eberly, 1840–1917
Deer Running 61.25
Ink on paper, 18⅜ x 25⅜ in. (46.7 x 64.5 cm.)
Gift of friend of Alvan Tallmadge, 1961

Louis Michel Eilshemius, 1864–1941
Nymph with Pink Scarf, 1916 64.42
Oil on composition board, 31 x 40¾ in. (78.7 x 103.5 cm.)
Signed lower right: Eilshemius
Gift of Roy R. Neuberger, 1964

Raphael T. Ellender, 1906–1972
Untitled 71.18
Ink on paper, 16¾ x 13⅜ in. (42.5 x 34 cm.)
Signed lower center: Ellender
Gift of the artist, 1971

Dean Ellis, born 1922
Evening, Spain, 1958 59.1
Oil on masonite, 20 x 30 in. (50.8 x 76.2 cm.)
Signed lower right: Dean Ellis
Gift of the American Academy of Arts and Letters: Childe
 Hassam Fund, 1959

Richard Estes, born 1936
Aerial: Loading Red Truck with Oil Drums 84.18
Watercolor on paper, 7¾ x 9½ in. (19.7 x 24.1 cm.)
Gift of Katherine K. Goodman, 1984

De Scott Evans (attributed to), 1847–1898
A New Variety, Try One 76.42.2
Oil on canvas, 12⅛ x 10 in. (30.8 x 25.4 cm.)
Signed lower right: S. S. David
Gift of Dorothy Hubbard Appleton, 1976
Cat. no. 9

Ralph Fabri, 1894–1975
Houses of Bangkok 75.37
Acrylic on panel, 19 x 32 in. (48.3 x 81.3 cm.)
Signed lower left: Ralph Fabri
Gift of Donald Holden, 1975

Alfeo Faggi, 1885–1966
Descent from the Cross, 1942 45.2
Bronze, H. 24½ in. (62.2 cm.)
Signed and dated lower left: A. Faggi/1942
Gift of Sylvia Shaw Judson, 1945

Ralph Fanning, 1889–1971
Building the Art Museum, 1929 72.24
Conté crayon on paper, 14¼ x 11¼ in. (36.2 x 28.6 cm.)
Signed, dated, and inscribed lower right: Building the
 Art Museum/Columbus, O. Nov. 22/29/Ralph Fanning
Gift of the College of the Arts, Ohio State University,
 1972

Henry F. Farny, 1847–1916
Apache Indians in the Mountains, 1895–1898 37.146
Gouache on paper, 21⅞ x 16¼ in. (55.6 x 41.3 cm.)
Signed, dated, and inscribed lower right: To Colonel
 Minor/in friendly remembrance/from/H. F. Farny/95/98
Bequest of Dr. Hervey Williams Whitaker, 1937

Heide Fasnacht, born 1951
Pell Mell II, 1985 86.9
Wood and India ink, H. 58⅝ in. (148.8 cm.)
Purchased with funds made available from the Awards
 in the Visual Arts program, 1986

Fasnacht, *Pell Mell II*

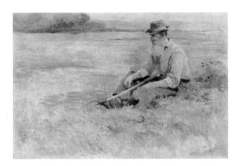

Fauley, *Rest*

Feeley, *Aludra*

Ferrara, *Breaktower*

Albert C. Fauley, 1858–1919
Rest, 1900 20.15
Oil on canvas, 14 x 20 in. (35.6 x 50.8 cm.)
Signed and dated lower right: Albert C. Fauley/1900
Source unknown, 1920

Albert C. Fauley, 1858–1919
Sail Boat 37.12
Oil on canvas, 20 x 16 in. (50.8 x 40.6 cm.)
Signed lower left: A. C. Fauley
Bequest of Dr. Hervey Williams Whitaker, 1937

Paul Terence Feeley, 1910–1966
Aludra, ca. 1960 85.24.2
Enamel on canvas, 80½ x 55 in. (204.5 x 139.7 cm.)
Gift of the Betty Parsons Foundation, 1985

Paul Terence Feeley, 1910–1966
El 20, 1965 85.24.5
Painted wood, H. 8 in. (20.3 cm.)
Gift of the Betty Parsons Foundation, 1985

Lyonel Feininger, 1871–1956
Blue Coast, 1944 51.13
Oil on canvas, 18 x 34 in. (45.7 x 86.4 cm.)
Signed upper left: Feininger
Museum Purchase: Howald Fund, 1951
Cat. no. 66

Jackie Ferrara, born 1929
Breaktower, 1984 84.1
Cedar, H. 144 in. (365.8 cm.)
Gift of Cardinal Industries, Inc., 1984

E. Loyal Field, 1856–1914
A Day in November 64.29
Oil on canvas, 30 x 25 in. (76.2 x 63.5 cm.)
Signed lower left: E. LOYAL FIELD
Gift of the Hildreth Foundation in memory of
 Mr. and Mrs. Louis R. Hildreth, 1964

Joseph Fitzpatrick, born 1925
The Umbrella, ca. 1964–1965 67.8
Oil on canvas, 54 x 48 in. (137.2 x 121.9 cm.)
Museum Purchase: Howald Fund, 1967

Joseph Fitzpatrick, born 1925
Promenade 70.6
Mixed media, H. 7¾ in. (19.7 cm.)
Signed and inscribed on bottom: Joseph Fitzpatrick/
 Promenade
Museum Purchase: Howald Fund, 1970

Dan Flavin, born 1933
Untitled (to Janie Lee) one, 1971 79.53
Blue, pink, yellow, and green fluorescent light
 (from edition of 5), L. 96 in. (243.8 cm.)
Gift of Mr. and Mrs. William King Westwater, 1979
Cat. no. 78

Helen Frankenthaler, born 1928
Captain's Paradise, 1971 72.27
Acrylic on canvas, 60 x 156 in. (152.4 x 396.2 cm.)
Signed and dated lower left: Frankenthaler '71
Purchased with the aid of funds from the National
 Endowment for the Arts and two anonymous donors,
 1972
Cat. no. 75

Ron Franks, born 1937
Whistle Stop Three, 1971 71.16
Acrylic on canvas, 31¾ x 46 in. (80.6 x 116.8 cm.)
Signed and dated lower right: RON FRANKS 371
Theodore R. Simson Purchase Award, 1971

John Freeman, born 1922
Engine II, 1955 55.59
Oil on composition board, 36 x 24 in. (91.4 x 61 cm.)
Signed lower right: J. Freeman
Purchased with funds from the Alfred L. Willson
 Foundation, 1955

Freeman, *Red Ribbon*

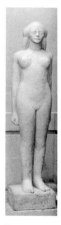

Frey, *Figure of a Girl*

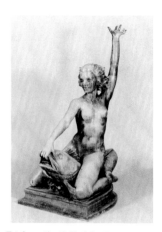

Frishmuth, *Call of the Sea*

Gagnon, *Her Powers of Observation Were the Key to Her Intellect*

John Freeman, born 1922
Landscape, 1962 63.12
Oil on wood, 24⅝ x 23¾ in. (62.5 x 60.3 cm.)
Museum Purchase: Howald Fund, 1963

John Freeman, born 1922
Intruder, 1966–1967 67.22
Acrylic lacquer and mirror on masonite, 51 x 27½ in.
 (129.5 x 69.8 cm.)
Howald Memorial Purchase Award, 1967

John Freeman, born 1922
Red Ribbon, 1969 70.5
Acrylic lacquer on masonite, D. 16½ in. (41.9 cm.)
Museum Purchase: Howald Fund, 1970

Erwin F. Frey, 1892–1967
Woman with Bird, 1927 73.22
Bronze, H. 35½ in. (90.2 cm.)
Signed and dated on base: E. Frey/1927
Bequest of Gerald Fenton, 1973

Erwin F. Frey, 1892–1967
Resignation, 1939 41.12
Marble, H. 77¼ in. (196.2 cm.)
Museum Purchase: Howald Fund, 1941

Erwin F. Frey, 1892–1967
Christ After the Resurrection, 1945–1955 60.21
Limestone, H. 78 in. (198.1 cm.)
Museum Purchase: Howald Fund, 1960

Erwin F. Frey, 1892–1967
Figure of a Girl, 1946 64.3
Marble, H. 89 in. (226.1 cm.)
Signed and dated on base: Erwin F. Frey/1946
Gift of Gerald B. Fenton, 1964

Erwin F. Frey, 1892–1967
Female Torch Bearer 86.22

Cast plaster, H. 15 in. (38.1 cm.)
Gift of Thomas R. Smith, 1986

Harriet Whitney Frishmuth, 1880–1980
Call of the Sea, 1924 84.4
Bronze, H. 46½ in. (118.1 cm.)
Inscribed on base: ©/Harriet W.Frishmuth.1924./
 GORHAM CO. FOUNDERS
Bequest of Rachel Hanna Fulton Allard, 1984

Sue Fuller, born 1914
Noren-Gai, 1955 59.18
Collage on paper, 18 x 14¾ in. (45.7 x 37.5 cm.)
Signed and dated lower left: Sue Fuller '55
Purchased with funds from the Alfred L. Willson
 Foundation, 1959

Kathleen Gagnon, born 1954
*Her Powers of Observation Were the Key to Her
 Intellect*, 1982 83.19
Plaster relief, 25⅝ x 22¾ in. (65 x 57.7 cm.)
Ferdinand Howald Memorial Purchase Award from the
 73rd Annual Columbus Art League Exhibition, 1983

Albert Eugene Gallatin, 1881–1952
Forms, 1949 53.9
Oil on canvas, 25 x 30 in. (63.5 x 76.2 cm.)
Signed and dated on reverse, upper left: A.E. Gallatin/
 Dec. 1949
Gift of Rose Fried, 1953

Emil Ganso, 1895–1941
Nude Back, 1931 69.13
Crayon on paper, 15 x 19⅞ in. (38.1 x 50.5 cm.)
Signed and dated lower right: Ganso/31/31
Purchased with funds from the Alfred L. Willson
 Foundation, 1969

Henry M. Gasser, 1909–1981
Bluff House 68.26

Gatins, *Landscape for a Columbus Summer*

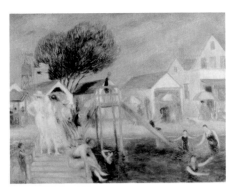

Glackens, *Pier at Blue Point*

Golfinopoulos, *Number 7*

Watercolor on paper, 21¾ x 29¾ in. (55.2 x 75.6 cm.)
Signed lower right: H. Gasser
Gift of the artist and Grand Central Art Galleries, 1968

Eglé Gatins, born 1950
Landscape for a Columbus Summer, 1974 74.27
Mixed media, 36½ x 48½ in. (92.7 x 125.7 cm.)
Purchased with funds from the Alfred L. Willson
 Charitable Fund of The Columbus Foundation, 1974

Eglé Gatins, born 1950
And Don't Go, 1975 75.30
Collage, 50¼ x 38 in. (127.6 x 98.5 cm.)
Frances Piper Memorial Purchase Award, 1975

Marion T. Gatrell, 1909–1984
Night Watch, 1950 76.7
Oil on masonite, 14½ x 17½ in. (36.8 x 44.5 cm.)
Museum Purchase: Howald Fund, 1976

Marion T. Gatrell, 1909–1984
Corridor No. 2, 1965 66.21
Oil on canvas, 25¾ x 38 in. (65.4 x 96.5 cm.)
Signed lower right: Marion Gatrell
Purchased with funds from the Alfred L. Willson
 Foundation, 1966

Robert M. Gatrell, 1906–1982
View of Bowback Lake, 1952 54.46
Oil on masonite, 26 x 38 in. (66 x 96.5 cm.)
Signed lower right: R. M. Gatrell
Museum Purchase: Howald Fund, 1954

Robert M. Gatrell, 1906–1982
Copse #54, 1967 73.11
Ink on paper, 23¾ x 34 in. (60.3 x 86.4 cm.)
Signed lower right: R. M. Gatrell
Theodore R. Simson Purchase Award, 1973

Dorothy Getz, born 1901
Standing Woman, 1966 66.24
Bronze, H. 8 in. (20.3 cm.)
Purchased with funds from the Alfred L. Willson
 Foundation, 1966

Charles Dana Gibson, 1867–1944
Mark Twain 59.34
Ink on paper, 7⅞ x 5⅞ in. (20 x 14.9 cm.)
Signed lower center: C. D. Gibson
Gift of Ralph L. Appleton and W. E. Benua, 1959

Robert Swain Gifford, 1840–1905
At Anchor, 1875 64.27
Oil on canvas, 24¼ x 18¼ in. (61.6 x 46.4 cm.)
Signed and dated lower right: R. Swain Gifford/1875
Gift of the Hildreth Foundation in memory of
 Mr. and Mrs. Louis R. Hildreth, 1964

William Glackens, 1870–1938
The Riot in Bombay, ca. 1897–1899 68.30
Ink on paper, 17⅛ x 18⅛ in. (43.5 x 46 cm.)
Signed and inscribed lower right: W. J. Glackens/The
 Riot in Bombay
Gift of Mr. and Mrs. James Fullington, 1968

William Glackens, 1870–1938
Pier at Blue Point, 1914 31.171
Oil on canvas, 25⅞ x 32 in. (65.7 x 81.3 cm.)
Signed lower left: W. Glackens
Gift of Ferdinand Howald, 1931

William Glackens, 1870–1938
Beach Scene, New London, 1918 31.170
Oil on canvas, 26 x 31⅞ in. (66 x 81 cm.)
Signed lower left: W. Glackens
Gift of Ferdinand Howald, 1931
Cat. no. 29

William Glackens, 1870–1938
Bathing Near the Bay, 1919 31.169
Oil on canvas, 18 x 23⅞ in. (45.7 x 60.6 cm.)
Signed lower right: W. Glackens
Gift of Ferdinand Howald, 1931

Peter Golfinopoulos, born 1928
Number 7, 1963 75.27
Oil on canvas, 49¾ x 74⅛ in. (37.5 x 190.8 cm.)
Museum Purchase: Howald Fund, 1975

Goodman, *Figures on a Dune*

Goodnough, *Subway*

Grausman, *Portrait Bust of Edward Gorey*

Sidney Goodman, born 1936
Figures on a Dune, 1977–1978 86.12.1
Oil on canvas, 58¼ x 80 in. (147.9 x 203.2 cm.)
Signed and dated lower left: Goodman 77– 78
Gift of Arthur J. and Sara Jo Kobacker, 1986

Robert Goodnough, born 1917
Subway, 1959 71.4
Oil on canvas, 59 x 69¾ in. (149.9 x 177.2 cm.)
Signed and dated lower right: Goodnough 59
Museum Purchase: Howald Fund, 1971

J. Jeffrey Grant, 1883–1960
Sea Gulls' Rock, 1921 45.16
Oil on canvas, 30 x 40 in. (76.2 x 101.6 cm.)
Signed and dated lower right: J. JEFFREY GRANT 1921
Bequest of Edward D. and Anna White Jones, 1945

Walter Granville-Smith, 1870–1938
Autumn, 1922 54.50
Watercolor on paper, 11⅝ x 15½ in. (29.5 x 39.4 cm.)
Signed, dated, and inscribed lower left:
 To Mrs. Kirkpatrick / W. Granville-Smith/1922
Gift of Mrs. W. A. Kirkpatrick, 1954

Philip Grausman, born 1935
Portrait Bust of Edward Gorey, 1977 80.8
Bronze, H. 17 in. (43.2 cm.)
Purchased with funds from the Livingston Taylor Family
 and the National Endowment for the Arts, 1980

Philip Grausman, born 1935
Nude Reclining, 1980 86.15
Graphite on paper, 13½ x 20¼ in. (34.3 x 51.4 cm.)
Signed and dated lower left: Grausman/1980
Gift of an anonymous donor, 1986

Morris Graves, born 1910
Duck, 1954 57.40
Ink and wash on paper, 12¾ x 18⅝ in. (32.4 x 47.3 cm.)
Signed and dated lower right: Graves '54
Purchased with funds from the Alfred L. Willson
 Foundation, 1957

Gray, *Gardens of the Villa d'Este*

Greene, *Rock Harbor*

Cleve Gray, born 1918
Gardens of the Villa D'Este, 1949 52.31
Oil on canvas, 47¼ x 29½ in. (120 x 74.9 cm.)
Signed and dated lower left: Gray—'49
Museum Purchase: Howald Fund, 1952

Joseph Green (Joseph G. Butler III), 1901–1981
Tortola, 1945 46.56
Watercolor and ink on paper, 13⅝ x 20¾ in.
 (34.6 x 52.7 cm.)
Signed and dated lower left: JOS GREEN/45
Museum Purchase: Howald Fund, 1946

Balcomb Greene, born 1904
Morning Sun, 1970 76.2
Oil on canvas, 62 x 50 in. (157.5 x 127 cm.)
Signed lower right: Balcomb Greene
Anonymous gift, 1976

Balcomb Greene, born 1904
Rock Harbor, 1972 75.52
Oil on canvas, 60 x 54 in. (152.4 x 137.2 cm.)
Museum Purchase: Howald Fund, 1975

Griffith, *Yellow Legs*

Gwathmey, *Mother and Child*

Halpert, *Still Life by Window*

Gertrude Greene, 1911–1956
Composition D, 1948 76.3
Oil on canvas, 40 x 29¾ in. (101.6 x 75.6 cm.)
Gift of Balcomb Greene, 1976

Dennison W. Griffith, born 1952
Yellow Legs, 1983 83.1.1 &.2
Acrylic, enamel, oilstick on canvas, 60¹/₁₆ x 96¹/₁₆ in.
 (152.6 x 244 cm.)
Signed upper right: Dennison W. Griffith
Bevlyn and Theodore Simson Purchase Award from the
 73rd Annual Columbus Art League Exhibition, 1983

Chaim Gross, born 1904
Happy Mother, 1958 82.2
Bronze (from edition of 6), L. 82 in. (208.2 cm.)
Signed and dated top left of base: Chaim Gross 1958.
 Foundry mark on left side of base: Bedi-Makky Art
 Foundry N.Y.
Gift of Ashland Oil, Inc., 1982
Cat. no. 70

George Grosz, 1893–1959
Group of Figures, ca. 1921 68.3
Ink on paper, 7 x 8½ in. (17.8 x 21.6 cm.)
Signed lower right: Grosz
Museum Purchase: Howald Fund, 1968

Robert Gwathmey, 1903–1988
Mother and Child, 1980 86.12.2
Oil on canvas, 40¼ x 34 in. (102.2 x 86.4 cm.)
Signed bottom right: Gwathmey
Gift of Arthur J. and Sara Jo Kobacker, 1986

Maurice Stewart Hague, 1862–1943
After the Storm 15.1
Oil on canvas, 30 x 40 in. (76.2 x 101.6 cm.)
Signed lower right: Maurice S. Hague
Museum purchase, 1915

Gilbert Hall, born 1926
Birds on a Limb, 1959 60.33

Oil on canvas, 56 x 42¾ in. (142.2 x 108.6 cm.)
Signed and dated lower right: Hall '59
Museum Purchase: Howald Fund, 1960

Samuel Halpert, 1884–1930
Still Life by Window, 1913 70.19
Oil on canvas, 30 x 25 in. (76.2 x 63.5 cm.)
Signed and dated lower right: S. Halpert—13
Museum Purchase: Howald Fund, 1970

Adolfo Halty-Dubé, born 1915
The Fish Eats the Fish 55.11
Oil on masonite, 26 x 44¼ in. (66 x 112.4 cm.)
Signed lower left: Halty
Gift of the artist, 1955

Edward Wilbur Dean Hamilton, 1864–1943
Mrs. Earle C. Derby, 1895 58.39
Watercolor and pastel on paper, 37½ x 23 in.
 (95.2 x 73.7 cm.)
Signed and dated lower left: E.W.D. Hamilton 1895
Gift of Mrs. Earle C. Derby, 1958

Edward Wilbur Dean Hamilton, 1864–1943
Mrs. Earle C. Derby, 1908 58.38
Oil on canvas, 42 x 30 in. (106.7 x 76.2 cm.)
Signed and dated lower right: Wilbur Dean Hamilton/
 1908
Gift of Mrs. Earle C. Derby, 1958

William Michael Harnett, ca. 1848–1892
After the Hunt, 1883 19.1
Oil on canvas, 52½ x 36 in. (133.4 x 91.4 cm.)
Signed with monogram and dated lower left:
 W.M.Harnett/München/1883
Bequest of Francis C. Sessions, 1919
Cat. no. 8

George Overbury "Pop" Hart, 1868–1933
West Indies Market, 1922 63.36
Watercolor on paper, 11⅞ x 14½ in. (30.2 x 36.8 cm.)
Inscribed lower left: West Indies
Museum Purchase: Howald Fund, 1963

Haseltine, *Venice*

Hartley, *Pre-War Pageant*

Hartley, *Sail Boat*

Marsden Hartley, 1877–1943
Cosmos (formerly *The Mountains*), 1908–1909 31.179
Oil on canvas, 30 x 30⅛ in. (76.2 x 76.5 cm.)
Signed lower right: MARSDEN HARTLEY
Gift of Ferdinand Howald, 1931
Cat. no. 39

Marsden Hartley, 1877–1943
New England Farm, ca. 1909–1911 31.181
Oil on panel, 11½ x 11½ in. (29.2 x 29.2 cm.)
Signed lower right: MARSDEN HARTLEY
Gift of Ferdinand Howald, 1931

Marsden Hartley, 1877–1943
The Mountain, Autumn, ca. 1910–1911 31.180
Oil on panel, 11⅝ x 11½ in. (29.5 x 29.2 cm.)
Signed lower right: MARSDEN HARTLEY
Gift of Ferdinand Howald, 1931

Marsden Hartley, 1877–1943
Still Life No. 1, 1912 31.184
Oil on canvas, 31½ x 25⅝ in. (77.5 x 65.1 cm.)
Signed lower left: Marsden Hartley
Gift of Ferdinand Howald, 1931

Marsden Hartley, 1877–1943
Berlin Ante War, 1914 31.173
Oil on canvas with painted wood frame, 41¾ x 34½ in.
 (106 x 87.6 cm.)
Gift of Ferdinand Howald, 1931
Cat. no. 40

Marsden Hartley, 1877–1943
Pre-War Pageant, 1914 31.175
Oil on canvas, 40 x 32 in. (101.6 x 81.3 cm.)
Gift of Ferdinand Howald, 1931

Marsden Hartley, 1877–1943
Sail Boat, ca. 1916 31.183
Oil on pasteboard, 15⅝ x 11½ in. (39.7 x 29.2 cm.)
Signed lower left: Marsden Hartley
Gift of Ferdinand Howald, 1931

Marsden Hartley, 1877–1943
The Blue Cup (or *Color Analogy*), ca. 1918 31.174
Oil on panel, 19¾ x 15⅝ in. (50.2 x 39.7 cm.)
Gift of Ferdinand Howald, 1931

Marsden Hartley, 1877–1943
Lilies in a Vase, ca. 1920 31.178
Oil on pasteboard, 27 x 19⅛ in. (68.6 x 48.6 cm.)
Gift of Ferdinand Howald, 1931

Marsden Hartley, 1877–1943
New Mexico Recollections, 1923 31.182
Oil on canvas, 17½ x 30 in. (44.5 x 76.2 cm.)
Signed, dated, and inscribed on reverse: Recollection
 1923 Marsden Hartley
Gift of Ferdinand Howald, 1931

Marsden Hartley, 1877–1943
The Window, ca. 1924 31.187
Oil on canvas, 35⅝ x 25⅝ in. (90.5 x 65.1 cm.)
Inscribed on reverse, on stretcher: The Window, Marsden
 Hartley
Gift of Ferdinand Howald, 1931

Marsden Hartley, 1877–1943
*The Spent Wave, Indian Point, Georgetown,
 Maine*, 1937–1938 81.13
Oil on academy board, 22½ x 28½ in. (57.1 x 72.4 cm.)
Signed, dated, and inscribed paper label on reverse in
 artist's hand: THE SPENT WAVE/INDIAN POINT/
 GEORGETOWN/MAINE 1937–38/Marsden Hartley
Museum Purchase: Howald Fund II, 1981
Cat. no. 41

William Stanley Haseltine, 1835–1900
Venice 52.8
Watercolor on paper, 11¾ x 18¼ in. (29.8 x 46.4 cm.)
Signed lower right: WSH
Gift of Helen Haseltine Plowden, 1952

Hayden, *Apple Blossoms, No. 1*

Healy, *Maréchal Soult*

Heimdal, *Scanning the Horizon*

Childe Hassam, 1859–1935
The North Gorge, Appledore, Isles of Shoals, 1912
 [57]43.9
Oil on canvas, 20 x 14 in. (50.8 x 35.6 cm.)
Signed and dated lower right: Childe Hassam 1912
Bequest of Frederick W. Schumacher, 1957
Cat. no. 16

Earl Hassenpflug, born 1926
Setting Sun, ca. 1968 69.5
Charcoal on paper, 29 x 22⅞ in. (73.7 x 58.1 cm.)
Museum Purchase: Howald Fund, 1969

Duayne Hatchett, born 1925
Flight No. 1, 1959 65.38
Bronze, H. 9 in. (22.9 cm.)
Signed on bottom: Duayne Hatchett
Purchased with funds from the Alfred L. Willson
 Foundation, 1965

Duayne Hatchett, born 1925
Flight No. 2, ca. 1964 65.39
Bronze, H. 7¾ in. (19.7 cm.)
Signed on bottom: Duayne Hatchett
Purchased with funds from the Alfred L. Willson
 Foundation, 1965

William Hawkins, born 1895
Red Dog Running III, 1986 86.24
Oil on board, 48 x 60 in. (121.9 x 152.4 cm.)
Gift of an anonymous donor, 1986

Edward Parker Hayden, 1858–1921
Apple Blossoms, No. 1, 1899 76.42.6
Watercolor on paper, 14 x 19 in. (35.6 x 48.3 cm.)
Signed lower left: Edward Parker Hayden 99
Gift of Dorothy Hubbard Appleton, 1976

Edward Parker Hayden, 1858–1921
The Coming Storm, 1914 64.32
Oil on canvas, 18 x 24⅛ in. (45.7 x 61.3 cm.)

Signed and dated lower left: E. P. Hayden/1914
Gift of Eleanor Hayden MacLean, 1964

Edward Parker Hayden, 1858–1921
Landscape 76.42.8
Oil on panel, 7⅞ x 13¹/₁₆ in. (20 x 33.2 cm.)
Gift of Dorothy Hubbard Appleton, 1976

Edward Parker Hayden, 1858–1921
Landscape 76.42.7
Watercolor on paper, 12⅞ x 19⅛ in. (32.7 x 48.6 cm.)
Signed lower left: Edward Parker Hayden
Gift of Dorothy Hubbard Appleton, 1976

David Hayes, born 1931
Centaur, 1973 74.35
Steel, H. 135 in. (343 cm.)
Signed and dated on rear leg: Hayes 1973
Purchased with the aid of funds from the National
 Endowment for the Arts and the Women's Board
 of the Columbus Gallery of Fine Arts, 1974

David Hayes, born 1931
Fisher's Island, 1974 74.36
Gouache on paper, 30 x 22¼ in. (76.2 x 56.5 cm.)
Signed and dated lower right: David Hayes 1974
Gift of the artist, 1974

David Hayes, born 1931
Drawing for Landscape Sculpture, 1980 81.8
Ink and gouache on paper, 22¼ x 30 in. (56.5 x 76.2 cm.)
Signed and dated lower right: David Hayes 1980
Gift of the artist, 1981

Martin Johnson Heade, 1819–1904
Marsh Scene: Two Cattle in a Field, 1869 80.2
Oil on canvas, 14⅜ x 30¼ in. (36.5 x 76.8 cm.)
Signed and dated lower right: M/Heade · 69
Acquired through exchange: Bequest of J. Willard Loos,
 1980
Cat. no. 6

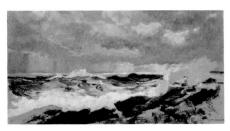

Hekking, *Winter Seas at Lobster Cove, Monhegan Island, Maine*

Henri, *Street in Paris*

Herndon, *I-690*

George P. A. Healy, 1813–1894
Maréchal Soult, 1840 62.85
Oil on panel, 21¾ x 14 in. (54.9 x 35.6 cm.)
Dated lower right: Sept. 25th 1840
Museum Purchase: Schumacher Fund, 1962

Erwin F. Hebner, born 1926
Singer, 1961 62.65
Ink on paper, 17½ x 23⅜ in. (44.5 x 59.4 cm.)
Signed and dated lower center: Hebner/'61
Museum Purchase: Howald Fund, 1962

Georg Heimdal, born 1943
Scanning the Horizon, 1985 85.26
Acrylic on canvas, 36 x 48 in. (91.4 x 121.9 cm.)
Ferdinand Howald Memorial Purchase Award from the
 75th Annual Columbus Art League Exhibition, 1985

Wilmot Emerton Heitland, 1893–1969
Quince Street 57.3
Watercolor on paper, 21¼ x 29¼ in. (54 x 74.3 cm.)
Signed lower right: Heitland
Gift of the National Academy of Design: Ranger Fund,
 1957

William M. Hekking, 1885–1970
Winter Seas at Lobster Cove, Monhegan Island, Maine
 67.17
Oil on masonite, 23⅞ x 42 in. (60.6 x 106.7 cm.)
Signed lower right: Wm. M. Hekking
Museum Purchase: Howald Fund, 1967

John Edward Heliker, born 1909
Sketching 71.17
Watercolor and graphite on paper, 7⅜ x 11 in.
 (18.7 x 27.9 cm.)
Signed lower center: Heliker
Museum Purchase: Howald Fund, 1971

Robert Henri, 1865–1929
Street in Paris, 1894 61.31

Ink on paper, 4½ x 5½ in. (11.4 x 14 cm.)
Signed lower left: Robert Henri
Museum Purchase: Howald Fund, 1961

Robert Henri, 1865–1929
Miss Jesseca Penn, 1907 71.3
Oil on canvas, 32 x 26 in. (81.3 x 66 cm.)
Museum Purchase: Howald Fund, 1971

Robert Henri, 1865–1929
Dancer in a Yellow Shawl, ca. 1908 10.2
Oil on canvas, 42 x 33½ in. (106.7 x 85.1 cm.)
Signed lower left center: Robert Henri
Museum purchase, 1910
Cat. no. 23

Robert Henri, 1865–1929
Self-Portrait 62.84
Graphite on paper, 8⅞ x 5½ in. (22.5 x 14 cm.)
Museum Purchase: Howald Fund, 1962

Robert Henri, 1865–1929
Sketch of a Girl 66.38
Ink on paper, 10 x 8 in. (25.4 x 20.3 cm.)
Inscribed lower right by executor of the artist's estate:
 Robert Henri/J C L [John C. LeClair]
Museum Purchase: Howald Fund, 1966

Carolyn Herbert, active twentieth century
Afternoon 46.55
Watercolor on paper, 11¾ x 17⅝ in.
 (29.9 x 44.8 cm.)
Signed lower right: C. Herbert
Museum Purchase: Howald Fund, 1946

Charles Laylin Herndon, born 1947
I-690, 1971 74.11
Iron, L. 144 in. (365.8 cm.)
Purchased with funds from the Alfred L. Willson
 Charitable Fund of The Columbus Foundation, 1974

Horwood, *Phonograph*

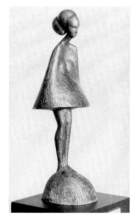

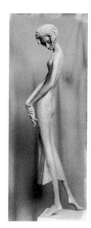

Holty, *Figure*

Hostetler, *Standing Woman* Iselin, *Eve*

Richard A. Hickham, born 1944
Tribute to Genet, 1969 71.20
Graphite on paper, 24 x 36 in. (61 x 91.4 cm.)
Signed and dated lower right: Richard A. Hickham 69
Museum Purchase: Howald Fund, 1971

Adrienne Hoard, born 1949
Blue Nun, 1978 80.30
Acrylic on canvas, 48 x 96 in. (121.9 x 243.8 cm.)
Signed and dated top center: a.w. hoard 1978
Gift of the artist, 1980

Carl Holty, 1900–1973
Figure, 1948 73.10.1
Oil on masonite, 47¾ x 39¾ in. (121.3 x 101 cm.)
Signed lower left: Carl Holty. Signed, dated, and
 inscribed on reverse: Carl Holty—1948—Athens
 Georgia/—Figure—
Gift of Lewis Galantiére in memory of Nancy Galantiére,
 1973

Carl Holty, 1900–1973
Violet and Green Study, 1957 73.10.2
Oil on canvas, 18 x 32 in. (45.7 x 81.3 cm.)
Signed, dated, and inscribed on reverse, upper left:
 Carl Holty—57/Violet and Green Study
Gift of Lewis Galantiére in memory of Nancy Galantiére,
 1973

Winslow Homer, 1836–1910
Haymaking, 1864 42.83
Oil on canvas, 16 x 11 in. (40.6 x 27.9 cm.)
Signed and dated lower left: Homer/64
Museum Purchase: Howald Fund, 1942
Cat. no. 1

Winslow Homer, 1836–1910
Girl in the Orchard, 1874 48.10
Oil on canvas, 15⅝ x 22⅝ in. (39.7 x 57.5 cm.)
Signed and dated lower right: Winslow Homer 1874.

Inscribed upper left on stretcher frame: Winslow
 Homer/51 W 10th/N.Y.
Museum Purchase: Howald Fund, 1948
Cat. no. 2

James R. Hopkins, 1877–1969
Seated Nude, ca. 1915 72.46
Oil on canvas, 26 x 31¾ in. (66 x 80.7 cm.)
Signed lower left: James R. Hopkins
Museum Purchase: Howald Fund, 1972

Stella Ruth Hopkins, active twentieth century
Battle of Manila Bay 42.88
Oil on canvas, 22⅛ x 48 in. (56.2 x 121.9 cm.)
Signed lower right: S.R.H.
Gift of Walter W. Hamilton, 1942

Edward Hopper, 1882–1967
Morning Sun, 1952 54.31
Oil on canvas, 28⅛ x 40⅛ in. (71.4 x 101.9 cm.)
Signed lower right: Edward Hopper
Museum Purchase: Howald Fund, 1954
Cat. no. 67

Robert Horwood, ca. 1900–1955
Phonograph, ca. 1925 85.21
Oil on canvas, 8 x 15 in. (20.3 x 38.1 cm.)
Signed bottom left: Horwood
Gift of the Salander-O'Reilly Galleries, 1985

David Hostetler, born 1926
Standing Woman, ca. 1974 80.31
Bronze, H. 28 in. (71.1 cm.)
Inscribed on right of base: D. Hostetler
Gift of Mr. and Mrs. David J. Baker, 1980

Anna Hyatt Huntington, 1876–1973
Yawning Panther 38.22
Bronze, H. 8⅜ in. (21.3 cm.)
Gift of the artist, 1938

Jenkins, *Phenomena: Hoisting the Colors*

Johnson, *Still Life with Torso*

Kane, *Portrait of Maggie*

Peter Hurd, 1903–1984
Festival of San Patricio, 1966 67.4
Watercolor on paper, 24 x 38¾ in. (61 x 98.4 cm.)
Museum Purchase: Howald Fund, 1967

George Inness, 1825–1894
The Pasture, 1864 54.36
Oil on canvas, 11½ x 17½ in. (29.2 x 44.5 cm.)
Signed and dated lower right: G. Inness 1864
Bequest of Virginia H. Jones, 1954
Cat. no. 3

George Inness, 1825–1894
Shower on the Delaware River, 1891 54.2
Oil on canvas, 30¼ x 45⅛ in. (76.8 x 114.6 cm.)
Signed and dated lower right: G. Inness 1891
Museum Purchase: Howald Fund, 1954
Cat. no. 4

Lewis Iselin, born 1913
Dorothy Sefton, 1958 60.32
Bronze, H. 14½ in. (36.8 cm.)
Museum Purchase: Howald Fund, 1960

Lewis Iselin, born 1913
Eve, 1959 64.1
Bronze, H. 72 in. (182.9 cm.)
Signed on base: L. Iselin
Gift of the artist, 1964

Karl Jaeger, born 1930
Astrid J 65.32
Plexiglas and wood light box, 22 x 36 in. (55.9 x 66 cm.)
Museum Purchase: Howald Fund, 1965

Henrietta Lewis Jamison, 1862–1895
The Lanterns 50.36
Oil on canvas, 16 x 12¾ in. (40.6 x 32.4 cm.)
Signed lower left: H. L. Jamison
Bequest of Effie Duncan, 1950

Paul Jenkins, born 1923
Phenomena: Hoisting the Colors, 1973 74.28
Acrylic on canvas, 76 x 141 in. (193 x 358.1 cm.)
Purchased with the aid of funds from the National
 Endowment for the Arts and the Women's Board of
 The Columbus Gallery of Fine Arts, 1974

John Christen Johansen, 1876–1964
Interior with Figures, 1921 24.2
Oil on canvas, 30 x 35 in. (76.2 x 88.9 cm.)
Signed and dated lower left: J. C. Johansen 1921
Gift of the National Academy of Design: Ranger Fund,
 1924

Carlyle D. Johnson, born 1950
Adinka Landscape Assemblage #2, ca. 1977 77.6
Acrylic on canvas, 23½ x 17½ in. (59.7 x 44.5 cm.)
Jean Lamb Hall Memorial Purchase Award from the 67th
 Annual Columbus Art League May Show, 1977

Roman Johnson, born 1917
Still Life with Torso, 1976 77.10
Oil on canvas, 29½ x 49⅝ in. (74.9 x 126 cm.)
Signed upper right: ROMAN.76
Gift of Mrs. Ursel White Lewis, 1977

Murray Jones, 1915–1964
Nara I, 1961 64.34
Lacquer collage on masonite, 47¼ x 51¼ in.
 (120 x 130.2 cm.)
Signed and dated on reverse, center: Murray Jones 1961
Gift of the Roy R. & Marie S. Neuberger Foundation and
 funds from the Alfred L. Willson Foundation, 1964

Juris A. Kakis, born 1938
Orangeman, 1970 70.27
Acrylic on canvas, 60 x 48 in. (152.4 x 121.9 cm.)
Theodore R. Simson Purchase Award, 1970

John Kane, 1860–1934
Portrait of Maggie, ca. 1929 80.23

Keith, *Yosemite Valley*

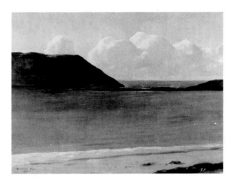

Kent, *Pollock Seining*

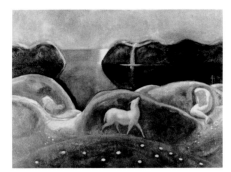

Kent, *Pastoral*

Oil on canvas, 23 x 19⁵⁄₁₆ in. (58.4 x 49.1 cm.)
Signed upper left: John Kane
Museum Purchase: Howald Fund II, 1980

William Keith, 1839–1911
Yosemite Valley, 1882 19.7
Oil on canvas, 30 x 24½ in. (76.2 x 62.2 cm.)
Signed and dated lower right: W. Keith/82
Bequest of Francis C. Sessions, 1919

Rockwell Kent, 1882–1971
Pollock Seining, 1907 31.193
Oil on canvas, 34⅛ x 43⅞ in. (86.7 x 111.4 cm.)
Signed and dated lower left: Rockwell Kent/1907
Gift of Ferdinand Howald, 1931

Rockwell Kent, 1882–1971
Men and Mountains, 1909 31.190
Oil on canvas, 33 x 43¼ in. (83.8 x 109.9 cm.)
Signed and dated lower left: ROCKWELL KENT 1909
Gift of Ferdinand Howald, 1931
Cat. no. 33

Rockwell Kent, 1882–1971
Pastoral, 1914 31.192
Oil on canvas, 33 x 43½ in. (83.8 x 110.5 cm.)
Signed, dated, and inscribed lower right: Rockwell
 Kent—Newfoundland—1914
Gift of Ferdinand Howald, 1931

Rockwell Kent, 1882–1971
Newfoundland Ice, 1915 31.191
Oil on panel, 11⅞ x 16 in. (30.2 x 40.6 cm.)
Signed and dated lower right: Rockwell Kent 1915
Gift of Ferdinand Howald, 1931

Rockwell Kent, 1882–1971
Angel, ca. 1918 31.189
Oil on glass, 7½ x 9⅝ in. (19.1 x 24.5 cm.)
Gift of Ferdinand Howald, 1931

Rockwell Kent, 1882–1971
Maid and Bird, ca. 1918 31.188
Oil on glass, 9⅝ x 7⅜ in. (24.5 x 18.7 cm.)
Gift of Ferdinand Howald, 1931

Michael Kessler, born 1954
The Nagual's Time, 1985 86.10
Oil on canvas, 67 x 86 in. (170.2 x 218.4 cm.)
Purchased with funds made available from the Awards
 in the Visual Arts program, 1986

Hal Kinder, active twentieth century
A Wet Day at Allen's Cove 61.104
Watercolor on paper, 20¼ x 27½ in. (51.4 x 69.9 cm.)
Signed lower right: Kinder [with illegible markings]
Museum Purchase: Howald Fund, 1961

Robert D. King, born 1915
Dawn, 1960 62.64
Ink and wash on paper, 21¾ x 26¾ in. (55.2 x 67.9 cm.)
Signed lower left: R. King
Howald Memorial Purchase Award, 1962

Robert D. King, born 1915
Equals 56.35
Pastel and watercolor on paper, 31⅛ x 25 in.
 (79.1 x 63.5 cm.)
Signed lower left: R. King
Museum Purchase: Howald Fund, 1956

William King, born 1925
Twins, 1973 79.54
Sheet aluminum, H. 144 in. (365.8 cm.)
Given in loving memory of H. Richard Peterson Niehoff
 by Mrs. H. Richard Peterson Niehoff, H. R. Peterson
 Niehoff, Christopher Will Niehoff, Patricia LeVeque
 Niehoff and Elsa Will Niehoff, 1979

Dong Kingman, born 1911
From My Hotel Window, Japan, 1954 58.8

Kessler, *The Nagual's Time*

King, *Twins*

Kingman, *From My Hotel Window, Japan*

Watercolor on paper, 21¾ x 14½ in. (55.3 x 36.8 cm.)
Signed, dated, and inscribed lower right: A sketch/from
 Room 828/Marimouchi/Hotel Morning of Manis/1954/
 Kingman
Purchased with funds from the Alfred L. Willson
 Foundation, 1958

Mary Kinney, born 1929
Outdoors No. 20, 1974 74.12
Watercolor on paper, 22 x 30 in. (55.9 x 76.2 cm.)
Signed lower right: M. Kinney
Purchased with funds from the Alfred L. Willson
 Charitable Fund of The Columbus Foundation, 1974

Ray Kinsman-Waters, 1887–1962
Flood Refugees, 1937 37.5
Gouache on paper, 19⅝ x 25 in. (49.9 x 63.5 cm.)
Signed and dated upper left: R. KINSMAN-WATERS/1937
Gift of the Columbus Art League, 1937

Vance Kirkland, 1904–1981
Vibrations of Turquoise on Yellow, 1967 67.49
Oil on canvas, 60 x 60 in. (152.4 x 152.4 cm.)
Signed, dated, and inscribed on reverse, upper center:
 VIBRATIONS OF TURQUOISE ON YELLOW/No. 20 1967/
 60 x 60/VANCE KIRKLAND/(Kirkland)
Museum Purchase: Howald Fund, 1967

Harriet R. Kirkpatrick, 1877–1962
Berchtesgaden 60.55
Watercolor on paper, 12 x 9¹⁄₁₆ in. (30.5 x 23.7 cm.)
Signed lower right: H. Kirkpatrick
Gift of Ernest Zell, 1960

Josephine Klippart, 1848–1936
Tulips 19.54
Oil on canvas, 20 x 27 in. (50.8 x 68.6 cm.)
Signed lower left: Josephine Klippart
Bequest of Francis C. Sessions, 1919

Daniel Ridgway Knight, 1839–1924
The Gathering, 1882 82.14.1
Watercolor on paper, 14¼ x 10 in. (36.2 x 25.4 cm.)
Signed, dated, and inscribed bottom left: D. Ridgway
 Knight Paris 1882
Gift of Mrs. Leon Watters, in memory of her daughter,
 Frances Nathan Lazarus, 1982

Daniel Ridgway Knight, 1839–1924
The Water Carrier, 1883 82.14.2

Kinsman-Waters, *Flood Refugees*

Knight, *The Gathering*

Kohlmeyer, *Symbols 82-1*

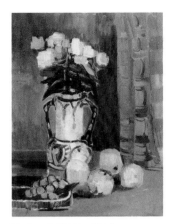

Kuehn, *Still Life with Flowers*

Kuhn, *Salt Mists*

Watercolor on paper, 13¾ x 10 in. (35 x 25.4 cm.)
Signed and dated on bottom right: Ridgway Knight 1883
Gift of Mrs. Leon Watters, in memory of her daughter,
 Frances Nathan Lazarus, 1982

Daniel Ridgway Knight, 1839–1924
Village Scene, 1884 (?) 82.14.3
Watercolor on paper, 14 x 10 in. (35.6 x 25.4 cm.)
Signed and dated bottom right: D. Ridgway Knight Paris
 1884[?]
Gift of Mrs. Leon Watters, in memory of her daughter,
 Frances Nathan Lazarus, 1982

Daniel Ridgway Knight, 1839–1924
The Idler 76.42.9
Oil on canvas, 21⅞ x 18⅜ in. (55.6 x 46.7 cm.)
Signed and inscribed lower left: D. Ridgway Knight,
 Paris
Gift of Dorothy Hubbard Appleton, 1976

Ida Kohlmeyer, born 1912
Symbols 82–1, 1982 85.14
Mixed media on canvas, 36 x 35½ in. (91.4 x 90.1 cm.)
Signed and dated bottom right: Kohlmeyer 1982
Gift of Victoria E. Schonfeld, 1985

William Kortlander, born 1925
Shelter, 1963 63.41
Charcoal on paper, 18½ x 24½ in. (47 x 62.2 cm.)
Museum Purchase: Howald Fund, 1963

William Kortlander, born 1925
A Sparrow for Mom, 1964 64.7
Casein on paper, 18 x 24¼ in. (45.7 x 61.6 cm.)
Museum Purchase: Howald Fund, 1964

William Kortlander, born 1925
Study for *A Sparrow for Mom*, 1964 66.26
Graphite on paper, 17¾ x 12 in. (45.1 x 30.5 cm.)
Purchased with funds from the Alfred L. Willson
 Foundation, 1966

Doris Barsky Kreindler, 1901–1974
Hardinger Fjord, ca. 1965 76.38.1
Oil on canvas, 50⅛ x 40⅛ in. (127.2 x 101.9 cm.)
Signed bottom right: Kreindler
Gift of Harry E. Kreindler, 1976

Doris Barsky Kreindler, 1901–1974
St. Maarten Sunset, ca. 1970 76.38.2
Oil on canvas, 41⅞ x 46 in. (106.4 x 116.9 cm.)
Signed bottom right: Kreindler
Gift of Harry E. Kreindler, 1976

Edmund Kuehn, born 1916
Still Life with Flowers, 1939 66.7
Oil on canvas, 20⅛ x 14⅛ in. (51.1 x 35.9 cm.)
Museum Purchase: Howald Fund, 1966

Edmund Kuehn, born 1916
Okinawa No. 1, 1946 47.98
Casein on paper, 14⅜ x 18⅜ in. (36.5 x 46.7 cm.)
Signed, dated, and inscribed lower right: Okinawa '46
 Edmund Kuehn/J.19
Purchased with funds from the Alfred L. Willson
 Foundation, 1947

Edmund Kuehn, born 1916
Okinawa No. 2, 1946 47.99
Casein on paper, 14½ x 19½ in. (36.9 x 49.5 cm.)
Signed, dated, and inscribed lower right: Edmund
 Kuehn '46 / Okinawa F 17
Purchased with funds from the Alfred L. Willson
 Foundation, 1947

Walt Kuhn, 1877–1949
Salt Mists, 1910–1911 83.22
Oil on canvas, 25 x 30 in. (63.5 x 76.2 cm.)
Signed bottom left: Walt Kuhn
Gift in memory of Derrol R. Johnson from his family,
 1983

Kuniyoshi, *Boy Stealing Fruit*

Kutchin, *Girl in Green*

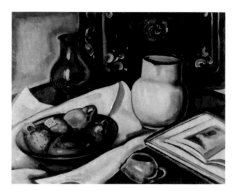
Kutchin, *Still Life*

Walt Kuhn, 1877–1949
Veteran Acrobat, 1938 42.84
Oil on canvas, 24 x 20 in. (61 x 50.8 cm.)
Signed and dated upper right: Walt Kuhn/1938
Purchased by special subscription, 1942
Cat. no. 63

Yasuo Kuniyoshi, 1889–1953
Boy Stealing Fruit, 1923 31.194
Oil on canvas, 20 x 30 in. (50.8 x 76.2 cm.)
Signed and dated lower left: Yasuo Kuniyoshi '23
Gift of Ferdinand Howald, 1931

Yasuo Kuniyoshi, 1889–1953
Cock Calling the Dawn, 1923 31.195
Oil on canvas, 30 x 25 in. (76.2 x 63.5 cm.)
Gift of Ferdinand Howald, 1931

Yasuo Kuniyoshi, 1889–1953
The Swimmer, ca. 1924 31.196
Oil on canvas, 20½ x 30½ in. (52.1 x 77.5 cm.)
Gift of Ferdinand Howald, 1931
Cat. no. 56

Lucius Brown Kutchin, 1901–1936
Portrait of Harriett Evans (nee Heller), ca. 1920 85.15.4
Oil on board, 11 x 9½ in. (27.9 x 24.1 cm.)
Gift of Browne Pavey, 1985

Lucius Brown Kutchin, 1901–1936
Untitled (Pink Surry), ca. 1928 85.15.10
Monotype with pastel, graphite, and watercolor on
 paper, 11 x 16½ in. (27.9 x 41.9 cm.)
Signed bottom right: Lucius Kutchin
Gift of Browne Pavey, 1985

Lucius Brown Kutchin, 1901–1936
Still Life, ca. 1929 85.15.3
Oil on board, 20 x 24 in. (50.8 x 61 cm.)
Signed bottom right: Lucius Kutchin
Gift of Browne Pavey, 1985

Lucius Brown Kutchin, 1901–1936
Girl in Green, ca. 1930 79.84
Oil on panel, 35⅞ x 28 in. (91.2 x 71.1 cm.)
Gift of Miss Stella Milburn, 1979

Lucius Brown Kutchin, 1901–1936
Untitled Portrait, ca. 1930 85.15.7
Monotype with graphite on paper, 14¼ x 10 in.
 (36.2 x 25.4 cm.)
Signed bottom right: Lucius Kutchin
Gift of Browne Pavey, 1985

Lucius Brown Kutchin, 1901–1936
Untitled Portrait, ca. 1930 85.15.8
Monotype with graphite on paper, 13½ x 10 in.
 (34.3 x 25.4 cm.)
Signed bottom right: Lucius Kutchin
Gift of Browne Pavey, 1985

Lucius Brown Kutchin, 1901–1936
Untitled Portrait, ca. 1930 85.15.9
Monotype with pastel on paper, 14 x 10 in.
 (35.6 x 25.4 cm.)
Signed bottom right: L Kutchin
Gift of Browne Pavey, 1985

Lucius Brown Kutchin, 1901–1936
Mother and Child, ca. 1932 55.7
Oil on masonite, 36 x 28 in. (91.4 x 71.1 cm.)
Signed lower right: Lucius Kutchin
Gift of Harriet Kirkpatrick, 1955

Lucius Brown Kutchin, 1901–1936
Girl in Cafe, ca. 1935 70.41
Oil on canvas, 32¼ x 30¼ in. (81.9 x 76.8 cm.)
Signed lower right: Lucius Kutchin
Museum Purchase: Howald Fund, 1970

Lucius Brown Kutchin, 1901–1936
Boy with Guitar—Santa Fe, 1936 37.23

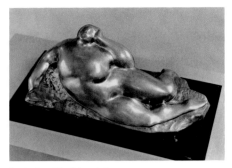

Lachaise, *The Mountain*

Lamie, *Everybody Needs Going Out*

La Verdiere, *Memorial*

Oil on composition board, 38 x 29¼ in. (96.5 x 74.3 cm.)
Signed and dated lower right: Lucius Kutchin—36
Gift of Mrs. E. Louise Kutchin, 1937

Lucius Brown Kutchin, 1901–1936
Still Life 47.82
Oil on canvas, 36⅝ x 34½ in. (93 x 87.6 cm.)
Signed lower right: Lucius Kutchin
Gift of Mrs. E. Louise Kutchin, 1947

Gaston Lachaise, 1886–1935
The Mountain, 1924 83.13
Bronze, H. 7¹⁵⁄₁₆ in. (20.8 cm.)
Inscribed on reverse: LACHAISE ESTATE 9/11
Museum Purchase: Bequest of George S. McElroy, 1983

John La Farge, 1835–1910
Girl in Grass Dress (Seated Samoan Girl), 1890 66.39
Oil on panel, 12 x 10 in. (30.5 x 25.4 cm.)
Museum Purchase: Schumacher Fund, 1966
Cat. no. 13

Mabel La Farge, 1875–1944
Water Lilies 86.16
Watercolor on paper, 9¼ x 10¼ in. (23.5 x 26 cm.)
Signed bottom right: Mabel La Farge
Gift of Coe Kerr Gallery in honor of Budd Harris Bishop, 1986

Richard Lahey, 1893–1978
A Summer in Ogunquit, 1961 63.18
Oil on masonite, 45¼ x 72 in. (114.9 x 182.9 cm.)
Signed upper right: Richard Lahey
Museum Purchase: Howald Fund, 1963

William W. Lamb, Jr., born 1934
Untitled, 1966 66.23
Steel, H. 78 in. (198.1 cm.)
Howald Memorial Purchase Award, 1966

Philip Lamie, born 1960
Everybody Needs Going Out 86.20

Wood, H. 62 in. (157.5 cm.)
Ferdinand Howald Memorial Purchase Award from the
 76th Annual Columbus Art League Exhibition, 1986

Bruno La Verdiere, born 1937
Memorial, 1972–1974 80.18.1–.7
Stoneware, largest piece H. 57½ in. (146.1 cm.)
Purchased with funds from the Alfred L. Willson
 Charitable Fund of The Columbus Foundation and the
 National Endowment for the Arts, 1980

Ernest Lawson, 1873–1939
Hills at Inwood, 1914 31.200
Oil on canvas, 36 x 50 in. (91.4 x 127 cm.)
Signed and dated lower right: E. Lawson/1914
Gift of Ferdinand Howald, 1931

Ernest Lawson, 1873–1939
Cathedral Heights, ca. 1915 31.198
Oil on canvas, 25⅜ x 30¼ in. (64.5 x 76.8 cm.)
Signed lower left: E. Lawson
Gift of Ferdinand Howald, 1931

Ernest Lawson, 1873–1939
The Hudson at Inwood 31.201
Oil on canvas, 30 x 40 in. (76.2 x 101.6 cm.)
Signed lower right: E. Lawson
Gift of Ferdinand Howald, 1931
Cat. no. 26

Rico Lebrun, 1900–1964
Centurion's Horse, 1948 53.8
Oil on canvas, 80 x 36 in. (203.2 x 91.4 cm.)
Signed and dated lower left: Lebrun 1948
Museum Purchase: Howald Fund, 1953

Rico Lebrun, 1900–1964
Crucifixion Series, 1948 81.11.2
Ink on paper, 18¼ x 24⅞ in. (46.4 x 63.2 cm.)
Signed and dated upper right: Lebrun 1948
Gift of Regina Kobacker Fadiman, 1981

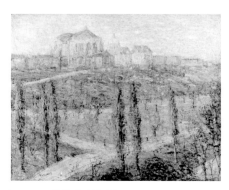

Lawson, *Cathedral Heights*

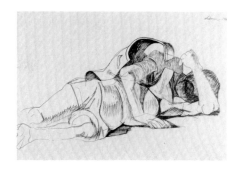

Lebrun, *Crucifixion Series*

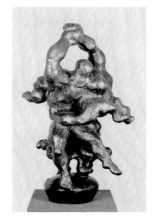

Lipchitz, *The Dance*

Doris Leeper, born 1929
Sculptural Shapes: 6, 1978 81.10.2
Oil and graphite on paper, 13 x 13 in. (33 x 33 cm.)
Signed in pencil (twice) upper left: D. Leeper
Gift of the American Academy and Institute of Arts and
 Letters, Hassam and Speicher Purchase Fund, 1981

Doris Leeper, born 1929
Sculptural Shapes: 7, 1978 81.10.1
Oil on paper, D. 15⅜ in. (39.1 cm.)
Signed in pencil along lower center edge: Leeper
Gift of the American Academy and Institute of Arts and
 Letters, Hassam and Speicher Purchase Fund, 1981

Norbert Lenz, born 1900
Untitled 85.5.1
Pencil, India ink, and colored pencil on paper,
 7¾ x 9¾ in. (19.7 x 24.7 cm.)
Signed top left: Norbert Lenz
Gift of Mr. Joseph Erdelac, 1985

David Levine, born 1926
Auguste Rodin, 1965 66.43
Ink on paper, 14 x 11 in. (35.6 x 27.9 cm.)
Signed and dated lower right: D. Levine '65
Museum Purchase: Howald Fund, 1966

David Levine, born 1926
Susan Sontag, 1966 66.44
Ink on paper, 13⅝ x 11 in. (34.6 x 27.9 cm.)
Signed and dated lower right: D. Levine '66
Museum Purchase: Howald Fund, 1966

Jack Levine, born 1915
The Trial (study), 1953–1954 54.50
Oil on canvas, 40 x 36 in. (101.6 x 91.4 cm.)
Signed lower left: J. Levine
Museum Purchase: Howald Fund, 1954

Jack Levine, born 1915
The Judgement of Paris (study), 1963 63.39

Ink on paper, 11¼ x 16¾ in. (28.6 x 42.5 cm.)
Signed lower left: J Levine
Museum Purchase: Howald Fund, 1963

Victor Liguori, born 1931
Descent, 1962 62.87
Oil on canvas, 72 x 53¾ in. (182.9 x 136.5 cm.)
Signed lower right: V. Liguori
Purchased with funds from the Alfred L. Willson
 Foundation, 1962

Jacques Lipchitz, 1891–1973
The Dance, 1936 79.76
Bronze, H. 41 in. (104.1 cm.)
Signed on base: J. Lipchitz
Given in memory of E. Paul Messham by his daughter
 Paula Messham Watkins, 1979

Dotti Lipetz, born 1922
Through the Back Door, 1956 56.32
Gouache on paper, 29 x 17¾ in. (73.7 x 45.1 cm.)
Signed and dated center left: Dotti '56
Museum Purchase: Howald Fund, 1956

Seymour Lipton, 1903–1987
Tower of Music 85.24.6
Bronze, H. 10½ in. (26.7 cm.)
Gift of the Betty Parsons Foundation, 1985

Simon Lissim, 1900–1981
The Yellow Sultan, 1939 76.12
Gouache on paper, 39⅜ x 28 in. (100 x 71.1 cm.)
Signed and dated lower right: Simon Lissim, 1939
Museum Purchase: Howald Fund, 1976

Edgar Littlefield, 1905–1970
Pisces, 1936 36.37
Stoneware, H. 10¼ in. (26 cm.)
Signed under fin: E.L.
Gift of Frederick W. Schumacher, 1936

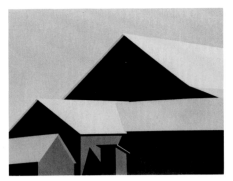

Littlehale, *Barn Roofs*

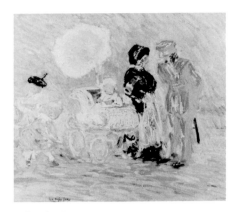

Luks, *Gossip*

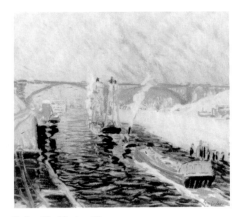

Luks, *The Harlem River*

Dorothy Moody Littlehale, 1903–1987
Barn Roofs, 1975 75.15
Oil on canvas, 48 x 60 in. (121.9 x 152.4 cm.)
Theodore R. Simson Purchase Award, 1975

George Luks, 1867–1933
Bridge over the Seine, ca. 1900 63.15
Ink on paper, 7½ x 9¾ in. (19 x 24.8 cm.)
Museum Purchase: Howald Fund, 1963

George Luks, 1867–1933
Gossip, 1915 31.204
Pastel and watercolor on board, 13⅜ x 14¾ in.
 (34 x 37.5 cm.)
Signed lower left: George Luks
Gift of Ferdinand Howald, 1931

George Luks, 1867–1933
The Harlem River, 1915 31.205
Pastel and watercolor on paper, 13¾ x 14⅞ in.
 (34.9 x 37.8 cm.)
Signed lower right: George Luks
Gift of Ferdinand Howald, 1931

George Luks, 1867–1933
Playing Soldiers, 1915 31.206
Pastel and watercolor on paper, 13½ x 14⅜ in.
 (34.3 x 36.5 cm.)
Signed lower right: George Luks
Gift of Ferdinand Howald, 1931

George Luks, 1867–1933
Eugene Higgins, ca. 1915 73.34
Oil on canvas, 30 x 25 in. (76.2 x 61 cm.)
Signed lower right: George Luks
Gift of Norman Hirschl, 1973

George Luks, 1867–1933
Heavy Load 61.32
Lithographic crayon on paper, 6⅜ x 10¼ in.
 (16.2 x 26 cm.)
Signed and inscribed lower left:
 To Mrs. Buckner/ George Luks
Museum Purchase: Howald Fund, 1961

August F. Lundberg, 1878–1928
Self-Portrait, 1917 73.15
Oil on canvas, 40 x 30 in. (101.6 x 76.2 cm.)
Signed and dated lower center: A. F. Lundberg, 1917
Museum Purchase: Howald Fund, 1973

Stanton Macdonald-Wright, 1890–1973
Still Life No. 2, 1917 31.277
Watercolor on paper, 12½ x 15⅜ in. (31.8 x 39.1 cm.)
Signed, dated, and inscribed lower right: S. Macdonald
 Wright/New York 1917
Gift of Ferdinand Howald, 1931

Stanton Macdonald-Wright, 1890–1973
California Landscape, ca. 1919 31.275
Oil on canvas, 30 x 22⅛ in. (76.2 x 56.2 cm.)
Gift of Ferdinand Howald, 1931
Cat. no. 47

Stanton Macdonald-Wright, 1890–1973
Still Life No. 1 31.276
Oil on pasteboard, 16 x 20 in. (40.6 x 50.8 cm.)
Signed upper right: S Macdonald Wright
Gift of Ferdinand Howald, 1931

Reino Mackie, born 1913
Untitled (Head) 37.149
Wood, H. 15¹⁵⁄₁₆ in. (40.5 cm.)
Source unknown

Alan Magee, born 1947
Three Envelopes, 1982 82.9
Watercolor and colored pencil on paper, 20¾ x 18⅛ in.
 (52.7 x 46 cm.)
Signed lower right: Alan Magee
Purchased with funds from the Alfred L. Willson
 Charitable Fund of The Columbus Foundation, 1982

Benjamin Lee Mahmoud, born 1935
Seated Personage, 1960 60.61
Oil on canvas, 60 x 50 in. (152.4 x 127 cm.)
Signed and dated upper left: Mahmoud 2/60. Signed and
 inscribed on reverse, upper left: 6.7–6–5/Mahmoud.
 Inscribed on reverse, upper right: Seated Personage

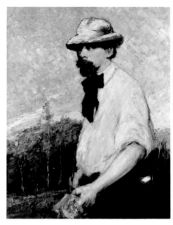

Lundberg, *Self-Portrait*

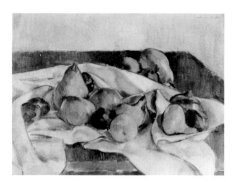

Macdonald-Wright, *Still Life No. 1*

Magee, *Three Envelopes*

Purchased with funds from the Alfred L. Willson
 Foundation, 1960

Edward Middleton Manigault, 1887–1922
The Rocket, 1909 81.9
Oil on canvas, 20 x 24 in. (50.8 x 61 cm.)
Signed and dated lower left: Manigault 09
Museum Purchase: Howald Fund II, 1981
Cat. no. 34

Edward Middleton Manigault, 1887–1922
Procession, 1911 31.208
Oil on canvas, 20 x 24 in. (50.8 x 61 cm.)
Signed and dated lower right: Manigault 1911
Gift of Ferdinand Howald, 1931
Cat. no. 35

Edward Middleton Manigault, 1887–1922
Nude, 1913 70.33
Graphite on paper, 11¼ x 8¾ in. (28.6 x 22.2 cm.)
Signed and dated lower left: Manigault/1913
Purchased with funds from the Alfred L. Willson
 Foundation, 1970

Man Ray, 1890–1976
Still Life No. 1, 1913 31.257
Oil on canvas, 18 x 24 in. (45.7 x 61 cm.)
Signed and dated lower right: Man Ray 1913
Gift of Ferdinand Howald, 1931

Man Ray, 1890–1976
Madonna, 1914 31.255
Oil on canvas, 20⅛ x 16⅛ in. (51.1 x 41 cm.)
Signed lower left: Man Ray. Inscribed upper left to right:
 IN/ANNO D MCMXIV
Gift of Ferdinand Howald, 1931

Man Ray, 1890–1976
Still Life No. 3, 1914 31.259
Oil on canvas, 10⅛ x 8⅛ in. (25.7 x 20.6 cm.)
Signed and dated lower left: Man Ray/1914
Gift of Ferdinand Howald, 1931

Man Ray, 1890–1976
Jazz, 1919 31.253
Tempera and ink (aerograph) on paper, 28 x 22 in.
 (71.1 x 55.9 cm.)
Gift of Ferdinand Howald, 1931
Cat. no. 43

Man Ray, 1890–1976
Regatta, 1924 31.256
Oil on canvas, 20 x 24¼ in. (50.8 x 62.2 cm.)
Signed and dated lower right: Man Ray 1924
Gift of Ferdinand Howald, 1931
Cat. no. 44

Man Ray, 1890–1976
Le Grand Palais, ca. 1924 31.254
Oil on canvas, 19⅝ x 24 in. (49.8 x 61 cm.)
Gift of Ferdinand Howald, 1931

Man Ray, 1890–1976
Still Life No. 2 31.258
Oil on canvas, 13½ x 9½ in. (34.3 x 24.1 cm.)
Signed upper right: Man Ray
Gift of Ferdinand Howald, 1931

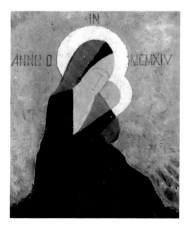

Man Ray, *Madonna*

Paul Manship, 1885–1966
Diana, 1921 80.24
Bronze (cast 7), H. 37½ in. (95.3 cm.)
Inscribed and dated on underside of leaves: Paul
 Manship 1921 ©/No. 7. Foundry stamp on base:
 Roman Bronze Works N.Y.
Museum Purchase: Howald Fund II, 1980
Cat. no. 57

John Marin, 1870–1953
Tyrolean Mountains, 1910 31.234
Watercolor on paper, 14½ x 17¾ in. (36.8 x 45 cm.)
Signed and dated lower left: Marin 10
Gift of Ferdinand Howald, 1931

John Marin, 1870–1953
Summer Foliage, 1913 31.232
Watercolor on paper, 15½ x 18½ in. (39.4 x 47 cm.)
Signed and dated lower right: Marin 13
Gift of Ferdinand Howald, 1931

John Marin, 1870–1953
Landscape, 1914 31.219
Watercolor on paper, 18½ x 16 in. (47 x 40.6 cm.)
Signed and dated lower left: Marin/14
Gift of Ferdinand Howald, 1931

John Marin, 1870–1953
Seaside, An Interpretation, 1914 31.227
Watercolor and graphite on paper, 15½ x 18½ in.
 (39.4 x 47.3 cm.)
Signed and dated lower left: Marin 14
Gift of Ferdinand Howald, 1931

John Marin, 1870–1953
The Violet Lake, 1915 31.235
Watercolor on paper, 15½ x 18⅝ in. (39.4 x 47.3 cm.)
Signed and dated lower left: Marin 15
Gift of Ferdinand Howald, 1931

John Marin, 1870–1953
Breakers, Maine Coast, 1917 31.211
Watercolor on paper, 15⅞ x 18⅝ in. (40.3 x 47.3 cm.)
Signed and dated lower right: Marin/17
Gift of Ferdinand Howald, 1931

John Marin, 1870–1953
Study of the Sea, 1917 31.231
Watercolor and charcoal on paper, 16 x 19 in.
 (40.6 x 48.3 cm.)
Signed and dated lower right: Marin/17
Gift of Ferdinand Howald, 1931

John Marin, 1870–1953
Autumn, 1919 31.209
Watercolor on paper, 18¾ x 16 in. (47.6 x 40.6 cm.)
Signed and dated lower left: Marin 19
Gift of Ferdinand Howald, 1931

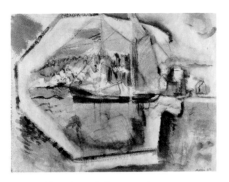

Marin, *Ship, Sea and Sky Forms (An Impression)*

John Marin, 1870–1953
From the Ocean, 1919 31.215
Watercolor and charcoal on paper, 15⅞ x 19 in.
 (40.3 x 48.2 cm.)
Signed and dated lower left: Marin 19
Gift of Ferdinand Howald, 1931

John Marin, 1870–1953
Red Sun, 1919 31.223
Watercolor and charcoal on paper, 16 x 19 in.
 (40.6 x 48.3 cm.)
Signed and dated lower left: Marin 19
Gift of Ferdinand Howald, 1931

John Marin, 1870–1953
Sunset, Maine Coast, ca. 1919 31.233
Watercolor on paper, 15½ x 18½ in. (39.4 x 47 cm.)
Gift of Ferdinand Howald, 1931
Cat. no. 42

John Marin, 1870–1953
Sailboat in Harbor, ca. 1920 31.224
Watercolor on paper, 19 x 16 in. (48.3 x 40.6 cm.)
Gift of Ferdinand Howald, 1931

John Marin, 1870–1953
Off Stonington, 1921 31.228
Watercolor and charcoal on paper, 16 x 19 in.
 (40.6 x 48.3 cm.)
Signed and dated lower right: Marin/21
Gift of Ferdinand Howald, 1931

John Marin, 1870–1953
A Piece of Stonington, 1922 31.222
Watercolor, graphite, and charcoal on paper, 14⅝ x
 17⅜ in. (36.9 x 44.1 cm.)
Signed and dated lower right: Marin 22
Gift of Ferdinand Howald, 1931

John Marin, 1870–1953
A Study on Sand Island, 1922 31.230
Watercolor and charcoal on paper, 14⅛ x 17 in.
 (36 x 43.2 cm.)

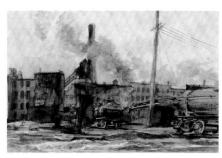

Marsh, *Untitled* (Buildings)

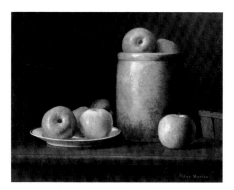

Martin, *Still Life with Apples*

McClelland, *Lancaster, Main Street*

Signed and dated lower right: Marin 22
Gift of Ferdinand Howald, 1931

John Marin, 1870–1953
Ship, Sea and Sky Forms (An Impression), 1923 31.218
Watercolor on paper, 13½ x 17 in. (34.3 x 43.2 cm.)
Signed and dated lower right: Marin 23
Gift of Ferdinand Howald, 1931

Reginald Marsh, 1898–1954
Untitled (Factories), 1931 79.34.4
Watercolor on paper, 14 x 20 in. (35.5 x 50.8 cm.)
Signed and dated lower right: Reginald Marsh '31
Bequest of Felicia Meyer Marsh, 1979

Reginald Marsh, 1898–1954
Untitled (Buildings), ca. 1931 79.34.3
Watercolor on paper, 14 x 20 in. (35.5 x 50.8 cm.)
Bequest of Felicia Meyer Marsh, 1979

Reginald Marsh, 1898–1954
Hudson Bay Fur Company, 1932 56.1
Egg tempera on muslin mounted to particle board,
 30 x 40 in. (76.2 x 101.6 cm.)
Signed and dated lower right: Reginald Marsh 1932
Museum Purchase: Howald Fund, 1956
Cat. no. 62

Reginald Marsh, 1898–1954
Untitled (Girl Walking Down Street), ca. 1948 (recto)
 79.34.1.1
Untitled (Cigarette Girl), ca. 1948 (verso) 79.34.1.2
Egg tempera on paper, 31½ x 23 in. (80 x 58.5 cm.)
Bequest of Felicia Meyer Marsh, 1979

Reginald Marsh, 1898–1954
Untitled (Beach Scene) (recto) 79.34.2.1
Untitled (Beach, People in Surf) (verso) 79.34.2.2
Ink wash on paper, 21⅞ x 29⅞ in. (55.6 x 76 cm.)
Bequest of Felicia Meyer Marsh, 1979

Silas Martin, 1841–1906
The Lesson 19.76

Oil on canvas, 20 x 15⅛ in. (50.8 x 38.4 cm.)
Signed lower left: Silas Martin
Bequest of Francis C. Sessions, 1919

Silas Martin, 1841–1906
Still Life with Apples 40.53
Oil on canvas, 18 x 22 in. (45.7 x 55.9 cm.)
Signed lower right: Silas Martin
Gift of Orlando A. Miller, 1940

Bill Mauldin, born 1921
Heat Rash 72.39
Graphite and ink on paper, 8 x 10 in. (20.3 x 25.4 cm.)
Signed and inscribed lower left: Bill Mauldin/Heat Rash
Museum Purchase: Howald Fund, 1972

Alfred Maurer, 1868–1932
Still-Life with Red Cheese, ca. 1928–1930 83.30
Oil on board, 18 x 21¾ in. (45.7 x 55.2 cm.)
Signed lower right: A. H. Maurer
Acquired through exchange: Gift of Ione and Hudson D.
 Walker and the Howald Fund, 1983
Cat. no. 64

Leland S. McClelland, born 1914
Lancaster, Main Street, 1965 66.22
Watercolor on paper, 19 x 24 in. (48.3 x 61 cm.)
Signed and dated lower right: Leland S./McClelland/'65
Purchased with funds from the Alfred L. Willson
 Foundation, 1966

Leland S. McClelland, born 1914
North Broadway United Methodist Church, 1982 87.2
Watercolor on paper, 23 x 16½ in. (sight)
 (58.4 x 41.9 cm.)
Gift of Dr. and Mrs. William E. Smith, 1987

Helen McCombs, active twentieth century
Owl 61.47
Watercolor on paper, 17½ x 13¾ in. (44.5 x 34.9 cm.)
Signed lower right: Helen McCombs, 1961
Purchased with funds from the Alfred L. Willson
 Foundation, 1961

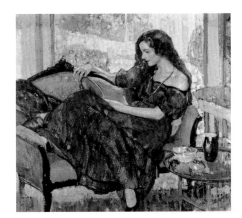

Morris, *"Still Point, Holding Place, Bedrock"*
Series 72

McFee, *Still Life*

Miller, *Miss V. in Green*

Henry Lee McFee, 1886–1952
Still Life, 1916 31.207
Oil on canvas, 20 x 16 in. (50.8 x 40.6 cm.)
Signed and dated lower left: McFee/1916
Gift of Ferdinand Howald, 1931

Clement Meadmore, born 1929
Out of There, 1974 79.15
Painted aluminum (edition of 2), L. 201 in., H. 78 in.
 (L. 510.5 cm., H. 198.12 cm.)
Gift of Ashland Oil, Inc., 1979
Cat. no. 79

Clement Meadmore, born 1929
All of Me, 1977 80.39
Bronze, H. 10⅜ in. (26.3 cm.)
Signed and dated near bottom: Meadmore '77 9/10
Acquired through exchange, 1980

John Liggett Meigs, born 1916
Valley, Autumn, 1966 67.5
Watercolor on paper, 21 x 28 in. (53.3 x 71.1 cm.)
Signed and dated lower right: John Meigs/66
Museum Purchase: Howald Fund, 1967

Waldo Midgley, 1888–?
Winter Street 69.6
Watercolor on paper, 14 x 19¹⁵⁄₁₆ in. (35.6 x 50.6 cm.)
Signed lower right: Waldo Midgley. Signed and inscribed
 on reverse, lower right: Winter Street by Waldo
 Midgley
Museum Purchase: Howald Fund, 1969

Kenneth Hayes Miller, 1876–1952
Recumbent Figure, ca. 1910–1911 31.237
Oil on paper, 12½ x 16⅝ in. (31.8 x 42.2 cm.)
Signed lower left: Hayes Miller
Gift of Ferdinand Howald, 1931

Richard Miller, 1875–1943
Miss V. in Green 45.8
Oil on canvas, 33¾ x 35½ in. (85.7 x 90.2 cm.)

Signed lower left: Miller
Bequest of Edward D. and Anna White Jones, 1945

Fred Mitchell, born 1923
Figure in Autumn Landscape, 1957 62.44
Oil on canvas, 40 x 40 in. (101.6 x 101.6 cm.)
Signed and dated lower right: Fred Mitchell 57
Museum Purchase: Howald Fund, 1962

Georgette Monroe, active twentieth century
El Atoron 48.31
Watercolor and ink on paper, 13⅜ x 18½ in. (34 x 47 cm.)
Signed lower right: G. Monroe
Purchased with funds from the Alfred L. Willson
 Foundation, 1948

Edward Moran, 1829–1901
The Bell-Buoy 19.56
Oil on canvas, 26¼ x 36¼ in. (66.7 x 92 cm.)
Signed lower left: Edward Moran
Bequest of Francis C. Sessions, 1919

Peter Moran, 1842–1914
The Orchard 19.31
Oil on canvas, 12 x 16 in. (30.5 x 40.6 cm.)
Signed lower right: P. Moran
Bequest of Francis C. Sessions, 1919

Carl A. Morris, born 1911
"Still Point, Holding Place, Bedrock" Series 72, 1972 73.7
Oil on canvas, 63 x 76¼ in. (160 x 193.9 cm.)
Signed and dated lower right: Carl Morris 72
Museum Purchase: Howald Fund, 1973

George L. K. Morris, 1905–1975
Crossed Triangles, 1953 79.14
Oil on canvas, 29 x 23½ in. (73.6 x 59.7 cm.)
Signed lower right: Morris
Museum Purchase: Howald Fund, 1979

Philip Morsberger, born 1933
The Children's Hour 68.23

Morris, *Crossed Triangles*

Myers, *An Interlude*

Naylor, *Streams*

Acrylic, oil, and collage on canvas, 42½ x 72 in.
 (107.3 x 182.9 cm.)
Howald Memorial Purchase Award, 1968

Philip Mullen, born 1942
Feininger II, 1982 85.17
Acrylic on canvas, 72 x 52 in. (182.8 x 132 cm.)
Gift of the artist, 1985

John Francis Murphy, 1853–1921
Sunset, 1889 45.24
Oil on canvas, 14 x 19 in. (35.6 x 48.3 cm.)
Signed and dated lower left: J. Francis Murphy 89
Bequest of John R. and Louise Lersch Gobey, 1945

John Francis Murphy, 1853–1921
The Mill Race, Arkville, 1897 72.38
Oil on canvas, 11¼ x 15¾ in. (28.6 x 40 cm.)
Signed and dated lower left: J. Francis Murphy 97. Dated
 and inscribed on reverse, upper left: The Mill Race/
 1897 Arkville
Museum Purchase: Howald Fund, 1972

John Francis Murphy, 1853–1921
The Little Bridge (or *Autumn Woods*), 1898 75.49
Oil on canvas, 11¹⁄₁₆ x 16 in. (28.1 x 40.6 cm.)
Signed and dated lower left: J. Francis Murphy/98
Museum Purchase: Howald Fund, 1975

Jerome Myers, 1867–1940
An Interlude, 1916 31.238
Oil on canvas, 18 x 24 in. (45.7 x 61 cm.)
Signed, dated, and inscribed lower right: Jerome Myers,
 1916/N.Y.
Gift of Ferdinand Howald, 1931

Jerome Myers, 1867–1940
Blind Man's Bluff 60.29
Conté crayon on paper, 8½ x 11 in. (21.6 x 27.9 cm.)
Signed lower right: Jerome Myers
Purchased with funds from the Alfred L. Willson
 Foundation, 1960

Jerome Myers, 1867–1940
Horses 60.30
Graphite and watercolor on paper, 8½ x 11¼ in.
 (21.6 x 28.6 cm.)
Signed lower left: Jerome Myers/Em
Purchased with funds from the Alfred L. Willson
 Foundation, 1960

Jerome Myers, 1867–1940
The Tenor 70.32
Charcoal and ink on paper, 7½ x 9¾ in. (19 x 24.8 cm.)
Signed and inscribed lower left to right: 380 Jerome
 Myers/The Tenor
Purchased with funds from the Alfred L. Willson
 Foundation, 1970

Elie Nadelman, 1882–1946
Figurine, ca. 1940–1945 76.8
Plaster, H. 7 in. (17.8 cm.)
Museum Purchase: Howald Fund, 1976

Robert Natkin, born 1930
Apollo Series, 1978 82.1
Acrylic on paper, 35 x 45½ in. (88.8 x 115.5 cm.)
Signed lower center: Natkin
Gift of Max Weitzenhoffer, 1982

Robert Natkin, born 1930
Hitchcock Series: Anticipation of the Night, 1984 85.11
Acrylic on canvas, 84 x 94 in. (213.2 x 238.6 cm.)
Signed lower left: Natkin
Museum Purchase: Howald Fund, 1985
Cat. no. 85

John Geoffrey Naylor, born 1928
Streams, 1982 82.6
Stainless steel, H. 384 in. (975.4 cm.)
Given by The Wasserstrom Foundation and the
 Wasserstrom Companies on behalf of their Associates;
 Design partially funded by the National Endowment
 for the Arts, 1982

Niehaus, *Abraham Lincoln*

Novros, *Untitled (No. 2)*

O'Keeffe, *Canna Lily*

Louise Nevelson, 1899–1988
Landscape in the Sky, 1956 71.7
Graphite on paper, 20 x 26 in. (50.8 x 66 cm.)
Signed, dated, and inscribed lower left to right:
 Landscape in the Sky Louise Nevelson 56
Museum Purchase: Howald Fund, 1971

Louise Nevelson, 1899–1988
Sky Cathedral: Night Wall, 1963–1976 77.20
Painted wood, 114 x 171 in. (289.6 x 434.3 cm.)
Gift of Eva Glimcher and Derby Fund Purchase, 1977
Cat. no. 77

Louise Nevelson, 1899–1988
Collage, 1974 78.7
Cardboard and black painted wood, H. 60½ in.
 (153.5 cm.)
Signed and dated lower right: Louise Nevelson—74
Gift of Mr. Arnold Glimcher in honor of his mother,
 Mrs. Eva Glimcher, 1978

Charles Henry Niehaus, 1855–1935
Abraham Lincoln, 1890 43.1
Marble, H. 29 in. (73.7 cm.)
Museum Purchase: Howald Fund, 1943

Alice E. Nissen, active twentieth century
Queen Anne's Lace, 1943 59.28
Tempera on paper, 19⅜ x 12¹⁄₁₆ in. (49.2 x 30.6 cm.)
Signed and dated lower right: Alice E. Nissen/1943
Gift of F. Stanley Crooks, 1959

John Noble, 1874–1934
The Path of the Moon, 1927 69.9
Oil on canvas, 8¼ x 11 in. (21 x 27.9 cm.)
Signed lower left: J. Noble
Museum Purchase: Howald Fund, 1969

Kenneth Noland, born 1924
Shadow on the Earth, 1971 72.28
Acrylic on canvas, 93 x 64¼ in. (236.2 x 163.2 cm.)

Purchased with the aid of funds from the National
 Endowment for the Arts and two anonymous
 donors, 1972
Cat. no. 76

David Novros, born 1941
Untitled (No. 2), 1971 80.1
Oil on canvas, 84 x 108 in. (213.4 x 274.3 cm.)
Gift of Samuel P. Reed, 1980

Ervin S. Nussbaum, born 1914
The Synagogue, ca. 1939 39.9
Oil on canvas, 22¼ x 26 in. (56.5 x 66 cm.)
Signed lower right: Nussbaum
Gift of the Patrons of the Columbus Art League, 1939

Georgia O'Keeffe, 1887–1986
Canna Lily, 1919 77.23
Watercolor on paper, 23 x 12⅞ in. (58.4 x 32.7 cm.)
Museum Purchase: Derby Fund, 1977

Georgia O'Keeffe, 1887–1986
Autumn Leaves—Lake George, N.Y., 1924 81.6
Oil on canvas, 20¼ x 16¼ in. (51.4 x 41.3 cm.)
Museum Purchase: Howald Fund II, 1981
Cat. no. 38

Charles I. Okerbloom, Jr., born 1908
View of Garapan from Japanese Bank Building, 1944 46.57
Watercolor on paper, 14 x 20¼ in. (35.6 x 51.4 cm.)
Signed and dated lower left: Charles Okerbloom Jr./Nov.
 1944
Museum Purchase: Howald Fund, 1946

Richard F. Outcault, 1863–1928
Buster Brown 72.41
Ink and watercolor on paper, 23⁷⁄₁₆ x 19¾ in.
 (59.5 x 50.2 cm.)
Signed lower right: R. F. Outcault/Jan. 16
Museum Purchase: Howald Fund, 1972

Walter Pach, 1883–1958
Old Sod, 1905 56.45
Oil on canvas, 19 x 14 in. (48.3 x 35.6 cm.)

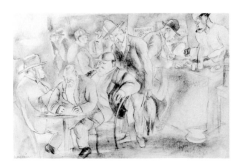

Pascin, *Oyster Bar*

Pène du Bois, *Table Top and Chair*

Signed, dated, and inscribed lower right: Walter Pach/
 1905/d'apres/W. Magrath
Gift of Marion Swickard, 1956

Albert Paley, born 1944
Plant Stand, 1984 86.4
Mild steel, slate top, H. 49½ in. (125.7 cm.)
Stamped on bottom: PALEY
A Gift from Beaux Arts, family, and friends in memory
 of Mary Lou Chess and Donna Gifford Walker, 1986

Fred Pallini, born 1942
Construction #1, 1963 63.40
Steel, H. 66 in. (167.6 cm.)
Museum Purchase: Howald Fund, 1963

William C. Palmer, born 1906
February Fields, 1958 59.17
Oil on canvas, 20 x 24 in. (50.8 x 61 cm.)
Signed and dated lower center: William C. Palmer 58
Museum Purchase: Howald Fund, 1959

Jules Pascin, 1885–1930
Lunch Room, ca. 1917 31.73
Charcoal, ink, and watercolor on paper, 9⅝ x 12⅝ in.
 (24.5 x 32.2 cm.)
Signed lower right: pascin
Gift of Ferdinand Howald, 1931

Jules Pascin, 1885–1930
Oyster Bar, ca. 1917 31.76
Ink, graphite, and watercolor on paper, 8 x 11¾ in.
 (20.3 x 29.8 cm.)
Signed lower left: pascin
Gift of Ferdinand Howald, 1931

Jules Pascin, 1885–1930
Street in Havana, ca. 1917 31.81
Graphite, watercolor, and pastel on paper, 9¾ x 8¼ in.
 (24.8 x 21 cm.)
Signed and inscribed lower left to center: pascin Saurnon
 c-ihon
Gift of Ferdinand Howald, 1931

Jules Pascin, 1885–1930
*The Lord God Appears to Brigham Young Commanding Him
 to Increase and Multiply*, ca. 1927–1928 78.4

Carbon transfer on paper, 14¾ x 19¾ in. (37.5 x 50.2 cm.)
Gift of David L. Hite, 1978

Jules Pascin, 1885–1930
Nude 31.74
Ink and watercolor on paper, 9¾ x 14¾ in. (25 x 37.5 cm.)
Signed lower right: pascin
Gift of Ferdinand Howald, 1931

Donald Peake, born 1932
The Eve Before Eden, 1972 72.18
Mixed media on canvas, 45⅞ x 50 in. (116.5 x 127 cm.)
Signed and dated on reverse: Peake 72
Theodore R. Simson Purchase Award, 1972

Mel Pekarsky, born 1934
Horizons, 1973 73.16
Oil and graphite on paper, 15 x 15 in. (38.1 x 38.1 cm.)
Signed and dated lower right: MP 73
Purchased with funds from the Alfred L. Willson
 Charitable Foundation of The Columbus Foundation,
 1973

Guy Pène du Bois, 1884–1958
Table Top and Chair, 1905 61.23
Graphite on paper, 8⅛ x 9½ in. (20.6 x 24.1 cm.)
Museum Purchase: Howald Fund, 1961

Guy Pène du Bois, 1884–1958
Seated Figures on Deck of Shop, ca. 1905 61.22
Graphite on paper, 7¾ x 5 in. (19.7 x 12.7 cm.)
Signed lower right center: G. Pène du Bois
Museum Purchase: Howald Fund, 1961

Guy Pène du Bois, 1884–1958
Woman Playing Accordion, 1924 80.3
Oil on canvas, 48 x 38⅛ in. (122 x 96.8 cm.)
Signed and dated lower right: Guy Pène du Bois '24
Acquired through exchange: Bequest of J. Willard Loos,
 1980
Cat. no. 59

Joseph Pennell, 1857–1926
Washington Square, New York, 1908 66.42

Prendergast, *St. Malo No. 1*

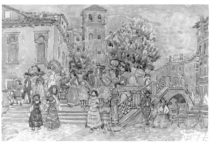

Prendergast, *Venice*

Poor, *Still Life—Pears*

Pastel on paper, 11 x 8⅜ in. (27.9 x 21.3 cm.)
Purchased with funds from the Alfred L. Willson
 Foundation, 1966

James Penney, born 1910
Green Stockings, 1961 61.24
Oil on canvas, 29¾ x 48 in. (75.6 x 121.9 cm.)
Signed lower right: Penney
Museum Purchase: Howald Fund, 1961

James Penney, born 1910
Freighter 56.46
Watercolor on paper, 27 x 19½ in. (68.6 x 49.5 cm.)
Signed lower right: James Penney
Museum Purchase: Howald Fund, 1956

Stephen Pentak, born 1951
Pool, 1984.8, 1984 84.19
Oil on paper, 30 x 22 in. (76.2 x 55.9 cm.)
Bevlyn and Theodore Simson Purchase Award from the
 74th Annual Columbus Art League Exhibition, 1984

Herbert Perr, born 1941
Actin, 1970 71.13
Acrylic on canvas, 96 x 72 in. (243.8 x 182.9 cm.)
Museum Purchase: Howald Fund, 1971

Gabor Peterdi, born 1915
Flowers, 1981 85.27.1
Ink on paper, 11 x 13 in. (27.9 x 33 cm.)
Signed and dated lower right: Peterdi 81
Gift of Dr. and Mrs. Arthur E. Kahn, 1985

Richard J. Phipps, born 1928
Kitty Hawk, 1971 71.10
Watercolor on paper, 17⅝ x 23½ in. (44.8 x 59.7 cm.)
Signed lower right: R. Phipps
Museum Purchase: Howald Fund, 1971

Jack Piper, born 1927
Persephone, 1963 63.32
Oil on canvas, 20 x 16 in. (50.8 x 40.6 cm.)
Museum Purchase: Howald Fund, 1963

Robert Pitton, born 1921
Floor Piece No. 1, 1976 76.15

Acrylic, H. 50¾ in. (128.9 cm.)
Theodore R. Simson Purchase Award, 1976

Ogden M. Pleissner, born 1905
Roof Tops, Carcassonne, 1969 70.2
Watercolor on paper, 6¾ x 9¹¹⁄₁₆ in. (17.1 x 24.6 cm.)
Signed lower left: Pleissner
Museum Purchase: Howald Fund, 1970

Henry Varnum Poor, 1888–1970
Still Life—Pears 34.1
Oil on panel, 9⅞ x 11⅞ in. (25.1 x 30.2 cm.)
Signed lower left: H V Poor
Purchased by popular subscription, 1934

Maurice Prendergast, 1858–1924
St. Malo No. 1, ca. 1907–1910 31.246
Watercolor and graphite on paper, 13½ x 19¼ in.
 (34.3 x 48.9 cm.)
Signed lower left: Prendergast
Gift of Ferdinand Howald, 1931

Maurice Prendergast, 1858–1924
St. Malo No. 2, ca. 1907–1910 31.247
Watercolor and graphite on paper, 12¾ x 19¼ in.
 (32.4 x 48.9 cm.)
Signed lower left center: Prendergast
Gift of Ferdinand Howald, 1931
Cat. no. 27

Maurice Prendergast, 1858–1924
Venice, ca. 1911–1912 31.251
Watercolor and graphite on paper, 14⅝ x 21¼ in.
 (37.2 x 54 cm.)
Signed lower right center: Prendergast
Gift of Ferdinand Howald, 1931

Maurice Prendergast, 1858–1924
Seashore, ca. 1912–1913 86.19
Oil on canvas, 19¾ x 28 in. (50.2 x 71.1 cm.)
Gift of Mr. and Mrs. Frederick Jones, 1986

Maurice Prendergast, 1858–1924
The Promenade, ca. 1912–1913 31.244
Oil on canvas, 28 x 40¼ in. (71.1 x 102.2 cm.)
Signed lower left: Prendergast
Gift of Ferdinand Howald, 1931
Cat. no. 28

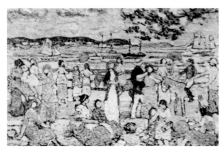

Prendergast, *Along the Shore*

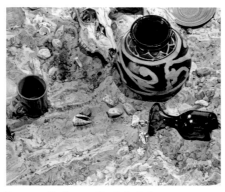

Ransom, *Earthscape: Dry Lake Bed*

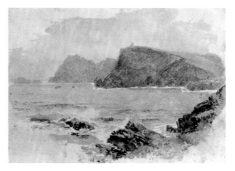

Richards, *Glen Head, County Donegal, Ireland*

Maurice Prendergast, 1858–1924
Playtime, ca. 1913–1915 31.243
Watercolor and pastel on paper, 14¾ x 22 in.
 (37.5 x 55.9 cm.)
Gift of Ferdinand Howald, 1931

Maurice Prendergast, 1858–1924
Outskirts of the Village, 1916–1918 31.242
Watercolor and pastel on paper, 13¹¹⁄₁₆ x 19¹¹⁄₁₆ in.
 (34.8 x 50 cm.)
Signed lower center: Prendergast
Gift of Ferdinand Howald, 1931

Maurice Prendergast, 1858–1924
Along the Shore, ca. 1921 31.252
Oil on canvas, 23¼ x 34 in. (59.1 x 86.4 cm.)
Signed lower left center: Prendergast
Gift of Ferdinand Howald, 1931

Damian Priour, born 1949
Stonelith #105, 1986 87.1
Limestone and glass, H. 71⅛ in. (180.64 cm.)
Gift of Burgess and Niple, Limited, 1987

Milne Ramsay, 1847–1915
End of Day, ca. 1895 86.17
Oil on panel, 6⅝ x 11½ in. (16.8 x 29.2 cm.)
Signed lower right: Milne Ramsay
Gift of Warren Adelson in honor of Budd Harris Bishop,
 1986

Kay Randolph, born 1916
Still Life, 1964 65.4
Oil on canvas, 23½ x 17½ in. (59.7 x 44.5 cm.)
Museum Purchase: Howald Fund, 1965

Henry Ransom, born 1942
Earthscape: Dry Lake Bed, 1978 79.6
Oil on canvas, 38 x 44 in. (96.5 x 111.8 cm.)
Museum Purchase: Trustees Fund, 1979

Flora MacLean Reeder, 1887–1965
Lilacs and Tulips 66.45

Oil on canvas, 38 x 30⅛ in. (96.5 x 76.5 cm.)
Signed lower right: Flora MacLean Reeder
Gift of William T. Emmet, Jr. and Thomas A. Emmet,
 1966

Sophy Pollak Regensburg, 1885–1974
Lowesdorf Mug with Flowers 87.3
Casein on canvas, 14 x 11¾ in. (35.6 x 29.8 cm.)
Gift of Mr. and Mrs. Leonard Feist, 1987

Harry A. Rich, active twentieth century
Requiem, 1955 58.19
Oil on composition board, 27½ x 48 in. (69.9 x 121.9 cm.)
Signed and dated lower left: H. Rich '55
Frederick W. Schumacher Purchase Award, 1958

William Trost Richards, 1833–1905
Glen Head, County Donegal, Ireland, ca. 1890 53.74
Watercolor on paper, 5⅜ x 7⅜ in. (13.7 x 18.9 cm.)
Gift of the National Academy of Design: Mrs. William T.
 Brewster Bequest, 1953

William Trost Richards, 1833–1905
The Wave, 1900 19.100
Oil on canvas, 30 x 52 in. (76.2 x 132.1 cm.)
Signed and dated lower left: Wm. T. Richards, 1900
Source unknown, 1919

Constance Richardson, born 1905
Duluth, Minnesota, 1954 66.40
Oil on masonite, 20 x 31½ in. (50.8 x 79 cm.)
Museum Purchase: Howald Fund, 1966

George Rickey, born 1907
Two Lines Up Excentric Variation VI, 1977 78.31
Stainless steel (1 of 3), H. 264 in. (670.6 cm.)
Signed, dated, and inscribed on base: 1/3 Rickey 1977
Given by the family of the late Albert Fullerton Miller in
 his honor and memory, 1978
Cat. no. 81

Christopher Ries, born 1952
Wave in Space, 1978 80.6

Rinehart, *Mrs. Ezra Bliss*

Robus, *Cellist*

Rockwell, *Soda Jerk* (cover, *Saturday Evening Post*, August 22, 1953)

Lead crystal, H. 15½ in. (39.4 cm.)
Inscribed bottom right: Christopher Ries 1978
A Gift from Beaux Arts and friends in memory of Nancy
 Howe Michael and Marcia Walker Diwik, 1980

William Henry Rinehart, 1825–1874
Mrs. Ezra Bliss, 1869 47.104
Marble, H. 27 in. (68.6 cm.)
Signed, dated, and inscribed on reverse: WM. H.
 RINEHART/SCULPT ROMA. 1869
Gift of Dr. Ezra Bliss, 1947

Donald Roberts, born 1923
Tall Pines, 1955 56.33
Watercolor and ink on paper, 30⅛ x 21⅛ in.
 (76.5 x 53.7 cm.)
Signed and dated lower left: Donald Roberts—55
Museum Purchase: Howald Fund, 1956

Boardman Robinson, 1876–1952
On the Rialto 68.37
Ink and graphite on paper, 9¾ x 5 in. (25 x 12.7 cm.)
Signed and inscribed lower left to center: Boardman
 Robinson "On the Rialto"/Boardman Robinson
Museum Purchase: Howald Fund, 1968

Theodore Robinson, 1852–1896
Fifth Avenue at Madison Square, 1894–1895 31.260
Oil on canvas, 24⅛ x 19¼ in. (61.3 x 48.9 cm.)
Signed lower left: Th. Robinson
Gift of Ferdinand Howald, 1931
Cat. no. 19

Hugo Robus, 1885–1964
Cellist, 1950 53.12
Plaster, H. 17½ in. (44.4 cm.)
Signed on back: Hugo/Robus
Purchased with funds from the Alfred L. Willson
 Foundation, 1953

Hugo Robus, 1885–1964
Figure in Grief, original plaster 1952, cast ca. 1963 68.6
Bronze (from edition of 6), H. 12 in. (30.5 cm.)
Signed on back of figure: Hugo Robus. Foundry mark:
 Fonderia Battaglia & C. Milano
Gift of Hugo Robus, Jr. in memory of his father, 1968
Cat. no. 69

Norman Rockwell, 1894–1978
Soda Jerk (cover, *Saturday Evening Post*, August 22, 1953),
 ca. 1953 74.38.4
Oil on canvas, 36 x 34 in. (91.4 x 86.4 cm.)
Signed lower right: Norman/Rockwell
Bequest of J. Willard Loos, 1974

Norman Rockwell, 1894–1978
Morning After the Wedding (or *The Chambermaids*) (cover
 Saturday Evening Post, June 29, 1957), ca. 1957
 74.38.16
Oil on canvas, 33 x 31 in. (83.8 x 78.7 cm.)
Signed upper left: Norman/Rockwell
Bequest of J. Willard Loos, 1974

Kurt Ferdinand Roesch, 1905–1984
Girl with Moths, 1948 53.10
Watercolor and charcoal on paper, 18⅜ x 14 in.
 (46.7 x 35.6 cm.)
Signed, dated, and inscribed lower left: To Rose Fried,
 Dec. 1948, Roesch
Gift of Rose Fried, 1953

Kurt Ferdinand Roesch, 1905–1984
Juggling, 1969 70.3
Oil on canvas, 50 x 42⅛ in. (127 x 107 cm.)
Signed lower left: Roesch
Gift of the artist, 1970

Severin Roesen, 1815 or 1816–after 1872
Still Life 80.32

Rockwell, *Morning After the Wedding* (or *The Chambermaids*) (cover, *Saturday Evening Post*, June 29, 1957)

Rosen, *Broad Street Bridge*

Rosenthal, *Rosenthal Suite #21*

Oil on canvas, 21¾ x 26¾ in. (55.3 x 67.9 cm.)
Signed lower right: S Roesen
Acquired through exchange: Bequest of J. Willard Loos, 1980
Cat. no. 7

Robert H. Rohm, born 1934
Well Fleet, 1956 57.33
Charcoal on paper, 28 x 22 in. (71.1 x 55.9 cm.)
Signed and dated lower center: Rohm 56
Museum Purchase: Howald Fund, 1957

Charles Rosen, 1878–1950
Broad Street Bridge, ca. 1924 38.4
Oil on canvas, 24 x 32 in. (61 x 81.3 cm.)
Signed lower right: Charles Rosen
Gift of Mrs. Edward W. Campion in memory of John L. V. Bonney, 1938

Bernard Rosenthal, born 1914
Rosenthal Suite #21 80.28.1–.5
Painted steel, largest piece H. 30⅛ in. (76.5 cm.)
Gift of Barbara and Larry J. B. Robinson, 1980

Doris Rosenthal, ca. 1900–1971
En La Tarde 76.37.2
Charcoal and pastel on paper, 24 x 18¾ in. (60.9 x 47.6 cm.)
Signed and inscribed lower center: Doris Rosenthal/ Ocotlan/Oaxaca. Inscribed lower left: En la Tarde
Bequest of Doris Rosenthal, 1976

Doris Rosenthal, ca. 1900–1971
Girl with Banana Leaf Stalk 76.37.1
Charcoal on paper, 23⅞ x 18¾ in. (60.6 x 47.6 cm.)
Signed left center: Doris Rosenthal
Bequest of Doris Rosenthal, 1976

Doris Rosenthal, ca. 1900–1971
Hillside Huchnetanango 76.37.3

Charcoal and pastel on paper, 18¾ x 23¾ in. (47.6 x 60.3 cm.)
Signed and inscribed lower left: Hillside Huchnetanango, Doris Rosenthal
Bequest of Doris Rosenthal, 1976

Mel Rozen, born 1942
Double Dipper, 1978 79.16
Watercolor dye and acrylic on canvas, 72 x 48 in. (182.9 x 122 cm.)
Theodore R. Simson Memorial Purchase Award from the Columbus Art League 69th Annual Spring Show, 1979

Jon Rush, born 1935
Composition, 1961 62.30
Bronze, H. 7¼ in. (18.4 cm.)
Museum Purchase: Howald Fund, 1962

Walter Russell, 1871–?
Autumn 76.43
Oil on canvas, 25 x 30 in. (63.5 x 76.2 cm.)
Gift of Mr. and Mrs. Michael C. Palmer, 1976

Albert Pinkham Ryder (attributed to), 1847–1917
Returning Home 31.261
Oil on canvas, 6⅞ x 12 in. (17.5 x 30.5 cm.)
Gift of Ferdinand Howald, 1931

Albert Pinkham Ryder, 1847–1917
Spirit of Autumn, ca. 1875 [57]47.68
Oil on panel, 8½ x 5¼ in. (21.6 x 13.3 cm.)
Signed lower left: A. P. Ryder
Bequest of Frederick W. Schumacher, 1957
Cat. no. 10

Annette Johnson St. Gaudens, 1869–1943 and Louis St. Gaudens, 1845–1913
Portrait Relief of Paul St. Gaudens, ca. 1900 39.49

Schary, *Abstraction, New York*

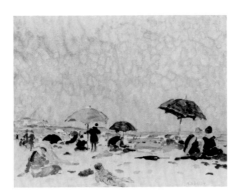

Schille, *Midsummer Day*

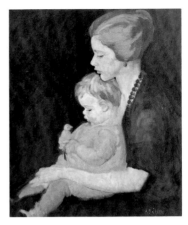

Schille, *Anne and Beau* (formerly *Babe and Bird*)

Bronze, D. 4⅛ in. (10.5 cm.)
Gift of Annette Johnson St. Gaudens, 1939

John Singer Sargent, 1856–1925
Carmela Bertagna, ca. 1880 [57]43.11
Oil on canvas, 23½ x 19½ in. (59.7 x 49.5 cm.)
Signed upper right: John S. Sargent. Inscribed upper
 left: à mon ami Poirson. Inscribed lower left:
 Carmela Bertagna/Rue du/16 Maine
Bequest of Frederick W. Schumacher, 1957
Cat. no. 17

Morton Livingston Schamberg, 1881–1918
Composition, 1916 31.262
Watercolor and graphite on paper, 11½ x 9½ in.
 (29.2 x 24.1 cm.)
Signed and dated upper right: Schamberg/1916
Gift of Ferdinand Howald, 1931

Morton Livingston Schamberg, 1881–1918
Telephone, 1916 31.263
Oil on canvas, 24 x 20 in. (61 x 50.8 cm.)
Signed and dated upper right: Schamberg/1916
Gift of Ferdinand Howald, 1931
Cat. no. 45

Saul Schary, 1904–1978
Abstraction, New York 31.264
Watercolor and ink on paper, 13 x 10⅜ in. (33 x 26.4 cm.)
Signed lower right: Schary
Gift of Ferdinand Howald, 1931

Saul Schary, 1904–1978
At Daniel's Dinner, 1948 71.2
Graphite on paper, 10¼ x 9 in. (26 x 22.9 cm.)
Signed and inscribed center: At Daniel's/dinner/Schary
Gift of Zabriskie Gallery, 1971

Fredi Schiff, born 1915
The Studio 38.3

Oil on canvas, 24 x 20 in. (61 x 50.8 cm.)
Gift of Robert W. Schiff, 1938

Alice Schille, 1869–1955
Dutch Village Gossip, ca. 1905 60.56
Watercolor on paper, 8½ x 11 in. (21.6 x 27.9 cm.)
Signed lower right: Alice Schille
Gift of Ernest Zell, 1960

Alice Schille, 1869–1955
Early Morning in an Old Church, ca. 1908 37.20
Watercolor on paper, 20¾ x 17½ in. (52.7 x 44.4 cm.)
Signed lower right: A. Schille
Bequest of Josephine Klippart, 1937

Alice Schille, 1869–1955
Marketplace at Le Puy, ca. 1911 12.1
Watercolor, gouache, and conté crayon on paper,
 23 x 18 in. (53.4 x 45.7 cm.)
Signed lower left: A. Schille
Museum Purchase, 1912

Alice Schille, 1869–1955
The Passing Years (formerly *Madame Deschamps*),
 ca. 1913 78.19.4
Watercolor, gouache, and conté crayon on paper,
 20 x 23¾ in. (50.8 x 60.3 cm.)
Signed lower left: A. Schille
Gift of Mrs. Ralph H. Trivella, 1978

Alice Schille, 1869–1955
Midsummer Day, ca. 1916 31.265
Watercolor, gouache, and conté crayon on paper,
 11½ x 13⅝ in. (29.2 x 34.6 cm.)
Signed lower right: A. Schille
Gift of Ferdinand Howald, 1931

Alice Schille, 1869–1955
Sea and Tidal River, 1916 31.266

Watercolor, gouache, and conté crayon on paper,
11½ x 13⅝ in. (29.2 x 34.6 cm.)
Signed lower right: A. Schille
Gift of Ferdinand Howald, 1931

Alice Schille, 1869–1955
Grandmother, ca. 1920 56.50
Oil on canvas, 30 x 25⅞ in. (76.2 x 65.7 cm.)
Signed lower right: A. Schille
Gift of Mrs. Hugh Doyle, 1956

Alice Schille, 1869–1955
Straw Hats, ca. 1923 66.2
Watercolor, gouache, and conté crayon on paper,
17⅜ x 20⅜ in. (44.1 x 52 cm.)
Signed lower right: Alice S. Schille
James F. Merkle Memorial Fund Purchase, 1966

Alice Schille, 1869–1955
Anne and Beau (formerly *Babe and Bird*),
 ca. 1925 80.4
Oil and gouache on panel, 30 x 24⅞ in. (76.2 x 63.2 cm.)
Signed lower right: A. Schille
Gift of Mrs. Henry S. Ballard, 1980

Alice Schille, 1869–1955
Three Lazarus Daughters (Charlotte, Jean, and Babette),
 ca. 1929 52.50
Oil on canvas, 40 x 50 in. (101.6 x 127 cm.)
Signed lower left: A. Schille
Gift of Robert Lazarus, Sr., 1952

Alice Schille, 1869–1955
Guatemalan Scene, ca. 1930 75.31
Watercolor on paper, 14¾ x 19¾ in. (37.5 x 50.1 cm.)
Signed lower right: A. Schille
Gift of Heritage Gallery in memory of Carlton S.
 Dargusch, Jr., Frederick W. LeVeque and Edgar T.
 Wolfe, Jr., 1975

Tobias Schneebaum, born 1921
Untitled, 1969 72.2
Oil on canvas, 11⅞ x 9 in. (30.1 x 22.9 cm.)
Signed and dated on reverse: Schneebaum/'69
Museum Purchase: Howald Fund, 1972

Jason Schoener, born 1919
Sunion, Greece, 1962 63.14
Oil and wax on canvas, 40 x 30 in. (101.6 x 76.2 cm.)
Signed lower left center: Schoener
Museum Purchase: Howald Fund, 1963

Jason Schoener, born 1919
Isola Del Giglio, Italy 68.2
Watercolor on paper, 9½ x 12⅝ in. (24.1 x 32 cm.)
Signed lower right: Schoener
Museum Purchase: Howald Fund, 1968

Karl Schrag, born 1912
Full Moon After the Rain, 1973 74.3

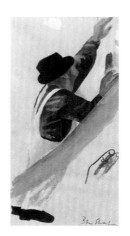

Shahn, *Carpenter's Helper #2*

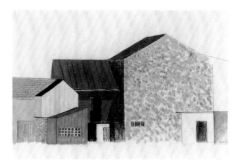

Sheeler, *Bucks County Barn*

Gouache on paper, 25½ x 33¾ in. (64.8 x 85.7 cm.)
Signed lower left: Karl Schrag
Gift of the American Academy of Arts and Letters:
 Childe Hassam Fund, 1974

George Segal, born 1924
Girl on Blanket, Full Figure, 1978 80.7
Painted plaster, H. 76 in. (193 cm.)
Purchased with funds from the Livingston Taylor Family
 and the National Endowment for the Arts, 1980
Cat. no. 82

Virginia Seitz, active twentieth century
Moon Run 77.7
Oil and mixed media on panel,
 24½ x 24½ in. (62.2 x 62.2 cm.)
Etched in wood lower right: Seitz
Howald Memorial Purchase Award from the 67th Annual
 Columbus Art League May Show, 1977

Ben Shahn, 1898–1969
Carpenter's Helper #2, ca. 1940–1942 72.37
Gouache on paper, 10⅝ x 5½ in. (27 x 14 cm.)
Signed lower right: Ben Shahn
Museum Purchase: Howald Fund, 1972

Charles Sheeler, 1883–1965
Lhasa, 1916 31.100
Oil on canvas, 25½ x 31¾ in. (64.8 x 80.6 cm.)
Signed and dated lower right: Sheeler/1916
Gift of Ferdinand Howald, 1931
Cat. no. 50

Charles Sheeler, 1883–1965
Bucks County Barn, 1918 31.101
Gouache and conté crayon on paper, 16⅛ x 22⅛ in.
 (41 x 56.2 cm.)
Signed and dated lower right: Sheeler 1918
Gift of Ferdinand Howald, 1931

Shineman, *Smoke and Ash*

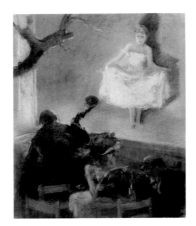

Shinn, *Girl with Red Stockings*

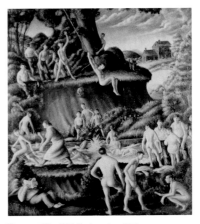

Singer, *The Old Swimming Hole*

Charles Sheeler, 1883–1965
Barns, ca. 1918 72.40
Conté crayon on paper, 6 x 8 in. (15.2 x 20.3 cm.)
Museum Purchase: Howald Fund, 1972

Charles Sheeler, 1883–1965
Chrysanthemums (formerly *Dahlias and White Pitcher*),
 1923 31.104
Gouache, conté crayon, and graphite on paper,
 25½ x 19 in. (64.8 x 48.3 cm.)
Signed and dated lower right: Sheeler 1923
Gift of Ferdinand Howald, 1931

Charles Sheeler, 1883–1965
Still Life with Peaches, 1923 31.105
Pastel on paper, 15⅝ x 11¼ in. (39.7 x 28.6 cm.)
Signed and dated lower right: Sheeler 1923
Gift of Ferdinand Howald, 1931

Charles Sheeler, 1883–1965
Still Life and Shadows, 1924 31.106
Conté crayon, watercolor, and tempera on paper,
 31 x 21 in. (78.7 x 53.3 cm.)
Signed and dated lower right: Sheeler 1924
Gift of Ferdinand Howald, 1931
Cat. no. 51

Hoyt Leon Sherman, 1903–1981
Morning Light, 1924 37.7
Oil on canvas, 26 x 32 in. (66 x 81.3 cm.)
Signed lower right: Hoyt Leon Sherman
Robert W. Schiff Purchase Award, 1937

Hoyt Leon Sherman, 1903–1981
Spanish Boy (Cosecha), 1935 36.23
Oil on canvas, 20⅛ x 16⅛ in. (51.1 x 41 cm.)
Gift of C. Seissel Rindfoos, 1936

Hoyt Leon Sherman, 1903–1981
Traffic Patterns—60 MPH, 1962 65.25
Oil on canvas, 26 x 32 in. (66 x 81.3 cm.)
Anonymous gift, 1965

Larry Shineman, born 1943
Smoke and Ash, 1974 74.15
Mixed media on canvas, 65½ x 98½ in.
 (166.4 x 250.2 cm.)
Purchased with funds from the Alfred L. Willson
 Charitable Fund of The Columbus Foundation, 1974

Everett Shinn, 1876–1953
Luxembourg Gardens, Paris, 1900 57.1
Graphite and watercolor on paper, 4¾ x 7½ in.
 (12.1 x 19.1 cm.)
Signed and dated lower left: E. Shinn/1900
Museum Purchase: Howald Fund, 1957

Everett Shinn, 1876–1953
Arrangement for Louis IV Ceiling, 1906 77.22
Red crayon on paper, 14¹¹⁄₁₆ x 22⁹⁄₁₆ in.
 (37.2 x 57.3 cm.)
Signed and dated lower left: Everett Shinn/1906.
 Signed and inscribed lower right: Arrangement for
 Louis IV Ceiling, Everett Shinn, 112 Waverly Place,
 New York City
Gift of Mr. and Mrs. Everett D. Reese, 1977

Everett Shinn, 1876–1953
Girl with Red Stockings, 1930 55.24
Pastel on paper, 11¼ x 10 in. (28.6 x 25.4 cm.)
Signed and dated lower center: E. Shinn/1930
Museum Purchase: Howald Fund, 1955

Bevlyn Simson, born 1917
Pie in the Sky, 1970 71.34
Acrylic on canvas, 23¾ x 29¾ in. (60.2 x 75.6 cm.)
Gift of Mr. and Mrs. Sheldon Ackerman, 1971

Bevlyn Simson, born 1917
Triptych II (Cincinnati Triptych), 1970 72.14
Acrylic on canvas, 48 x 72 in. (121.9 x 182.9 cm.)
Museum Purchase: Howald Fund, 1972

Clyde Singer, born 1908
The Old Swimming Hole, 1937 38.2

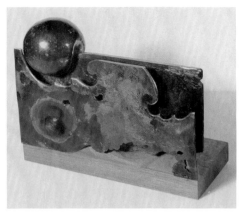

Slaughter, *Beached*

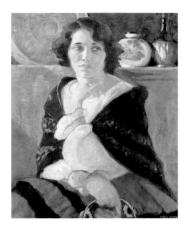

Smith, *Intermission*

Sommer, *Landscape*

Oil on canvas, 46⅛ x 40¼ in. (117.2 x 102.2 cm.)
Signed and dated lower left: Singer Oct. 1937
Gift of Orlando A. Miller, 1938

Todd Slaughter, born 1942
Duet, 1969 69.11
Epoxy, H. 20½ in. (52.1 cm.)
Howald Memorial Purchase Award, 1969

Todd Slaughter, born 1942
Beached, 1971 72.22
Bronze and wood, H. 7 in. (17.8 cm.)
Purchased with funds from the Alfred L. Willson
 Charitable Fund of The Columbus Foundation, 1972

John Sloan, 1871–1951
East Entrance, City Hall, Philadelphia, 1901 60.6
Oil on canvas, 27¼ x 36 in. (69.2 x 91.4 cm.)
Signed and dated upper right: John/Sloan/1901
Museum Purchase: Howald Fund, 1960
Cat. no. 24

John Sloan, 1871–1951
Spring Planting, Greenwich Village, 1913 80.25
Oil on canvas, 26 x 32 in. (66 x 81.3 cm.)
Signed lower right: John Sloan. Signed and inscribed on
 reverse of canvas: Spring Planting/John Sloan.
 Inscribed along top of stretcher: SPRING PLANTING
 GREENWICH VILLAGE N.Y./John Sloan. Inscribed
 along bottom of stretcher: Spring Planting Greenwich
 Vill/John Sloan.
Museum Purchase: Howald Fund II, 1980
Cat. no. 25

Hunt Slonem, born 1951
Red Mask, 1983 84.17
Oil on canvas, 72 x 72 in. (182.9 x 182.9 cm.)
Gift of Captain and Mrs. Charles E. Slonim, 1984

F. Sterling Smith, born 1917
Spring Landscape, ca. 1951 52.47
Oil on panel, 8 x 22⅝ in. (20.3 x 57.5 cm.)

Signed on reverse, right center: F. S. Smith
Museum Purchase, 1952

Vincent Smith, born 1929
The Black Family, 1972 75.17
Oil and collage on canvas, 50 x 40 in. (127 x 101.6 cm.)
Signed lower right: Vincent
Museum Purchase: Howald Fund, 1975

Yeteve Smith, 1888–1957
Intermission, ca. 1926 69.16
Oil on canvas, 32¼ x 26 in. (81.9 x 66 cm.)
Signed lower right: Yeteve Smith
Bequest of Roswitha C. Smith, 1969

Kenneth Snelson, born 1927
V-X, 1974 85.1
Stainless steel and wire (edition of 2),
 H. 96 in. (243.8 cm.)
Given to the Columbus Museum of Art by friends in
 memory of Frances N. Lazarus, 1985
Cat. no. 74

Kenneth Snelson, born 1927
Working Model for V-X, 1968 85.2
Aluminum and stainless steel wire, H. 10¼ in. (26 cm.)
Gift of the artist, 1985

Kenneth Snelson, born 1927
Free Ride Home (Model), 1974–1978 81.14
Aluminum with stainless steel cable, H. 22¾ in.
 (57.7 cm.)
Purchased with funds from the Alfred L. Willson
 Charitable Fund of The Columbus Foundation, 1981

William Sommer, 1867–1949
Landscape, ca. 1935 85.5.2
Watercolor on paper, 11 x 15 in. (28 x 38.1 cm.)
Signed lower right: Wm Sommer
Gift of Joseph Erdelac, 1985

William Sommer, 1867–1949
Brandywine Landscape, ca. 1935 85.5.3

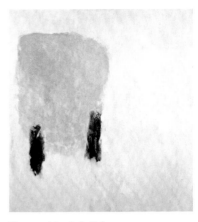

Speicher, *Peonies in a Pottery Vase*

Springer, *Forest Scene*

Stamos, *Mandrake Echo*

Watercolor on paper, 12½ x 18 in. (31.7 x 45.7 cm.)
Signed lower center: Wm Sommer
Gift of Joseph Erdelac, 1985

William Sommer, 1867–1949
Country Landscape, 1943 50.38
Watercolor on paper, 11¾ x 17 in.
 (29.8 x 43.2 cm.)
Signed and dated lower right: Wm. Sommer/1943
Purchased with funds from the Alfred L. Willson
 Foundation, 1950

Raphael Soyer, 1899–1987
Odalisque, 1928 31.267
Oil on canvas, 25⅛ x 20⅛ in. (63.8 x 51.1 cm.)
Signed and dated lower right: Raphael Soyer/1928
Gift of Ferdinand Howald, 1931

Eugene E. Speicher, 1883–1962
The Nude Back 58.34
Oil on canvas, 29¼ x 36¼ in. (74.3 x 92 cm.)
Signed upper left: Eugene Speicher
Museum Purchase: Howald Fund, 1958

Eugene E. Speicher, 1883–1962
Peonies in a Pottery Vase 55.23
Oil on canvas, 22 x 19⅛ in. (55.9 x 48.6 cm.)
Signed upper right: Eugene Speicher
Museum Purchase: Howald Fund, 1955

Eugene E. Speicher, 1883–1962
Spring Bouquet 55.22
Oil on canvas, 17½ x 16¼ in. (44.4 x 41.3 cm.)
Signed lower left: Eugene Speicher
Museum Purchase: Howald Fund, 1955

Niles Spencer, 1893–1952
Corporation Shed, ca. 1928 31.269
Oil on canvas, 20 x 33¼ in. (50.8 x 84.4 cm.)

Signed lower left: Niles Spencer
Gift of Ferdinand Howald, 1931

Niles Spencer, 1893–1952
Buildings 31.268
Oil on canvas, 24 x 30 in. (61 x 76.2 cm.)
Signed lower left: Niles Spencer
Gift of Ferdinand Howald, 1931
Cat. no. 55

Carl Springer, 1874–1935
Forest Scene, 1912 28.1.2
Oil on canvas, 32 x 40¼ in. (81.3 x 102.2 cm.)
Signed and dated lower right: Carl Springer/12
Source unknown

Carl Springer, 1874–1935
Edge of the Woods 28.1.1
Oil on canvas, 30 x 36 in. (76.2 x 91.4 cm.)
Signed lower right: Carl Springer
Gift of Claude Meeker and Edward Orton, Jr., 1928

Frederick M. Springer, born 1908
Johnathan Creek, 1931 32.3
Oil on canvas, 40 x 48 in. (101.6 x 121.9 cm.)
Signed lower right: Frederick M. Springer
Gift of the artist, 1932

Theodoros Stamos, born 1922
The Greek Islands, 1959 (?) 85.24.3
Pastel on board, 16 x 13½ in. (40.1 x 34.3 cm.)
Signed, dated, and inscribed lower center: (The Greek
 Islands)/For Betty with Appreciation/Stamos 1959[?]
Gift of the Betty Parsons Foundation, 1985

Theodoros Stamos, born 1922
Mandrake Echo, ca. 1962–1964 66.30
Oil on canvas, 68 x 60 in. (172.7 x 152.4 cm.)
Gift of the artist and purchased with funds from the
 Alfred L. Willson Foundation, 1966

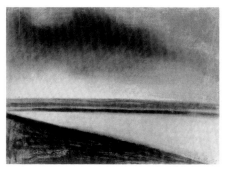

Stella, *Nocturne*

Sugarman, *Cade*

Taaffe, *Plant Sociology*

Julian Stanczak, born 1928
Enclosed, 1970 82.13
Acrylic on canvas, 47½ x 71½ in. (120.7 x 181.6 cm.)
Signed and dated on reverse: J. Stanczak 1970
Gift of Norman and Carolyn Carr, 1982

Richard Stankiewicz, 1922–1983
Untitled, 1979–21, 1979 80.21
Steel, H. 63⅞ in. (162.2 cm.)
Purchased with funds from an anonymous donor and
 the National Endowment for the Arts, 1980
Cat. no. 83

Joseph Stella, 1880–1946
Nocturne 64.52
Pastel on paper, 18 x 24 in. (45.7 x 61 cm.)
Signed lower right: Joseph Stella
Museum Purchase: Howald Fund, 1964

Jarvis Anthony Stewart, 1914–1981
Farm, 1951 56.29
Oil on canvas, 26¾ x 35 in. (67.9 x 88.9 cm.)
Signed lower right: Stewart
Museum Purchase: Howald Fund, 1956

Ary Stillman, 1891–1967
Rhythm in Depth, 1953 76.46
Oil on canvas, 39¾ x 30 in. (101 x 76.2 cm.)
Signed lower left: Stillman
Gift of the Stillman-Lack Foundation, 1976

Gilbert Stuart (attributed to), 1755–1828
George Washington, ca. 1802 [57]39.29
Oil on canvas, 48 x 37 in. (121.9 x 94 cm.)
Bequest of Frederick W. Schumacher, 1957

Walter Stuempfig, Jr., 1914–1970
Three Glasses, 1966 68.32
Oil on canvas, 8¾ x 12 in. (22.2 x 30.5 cm.)
Signed upper left: W.S.
Museum Purchase: Howald Fund, 1968

George Sugarman, born 1912
Cade, 1975–1977 78.23
Sandblasted aluminum, H. 56 in. (142.2 cm.)
Signed front lower right: Sugarman
Purchased with funds from the Alfred L. Willson
 Charitable Fund of The Columbus Foundation and the
 National Endowment for the Arts, 1978

Thomas Sully (attributed to), 1783–1872
A Baltimore Girl [57]31.299
Oil on canvas, 29½ x 24½ in. (74.9 x 62.2 cm.)
Bequest of Frederick W. Schumacher, 1957

Thomas Sully, 1783–1872
Portrait of a Woman 55.1
Oil on canvas, 30 x 25 in. (76.2 x 63.5 cm.)
Gift of Mrs. Earle C. Derby, 1955

Robert Swain, born 1940
Untitled, 1975 76.1
Acrylic on canvas, 84 x 84 in. (213.4 x 213.4 cm.)
Museum Purchase: Howald Fund, 1976

Susan Taaffe, born 1957
Plant Sociology, 1986 86.21
Oil on wood, H. 30 in. (76.2 cm.)
Ferdinand Howald Memorial Purchase Award from the
 76th Annual Columbus Art League Exhibition, 1986

Alvan Tallmadge, 1893–ca. 1970
Iglesia La Salud, San Miguel, 1969 71.11
Ink and watercolor on paper, 14½ x 10⅜ in.
 (36.8 x 26.3 cm.)
Signed and dated lower left: Tallmadge '69
Museum Purchase: Howald Fund, 1971

Ralston Carlton Thompson, 1904–1975
Gullies, 1946 77.2.1
Charcoal on watercolor paper, 19½ x 27 in.
 (49.5 x 68.6 cm.)
Signed bottom right: Ralston Thompson
Gift from the Estate of Ralston Thompson, 1977

Thompson, *Trees and Rock Forms*

Tolstedt, *Flag Sequence Series III*

Trova, *Profile Canto A/S*

Ralston Carlton Thompson, 1904–1975
Menemsha No. 2, 1947 77.2.2
Ink and wash on watercolor paper, 10⅜ x 16½ in.
 (26.4 x 41.9 cm.)
Signed bottom right: Ralston Thompson
Gift from the Estate of Ralston C. Thompson, 1977

Ralston Carlton Thompson, 1904–1975
Village Square—Zocalo, 1952 77.2.4
Oil on canvas, 30¼ x 40 in. (76.8 x 101.6 cm.)
Gift from the Estate of Ralston C. Thompson, 1977

Ralston Carlton Thompson, 1904–1975
Tidal Pool No. 3, 1966 77.2.6
Oil on canvas, 35¾ x 47½ in. (90.8 x 120.7 cm.)
Gift from the Estate of Ralston C. Thompson, 1977

Ralston Carlton Thompson, 1904–1975
Cholula #3 54.44
Ink on paper, 12½ x 19 in. (31.8 x 48.3 cm.)
Signed lower right: Ralston Thompson
Museum Purchase: Howald Fund, 1954

Ralston Carlton Thompson, 1904–1975
Trees and Rock Forms 64.35x
Oil on canvas, 39¾ x 29⅜ in. (101 x 74.6 cm.)
Museum Purchase: Howald Fund, 1964

William J. Thompson, born 1926
Angel, 1958 60.31
Bronze, H. 6¾ in. (17.1 cm.)
Beaux Arts Purchase Award, 1960

William Thon, born 1906
Windy Mykonos, 1959 60.20
Watercolor and resist on paper, 20 x 26¼ in.
 (50.8 x 66.7 cm.)
Signed lower right: Thon
Gift of Mr. and Mrs. Gerald B. Fenton, 1960

James Thurber, 1894–1961
Football (for *The New Yorker*, October 29, 1932), 1932
 60.24

Ink on paper, 7⅜ x 8⅜ in. (18.7 x 21.3 cm.)
Signed lower right: Th. Inscribed upper right: Football.
 Inscribed and dated on reverse center: Lineup of
 Football Players/from New Yorker/10/29/32
Purchased with funds from the Alfred L. Willson
 Foundation, 1960

James Thurber, 1894–1961
Signals (for *The New Yorker*, October 5, 1932), 1932
 60.25
Ink on paper, 6¾ x 10½ in. (17.2 x 26.7 cm.)
Signed and inscribed lower right: Th/Signals. Inscribed
 and dated on reverse: 2 football players/Published in
 New Yorker/10/5/32
Purchased with funds from the Alfred L. Willson
 Foundation, 1960

James Thurber, 1894–1961
Happy New Year (or *Dogs*), ca. 1932 60.23
Graphite on paper, 5¼ x 8¾ in. (13.3 x 22.2 cm.)
Signed lower right: Jim Thurber. Inscribed upper right:
 Happy/New/Year
Purchased with funds from the Alfred L. Willson
 Foundation, 1960

James Thurber, 1894–1961
Two Men in a Doorway, ca. 1933 60.26
Ink on paper, 8½ x 6¾ in. (21.6 x 14.6 cm.)
Inscribed on reverse: drawn about 1933
Purchased with funds from the Alfred L. Willson
 Foundation, 1960

James Thurber, 1894–1961
Thurber and His Circle 60.22
Ink on paper, 8¼ x 10¾ in. (21 x 27.3 cm.)
Signed and inscribed lower center to right: Thurber and
 His Circle / James Thurber
Purchased with funds from the Alfred L. Willson
 Foundation, 1960

Lowell Tolstedt, born 1939
History of an Anonymous Blueberry Muffin, 1969 71.21

Tworkov, *SR-Pt-70-#6*

Graphite and watercolor on paper, 22¾ x 34 in.
 (57.8 x 86.4 cm.)
Signed and inscribed lower center to right: Lowell
 Tolstedt, History of an Anonymous Blueberry Muffin
Purchased with funds from the Alfred L. Willson
 Charitable Fund of The Columbus Foundation, 1971

Lowell Tolstedt, born 1939
Flag Sequence Series III, 1973–1974 75.19
Graphite on paper, 39⅝ x 50½ in. (100.7 x 128.3 cm.)
Signed lower right: Lowell Tolstedt. Inscribed lower left:
 Flag Sequence
Purchased with funds from the Alfred L. Willson
 Charitable Fund of The Columbus Foundation, 1975

George Tooker, born 1920
Cornice, ca. 1949 80.26
Tempera on panel, 24 x 15½ in. (61 x 39.4 cm.)
Signed lower right: Tooker
Museum Purchase: Howald Fund II, 1980
Cat. no. 71

Ernest Trova, born 1927
Profile Canto A/S, 1976 81.25
Welded and painted steel plate, H. 142 in. (360.6 cm.)
Gift of the Siteman Organization, 1981

John Henry Twachtman, 1853–1902
Court of Honor, World's Columbian Exposition, Chicago,
 1893 [57]43.10
Oil on canvas, 25 x 30 in. (63.5 x 76.2 cm.)
Signed lower right: J. H. Twachtman
Bequest of Frederick W. Schumacher, 1957
Cat. no. 15

John Henry Twachtman, 1853–1902
Branchville 79.104
Oil on canvas, 60 x 80 in. (152.4 x 203.2 cm.)
Gift of Mr. and Mrs. Harry Spiro, 1979

Stanley Jan Twardowicz, born 1917
Fishing Shacks, 1946 48.7
Casein on paper, 12¼ x 19 in. (31.1 x 48.3 cm.)

Signed and dated lower right: Stanley '46
Purchased with funds from the Alfred L. Willson
 Foundation, 1948

Stanley Jan Twardowicz, born 1917
Fetish, 1960 63.7
Oil on canvas, 71½ x 48¼ in. (181.6 x 122.5 cm.)
Signed on reverse: Stanley Twardowicz
Museum Purchase: Howald Fund, 1963

Jack Tworkov, 1900–1982
SR-Pt-70-#6, 1970 76.18
Charcoal and conté crayon, 25½ x 19¾ in.
 (64.8 x 50.2 cm.)
Inscribed in pencil lower left: A SR-Pt-70-#6.
 Inscribed in conté crayon lower right: J2/70
Purchased with funds from the Alfred L. Willson
 Charitable Fund of The Columbus Foundation, 1976

Walter Ugorski, born 1932
Olentangy Landscape 67.9
Oil on canvas, 50¼ x 60½ in. (127.6 x 153.7 cm.)
Signed lower left: Ugorski
Museum Purchase: Howald Fund, 1967

John Ulbricht, born 1926
Earthscape II, 1961 62.79
Oil on canvas, 43½ x 56½ in. (110.5 x 143.5 cm.)
Signed lower right: Ulbricht. Signed, dated, and
 inscribed on reverse: 1961/Earthscape II John Ulbricht.
Museum Purchase: Howald Fund, 1962

Stanbery Van Buren, died 1926
Venetian Square, 1909 09.1
Oil on canvas, 31 x 22⅛ in. (78.7 x 56.2 cm.)
Signed and dated lower left: Stanbery Van Buren 1909
Museum Purchase, 1909

Anne Gatewood Van Kleeck, active twentieth century
Standing Woman 59.6
Bronze, H. 14 in. (35.6 cm.)
Museum Purchase: Howald Fund, 1959

Barbara Veatch, born 1949
Angel of Darkness, 1983 83.20
Pastel on paper, 26 x 39¾ in. (66 x 101 cm.)
Signed lower right corner: Veatch
Bevlyn and Theodore Simson Purchase Award from the
 73rd Annual Columbus Art League Exhibition, 1983

Elihu Vedder, 1836–1923
The Venetian Model, 1878 69.7
Oil on canvas, 18 x 14⅞ in. (45.7 x 37.8 cm.)
Signed and dated lower left: Vedder/1878
Museum Purchase: Schumacher Fund, 1969
Cat. no. 12

Robert Vickers, born 1924
Vezélay Revisited, 1956 56.47
Oil on canvas, 22 x 30 in. (53.3 x 76.2 cm.)

Signed lower right: R. Vickers. Signed and dated on
 reverse center: R. Vickers/1956
Museum purchase: Howald Fund, 1956

Angela von Neumann, born 1928
Undersea, 1964 64.33
Oil on canvas, 39 x 31⅜ in. (99.1 x 79.7 cm.)
Signed lower left center: Angela von Neumann. Signed,
 dated, and inscribed on reverse upper right: Undersea/
 Jan.-1964/Angela Von Neumann
Museum Purchase: Howald Fund, 1964

Horatio Walker, 1858–1938
Barnyard Scene 59.32
Watercolor on paper, 7¾ x 10⅝ in. (19.7 x 27 cm.)
Signed lower left: Horatio Walker
Museum Purchase: Howald Fund, 1959

Abraham Walkowitz, 1880–1965
Figure Studies, 1905 75.28
Graphite on paper, 14 x 8½ in. (35.6 x 20.4 cm.)
Signed and dated lower center: A. Walkowitz/1905.
 Signed on reverse, upper left: A. Walkowitz
Museum Purchase: Howald Fund, 1975

Abraham Walkowitz, 1880–1965
Trees and Flowers, 1917 31.273
Watercolor and graphite on paper, 15½ x 29½ in.
 (39.4 x 74.9 cm.)
Signed and dated lower left: A. Walkowitz 1917
Gift of Ferdinand Howald, 1931

Abraham Walkowitz, 1880–1965
Bathers 31.271
Watercolor and graphite on paper, 15¼ x 29 in.
 (38.4 x 73.7 cm.)
Signed lower left: A. Walkowitz
Gift of Ferdinand Howald, 1931

Abraham Walkowitz, 1880–1965
Bathers Resting 31.270
Watercolor and charcoal on paper, 14½ x 21⅛ in.
 (36.8 x 53.7 cm.)
Signed lower right: A. Walkowitz
Gift of Ferdinand Howald, 1931

Abraham Walkowitz, 1880–1965
Decoration—Figures in Landscape 31.272
Watercolor on paper, 12⅝ x 37 in. (32.1 x 94 cm.)
Signed lower left: A. Walkowitz
Gift of Ferdinand Howald, 1931

Martha Walter, 1875–1976
Two on the Beach, ca. 1914 78.1
Oil on canvas mounted on panel, 6 x 8¼ in.
 (15.2 x 20.9 cm.)
Gift of Mr. and Mrs. John Connally in memory of
 Jack Schmidt, 1978

Max Weber, 1881–1961
Still Life, 1921 31.274
Oil on canvas, 15⅛ x 21¼ in. (38.4 x 54 cm.)

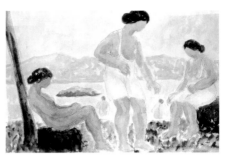

Walkowitz, *Bathers Resting*

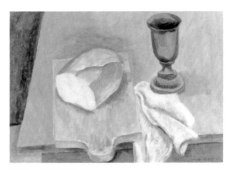

Weber, *Still Life*

Signed and dated lower right: Max Weber 1921
Gift of Ferdinand Howald, 1931

Max Weber, 1881–1961
The Wayfarers, ca. 1940 58.33
Oil on canvas, 26¼ x 32¼ in. (66.7 x 81.9 cm.)
Signed lower right: MAX WEBER
Museum Purchase: Howald Fund, 1958

Elbert Weinberg, born 1928
Dog House Outgrown, 1973 76.5
Bronze, H. 6¼ in. (15.9 cm.)
Signed on base: Weinberg
Museum Purchase: Howald Fund, 1976

Mac Wells, born 1925
Untitled #6, 1970 71.14
Acrylic on canvas, 78 x 78 in. (198.1 x 198.1 cm.)
Museum Purchase: Howald Fund, 1971

Richard Wengenroth, born 1928
Alma Mater, ca. 1953 58.42
Tempera on paper, 24¾ x 18⅞ in. (62.9 x 47.9 cm.)
Museum Purchase, 1958

Byron F. Wenger, 1898–1976
Bull Calf (pair), 1929 44.1.1 & .2
Ceramic, H. 10½ in. (26.7 cm.)
Signed and dated on base: Wenger 29
Gift of Mrs. Ralph H. Beaton, 1944

Byron F. Wenger, 1898–1976
Thundergod, ca. 1929 81.17
Bronze, H. 17 in. (43.2 cm.)
Signed on base: Wenger
Gift of Hermine Summer, 1981

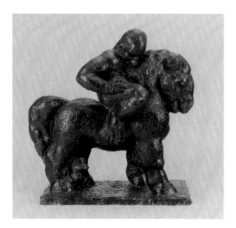

Wenger, *Thundergod*

Wilke, *California*

Witkin, *Excelsior*

Byron F. Wenger, 1898–1976
Male Nude 36.16
Plaster, H. 29½ in. (75 cm.)
Signed on base: B F W
Gift of Friends of Art, 1936

Tom Wesselmann, born 1931
Study for Seascape #10, 1966 76.33
Acrylic on corrugated cardboard mounted on particle
 board, 48 x 62 in. (121.9 x 157.5 cm.)
Purchased with the aid of funds from the National En-
 dowment for the Arts and an anonymous donor, 1976
Cat. no. 73

Benjamin West, 1738–1820
Study of a Chair and Drapery 65.45
Chalk on paper, 12⅛ x 8½ in. (30.8 x 21.6 cm.)
Purchased with funds from the Alfred L. Willson
 Foundation, 1965

James A. McNeill Whistler, 1834–1903
Study of a Head (Portrait of Algernon Graves),
 ca. 1881–1885 [57]43.8
Oil on canvas, 22⅝ x 14½ in. (57.5 x 36.8 cm.)
Signed center right with butterfly symbol
Bequest of Frederick W. Schumacher, 1957
Cat. no. 14

Harry Wickey, 1892–1968
The Otter Kill 56.22
Ink on paper, 7⅞ x 11⅞ in. (20 x 30.2 cm.)
Signed lower right: Wickey
Museum Purchase: Howald Fund, 1956

Harry Wickey, 1892–1968
Women on the Beach 56.27
Conté crayon on paper, 4¾ x 6⅝ in.
 (12.1 x 16.8 cm.)
Signed lower right: Wickey
Museum Purchase: Howald Fund, 1956

Ulfert Wilke, 1907–1987
California, 1967 71.8
Acrylic on canvas, 69 x 56 in. (175.3 x 142.2 cm.)
Signed with monogram and dated on reverse, upper
 right and upper left: A/UW/67
Museum Purchase: Howald Fund, 1971

Ralph E. Williams, born 1946
The Kiss, 1972 75.5
Oil on canvas, 39¾ x 46 in. (101.6 x 116.8 cm.)
Signed lower right: Ralph E. Williams
Purchased with funds from the Alfred L. Willson
 Charitable Fund of The Columbus Foundation, 1975

Roger Williams, born 1946
Paint Brush, 1970 70.17
Graphite, pastel, and brass screws, 31 x 24½ in.
 (78.7 x 62.2 cm.)
Signed, dated, and inscribed lower right: 2xs52 Roger
 Williams 70
Purchased with funds from the Alfred L. Willson
 Foundation, 1970

Roger Williams, born 1946
Pie Man, 1970 70.26
Acrylic on canvas, 59½ x 60 in. (151.1 x 152.4 cm.)
Howald Memorial Purchase Award, 1970

Roger Williams, born 1946
Color Freeway #116, 1972 73.12
Acrylic on canvas, 60¼ x 92⅝ in. (153 x 235.3 cm.)
Museum Purchase: Howald Fund, 1973

Robb Wilson, born 1932
Fountain, ca. 1969 70.29
Stoneware, H. 16½ in. (41.9 cm.)
Signed on base: Robb Wilson
Beaux Arts Purchase Award, 1970

Isaac Witkin, born 1936
Excelsior, 1978 78.22

Young, *Right to the Jaw*

Youngerman, *Juba*

Zajac, *Metamorphosis, Rome Series*

Steel, H. 25 in. (63.5 cm.)
Signed and dated: Witkin 1978
Purchased with funds from the Alfred L. Willson
 Charitable Fund of The Columbus Foundation and the
 National Endowment for the Arts, 1978

Andrew Wyeth, born 1917
Inland Shell, 1957 82.15
Watercolor and gouache on paper, 13½ x 21½ in.
 (34.3 x 54.6 cm.)
Signed lower right: Andrew Wyeth
Gift of Mr. and Mrs. Harry Spiro, 1982
Cat. no. 72

Henriette Wyeth, born 1907
Easter Lilies, 1964 67.3
Oil on canvas, 35 x 30 in. (88.9 x 76.2 cm.)
Signed lower left: Henriette Wyeth
Museum Purchase: Howald Fund, 1967

John Wynne, born 1921
Interior with Figure, 1952–1953 55.14
Ink on paper, 19¾ x 29¼ in. (50.2 x 74.3 cm.)
Signed and dated on mat lower right: John Wynne,
 Winter, 1952–53. Inscribed lower left: Interior with
 figure
Museum Purchase: Howald Fund, 1955

Mahonri M. Young, 1877–1957
The Knock-Down, original plaster 1928, posthumous
 cast 1960 60.49
Bronze, H. 22¾ in. (57.8 cm.)
Signed on base: © Mahonri
Museum Purchase: Howald Fund, 1960

Mahonri M. Young, 1877–1957
Right to the Jaw, original plaster 1928, posthumous
 cast 1960 60.50
Bronze, H. 16 in. (40.6 cm.)
Signed on base: © Mahonri
Museum Purchase: Howald Fund, 1960

Jack Youngerman, born 1926
Juba, 1980 81.23
Cast fiberglass, H. 67 in. (170.2 cm.)
Signed and dated lower edge: J Y 1980 1/3
Gift of Mr. and Mrs. Sidney M. Feldman, 1981

Jack Zajac, born 1929
Metamorphosis, Rome Series, 1959 82.5.1
Bronze, H. 9 in. (22.9 cm.)
Gift of Regina Kobacker Fadiman, 1982

Laura Ziegler, born 1927
The Friar, ca. 1949 57.39
Bronze, H. 18½ in. (47 cm.)
Museum Purchase: Howald Fund, 1957

Laura Ziegler, born 1927
The Friar, 1954 59.30
Ink on paper, 7⅞ x 5¼ in. (20 x 13.3 cm.)
Signed and dated lower right: '54 L. Ziegler
Purchased with funds from the Alfred L. Willson
 Foundation, 1959

Laura Ziegler, born 1927
Raphello, 1956 58.43
Ink on paper, 7¾ x 5¼ in. (19.7 x 13.3 cm.)
Signed, dated, and inscribed lower right: Laura
 Ziegler/Rome 1956
Purchased with funds from the Alfred L. Willson
 Foundation, 1958

Laura Ziegler, born 1927
Walking Friar, ca. 1965 68.7
Bronze, H. 34 in. (86.4 cm.)
Museum Purchase: Howald Fund, 1968

Laura Ziegler, born 1927
Study for a Fountain I, 1972 73.30
Bronze, H. 18 in. (45.7 cm.)

Ziegler, *Walking Friar*

Zorach, *The Fishermen*

Zorach, *Seated Dancer*

Purchased with funds from the Alfred L. Willson
 Charitable Fund of The Columbus Foundation and the
 Howald Fund, 1973

William Zimmerman, born 1937
American Woodcock, 1975 75.45
Watercolor on paper, 13¾ x 12¾ in. (34.9 x 32.4 cm.)
Signed lower right: Wm. Zimmerman
Purchased with funds from the Alfred L. Willson
 Charitable Fund of The Columbus Foundation, 1975

Marguerite Zorach, 1887–1968
Rendezvous in Yosemite, 1921 73.18
Oil on canvas, 25 x 20⅛ in. (63.5 x 51.1 cm.)
Signed and dated lower right: M. Zorach/1921
Museum Purchase: Howald Fund, 1973

William Zorach, 1887–1966
Cart and Horse at Water's Edge, 1916 31.278
Watercolor and graphite on paper, 11⅞ x 9¼ in.
 (30.2 x 23.5 cm.)
Signed and dated lower right: Wm. Zorach 1916
Gift of Ferdinand Howald, 1931

William Zorach, 1887–1966
The Fishermen, 1916 31.279
Watercolor and graphite on paper, 12 x 9⅞ in.
 (30.5 x 25.1 cm.)
Signed and dated lower right: Wm. Zorach, 1916
Gift of Ferdinand Howald, 1931

William Zorach, 1887–1966
Marine, 1916 31.280
Watercolor on paper, 13⅜ x 15⅝ in. (34 x 39.7 cm.)
Signed and dated lower right: William Zorach—1916—
Gift of Ferdinand Howald, 1931

William Zorach, 1887–1966
Seated Dancer, 1964 85.10
Bronze, H. 33 in. (83.8 cm.)
Signed, dated, and inscribed top back of seat: © 1964
 William Zorach/4/6. Inscribed bottom back of seat:
 BEDI-MAKKY N.Y.
Museum Purchase: Howald Fund, 1985

Anonymous (after Edward Savage), early 19th century
The Family of George Washington [57]48.32
Oil on canvas, 28 x 35½ in. (71.1 x 89.2 cm.)
Bequest of Frederick W. Schumacher, 1957

Anonymous, 19th century
Kneeling Figure x.501
Marble, H. 25½ in. (64.8 cm.)
Anonymous gift

Anonymous
Landscape 76.42.4
Watercolor on paper, 11¼ x 15¼ in. (28.6 x 38.7 cm.)
Signed lower left: Everett
Gift of Dorothy Hubbard Appleton, 1976

Anonymous
Seascape 76.42.5
Watercolor on paper, 11¼ x 15½ in. (28.6 x 39.4 cm.)
Gift of Dorothy Hubbard Appleton, 1976

Anonymous (formerly attributed to George Bellows),
 early 20th century
The Mastermind (Melvin F. Bragdon), 1912 62.73
Oil on canvas, 22¼ x 16 in. (56.5 x 40.6 cm.)
Inscribed by unknown hand, lower right: George Bellows
Bequest of Eloise Bragdon, 1962

Other American Collections—a Summary

FOLK ART

The museum's collection of American folk art includes paintings, drawings, watercolors, Fraktur, coverlets, and carvings by nineteenth- and twentieth-century artisans.

The centerpiece of this collection is a group of one hundred woodcarvings by Elijah Pierce, the son of a former slave, who settled in Columbus, Ohio, in the 1920s. Pierce has been honored by exhibitions in this country and abroad and is today acknowledged as one of the country's foremost folk artists. The museum's collection of Pierce objects is comprehensive, including both biblical and secular works from 1927 to the early 1980s. One of his masterpieces, *The Crucifixion* (cat. no. 61), is highlighted in Part One of this catalogue.

Elijah Pierce, 1892–1984
The Book of Wood (detail), 1932–1936
Painted wood relief, 28 x 35 in. (71.1 x 88.9 cm.)
Museum Purchase
85.3.2. b

DECORATIVE ARTS AND POTTERY

Art glass from New England and representative examples by Steuben, Tiffany, and Millville craftsmen form the basis of the museum's holdings in American decorative arts. Featured in this collection are signed works by prominent makers such as Dominick Labino and Isamu Noguchi.

The museum's ceramic collection is representative of both modern and contemporary crafts movements, with earlier works by Arthur Baggs, Edgar Littlefield, Otto and Gertrude Natzler, and contemporary works by Jack Earl, David Snair, and Ban Kajitani, among others.

Pottery by Native Americans of the Southwest includes examples by the Anasazi, the Acoma, and the Mericopa tribes, and from the pueblos of Santa Clara, Santa Domingo, and Santa Ildefonso. Watercolors, nineteenth-century saddle blankets, rugs, and jewelry round out this part of the collection.

Steuben Glass Works,
 twentieth century
Vase (Blue Aurene)
Blown glass, H. 6¼ in. (15.9 cm.)
Gift of Audrey Prine Bussert in
 memory of Edna Miller Prine
81.30

PRINTS AND PHOTOGRAPHY

The museum's print collection, numbering more than 2,500 works, includes lithographs by George Bellows, woodblock prints by Rockwell Kent, and etchings by Childe Hassam and John Sloan. Contemporary printmakers such as Sam Francis, Red Grooms, Philip Pearlstein, Edward Ruscha, Frank Stella, and Roy Lichtenstein are prominently represented, as are local and regional artists. Among the photography holdings are works by Edward Steichen, Walker Evans, and Bernard and Hilda Becher.

Edward Steichen, 1879–1973
Henri Matisse
Black and white photograph,
 11 x 8 in. (27.9 x 20.3 cm.)
Museum Purchase: Howald
 Fund
76.28